# Nicholas Ray

Also by Patrick McGilligan

*Cagney: The Actor as Auteur*

*Robert Altman: Jumping Off the Cliff*

*George Cukor: A Double Life*

*Jack's Life: A Biography of Jack Nicholson*

*Fritz Lang: The Nature of the Beast*

*Clint, the Life and Legend: A Biography of Clint Eastwood*

*Film Crazy: Interviews with Hollywood Legends*

*Alfred Hitchcock: A Life in Darkness and Light*

*Oscar Micheaux: The Great and Only*

Edited by Patrick McGilligan

*Tender Comrades: A Backstory of the Blacklist* (with Paul Buhle)

*Six Scripts by Robert Riskin*

*Backstory: Interviews with Screenwriters of Hollywood's Golden Age*

*Backstory 2: Interviews with Screenwriters of the 1940s and 1950s*

*Backstory 3: Interviews with Screenwriters of the 1960s*

*Backstory 4: Interviews with Screenwriters of the 1970s and 1980s*

*Backstory 5: Interviews with Screenwriters of the 1990s*

# Nicholas Ray

*The Glorious Failure of an*
*American Director*

## PATRICK McGILLIGAN

*it***books**

AN IMPRINT OF HARPERCOLLINS*PUBLISHERS*

# it*books*

A hardcover edition of this book was published in 2011 by It Books, an imprint of HarperCollins Publishers.

NICHOLAS RAY. Copyright © 2011 by Patrick McGilligan. All rights reserved. Printed in the United States of America. No part of this book may be used or reproduced in any manner whatsoever without written permission except in the case of brief quotations embodied in critical articles and reviews. For information address HarperCollins Publishers, 10 East 53rd Street, New York, NY 10022.

HarperCollins books may be purchased for educational, business, or sales promotional use. For information please write: Special Markets Department, Harper-Collins Publishers, 10 East 53rd Street, New York, NY 10022.

First It Books paperback published 2012.

*Designed by Ashley Halsey*

Library of Congress Cataloging-in-Publication Data has been applied for.

ISBN 978-0-06-073138-0

12 13 14 15 16 OV/QG 10 9 8 7 6 5 4 3 2 1

*To the memory of my friend Joel Gersmann,*
*another glorious Wisconsin director*
*(1942–2005)*

# Contents

VIII    *Contents*

# The Iron Fist, the Velvet Glove

## AUGUST 7, 1911

Nicholas Ray was a kind of human jigsaw puzzle, the pieces of his mystery scattered and lost over time.

Many of his films were haunted by bruised young people, threatened, damaged, or twisted by events beyond their control. Their suffering often begins in youth, its source a secret buried there.

Mementos of childhood crop up in Ray's films like missing pieces of the puzzle. Sports trophies line the top of a dresser in the room of an embittered detective in *On Dangerous Ground*. A broken-down rodeo champion finds a rodeo handbill, cap pistol, and tobacco-can bank squirreled away in a crawl space under his old homestead in *The Lusty Men*. ("I was looking for something I thought I lost," he tells an old-timer carrying a shotgun who interrupts his search.) Sprawled drunkenly on the ground, James Dean pulls a scrap-paper blankie over a cymbal-banging monkey toy during the opening credits of *Rebel Without a Cause*. ("Can I keep it?" he pleads when arrested.)

Even so, the source of hurt is private and vague and remote—not, as in the case of another Wisconsin filmmaker, as knowable as a certain Rosebud sled.

In his films, Ray tended to load the blame on mother and father fig-

ures. The parents in *Rebel Without a Cause* are fundamentally clueless. The drug-addicted father in *Bigger Than Life* tries to use a scissors to sacrifice his young son to God. Fathers are faulted the most in Ray's films, while mothers linger in the shadows, blurry and complicit.

His unorthodox "heroes" (the drug-addicted father is one) are destined to fail. The obstacles they face are nothing compared to their own neuroses. They are burdened above all by their integrity.

Ray's intense, searching visual style mirrored his personal struggles. His best films—a list that would arguably include *They Live by Night, In a Lonely Place, On Dangerous Ground, The Lusty Men, Johnny Guitar, Rebel Without a Cause, Bigger Than Life, Bitter Victory,* and *Party Girl*—can't easily be categorized. They owe something to Hollywood, where he never quite fit in, and everything else to his iconoclastic sensibility. First to the influential French critics of *Cahiers du Cinéma* and *Positif* in the 1950s, and to every succeeding generation of film fans since, Ray has become a symbol of artistic purity and tragic flaws: a test case of auteurist worship.

In his life, as in his films, everything began at home—hope and trouble, strength and fissures.

<div align="center">✳</div>

Home sweet home for Nicholas Ray was an all-American city that was rugged and beautiful, as ideal on the surface as an airbrushed portrait of the director at the peak of his fame.

Christened as a fur-trading post in 1841, La Crosse was settled on the eastern banks of the Mississippi River, at the confluence of the Black and La Crosse Rivers along what would become the border of Wisconsin (which became a state in 1848) and Minnesota (which followed in 1858). From a handful of houses, the town swiftly multiplied into a booming gateway to the West for merchants and adventurers. Germans and Norwegians swarmed in on packed trains and cattle cars from Milwaukee. By 1880, La Crosse had grown into the fourth-largest community in Wisconsin.

"Here is a town," declared the former steamboat pilot Samuel Clemens, a.k.a. Mark Twain, in his 1883 tall-tale memoir and travelogue *Life on the Mississippi,* "with electric lighted streets, and blocks of buildings, which are stately enough and also architecturally fine enough to command respect in any city. It is a choice town." And a choice setting: With its lush

greenery and majestic bluffs spared by the Ice Age, surrounding fertile farmlands, crystalline rivers and lakes, dense forests, and plentiful hunting and fishing, the area was hailed locally as "God's Country."

By the early 1880s, members of a German clan named Kienzle had reached God's Country. Nicholas Ray's German-born grandparents stopped briefly in the Teutonic stronghold of Milwaukee before heading to La Crosse, where they would eventually raise a brood of three sons and five daughters. Their oldest son, Raymond Nicholas Kienzle, was born in Milwaukee in 1863; he would wed twice, the first time at a tender age in Milwaukee, before meeting Nicholas Ray's mother. Kienzle's second marriage, in La Crosse in 1888, didn't last much longer than the first, though it produced two daughters, who continued to live near their father after their parents divorced.

An enigmatic, forbidding figure Raymond N. Kienzle was, as Ray himself recalled him. In his earliest photographs he wears an ironic smile, but later in life a walrus mustache and the El Producto cigar invariably lodged in his mouth gave him the gravitas of a successful tradesman. The Kienzles were building contractors, specializing in masonry, brick, and stonework for public edifices and luxurious homes for rich clientele, and in the 1890s Raymond, the oldest son, took over the family business.

Late in that decade, Kienzle got a big job renovating Gale College, a Presbyterian institution recently absorbed by the Lutheran ministry, in the town of Galesville, about twenty-five miles north of La Crosse. While there he met a quiet and kindhearted woman eleven years his junior. Slender and bespectacled Olene Toppen, known as Lena, had been raised on a nearby farm, one of nine children born to parents who were natives of Norway.

The couple married in 1898 and soon moved onto four acres near Galesville. Their land included a brickyard factory where Kienzle employed a handful of workers. Kienzle took local commissions, including a cement archway entrance to Galesville's High Cliff Park, but also jobs that took him away for weeks elsewhere in the Midwest and as far as the Deep South.

All four of the couple's children were born in the small town of Galesville: three girls—Alice (b. 1900), Ruth (b. 1903), Helen (b. 1905)—and, at last, a son. Raymond Nicholas Kienzle Jr. came bawling into the world on August 7, 1911. As a boy he would be called "Junior" or "Ray," and in due

time he would drop the name "Kienzle," reverse the order of his first and middle names, and adopt "Nicholas Ray" as his identity.

After he turned fifty, Raymond Sr. decided to cut back on his factory work and travel. He put the trappings of his business—the brick machines, molders and sanders, kiln, sheds and tools, and the Galesville land itself—up for sale, and in stages moved his family back to La Crosse, purchasing a series of houses co-owned or shared by Kienzle relatives. By 1920 the Kienzles had landed in a house at 226 West Avenue North, near the corner of Vine, facing west toward downtown and, just about a mile away, the river the Indians called "the Father of Waters."

＊

Especially after *Rebel Without a Cause,* the mythology surrounding Nicholas Ray tended to highlight stories of a misspent youth, complete with drinking, truancy, car thievery, brushes with the police, and flirtations with his father's mistresses.

In many ways, however, his boyhood offers a scrapbook of an American idyll.

Galesville wasn't far from La Crosse, and in the early years the Kienzles made regular trips to the bigger city for shopping, holidays, and visits to relatives. It was the city's first-rate public schools that eventually lured the family to return there permanently. Although the countryside was still dotted with a few tepees, and scattered steamboats continued to roam the Mississippi, by 1920 Mark Twain's "choice town" had transformed itself from prairie way station to glittering metropolis. La Crosse's streets were lit with electricity and paved with stone, whizzing with automobiles and streetcars; most neighborhoods had sidewalks and garbage collection, and thousands of households had telephones.

La Crosse had cause for civic pride, though the lives of its citizens were subject to the whims of extreme weather. The wind whipped across the Mississippi—perhaps not quite "like emery cloth tearing across their faces," as René Hardy wrote of the searing ghibli in *Bitter Victory,* but turbulently in the summers and frigidly in the winters. Those winters, which brought snow and ice before Thanksgiving most years, were the real endurance test. Yet La Crossians embraced the season with skiing and skating and an annual winter carnival that featured dozens of floats

and fur-wrapped marching bands and employee clubs representing local businesses. Ray must have remembered the strong wind, for it often blew dramatically through key scenes of his films—sending up a murderous sandstorm in *Bitter Victory,* howling outside as Mercedes McCambridge makes her grand entrance in *Johnny Guitar,* blowing back the hair of the mourning teenage rebels standing cliff-side in *Rebel Without a Cause.*

The Kienzles lived on a street with several other Kienzle aunts and uncles, in a two-story house that was large but not architecturally fine: "a big yellow barn," remembered Ferdinand Sontag, a neighbor and classmate of Ray's. The living room featured a parquet floor and an Italian marble fireplace; antlered heads decorated the walls, and the family's shelves were crammed with books. There was a separate piano room; Lena Kienzle played violin, and all her children learned to play at least one musical instrument. For supper, the dining room was set with linen and lace; for parties and holidays, the house filled with relatives, friends, and flowers.

By 1920, Ray's father was semiretired, but he still took small jobs as a bricklayer, cement man, and plasterer. He was active in the chamber of commerce, while his wife earned plaques volunteering with the Red Cross and Community Chest. Though raised as a Catholic, Raymond Sr. had been excommunicated after his first divorce; for a time he joined the Congregational Church, but eventually drifted away from organized religion. His wife, brought up as a strict Lutheran, trended toward Methodism and faithfully took her children to services and Sunday school. Ray Jr. had been steeped in the Bible, long before the temerity of his film *King of Kings.*

Ray Jr. was a Boy Scout, a good boy who delivered patriotic speeches in grade school. On Election Day in 1924, as President Calvin Coolidge faced off against Democratic candidate John W. Davis and Wisconsin Progressive Robert M. La Follette Sr., the thirteen-year-old eighth-grader urged his Lincoln Junior High School classmates to remind their parents to vote.

All three of Ray's sisters doted on their young brother, the only boy in the family. His siblings were all pretty, with wavy hair like their mother's, good-humored but serious-minded, anxious to leave home and La Crosse.

They also nursed ambitions beyond marriage. The eldest, Alice, had already graduated from nursing school by the time of her young brother's Election Day speech; after exchanging vows in the Kienzle living room, she moved with her husband to Madison, the college town that was swiftly surpassing La Crosse in size and prospects and glamour. The next-oldest

sister, Ruth, was on the verge of departing for Chicago. One by one the girls left—with Ray Jr.'s favorite, Helen, closest to him in age, the last to go.

Ray felt particularly close to Helen—close enough that, in one of his autobiographical jottings, he confessed that his first crush was on her. "Ever since I was four and she was nine I've wanted to make it with my sister Helen," he noted wryly, "because she was my sister." Years later, reflecting on some of his adult relationships, he would joke about a history of similar improprieties and feeling "bent towards incest with other people's children and wives, ex-wives, and daughters and such."

By the time Ray was a freshman at La Crosse Central High School, Helen too had graduated and was planning her escape. The table settings dwindled at home. Ray felt abandoned and lonesome, and this loneliness, which was with him from earliest memory, never abated. It was fundamental to his character and the themes of his films—which were often preoccupied with "the loneliness of man," he noted, peopled by characters who suffer "much agony and much searching," culminating in a private despair.

In youth and manhood alike, Ray too was a soul-searcher in tortured colloquy with himself.

＊

His mother lavished attention on the girls, but when it came to Ray Jr. she deferred to her husband.

Raymond N. Kienzle Sr. was tall, his size and erect carriage lending him a larger-than-life air. The filmmaker romanticized his father later in life, once boasting that Raymond Sr. had "built levees, docking areas for steamboats and dykes against floods," as well as "colleges, creameries, whorehouses, cathedrals, and breweries." Beyond his success as a contractor, his father had other positive qualities: Raymond Sr. loved music and literature, politically a Republican, he was known to speak out against racial prejudice at the dinner table. In 1924 he may even have voted for the spoiler La Follette, who carried only one state—Wisconsin.

But Raymond Sr. cast a formidable shadow. His son's delinquency started as early as his Boy Scout years, by which time he was already smoking and drinking and playing hooky. A stern disciplinarian, the father had an iron fist, punishing his son physically for his indiscretions. And there was something else: As the director put it once, he was raised under "the

lash of alcoholism." Though Lena Kienzle was a teetotaler, her husband was a dedicated alcoholic. Drinking was one way to imitate his father. "All during childhood and Prohibition," the filmmaker recalled years later, "there was booze in the house, and on the street. At home it was for stealing: I stole my first pint at ten. On the street it was for buying—grain alcohol mixed with sugar and hot water—with money stolen from home. . . .

"I learned about Aqua Velva long before I started shaving. No, I didn't drink it. I poured it over the sheets or into the bathtub to clear the smell of my puke."

The household was filled with tension. Ray's parents slept in separate bedrooms, and after dinner Raymond Sr. often disappeared, prowling a city that despite Prohibition was flush with speakeasies and saloons. Sometimes he didn't come home until the next day.

"If he had the guts to knock Mom cold once," Jim Stark (James Dean) muses harshly in *Rebel Without a Cause,* "then maybe she'd be happy and stop picking on him."

Raymond Sr. had a series of mistresses, one of whom his son learned about around age fourteen. "At fifteen, I made an unsuccessful pass at her," he recalled ruefully. Womanizing, a lifelong habit embedded in his youth, was another way for the son to emulate his father.

Raymond Sr. loved flashy cars—his name often appeared in the local paper as one of the first owners when a shipment of new models landed in town—and he had ulterior motives for teaching his young son to drive. "I learned to drive when I was thirteen," Ray recalled, "so I could get my father home safe from his nightly rounds of speakeasies and bootleggers. Sometimes I'd wait for him in the car and masturbate." This peculiar father-son bond—this sharing of drink and women and cars, often with punishment lurking—became a blueprint for what filmmaker Mark Rappaport described as the "Gordian knot of unbelievably complicated father-son, older man–young man relationships" in Ray's life and films.

In 1927, the Kienzle family changed forever. One night in the fall, Raymond Sr. went missing. Searching for him, Ray tracked down his father's current mistress in "a speakeasy across from a brewery my father had built. She led me to a hotel room. He was lying in sweat and puke, with puke pans on the floor at the side of the bed. I took him home and nursed him through the night." Twenty years later, that memory was echoed by dialogue he wrote for Farley Granger's character, recalling his own youth-

ful trauma, for a scene in *They Live by Night:* "Pa turned to me like he was trying to say something. I saw his face . . . white. Like he was gonna cry."

Ray dragged his father home to recover. The next day he skipped his Latin class, as usual, decamping to a pool hall to practice three-cushion billiards with pals. His mother had to track him down by phone to tell him his father had passed away.

Convinced that the doctor who had treated his father was a dope addict ("before I left for school I watched him heat a substance in a spoon and draw it into a hypodermic"), Ray persuaded his mother to file a lawsuit against the physician. When the court date came, however, Ray was "so pissed on home brew" that he "couldn't testify," so his family lost.

"The next day I saw the doctor walking on Main Street," Ray said. "I was driving a new Oakland Cabriolet. I was drunk. I ran the car at him across from the cathedral my father had built. A fire hydrant got in the way."

No documents have survived to verify Ray's account of the malpractice suit or the reckless driving citation ("my first ticket") he recalled receiving for the hydrant incident. Yet his father's death is documented in official records and the city newspaper: Raymond Nicholas Kienzle Sr. died on November 11, 1927, at the age of sixty-four. Ray's three sisters, now all married, returned to La Crosse to grieve. Though the Kienzles kept in close touch and clung to each other in many ways, they wouldn't reunite for another twenty years.

Just sixteen, Ray was bereft; he felt more alone and abandoned than ever. "Nick didn't have a father," Susan Ray, his fourth wife, insisted in an interview years later. "A drunk is not a father. I think he was looking for that. And when people have a piece missing they *magnetize* it in different ways."

"I hated my father for dying too soon," the director himself wrote with curious vehemence, "while in earlier years, when it was normal to want him out of the way—because he was a rival for the warmth of my mother, a witness to my fear, scorner of my pimples, withholder of money, knower of my sexual agonies, punisher of all my indiscretions, and an embarrassment in his work clothes and accent—I hadn't been strong enough to kill him."

Hate and love mingled uncomfortably in Ray's psyche, and he never forgot those feelings of loss and need. "A boy needs a father at certain times in his life so he can kick him in the shins," Ray reflected one time, "so he

can fight for the love of his mother. The boy misbehaves at one point, runs away at another, while his father remains constant, a gauge against which the boy can measure himself. Take that away and the spine is lost."

✳

Raymond N. Kienzle Sr. had prospered with the growth of La Crosse, and in death he provided well.

According to probate files, Kienzle owned land parcels worth an estimated $15,000, and goods and savings worth another $6,000. His will granted no bequests for his five daughters (including the two daughters from his second marriage), all of whom were married to husbands with jobs and assets; nor did he set aside any sum for his underage son. The estate was consigned entirely to his wife, unless she remarried. Two years later, the Wall Street crash would rattle these holdings, but Lena Kienzle proved capable as a money manager. She never remarried, and she lasted on the inheritance until her death in 1959.

Twenty-one thousand dollars was a considerable sum in 1926, qualifying the Kienzles as solidly middle-class; the family even employed a maid. Still, their affluence didn't hold a candle to the fortunes of the first families of La Crosse, the barons of lumber, railroads, rubber, and beer who lived in mansions in the city's older, grander districts—mansions built by contractors like Kienzle himself.

Among these families were the Loseys, descended from Joseph W. Losey, a lawyer, district attorney, and city councilman who had helped bring the railroad and waterworks to La Crosse in the mid-nineteenth century, and acquired and laid out the spacious grounds of the city cemetery. Losey's grandson and namesake, Joseph Losey, born in 1909, was an older classmate of Ray Kienzle Jr.'s at La Crosse Central High School.

The young son of a prominent family, Joseph Losey could drive his car along the city's bluffs on Losey Boulevard, a scenic roadway named for his grandfather. He vacationed abroad with his family and left La Crosse behind after graduation, heading east to college. Ray Kienzle was fortunate to make the occasional trip to Minneapolis, Madison, Milwaukee, and Chicago; his was more like the family in *Bigger Than Life*, gazing at exotic posters for destinations they couldn't afford to visit. Though the two young men grew up in the same time and place and attended the same

schools—and both went on to become movie directors—the age and class differences between them meant that Ray Kienzle Jr. and Joseph Losey had only a nodding acquaintance in La Crosse. Their hometown connection would bring them closer as adults, in New York and Hollywood and still later in Europe.

Yet Losey recalled things quite differently. "*His* family had much more money than ours," Losey insisted, though he himself was the true child of privilege. It was a mark of Losey's character that he always assumed a posture of lowliness, while Ray hid his humbler origins by armoring himself with grandiosity. Mutual friends were sometimes fooled. "I knew them both in Hollywood," recalled actress Betsy Blair. "It's funny, both came from the same town in Wisconsin. One came, I heard, from a wealthy family, and the other came from the other side of the tracks. I assumed it was Nick who came from the wealthy family. He had a kind of elegance, arrogance, an aura, a princely manner, while Losey was [socially] awkward, often dressed messily, and [was] not so handsome."

✳

If Ray Kienzle Sr. was the iron fist, his wife Lena was the velvet glove.

If Nicholas Ray felt he was competing with his father, even for his mother's love—if, like certain characters in his films, he wished he had done more to fight for her affection—perhaps it was because Mrs. Kienzle gave her children that love so freely. Ray's mother pampered him throughout his childhood, and especially after her husband's death.

In turn, Ray absorbed his mother's temperament, developing a personality that couldn't have been farther from that of a teenage delinquent. Despite his angst and streak of rebellion, he was sweet like his mother, earnest—in a word, *nice*. As an adult he would be the sweetest of all Hollywood directors, a breed more known for the iron-fistedness evinced by his father. "One of the nicest people I've met," recalled Ernest Borgnine, who appeared in Ray's films *Johnny Guitar* and *Run for Cover*, "as well as a helluva director."

As a teenager, Ray had a beautiful smile and a repertoire of grins—sly, shy, amused, mischievous. Beneath them, however, he remained fundamentally restless and lonely. Though sometimes garrulous, Ray was also prone to long, ambiguous silences. Like James Dean in *Rebel Without a*

*Cause,* who screams at his parents, "You're not listening to me!" he yearned for someone to talk to—or to listen to him.

In youth and adulthood alike, drinking colored everything. After his father's death, his delinquent habits worsened. His mother had endless patience but no answers. She appealed to her daughters, his sisters—the first of many women in his life to offer Ray a safety net.

Early in 1928, the sixteen-year-old was sent to live with Ruth and her husband in Chicago (the "Near North Side" of Chicago, where Gloria Grahame's character in *In a Lonely Place* claims she logged time as a Fuller Brush Girl). It may not have been the first time he was pulled from school in La Crosse. "I got kicked out of high school seventeen times," the director liked to brag. "I'd been a member of a youth gang," he boasted on another occasion, "the president of an illegal fraternity in high school." He was surely exaggerating, but the details in his most personal film, *Rebel Without a Cause,* suggest a familiarity with stolen cars and sympathetic police, and he did vanish to Chicago more than once as a young man.

Ruth Kienzle—"the most sophisticated" of his three sisters, according to Bernard Eisenschitz in his admirable and admiring book *Nicholas Ray: An American Journey*—had fanned her brother's earliest interest in show business, taking Ray to stage shows and his first motion pictures. The very first was D. W. Griffith's *The Birth of a Nation,* playing at a Main Street theater in late 1915, when "Junior" was just four years old.

As a teenager Ruth was enamored of show business and thought about becoming an actress until her father tamped down her dreams. Now employed by the society fixture Edith Rockefeller McCormick—daughter of oil tycoon John D. Rockefeller and divorced wife of International Harvester executive Harold F. McCormick—Ruth "released some of her frustrations by continuing to guide me to concerts, theatres, and nightclubs in Chicago during the Capone years," Ray recalled. The director would revisit this boisterous era in *Party Girl,* the semimusical gangster picture he made for MGM in 1958.

In Chicago, the wayward youth was enrolled at Waller High School,* and under his watchful sister's care his behavior improved enough that he was allowed to return to La Crosse Central High School halfway through his senior year. His habit of shuttling back and forth between Chicago and

---

\* The school is known today as Lincoln Park High School.

La Crosse was well-known enough that the school paper joked about it on February 5, 1929, reporting that "Ray Kienzle becomes a student again."

Ray Kienzle's name came up often in the high school paper and yearbook, often in the context of jokes, but always fond ones. He was well liked, popular with both peers and his teachers, who shook their heads bemusedly over his failings. He was a little like the teacher's pet in *Bigger Than Life,* who looks stumped when asked to name the Great Lakes but is trusted by James Mason to preside over the class when the teacher steps away.

Kienzle already had the reputation of a pleasure-seeking spendthrift. (Maynard L: "I spent ten dollars on a canary last week." Ray K: "That's nothing, I spent fifty dollars on a lark last night.") He was good-humored and self-deprecating, especially about his grades. ("I got an A- - once—in slumber," he wrote under his class picture in the yearbook.)

Kienzle played some football and basketball as an underclassman, but his athleticism was a bit of a ruse, like James Mason's in *Bigger Than Life.* (Boasting of his own high-school pigskin triumphs—"third-string sub to hero in twenty seconds!"—Mason's character puts his young son through intense football drills, until his life spirals out of control and his glory days are revealed as delusions.) For Ray, sports and machismo were more a means to kinship; and by senior year he was a cheerleader on the pep squad.

By then, his real interest had shifted to the debate team. Public Speaking was his new favorite class, and he followed his sister Helen in taking private lessons from local elocutionist Winona Hauser, who also helped direct stage plays at La Crosse Teachers College. Kienzle blossomed under Hauser's tutelage, his oratory showing flair and promise. Her brother had "a very nice speaking voice," according to Helen, "well-modulated."

More important, by senior year Kienzle had gravitated to the Falstaff Club, which mounted the high school plays. Most if not all of his Falstaff tenure was spent backstage; his name appears on none of the published cast lists. Yet Kienzle found allies in fellow students like Mrs. Hauser's son Alonzo, a budding sculptor, and Russell Huber, an older boy who exhorted Kienzle to try anything. Such kindred spirits must have been all the more welcome to a brooding young man living alone with his mother.

✳

One feature of La Crosse's bustling local arts scene was the Guy and Eloda Beach Stock Company, which usually threw down stakes in the river city during the holiday season, offering a range of familiar plays and variety shows at the Majestic Theater downtown. Eloda, a diminutive, bubbly redhead, and her husband, Guy, an all-purpose lead who also directed the shows, lived part of the year in the city—they were "famous in La Crosse," as people liked to say—but they toured the Midwest tirelessly for ten years after the First World War.

The Beaches' weekend matinees drew farm families from miles around, and they often recruited townies as supernumeraries. Guy Beach had a theatrical personality and served as an example of professionalism and versatility to any number of young actors who got their start with him. Kienzle soon became Guy Beach's number one fan. He hung around behind the curtain and memorized his first lines for crowd scenes in Beach Stock Company plays.

The theater wasn't Kienzle's only interest. By the late 1920s, radio broadcasting was catching fire across America, and La Crosse Central High launched radio classes as part of its speech curriculum. In conjunction with Herbert Hoover's inaugural address in the first week of March 1929, which was aired at the school on specially installed auditorium speakers, the local radio station, WKBH, announced a contest for aspiring radio hosts. The contest was sponsored by Tri-State, an ice cream company servicing Iowa, Minnesota, and Wisconsin.

Members of the school's senior class were invited to compete for the title of best emcee for a musical radio program. In the elimination trials, which went on for months at the station's headquarters in the magnificent Stoddard Hotel downtown, contestants took full charge of the mike. They were judged for their "promptness and snappiness" as well as "inflection, tone, volume and articulation" and "interpretation or description of music and artists." "The quality of [their] picture words" was essential, according to press accounts, but so was "that indefinite necessity, 'air personality,' a quality akin to the well-known 'it.'" Eventually the field was narrowed to five finalists, all of whom received private coaching from the head of the high school speech department before the last round.

One of those five finalists was Kienzle. By now he was impressively tall like his father, gangly but handsome, with piercing pale blue eyes and wavy dark blond hair like his mother. Thanks to the guidance of his sisters and mother, the camaraderie of the debate team and Falstaff Club, and the guiding influences of Winona Hauser and Guy Beach, in just months he had transformed himself from a drink-addled miscreant to a polished, confident radio host. To his sweet personality the seventeen-year-old had added a distinct theatrical veneer—an "on-air personality," as it were.

Sure enough, when the results came in that July, Ray Kienzle was the last host standing. Ray often boasted about winning the contest in later interviews, recalling that it garnered him a scholarship to "any university in the world." The La Crosse newspaper published Kienzle's yearbook photograph, with the victor sporting a suit and tie and a toothy grin. His radio training would be good practice for his future Hollywood profession, which would demand the same take-charge personality, imagination, and gift for translating words into pictures.

✳

In 1958, in his first interview with the French film journal *Cahiers du Cinéma*, Ray said he was "absolutely incapable" of recalling exactly why he was drawn so early to a life in the theater. "Did it come from a feeling of revolt, from a particular pressing influence, from a need to attract attention, or from something else? I don't know . . ."

It certainly wasn't the lure of college. Regardless of the prize he'd won, Ray's abysmal high school grades left him with few options for higher education. It wasn't just the suspensions and absences—it took real lassitude to graduate 152nd out of 153 students in the La Crosse Central class of 1929. Ray did draw good grades in his preferred subjects—English, salesmanship, and public speaking—but he flunked Latin, physics, and geometry. Indeed, the La Crosse newspaper listed him as a "night school graduate."

Ray found a temporary solution in a public institution just a short bicycle ride away from his home. La Crosse State Teachers College was a onetime "normal school" primarily dedicated to training teachers.* As a teachers college it had a limited curriculum, offered no graduate programs

---

* The school has since become the University of Wisconsin–La Crosse.

or professional coursework, and had few doctorates among its faculty. Yet the school had a forceful new president, George Snodgrass, and under his leadership it was making strides toward becoming a fully accredited liberal arts college and had just begun issuing four-year degrees.

Despite its fledgling academic standing, there was no social stigma attached to Teachers College. To the contrary, it was customary for La Crosse high school graduates to matriculate there while saving up for—or awaiting admission to—more exclusive colleges, particularly the University of Wisconsin in Madison. The new freshman class of 1929 included Ray Kienzle as well as his friends Robert Fries and Clarence Sezezechowski, both former Central High School debaters and Falstaffians. Indeed, Kienzle's debate and drama clique swept the campus in the fall of 1929; soon he and his friends had taken over the Buskin Club, the elite stage society, and the *Racquet,* the student newspaper.

In those days drama was considered essential to teacher training, and Teachers College had an exceptional speech department, which, besides producing established plays and original works by students, hosted professional touring troupes and noteworthy guest lecturers.

The Buskin Club presented one-acts at each of its meetings, mounted ambitious all-campus shows, and performed playlets in neighboring towns. The Buskineers also spearheaded campus-wide social activities, hosting the semiformal annual Buskin Hop in the ballroom of the Stoddard Hotel. "*The* social event of the year," recalled Ferdinand Sontag, a classmate of Ray's at both La Crosse Central and Teachers College.

New Buskin Club aspirants had to survive an audition. Now growing into a handsome young man with a cultivated voice, Kienzle made an impression at the fall meeting and was quickly voted in. It didn't hurt that other new members included Fries, Sezezechowski, and Sontag, all pals or acquaintances, along with Kathryn Snodgrass, probably Ray's first true girlfriend. Later in life Ray would gravitate toward many smart, beautiful women in the spotlight—Judy Holliday, Shelley Winters, Marilyn Monroe, Joan Crawford, Jayne Mansfield, Zsa Zsa Gabor, and more. The bright, witty, bobbed-haired Kay Snodgrass, the daughter of the Teachers College president and therefore herself "famous in La Crosse," might be considered the first.

Although Kienzle started out backstage (initially as the club's advertising manager), he made a splash in his second semester as coauthor, with

Snodgrass, of an "original musical comedy revue" called *February Flurries*. Interestingly, the revue was a "take-off on all-singing, dancing, talking pictures" following the misadventures of a college student who decides to seek his fortune in Hollywood. *February Flurries* featured skits, songs, dances, even "Eccentric Clogging." Both writers played leads, with Kienzle also serving as the master of ceremonies—not unlike the job of a radio announcer, or a movie director.

The staging of *February Flurries,* guided by Professor D. O. Coates with the help of Winona Hauser, proved a milestone for Ray, cementing his local profile. The *Racquet,* the school's student weekly, held nothing back, describing the revue as "one of the greatest achievements" in the college's history of stage productions. To mark the show's opening, the paper spread photographs of Ray and Snodgrass across the front page—and later dropped gossip-column-style hints about their love life, noting sightings of "Ray and Kay" cozily driving around town in her Studebaker.

As his high school grades in salesmanship attest, Ray had an early knack for self-promotion, but publicity in the *Racquet* wasn't hard to generate—especially considering that Kay Snodgrass served as the paper's features editor. By February, Ray himself had been installed as sports editor, often writing unbylined accounts of diverse athletic events. Soon Robert Fries became the paper's editor in chief and Clarence Sezezechowski—who changed his unwieldy last name to the better byline of "Hiskey"—joined them as a staff artist and all-purpose reporter.

In April 1930 the *Racquet* carried another front-page photo of Ray Kienzle, this time trumpeting his lead in *The New Poor,* a three-act comedy that was the main Buskin production of the year. Kienzle played the Grand Duke, a role his friend Russell Huber had played in their high school. Huber drove up from Chicago for opening night weekend. While in La Crosse, he talked up the University of Chicago, where he was a theater major. Huber was especially enthusiastic about the English class taught by Thornton Wilder, a Pulitzer Prize winner in 1928 for his novel *The Bridge of San Luis Rey.*

Wilder had impressed Ray when the author, a native of Madison, Wisconsin, spoke at Teachers College earlier in the semester. Wilder delivered a riveting address to a packed audience, proclaiming that literature should reflect "a true expression of life," a credo that seemed to capture the spirit of hard times after the Wall Street crash and the onset of the

Great Depression. Wilder's "brilliant and ingenious" language dazzled the college crowd, according to a *Racquet* account, and the La Crosse students realized "they had for a brief time met a person to whom the term materialistic American could not apply." After the lecture, Ray made a point of shaking Wilder's hand.

Wilder wasn't the University of Chicago's only attraction. The school's innovative new president, Robert Maynard Hutchins, had taken office in 1929 as a champion of great books and ideas. Kienzle hadn't read many great books yet, but working for the *Racquet* got him into the lifelong habit of reading newspapers—clipping items of interest—and both the *Racquet* and the *La Crosse Tribune and Leader-Press* covered the educator's every bold move.

Kienzle told Huber he was determined to join him in Chicago.

✳

All of La Crosse rushed outside gratefully to greet the summer, which was inevitably short, hot, muggy, and bug infested, but studded with parades, festivals, traveling circuses, and Wild West shows. A lifelong music lover, Nicholas Ray never forgot the revelation of hearing "The Dardanella Blues" played on a summer night down at the waterfront by a band featuring pianist Lil Hardin and her husband, trumpeter Louis Armstrong.

It must have been during the summer of 1930 that Kienzle made a little pocket money traveling with stunt fliers, according to later movie-studio publicity.

The college itself was quiet and dark in the summer. Summertime was slow and the living was lazy in La Crosse; the river sometimes overflowed its banks, raising a stench in the area. Storms raged and the sun blazed, sometimes in the same day. Kienzle, Kay Snodgrass, and friends haunted the downtown ice cream and sweet shops, making one cherry phosphate last for hours. They cruised the city in Snodgrass's Studebaker, lollygagging in the city's beautiful manicured parks.

Some days the only thing to do was climb "Ole Granddad," a landmark steep cliff rising six hundred feet above the downtown—like the one that gives a scared boy his last refuge in *On Dangerous Ground,* or the "big high bluff" where the chickie run proves fatal in *Rebel Without a Cause.* Climbing Ole Granddad was a cherished pastime in La Crosse; there you could

stare across the Mississippi, following the roads that twisted west, or lie on your back with a girl, trying to pick out the stars and constellations.

"I was just thinking," James Dean says to Sal Mineo as they stargaze at the planetarium in *Rebel Without a Cause,* "that once you've been up there, you've been someplace."

*

Ray Kienzle was nineteen years old, but he hadn't been much of anywhere, not yet. He would stay in La Crosse another year, mostly dodging education but staying productive in radio and theater.

Although his scholarship to "any university in the world" may have expired, the problems keeping him from transferring to the University of Chicago weren't really financial. Weak grades and his aversion to the classroom prompted Kienzle to skip the fall 1930 semester at Teachers College. Instead he helped out behind the scenes on Buskin Club projects and took the lead in organizing a college hour of playlets performed on Thursday mornings on WKBH.

Then, still not ready for Chicago, he returned to Teachers College for the spring semester of 1931. He came roaring back to the campus, stepping in for Kay Snodgrass (by then the two had broken up, and Kay had transferred to the University of Wisconsin in Madison) as a features editor at the *Racquet.* He also became the unchallenged leading light of the Buskin Club shows, on- and offstage.

By now Ray was a self-styled artiste, affecting a costume of flowing coats—and even a cape—that reflected his expanding horizons. Once a reluctant reader, now he devoured challenging poetry and plowed through political tracts. The college sophomore was undergoing a process of radicalization; living at home, he had no money for luxuries and decided he didn't need them. Like Thornton Wilder, Kienzle didn't intend to become a "materialistic American."

As the unemployment and poverty of the Depression spread, hobos and jobless drifters began popping up all over the country. La Crosse's homeless population was burgeoning. Troubles abroad made headlines in the city newspapers Ray Kienzle devoured. And although black people were scarce in La Crosse, reports of race crime and injustice were a fixture in the news.

None of this was lost on Ray Kienzle or his peers at the *Racquet.* By

the spring of 1931 Ray was contributing a new column called "The Bull-shevist"—a pun on "The Bolshevist"—under the byline "R.N.K." His writing style was stream-of-consciousness, with the dashed-off feeling of a diary—an intimate voice that would become a trademark of his writing. "The Bull-shevist" offered gossip, humor, musings, and one-liners about campus events and activities. While much of it was written in a kind of code that would have been clear to students in the know, at times it was rambling, even incomprehensible.

"Thoughts while in Bath," "R.N.K." scribbled on one occasion. "Among those present. O salt of the earth. A doll buggy is disturbing. Fights are interesting if only for the melodramatic reconciliations. Would like to see a ten-round Frazee-Sanders go. Cashman has an entirely tough role for tonight.* Confident that this lad won't hand us so much ad libing [*sic*] we have a pleasant enemy ahead of us. Then the Buskin to-do. Water doesn't take on silver nitrate. Neither does soap . . ."

For the first time in his published writing, which until now had focused narrowly on campus sports, Ray was giving rein to left-wing sentiments. In one column, he heaped scorn on the "voting intelligence" of the city electorate, deriding "our newly installed mayor [who has] declared himself in favor of beer." In another, he chided the *Tribune and Leader-Press* for an editorial about student misconduct, declaring that the paper ought to "harp more on the environment," which he felt was more responsible for encouraging negative behavior and attitudes than harmless student hijinks. "A paper should be more concerned with the welfare of the city and its citizens," he declared. But at nineteen Ray was hardly an ideologue; he also poked fun at doctrinaire-ism—at all -isms, for that matter. ("The distribution of will-power, and not wealth, should be contested by socialists and communists," he wrote.)

Politics did not consume his energies. He spent most of his spring term busying himself with his weekly morning radio show and Buskin Club playlets (even, one night, mounting a one-act play in French). He still led school cheers at bonfires and pep rallies and could be spotted at every major college sporting event, often writing up the games afterward. A regular Big Man On Campus was he.

---

\*   Frazee and Sanders were popular professors. Cashman was a fellow student and Buskin Club member.

Though Ray was seen with an endless number of girlfriends after Kay Snodgrass's departure, he assured the readers of "The Bull-shevist" that none of them was "special." Then as ever, he tended to turn romances—and even friendships—into endurance tests. He didn't sleep well, and his restlessness came alive especially at night. He hated to be alone; instead he stayed out all night, dancing, drinking, and playing cards, taking pride in stumbling home at dawn.

"You think the end of the world will come at night time?" Sal Mineo asks at the end of *Rebel Without a Cause,* just before he is gunned down.

"Uh-uh," James Dean replies. "At dawn."

<p style="text-align:center">❊</p>

The summer of 1931 stretched ahead. This must have been the summer Kienzle traveled to the West Coast—"my first hitch-hike to California"—to visit his oldest sister, Alice, and her husband. Later studio publicity claimed that he tried "his luck as an extra" in Hollywood on this trip; more plausibly, he recalled spotting one of his literary idols on the beach: Robinson Jeffers, a poet whose preference for the divine (over the solipsistic ways of man) appealed to Ray's own idealism.

He had left for California uncertain whether his dreams of transferring to Chicago would ever be realized. His grades were perpetually feeble; he was always retaking French I, for instance, never quite satisfying the requirements. (Though he liked French—even dropping a phrase or two into *Rebel Without a Cause*—years later he cheerfully confessed to a group of Parisian cinephiles that his command of the language was negligible.)

Yet he had worked hard at improving his overall academic performance, and finally it paid off. When he returned from California, an admission letter from the University of Chicago was waiting for him.

## Chapter Two

# *"Struggle Is Grand"*

### 1931–1934

Founded in 1890 by John D. Rockefeller, the University of Chicago was one of America's leading liberal arts colleges, set like a gem in Hyde Park and dominated by English Gothic buildings replete with towers, cloisters, and gargoyles. Its rarefied intellectual atmosphere and research programs guaranteed a steady yield of Nobel laureates—while the pulsing nightlife of Chicago was an equally powerful attraction for undergraduates.

After two halting years at La Crosse, Kienzle entered the prestigious private university in the fall of 1931 classified as a transfer freshman with "advanced standing"—meaning that some, but not all, of his La Crosse courses were accredited. His first-semester curriculum included old standbys like elementary French and public speaking, as well as a course called The Plays of Shakespeare.

Russell Huber was already gone, having finished his studies and returned to La Crosse. But Thornton Wilder remembered Ray and was expecting him. The transfer freshman was not eligible for the advanced course Wilder was teaching, Greek and Roman Masterpieces. But Wilder's lectures were open to all, and the famous professor lived in a student dormitory, where, he sometimes grumbled, students freely interrupted him and his writing regimen.

Professorial in appearance and personality, Wilder was "a tall man
[ . . . ] without the grace some tall men have," recalled director Elia Kazan,
who later worked closely with the playwright while staging *The Skin of Our
Teeth* on Broadway, "unnaturally thin, rickety, his complexion a washroom
green." To Ray Kienzle, however, Wilder was a golden exemplar of the
writer's life.

By his own account, Kienzle was an apt pupil more of life than of
coursework, which he habitually shirked. He recalled pledging to a frater-
nity within two weeks of arrival and playing football on a team of Greeks.
Women then as ever were one of his priorities. "I was continually stand-
ing on the tip of my stiff prick and therefore wanted, as in the old Jewish
curse, to go from bed to bed to room to room in every girls' dormitory," he
said. Drinking was another. "I took along [to Chicago] two gallon tins of
undiluted grain alcohol," he boasted.

More constructively, Kienzle joined the Student Dramatic Associa-
tion. His soulful personality, combined with his magnetic physical pres-
ence, quickly won over the faculty adviser, a drama professor named Frank
Hurburt O'Hara. Kienzle's initial triumph was surviving an open tryout
of one hundred of his peers for the first major show of the season: A. A.
Milne's three-act comedy *To Meet the Prince.* He secured the smallest of
eleven parts, delivering a few lines as the prince's secretary during the
show's brief November run.

The second Student Dramatic Association production in December
was more propitious, for it augured the world premiere of three one-act
plays by Wilder himself. *The Long Christmas Dinner, Queens of France,* and
*The Happy Journey to Trenton and Camden* were rehearsed for twice as long
as the usual student production, with the playwright himself monitoring
the auditions and run-throughs and attending every performance at the
Reynolds Club.

With Wilder's blessing, Kienzle landed the pivotal role of the Stage
Manager in *The Happy Journey,* a character anticipating a similar one in
*Our Town,* the play for which Wilder would earn a second Pulitzer Prize
later in the decade. (The role was so important to *Our Town* that Wilder
himself stepped into the part for two weeks during the play's initial Broad-
way run.) The Stage Manager was a sort of a radio host or master of cere-
monies; in *The Happy Journey,* he introduced the characters, acted bits, and
smoothed transitions in Wilder's loosely structured portrait of an average
American family on an automobile excursion.

Besides the acting experience it gave him, *The Happy Journey* gave Kienzle an opportunity to watch and learn as one of America's literary giants nursed his new work to life. Wilder advised on blocking and nuances, and even adjusted his own text during rehearsals. Ray and the other students delighted in "Wilder on stage," as the school yearbook reported, the playwright bristling with "Wilderian gestures and gesticulations."

Always armed with more questions than answers, Kienzle observed Wilder closely, pondering his decisions, buttonholing the playwright whenever something puzzled him. Eventually they developed a true mentor-protégé bond, with Wilder's preference for simple, natural drama influencing Ray's emerging artistic philosophy.

The premiere of the Wilder one-acts was the social highlight of the year at the University of Chicago. President Hutchins even bought out the entire house one night for a special performance for privileged alumni and friends. "Diamonds, emeralds, society, literati, a four night run, calls for author," reported the university yearbook. "All time record broken for Reynolds Club audiences."

Another inspiration to Ray, as much a father figure as a mentor—certainly he was old enough to be his father—was Frank Hurburt O'Hara, the adviser of the Student Dramatic Association and the director of the Wilder plays. A onetime promising short-story writer and newspaper drama critic, O'Hara had been a pillar of the Chicago faculty since 1924, one of the most popular professors on campus. In the 1930s, he would go on to write several distinguished histories of the theater. A tall, handsome bachelor with wavy silver hair, O'Hara supervised many extracurricular activities on campus—including the Blackfriars and the Mirror, drama groups for upperclassmen and women respectively—but freshman drama was his special charge.

Ray Kienzle spent his spare time (too much of it, by his own admission) sampling Chicago's rowdy music clubs, dance halls, and bars. He couldn't afford tickets to the expensive road-show plays presented in the ornate palaces of the Loop. But Professor O'Hara had orchestra seats for the prime attractions, and he befriended Kienzle, accompanying him to touring productions and sometimes bringing him along to elegant private dinner parties with Chicago's aristocracy and marquee theatrical names sprinkled among the guests. Wilder was a regular at the theater outings and dinner parties, and so was a mutual friend of his and O'Hara's, Inez Cunningham, a dynamic former *Chicago Tribune* film critic and arts editor

who had married into high society. Mrs. Cunningham's first husband had committed suicide, and now Mrs. Cunningham was being wooed by Harold Stark, a moodily handsome writer who had worked for the *New York Tribune* in the early 1920s and published a book of interviews with artists and celebrities such as Eugene O'Neill, Isadora Duncan, Theodore Dreiser, Nazimova, and Konstantin Stanislavski. Stark had just left a position as assistant director of the Minneapolis Art Institute and had since become an art critic and lecturer. Kienzle was drawn to his passion and intellect.

The young man from Wisconsin cultivated his lifelong knack for mingling—whether with celebrities or coal miners—at these gatherings. But Professor O'Hara's many kindnesses "bewildered me," Ray would recall years later. "I was not so brilliant as a young actor to warrant that kind of attention."

Late that October, a revival of Richard Brinsley Sheridan's comedy of manners *The School for Scandal* was mounted at the Grand Opera House, with Ethel Barrymore, the reigning first lady of the American stage, playing Lady Teazle. One night during the run, Ray recalled—it was a favorite anecdote—Professor O'Hara presided over a private dinner in honor of Barrymore. To the delight of the guests, the great lady inveighed against George S. Kaufman and Edna Ferber's *The Royal Family,* in which the actress was satirized as a prima donna capable of missing the opening curtain.

Suddenly, after holding forth about the sacrilege, the great lady interrupted her tirade in horror to ask the time. She was about to miss her own curtain! As she rushed off to avert disaster, Ray marveled at the spectacle of it all. "How privileged, how truly *in,* I had been, to actually smirk at Edna Ferber in company with the truly adult," he recalled. "A night on the heights . . ."

The Barrymore story was only the first of many diva episodes Ray would suffer in his career. But what happened next was just as memorable and privileged—as formative a Chicago experience, in its way—as apprenticing with Thornton Wilder.

After dinner, Professor O'Hara offered Kienzle a ride back to campus. "For some reason unknown to me," the professor drove his car to the edge of the "savage black water" of Lake Michigan and parked there. "I knew the approach of a man who liked other men was about to happen," as the director told a class in the 1970s. "He caressed me. I wanted to please him.

God knows I wanted to say thank you, somehow I wanted to say thank you. I said thank you. He unbuttoned my trousers. I wanted to come if he wanted me to come. I stroked his gray-white hair. I couldn't come. We drove back to campus."

Ray never said whether this was his first sexual contact with a man, and his language in telling the story ("I knew the approach . . .") suggests that it wasn't. Even as a young man, a sports cheerleader with a macho swagger, Ray was confused by his own sexuality. "I didn't know whether I wanted to be a homosexual or not," he reflected years later. "Homosexual was not in my vocabulary. Did I love and revere men more than women? I think I did."

But in these early years he hid any attraction to men, and throughout his life he wore his womanizing as a badge of honor. He would conduct highly public romances with women and guard his homosexual or bisexual side for decades, until he was all but washed up as a Hollywood director. Even then, Ray was capable of being coy or unforthcoming. Once, for example, he was asked publicly about the bisexual motifs in *Rebel Without a Cause*. "I'm not sure whether you mean the bisexuality of Jim, or the bisexuality of Sal [Mineo], or the bisexuality of myself," he answered. "I am *not* bisexual, but anyone who denies having a fantasy or a daydream denies having eaten a bowl of mashed potatoes."

However he privately defined his divided sexuality, Ray recognized that it informed his art in beneficial ways. As Ray mused years later, "That specific situation [in Chicago] brought to light an attitude in myself not consistent with the social denigration of homosexuals in those days. Later that attitude became very helpful to me in understanding and directing some of the actors with whom I've worked. I believe that I have been or would be successful in exposing the feminine in the roughest male symbol the public could accept. I always suspect the warmth or tenderness or color range of a person who publicly disports himself in either too strict a feminine or too strict a masculine role."

Father-son-lover formulas would haunt Ray's life. But whatever effect O'Hara's overtures had on Ray was short-term. His first semester at the University of Chicago would also be his last. Whether the cause was tensions over his relationship with O'Hara or Ray's continued drinking and poor grades, the newly transferred freshman lasted only one term before returning to La Crosse at Christmas.

✳

Not that Ray Kienzle returned with his tail between his legs. Rather, he took a bold step that evidenced his growing ambitions. In early January 1932, he announced the formation of a citywide dramatic organization called the La Crosse Little Theatre Group. Although Kienzle did not immediately reenroll in Teachers College, most of his new group's members were stalwarts from the Buskin Club, including Ferdinand Sontag as business manager and Clarence Hiskey as backstage utility man. Russell Huber, now a University of Chicago graduate, ran workshops for the group, and Teachers College speech professor Helen Dyson agreed to direct some of the plays.

The group's high-minded values were Kienzle's—including its insistence on artistic purity, which became a hallmark of Nicholas Ray's career. The Little Theatre Group's productions would be in "no way commercial," according to the official announcement of its formation in the *Tribune and Leader-Press*. "It is a purely amateur group, whose purpose is to develop the dramatic talent of its members for the enjoyment of the members themselves."

The group's premiere offering was a night of one-acts that drew heavily on Ray's semester at the University of Chicago. Professor Dyson directed an A. A. Milne playlet, while Kienzle promoted himself from Stage Manager to actual director of only the second-ever staging of Thornton Wilder's *The Happy Journey to Trenton and Camden*. The twenty-year-old Ray Kienzle had "studied with Thornton Wilder" and "secured the author's permission," reported a La Crosse newspaper. Wilder's permission was granted for one performance only, in the Teachers College auditorium, to a nonpaying audience limited to Little Theatre Group membership—plus local reviewers, of course.

The play's free-form structure depended "entirely on the ability of the actors to carry the audience with them," the critic for the La Crosse paper noted. But Ray was already demonstrating his gift for guiding players with whom he felt an affinity. The local drama critics applauded the performances under his direction, including Huber's work as Stage Manager, the role Kienzle had originated in Chicago. (Wilder's script was tweaked to suggest that the family's automobile had come from "the Huber-Kienzle

factory.") "Thoroughly satisfying entertainment," pronounced one La Crosse reviewer, "a distinct success."

Professor Dyson, who directed the other half of the bill, was a darling of the college community and another mentor to Kienzle. She had been directing plays in La Crosse since the mid-1920s, often playing the leads in her own productions. A lifelong spinster, Dyson was old enough to be Ray's mother; he and she were inseparable during the Little Theatre Group days.

The first half of 1932 was a busy time for Kienzle and his Little Theatre Group. He acted in or directed several workshop productions, including Edna St. Vincent Millay's dark, absurdist antiwar play *Aria da Capo.* He led a troupe of friends to a regional Little Theatre tournament in Winona, Minnesota, where he tied for first place in acting honors. And finally, in late April, Kienzle starred in and directed the organization's first major production: Noël Coward's *Hay Fever,* presented on the stage at Lincoln Junior High School. Reviewers praised Ray's sly performance as the ill-mannered, ultra-bohemian Simon—"a ticklish part, wavering as it does between super-adolescence and epigrammatical sophistication," as the *La Crosse Tribune and Leader-Press* observed.

The Little Theatre Group was so successful the company offered a return engagement of Wilder's *The Happy Journey* and Millay's *Aria da Capo* in June. Then, over the summer of 1932, the group branched into children's theater. With his reputation now soaring in La Crosse cultural circles, Ray opened a "private school in drama," teaching students aged seven to fifteen at his mother's house on West Avenue North, where he still lived. Ray presided over a six-week curriculum of morning classes in "pantomime, poise development, corrective and development speech, all to be done in recreational fashion," according to one newspaper account.

His Chicago acquaintance Harold Stark, who was gathering material for a lecture tour, came to visit during the summer. Their friendship deepened as Ray briefly traveled along on Stark's expedition, photographing mansions high above the river towns along the Mississippi evincing the "Steamboat Gothic" style of the pre–Civil War era.

The crowning glory of that summer of 1932—the last Ray would spend in La Crosse—was the city's Washington Bicentennial Pageant, a three-day festival held in conjunction with July Fourth festivities. La Crosse loved a parade, and the annual parade of parades was this procession

winding through downtown streets featuring hundreds of singers and dancers, marching bands and bugle corps, costumed historical characters, floats, flag bearers, and the reigning Miss La Crosse. And leading all the marchers that year was the recent college dropout Ray Kienzle Jr., appearing in costume as "young George Washington." It was a scene that epitomized the all-American side of Ray's boyhood—and doubtless furnished inspiration for the memorable July Fourth sequences in *Wind Across the Everglades,* a film Ray would make a quarter-century later.

<div align="center">✳</div>

The year that Ray Kienzle pranced down the streets of La Crosse as George Washington, carrying an American flag, was probably also the year he and Clarence Hiskey tried their darndest to form a youth chapter of the U.S. Communist Party.

Economic conditions had been deteriorating in the United States since the late 1920s, and Kienzle came back from Chicago fired with a desire to change the oppressive capitalist system. The University of Chicago was teeming with left-wing ferment: In the academic year 1931–32 alone, speakers there included Jane Addams, the Hull House founder and social crusader, and Ben Reitman, anarchist and physician to the poor (as well as Emma Goldman's lover).

La Crosse was hardly a revolutionary breeding ground, however, and Kienzle hadn't yet found a way to connect his artistic goals with his deepening social conscience. After mornings spent teaching theater to children, he and Clarence Hiskey and Robert Fries convened evening meetings at the Kienzle residence to agitate for the betterment of society. By now Kienzle was listing the home's side entrance as his address, yet his mother frequently opened the door to welcome his guests, a warm and pleasant hostess to child performers and incipient Communists alike.

The meetings were open to all, and Ferdinand Sontag and another Teachers College acquaintance, both of them virulent *anti*-Communists, attended the meetings to counter the arguments of their left-leaning classmates.

At "the first Communist meeting," Sontag reminisced, "there were some projects that were discussed. There was a little guy, who had a grease pot sandwich shop on Sixth and Main Street, and he wasn't paying his

waitresses enough and he was scum. He was what the Russians called the bourgeois. Those terms were freely bandied about. We were going to run a strike on him according to Mr. Kienzle—this little restaurant operator."

The strike plan must have fizzled—there is no record of it in La Crosse newspapers—but the true believers kept up their efforts. In early October, Kienzle and his ragtag cadre convened at the La Crosse Union Hall to hear an address by James W. Ford, a candidate for vice president on the Communist Party USA ticket in the upcoming national elections. The college Communists cheered Ford's speech and shook his hand; then, because Ford was African American—"colored," in the terminology of the day—and no La Crosse hotel would admit him, he was invited to bunk at the Kienzle home.

This couldn't have escaped the notice of Federal Bureau of Investigation (FBI) agents, who followed high functionaries of the U.S. Communist Party around America, jotting down the names of all their local contacts and conspirators. In the case of La Crosse they must have gotten at least two names: Clarence Hiskey and Ray Kienzle.

✳

In the fall of 1932, Ray Kienzle was back in classes at Teachers College, back with a new column in the *Racquet,* back playing lead roles in plays for the Buskin Club.

His hair was long now, his wardrobe all black and bohemian. Already a campus legend for his night-owl lifestyle ("I have been known to like a party," he averred in the *Racquet*), Kienzle was still not wooing any girl in particular. He was playing the field, he informed readers, "apparently free of amorous entanglements."

The *Racquet* had a new editor, not one of the old Central High gang, and Kienzle may have had to soft-pedal the politics in his revamped column, now titled "Bazaar Bizarre" and bylined "r.n.k." in the style of e. e. cummings. "Bazaar Bizarre" was just as likely to quote Masefield, the English poet laureate, as Marx.

As usual, however, "r.n.k." wrote as though he was conducting an internal debate with himself, like one of the characters in his films who stared into mirrors, as though waiting for the image to reply. When homecoming came around, "r.n.k." used the column to wonder aloud whether the annual

celebration, which once had compelled his interest, was now too trivial a subject for a socially conscious, artistic young man who hoped " to strive toward a bit of originality, or at least individualism" in his column.

Yielding to temptation, "r.n.k." went ahead and wrote about homecoming, but with a nostalgic air, recalling friends and sports heroes who no longer graced the campus. His college days were winding down, he sensed, and he knew he was marking time. "I am lost in reminiscences of affairs, love and otherwise, but love mostly, and of the Stoddard and of the Blue Moon, along with dens of iniquity," he mused in the column. "It's reactionary to be talking and thinking like this, but if you don't mind I'll allow myself."

Fretting aloud about the "prostitution of art" in a play he'd traveled all the way to Milwaukee to see—only to be disappointed by—Kienzle seemed more troubled by the possibility that he was selling out his own artistic ideals by prolonging his adolescence in La Crosse. Consulting a dictionary, he defined "prostitution of art" for his readers as "an act of setting oneself to sale, or of devoting to base or unworthy purposes what is in one's power; as the prostitution of abilities."

That December Kienzle took one last curtain call for the Buskin Club, portraying the weak-willed Reverend James Morrell opposite Professor Dyson as the eponymous "modern woman" of George Bernard Shaw's *Candida*. The *Racquet* praised his local swan song as "perfection," adding, "His role was a difficult one but Kienzle lived up to his reputation as a first-class actor."

No longer was this canned tribute from cronies at the *Racquet*. Even Ferdinand Sontag, who had personal as well as political reservations about Kienzle (finding his classmate self-involved, "an overly-fond-of-himself individual"), thought his contemporary outclassed everyone else on the La Crosse theater scene. "I knew what he was doing as far as acting, and his acting ability in my book was good," recalled Sontag, who at the time was president of the Buskin Club.

Since the delinquency of his high school days, he had evolved into a young man brimming with intelligence and positive purpose. He had scaled the heights of local accomplishment, developing a charismatic, even flamboyant personality to match his strapping good looks. Long before Nicholas Ray had achieved worldwide fame as a motion picture director, he was "famous in La Crosse." But for now Ray Kienzle had outgrown his hometown.

Finally, at the end of the semester, Ray bid adieu to the Buskin Club and Teachers College. Friends and classmates saw him as "a really unusual character," in Sontag's words, "not sure of which direction he was going, but he was going *some* place."

Restless energy always fueled Ray's angst, and it didn't often point in any clear direction. In the months that followed, he explored his nearby options: He went to Minneapolis to visit friends and see art exhibits, to Madison for college events and parties, to Milwaukee for important plays, to Chicago to catch up with Harold Stark and Professor O'Hara and Thornton Wilder.

Kienzle was conflicted about his ambitions: Should he try for a career as a stage actor or director? Did radio offer the best possibilities? Perhaps he should strive to become a writer?

He talked it over with people. Everyone in Chicago was buzzing about Frank Lloyd Wright, who in October 1932 had launched an experiment in communal living, learning, and arts appreciation at his Taliesin home in Spring Green, Wisconsin, about ninety miles southeast of La Crosse. The experiment was called the Taliesin Fellowship, and young people were flocking to the architect's compound there, eager to study architecture and the arts at the master's feet.

Inez Cunningham knew the world-famous architect; so did Harold Stark, who had arranged a lecture by the architect at the Minneapolis Art Institute when on the staff there. Professor O'Hara and Thornton Wilder also knew the Wisconsin architect. Wilder wasn't alone in urging Kienzle to consider joining the Fellowship, but the playwright carried the most prestige with Kienzle—and with Frank Lloyd Wright. Wilder offered to speak to the architect on Kienzle's behalf.

The prospect intrigued Ray. His father had been a mere builder; perhaps his son would go him one better and carve a name for himself in the world of design and architecture.

For the time being, however, Ray Kienzle found himself stuck in La Crosse. He reenlisted with the Little Theatre in January 1933, taking on a few small acting roles and helping Russell Huber with his workshops while biding time and awaiting word from Wilder.

﹡

Nineteen thirty-three was a ghost year for Ray Kienzle, a time of false starts and soul-searching. Sometime early that year, he took a cue from Clarence Hiskey, née Sezezechowski, and changed his name to something with billboard flair: He began signing his letters "Nicholas Ray."

A short time later, Thornton Wilder performed his good turn and the newly christened Nick Ray went to meet Frank Lloyd Wright in Spring Green. The young man from La Crosse was transfixed by the renowned architect, who, in his sixties, was at the height of his reputation, and who, in person—flowing white hair, black hat and cape—was every bit the self-conscious artiste Wilder was not.

Wright greeted the young man in courtly, fatherly fashion, introducing him to his young wife, Olgivanna, and escorting him around the grounds of Taliesin, where his growing family of followers were engaged in frenetic activity. The architect painted Taliesin as a budding temple of the arts, where writers, poets, dancers, and artists would mingle and cross-fertilize their ideas and talents. When Ray arrived, the members of the Fellowship, known as apprentices, were constructing a playhouse for stage shows and motion picture screenings.

Wright may have been at the peak of his fame, but financially he was scraping the bottom. He had devised the Fellowship at least in part to bring in the extra revenue he desperately needed to pay his debts and back taxes. Every honored member of the Fellowship was dunned an annual tuition of six hundred dollars for room and board and drawing materials, to be paid in advance or earned through physical labor. Wright was inflexible about the tuition payment. As Roger Friedland and Harold Zellman recount in *The Fellowship: The Untold Story of Frank Lloyd Wright and the Taliesin Fellowship*, references were all well and good, but not even skilled draftsmanship would guarantee entrée. "Those with the money were, for the most part, encouraged to come," the authors wrote.

"I can't draw a straight line with a T square or a triangle," Ray confessed years later. "I could not carve a square block out of sandstone." With his background in stagecraft, however, Ray seemed just the man to oversee the stage shows in Taliesin's planned playhouse. Wright warmed to the idea, mentioning the American poet Richard Hovey's lyric master-

piece *Taliesin: A Masque,* which celebrated the Welsh druid-bard for whom Wright had named his family estate. Hovey's dramatic poem might offer an evening's diversion for the Fellowship, Wright suggested, though it would require clever adaptation. Ray promised to look into it.

Ray yearned to join Wright's family of apprentices, but the architect was vague about his timetable, and the young man from La Crosse didn't have the six hundred dollars—a fortune to him. Summer rolled around, and Ray still didn't have the money, so he struck out for New York. Harold Stark had moved there ahead of him, living in New York hotel rooms while writing art criticism and giving talks on the radio; another friend, Ray's La Crosse buddy Alonzo Hauser, was living in Greenwich Village. Professor Dyson, who had studied at Columbia University, rhapsodized about the city that never slept, the nerve center of American theater—and a hotbed of leftist fervor. In the bitter depths of the Depression, the plays and shows produced in New York were increasingly tinged red.

Ray was invited to crash at the West Eleventh Street apartment of Hauser, now an up-and-coming sculptor preparing his first public exhibitions. Young artists of every sort were streaming into Manhattan, many, like Ray, congregating in the bohemian West Village. As he wandered the streets wide-eyed, taking in the crush on the streets and the zoo of strange people, Ray felt like a blank slate, empowered to reinvent himself. He never lost his love of New York as a home of never-ending hopes and dreams.

At first, though, Ray found it hard to find a foothold in the city. He kept in touch with Wright, sending him cards and letters from Hauser's address. He spent some time working away at Hovey's poem: Adapting it into a theater piece was difficult, Ray wrote to the architect, but ultimately possible. If it could be "thrashed over in rehearsal" in Spring Green, Ray could promise "a very palatable presentation."

Still, the matter of the Fellowship tuition lingered unresolved. Ray talked things over with Harold Stark, who wanted to cultivate his relationship with Wright, and between them they hit upon a scheme. Ray could draw on his organizing and promoting skills, and Stark could use his lecture circuit contacts, and together they would plan a national speaking tour for Wright. They could book the architect at colleges and museums for one-night talks for $250 and a percentage of the ticket sales. Wright was already in demand as a public speaker, but his schedule could be organized better

to provide another supplement to the architect's income. Ray's proposed 30 percent commission of the receipts would go toward his tuition.

From his perch in New York, all things seemed doable. Ray enthusiastically dummied up a prospectus, complete with cost estimates ($41.50 per 1,000 brochures) and text hailing Wright's greatness. Calling it "a fairly refined piece of salesmanship," Ray sent the sample brochure to the architect from his Greenwich Village crash pad. The sample was imperfect, Ray conceded apologetically; it needed revision and refinement. Still, he wrote, it was a promising start.

Ray's correspondence with Wright was full of flattery for the architect, but it also furnished a platform for his ongoing dialogue with himself. These were "dark years," the twenty-two-year-old wrote, and people everywhere were plagued by inner doubts and fears. Artistic "lightning," Ray wrote optimistically, could alleviate those problems; "sharp, stirring stuff that bolts us from within or without, and leaves the self in a fever of creation." Great men "above me," Ray added, giants like Wilder and Wright, were his inspiration. "Within—as yet," he added, "je ne sais quoi."

In August, Ray and Stark traveled back to the Midwest, trying to get Wright's lecture tour finalized, visiting Taliesin for overnights, then heading back to Chicago for longer stays. Ray's friendships with Inez Cunningham and Stark boosted his chances with Wright. Mrs. Cunningham wielded social influence, and not only was Stark a champion of modernism in art and architecture, he had grown up in a landmark river valley mansion in Auburn, Indiana, known as Hilforest House,* which had been photographed by noted Cincinnatian Paul Briol. Stark liked to refer to it as an "1850 F.L. Wright house."

While Stark had family resources, Ray was pinching pennies. He wrote Wright repeatedly on changing letterhead ("I continue to battle against the pressure of circumstances," he said, and that included borrowed stationery.) Once, when Wright's secretary urged Ray to reply quickly by telegram, he couldn't comply. He was "thoroughly broke," he later explained, and found it "rather difficult to apologize for the lack of a nickle [sic]."

When visiting Chicago, Ray also rendezvoused with Thornton Wilder

---

* The house is known today as "Hillforest House," but letterhead from Stark's time spells it "Hilforest."

and didn't miss a chance to remind Wright of his strong ties with the playwright, dangling the possibility that he could coax Wilder to Taliesin.

Spending a morning with Wilder was "very stimulating (his architecture of speech and prose is exceptionally fine)," Ray wrote to the architect on August 10, 1933. The morning meeting "culminated" with conversation about Taliesin "and the taking of our pictures together," Ray wrote. He said he yearned and prayed to join the Fellowship, and if he did, perhaps Wilder would consent "to be my, or our guest" at Spring Green.

Ray and Stark spent much of August in Chicago or at Hilforest, trying to pump life into the lecture tour plans. While in Chicago they toured the exhibits of modern housing at the ongoing World's Fair celebrating the city's centennial, with Stark assuring Wright in a letter that "that phase of modern architecture should be called AM I WRONG."

But Wright's initial enthusiasm waned, and he soon grew wary of the planned speaking tour. Stark's art lectures never grew beyond small museums and nonlucrative women's clubs, and Ray boasted no high-level contacts outside his home state. Even in Wisconsin he found little traction.

Ray tried proposing that Wright start out with an appearance in La Crosse, inviting the architect to save on costs by staying at his mother's house, but the architect demurred. When Ray journeyed to Milton College, south of Madison near Janesville, to pitch Wright's availability, he met with the dean and was chagrined to learn the institution was now foundering and that visiting lectures paid little.

By the end of the summer the tour scheme was looking problematic. Ray visited Spring Green one last time before leaving Wisconsin, performing a solo dramatic recital for members of the Fellowship and staying overnight at Taliesin—albeit "as a paying guest," in his words.

This time he thought Wright seemed indifferent to his higher ambitions, and Ray left for New York discouraged, convinced he'd missed his window of opportunity. On September 15, in the midst of hitchhiking back east (Stark stayed behind in Chicago), Ray wrote the architect lamenting their inability to connect. "I am sorry that you lost sight of me," he told Wright, adding obscurely, "It is probably my fault since I still clutter myself with sentiment."

Taking Ray by surprise, Wright wrote back to him promptly, explaining that the only reason he had lost sight of Ray was that "my head is under" with personal and professional stress. The architect vowed even to recon-

sider a La Crosse speaking engagement, if that might revive the lecture tour plan. "It is very difficult to live up to the pressure these days," Wright wrote sympathetically, likening their respective difficulties by echoing a phrase from one of Ray's own letters.

Wright's missive buoyed Ray, with its implication that the young man might yet be admitted to the Fellowship. He wrote back excitedly, even going so far as to ask if he could do any favors for Wright in New York. Or maybe Wright could do him a favor: Did the architects have any job contacts in the theater world? Ray vowed to save his earnings for Taliesin. "I'll work like the devil," he promised.

And Ray did work like the devil, scrounging for any arts-related job he could find, "making a pest of myself at the theaters," even posing in the buff, for a brief spell, for "a stupid art class" taught by the Lithuanian sculptor William Zorach, one of Alonzo Hauser's guiding lights at the Art Students League. Ray now counted a number of painters and sculptors among his growing circle of friends, and nudity would become a comfortable habit for him. The odd jobs added up. "I begin eating regularly," Ray wrote to Wright in October.

Not that the young man was complaining. "Struggle is grand," he wrote to Wright. "Its [*sic*] what we young should live with a great deal more than we do; it is a little under-nourishing to the body sometimes, but what matter, it is as solid as pain." He didn't know where his next meal was coming from, Ray wrote, but he knew he was on the right path.

Twenty years later, as he worked with James Dean in New York while preparing *Rebel Without a Cause,* Ray studied the young star as though staring into his own past and this time when he was a nobody struggling for recognition. "The drama of his life," Ray wrote of Dean, "was the drama of desiring to belong, and fearing to belong. (So was Jim Stark's.) It was a conflict of violent eagerness and mistrust, created very young. It lay embedded in his personality, with its knife-sharp awareness and inquiring spirit . . .

"Every day," the director said, continuing, Dean "threw himself hungrily upon the world like a starving animal that suddenly finds a scrap of food. The intensity of his desires, and his fears, could make the search at times arrogant, egocentric; but behind it was such a desperate vulnerability that one was moved, even frightened. Probably, when he was cruel or faithless, he thought he was paying off an old score. The affection he rejected was the affection that had once been his and found no answer."

Circulating widely, yearning yet fearing to belong, saddled with a desperate vulnerability, Ray began to make connections. At the end of October he auditioned and was offered a spot in a Broadway play, a translation of a Walter Hasenclever comedy about a statue of Napoleon springing to life, called *Her Man of Wax*. He rejected the role, though, later explaining that he didn't like the play's "sexual" component. Perhaps the small part—an effeminate character—discomfited him.

Instead, he gravitated to a nonpaying, left-wing group. An offshoot of the Workers Laboratory Theatre, which performed at the New School for Social Research, City College, and other Village venues, the Theatre Collective was gearing up for its maiden showcase, a proletarian drama called *Dirt Farmer* that was culled from a story by a young Communist named Whittaker Chambers.

Soon, Ray made another, even more promising score: falling in love.

In Ray's film *In a Lonely Place*, the screenwriter Dix (Humphrey Bogart) gives Laurel (Gloria Grahame) ten seconds to answer his marriage proposal. Ray fell in love almost as fast and easy. He went all the way, buying flowers with spare change and virtually moving in with his new girlfriend.

She was born Jean Abrahams, but like Ray had recently anglicized her surname (to Abrams); soon she would complete the transformation by adopting the pen name Jean Evans. Born in Winnipeg in 1912, Evans was petite and dark haired, with an aquiline nose. She had a lean and hungry look, but with voluptuous curves. Like Ray, she had left behind an unhappy upbringing. Like him she was also an aspiring writer—although Evans was prone to writer's block, whereas words gushed from Ray whenever he sat down to write.

Another newcomer to New York, Evans shared a place with friends not far from Alonzo Hauser's apartment. Ever the unabashed nudist, Ray began by dropping by and stealing hot baths in her tub. Her fond nickname for him was "Nickel," which was about all he ever had in his pocket. "We fell in love and became inseparable," she later recalled. "We were poor, but it was a happy time. We were both rebelling against middle-class respectability."

In November 1933, however, Frank Lloyd Wright came to New York to speak at Columbia University. Ray went to meet up with the architect.

The timing was good. The apprentices had just completed work on the Hillside Playhouse, a huge vaulted room with an upper stage, a lower

level, and a splendid fireplace. Its open space was adaptable for concerts, plays, film showings, and other performances. (The seats could even be removed for dancing.) Two hundred people filled the playhouse for its grand opening in November 1933, hearing a welcoming speech from Wright and enjoying a German film.

Since its public unveiling, however, the playhouse had been dormant, for practical reasons: The large building required steam heating for the cold Wisconsin winters. Once the steam heat was fully installed, the theater would have to be booked up with plays and other artistic offerings besides the planned weekly movie screenings.

At last, on a walk together after his Columbia lecture, Wright unequivocally invited Ray to come and live with his community of followers. He needed someone to organize the playhouse and turn it into the heart and soul of Taliesin. Even so, probably the decisive factor for Wright was Harold Stark's willingness to pay twenty dollars every two weeks out of his own pocket to augment Ray's "scholarship." Perhaps too the playhouse would turn a profit from tickets to the public events.

Ray hadn't gotten very far with the Theatre Collective, and he would have to abandon his new sweetheart Jean Evans in New York. Yet now his focus shifted to Taliesin, and his personal relationships, as always, were subordinated to his professional goals. After a quick trip home to La Crosse for Thanksgiving, he was in the bosom of Taliesin by Christmas.

<div align="center">✳</div>

Taliesin, which means "shining brow" or "radiant brow," was the name of the architect's estate, slung on the crest of a hill outside the small town of Spring Green, overlooking a valley settled by Wright's maternal ancestors in the nineteenth century.

Beleaguered financially, Wright had retreated from Chicago to Taliesin in the 1920s, making the ancestral home his permanent residence. The main house on the grounds burned twice in that decade, but Wright had rebuilt it twice before renovating the place a third time to accommodate his brotherhood of young artistic aspirants known as the Fellowship. Wright's office and living quarters in the main building were expanded to include new studios. The nearby Hillside Home School, administered by Wright's aunts, was converted into a drafting studio, rooms for appren-

tices, a dining hall, and the Hillside Playhouse performance space. The apprentices dubbed it "Unit Number Two."

Only a handful of the roughly thirty apprentices had the privilege of assisting Wright and his professional staff on architectural drawings or scale models. Especially during the first years of Taliesin, the Fellowship was more of a volunteer workforce, hammering, sawing, pipe-fitting, and tilling the soil in furtherance of Wright's grand vision.

The long Fellowship days began, in Ray's words, at an "orthodox 5:30, with breakfast at orthodox 6, and work after 7—willingly adding tired to tired and adding it again for tomorrow and tomorrow and tomorrow." In every season but summer, the first order of business was cutting and chopping massive amounts of cordwood to stoke the sixteen fireplaces and three boilers. After the physical work ended at four P.M., a "tea and conversation" break was followed by individual or group artistic pursuits (including, but not limited to, writing or composing, sketching, painting, sculpting or weaving, designing costumes or sets or rehearsing plays), until a clanging bell announced the family-style dinner at seven. Lights went out at ten—again, "orthodox."

Wright once described Taliesin as "a station for the flight of the soul." Beyond his architectural goals, the architect was a passionate advocate for the primacy of nature and preached the truth and beauty of organic art and architecture. He was contemptuous of academic education and favored practical education—learning by doing. Besides Ray, he had sprinkled other nonarchitects among the apprentices: poets, musicians, and a variety of visual artists. "Mr. Wright believed that architecture was the citadel for all of the arts," Ray explained years later, "and where all arts joined and met in unity and full expression." Under Wright's leadership the Fellowship was expected to commune physically as well as intellectually, striving toward an ultimately spiritual kinship.

One of Wright's pet ideas was that Taliesin would provide uplifting entertainment for the common man as well as the brotherhood. The apprentices spent the first year after the founding of the Fellowship carving the Hillside Playhouse out of the old Hillside Home School gymnasium (using "native materials, stones from the surrounding hills and rough lumber from the woods," according to a local press account). By the time Ray arrived on the scene in late 1933, the playhouse was in its last stages of gestation, being fitted with its all-important steam pipes.

The young man from La Crosse, the son of a builder, rolled up his sleeves and got to work. The Fellowship was the kind of surrogate family he sought to find and replicate in various ways throughout his life. The whirlwind of action in Spring Green was the type that would always absorb him in years to come, distracting him from his inner fears and doubts. One of Ray's virtues as a director was the zest with which he took on the endless stages of a challenging film project; he was capable of losing himself happily in the most arduous and trouble-plagued productions.

After the orthodox hour of four P.M., every day, Ray juggled his playhouse activities. Early in January he performed solo for one assembly ("an interpretation of the play by one of the apprentices will help to make the afternoon more interesting and enjoyable") while rehearsing actors for a musical farce called *Piranese Calico* for later that month.* *Piranese Calico* was the Fellowship's "first attempt," Ray explained in a subsequent article for a Wisconsin newspaper, "to establish drama as architecture, where it belongs, and do it indigenously as possible" in Hillside's small, non-proscenium theater space. Taliesin's maiden production was "apprentice-written, apprentice-directed, apprentice-acted, and the music, apprentice-composed," according to Ray; he himself cowrote, directed, and acted in the short play. The playhouse itself, he said, continuing, was "neither temple nor brothel, but a place where stage and audience architecturally melt rhythmically into one, and the performance—the play of the senses—and the audience blend together into an entity because of the construction of the whole."

Saturdays at Taliesin were set aside for rest, recreation, and rehearsal; Sundays were thrown open to the general public for presentations like *Piranese Calico*.

Sundays began with morning chapel services in the little Unity Chapel across the valley, where religious figures from various denominations delivered secular homilies, often driving to Taliesin from Madison to do the honors. Regardless of their individual religious preferences, the apprentices were expected to attend and join lustily in the hymn singing.

On Sunday afternoons everyone would gather enthusiastically for the weekly playhouse program. Members of the Fellowship demonstrated their

---

* Although director of *Piranese Calico* was Ray's first major Taliesin credit, he would see his name misspelled in the local Spring Green newspaper as "Nicholas Bay."

specialties, but visiting artists also performed. There might be exhibits: weavings, pottery, watercolors, sculptures. Musical presentations included recitals of Schubert lieder, piano sonatas, or Rimsky-Korsakov songs for harp and voice. There were spoken-word offerings by apprentices, sometimes puppeteers or magicians. Afterward, there was cake and coffee.

The record of the playlets Ray staged at Taliesin is sparse, but besides *Piranese Calico* he mounted a Victorian matrimonial pantomime in February and *The Minuet,* a charming one-act eighteenth-century vignette, in April.

The playhouse was just as focused on cinema as on live theater, and the calendar of screenings was arguably one of America's most sophisticated. Foreign films dominated the schedule: often they were Soviet, German, or Japanese productions; favorite artists included Sergei Eisenstein, René Clair, and Carl Dreyer. The feature films were usually preceded by a Walt Disney cartoon and newsreel or a nature short. Film esoterica was one of the prides of Taliesin, and film lovers drove from miles around to see movies unavailable in Madison or Milwaukee. (Fellowship members were rankled that Spring Green locals shied away from such fare, so they periodically hosted exemplary Hollywood films to keep them coming back.)

This was Ray's first known exposure to cosmopolitan filmmaking outside the standard commercial mold. "The medium of the celluloid strip and the sound track is given full vent in a kind of release," Ray rhapsodized in one of the Wisconsin newspaper accounts, "as the audience in comfort, sipping coffee and eating cakes and smoking, witnesses one of the world's finest picture plays."

Wright charged admission to the weekend entertainment and screenings, and by the spring of 1934 he'd begun charging for tours of the grounds as well; the tours drew visitors from far and wide, and gave Taliesin a fresh revenue stream that continues to this day.

On Sunday nights, after the hoi polloi had gone home, Taliesin hosted serious talks for the apprentices on topics ranging from American existentialism to life in twelfth-century Italy, followed by fireside drink and discussion. The honored guests ranged from celebrated figures like artist-illustrator Rockwell Kent, showing "movies taken in Greenland and talking informally of his natural philosophy," to local professors from the University of Wisconsin. The guest lectures often leaned left, and the contemporary "Soviet experiment" in social engineering was a re-

curring topic on Sunday nights, with screenings of the latest Soviet films augmented by eyewitness updates from travelers recently returned from Stalin's Russia.

Sometimes, the speaking obligation fell to Wright himself, the guru and patriarch of the Fellowship. The architect would extemporize, ranging freely, sometimes abstrusely. On one occasion, rising after a luncheon in Madison to expound on "Art and Beauty," Wright turned to "The Nightingale" by Hans Christian Andersen, reading the fable aloud "simply and beautifully," if at inordinate length. "The mixed audience," reported one apprentice among the gathering, "and Fellowship apprentices were breathless. Many are still wondering, no doubt, what happened."

Wright oversaw the weekend programming and the invitation of noteworthy guests. But Ray quickly became the master of ceremonies of Sunday afternoons. A few short weeks after joining the Fellowship, an announcement made it official: The pipe-fitting apprentice was the new director of the Taliesin playhouse.

✳

Happy days they were for Ray, at least at first, and he was "frightfully eager to make good," as even Wright later admitted. He soaked up the advanced intellectual discourse he had shirked in his academic life in La Crosse and Chicago. Ideas were in the air the Fellowship breathed, and whether at work in the fields or in formal group sessions one could expect the discussion to range widely, from Walt Whitman and Schopenhauer to Nietzsche, Spengler, Thoreau, and Marx. The apprentices took special pleasure in their knowledge of film, debating the aesthetics of German Expressionism or the editing principles of Eisenstein.

Meals at Taliesin were communal, with the apprentices rotating as cooks of the nightly feasts. On weekends there were wild parties, wild drinking, wild dancing until the wee hours. "Our way back across the fields is lighted by the moon," wrote Ray, "or its handy and unpretentious substitute, the flashlight." From time to time the apprentices would pile into a caravan of cars and drive to Madison to attend a university symposium, or a recital by the Indian modern dancer Uday Shankar. Sometimes they headed to Spring Green on Saturday night to take in the bars or the latest Hollywood movie at the Rex Theatre downtown.

Romances blossomed among the apprentices, and—as would be the case throughout his life—Ray's easygoing manner and magnetic looks crossed age and class and gender. "Nick cut a handsome figure," recalled actor Christopher Plummer, who met him later during his Hollywood career. "He was a very sensual man—attractive to both men and women."

But not everyone found the brooding young man attractive. Henry Schubart, who roomed with Ray briefly at Taliesin, said that Ray could be "tempestuous, to say the least." One cold winter night, after drinking too much moonshine, the two got into a fistfight in the snow, though Schubart couldn't recall why. "He loved poetry and literature," Schubart said, "but I always had the feeling that he was internally nihilistic, defensive, and not basically productive."

Early on, it must have been clear to the other apprentices that Ray was a favorite of Wright's: In one of the few columns the architect himself wrote for the local papers about the Fellowship—under a nom de plume, of course—he singled Ray out ("big fellow—looks strong") as one apprentice who threw himself wholeheartedly into the social life of Taliesin.

Dispatches from Taliesin were not only a form of publicity but a sign of the master's approval. Just one year earlier, "r.n.k." had been writing a tidbits column and reporting on sports for a campus newspaper. Now, as "Nicholas Ray," he was among the privileged few whose byline Wright approved to spread the word of Taliesin.

In Madison's *Wisconsin State Journal,* Ray published a virtual manifesto on contemporary theater, headlined "Taliesin Student Calls Theater 'Idiot Child of a Sane Yesterday.'" Mingling high-flown language with Wright's native radicalism, Ray declared himself a modernist who wished to tear down the artificial barriers between performance and audience. He attacked the traditional "picture frame theater" and made a point of excoriating Madison's beloved Bascom Hall, the main stage for University of Wisconsin dramatic productions, as a "hideous anachronism. "I wonder how an individual possibly can feel in harmony (not necessarily in moral agreement) with a 20th century play, almost by necessity a series of 'stills,' produced in a place that is in spirit 17th century construction. Or is it possible that the aesthetic sins of the fathers inhere also, and we have been born with layer upon layer of dead skin or hard shell over our sensitivities?

"Tradition—as a sense of continuity of past into present—is an admi-

rable sense to possess," Ray's manifesto continued, "but when it goes far-
ther than that and is personified by institutions that exist as traditions as
the only valid basis, it often becomes irritating, and is, more than irritat-
ing, a positive sign of impotence."

When that column was published, on April 2, 1934, Ray was firmly en-
sconced as one of the brightest, most promising of Wright's acolytes, with
the title of director of the playhouse. Within the month, however, the
twenty-two-year-old would do something that alienated his benefactor.

Ray's own memories of their falling-out varied. According to a fuzzy
version of events in Bernard Eisenschitz's book, Ray said that he had "a
battle with Wright over the word 'organize.'" But years later the director
told a Madison, Wisconsin, college audience that the confrontation was
more aesthetic than political, occurring when Wright proposed building
a sandstone façade to cover "some beautiful oak panels" at Taliesin. Ac-
cording to Ray, he asked innocently: "Is that it, Mr. Wright? What looks
organic *is* organic?" The architect reacted with such "vitriol," according to
Ray's account in a Madison newspaper, that he was forced to depart from
Spring Green the following day.

The contemporary film critic Jonathan Rosenbaum, Ray's steadfast
admirer, related a similar version of Ray's "falling out with Wright," dating
from the last time he saw the director socially, at a Soho bar in 1977. In
an expansive mood that night, Ray gestured animatedly as he conjured
the long-ago scene, involving "a fairly modest architectural suggestion or
question on Ray's part that had provoked the full wrath of the great man's
conceit," as Rosenbaum wrote after Ray's death. "The curious thing about
this tale now, as I try to remember it, is that the actual details of the en-
counter remain only shadowy sketches."

However shadowy, the breach was irreconcilable. Ray abandoned
Taliesin under a cloud. "I have felt the hand of genius," Ray is said to have
written to girlfriend Jean Evans from Spring Green before hastily leaving
for New York, "and it is a heavy hand."

※

But was Ray's shifting account of the breach deliberately shadowy—
cloaking another mystery, another wound to his soul?

Had Wright and Ray argued about a particular program he wanted

to produce, or about the overall artistic agenda of the playhouse? Had the famous architect dismissed his favorite young disciple because he couldn't easily pigeonhole or control him? Had Ray, in some way, exposed his secret attraction to men?

According to Friedland and Zellman's *The Fellowship,* Wright had a complicated, conflicted attitude toward homosexuality. The architect "cast himself as an image of American manhood" and enjoyed the "heterosexual strut" that yielded, in his case, a tangled love life with overlapping wives and mistresses. At times, though, Wright seemed unsure of his masculinity; he evinced certain "effeminate tendencies," according to Friedland and Zellman, and may have experienced homosexual desires toward close friends without acting upon them. Through the years, Taliesin gave safe harbor to quite a few homosexuals, and gay members of the Fellowship enjoyed their share of love affairs. Yet several times, privately and publicly, the architect upbraided homosexual men as degenerate "pansies" who showed "a weakness of character, backsliding toward the primitive."

Had Ray displayed that same weakness of character, that degenerate trait? Had he even stooped to trysting with another member of the Fellowship?

Some years later, Jean Evans interviewed Frank Lloyd Wright in her capacity as a journalist. When she mentioned her old boyfriend—by then her ex-husband—she was taken aback by the architect's "moralistic and vindictive" rebuke of his former apprentice. Among other things, Wright denounced Ray as a homosexual.

Research for this book has shed additional light on this murky setback early in Ray's career. To the one person to whom Wright felt he owed an explanation—Harold Stark, Ray's affluent friend, the author and art critic who'd been making bimonthly installments on his tuition—the architect privately gave an account of the incident that precipitated Ray's dismissal.

"There is a weakness in the lad that unfits him for the freedom of life here," Wright wrote in a letter to Stark. "A glass of wine and he is out to town to finish up in a plain drunk. I argued the matter several times and he is a promising penitent, always."

On the evening of April 21, Wright reported, Ray went to Spring Green with "some of the boys," ostensibly to see the new motion picture at the Rex. "He disappeared in town without any of the boys noticing it,"

wrote Wright. "About an hours [*sic*] later my secretary was called out to find Nick dead drunk on the street and bruised from a fight he had had with one of the local drunks. About twenty-five people were watching the whole performance with apparent amusement. There have been several occasions before where he has enacted this kind of performance, and I have repeatedly warned him.

"I have cited to him your sacrifice in his behalf, which he recognizes fully enough, I believe," Wright continued. "But there is that in the book that will get him general recognition as a *weak sister,* I'm afraid."

"I am letting him out today," Wright's letter concluded sympathetically, "and no doubt you will hear from Nick himself. He is intelligent and has many charming qualities, notwithstanding his defects. He should make the most of them."

The letter is dated April 22, 1934. Wright was more than amenable to having Thornton Wilder make a guest appearance at Taliesin, but the playwright whose services Ray dangled before the architect never did materialize at Spring Green. Harold Stark, who ended his friendship with Ray as a consequence of this incident, did, though, lecturing the Fellowship on the "Steamboat Gothic" style of river architecture.

<div align="center">✳</div>

How could Ray feel anything but humiliation or betrayal to have been banished from the utopia of Taliesin?

One scar would follow another in Ray's life, adding layers of complexity to his personality and character and art.

And yet, curiously, in public Ray never spoke less than warmly about the architect and his gloriously failed stint at Taliesin. In interviews with publicists and journalists over the years, Ray always emphasized the broad artistic and philosophical perspective he had absorbed at Taliesin. He even linked his own preference for the wide-screen CinemaScope format, with its horizontal lines of visual expression, to Wright's aesthetic: "the horizontal was essential for Wright."

In private, Ray was nearly as positive. The apprentice was anxious to repair his rift with the master, corresponding with him several times after

---

*    Author's emphasis.

leaving the Fellowship. In one 1937 letter, he told the architect, "I think of you and Taliesin often, with warmth." In that letter, which came three years after his removal from Spring Green, Ray attributed "one of the principal causes of my 'maladjustment' while living at Taliesin" to his lingering loneliness for Jean Evans, whom he'd left back in New York. (Wright dictated a cordial but noncommittal reply: "Glad to hear from you. Hope things come through alright . . .")

Whatever the precise nature of his "maladjustment," leaving the Fellowship meant the end of all those promising tomorrows at Taliesin. After saying good-bye to his mother in La Crosse, Ray left Wisconsin in the late spring. He would never again live in his home state.

According to Bernard Eisenschitz, instead of returning to New York Ray left immediately for Mexico. Yet surely he was back in Greenwich Village by late May 1934, briefly helping the Theatre Collective stage an evening of playlets, with *Aria da Capo* topping the bill. The group performed Millay's one-act, a Ray favorite, a number of times in the late spring and early summer at several Lower Manhattan venues. (Ray and the left-wing Theatre Collective presented it as *Aria da Capo in Red*.)

However, Ray had fallen deep into what Jean Evans liked to call a "blue funk." (She was susceptible to them too.) In a pattern he'd repeat after other disasters in his life, Ray abandoned Jean Evans and New York and headed to Mexico in a car driven by Frederick W. Dupee. Dupee, who barely knew Ray, would go on to a distinguished career as a literary critic and founder of the *Partisan Review* and the *New York Review of Books*. But they had a few things in common: Chicago (where Dupee was born and raised), some mutual friends, their shared left-wing politics, and a deep desire "to write something" while exploring south of the border.

The two men separated in Mexico City. Ray wandered the city seemingly without purpose—another pattern that would recur. He wrote to "My dear Mr. and Mrs. Wright" from Acapulco, reporting that happiness was scarce on the ground in Mexico. "Mexico is essentially a sad country (I think a thing I've had too much in common with it) and that thunder is always threatening," Ray wrote. All the fiestas ended sadly too, he added.

Yet he had found peace in Acapulco, Ray admitted; the ocean calmed him and the natives were pleasant. He was anxious to write something of merit but found that Mexico had a quality in common with Spring Green: "stuff too overpowering for me to cope with."

Playing to Wright's interests, Ray reported on Mexico City's building boom. He cited Carlos Obregón Santacilia as akin to "F. L. W." and said he'd briefly occupied a house designed by Juan O'Gorman in San Angel, a section of Mexico City. But he derided Gorman's architecture as inhuman and cliché.

Ray described tramping through the jungles of the Yucatán, traveling to Oaxaca, and toiling briefly in the jewel mines of Taxco. Living on tortillas, he was nostalgic for the communal meals at Taliesin and said he wished he could return and join the group cooking next Sunday night. "Retrospect from a distant perspective is often painful," he wrote wistfully to Wright, less than two months after leaving Spring Green.

Ray's letters to Taliesin are the only surviving artifacts from this trip. Yet they confirm that, as always, the adventure was a tonic for him. He got his drinking under control and concluded his painful period of retrospect, feeling renewed and reinvigorated. By the end of 1934 he had shoved the writing urge aside and decided that what gave him the most pleasure in life was acting and theater. Lured by left-wing friends who promised exciting stage work, Ray hopped a bus back to Jean Evans and New York.

# CHAPTER THREE

# *Agitation of the Essence*

## 1935–1940

Ray was back in New York by January 1935, tan, rejuvenated, and armed with a new moniker—"Nik Ray"—to match his new proletarian persona. He went straight from the bus station to a five-room apartment in a brownstone in the East Village, home and headquarters of a fledgling group calling itself the Theatre of Action. A group of Theatre Collective and Workers Laboratory Theater loyalists had merged and taken over a Thirteenth Street flat, dedicating themselves to left-wing stage activities. The Theatre of Action dubbed themselves the "Shock Troupe"—the shock troops of the theater revolution, as one member recalled, "ready to jump into action at a moment's notice."

While Ray was in Mexico the radical theater movement had exploded across America.

Almost overnight, "agitprop" (agitation and propaganda) groups had blossomed in hundreds of cities, towns, and rural communities, each "advancing with true Marxist fervor toward the establishment of a Theater of the Left," as Bosley Crowther wrote in the *New York Times* in April 1935. Though the movement was national ("a consequence partly of the voiceless unrest among the masses of employed and unemployed workers, victims of economic depression, and partly the fermented disgust of revolutionary

theatrical artists with the narrowing potentialities of the commercial the-
atre," in Crowther's words), New York led by number and example.

The left-wing theater boom had begun in the late 1920s, when promi-
nent New York stage organizations such as the New Playwrights Theatre,
the Theatre Union, and the Group Theatre began to tack leftward. The
best-known groups were professional, no matter how little they paid them-
selves, but by 1935 dozens of small amateur agitprop troupes flourished in
the city. Often fly-by-night groups employing blue-collar workers, they in-
corporated dancers, musicians, magic acts, puppeteers, and/or children's
theater units. Some performed in German or Yiddish.

The most famous of the troupes was the Group Theatre, which had
been around since 1931. It was "probably the single greatest group of the-
ater intellectuals who ever existed together as a cohesive unit," in the
words of Martin Ritt, a young actor on the fringes of the movement who
would later become a Hollywood director. The Group didn't start out as
an ideological vehicle, but its embrace of left-wing drama intensified with
the Depression.

Just before Ray's return to New York, in January 1935, the Group had
set a high bar of "originality and fire," in cofounder Harold Clurman's
words, with its production of Clifford Odets's *Waiting for Lefty,* a one-act
agitprop play that declared revolution on old-fashioned drama. Odets's
play offered a portrait of a group of taxi drivers debating whether or not to
strike as they await their leader, Lefty, who never appears. In the cast was
a young aspiring actor named Elia Kazan, who was destined to become a
friend to "Nik Ray" and arguably his most important mentor.

\*

Although the names and faces varied, the Theatre of Action headquarters
housed only about a dozen comrades at any given time. Among them were
several actors who stuck mainly to theater and New York in their careers
and a handful who would carve bigger names for themselves. Among these
were Earl Robinson, a lanky songwriter from Seattle whose labor union
standard "Joe Hill" and "Ballad for Americans" cantata would enter the
American songbook, and Norman Lloyd, a classically trained actor who
joined the collective after Ray, in 1936, and whose career would intertwine
with those of Orson Welles, Jean Renoir, and Alfred Hitchcock.

One of the female converts to the cause was Jean Evans. Ray and his girlfriend were ready to resume their romance. Both were anxious to leave behind painful upbringings. Both were prone to introspection and depression, though Evans invariably offered a pleasant face to the world. The two would offer deep consolation to each other in the years ahead.

Often, Ray and Evans shared a room piled with people. Like Taliesin, the Theatre of Action was a communal tribe, sharing rent and board, cooking and chores, daily group study, discussion, rehearsal, and performance. Evans was unusual among the women for her subtle beauty, but also because she was one of the designated writers who researched and composed topical sketches for the group to perform. Women were in a minority in the collective, and most were actresses. The actresses especially tended to be "not beautiful," according to Norman Lloyd. "It was more realistic, the directors of social theatre felt, to have people who might be right out of the subway; it was their rebellion against the idea of a beautiful ingénue, like Dorothy McGuire or Jane Wyatt."

To be fair, the men were generally subway types too: "about five feet six inches, thin, wiry, with lightning reflexes—Jewish, street-smart, many of them brought up by left-wing parents," recalled Elia Kazan, who moonlighted with the Theatre of Action during his time at the Group Theatre.

All the more reason "Nik Ray" stood out. He wasn't from Brooklyn; nor was he Jewish or the product of left-wing parents. To fellow member Will Lee, Ray was more "like a fresh wind blowing" from the Midwest. He was tall and strong, with wide shoulders, a handsome, carved face, and a smile or grin much of the time—a quiet, deferential, mild-mannered lumberjack of a man.

Ray had taken to the communal lifestyle at Taliesin, and at the Theatre of Action he dove right in. "Sometimes we'd get testy over the chores," Robinson recalled, but Ray never turned up his nose at kitchen duty or housekeeping. The "meals" they prepared included a steady diet of "apples, peanut butter, stale bread, cabbages," according to Kazan, but Ray didn't complain. The collective prided itself on a food budget of a few dollars per day, though one summer they even hired a left-winger who knew how to bake and cook.

The Theatre of Action also followed a Taliesin-like "orthodox" timetable. Each day began strictly at nine A.M., with a collective stretching session at a leased loft in a nearby building. A number of dancers from

Martha Graham's company—Anna Sokolow, Doris Dudley, sometimes Graham herself—led movement and exercise classes. At eleven A.M., voice specialists arrived for diction and accent training. For lunch the group often pooled their change and invested in a subway ride to a city museum.

If Taliesin was Ray's true college, the Theatre of Action was his graduate program. Everything the members did was for the betterment of art, society, and themselves. Besides discipline and stamina, keen intelligence was one thing they all had in common. The collective was another fellowship abrim with stimulating ideas, with conversation and debate about politics, values, and beliefs all day and into the night.

Ironically, Ray's abortive stint with Frank Lloyd Wright boosted his cachet among his fellow actors. In the group discussions, some saw him as a heartland intellectual who could hold his own with the most sophisticated New Yorkers. But others found him airy, hesitant, or tongue-tied, intimidated by the subway types. There was always that contradiction in Ray's personality: at times talkative and coherent, even eloquent, he sometimes struggled to find the right words, as though he were muttering to himself rather than debating with others.

"He was always interesting, strange, very much like Joe Losey," recalled Norman Lloyd, who worked with both Ray and Losey in New York in the 1930s. "Strange . . . and I would suppose inarticulate. Couldn't quite understand what he was saying all the time. And we used to kid about that, you know, not so much to Nick because we didn't want to hurt his feelings, but you'd go over and say to someone, 'What the hell was he talking about?'"

After lunch, at one thirty P.M., the group plunged into eurhythmics, followed by the main acting and improvisation classes, with members of the Group Theatre dropping by to expound on modern Soviet stage methods and techniques. This was Ray's first glimpse of the intense, charismatic Kazan, whom he saw instantly as a blood brother. Born in 1909, Kazan was only a few years older than Ray, but he could have been the wiser older brother Ray never had.

The Group Theatre members were celebrities compared to the nobodies of the Theatre of Action. (Both groups lived collectively, Kazan recalled, but the Theatre of Action had "crummier" digs; in comparison, the Group Theatre's "apartment wasn't bad.") But Kazan himself occupied the lowest niche of the Group. Known by the "faceless nickname" of "Gadget,"

or "Gadge," for his mastery of backstage gadgets, he got few chances to act in an ensemble with so many towering performers. When Kazan rose from the audience to denounce his rat-fink brother in *Waiting for Lefty*, theatergoers roared with applause without recognizing the obscure player; they mistook Kazan for the character he was playing, a real man off the streets stepping out of the crowd.

Kazan was almost as faceless as the lowly Theatre of Action, and seeking wider recognition is what brought him to their doorstep. He was on fire with energy and ambition, "really burning" to make his mark, in the words of Norman Lloyd. Kazan had even started wearing the leather jacket and worker's cap of his *Waiting for Lefty* character, so that people would recognize him on the street. A homely peacock, short, with a long thin beak and frizzy black hair, Kazan posed as the ultimate subway type. Some people didn't warm to him ("I never liked him much," Losey said insistently years later), but most of the Theatre of Action collective did.

"They became my personal acting company," Kazan later boasted, "and I became, for a time, their hero. In improvisation, they'd do anything I asked." The Theatre of Action took risks, Kazan said, even beyond what the Group was willing to try. "They did something more 'professional' actors would not: go to the limit in improvisation. Scenes of anger had to be stopped short of bodily harm, love scenes cut off before they reached a final intimacy."

At that time Kazan was preaching from the Group's first publication, a translated history of Moscow's First Studio focusing in part on the acting theories of Leopold Sulerzhitsky.* An apostle of "the theater of true feelings," Sulerzhitsky was a luminary of the Moscow Art Theater, and a contemporary influence on Konstantin Stanislavski, the father of what became known as Method acting. Sulerzhitsky was a marker on the road to the Method; among his prize students was Yevgeny Vakhtangov, who succeeded Sulerzhitsky at the First Studio after the latter's death.

Sulerzhitsky advised actors to deep-think their parts, finding clues to their characters within themselves. Under Kazan's influence, Sulerzhitsky's principles became a salient feature of Nicholas Ray's approach to acting and directing. Sulerzhitsky's theater of true feelings, and the

---

* *The First Studio: Sullerzhitsy-Vackhtangov-Tchekhov* by P. A. Markov (Group Theatre, 1934).

Soviet emphasis on realism, complemented Thornton Wilder's quest for the "true expression of life" and Frank Lloyd Wright's exaltation of organic elements in the arts. Ray fell in love with the theories tripping from Kazan's tongue, absorbing all their abstruse nuances like mother's milk.

Vsevolod Meyerhold, a Russian theater director who sought to tear down barriers between performers and audience—a philosophy Ray first espoused at Taliesin—was another exemplar touted by Kazan. Meyerhold's reliance on symbolism and décor, along with Vakhtangov's stylized, highly emotional "fantastic realism," resonated with Ray.

The director often said he never forgot Vakhtangov's pioneering essay "The Agitation from the Essence," which served as his "principal guideline" when directing actors (though he conceded that the same ideas were "not so fruitful" when it came to his "personal relationships"). In "The Agitation from the Essence," Vakhtangov argued that an actor's feelings "must not be ready-made beforehand on the shelf of his soul"; instead they should "arise spontaneously on the stage, depending upon the situations in which the actor finds himself." The actor should transpose the psychology of the character to his own sphere, rather than trying to embody the character purely through imagination, profound empathy, or affective memory. "It is necessary to live your own temperament on the stage," Vakhtangov wrote, "and not the supposed temperament of the character." In other words, an actor must find something in common with his character. The actor's—or director's—job was to agitate, or inspire, this essence.

Of course the beauty of Kazan—even then but certainly later in his extraordinary stage and film career—was that he learned every trick in the book and never hesitated to discard one theory for another. "Whatever works, works," he proclaimed; later, when he drifted from realism into emotionalism, he would advise his actors to "turn trauma into drama"— in other words, to channel their personal traumatic backgrounds into a characterization in order to heighten the emotionalism of a performance.

"Whatever works, works" and "Turn trauma into drama": words of wisdom from brother Kazan that rang loud and clear to Ray. He added it all to his storehouse.

✳

When the afternoons of practice and improvisation ended, Kazan usually flew back to his cozier Group Theatre nest. The "shock troupe," mean-

while, plunged into its public performances, with Ray relegated to much the same journeyman status as Kazan in the Group Theatre. Never a star or leader in the collective, he tended to play the smallest parts—though Earl Robinson recalled that he was "a powerhouse on wheels" when throwing himself into a scene. Most viewed him as a valued, enthusiastic role-player who contributed in numerous ways, from singing bass on a version of "Casey Jones," with revamped militant lyrics adapted for seven-part harmony, to "carrying the whole set" on the subway, in the words of Robinson, with those "broad, strong shoulders."

The collective performed its sloganeering skits at "every strike, every picket line, political campaigns, the backs of trucks," Ray recalled. It was "guerrilla theater" before the term existed, he explained in a 1970s interview. "We invented dramatic montage; we'd go to a picket line or a factory or just perform on a subway, with one five-hundred-watt lamp and a chair." They passed the hat for rent and food and sometimes set up cots for the night right where they performed. "Our lives obeyed the slogan, 'Theatre is a weapon in the class struggle,'" Robinson said. "A strike was a sacred obligation."

Besides workers' issues, the Theatre of Action campaigned for racial equality and justice in controversial court cases. They savagely satirized New York mayor Fiorello La Guardia, a liberal Republican whose policies didn't go far enough for them. They opposed fascism at home and abroad, devoting one of their playlets, *Free Thaelmann,* to the Gestapo's 1933 arrest of Ernst Thälmann, a leader of Germany's Communist Party. "We were a Communist theatre," said Robinson insistently years later. "Absolutely, no question about it."*

Officially, the Theatre of Action was leaderless; that was part of its mystique. Its members viewed acting as more important than writing and directing, often construing the latter as a group effort rather than any individual's responsibility. The two nominal leaders, however, were Stephen Karnot, its business adminstrator (and husband of an actress in the group), and Al Saxe, the creative head. Karnot, who could read and speak Rus-

---

* All the arts were trending toward the left and the Communist Party. Ray's pal from La Crosse, Alonzo Hauser, was busy finishing a portrait of Angelo Herndon, a Communist Party organizer from Atlanta facing imprisonment on trumped-up charges, while another friend in their artists' circle, Aaron Ben-Schmuel, was working on a sculpture entitled "Head of Lenin."

sian, had personally studied with Meyerhold in Moscow; Saxe, the most experienced, competent director among them, had an intellectual's grasp of Marxism and kept up on the latest Soviet axioms. As Ray recalled years later, it was Saxe who taught him how to "use 'affective memory' correctly"—that cornerstone of the Stanislavski system and later New York Method, whereby the actor conjures memories from related situations in his own past in order to impart those emotions to his character.

Karnot and Saxe were also both members of the Communist Party. Not every member of the Theatre of Action was a card-carrying Communist: Norman Lloyd, for example, never joined the party. But most were—including Earl Robinson, who could slip Thomas Jefferson into the same sentence as Karl Marx; Jean Evans, entreated by her boyfriend to join the Party; and Ray himself, who had first subscribed informally back in La Crosse. Yet in his political activities too, Ray was more a role-player than a leader, attending meetings and events but rarely speaking up with the vehemence that was fashionable among the subway types.

＊

While rehearsing and performing their agitprop skits, Ray and the other members of the Theatre of Action dreamed of a bigger arena for their talents and beliefs. In early 1935 they were urged by Communist Party functionaries to turn professional, paying themselves small salaries in order to qualify for membership in Actors Equity and promote militancy in the stage union. They began raising money from left-wing angels for their first midtown production.

The Theatre approached two of its advisory board members—Clifford Odets and Albert Maltz, both luminaries of the radical theater movement—hoping one or the other would contribute a work-in-progress for a main stage production. This was probably the first time Ray crossed paths with Odets, a promethean figure who would supplant Thornton Wilder as his literary god. But Odets and Maltz both demurred, and it fell to the collective to scrape together a valid play.

By February they had a title, *The Young Go First,* and the beginnings of a script that depicted militaristic conditions in youth camps operated by the Civilian Conservation Corps (CCC), a New Deal work relief program for young men, charged with improving public lands. The writers

were Peter Martin, the collective's "chief playwright," in the words of Earl Robinson—though Martin was no Maltz or Odets—and "George Scudder," a pseudonym "literally picked from the phone book" to protect the identity of Arthur Vogel, a friend of the collective who had survived an unpleasant stint with the highly regimented CCC. Vogel's tales of hardship had riveted the group.

Martin and Scudder received additional help from Charles Friedman, another board member who contributed to Theatre of Action affairs, and in the end got sage advice from John Howard Lawson, a doyen of the New Playwrights Theatre. Lawson, as big a name as Odets, invited Friedman, Martin, and Vogel up to his colonial mansion on Long Island to help structure the episodes devised by the collective.

Al Saxe was the logical choice to stage *The Young Go First,* even though his rigorous intellectualism did not always inspire confidence. Though he was beloved within the collective, Saxe could sometimes be too forceful and intimidating. Ray "worshipped" Saxe, but also "was frightened of him," recalled Perry Bruskin, a Theatre of Action member.

Kazan had begun to hang around late in the days, sensing an opportunity. With his subway looks, it was becoming clear that he wouldn't have much of a future as a glamorous leading man. Yet he saw the chance to turn his love for acting into the fulcrum of a directing career. Unlike Saxe, Kazan had no intellectual pretensions; he didn't frighten green, aspiring actors. An actor at heart, Kazan befriended and beguiled most performers, teasing miracles out of them.

Not long after the announcement that rehearsals were starting for *The Young Go First,* Kazan stepped in to assist Saxe, eventually becoming the play's codirector and all but shouldering Saxe aside. In his memoir, Kazan wasn't shy about taking the hero's credit for the first Theatre of Action production. "The script was incomplete—there was no third act," he wrote, "so I decided to create it by improvisation, placed a stenographer in the first row to take down what the actors said in the structure of scenes I'd arranged. I edited what she gave me into a satisfactory final act, and the play was realized. This impressed the actors, and I became even more admired."*

---

\* Incidentally, neither Kazan nor the unsung female "stenographer" was credited as a writer when the play opened.

Whether or not he improvised the third act, everyone agrees Kazan was a godsend to the Theatre of Action. But "Nik Ray" kept to the background, eleventh-billed as the camp barber in *The Young Go First*. Kazan gave this first stage of their acquaintance only glancing mention, with scant warmth, in his memoir.

At first, Ray struck up a closer empathy with Kazan's wife, Molly Day Thacher. A tall, deep-voiced, cultured blonde, Thacher was an unsung writer and editor who often contributed silently to her husband's projects. She had met Kazan when both were at the Yale School of Drama. When Kazan went into acting, Thacher became a volunteer worker for the Theater Union, a reader for the Group Theatre, and an editor of *New Theater* magazine. The couple had just collaborated with documentary filmmaker Ralph Steiner on an experimental short film, *Pie in the Sky,* which was being screened around town while *The Young Go First* was in rehearsal.

Being "codirected" by Kazan, even at this formative stage of his career, was like being a student in a master class. Kazan studied the actors as closely as they watched him, deriving much of his staging from the actors' own ideas and behavioral traits. Kazan was results-oriented, and the results he got were sometimes amazing. Kazan brought "this tremendous energy and this tremendous interest in you as an actor," explained Norman Lloyd, who was in *The Crime,* the second play Kazan codirected for the Theatre of Action. "He preserved your ego, so to speak, by being constantly interested in you, with fantastic energy which communicated itself to you and you gave it back, and there was this kind of great flow."

Inspired by Kazan, Ray and the collective threw themselves into *The Young Go First* when it opened at the Park Theatre, not far from Broadway at Columbus Circle, in late May 1935. The opening-night crowd was packed with left-wing friends and sympathizers who warmly applauded the Theatre of Action's condemnation of the CCC. "Perhaps a little too warmly," chided the *New York Times* critic, who thought the cast was stronger than the patched-together script. *Variety* agreed the play was "bad, very bad"—but went out of its way to mention "Nik Ray," despite his low billing among "several actors in the troupe," as one who "looks like a film bet."

The negative reviews were a blow to the young troupe, who had scavenged the financing and paid themselves scale for months, pinning their hopes on success. John Howard Lawson, a stand-up guy, penned a sharp

letter to the *Times* complaining about its review: *The Young Go First,* he insisted, was "thrilling" and "acted with great glow and vigor" by "brilliantly promising professionals." But the damage was done; the show hung on for five weeks before closing.

Nursing their disappointment, the collective retreated to new headquarters on East Twenty-seventh Street—a bigger space that Charles Friedman had wangled from a wealthy handbag manufacturer. The members debated whether to follow up their first three-act play with a musical revue or another straight-line message drama. Various possibilities were floated in the press, yet one by one the projects evaporated. "All very indefinite," reported the *New York Times.*

Over the summer of 1935, though, the Theatre of Action gradually rebounded. The East Twenty-seventh Street building opened up separate rooms for members of the collective and, eventually, even shared private accommodations for Ray and Evans. The months of struggle had brought the two closer together. The "orthodox" regimen and cramped quarters had tempered Ray's drinking, and the Communists were officially puritanical (if, often, personally hypocritical) about womanizing.

The collective resumed its classes and spot agitprop performances. They recruited a handful of new eager beavers, including Norman Lloyd, who was sent over by Joseph Losey after he'd directed Lloyd in a stage play in Boston. The Theatre of Action was "one of the first theatre groups to use The Method in a social way," Lloyd recalled fondly. "They were a mobile theater, going to picket lines, union halls and all over town. They were very good at singing, dancing and cabaret, in a European tradition."

While Saxe and Kazan huddled with possible investors and theater-of-the-left playwrights, Ray and the others waited for the two codirectors to decide the group's next move. The more esoteric parts of their regimen petered out, but acting classes persisted under Kazan's friend Bobby Lewis, another emissary from the Group Theatre. "We were in a sense a studio of the Group," recalled Lloyd.

Finally the decision was announced: Saxe and Kazan would codirect an evening of disparate one-acts, crowned by a new message playlet called *The Crime* by Michael Blankfort, an established radical playwright. Clearly patterned after the popular *Waiting for Lefty,* Blankfort's play concerned meatpacking workers who are debating whether to defect from the corrupt

American Federation of Labor (AFL) and join the more progressive Congress of Industrial Organization (CIO). The Theatre of Action could take months to craft and polish the material for a March 1936 slot in a Lincoln Center series sponsored by *New Theatre* magazine.

Again Saxe and Kazan worked as a tag team. "Al Saxe would start an improvisation by having us lie on the floor in pairs," recalled Lloyd. "We were 'the town asleep in the morning before the strike, before going out on the picket lines.' This was to find relationships.

"Kazan would come in to run rehearsals, and he would supervise improvisations too. I was attracted to the Method in the hands of Kazan; he was craftsman-like with it. Al Saxe, on the other hand, seemed to be prying into personal lives; he psychologized, which I resisted. In the abandoned factory loft where we rehearsed, we would pretend dawn was breaking on our improvisation as townspeople, lying in couples on the floor. 'And did you *feel* anything for her, lying there?' Saxe would demand. Instinctively, I resisted, although I did feel something.

"Kazan, however, got very good performances out of us when we did the play."

Lloyd, the newcomer, was awarded the lead, playing the main labor organizer. After months as a dutiful member of the collective, Ray was still relegated to the large supporting cast. A bider of time, he continued to watch and listen to lessons from both Saxe (the strict psychologizer) and Kazan (who continued to advocate "whatever works").

In the months ahead, even as they were rehearsing the night of one-acts, the Theatre of Action stayed politically engaged, cranking out skits and shows for political benefits. But their own finances suffered, and by the time *The Crime* was unveiled in March 1936 their material circumstances were dire. Since the days of *The Young Go First,* the Theatre of Action had become an increasingly shoestring enterprise: Where that play had boasted sets by the eminent production designer Mordecai Gorelik, everything about *The Crime* was bare-bones, including "skeleton sets."

The comparisons to *Waiting for Lefty* did not help matters. *The Crime* was an altogether gloomier proposition, with a central character who ultimately betrays the labor movement. The negative reviews didn't hurt the left-wing collective as much as the feeling that they'd deviated from the correct path. "It dawned on us that, however psychologically shrewd a portrait Blankfort had drawn" of the union leader who rats out his cause, Earl

Robinson wrote years later, "we simply did not want to expose any nega-
tive side to the labor movement."*

Something was dawning on Elia Kazan too. He also felt betrayed—by
the Theatre of Action. Working closely with the group, he learned that he
"was not a collective person, or a bohemian; I was an elitist." Collective
decision-making, he decided, was anathema to creativity. He was repulsed
by the group's "squalid," often "rancorous" togetherness, "sleeping three to
a room." ("Where did they fuck? I wondered.") Worst of all, Kazan claimed
in the autobiography he wrote fifty years later, he had finally realized that
the agitprop group was taking marching orders from the Communist
Party. Kazan had already been growing disenchanted with the left-wing
ideologues of the theater world, and this was just another brick in the wall.

Kazan said good-bye to the Theatre of Action and moved on with his
ambitions.

<p style="text-align:center">❄</p>

For Ray, the experience was altogether different: He may never have been
as happy as during his time with the Theatre of Action. A collectivist and
bohemian, at least in those years, he didn't mind the squalid lifestyle that
came with it. Although his Communism was the tag-along kind, he would
remain in the Party for the rest of the 1930s.

The Theatre of Action served as another substitute family for Ray,
like the Buskin Club or Taliesin: dysfunctional like all families, but fun-
damentally caring and supportive. Over the next ten years, as he divided
his time between New York and Washington, D.C., you might say that
Ray became the ultimate "Gadge" in left-wing show-business circles—an
invaluable factotum who didn't mind anonymity and showed little inter-
est in personal aggrandizement. Where Kazan was a cocksure go-getter,
Ray was an introvert who struggled with his own inner voices. It would
take him ten years to build the confidence and strength Kazan already
displayed.

---

* Ironically, as Robinson recalled in his memoir *Ballad of an American: The Auto-
  biography of Earl Robinson,* playwright Blankfort himself betrayed the left-wing
  movement two decades later with cooperative testimony in front of the House
  Un-American Activities Committee.

*The Crime* straggled on for a few more performances before the rapidly crumbling Theatre of Action abandoned the one-act. The East Twenty-seventh Street rooms quickly emptied out, and Ray and Jean Evans moved into their own place uptown on Fifty-second Street.

Because the Theatre of Action had been nominally professional, Ray and Evans qualified for emergency unemployment relief, allowing them to draw a weekly welfare check for subsistence. They felt as rich as Rockefellers in their new flat, and in April 1936 they got married in a civil ceremony at city hall. Esther McCoy, a young architecture critic who was friends with Jean Evans, was maid of honor, and Theatre of Action stalwart Al Saxe was best man.

On his marriage certificate, the twenty-four-year-old husband listed his occupation as "actor." That was still Ray's dream. His hopes were dashed the following month, however, when his best man held auditions for a George Bernard Shaw one-act called *The Great Catherine,* which Saxe was directing as part of an evening of playlets sponsored by the Federal Theatre, presented at the Experimental Theatre at Sixty-third and Broadway. Ray went up against David Kerman, another Theatre of Action Johnny-come-lately, for the role of Patiomkin (a.k.a. Potemkin), the crafty Russian prince who is the empress's lover in the comedy. Shaw had been Ray's forte in La Crosse, and he coveted the juicy role. But Ray was passed over in favor of Kerman, leaving him "very unhappy" about the casting, as Kerman recalled. Worse yet, the newly married man was left out of the cast altogether. The end was near for alter ego "Nik Ray."

❈

Once the Theatre of Action disbanded, its unemployed members scattered only briefly before reuniting and flowing into the Works Progress Administration's Federal Theatre Project. The next wave of left-wing theater would be subsidized by President Franklin Delano Roosevelt's New Deal.

The Federal Relief Appropriation Act, passed by the U.S. Congress in the spring of 1935, allocated $5 billion to create jobs for the jobless. Out of this legislation grew the WPA and its many satellites—including the Federal Theatre Project, established to launch or underwrite programs that stimulated the employment of stage artists. Harry Hopkins, the chief architect of the WPA, appointed a friend, Hallie Flanagan, the director of

Vassar College's experimental theater, to administer the Federal Theatre. He announced the goal of fostering "free, adult, uncensored theater," in Hopkins's words, throughout the fifty states. By the end of 1935, Flanagan had appointed playwright Elmer Rice, another advocate of theatrical experimentation, to head the new Federal Theatre's all-important New York City branch.

Flanagan had been greatly influenced by Stanislavski and Meyerhold during a 1926 visit to Russia; while at Vassar, she had staged provocative dramas based on true-life and topical events. But she was a New Deal idealist, not a Communist. She didn't foresee, or initially care about, just how thoroughly Federal Theatre–affiliated troupes, in New York and across the United States, would be swarmed by jobless left-wing or Communist theater personnel.

At Flanagan's suggestion, Rice began planning a series of large-scale "Living Newspaper" plays spun from the news and headline events, designed to put a maximum number of unemployed journalists and theater people alike to work. Rice appointed Morris Watson, an out-of-work officer of the National Newspaper Guild, to head the New York Living Newspaper unit.

The first announced Living Newspaper play, however, had turned into a fiasco. The script for *Ethiopia,* dealing with Italy's October 1935 invasion of the African nation, was proudly leftist, incorporating real-life diplomats and foreign ministers as characters while sharply condemning the world's democracies for tolerating Mussolini. When furious isolationists in Congress denounced the show, Flanagan was forced to order compromises; after defiantly inviting press and dignitaries to a full dress rehearsal, Rice resigned. *Ethiopia* was canceled a short time later.

To direct the second Living Newspaper production, Hallie Flanagan and Morris Watson chose that *other* young man from La Crosse: Joseph Losey, who had just finished staging Rudolph Fisher's play *Conjur' Man Dies* for producer John Houseman and the WPA-funded Negro Theater of Harlem.

In Losey's hands the second Living Newspaper show would prove as sensational as *Ethiopia. Triple-A Plowed Under,* as it was called, sketched the struggle of American farmers in the 1920s and 1930s, the widespread drought, the farmer-consumer cooperatives, and the fate of the Agricultural Adjustment Administration (AAA) at the whim of the conservative Supreme

Court. Again, characters in the elaborate piece of agitprop were based on real people, including Earl Browder, head of the U.S. Communist Party, and the "nine old men" (as Roosevelt had dubbed them) of the Supreme Court, which had struck down the AAA and other New Deal programs.

This time, however, Flanagan deftly mediated changes in the script, and the play was allowed to open in March 1936. Outside the theater there was picketing; inside the lobby police stood guard; in the audience reactionary plants stood and shouted their objections. Nevertheless, *Triple-A Plowed Under* scored a hit with New York critics; the play ran on Broadway for two months around the same time *The Crime* was proving the swan song of the Theatre of Action.

Losey's contract was renewed, and he was announced as director of the third Living Newspaper. Knowing Ray was out of work, Losey offered him a job with the new Federal Theatre production. The acting involved would be trivial. The important thing is that Joseph Losey was the first to recognize that Ray's future did not lie in performing. Instead, Losey promoted Ray to stage manager.

✳

The two had crossed paths with increasing frequency in New York theater and left-wing circles; Losey had kept up with the Theatre of Action, seeing both *The Young Go First* and *The Crime*.

They had known each other only superficially in high school, and Losey was gone before Ray became "famous in La Crosse." But Losey knew about Ray's directing and producing accomplishments in the city from their mutual friend Russell Huber and from Ray's high school classmate Mary Losey, Joseph's younger sister, with whom Losey shared an apartment in Manhattan.

In these early days of their respective careers, Losey outshone not just Ray but even Elia Kazan. After attending Harvard and Dartmouth, he had directed notable plays in Boston and on Broadway; he had just returned from a long stay in the Soviet Union, where he had mingled with the titans and innovators of Moscow theater. Losey had rubbed shoulders with Bertolt Brecht and directed a version of *Waiting for Lefty;* he had attended rehearsals run by Stanislavski, watched Okhlopkov block a play, sat in on Meyerhold's classes.

Engaged to marry the iconoclastic fashion designer Elizabeth Hawes,

who had accompanied Losey to the Soviet Union and who created the costumes for *Triple-A Plowed Under*, Losey even had posed for an Edward Steichen portrait—"arms resolutely crossed, mouth heavy, eyes faintly resentful, expression resolute and sullen," in the words of one biographer.

Ray's friendship with Losey never quite transcended Losey's patrician superiority. Some, like John Houseman, who knew them both, saw theirs as a love-hate relationship. More than once, however, Losey would throw Ray a lifeline, as he did in the late spring of 1936.

When he contacted Ray, Losey was already deep into the planning of the next Living Newspaper. Called *Injunction Granted*, the play would recount the history of organized labor's unfair treatment in American courts. The text would be as inflammatorily left-wing as the previous Living Newspapers, extolling the Molly Maguires, Sacco and Vanzetti, the Haymarket Square martyrs, the Pullman strikers, and CIO founder John L. Lewis, while excoriating Mayor La Guardia, newspaper magnate William Randolph Hearst, and the Supreme Court. Morris Watson, the Newspaper Guild activist who headed the New York unit,* and journalist Arthur Arent were busy collating the skits and contributions of unemployed colleagues.

*Injunction Granted* would be the largest, most ambitious Living Newspaper yet. As backstage manager, Ray would preside over one hundred and twenty-five performers dispersed over one hundred separate scenes, with a Rube Goldberg–type set subdivided into platforms, ramps, levels, and steps. The production would entail five hundred lighting cues and one hundred and forty musical ones (the Virgil Thomson score would be played by a singular orchestra heavy on snare, kettle drums, ratchets, sirens, and ship's bells). Last but not least, Losey planned on using lantern slides and projectors to cast headlines and photographic images on a screen overhead.

They rolled up their sleeves and dug in, aiming for a late-July opening. Losey was yet another sterling role model for future film director Ray. While Kazan's effect on Ray was obvious, Losey's influence was more ambiguous. Never known as a nurturer of actors, Losey still managed to extract strong performances from his players; he directed less like a friend than a general, cold and domineering. He was less interested in theatrical intimacy than in intricate construction and mise-en-scène.

For *Injunction Granted*, Losey would draw heavily on Meyerhold's ideas

---

\*  Morris Watson, himself fired for helping to organize the Newspaper Guild, fought his case up to the Supreme Court and won.

of symbolism and on the epic style of the German director Erwin Piscator. Like them, Losey wanted to erase the barriers between stage and spectator. More visually oriented than many theater directors, he employed an Eisenstein-like compression of many small quick scenes in his Living Newspapers—a style "approaching a movie technique," in his words.

Ray had friends galore in the large cast, including Norman Lloyd, one of several Theatre of Action veterans recruited for roles. Lloyd again claimed top billing as master of ceremonies of the extravaganza, playing a pantomiming clown who plunks a Virgil Thomson ditty on his toy piano. The backstage manager had a few bits onstage, way down in the billing, still stubbornly listed as "Nik Ray."

Anticipation mounted for the July opening, but so did opposition from rabid anti–New Dealers, who saw *Injunction Granted* as nothing less than veiled Communist propaganda. Once again Hallie Flanagan had to plead for script softening; Watson and Arent were amenable, and solutions were negotiated, but Losey quit in a huff just before opening night. "I was not a member of the Communist Party at that time," he always insisted. (He did join later.)

Ray stayed on, however—the first dramatic evidence of the practical streak that would mark his career in New York and later in Hollywood. More than once he inherited other stage or film directors' unfinished works, several times completing projects abandoned by his predecessors. In this case, Ray effectively supervised the toned-down *Injunction Granted* after Losey resigned, directing backstage traffic while overseeing the scenery, lighting, and musical cues.

Perhaps Ray was covering for Losey, who had the luxury of making a grand gesture of defiance while keeping in touch with the stage manager about fine points of the show. The two remained friendly, and soon after, when Losey announced plans to form a "Social Circus," a new left-wing theater ensemble that aimed for topical cabaret and meaningful political plays without qualms or censorship, Ray was one of the first to donate to the cause. (Kazan was another.)*

When *Injunction Granted* opened in the last week of July 1936, liberal and left-leaning reviewers praised the latest Living Newspaper, while

---

* But there were not enough donations and Losey's "Social Circus" died stillborn.

the political right heaped predictable scorn upon it. But the crowds were steady—Flanagan privately maintained that union leaders ordered their faithful to fill the theater—and Ray maintained his perch as stage manager throughout the three-month run. It was the best money he had yet earned in New York.

<p style="text-align:center">✳</p>

"Nik Ray" the actor still made fleeting appearances for political causes. One last glimpse of that identity came in September 1936, for a hotel ballroom presentation of Kenneth White's *Who Fights This Battle?* directed by none other than Joseph Losey. Five performances aided the anti-Franco forces led by Communists in the Spanish Civil War. Paul Bowles contributed the music, and Earl Robinson served as pianist, organist, and conductor. Ray and Norman Lloyd both performed key roles onstage.

By the time the Living Newspaper play closed in October, "Nik Ray" had reverted permanently to Nicholas Ray. More important, less than two years after returning to New York from Mexico, Ray had fixed his place in left-wing circles as not just an obscure actor but as a backstage manager who could be trusted with a job as big, complex, and pressure-ridden as *Injunction Granted.*

Morris Watson, who was grateful to him for sticking with *Injunction Granted,* recommended Ray for his next paying job, which entailed another promotion. In the words of the first small item ever to mention him in the *New York Times,* Ray was tapped to "head the professional labor-drama school" of Brookwood Labor College, located about forty miles north of New York.

Though it resembled a traditional campus on an estate outside the village of Katonah, in Westchester County, Brookwood was a college that trained labor union organizers and officers. Founded in 1919, and financed by radical idealists and workers' organizations, the college offered a socialist-based education that supported goals of peace and unionism. Over time Brookwood had aligned itself with the upstart CIO against the conservative AFL.

The college prided itself on original theater laced with labor songs and humor, often a collaborative effort between students and the faculty. One of its celebrated plays was *Sit-Down,* which portrayed the 1936–37 sit-

down strike of the United Automobile Workers (UAW) against General Motors in Detroit. (The sit-down tactics won the recognition of the UAW as bargaining agent.) Ray had enjoyed *Sit-Down* during its rowdy tour of northeastern cities.

Kindred spirit Earl Robinson (like Ray one of the few non–New Yorkers in the Theatre of Action) went along on the adventure as resident composer of Brookwood's drama program. "We had two hours a day," Robinson remembered. Ray "was allowed to put together a group of performers, and I would be an integral part of it as music director. Nick was to build a show to take touring through the unions in the spring. We worked with improvisation—all the things he'd learned during the Theatre of Action he was applying here as director. We had rehearsals, worked with the union members in production stuff, and had music classes."

They were hired for eight months at $120 monthly, but their tenure lasted less than three. Drained by AFL-CIO warfare and other factional infighting, Brookwood Labor College was steadily losing benefactors and cutting programs. It would close permanently early in 1938.

Ray managed to get out before Thanksgiving 1936. Having seen the handwriting on the wall, he applied for a management post with the Works Progress Administration in Washington, D.C. By January he and Jean Evans had moved from their New York apartment into a large house in Arlington, Virginia, a short drive from the nation's capital. In six brief months Ray had gone from welfare checks to an annual salary of $3,200, and from nonentity in the Theatre of Action to a man suddenly thrust into the center of national culture—and controversy.

✳

A few hours from New York by car or train, Washington was worlds apart from anything in Ray's experience. Arriving in the dead of winter, Ray found the city to be southern in climate and backward in other ways. For one thing, everything revolved around the government.

Ray had received the tip about the job opening from sculptor Lenore Thomas, a friend of Alonzo Hauser's working for the WPA in Washington. Someone was needed to run the theater branch of the Resettlement Administration, which was in the process of being absorbed by the Recreation Division of the WPA. Part of the same New Deal agenda that

fostered the Federal Theatre Project, the Recreation Division special-
ized in "folklore studies," collecting folk art documents and dispatching
out-of-work artists of all types to rural and neglected areas of America,
where they were expected to nurture grassroots culture. Its offices were in
the Walker-Johnson building on New York Avenue, just a block from the
White House.

The WPA empowered a number of folklore divisions to collect all
manner of cultural artifacts: photographs; the texts of local plays; tran-
scriptions and recordings of folk songs, tall tales, and oral legends; all
manner of artwork and crafts; and documentation of community dances
and rituals. Intended for future use by scholars and entertainers, the arti-
facts were archived by the Library of Congress and cooperating universi-
ties. This national treasure hunt enlisted unemployed professionals from
all walks of life, and Ray wasn't the only one destined for later fame. For
that matter, many of the folk artists they discovered would also go on to
popular acclaim.

Ray's original mandate was theater, but his interest in architecture,
art, and music allowed him to range widely—never more widely than in his
three years with the WPA. Nor did he ever travel as freely inside the United
States. Though his job was to assign and support others in the field, he hated
being cooped up inside his office, and he journeyed to many small towns
and communities throughout the East Coast and parts of the Midwest and
South to distribute funds, meet local artists, and cheerlead the arts.

At first Jean Evans accompanied him on these adventures, especially
in 1937, his first exciting year with the WPA. They ventured into the Al-
leghenies near Pittsburgh, where Ray had been alerted to the genius of an
ancient fiddler, whose tunes they collected. ("Cabbage soup with a piece of
pork and canned corn had been the evening meal," he wrote.) They spent
weeks in North Carolina helping rural inhabitants stage a harvest pageant,
and similarly generous time on a farm near Scottsboro, Alabama, helping
shape a local program of folk ballads, dance, and theater.

Together they traveled throughout Appalachia and as far south as
Florida, Louisiana, and Texas, meeting fishermen and miners and share-
croppers and tenant farmers, rallying enthusiasts and experts and artists
for community festivals, performance recitals, plays, concerts, art exhib-
its, and radio broadcasts in small towns and cities. "I lit a show with miners'
lamps and used a haywagon for a stage," Ray recalled proudly years later.

When Jean stayed home, other companions hopped in the car. When Elia Kazan visited Washington, he ended up hitching a ride with Ray to Louisiana to meet Huddie Ledbetter, the gravelly-voiced folk and blues musician who called himself Lead Belly and whose checkered past included incarceration for violent crimes. Though armed with an introduction from WPA musicologist Alan Lomax—whose father had discovered Lead Belly, only to be sued by the singer later to void their contract—they didn't know what to expect. Ledbetter kindly invited them into his home, served them rice and beans, and later serenaded the two with "Mary Don't You Weep, Don't You Mourn," "a song about Tennessee water" tasting "like turpentine," as Kazan reminisced in his autobiography, and "Irene," the latter destined to become "a big fat bourgeois hit."

Like Ray, who was also meeting the legendary musician for the first time, "I was in awe of Lead Belly," Kazan recalled. "He was reputed to have killed a man in a 'bottomland fracas.' Had he? . . . Either way, they'd hung it on him and packed him off to a prison camp."

Some of the folk artists Ray encouraged were apolitical, but often enough the arts projects reflected his own leftist politics. While in Alabama, he received a letter from white high school students from a town forty miles south of Birmingham, asking for advice and assistance in staging an antiprejudice play. He drove to meet with them and help with their plans. Visiting Chattanooga, Tennessee, he assisted a chapter of the militant International Ladies Garment Workers, sponsoring a play protesting Japanese aggression in the Sino-Japanese War.

After all, nurturing the folk arts had been part and parcel of the left-liberal New Deal agenda ever since FDR was first elected. Eleanor Roosevelt took a special interest in the WPA's artistic reclamation missions, inviting many of the traditional musicians first recorded by Ray or the Lomaxes to the White House and the presidential retreat at Warm Springs, Georgia. Ray attended conferences and social occasions with the First Lady as well as FDR's top advisers, though it may be too much to believe that he was "a dear friend of the La Follettes and of Eleanor Roosevelt," as his sister Helen claimed, after visiting Washington and attending one of the WPA shows on the White House lawn with Mary La Follette.*

---

* Mary La Follette was the mother of Robert La Follette Sr. and grandmother of Robert ("Young Bob") La Follette Jr., the Wisconsin Progressive Party adherent who succeeded his father as senator from Wisconsin.

Ray found other ways to bring his fieldwork back to Washington. Late in 1937, for example, he hosted a series of talks at the Federal Workers School on Seventeenth Street. He debated the transformative political power of poetry with writer Floyd Dell, a firebrand who had been a leader of the Chicago Renaissance, a founder of the Provincetown Players and an editor of the radical magazine *New Masses*; now he was drawing a WPA paycheck. According to one Washington paper, Dell argued, "by quoting poetry, that poetry cannot have effect on trade unions or the labor movement generally," while Ray argued "with equal heat that poetry can and does have a tremendous effect on labor and union activity." The audience was treated to phonograph recordings of sharecroppers reciting verse, which Ray himself had recorded.

One can imagine the smile on Ray's face as he listened to those sharecroppers. The first year was a time of hard work but also sunny optimism, and no one seemed more hardworking or optimistic than the tall, broad-shouldered WPA emissary. No one was more patient with the amateurs, and ever since his College days Ray had been equally at ease mingling with dignitaries.

The happy, optimistic year 1937 was topped when Jean became pregnant—or, as Ray boasted proudly in a letter, when his wife announced she was "with stowaway which will gain air on its face and consciousness sometime in November." Gaining air on November 24, the stowaway was named Anthony Nicholas Ray, his first name a nod to Anthony Mann, an older stage-director friend of Ray's back in New York whose career was gathering momentum with the Federal Theatre.

✳

No one embodied the spirit of optimism more than Alan Lomax, a tall, swarthy Texan with a booming speaking (and singing) voice. He and Ray became soul mates during the WPA years. Ray "was certainly one of the most splendid young men in the whole world," Lomax once recalled. "He seemed to me to be the person I'd always dreamed of being. He was very powerful and gentle and wonderful to look at. He had a kind of a grin and a laughter that were the same thing. They were always playing on his face when he was discussing the most serious matters."

Collecting folk traditions ran in Lomax's genes, and he intended to live up to the legacy of his father, the pioneering musicologist John A.

Lomax, who was semiretired by the late 1930s but still an honorary cura-
tor of the Archive of American Folk Song in Washington. Born in 1915,
Alan was slightly younger than Ray, and initially worked as assistant to
another pioneering archivist, Charles Seeger of the Federal Music Project,
from whose basement offices in the Library of Congress Lomax took up
the tireless pursuit and documentation of folk music.

Lomax's enthusiasm for his cause was boundless and infectious—
perhaps to a fault. One person who worked with Lomax compared him to
Casaubon, the mythology scholar in *Middlemarch,* who ensnared people
in the web of his enthusiasms and the "greater-than-self" importance of
his mission, then sucked all the vitality out of them before they realized
the mission was endless.

Ray fed on other people's energy and exuberance, and he was gladly in-
fected. By late 1937 their friendship had so blossomed that Lomax and his
wife, Elizabeth, moved into the Rays' Arlington house, which had extra
bedrooms. Soon, their shared house became an after-hours gathering spot
for itinerant musicians and WPA colleagues. Ray and Lomax doubled as
hosts; both frustrated vocalists, they sang duets and were even known to
sing along on their own field recordings. At parties or alone together, their
singing rang out competitively. Lomax thought of them "like Damon and
Pythias," in his words, "like brothers."

Community theater was a constant challenge for Ray; it was time-
consuming and expensive and difficult to nurture on the grassroots level.
Recording, in contrast, was something Ray had loved since his radio days,
and he could easily make recordings of individuals and small groups on
behalf of the WPA—and future generations—wherever he traveled. More
and more under the sway of Lomax, he lugged a cumbersome Presto re-
corder, complete with turntable and amplifier, along on the road.

Ray's musician friends and WPA colleagues were all the more precious
in Washington, where enemies of the New Deal were plentiful. Belief in
the transformative power of art was not the exclusive province of the left,
but it was an open secret that, as with the Theatre of Action or the Living
Newspaper, many members of the Ray/Lomax circle were Communists
or nearly so. "We had a small underground cell in Washington," sculptor
Lenore Thomas recalled. "None of us carried cards. Mostly we sat around
and talked and studied Marxism-Leninism, dialect materialism etc. We
were not very dangerous, but very earnest."

The WPA leftists grew apprehensive in August 1938 when the House Committee on Un-American Activities (later known by the acronym HUAC), spearheaded by Republicans and conservative Democrats, launched hearings into how the Communist Party USA supposedly overran the Federal Theatre Project. Stephen Karnot, Al Saxe, and other friends of the Rays were attacked in public testimony (one witness described Saxe, Ray's best man, as a zealot who "ate, drank and slept Communism"). The Theatre of Action and the Living Newspaper were among the offending groups cited in public testimony, with newspaper items and cast lists accepted as evidentiary material in executive session.

Hallie Flanagan was not allowed to defend her noble intentions for the Federal Theatre Project until December 1938, by which time she had been thoroughly pilloried by witnesses and the press. Conservative congressmen piled on, accusing her of Red sympathies and ties.

Six months later, in 1939, Congress canceled funding for the Federal Theatre Project. But the hearings had focused on New York, while the WPA cell in the government's own backyard escaped scrutiny. Ray and his leftist friends had left the Federal Theatre behind, and though it would remain a storied chapter in their lives, most people in the left-wing theater movement had already soured on a government program that never stopped trying to appease its right-wing critics. To Ray and the others, the HUAC episode was more of the same anti–New Deal wind that had been whipping up a frenzy ever since FDR was first elected. Before too long, they all felt, it would surely blow over.

❉

New York City was close enough for Ray to visit often, seeing friends and keeping up with theater and shows. In New York the latest vogue was political cabaret, and Manhattan nightclubs were suddenly teeming with topical song-and-dance message revues. Ray's favorite place was the Cabaret TAC (acronym for the Theatre Arts Committee for Peace and Democracy), a midtown nightspot, where his old musician friend Earl Robinson was among the performers. It seemed as though everyone on the left in show business was dabbling in café society revues, including Joseph Losey.

Ray and his D.C. friends thought the success of the Cabaret TAC might be replicated in Washington, and early in 1939 they formed the

Washington Political Cabaret. Their topical cabaret debuted in March of that year, above Childs Restaurant, a cafeteria chain for the working class, on Pennsylvania Avenue. Though not officially underwritten by the New Deal, most of the participants were Ray's WPA colleagues; in many ways, the cabaret summed up Ray's artistic eclecticism during the years 1937–39. At the same time, however, the program was not so very different from the loose-knit musical revues that Ray had staged back at La Crosse Teachers College, or that the Theatre of Action had performed on city streets in its heyday.

The song-and-dance numbers and message skits in Ray's cabaret were woven together by a master of ceremonies. Bernard C. Schoenfeld, at that time a radio writer for the Interior Department—later he too became a Hollywood director—wrote most of the sketches and song lyrics. Freda Berla composed the music, while the well-known modern dancer Sophia Delza contributed choreography. The approach was generally light and satirical ("intellectual entertainment, liberal in tone, but not grinding any one's particular axe," said the *New York Times*). But the song "Mister Lincoln" was an antiprejudice showstopper, and Jean Evans penned the show's ambitious, serious-minded centerpiece, "Message from a Refugee," involving the entire cast of fifteen performers.

Although Ray did a little writing—collaborating with Schoenfeld on a humorous sketch about a government gal, stranded by busy traffic on an F Street island, falling in love with a fellow castaway—his main contribution was directing. "Entire Production Staged by Nicholas Ray," the program announced; the Washington Political Cabaret got Ray his second mention in the *New York Times,* and the *Washington Post*'s drama critic, Richard L. Coe, agreed that the director was the revue's true "guiding star." Ray and friends had concocted a "novel and refreshing" way to spend Saturday nights out on the town, Coe wrote.

Ray reached another milestone a few weeks later, in June 1939, when the British sovereigns, Queen Elizabeth and King George V, visited Washington. In their honor, Ray helped Alan Lomax organize an "Evening of American Music" at the Executive Mansion. Besides popular recording star Kate Smith and classical singers Marian Anderson and Lawrence Tibbett, the entertainment they assembled included the Soco Gap Square-Dance Team from the Appalachians, the Coon Creek Girls from Kentucky, the North Carolina Spiritual Singers, and twenty-four-year-old Lomax himself singing cowboy songs to his own guitar accompaniment.

\*

The Washington Political Cabaret ran its course; as refreshing as the revue may have been, the capital cabaret couldn't count on New York–size audiences night after night.

Ray's initial fervor for the WPA had also begun to cool. He was a role player in the White House triumphs, and they were few and far between. None of his discoveries was another Lead Belly; more often he scrounged for obscure talent in the field, with limited time and money.

He made several trips to the Midwest, passing through Wisconsin and visiting his mother, one time ranging as far west as South Dakota. In October 1939, he convened a temporary WPA school in an armory in Mitchell, South Dakota, gathering specialists from Madison, Milwaukee, Des Moines, and the Dakotas for a two-week training course in arts and crafts and community recreation. In Mitchell, for example, Ray collected thirty-eight recordings on eleven twelve-inch discs. The modest pickings included a local production of *Romeo and Juliet,* area fiddlers, cowboy songs, Paul Bunyan tales, and area lumberjacks singing "Oh, Susannah!" and "Home on the Range."

"I was very irritated with the fact that I had only two or three hours at the most each day in which to find, make dates with, and record the few people I had at Mitchell," Ray wrote grumpily to Dr. Harold Spivack, chief of the Music Division at the Library of Congress on October 30, 1939, "and consequently I'm quite dissatisfied with the recordings."

Such trips could be a real letdown, replete with missed opportunities. Ray felt "confined to the Mitchell area because of my official responsibilities," he wrote, sacrificing "entrée to the river rats of the Jim, west of the Missouri River to the whole western South Dakota area, which includes mining and sheep and cattle industries. As well as an Indian reservation and a Mennonite colony."

He referred to a familiar ambition "to write something" worthwhile, this time for the WPA, explaining that he had been thwarted by bureaucratic demands. "I have made several attempts to outline and develop in a rather comprehensive way my ideas on the origin, development, and the decline of the Folk Theatre in America. I can not [*sic*] do it while I am being constantly interrupted by making train schedules and carrying on my other duties."

More often than not, Ray sat shuffling paperwork in his D.C. office, feeling increasingly imprisoned in the system. He had once fancied himself a stage performer, even a director, but now he was turning into a pencil-pushing bureaucrat. He began keeping a stash of bourbon in his desk drawer; between those dulling days at the office and his long nights with new musician friends in D.C. and on the road, his drinking, under control in New York, shot up.

✻

The birth of Ray's son, a joyous milestone in his life, marked the beginning of the end of his marriage and family in a way he couldn't have foreseen and that can't be easily explained. Both Jim Backus in *Rebel Without a Cause* and James Mason in *Bigger Than Life* long to be good fathers but fail spectacularly, grasping for excuses as they're overcome by drastic circumstances.

Jean Evans was pleasant and good-natured to a fault, but the steady stream of visitors to their Arlington house took a toll on the young mother and child. By the late 1930s the left-wingers were drifting away, but the musicians continued to proliferate: Lead Belly passed through often, as did the ragtime and jazz pianist Jelly Roll Morton, who was playing at D.C. clubs and recording for Lomax and the Library of Congress. Earl Robinson, Ray's musician friend from the Theatre of Action days, also crashed at the house whenever he came to town.

The house parties sometimes ran all night, and Ray was often the last one standing, smiling, bleary-eyed, a drink swirling in his hand. Home and family were personal prisons that Ray would flee or wreck repeatedly in his life; they were as anathema to him as a desk in an office. But Evans too struggled with domesticity and felt inadequate as a mother.

Ray's Washington friends, including Alan Lomax, liked to blame Ray's bad habits on the hectic lifestyle and pressures he suffered in New York; the New Yorkers he knew blamed his behavior on Washington, which they found a pretentious, treacherous maze. For Evans, her years in Washington were all about "rushing around, being impressed, impressing, grinding axes," in her words. "I despised all that."

In New York, Ray and Evans had enjoyed a loving, monogamous relationship for several years. But in Washington their marriage was endan-

gered not only by Ray's drinking and partying but by a resumption of the womanizing that came all too easily to a big, handsome, sweet-smiling man.

Everyone who knew the couple seemed to know about Ray's affairs, which hurt Evans even more. "He wasn't true to her," said Pete Seeger, archivist Charles Seeger's youngest son from his first marriage. The tall, thin, apple-cheeked Seeger hung around with the WPAers before dropping out of Harvard and joining the circle full-time. "I pitied his wife."

Later in his life, Ray would admit that he cycled through a pattern of attraction and repulsion with the women in his life. "Out of the blue he once told me, 'I'm afraid that sex destroys intimacy more often than it creates it,'" Gavin Lambert wrote of the director, who became his lover briefly in the mid-1950s. The only woman he was ever "truly happy with," Ray confessed, was Jean Evans—though he took the lead in destroying that happiness.

He and Evans talked over their differences. Evans insisted her husband should consult a psychologist about his self-destructive habits. She thrived on analysis and couldn't live without her appointments. Ray wasn't sure therapy would work for him, but he agreed to give it a try.

✳

Ray's WPA contract was due to run out but he continued to cast his lot with the indefatigable Alan Lomax. At one point the two friends had tried to collaborate on a play about "the growth of jazz," and another time they schemed to produce ten-minute films under Library of Congress sponsorship about "the Holiness Church, spirituals, railroad songs, and music of the Southwest," according to Lomax biographer John Szwed. Ray and Lomax envisioned the established documentarist Joris Ivens and budding filmmaker Joseph Losey—an occasional visitor to their shared home in D.C.—as partners in the formation of a small company devoted to making short, socially conscious films for theatrical release, but the idea died for lack of funding.

Though still engaged in field studies for the Library of Congress, in early 1940 Lomax was offered a chance to produce folk music segments for a long-running CBS radio series called *American School of the Air,* which was beamed into U.S. public schools for half an hour on Tuesday mornings. Lead Belly could be a headliner, and Pete Seeger, who had moved in

with the Rays and Lomaxes, would also play music and sing songs. Lomax was initially wary of radio, but Ray urged him to accept the offer and together they planned how to organize and script the show.

In the first week of March 1940, Ray, Lomax, and Seeger took the train to New York for the sold-out Grapes of Wrath concert to benefit migrant workers at the Forrest Theater. Seeger was somewhere on the bill—making an underwhelming public folksinging debut—but a dust-bowl balladeer from Oklahoma named Woody Guthrie proved the night's real sensation.

Guthrie had gained his first fame on the West Coast, touring migrant camps and singing topical songs on the airwaves, before his unabashed radicalism cost him his job (THIS MACHINE KILLS FASCISTS was scrawled on his guitar). After the Grapes of Wrath benefit, Ray and Lomax wended their way backstage and Lomax bent Guthrie's ear, persuading him to come to Washington, record his music for the Library of Congress, and join the *School of the Air* project.

Guthrie came and stayed as a guest at the Arlington house with Ray and his wife and the Lomaxes. The singer's musical purity and songs of the common man made him a god to some, but he was a god who chain-smoked and drank like a fiend and proudly lived the life of a rambler who didn't know or care where his next meal was coming from. He had a maddening habit, like Ray, of making you wait forever sometimes before he said something. He slept in bed in his muddy boots until reproached by his hosts and thereafter made a point of sleeping on the floor with his lumber jacket as a blanket. He preferred to eat while standing up—to avoid bourgeois softening, he explained. He played the same Carter Family recordings, especially his favorite outlaw ballad "John Hardy," over and over again, until people felt like screaming.

Aunt Molly Jackson, a Harlan County, Kentucky, militant folksinger also recording for Lomax and the Library of Congress, moved in around the same time. "Life was hell," Evans said. "Woody didn't talk. But he'd break empty liquor bottles by tossing them into the fireplace. Aunt Molly, whenever she slid from one end of the couch to the other, would say, 'Children, I tore my ass!' Then there was a cowboy who had ridden his horse all the way from Texas. He was recording at the Library of Congress too, so he tied the horse to a post in our back yard . . ."

Evans had found a new job, though, giving her an escape hatch and a temporary solution to her marriage woes. She was chosen from among

thousands of applicants for a post writing women's articles and Sunday human-interest features on the new advertising-free tabloid *PM*. A daily financed by unorthodox Chicago millionaire Marshall Field III, *PM* would become known to friends and foes alike as "a cross between *The New Yorker* and *The Daily Worker*" for its literate, left-wing slant. Buoyed by the prospect, Evans left for New York—and *PM*.

The folk music program *School of the Air* went ahead, but in half-baked fashion: After Guthrie and the others introduced their songs on air, CBS insisted on having them formally orchestrated by Aaron Copland or Seeger's respectable father, Charles. The result satisfied no one, and the series was called off after a few weeks. "The experiment, which must have cost CBS a small fortune, was a colossal failure," Lomax recalled.

Regardless, the experiment gave CBS a taste for folk music—and a measure of confidence in Lomax and his scruffy band of followers. Lomax pitched the network on a Plan B: a fifteen-minute, thrice-weekly, late-night radio show of folksy banter and traditional music, a kind of *School of the Air* for discerning adults. Lomax would supervise the show from Washington, but Ray and the musicians would stage the episodes in the network's broadcasting studios in New York. The arrangement allowed the musicians to work in New York, where they'd be able to line up more gigs—and allowed Ray to follow Jean Evans back to the city.

CBS said yes, adding the new late-night series to its projected fall 1940 lineup. While *School of the Air* had been virtually pro bono, its night-time spinoff, called *Back Where I Come From* (as in "Back where I come from, folks used to say . . ."), would bestow regular paychecks on Lomax (as writer-producer), Ray (cowriter and director), and the chronically empty-pocketed musicians. Guthrie and Seeger hit the road on a last tramp while the details were being ironed out.

Ray returned to New York in May 1940, briefly moving back into an East Village apartment with Jean Evans and their three-year-old son, Tony. Ray vowed to see a psychiatrist and quit boozing, but Evans saw through her husband's good intentions with sympathy and clarity. He was a "wonderful man, not to be married to," Evans told Bernard Eisenschitz.

Rather than live together fractiously, the couple soon decided on a formal trial separation. Ray began to live without a fixed address, crashing around in friends' apartments, which he liked. This was one of the things he had in common with Guthrie—settling down unsettled him.

Even as his marriage fell apart, Ray had to register for the draft, to comply with the yearlong peacetime conscription Congress had enacted after the fall of France in late June 1940. But something that Ray did or said caused him to be rejected by the draft. Eisenschitz wrote that Ray was pardoned from military service "because of rheumatoid arthritis and the congenital cardiac malfunction" that also hobbled his father and grandfather. In one interview, producer John Houseman said that Ray's "bad heart" had disqualified him; another time, Houseman attributed it to a "rheumatic heart" (a different condition altogether). But, according to Houseman, Ray exacerbated matters by informing the draft board— pointedly, just as he was separating from his wife—about "his homosexual experiences as a young man."

It's hard to know whether Ray had engaged in dalliances with other men since his fling with Professor O'Hara in Chicago, almost a decade before. But perhaps he did perceive a connection between the rupture of his marriage and his divided sexuality. Perhaps he did tell the draft board—and his wife—about his attraction to men.

Then again, Ray may also have had political motives. After the controversial Hitler-Stalin nonaggression pact in August 1939, the Communist Party USA staunchly promoted a neutral stance toward Hitler. Good Communists were expected to evade any commitments to U.S. military service—a diktat that persisted until Hitler invaded Russia in June 1941. From that point on, American Communists were encouraged to support the war . . . and enlist.

Whether he contrived to abide by the Hitler-Stalin pact, confessed his bisexuality, or pleaded a weak heart, Ray was disqualified from military service. Which left nothing more to stand in the way of the next stepping stone in his career: directing *Back Where I Come From.*

# *"Ungathered"*

## 1940–1946

In spite of his marital discord and draft pressures, Ray felt good to be back at home in New York. He spent the summer of 1940 shaping the pilot episode of *Back Where I Come From,* the radio show on which he and Alan Lomax intended to introduce the joys of folk music to the American public.

Nominally supervising the show from the remove of Washington, D.C., Lomax was the music expert and credited producer of the series. CBS network officials viewed Ray as his subordinate. But Ray was the man with radio experience who'd handle the actual broadcasting, and in practice Lomax treated Ray, who not only directed but also collaborated on the scripts, as an equal partner.

This was the first national forum for Nicholas Ray—the take-charge personality who had won a high school radio contest, whose eclectic creativity never slept during his college years, and who had honed his backstage management skills with the Federal Theatre Project and Works Progress Administration. Corralling so many individualistic musicians into one happy family would be a challenge, but it was one for which the Theater of Action had prepared Ray, teaching him patience and the ability to foster solidarity.

Along with Woody Guthrie, Lead Belly, and young Pete Seeger on

banjo, the cast included the rotund, dulcet-voiced Burl Ives, who was just beginning to make a name for himself as a folksinger; a silky-voiced African American folk and blues musician named Josh White, who'd risen out of the South to conquer New York; and the Golden Gate Quartet, a jubilee-style gospel unit from Virginia.

Each episode of *Back Where I Come From,* Lomax and Ray decided, would be stitched with a musical motif: "Nonsense Songs," "Work Songs," "Crime and the Weather," "True Love." In the beginning, Lomax generally wrote the first drafts, with Ray filling in, though as time went on they often reversed the order. Since everyone involved (except Lead Belly) was resolutely left-wing—either Communist Party members or sympathizers—each program also would deliver a message beyond the entertainment, lightly woven into the back-porch patter and songs.

Lomax and Ray were on the same wavelength, and the first script came together swiftly. Then, in the studio, Ray was back in his element, fine-tuning the recording setup—and, more important, fine-tuning performers unfamiliar with radio mikes. After working hard to set the right tone with the pilot episode, the show made its debut in August 1940; then, starting in September, it aired for fifteen minutes at ten thirty P.M. three nights a week. Ray and Lomax were disappointed when the respectable Clifton Fadiman, head of the Book of the Month Club, who'd agreed to narrate the series, quit after the pilot. But Earl Robinson and others would rotate as host after Fadiman's departure.

A worse blow came when Woody Guthrie, their marquee name, made an angry exit. From the start, Lomax and Ray had carefully crafted scripts for Guthrie to take the lead in threading the musical and political themes deftly through each show. Accounts differ, but evidently the cantankerous Guthrie grew discomfited by the show's audience-friendly approach—and by Ray. "Woody especially felt intimidated by Nick's giving him cues," wrote John Szwed in *Alan Lomax: The Man Who Recorded the World,* "and told him he froze whenever he pointed to him." Worse, according to Guthrie, Ray appeared to favor the crowd-pleasing Josh White over the grittier, more authentic bluesman Lead Belly.

Though White had his own story of struggle and hardship, having grown up making race records in Jim Crow–segregated South Carolina, and though even Guthrie considered him "the Joe Louis of the blues guitar," the bluesman had stirred some resentment by parlaying his hand-

some face and sweet-and-seductive baritone to advantage in New York. White's sweeter blues boasted a huge uptown Manhattan following; this irked Guthrie, who preferred the more subversive Lead Belly, considering him "a regular philosopher of chain gangs, prisons, wardens, and hard times in the country."

Indeed, Ray *was* favoring White. For one thing, Lead Belly couldn't read very well, making it difficult for him to manage his lines in the script. When retakes didn't help, Ray resorted to desperate measures. After Lead Belly sang, he directed White to step up to the mike and speak Lead Belly's lines. "The over-all effect was ludicrous," Charles Wolfe and Kip Lornell wrote in *The Life and Legend of Lead Belly*. Guthrie was "furious and constantly berated Ray," glaring at the director.

Ray stood his ground. He didn't quite flash the iron fist, but this early— and unsuccessful—attempt to face down a star may have taught him a lasting lesson in forbearance. Guthrie glared and glowered until late October, when he finally stalked out of the CBS studio one day in the middle of a rehearsal session and took to the road to seek the real America—where, as he once declared, "there's more of it under corn than under concrete." In a letter to Lomax, he blamed his abrupt split on the straitjacket of the show, not Ray. "The fifteen minutes was a little packed," Guthrie explained wryly. "The elevator run too straight up and straight down and the studio had too many radioactivities in it, and so I ducked off."

Knowing that Guthrie had clashed with Ray, Lomax tried to act as peacemaker, sending a November 1, 1940, letter to the singer at a forwarding address in California. "I wish there was some way you and Nick could get together again," Lomax wrote. "The first program that you failed to appear on just about broke my heart," he added. "I'd like to hear your side of the story."

But Guthrie did not write back. The show went on without the bard of the left, and Lomax stuck by Ray. The director felt miserable about alienating Guthrie, but everyone agreed that the singer had been looking for an out. Lead Belly himself was sanguine about the show, and Ray didn't give up on him. Lead Belly's role in the show kept evolving, as did everything else about *Back Where I Come From*. As far as anyone could tell, the series was a hit. The reviews were excellent, and the ratings were solid. Steady income had made Guthrie nervous. It made everyone else ecstatic.

The radio series was the first national exposure for all of them—including for the name Nicholas Ray, touted as the show's director in hundreds of CBS publicity items sent around to America's newspapers. So Ray and the others were all the more shocked when, in mid-February 1941, the ax fell on the show. According to Lomax, the word came down from on high: After six seemingly successful months on the air, CBS chairman William S. Paley let it be known that he personally objected to "goddam hillbilly music" on his network—and *Back Where I Come From* was abruptly canceled.

Ironically, a contrite Guthrie had just materialized, wiring Ray and offering to return to the broadcast. Informed that his gesture had come too late and the series had been dumped, Guthrie did an about-face, venturing a more generous assessment of the program and saying he wasn't surprised by its fate. "Too honest again I suppose?" he wrote Lomax. "Maybe not purty enough."

✳

Though the show was gone forever, the musical-political camaraderie would continue off the air.

Sometime in late 1940, Ray moved into a Greenwich Village loft with Pete Seeger and two other activist folksingers, Lee Hays and Millard Lampell. The apartment they shared became known as the Almanac House after Seeger, Hays, and Lampell—sometimes joined by others, including Josh White—began playing left-wing benefits as the Almanac Singers. Their repertoire consisted of pro-union, civil rights, and antiwar songs, reflecting the Communist Party USA's endorsement of the 1939 nonaggression pact between Hitler and Stalin. (After Germany invaded the Soviet Union in June 1941, the peace anthems were tossed into the circular file and the Almanac Singers began urging America to join the good fight against the Nazis.)

The Almanac House became Ray's home away from home; it was also a revolving door for countless musicians, usually with leftist stripes, dropping in during their East Coast travels. This was Ray's third experience in a commune living off family-style stewpot dinners, which were served to residents and visitors at a fourteen-foot picnic table with benches. On Sunday afternoons and weekend nights, the musicians charged guests a

quarter or thirty-five cents to attend folk and blues jam-session rent par-
ties, attended by some of New York's best traditional musicians. Beer was
ten cents a cup. As many as one hundred people attended the loft parties.

Another commune veteran, Earl Robinson from the Theatre of
Action, seemed omnipresent, though he didn't live at the Almanac House.
Burl Ives, whom Ray had befriended during their radio days, was often
there too. Besides their common love of folk music and similar political
views, Ray and the rotund singer went on marathon drinking bouts that
sometimes devolved into bouts of a different kind. More than once, Ray
liked to boast, they waded into brawls together.

After his radio series was canceled, Ray did return briefly to the arms
of Jean Evans, for one last serious try at family life. For a year and a half
he shuttled between the Almanac House (whose actual address changed
a few times) and stretches of rapprochement with Jean, moving into an
East Village apartment with her and their son, Tony. There he tried to
write something he could sell to radio or theater. While Ray was earning
radio money, the family even had employed a maid to help with cleaning
and babysitting Tony. Now they had "a tough time financially," as Evans
confessed, living on one income—hers. "Nick and I and Tony make a good
set-up," the *PM* journalist wrote to longtime friend Esther McCoy, "and I
think we're going to get really straight on our own problems. We've been
very happy in many ways—and there's something we've got now which we
never had before—a kind of cohesiveness that comes with trouble."

Ray finally began appointments with a psychiatrist. Swearing off
drink, he devoted himself to writing. "We haven't much social life these
days and we don't care much," his wife wrote McCoy cheerfully. "We sit
around with the few—very few—people who come up occasionally—drink
tea—talk—laugh—play with Tony—like old home week."

Ray had few job prospects. The Group Theatre had dissipated, and
Elia Kazan and Bobby Lewis came around making noises about launching
their own theater organization, to be called the Dollar Top Theatre (as in,
tickets would cost a "dollar top"). They met with Ray early in the summer,
looking to spin off a Dollar Top radio series like *The Mercury Theatre on
the Air*. Kazan was just back from Hollywood, where he'd acted in small
parts in a couple of Warner Bros. movies. He and Lewis still had to raise
substantial money, and the wealthy left-wing patronage they'd expected
was slow to coalesce. Still, both were optimistic.

Kazan was fond of Ray (they were "Gadget" and "Nik" to each other), but it was his wife, Molly, who really took Ray on as her personal rescue mission. Kazan didn't envision any truly important job for Ray in the Dollar Top Theatre: Zachary Metz, who had written and directed sketches for the Mercury Theatre, was the radio program's nominal head, and he was already busy creating a pilot to be hosted by Earl Robinson. But Kazan had been a fan of *Back Where I Come From,* and he thought Ray might supervise the music for the Dollar Top series and any other radio programming they initiated. Ray's friendship with Earl Robinson was part of his appeal, and Kazan also hoped Ray might recruit Alan Lomax as their folk music expert.

Meeting with Lewis, Kazan, and Thacher, Ray played them some favorite recordings and brainstormed ideas for packaging the series. Later that summer, Ray sent Lomax Kazan's prospectus for the Dollar Top Theatre, asking if he'd like to get involved.

Ray told Lomax that Kazan had encouraged his idea for a spinoff series featuring three characters who meet in a night school: a European refugee, who would give voice to the world situation; an authentic American, "a Woodrow Davy Wilson Crockett Guthrie"; and "a gal who can sing 'I Know Where I'm Goin'' and 'Darlin' Corey.'"* The night school premise would offer "a logical frame for saying anything we'd like to say," Ray wrote. He had started on the pilot, he told Lomax, but didn't want to show the folklorist any pages until he had finished.

Ray also made it clear in his letter, however, that he wasn't firmly attached to Kazan or the Dollar Top Theatre. Fishing for other opportunities, he told Lomax that he was willing to return to Washington and join him on some fieldwork, traveling around and recording folk music, if Lomax was willing. Aware that Lomax considered Washington a healthier environment for Ray than New York, the director pushed that button. "My need for getting out of New York for a while has become almost as important to me as the need to quit drinking was," he explained, "except I had to do the latter before I could realize the importance of getting out of

---

* "I Know Where I'm Goin'" is a traditional Scottish or Irish ballad about lost love; "Darlin' Corey" is a folk tune about a mountain woman recorded by many, including Burl Ives on his debut album, *Okeh Presents the Wayfaring Stranger,* in 1941.

here. I don't suppose it's a thoroughly accomplished fact, even yet—but the analyst feels pretty good about it. Or maybe he just wants me to get a job so I can start giving him some money for a change. Enough of that—but believe me—I honest to god think I've begun to grow up."

One thing Ray's letter omitted was any mention of his wife. By mid-summer, Ray had fallen into one of the deepest of his blue funks. He had quit his therapy sessions; the strain of psychoanalysis was so hard on him, Evans later recalled, that her husband lost his voice. When the Dollar Top Theatre went nowhere—and Lomax failed to bail him out—the family fell under the shadow of an eviction notice, and Ray started hitting the night-spots and drinking and staying away from home.

"That's a wife's profession," wrangler Robert Mitchum informs duti-ful wife Susan Hayward in Ray's *The Lusty Men,* "forgiving her husband." By September, though, Ray was no longer around to forgive. He had left the household, his first marriage finally over, though Evans wouldn't file the legal papers for several months. Throughout his life, Ray would sus-tain long friendships with women, but only brief marriages: At nearly five years, his marriage to Jean Evans would be the longest of four. Yet for the rest of his life he would stay close to her, looking to her not only as the mother of their son but also for advice on writing and scripts.

For her part, Evans forgave Ray. Though she felt "angry and resent-ful" about their breakup, her anger was directed largely inward, as she up-braided herself for being a flawed wife and mother. "I am the way I am and he is the way he is," she wrote to Esther McCoy, "and except for just and only that we could have had such a good life." Their friendship survived, "tinged with tenderness," as Bernard Eisenschitz wrote.

✳

By the early summer of 1941, Woody Guthrie had returned to live in New York, moving into the Almanac House and joining the Almanac Singers. The place became all the more a magnet for visiting folk and blues singers, and after leaving his family Ray too rejoined the musical commune.

*Back Where I Come From* was widely admired in left-wing circles, par-ticularly among musicians, and gave Ray a certain cachet. His roommates at the Almanac House knew he was out of work—and that his marriage had foundered as a consequence of his irresponsibility—but he always

had friends who rooted for him, overlooking his faults in the belief that he tended to hurt himself more than he hurt others. This blamelessness would serve Ray in good stead in Hollywood, but it can't have made any difference to the shame and guilt he carried with him.

After his radio money finally dried up, Ray was reduced to making pocket change helping out behind the scenes with benefits and shows in New York and other East Coast venues. Ever since his college days he'd prided himself on not needing much to live on—not true of Jean Evans and Tony, of course, and throughout his life Ray's support payments proved erratic.

What little money he had, he spent on nightlife. Ray was a habitué of nightclubs, concerts, and plays, whether on Broadway or off, political or pure entertainment. Now Ray seemed to take up permanent residence at the Village Vanguard, the bohemian basement club, where a troupe called the Revuers dished up the ne plus ultra in topical cabaret. The up-and-comers included the witty song-and-dance duo Betty Comden and Adolph Green, poker-faced comic Al Hammer, the versatilists John Frank and Julian Claman, and a deft blond comedienne named Judith Tuvim, who stopped the show belting out torch songs dressed as the Statue of Liberty. Young Leonard Bernstein was often to be seen pounding the piano.

Freed of marriage, Ray resumed his easy conquests of women in the late summer and fall. Alcohol was one escape from his domestic obligations; his many brief sexual relationships were another—a form of addiction and distraction in New York as well as later in Hollywood. With his blend of sweetness and vulnerability wrapped in a charismatic macho façade, not to mention his lasting power at parties, Ray fell into bed with numerous women with minimal effort. "What kind of person do you think a man wants?" Natalie Wood asks James Dean in *Rebel Without a Cause*. "A man who can be gentle and sweet, like you are . . . Strong." By the late 1950s, Ray boasted in a letter, he'd made his "march thru hundreds of women."

One of the "hundreds" said to have gone to bed with him more than once during this period was the actress and torch singer Libby Holman. Holman had been tarnished by scandal in 1932 after being indicted for the shooting death of her husband; though the charges were dropped, her career never really recovered. Ray had an undeniable affinity for broken or wounded people like Holman—like himself. Older than Ray,

Holman was also bisexual, like some of his lovers, and nonchalant, like certain others.

Sometimes, the intensity of Ray's infatuations with people seemed to vary in reverse proportion to their availability, friends thought. For a while Ray pursued Judy Tuvim, who would change her name in Hollywood and become famous as Judy Holliday. They had a mutual pal in John Houseman, whom Ray knew from the Federal Theatre (Tuvim had been a mere switchboard operator in Houseman and Orson Welles's legendary Mercury Theatre). But Tuvim recognized Ray's reckless ways, and she was wary enough to try to keep a platonic distance from him.

Ray was as much friend as lover to many women, and a staunch friend to many of the musicians who were part of the Almanac House scene. It might be said that Ray tried harder to help Lead Belly stop drinking than he tried on his own behalf. Though himself in need of a paying job, he arranged or staged countless gigs for his musician friends in the early 1940s, regardless of compensation. Even Woody Guthrie, a dedicated drinker and womanizer himself, held no grudge over his rift with Ray, and the two became chummy again once Woody was back in New York.

When Max Gordon, owner of the Village Vanguard, told Ray that the Revuers had been lured uptown to more lucrative engagements and asked if he knew of a replacement act, Ray returned to the notion—problematic on radio—of teaming Lead Belly and Josh White. Together, he told Gordon, the gritty bluesman and the silkier one would comprise "the greatest folksinging act in the country." Gordon was dubious but agreed to let the duo rehearse on his small stage.

One afternoon, Lead Belly and White showed up at the club with their instruments, and Ray talked the pair through a playlist, complete with some banter he had scribbled down. Gordon placed a bottle of rye on a table, said nothing, just watched and listened. Nobody paid much attention to him anyway until the liquid refreshment ran out. Then Ray and the musician duo asked for another bottle. One week and some twenty bottles of rehearsal later, Ray said they were ready.

All the giants of the idiom showed up on opening night in late November 1941: Guthrie and the rest of the Almanac Singers and Burl Ives and other folk-song luminaries, all craning their necks and cradling their guitars. It was a triumphant night for Lead Belly and White. Though Ray hadn't quite managed to get them to meld their styles, they were nonetheless

effective singing solos or trading verses.* Their six-month run at the Van-guard was a high point of folk music history.

Ray would score a similar success a short time later when he paired White with Libby Holman. The duo was Holman's idea, not Ray's; he and White were both skeptical when Holman first mentioned it to Ray. "White believed that white women could not sing black songs; they couldn't even understand them," biographer Jon Bradshaw wrote in *Dreams That Money Can Buy: The Tragic Life of Libby Holman*. "Ray, although he admired Lib-by's voice, didn't like it personally. She displayed, even flaunted, certain vocal affectations that although perfect for torch songs, were not compat-ible with the blues."

Holman waved off Ray's doubts, however, and soon he arranged for his sometime girlfriend and White to meet. The two clicked, and would go on to create a road show performing "Early American Blues and Other Songs," attracting attention—and controversy—as one of the first interra-cial musical teams ever to play large public concerts across America.

Although Lead Belly and Josh White both benefited from his advice, Ray seemed adrift in his own career. What he did for others he did regard-less of any potential for money or self-aggrandizement. Throughout life he was always generous with time and money, even when he had little to spare. If Ray had a bold plan for his own future, he didn't shout it from the rooftops. He did show around various stories he was writing, for this or that vague purpose, but they would come to naught. Meanwhile he scraped by, borrowing small sums of money from Alan Lomax, who was increasingly vexed when Ray stalled his promised repayments.

In December 1941—the same month when Lead Belly and Josh White

---

* Afterward, though he claimed to have enjoyed the show, Woody Guthrie wrote a long letter to proprietor Max Gordon, praising the performers but questioning Ray's staging and other aspects of the performance: the seating arrangements, the choice of songs, the acoustics (Josh White was using the club's only microphone, while Lead Belly had to bellow his songs), the patter of the female emcee, even the advertising display case out front. Perversely, Guthrie wrote his letter from the Almanac House, where he and Ray both were residing. "He's staying here at the Almanack house for a few days right now," Guthrie wrote, "till he can find him another place, I suppose this letter will be in the mail before he gets a chance to look it over." Showing the letter to Ray, Guthrie wrote Gordon, was up to him, "if you want to."

opened at the Village Vanguard and Jean Evans filed for divorce—the Japanese bombed Pearl Harbor. Ray landed not in the army but in clover: with another good government radio job and a new boss—John Houseman—whose helpfulness and influence would outstrip that of any previous mentor or friend.

✷

Nearly forty—a decade older than Ray—John Houseman was physically imposing: tall, elegant, always impeccably dressed, with pale blue eyes, aristocratic eyebrows, and a plummy, vaguely English accent. Behind the scenes he was the ablest of producers: "A great animator," in the words of Norman Lloyd, "he could make things happen." Houseman had helped many great things happen during his time with Orson Welles, including the Negro Theatre Project, the stage and radio productions of the Mercury Theatre, and a little picture called *Citizen Kane,* directed by Welles and produced by Houseman, which had premiered in May 1941.

By the end of 1941, though, Houseman was estranged from Welles and treading water in Hollywood under ill-defined contract to David O. Selznick. He was helping director Pare Lorentz prepare a documentary about the conditions of production-line industrial workers when a telegram arrived summoning him to the White House. In Washington, Houseman met with two men: playwright Robert Sherwood, a speechwriter and aide to President Roosevelt who was heading up the new Foreign Information Service to channel war news overseas, and William "Wild Bill" Donovan, a decorated World War I hero and career intelligence officer who was serving as a national security coordinator. They asked Houseman to organize the Overseas Radio Bureau under the Office of War Information, a division to be known as the Voice of America.

Quite apart from his impressive résumé in film, theater, and, crucially, broadcasting, Houseman held three nationalities before the age of twenty-one. In his words, he was "Rumanian by birth, French by inheritance, English by upbringing and naturalization." He knew Europe and spoke "French, German and Spanish and a smattering of Italian," which would aid his assignment to disseminate wartime propaganda to multiple foreign nations.

Houseman immediately foresaw the value of "music as an instrument

of propaganda" and he began planning to incorporate "a lot of music" into Voice of America broadcasts "in order to convince everybody—our allies, our enemies—that we were brothers under the skin." A fan of *Back Where I Come From* who recognized his own limitations as a musical expert, Houseman called Ray to Washington as soon as he'd accepted the Voice of America job and asked him to run the bureau's music branch. He also recruited the Lomaxes; the Voice of America would be headquartered in New York, but Houseman wanted Alan Lomax and his wife Elizabeth as advisers. (Alan's sister Bess would relocate to New York to organize the music library for the broadcasts.)

Ray was gung-ho about the job, talking it over with Houseman and the Lomaxes. (Corresponding with Woody Guthrie on December 13, 1941, Alan wrote, "Nick always looks happier outside of New York.") Up to this time Ray and Houseman had enjoyed only a passing acquaintance through mutual friends like Joseph Losey and Elia Kazan. As they brainstormed ideas for the Voice of America at the Washington meetings, though, their chemistry was fast and electric.

The laid-back Houseman was an enabler; Ray had management experience as well as pent-up energy and a bottomless well of ideas. Houseman would define the parameters, but Ray was ready for action. In Washington, Alan Lomax helped pass the torch to a new partnership: Houseman and Ray. Neither of them could have imagined the path and heights that partnership would reach.

Houseman flew back to Hollywood to arrange his personal affairs and vacate his house. Ray returned to New York, soon moving into temporary offices at the Foreign Information Service at 270 Madison Avenue. The important job—and its annual $3,800 salary—turned a new page in his career.

✳

With America at war, the Voice of America had to make a running, jumping start. As soon as possible in the New Year, the radio propaganda bureau had to assemble the manpower and technology necessary to beam "close to a thousand shows a day in twenty-two languages including Swahili," in Houseman's words, to armed forces and civilians overseas. Brief segments of daily news—carefully written and vetted before delivery by

actors—would be interspersed with music and drama and features. The BBC helped initially by lending its transatlantic medium-wave transmitters to the nascent American operation for several hours a day.

As with the Works Progress Administration, the talent wasn't all that hard to collect. The famous and destined-for-fame rushed to volunteer. A complete accounting of all the Voice of America personnel, in Houseman's words, would boast "native and foreign luminaries—journalists, authors, poets, designers, publishers, executives, actors, musicians, economists, philosophers, educators and financiers—of such celebrity in their past and future careers that it is almost impossible to believe that they were all assembled under one roof."

By midsummer of 1942, the Voice of America was on its feet and going strong. After a few months of Madison Avenue occupancy, the radio bureau took over the entire General Motors Argonaut Building on the corner of Fifty-seventh and Broadway, including a storefront that once had been a Cadillac showroom. The staff ballooned to three thousand people.

One of the people joining the talent stream was Constance Ernst, the daughter of American Civil Liberties Union cofounder Morris L. Ernst. A beautiful young woman whose dark eyes stared out from under a black mop of hair, Ernst had an executive mind and a can-do attitude to equal Ray's. After graduating from Bennington College, she had tried an acting career before landing backstage at the Mercury Theatre. Houseman knew her from the Mercury, and after that Ernst had been instrumental behind the scenes of the short-lived Cabaret TAC and then as a producer in radio for Norman Corwin. She could write, she could produce, and in a pinch Ernst could act or sing. Ray swiftly homed in on her to produce his music-oriented shows, and just as swiftly he fell head over heels. The two became inseparable.

Ernst was in charge of several Voice of America staple programs, including a series called *States of the Union,* based on Federal Writers Project guides to the states, and another mixing common people and celebrities on a panel that fielded burning questions on the war and American society. As Houseman anticipated, once again Ray's work went far beyond his job description. He ran the music division but took a hand in virtually everything else. He worked over Ernst's scripts, as well as those for other Voice of America broadcasts; conducted man-on-the-street interviews for news and features; and staged dramatic vignettes for the microphone.

His primary task was organizing the music for all the broadcasts—from background music for general programming to whole shows entirely devoted to music. Some of the music they used was prerecorded; some was performed "live" in the studio under Ray's direction. Some of the songs were traditional folk music; others were original, written to order on wartime topics.

All of Ray's New York folksinger friends joined the broadcasts. Among the Voice of America mainstays were Earl Robinson, Lead Belly, and the Almanac Singers with Woody Guthrie and a newcomer to the group, Oklahoma protest singer Sis Cunningham. The folksingers—dubbed "the barefoot brigade" inside the building for their informal wardrobe—drew on much the same repertoire they'd been grinding out at the Almanac House and for political benefits: work songs, battle songs, patriotic songs, songs condemning Nazis, and, increasingly, songs promoting the antifascist underground resistance in Europe, which very often involved Communists, and the bravery of America's new Soviet allies. (Pete Seeger sang the Russian national anthem for the Voice of America—*in Russian,* no less.)

Ray was still in and out of the Almanac House in the first half of 1942, and he staged a Town Hall concert in late June that offered a compendium of the Voice of America approach. Sponsored by *Native Son* author Richard Wright under the aegis of the Negro Publication Society, the concert featured Lead Belly, blues duo Sonny Terry and Brownie McGhee, and the Almanac Singers, sharing the stage with amateurs in military uniform or workingman's garb. Earl Robinson was the emcee of the show; Lee Hays and Millard Lampell wrote the script. A swing band was on the bill (the Nazis had denounced jazz as degenerate) but another musical highlight extolled the Red Army, which in the summer of 1942 was taking heavy losses battling Hitler in the Ukraine. "The wonderful 'Red Cavalry' song from Russia" generated storms of applause, as Howard Taubman wrote in the *New York Times.* It "almost stopped" the show.

Not everyone was happy about America's marriage of convenience with Stalin, however. The Voice of America programming, along with public events like the Town Hall concert, spurred a persistent rearguard attack from citizens and organizations pushing their anti-Communist views. Among these were "certain groups in exile and organized groups of hyphenated Americans," in Houseman's words, that were already jockeying for power in a postwar Europe.

It was Houseman's job to mediate disputes concerning the content of the radio shows, and in his autobiography he recounts a "most bizarre" example that involved Ray—Ray's politics and cleverness. The radio bureau had produced a program saluting Michigan as part of its *States of the Union* series, focusing largely on Detroit and "the hundreds of thousands of skilled workers freely organized in a great voluntary union—the United Auto Workers of the C.I.O.," in Houseman's words. This created an opportunity for a union song, and Ray suggested one he knew from his Brookwood Labor College days—"UAW-CIO"—sung by militants during the sit-down strikes of the mid-1930s.

As the recording was being pressed, however, Houseman fielded a call from the man in charge of labor relations for the Voice of America. Louis Cowan tremblingly relayed the complaint of James Petrillo, head of the Musicians Local 802 of the American Federation of Labor. "Some craft-union fink in our building must have denounced us to Petrillo," Houseman wrote, "who was now charging us with favoring the C.I.O. over the A.F.L. in our overseas propaganda, thus proving ourselves to be radical and subversive if not outright Communistic." Petrillo threatened to rescind the Voice of America's free access to music and musicians.

Alarmed, Houseman sent for Ray, Connie Ernst, Bess Lomax, and the Almanac Singers. "They took it calmly," wrote Houseman, noting "that Michigan was known as a C.I.O. state and, furthermore, that the A.F.L. was such a square, old-fashioned outfit that it did not even *have* a marching song of its own. However, if necessary, they would be delighted to create one."

The barefoot brigade marched off under Ray's command. By midafternoon they had returned with "a shiny new acetate entitled 'A.F.L.—The One and Only!'" Houseman recalled, "a standard marching song with banal lyrics, but it was executed with the same zest as the offending C.I.O. recording." Houseman phoned Petrillo, assuring him that he'd "been misinformed: an A.F.L. song every bit as rousing as the offending C.I.O. record had been in the Voice of America's library for weeks and had been frequently beamed overseas." He sent it over to Petrillo, who called back "delighted with the song and said he was recommending it for general use among the craft unions. And the O.W.I. continued to enjoy the free use of Union-recorded music."

Most of the anti-Red groups, Houseman felt, weren't simply opposed

to Communism; they were the same rabidly illiberal interest groups that had been dead set against the New Deal from the beginning. "It sometimes seemed," he wrote, "as if there were two wars being fought—our officially declared, national war against the Axis, and that other bloodless, continuing conflict between Roosevelt's New Deal and its enemies, who had grown increasingly frustrated and embittered during the ten years of his presidency."

The OWI was undoubtedly filled with people with "radical leanings," in Houseman's words, but he didn't care. Houseman wasn't alone in thinking that the former or current Communists were often the most dedicated workers with the sharpest minds. The Communists "talked sense," recalled author Howard Fast, who contributed to the daily newscasts; "they understood the forces involved in the war, and their positions were always constructive."

Was Ray himself still a Communist? That is unclear. By the time of the Voice of America, he probably had left the Party. The Hitler-Stalin Pact prompted a mass exodus, especially among Jews; many more quit when America entered World War II. Ray was tight-lipped about it. "We never really discussed politics," Ernst, herself not a Communist, recalled. "He lived his life very much in compartments—he was very masculine in that."*

The anti-Communist attacks on the Voice of America waxed and waned, and Houseman concluded that the opposition was pesky but manageable. Along with the so-called civic groups who monitored the radio propaganda bureau, however, the U.S. government still had pockets of resistance that worked independently of President Roosevelt and stubbornly subverted New Deal policies. Some of these made a veritable religion of anti-Communism. One was the Federal Bureau of Investigation (FBI).

Early in 1942, shortly after accepting his Voice of America post, Ray became the subject of his first known background check by the FBI. That is the date of the first document that exists in his FBI files, released to this author under Freedom of Information Act (FOIA) guidelines.

---

* Interestingly, Ernst's father, Morris Ernst, general counsel for the American Civil Liberties Union (ACLU), was already known as a virulent anti-Communist. In 1940 he led the ACLU in driving the veteran Communist Elizabeth Gurley Flynn off its board and passing a resolution that condemned and excluded Communists from membership.

Ray had likely been under intermittent FBI surveillance since his radical awakening in La Crosse. A confidential source gave his name to the Dies Committee as far back as 1938, when Congress was rooting around for Communists infesting the Federal Theatre Project. FBI memos in 1942 traced the full arc of Ray's pre–Voice of America career: his involvement in the Theatre of Action and the Living Newspaper; his brief teaching stint at Brookwood Labor College; his conspicuous employment by the Works Progress Administration in Washington, D.C.; along with the suspicion that Ray lived in a house hosting a Communist cell group, with Red literature bundled in the basement.

The memos note that Ray was once employed by CBS, though it doesn't mention whether the FBI contacted network boss William Paley or spread any rumors about Ray and others involved in *Back Where I Come From* that might have spurred cancellation of the radio series. (It remains a distinct possibility.) Curiously, perhaps for lack of inside informants, Ray's FBI file contains no mention of the Almanac House, where Ray had bedded down sporadically since late 1940.

At least once, Ray himself was questioned about his loyalties and politics. Asked in a 1975 interview whether he had ever been personally hassled by the House Committee on Un-American Activities (HUAC), Ray sidestepped the query, answering flippantly that he had been "thoroughly investigated" by the Office of Strategic Services (OSS) during wartime. (The OSS, precursor of the Central Intelligence Agency, or CIA, was run by Voice of America sponsor William "Wild Bill" Donovan under the auspices of the OWI.) "'On the night of so and so, such and such a young lady was seen to enter your apartment at 8:30 at night and not leave until eight the next morning. What do you have to say to that?' 'It was a delightful evening.' There were lots of questions like that. Finally, I said, 'Gentlemen, when I volunteered to serve the United States in this war I was not asked to take a vow of celibacy.' But they knew every goddamned thing about me."

The FBI scoured Ray's life, including his postal, bank, and police records, looking for aberrations. The investigation took months, carrying on until the late summer of 1942. In August the FBI drafted an official letter to government and law enforcement officials, classifying Ray as a proven Communist and recommending him and a long list of others for a secret "B-2" rating in government records, indicating their special level of

"dangerousness" to America. Ray and others on the B-2 list, according to the FBI, were legitimate candidates for "custodial detention in view of the existing emergency," i.e. the war.

This letter, urging detention for the program director for the Eastern Press and Radio Section of the Office of War Information—Ray's official title—was signed by none other than J. (John) Edgar Hoover, director of the FBI. Hoover routed the letter to the chief of the Special War Policies Unit in D.C. and the special agent in charge of the New York bureau of the FBI, while copying it to higher-ups in the Justice Department. Then he sat back and waited for approval to act.

Ray knew about the background check but not about its alarming result.

❋

Most FBI files are full of assumptions and errors—even ludicrous whoppers—and the agency certainly got it wrong when they reported, in late summer 1942, that the dangerous Communist running the music branch of the Voice of America was living with his wife and young son in an East Village flat.

In fact, Ray's divorce was moving along, and by the end of the summer he had moved in with Connie Ernst. Ray was back to his best smiling self, and Ernst was a big reason. While his lightness of heart was always ephemeral, hers was permanent. Serious and purposeful at work, she was invariably fun-loving and exuberant after hours. "She reminded me of a family of ponies bouncing around a field of daisies," wrote a friend who knew her later in London.

The two treasured their breaks and worked long past quitting time. Sometimes they'd try to catch the last movie of the night, often the latest Hitchcock. Hitchcock's plot-driven pictures were the opposite of Ray's own later films, but everyone loved a Hitchcock film; the director had even turned a folklorist-musicologist into the hero of *The Lady Vanishes*.

After the show, the couple often ended up at a favorite East Side restaurant for pasta. Houseman and other Voice of America personnel from the Argonaut Building would drift in for "midnight meetings," in Houseman's words, which "took on something of the character of a club or secret society." Years later, Ernst recalled that the group was like a tight-knit family, "ingrown and incestuous." Ray and his friends felt they were help-

ing to win the war: In his memoir, Houseman pronounced his time with the OWI and the Voice of America "one of the most satisfying affairs of my life," a period he spent in a "state of perpetual exhilaration."

On November 7, 1942, the day the Allies invaded Vichy-held North Africa, the Voice of America broadcast all night long, urging Vichy forces to surrender while appealing for the cooperation of North African civilians. Ray not only supervised all the music but also rushed to the Brooklyn Navy Yard, grabbing ship workers and French sailors and dragging them to the studio to fill airtime with interviews. It was an inspiring night for all.

The happy bubble didn't last long, however. The incessant memos and phone calls from anti-Communist pressure groups took a toll on group morale, and when the first hard blow came, not long after the North African triumph, it struck an unlikely enemy of the people.

In late 1942, Robert Sherwood asked Houseman to launch a sister Voice of America operation in London, aiming broadcasts directly at North Africa and Nazi-occupied Europe. Houseman was enthusiastic about the new assignment, and Ray and Ernst were eager to follow him abroad. Houseman reminded Sherwood that he was technically an "enemy alien" who hadn't held a U.S. passport for nine years, but Houseman's direct supervisor, Joseph Barnes, helped facilitate a speedy naturalization process, and in March 1943 the head of the radio propaganda bureau took an oath of U.S. citizenship, the "fourth nationality" of his life. A VIP seat was arranged for Houseman on an army bomber traversing the Atlantic.

Houseman still needed a valid passport, however, and the State Department mysteriously withheld its required approval. Or it may have been the Defense Department, for General Dwight Eisenhower had his differences with the Voice of America; the assignment overseas involved designating Houseman a colonel, and the armed services would have to sign off on his appointment. After weeks of waiting, Houseman went to Washington to meet with a general at the Pentagon. Examining his FBI and Civil Service files right there on a desk in front of him, the general grumpily agreed that Houseman had no apparent record of "disloyalty or subversion." Yet still his passport was stalled. Sherwood appealed directly to presidential adviser Harry Hopkins in the White House. An undersecretary of state reviewed Houseman's files—but then, finally, officially, denied his application for a U.S. passport.

Houseman was furious. He saw his "interdiction," he recalled, not as a "personal" affront but as "part of the continuing departmental struggle

between the State Department and the Voice of America." After finishing his work supervising all-night news bulletins in a dozen languages, issuing official reports on the summit meeting in Casablanca between British prime minister Winston Churchill and President Roosevelt, he sat down and wrote out his resignation.

Houseman then left immediately for Hollywood. He abandoned Ray and Ernst, who were still hoping to make their own move to London, to his replacement, Louis Cowan, a public relations and advertising man who had created the successful *Quiz Kids* radio show. Voice of America writer Howard Fast, himself rejected for an overseas assignment because of passport troubles, recalled Cowan as "very decent" if ineffectual. Ray, privately, called him "the great and brave Louis Cowan," meaning he was neither—especially compared to John Houseman.

❋

The secret club had lost its most prized member. John Houseman had been as much cheerleader as leader of his VOA colleagues, chortling and nodding and exclaiming, "Let's do it!" His advice was usually as modest and tactful as it was pointed and relevant. His absence would throw his bravery and greatness into relief—now, and again later in Ray's Hollywood career.

Writers Howard Fast, Robert Ardrey, and Molly Day Thacher, Kazan's wife, who had been an assistant to Houseman, were among the dispirited holdovers still clocking long hours at the Voice of America. Fast, Ardrey, and Thacher had their own reasons to be talking about Hollywood. And now, for the first time, Houseman's absence gave Ray cause to think seriously about motion pictures.

Until 1943, Ray had prided himself on being a radio and theater purist. Saying that a person emitted "the stink of the gallows," the air of "belonging to the theater," was the highest compliment he could pay to someone. But while working on radio propaganda scripts with Fast, Ardrey, and Thacher, and grumbling about the cloudy future of the Voice of America, Ray started hearing promising things about the film industry.

Fast's novel *The Last Frontier* had just been published to acclaim and was attracting option offers from the major studios. Ardrey, meanwhile, seemed like a kindred spirit to Ray; he'd also been a protégé of Thornton Wilder's at the University of Chicago and was a star of the college radio

station during Ray's student stint there. Ardrey's first for-hire screenplay, *They Knew What They Wanted,* had just been filmed. Fast and Ardrey were a couple of "real writers," from Ray's point of view, able to work freely on movies without becoming beholden to the studio system. If they didn't feel tainted by association with Hollywood, why should he?

Thacher also kept him up-to-date on her husband, Kazan, who had vaulted to success on Broadway in November 1942 with his masterful staging of Wilder's *The Skin of Our Teeth.* Months later, the play was still drawing packed audiences at the Plymouth Theatre. Never again would Kazan have to hunger for food—or recognition. Kazan the cocky subway type was on his way to becoming a smooth limousine type.

Thacher lived her life in her celebrity husband's shadow. Ray was sympathetic. As Thacher drew closer to Ray, she filled his ears with talk of her husband's limitless future, the gathering fruits of his success. On the heels of *The Skin of Our Teeth* and a series of other hit plays, Kazan was now weighing film-directing offers from Warner Bros. and 20th Century-Fox. If Ray's personal idol was going to Hollywood, why couldn't he?

Unlike Kazan, who was being offered bestselling properties on a silver platter, Ray would have to come up with his own stories. He brainstormed with Fast and Ardrey, passing along the writers' compliments in letters to Houseman, much as he had with Thornton Wilder and Frank Lloyd Wright. In mid-1943, the trio "went on a minor binge," Ray wrote to Houseman in Hollywood. "We were talking about the different kinds of movies we'd like to work on, and Ardrey said that if he went back to Hollywood at all he'd want to work with you over and above. Thought you'd like to know that."

Houseman had found a perch at Paramount, preparing a new film, *The Unseen,* based on a novel by British mystery author Ethel Lina White. Ray wrote the producer regularly, forwarding his ideas for stories that, for the first time, were imagined exclusively for the screen.

Ray could be an imperfect correspondent, his letters dotted with misspellings, grammatical errors, and circumlocutions; he once admitted to sometimes carrying "a creased and scrawling, pocket-ridden letter" around for weeks before getting up the courage to mail it. He sorely desired collaborators for his stories, but Fast and Ardrey were reluctant to volunteer. For one brainchild Ray turned to Alan Lomax's wife, Elizabeth. The story he proposed was mainly hers, he wrote Houseman; it wasn't much more than a "story idea," but if the producer was "at all interested,"

Ray could put it "in organized shape," with suggestions for "'situations.'"

Another idea, hatched with journalist William Lindsay White—also part of the Voice of America cadre—involved an émigré cabaret duo from Prague, Jirí Voskovec and Jan Werich, whose radio skits were beamed to Czechoslovakia and parts of Eastern Europe. The idea was to build a story about Voskovec and Ulrich arriving in America and visiting kin in Sacramento, California, then traveling across the United States by foot, boat, or vehicle, and their experiences would "serve to expose or interpret America to itself." Ray said the two characters might be treated like the two cricket fans in Hitchcock's *The Lady Vanishes.*

Ray's ideas were often sketchy, free-form, without a clear beginning, middle, or end. Ray felt insecure and defensive about their shortcomings. The Voskovec-Ulrich story had taken him a while to develop and he needed "to talk my ideas out with people more articulate" than himself, he explained to Houseman. "Maybe it's a hell of an idea," i.e., a rotten one, but he hoped the producer would look kindly on his efforts because he dearly wanted to work with him on "some one thing."

From time to time Houseman visited New York, and Ray sounded him out in person too. But when Connie Ernst was the first to get her promotion and transfer to the new Voice of America base in London, Ray's attention shifted with her. Hollywood was premature for him, a long shot; Ray told his Voice of America superiors he wanted to head overseas with Ernst. To do so, however, he would have to undergo the same passport and security check protocol that had humbled Houseman.

\*

Meanwhile, whether because of the hole left by Houseman's absence or his usual fear of domesticity, Ray was starting to drink again, disappearing on binges, passing out at dinner parties.

His behavior undermined the most important thing in his life: his relationship with Ernst. One time the two took a trip to Florida on a train filled with soldiers. "Once we were there he disappeared gambling," Ernst remembered. "It was very tricky, being with Nick."

---

\*   The 1938 film *The Lady Vanishes,* as Ray well knew, was also based on an Ethel Lina White novel; the reference would have resonated with Houseman.

Ray was dealing with his divorce and child support, but he told people, then and later, that his relationship with Ernst was true love. "We had once wanted to marry," he wrote, years afterward. According to Ernst, however, marriage was never in the cards. She was clear-eyed about her Voice of America colleague, and she had another prospective suitor, also with the OWI, whom she eventually married. Ray knew about the suitor, even scuffled with him once or twice.

He and she still worked closely together on Ernst's various series, and they vacationed together in Nantucket after broadcasting Robert Ardrey's final script for them: "White Collar Girl," with Ernst herself playing a typical American office worker. The two spent rainy days indoors, brewing ideas for Voice of America shows in London. "I kiss Connie for you on Sundays," Ray wrote Houseman. "She of course disapproves the high plane on which I keep them [the kisses]."

Although Ernst's transfer and passport were approved, Ray's kept being deferred. As of their August 1943 Nantucket interlude, though, he was still blithely looking forward to moving to London with his darling Connie. After Nantucket, Ray traveled to Chicago to work on a Voice of America segment about steelworkers, unaware that operatives under orders from J. Edgar Hoover were still dogging his footsteps, determined to prove his B-2 "dangerousness." According to the files obtained through FOIA, this was the FBI's last-ditch attempt to prove that Ray was engaged in "current activities" on behalf of the Communist Party. But the agency was unable to pinpoint any nefarious behavior.

Hoover found himself permanently thwarted, in the summer of 1943, when his secret indexing system for classifying the potential "dangerousness" of security threats was overruled as inherently valueless by the man at the very top of the U.S. legal hierarchy: U.S. Attorney General Francis Biddle. "The notion that it is possible to make a valid determination as to how dangerous a person is in the abstract and without reference to time, environment, and other relevant circumstances, is impractical, unwise, and dangerous," Biddle admonished Hoover.

The FBI's failure to prove that Ray was still a card-carrying Communist, along with the attorney general's finding against Hoover's security-threat index, inspired other anti-Communists inside the government to take matters into their own hands. In late July 1943, Ray's name surfaced publicly for the first time amid congressional hearings into new appropria-

tions for the London branch of the Office of War Information. Led by
Representative Richard B. Wigglesworth of Massachusetts, a number of
Republican congressmen openly questioned the loyalty of key personnel
attached to the OWI.

Wigglesworth interrogated Vernon A. McGee, an assistant director
acting as spokesman for the OWI, about a number of OWI personnel.
"Have you a Nicholas Ray" under salary? Wigglesworth demanded at one
point. "Has his background been checked?"

"The final investigation report has not yet been received," responded
McGee.

"Was he a director of the WPA Living Newspaper, and did he attend
the Fourth Congress League of American Writers, or at one time have a
lot of Communist literature stored in his basement in Virginia?"

"We have no evidence to that effect."

Evidence or not, in early November 1943, Representative Fred E.
Busbey, a Republican congressman from Illinois* and a member of a sub-
committee still reviewing the request for an extra $5 million in the budget
to fund the Voice of America expansion to London, rose on the floor of
the U.S. Congress to read a list of twenty-two individuals with "allegedly
Communist ideologies" who "are or were on the pay roll of the Office of
War Information."

"Nicholas K. Ray" was the seventeenth name on Busbey's list. And
there were others: The names included Houseman's direct superior,
Joseph Barnes, deputy director of Atlantic OWI operations ("whose at-
titude has been consistently pro-Soviet"), and Ray's friend, best man, and
former Theatre of Action comrade Al Saxe. "Representative Busbey said
he has reason to believe an investigating committee will be able to sub-
stantiate his information," reported a Washington newspaper.

This was the second time that Ray had been openly branded a Com-
munist. In private he took the matter lightly, asking Houseman in a letter
if he'd noticed the "honorable mention" he'd received in the *Congressional
Record*. He referred to it as his "graduation present" before his continued
matriculation overseas—still convinced that he was London-bound with
his beloved. Six weeks after the floor-of-Congress branding, however, the

---

* Super-patriot Fred E. Busbey, later a key supporter of Senator Joseph McCar-
thy, was a personal friend of J. Edgar Hoover and often fed off Hoover's anti-
Communist leaks and accusations.

official word came down: Ray's transfer to London was denied, his passport application rejected.

Although his onetime Communism was undoubtedly the main cause, other factors may have played a part. Once again, at another crucial moment in Ray's life, something murky transpired. Houseman, who was as close as anyone to Ray at this point in time, wrote later that Ray was "thrown out of the OWI." But he added a postscript—a curious one, considering Ray had boasted of *womanizing* in his version of the investigation: "I always thought [that Ray was thrown out] on political grounds, swept out along with the rest of us. But in fact, the ostensible reason was homosexuality."

As planned, Ernst would go on to London without Ray. The two agreed to suspend their romance indefinitely. On their last date, Ray, in a flash of dark humor, took Ernst to see Alfred Hitchcock's *Lifeboat*—a film about the sinking of a ship crossing the Atlantic during wartime.

Soon after she left for London, Nick Ray left for Hollywood.

✳

Two friends in higher places—Elia Kazan and John Houseman—encouraged Ray to leave his troubles behind and explore a possible future in the film industry on the West Coast.

Left to his own devices, Kazan might not have taken the initiative, but Molly Day Thacher urged her husband to bail out the disconsolate Ray. After finally accepting a contract with 20th Century-Fox, Kazan was on track to direct his first Hollywood picture. He invited Ray to be his all-purpose assistant behind the camera. What that entailed even Kazan didn't know.

According to Bernard Eisenschitz, when Kazan left New York for Los Angeles in mid-March 1944, he took Ray with him on the cross-country journey. Kazan doesn't think to mention Ray in his autobiography, *Elia Kazan: A Life,* noting instead that he enjoyed "an uninterrupted three days alone" on the train, plenty of time to reread *A Tree Grows in Brooklyn,* Betty Smith's bestselling quasi-autobiographical novel, which he had agreed to shape into a motion picture.

Whether he traveled separately or with Kazan, by late March 1944 Ray had taken up residence in the film capital. (The FBI was still keeping track of all his addresses.) After a temporary stay in Hollywood proper,

Ray found a place in Santa Monica, near Houseman. His fellow Voice of America refugee was involved in a romance with actress Joan Fontaine while producing a new film, *Miss Susie Slagle's,* the first directed by young left-wing New Yorker John Berry.

Meanwhile Kazan checked into the once-posh Garden of Allah hotel and took up duties at 20th Century-Fox, with the photography of *A Tree Grows in Brooklyn* scheduled to begin in April. The studio occupied vast acreage in the area of Los Angeles known as Century City. Ray's job title and salary were up in the air until early April, when Kazan got him a contract with an assigned office near his in a building on the lot. Ray would work, uncredited, as Kazan's "dialogue director."

Ray had arrived in Hollywood in a kind of daze. He felt tentative about everything in his future, including motion pictures. But for him work was always invigorating—and this was not only well-paid work, it was Ray's first opportunity since the Theatre of Action to learn directly from Kazan, who had grown in experience and stature since they last worked closely together.

Preparing actors for their auditions was his first order of business. As Ray would learn on his first Hollywood job, casting was negotiated between the director and the front office, with the front office reserving veto power. Kazan wanted actors who could deliver truthful performances in Betty Smith's realistic story, but he was good at finding performers with faces or backgrounds that could, at first, seem mismatched for their parts. The disparities appealed to the first-time director, who quickly proved adventurous about mixing and matching actors with diverse qualities.

"During the casting," Ray recalled years later, "some incredible tests were shot. For instance, [Kazan shot] a test of a remarkable actress, who later went through a long period of institutionalization. She must have been twenty-three or twenty-four, and very sophisticated at the time, with a fabulous body. At the request of the studio heads, they taped over her tits to give her a flat chest, so that she could appear for rehearsal and eventually an expensive test for the role of Francie, a twelve-year-old girl.

"We ended up with Peggy Ann Garner, a child actress with no stage experience, who could not be loaded down with any theories of acting. But she did have the experience of a broken family, a mother who was a lush and a bad check passer.

"[Playing the mother was] Dorothy McGuire, from a fairly elegant

background, well-educated, married into a Northeastern blue-blood family.

"And [playing the father was] Jimmy Dunn, who could have been a vaudeville comic, associated mostly with gamblers and musicians and burlesque people. He had all of the realistic qualities of the character. He was a drunk, drank himself out of the business. He was a constant risk in the minds of everybody. He was also a beautiful human being. And he gave an Academy Award–winning performance.

"Kazan's extraordinary technique brought them all together in a unit. He got them all in the same key, they all belonged together, not one note jarring. After the test with these three people, I made a note: 'When you find the real thing, fuck acting.'"

After the cast had been finalized and filming began, Ray performed a variety of tasks, rehearsing lines off-camera, even making sketches of proposed shots under Kazan's supervision. For the first time in his career he was called upon to think in cinematic terms, to consider how to compose stories visually, as a series of linked images. When he wasn't on the set he was often in the cutting room, watching the teams of editors splice takes together, trying to absorb visual continuity by studying their options and choices.

Ray was never reluctant to work late, and he took it upon himself to set up an informal series of after-hours tutorials with some of the veteran technicians. Thursday nights, after the last take of the day, Ray convened a small group—four editors and a projectionist—to talk filmmaking over drinks at the Luau tiki bar in Beverly Hills. He did the buying and, as always, more than his share of the drinking.

Already demonstrating his yen to diverge from the conventional studio approach, Ray brought along panels clipped from the *Steve Canyon* and *Terry and the Pirates* comics in the Los Angeles papers, "as references and [to] discuss the ideas and problems I'd accumulated during the week and not had a chance to resolve over the Movieola," in his words. "I brought the Dick Tracy strip too, once in a while. It was mostly too loose and uninterestingly stylized for me, but the compositions were tight, the two-shots were always great, the three-shots were always great, and the individuals were always in an interesting perspective to the background."

Ray had noticed that the "the old fashioned boys," as he called them (meaning such longtime contract directors as Henry King and Henry Hathaway), always organized their films in a standard way—"long shot, medium shot, close shot." Ray thought it might be refreshing to imitate the comic

strips with tighter shots, skewed angles, and extreme close-ups. This comic-strip approach could be a way to intensify the emotional impact of a scene, delivering a jolt to the audience. Lubricated with drink and bored with the rules of their craft, the editors thought Ray might be on to something.

The filming of *A Tree Grows in Brooklyn* lasted two months. Kazan even gave Ray a walk-on part as a bakery deliveryman, and publicly the director always praised his assistant's contribution to his debut feature, even if his memory of Ray's contribution was amorphous. "He hung around, took notes," Kazan recalled. "He edited them for himself and gave me a copy. A lot of them were influenced by [producer Louis B.] Lighton, and others were my own thoughts, or things I said. Nick liked that kind of generalization on aesthetics, etc."

Kazan had hired Ray at his wife's insistence, and their friendship was still an imbalanced one of unequals. In letters to Molly, Kazan complained that Ray and other Theatre of Action and Group Theatre alumni kicking around Hollywood expected too many favors from him. He also found Ray a bit too fawning for comfort. "It is very, very bad for him to work with me," Kazan wrote his wife after the filming of *A Tree Grows in Brooklyn* ended. "He respects me too much and is constantly trying to impress me. It's very pathetic, and everybody notices it. Not good."

❋

Plunged into this world where money and gorgeous women were abundant, where the premieres and parties never ceased and the sun shone every day, Ray tried to find a way to fit in.

He plugged quickly into the network of New York transplants Kazan complained about, many of them friends from radical theater, the WPA, and the Voice of America looking to find a new footing in Hollywood. In Hollywood, at least, the left-wing theater movement was still alive and well in 1944.

According to some accounts, Ray flitted in and out of the only real left-wing theater in town, the Actors Lab on Laurel Avenue, where screen artists burned the fat from their studio contracts mounting serious, sometimes political plays. He briefly involved himself with the Hollywood Writers Mobilization Committee for Democracy, which deployed liberal writers on topical issues—both groups designated by the U.S. attorney general as "Soviet communist controlled" in 1948.

But his politics had gotten him fired from the Voice of America, and Ray understood that he was at a career low point as well as a crossroads of opportunity. Though he stayed friendly with most of his left-wing peers in Hollywood, he also abandoned his radical activism of more than a decade with surprising ease, much as he slipped away from the bed of a woman.

Ray spent most of his free time socializing with other displaced New Yorkers. John Houseman invited him frequently for dinner, and the assistant director was a fixture at Gene Kelly and Betsy Blair's house parties every Saturday night; after Kelly joined the military, the parties shifted to MGM composer Saul Chaplin's place on Orange Grove Avenue.

The Kelly-Blair crowd was in their late twenties and early thirties, most of them, like Ray, just getting their bearings in the film business. Writer Millard Kaufman was often in attendance, as was left-wing actor Stanley Prager, who was always more hilarious in living rooms than in his fleeting movie roles. The Chaplins had two pianos at their house, and sometimes Saul and his wife, Ethyl, dueled at the pianos with witty lyrics and jokes. A busty blonde named Shelley Winters often insisted on belting out songs there too, to general dread.

Sometimes Ray came to these parties with a woman, but just as often he came alone, drinking, watching people, but saying very little. He indulged in "several affairs" during his 1944–45 tryout in Hollywood, according to Bernard Eisenschitz. Besides Winters, who would become a standby in Ray's life, the list included that lovely lady whose breasts were taped for her *A Tree Grows in Brooklyn* screen test; the tall, dark-haired actress Doris Dowling (Kazan had a long-running romance with her sister Constance); and perhaps Judith Tuvim, among the wartime influx to the film capital.

Tuvim and the Revuers came to town for a booking at the Trocadero, which got the cabaret troupe noticed and eventually signed by Ray's studio, 20th Century-Fox. But when the Revuers were all but expunged from *Greenwich Village,* their debut picture, the dispirited troupe split up. Soon after, Judy Tuvim became Judy Holliday, and she and Ray resumed their flickering relationship.

It was never a very cheery romance, for both Nick and Judy were known to wallow in their sorrows. One day Ray, Houseman, and Holliday drove over to the beach house of Broadway actress Doris Dudley, who was also trying to break into Hollywood. "Judy had a few drinks," recounted

Holliday biographer Will Holzman. "Nick had a few more. Both were depressed; Hollywood was squandering their talent. Life was awful, they agreed, and it looked worse with each drink. Somebody suggested a dip in the ocean.

"Judy and Nick waded out into the waves, when with inebriated wisdom they decided that life was no longer worth living. They swam straight out into Santa Monica Bay. The swells grew, the current stiffened, and they changed their minds. The only problem was they were a good distance from shore. Groggy and exhausted, they eventually struggled back to the earth. Houseman helped them to the house and provided them with coffee and dry clothes."

Connie Ernst wouldn't really count as one of Ray's Hollywood affairs, but the Voice of America producer contrived to be in Los Angeles in late summer, on assignment from London, and Ray and she briefly rekindled their affection. Like Jean Evans, the fun-loving Ernst was another of Ray's "lifelong loves." But then again he remained friends with quite a few of his former lovers; whether they were troubled or confident women, most simply held no grudge against him.

<p style="text-align:center">✳</p>

By August, Kazan was done with his work on *A Tree Grows in Brooklyn* and anxious to return to New York, where another Broadway directing job awaited him. Ray had no such glittering prospects ahead of him, and he was enjoying the novelty of his new life in California; he preferred to stay.

Coaxed by his wife, Kazan went to bat for Ray, reminding studio officials of the value of a man who was able to help out in so many ways behind the scenes, including screen testing, rehearsing actors, and critiquing scripts. Kazan was the studio's fair-haired boy, and Ray was widely seen as his protégé. The studio extended Ray's contract through the end of the year.

"They think him a bit strange, which he is," Kazan wrote to his wife on August 9 before leaving for New York, "and UNGATHERED (my opinion). Also he has a dangerous fault in work. You feel that he's thinking a little more about himself, and his angles, than of the material.

"This comes out of his uncertainty."

For the rest of the year, Ray floated around the lot, handed from pro-

ducer to producer, helping with menial tasks behind the scenes. Among the productions he worked on was a B movie quickie called *The Caribbean Mystery,* starring James Dunn from *A Tree Grows in Brooklyn.* Ray made suggestions that were incorporated into the script, but both his dialogue direction and touch-ups went uncredited on the screen, like everything else he would do at 20th Century-Fox.

He returned to the notion of writing a film of his own. Not alone: Ray enjoyed hatching script ideas in collaboration with New York acquaintances at Hollywood bars and restaurants, and when he wasn't scrounging for work at the other studios, in the first half of 1944, he was pitching stories and scripts to producers and friends.

He got a little attention from the local press, cropping up in an article in the *Los Angeles Daily News.* Columnist Virginia Wright trumpeted one of Ray's properties, written in tandem with the well-known actor Howard Da Silva, a friend from Da Silva's days in the Group Theatre. Understandably, the article focused on Da Silva, who had reclaimed his glowering-villain niche in Hollywood after five hundred Broadway shows as Jud in *Oklahoma!* But it gave an intriguing account of a story Ray had developed with the actor. "Doctors in the [Ray–Da Silva] screenplay hope to learn from the patient's reaction to insulin shock just what makes a Nazi tick," Wright wrote, describing the script. "What they do discover is the way the 'master race' virus is injected into each generation."

Ray had better luck with the Three Stooges than with the Master Race, helping out on the "original story" of a Moe, Larry, and Curly musical. *Swing Parade of 1946* had a long gestation period: An entire year would pass before the picture was released, emblazoning the name of Nicholas Ray on the screen for the first time. But the Three Stooges vehicle couldn't have been less consequential, and the studio, Monogram, ranked among Hollywood's lowliest.

<p style="text-align:center">✳</p>

"Ungathered": That had been Kazan's verdict, and Ray probably wouldn't have disagreed. He had had the rug pulled out from under his acting aspirations. The left-wing theater movement had stagnated. He had reason to feel betrayed by both CBS Radio and the Voice of America. And Ray was still uncertain about Hollywood—about his ideas, his future, the role he

might assume in filmmaking. But he was good at maintaining a mask of confidence, even as he struggled to keep his private uncertainty in check.

Truth be told, he still felt ambivalent about filmmaking. Unlike many of his New York friends, he hadn't grown up hooked on movies. He liked to tell this anecdote: Although *The Birth of a Nation* was imprinted on his memory as the first movie he'd seen as a boy, he'd never paid much attention to the names of directors. When he first arrived in Hollywood, he hung out a lot at Beverly Hills bars, drinking and bantering regularly at one place alongside a "nice old gentleman" whose mumbled name didn't ring any bells. Long after changing bars, he was shocked to realize that the man was D. W. Griffith. "I have never been a film buff," Ray explained. "If I had been a film buff I would have known."

John Houseman rode to Ray's temporary rescue in October, engaging him as his general assistant on a two-reeler the producer and screenwriter Philip Dunne had agreed to craft for the Office of War Information to help explain the American electoral system to foreigners.

Artist John Hubley, who had left Walt Disney after a bitter strike against the studio in 1941, was helping with the drawings and animation. Howard Koch, who had written Orson Welles's famous *War of the Worlds* script for the radio and *Casablanca* for Warner Bros., was penning the narration for the newsreel sections. John Berry, who had finished *Miss Susie Slagle's* at Paramount, was handling the staged scenes ("the milkman, the grocer, the office worker, the farmhand and the housewife," exercising "their democratic right by going into an enclosed booth in the local schoolhouse or barbershop and voting for the man of their choice," as the *New York Times* reported). The celebrated composer Virgil Thomson, a friend of Houseman's who also had pitched in at the Voice of America, was scoring the music. Ray's job was to advise and assist this exceptional team. The OWI production, called *Tuesday in November,* was eventually sent abroad in twelve languages; ironically, it would be the high point of Ray's first year in Hollywood.

Reappearing around then, at just the right time, was another old friend, who predated Elia Kazan and John Houseman. Joseph Losey had blown into Hollywood around the same time as Ray, planning the English-language version of Bertolt Brecht's *Galileo,* to star Charles Laughton. Brecht and Laughton were busy translating and refining the German text in Santa Monica, where Brecht, a refugee from Hitler, lived. In and out of

town, as the script revisions dragged on, Losey wangled a directing contract at Metro-Goldwyn-Mayer, making his first theatrical film there: a gripping two-reeler everyone was talking about called *A Gun in His Hand,* which was part of MGM's long-running *Crime Does Not Pay* series.

When President Franklin Delano Roosevelt passed away on April 12, 1945, the Hollywood left-liberal community organized a memorial at the Hollywood Bowl. Losey was picked to stage the event, working from a Writers Mobilization Committee script, and once again he asked Ray to serve as his backstage manager. The stars onstage included James Cagney, Ingrid Bergman, Orson Welles, and Frank Sinatra. Losey and Ray rustled up contributions from Earl Robinson and other New York arrivistes who had been sympathetic to the New Deal. More important, the executive producer of the event was Dore Schary.

Schary was already a storied figure in the movie business. Originally a writer (he'd won an Oscar for *Boys' Town* in 1938), Schary had become an admired producer for MGM and David O. Selznick, one who not only made intelligent films but was, everyone agreed, something even rarer in Hollywood: a genuine mensch. Schary, whose future would take him even higher in the Hollywood hierarchy, took note of both Losey and Ray.

<p style="text-align:center">✳</p>

Except for *Tuesday in November* Ray did not work with very closely with John Houseman in his first frustrating year in Hollywood. But the two men lived near each other in Santa Monica, they saw each other regularly, and as the months passed they drew closer as friends.

It was a frustrating time for Houseman too. Since leaving the Voice of America he had produced three quick, undistinguished pictures for Paramount. His love affair with Joan Fontaine had ended dismally. He'd just signed a new contract with RKO, improving his terms, but, like Ray, the producer felt conflicted about Hollywood and the film industry. Houseman's first love was the theater; he too missed "the stink of the gallows." When, at the beginning of the summer of 1945, he announced he was going to drive back east, taking a break from picture-making, Ray eagerly hopped in the car with him. Along for the ride was a box full of stories and screenplays from the RKO files, from which Houseman intended to choose his next film project.

They were congenial cross-country companions, musing over the stories and scripts, chewing on Hollywood gossip as Ray twirled the dial on the radio looking for good music.

Back in New York Ray saw old friends and caught up with his family (Jean Evans was thriving at *PM*), while Houseman went looking for remunerative work for them both. Houseman was soon bombarded by offers, including one from television—an improbable suitor.

Visiting the CBS offices one day, Houseman was hailed by a former associate who asked him if he would like to direct a television show. The medium had been introduced with hoopla at the 1939 New York World's Fair, but World War II had stalled the manufacture of TV sets and delayed the development of national programming. In New York, for instance, WCBW still broadcast only locally and in the evenings.

Why not? Houseman thought. He and Ray could do it together. For his first project, Houseman chose a popular radio drama called *Sorry, Wrong Number*. Lucille Fletcher, the wife of composer Bernard Herrmann, had written the half-hour radio show about a bedridden woman who overhears a murder plot on the telephone, gradually coming to believe that she herself is the intended victim. Agnes Moorehead had starred in repeat broadcasts of the drama, but these days Moorehead was busy in Hollywood, so Houseman gave the lead to veteran stage actress Mildred Natwick. Over the summer of 1945 he and Ray revised the script for television and cast the smaller parts.

Then, while preparing *Sorry, Wrong Number,* Houseman was approached to direct an ambitious musical for Broadway called *Lute Song,* based on a classic fourteenth-century Chinese play. He was happy again to nominate Ray as his assistant. When Houseman began to shift his attention to the more demanding stage production, it gave Ray another chance to spread his wings. The assistant took over the rehearsals and limited staging of *Sorry, Wrong Number.* Some sources credit him as director, but Ray's contribution stopped short of that. "When it came to air time," according to CBS staff director Frances Buss, "I directed the cameras."

The half-hour television show had a budget of only a thousand dollars and just two cameras for the simple coverage. Still, "artistically, the results were very satisfactory," *Variety* declared of the show, broadcast on January 30, 1946. All the advance publicity had touted Houseman's name, yet insiders knew that Buss and another unsung collaborator deserved

the applause. The *Billboard,* a key industry journal, complained of "so few Houseman touches," while lauding the contribution of Houseman's "alter ego, Nick Ray."

✳

Ray would continue in the role of Houseman's loyal alter ego in the year ahead.

*Lute Song* was a dream project for Michael Myerberg, who had hit the jackpot several years earlier as the producer of Thornton Wilder's *The Skin of Our Teeth*. For nearly a decade Myerberg had carried around a script for *Lute Song* by Sidney Howard, who had completed the adaptation before he died in 1939 (just before the premiere of the last film he wrote, *Gone With the Wind*). Veteran composer Will Irwin had contributed a score. Finally, in 1945, Myerberg had the necessary financial backing and stars lined up— and, in Houseman, the director he wanted.

By the fall, Ray was steeped in behind-the-scenes work on *Lute Song.* This time the challenges he and Houseman faced were bigger than those of a half-hour single-character drama confined to a cramped set. *Lute Song* boasted a large cast, including marquee attraction Mary Martin and a magnetic up-and-comer named Yul Brynner, with elaborate song-and-dance numbers. Houseman anticipated five months of polishing the musical on the road before hitting Broadway.

These months of difficult shared experience bound the producer to his resourceful assistant even more than their time at the Voice of America. He and Ray talked everything over: the script, the cast and performances, every nuance of the staging. They even traded ideas with other shows wending their way toward Broadway. At times *Lute Song* crossed paths with *Born Yesterday,* which was also on the road, and Houseman and Ray commiserated in hotel rooms with their old friend Judy Holliday, the star of Garson Kanin's play, anxious for their advice about what was shaping up to be her comedic breakthrough role.

As ever, Ray worked tirelessly during the long days and nights. Thrown into constant intimacy with his resourceful assistant, observing Ray under stress, Houseman began to see his friend's potential as an all-around talent whose promise might rival that of his old colleague Orson Welles. He recognized Ray's faults—the drinking, gambling, and womanizing. But such

faults were hardly rare in show business, and they didn't seem to hurt Ray's ability to function at a high level. His "unselfish collaboration," Houseman reflected, "was of inestimable value."

At last, after weaving through Washington, Philadelphia, New Haven, and Boston, *Lute Song* arrived on Broadway on February 2, 1946. And yet, despite its magnificent design and costumes, the luminaries involved both onstage and off, the Chinese spectacle proved a letdown: "the season's loveliest production and most charming failure," as *Time* lamented.

✳

Among the many people Ray and Houseman encountered on *Lute Song*'s road to Broadway was Herman Mankiewicz, the vaunted screenwriter of *Citizen Kane*. By the end of 1945, Houseman announced that his first official RKO project would be Mankiewicz's adaptation of a Wilbur Daniel Steel novel called *That Girl From Memphis*, a love story set amid the boom and bust of a frontier mining town. Ray joined Houseman and Mankiewicz for their periodic script discussions. All three loved to talk, sparring with ideas and trying to top each other. During moments alone, Houseman and Ray began to talk more seriously about making films together—with Houseman producing and Ray writing and/or directing.

In February 1946, RKO's production chief, Charles Koerner, unexpectedly took ill and died. Houseman knew and liked Koerner's assistant, William Dozier, who was temporarily placed in charge of production.* The day after *Lute Song* opened on Broadway, Houseman left New York for the West Coast. Ray and Mankiewicz, who expected to complete the script of *That Girl from Memphis* in Hollywood, rode with him in his car.†

Houseman's reminiscences show how clear-eyed he was about Ray, a "handsome, complicated man whose sentimentality and apparent softness covered deep layers of resilience and strength," in his words. On this and other travels Ray made for "a stimulating and sometimes disturbing companion," according to the producer, "garrulous and inarticulate; ingenuous and pretentious; his mind was filled with original ideas which he found

---

\* Houseman knew Dozier as a decent, intelligent producer but also, incidentally, as the man who had succeeded him as Joan Fontaine's lover (they would be married later in 1946).

† Mankiewicz's script for *That Girl from Memphis* was never completed or filmed.

difficult to formulate or express. Alcohol reduced him to rambling unintelligibility; his speech, which was slow and convoluted at best, became unbearably turgid after more than one drink.

"Yet," Houseman continued, "confronted with a theatrical situation or a problem of dramatic or musical expression he was amazingly quick, lucid and intuitive with a sureness of touch, a sensitivity to human values and an infallible taste that I have seldom seen equaled."

The trio made the drive across America in a week, listening to news bulletins and music and talking up the prospects of the new RKO regime in Hollywood.

Crossing the desert by night, they arrived in Los Angeles one morning in late February. Houseman had arranged a rented house in the hills above the Sunset Strip with a small guest bungalow for Ray, who was promptly added to the RKO payroll at $200 a week. Technically Ray was Houseman's assistant, but the producer was determined to reward his alter ego with greater opportunity, and digging through "piles of galleys, synopses and typescripts" in the studio story department, he came upon a novel called *Thieves Like Us* by Edward Anderson.

Houseman couldn't have chosen more wisely. Anderson's story, recounting the exploits of three escaped lifers in Texas and Oklahoma during the Depression, was like a Woody Guthrie song in cinematic form. As the escaped convicts embark on a murderous bank-robbing spree, the youngest, Bowie, indulges in a romance with Keechie, the niece of one of the gang. The story ends in a spray of police bullets; its title came from the gang leader, who insists that bankers are "thieves just like us."

"I decided, before I was halfway through it, that this was my next film," Houseman said. "It was a blend of chase and love story—the brief idyll of two lonely, emotionally stunted young people set in a world in which hunger, fear, treachery, and violence were essential components."

Originally published to acclaim in 1937, Anderson's novel was too violent for easy adaptation. RKO had script drafts in its files dating back to 1941, including one by the hard-boiled screenwriter Rowland Brown, but every version had run up against objections from the Production Code. Houseman offered the book to Ray, inviting him to try threading the needle—to craft a script that might stay faithful to the novel while clearing the hurdles of Hollywood censorship.

Ray thought he could write a detailed treatment that would point the way. If Dozier liked the treatment Ray wrote, Houseman said, maybe the

RKO chief would let him direct the film too. Galvanized by the possibility, Ray plunged into the work—the main chance of his career. Setting the older drafts aside, he started with chapter one of the book—writing "like a man possessed," as Houseman recalled. Now, while others partied and attended premieres, Ray worked days, nights, and weekends on an all-new script for "Thieves Like Us."

Ray and Houseman conferred constantly, though the producer would later insist that his own contribution to the script was modest. Ray's "personal experience of hard times" while traveling for the WPA, Houseman explained, enabled the younger man to re-create the "emotional reality" of the novel. "I'd come home at night and we'd go over it," the producer recalled. "I'd edit it a little, that's all, and it was very, very good." Houseman did allow that he wasn't sure if "Nick could ever have been a good writer, because his sense of organization, which was very strong as a director, was not so strong when he wrote." But adaptation came more naturally to Ray, giving him the solid structure of a novel to work with. "He was able to do *They Live by Night* simply because the book was there, and he was able to move within the book."

Ray took time out, in March 1946, for one last collaboration with Joseph Losey, who was staging the annual Academy Awards ceremony at the behest of Dore Schary. Once again Ray was a natural stage manager for Losey and for a show that would be broadcast nationally on radio from Grauman's Chinese Theatre. Losey's two-reeler, *A Gun in His Hand,* was one of the short-subject nominees, but it was a particular night of triumph for Elia Kazan, whose casting gambles on *A Tree Grows in Brooklyn,* his directing debut—the picture that had brought Ray to Hollywood—paid off with a special juvenile award bestowed on fourteen-year-old Peggy Ann Garner and a Best Supporting Actor Oscar for dark horse James Dunn.

\*

Ray toiled through the spring on his lengthy treatment while Houseman laid the groundwork for the production at RKO. Despite many false starts, Ray made steady progress. Just as he was nearing completion, early that summer, they picked up the trade papers one morning only to learn that "RKO had been sold and Bill Dozier liquidated," according to Houseman. "As usual in show business, all projects initiated by the previous man-

agement were automatically cancelled or shelved. I managed to keep Nick on the payroll for a few weeks; we finished the treatment, had it mimeographed—all 124 pages of it—and stole a dozen copies for future use."

RKO's president, Peter Rathvon, had assumed part ownership of the company, deposing Dozier. Rathvon called Houseman in, reassuring him that the studio would appoint a new production chief as soon as possible. In the meantime, he promised, he would submit Ray's treatment, when polished, to the Production Code office. Whatever happened, one thing was clear: It would be months before "Thieves Like Us" would get the green light. "The change of management did not affect my own contract," Houseman recalled, "which had two and a half years to run. But, if I was not going to make a film, I preferred to wait for the next phase of my contract back in New York."

Ray preferred to leave with him. The partners got back in Houseman's car and made "another of our high-pressure drives" back east, this time without Herman Mankiewicz. Houseman had another job waiting for both of them, something to keep them busy while Ray refined his "Thieves Like Us" treatment in the months ahead.

❋

Houseman had been tempted by an offer from a former colleague with the WPA-funded Negro Theater of Harlem. Perry Watkins, "the only black set-designer working in the New York theatre," in the producer's words, had plans to modernize, musicalize, and African Americanize *The Beggar's Opera,* John Gay's ballad opera set in the amoral thieves' world of eighteenth-century London. Bertolt Brecht and Kurt Weill had collaborated on a famous earlier musical adaptation called *The Threepenny Opera.* The new all-black version would boast a jazz score by Duke Ellington and lyrics by John La Touche, who had written lyrics for the left-wing anthem "Ballad for Americans" (composed by Earl Robinson) and the hit musical *Cabin in the Sky.*

First Houseman and Ray spent a few weeks fine-tuning a traveling edition of *Lute Song,* with Dolly Haas as Mary Martin's replacement. The much-touted Broadway musical had closed after a disappointing run of 126 performances, and a road show was needed to recoup the backers' investment.

By late August, "Twilight Alley," as the black version of *The Beggar's Opera* was called, was occupying all their time. As before, Houseman was the director, with his assistant Ray never far from his side. The modern dancer Valerie Bettis had been added to the list of stellar names behind the scenes, promising flamboyant choreography to go with the jazz score.

Before long, though, it became clear to Houseman and Ray that Watkins was in over his head as a novice producer. His financing was shaky, and by the time open auditions came around the producer still hadn't come up with a finished script or score. Ellington's endless road engagements, which he was loath to surrender, forced him to delegate the all-important music entirely to Billy Strayhorn, his principal composer and orchestrator. Strayhorn was more than willing and capable, but he was forced to collaborate with Ellington by phone from the road. La Touche, meanwhile, proved a shirker—"not only lazy" but "drinking," according to Houseman.

Alfred Drake, the original Curly in *Oklahoma!*, had been cast in advance as the scoundrel MacHeath ("Mack the Knife"), but it was up to Houseman and Ray to fill out the rest of the large ensemble. Zero Mostel, who had made his Broadway debut in an Elia Kazan play, was picked to play Peachum, the fence and thief-catcher. Ray lobbied successfully for his old flame Libby Holman as the cutpurse Jenny Diver, who betrays MacHeath. There were good parts for Harlem dancer Avon Long, who'd starred at the Cotton Club and played Sportin' Life in the 1942 revival of *Porgy and Bess,* and for Marie Bryant, a flashy dancer and bluesy vocalist who had been a headliner at the Cotton Club and the Apollo. Ray also found a small role for Perry Bruskin, his old friend from the Theatre of Action.

Still, the script, music, and financing refused to jell, and Houseman and Ray couldn't decide whether to stick with the troubled show. The tipping point was the news that came from RKO in August: Ray's "Thieves Like Us" treatment had been decisively rejected by the Production Code as "unacceptable" and "enormously dangerous," in large part because of "the flavor of condonation" attached to the character of the young criminal Bowie. Joseph I. Breen, the head censor, wrote Peter Rathvon a letter condemning Ray's adaptation as "invidious."

While Rathvon insisted that the studio wouldn't drop the project, Houseman and Ray were skeptical. The uncertainty left them "edgy and impatient," Houseman admitted. "Nick and I weighed the situation with all its attractions and dangers," the producer recalled. "We had little to

lose and the temptation was great." They agreed to stick with "Twilight Alley," which went ahead with rehearsals in late October, even though by then they still had only "the semblance of a first act," in Houseman's words.

The show hit the road, with Houseman and Ray hoping for a miracle.

※

Much to their surprise, Peter Rathvon kept his word; he didn't give up on "Thieves Like Us." While they were out on the road, Houseman and Ray decided that a revised treatment might fare better with the Hollywood censors. Ray stole time away from "Twilight Alley" to hone the treatment, showing his draft to three trusted writer friends: Alan Lomax, Connie Ernst, and his ex-wife, Jean Evans. He would incorporate their criticisms into the improved version.

Though Ray's treatment evolved from draft to draft, it always hewed close to the main characters and plot of the book. It was a shrewd edit of the story, sharpening the characters and intensifying the doomed romance between Bowie and Keechie. Several of Ray's signature films—most notably *In a Lonely Place, Johnny Guitar,* and *Rebel Without a Cause*—would involve a similar infusion of heartache and sentiment into the love story, the kind Ray imagined (and often acted out) in his own life.

Ray added personal touches and innovations as he went, creating a number of crucial scenes that weren't in the novel—from Bowie and Keechie's bus trip, and their roadside nuptials, to their later outing to a city park, followed by a wistful date at a nightclub where they are entertained by a Mexican dancer. Where Edward Anderson had taken a stoic attitude toward his characters, Ray was more empathetic. He liked losers—his films are filled with them—and, when in the grip of one of his blue funks, saw himself the same way.

The film's grandiloquent preface ("This is *not* an underworld movie . . . It is a Love Story; it is also a Morality Story in the tempo of our time") grew out of Ray's talks with Evans, according to Bernard Eisenschitz. Most of the deep background he sketched in was devoted to the two lovers (Bowie's reprehensible mother; Keechie, part-Indian, still a virgin "for no other reason than apathy induced by witnessing her own mother's actions"). Always trying to create emotional intimacy with his characters, in the treatment Ray had Bowie voice his thoughts out loud during solo scenes;

that device was ultimately cut from the final film, but Ray the former radio announcer would return to various kinds of narration again and again in future projects.

As he worked on the revision, and "Twilight Alley" inched along on its try-out tour, Ray also juggled affairs with several performers in the cast, among them a dancer named Royce Wallace and at least two of the billed stars, Marie Bryant and Libby Holman. Not for the first time, nor the last, did he allow his romantic pursuits to overlap and complicate his work.

<p style="text-align:center">✳</p>

During the out-of-town tryouts that zigzagged through Cleveland, Buffalo, Newark, and Hartford, "Twilight Alley" underwent "whirligig revisions and additions," in the words of David Hadju, Billy Strayhorn's biographer. Strayhorn was a blessing, filling urgent requests ("We really need a ballet number somewhere . . ."), but lyricist John La Touche never rose to the occasion.

By the time they arrived in New Haven, the penultimate stop before Broadway, the looming disaster was writ clear. Parts of the show were a mess. The third act was nonexistent. With so many famous names involved, the anticipation in New York was sky-high. But Houseman, defeated by the production's myriad problems, handed over more and more of the staging to his assistant, a workhorse with a grin.

They finally scraped bottom in New Haven. "Even in a town that was used to impromptu openings," remembered Houseman, "ours was unusually calamitous. The last twenty minutes of the show were virtually improvised by [Alfred] Drake and the cast." That was enough for Houseman: Accounts vary, but either he quit or was fired by the show's apprehensive backers.

Left nominally in charge, Ray led the cast and crew to Boston, where the show would have one last chance before its Broadway opening. Waiting to meet him was writer-director George Abbott, a renowned "doctor" of ailing plays, who'd been summoned for a miracle cure.

Though he was disarmingly placid amid the worst chaos, Ray had been undermined by Houseman's failure. He was still assistant director, but at best, his job now was to "assist" Abbott in his emergency measures during the show's two-week Boston run. According to Perry Bruskin, his

longtime friend, Ray made a big pretense of nonchalance, shooting craps
with the stagehands in the front of the theater while Abbott tried to sort
out the problems down front onstage.

One element Abbott wanted to sort out was Libby Holman. The aging
torch singer was not thriving in her role. (She did "not seem happy in the
role," wrote Elinor Hughes in the *Boston Herald*. "Neither vocally nor his-
trionically did she stand out.") Abbott personally disliked the songstress,
having clashed with her during rehearsals for another Broadway show he
doctored, *You Never Know*, several years earlier. Convinced that Holman
was too old to play Jenny Diver, he cut two of her songs in Boston, think-
ing that would prompt Holman to quit. When she hadn't before the end of
the run, he told his assistant to fire her.

Perhaps there was no good way to deliver the bad news, but Ray chose
to do it one morning after sleeping with her. "Libby took it calmly, even
gracefully, Ray thought," Holman biographer Jon Bradshaw wrote. She
turned her face to the wall. "'Everything I touch turns to shit,' she wept.

"'Not me, old girl,' said Ray, putting his arm around her. 'You've still
got me.'"

Not anymore, the actress replied furiously, ordering Ray to leave her
room. "You just fired me, and I don't mean sexually"—a rare on-the-record
rebuke for Ray the nice guy.

Abbott furiously slashed and restitched the jazz musical, announcing
that it would have a new title—*Beggar's Holiday*—as well as a fresh female
star (younger contralto Bernice Park) by the time it reached New York. "It
is probably superfluous to say," the *Boston Herald* acidly commented, "that
what it needs more than a different name is serious editing, pruning, and
a sense of direction."

*Beggar's Holiday* limped to Broadway in the last week of 1946. Nei-
ther of the famous directors involved wanted credit—or blame—for the
show. Houseman, who had been billed as director in Boston, "at his own
request," according to the *New York Times*, declined that honor in New
York; and "Abbott, called in at the eleventh hour to doctor up the produc-
tion, will not receive any credit for his work either.

"Only Nicholas Ray will be billed as director."

It was his first "real" directing credit, and the timing couldn't have
been better. Herman Mankiewicz had just phoned Houseman, tipping
him off that RKO was about to announce a new head of production:

Dore Schary. Though Houseman had never worked with Schary, he knew his reputation "as an educated, intelligent, progressive filmmaker." And Schary fondly remembered Ray from his involvement with the FDR memorial at the Hollywood Bowl and backstage at the 1946 Academy Awards show.

Houseman phoned Schary to congratulate him and to talk about Ray directing "Thieves Like Us." Schary was familiar with Ray's treatment, which Houseman assured him had been revised with censorship issues in mind. Schary liked fostering new talent, and he agreed that Ray, with a Broadway musical under his belt—even a flawed one—looked like a promising candidate to direct "Thieves Like Us." The RKO producer vowed to put the project on a fast track.

Shortly after the New Year, Ray jumped back in Houseman's car for the familiar long drive back to California. For once the two were happy to flee New York. For several years now Ray had served as Houseman's assistant. Yet Ray had grown over that time, and the producer knew that his assistant had done the lion's share of their television collaboration, aided him immeasurably during the staging of *Lute Song,* and covered for him on the *Beggar's Holiday* debacle. As the pair crossed America once more, listening to music and planning their film of "Thieves Like Us," there was an unspoken shift in the relationship between them: Houseman's alter ego no longer, Ray was coming into his own.

CHAPTER FIVE

# Atmosphere of Fear

1947–1949

Nineteen forty-six was the year W. C. Fields died and eight-year-old Natalie Wood had her first big role in a movie. Bing Crosby appeared in two of the year's top ten highest-grossing films, a list topped by Walt Disney's animated feature *Song of the South*. William Wyler's searching postwar drama *The Best Years of Our Lives* won seven major Oscars, including Best Picture. Hollywood had not only survived World War II but thrived, enjoying record attendance and profits; the American film industry was poised to dominate the new world markets opened up by victory.

Only in hindsight have film historians recognized that the record year of 1946 was also the beginning of the end of the Golden Age. Long-simmering labor unrest culminated in a bitter industry strike and the first in a series of layoffs that year, along with deepening inflation. And the worst was yet to come.

After ten years in lower tribunals, a momentous antitrust case, challenging the studios' monopoly on theater exhibition chains, was inching closer to a ruling by the U.S. Supreme Court. The rival medium of television, held in abeyance by government restrictions during wartime, was about to undergo a boom in programming and viewership. And in the spring of 1947 the House Committee on Un-American Activities (HUAC)

would convene secret hearings in downtown Los Angeles investigating Communist influence in the screen trade.

The old escapist formulas no longer struck the same chord with audiences. "Problem" pictures and film noir better reflected the fears and anxieties of the postwar years. A beleaguered Hollywood looked to a new, younger generation of filmmakers to put it back in touch with America.

Dore Schary led the "youth movement" at RKO, the smallest and shakiest of the so-called Big Five studios, which had long been a sanctuary for fledgling and iconoclastic screen artists. The studio had given Orson Welles a free hand with *Citizen Kane* and provided a haven for European refugees Fritz Lang and Jean Renoir. Its contract directors churned out the most arresting film noir and low-budget thrillers in Hollywood. The studio was known for taking chances on newcomers, making filmmakers out of cinematographer Ted Tetzlaff and editors Mark Robson and Robert Wise. The studio owned a forty-acre back lot in Culver City, but its main buildings and soundstages were located on Gower Street, in a neighborhood dubbed "Gower Gulch" after the innumerable Westerns made there by Goldwyn, Columbia, Paramount, and RKO.

In January 1947 the latest hope for RKO's future passed through the studio gates: tall, handsome Nicholas Ray, looking younger than his years.

He was thirty-five, a decade older than Welles had been when he took RKO and Hollywood by storm. Ray's résumé was long, eclectic, but filled with parallels to Welles's career, from his Wisconsin background to his working friendships with Herman Mankiewicz and John Houseman. Whispered comparisons to Welles might have daunted a lesser man, but Ray felt confident, determined to make his own first film as great as *Citizen Kane*.

❋

Ray and John Houseman moved back into their shared estate above the hills of Hollywood and took up adjoining offices at RKO, although Ray was no longer considered Houseman's assistant. Houseman easily persuaded Dore Schary to let Ray direct a few screen tests, and after the tests passed muster with the boss, early in February the studio announced that Ray would be the "writer-director" of RKO's planned adaptation of *Thieves Like Us*.

There was one slight problem: the "writer" part. Even though Ray's treatment was "half screenplay already," in Houseman's opinion, and "infused with the characteristic tone" of the eventual film, according to Bernard Eisenschitz, after months of augmentation Ray had ended up with a treatment 196 pages long. Only a Hollywood professional would know how to strip the story down to meet "the limitations of a medium-priced program picture," according to Houseman—and only a veteran of the system would know how to mediate the stubborn opposition of the Production Code Administration.

Back in December 1946, shortly before Schary's appointment as studio head, RKO officials had attended an "extraordinary session" at the censorship office, where "the entire staff of ten reviewers" and chairman Joseph I. Breen came together to critique Ray's latest draft treatment. The Hollywood censors hadn't budged. Every element of the story had to be softened: the characters, incidents, themes, and "general indictment of society which justifies the title."

Ray was as eager as Houseman to break the censorship logjam. With casting and preproduction duties looming before him, he agreed to hand over the final script to someone else. Houseman recommended a mutual friend, a former lawyer named Charles Schnee. Underrated in most accounts of Ray's career, Schnee would make important contributions to several of the director's finest pictures.

A Connecticut native and Yale Law School graduate, Schnee had practiced law for a few years before deciding he'd rather be a writer. He'd penned radio dramas for Houseman and the Mercury Theatre, and supplied Lee Strasberg with individual scenes to use in his acting classes. In 1943 Strasberg directed Schnee's first Broadway play, *Apology;* the play grabbed the attention of producer Hal Wallis, who signed Schnee to a contract after seeing it in New York.

Schnee made his mark quickly in Hollywood, doctoring a few scenes for John Berry's second feature, *From This Day Forward,* and scripting the hard-boiled *I Walk Alone*, a Hal Wallis production, for Burt Lancaster. Schnee had just finished a round of work on *Red River,* a cattle-drive Western destined to become a classic, for director Howard Hawks. (An Easterner to the core, Schnee had spent a summer during college working on a Wyoming ranch.)

Schnee was a proponent of research and realism, a philosophy congenial

to Ray, with his left-wing theater and archival background. "Perhaps my training as a practicing attorney in New York," Schnee once explained, "has persuaded me of the necessity to dig deep for the facts in writing a screenplay and to relate the characters to the situations with a realization of the over-all objective." He was also "flexible, fresh, imaginative," in Houseman's words, especially good with dialogue. In person Schnee was mild-mannered, puffing on a pipe as he listened during script discussions; he often finished troublesome scripts after other writers bailed out on them. He had the look and demeanor of a lawyer, and functioned like a lawyer, homing in on the thorniest issues any script presented.

Houseman cautioned Schnee to follow Ray's existing treatment as closely as possible. "I wanted really to do a transfer job," Houseman said later, "to transfer the treatment into a screenplay . . . I made it absolutely clear that I didn't want any original creative work, simply an effective job." By early February the trio was immersed in script talks, and later that month they visited the Production Code offices to haggle personally with Breen. RKO's censorship liaison, Harold Melniker, joined the meeting. This was Ray's first encounter with Hollywood censorship officials, but he did not feel daunted. After all, Ray was a veteran of FDR's New Deal bureaucracy in Washington, D.C., and he always had shown patience and tact in planning and budget meetings. During his screen career he would help negotiate compromises to many sensitive censorship issues.

As the trio listened, Breen itemized the sticking points. The three criminals were too brutal. The youngest, Bowie, showed no guilt. Keechie enabled Bowie's violent behavior. Bowie and Keechie obviously indulged in sexual relations before marriage. Edward Anderson's ending for the novel, in which the police gunned down Bowie and Keechie, offered little hope or uplift.

Consulting with Ray and Houseman, Schnee bent to the task, tailoring scenes and penning sharp dialogue where Ray's lines were long-winded or off the mark. He picked up on the "object tracks'" Ray had added to the story—the mutual gift of watches between Bowie and Keechie—and invested them with increasing meaning each time the young lovers synchronized their watches.

---

\* "Object track" is a screenwriters' term for an object that is tracked through the story line.

Wherever possible, Schnee also eliminated static scenes and added action to the story. For example, Ray's original opening had a Lead Belly– type prisoner singing the blues in the penitentiary where the three lifers are being held. The breakout was more heard than seen, and the convicts made their escape by train. Schnee saved screen and production time by going back to the novel and starting with the prisoners racing down a country road in a stolen car. That led to the film's opening scene—and inspired Ray's daring idea to film their escape using aerial photography.

In his treatment, Ray had also written scenes to intensify the muted radicalism of the novel, blaming the desperate actions of the hardened criminals on social inequities. Breen complained that there were too many such scenes, and Schnee had to eliminate or temper a few. This included the one Ray himself had devised, in which Bowie and Keechie marry at a roadside chapel after impulsively abandoning their seats on a Greyhound bus. Schnee replaced the social commentary in Ray's version with bitter humor. (The marriage sequence also gave the filmmakers a way to soften the censor-flagged lovemaking between Keechie and Bowie, which leads to Keechie's pregnancy.)

Scene by scene, the violence of the story had to be moderated. A po- liceman who was killed in Ray's treatment would now be merely wounded. Bowie would be given a "soft heart" and other "likeable" traits (he drinks milk, holds boyish superstitions, even cradles a baby in one scene). The Production Code even regarded the original book title as subversive, with its implication that all businessmen and bankers were "thieves like us." RKO would have to find a new title.

Schnee wrote for two months—making "extensive changes," accord- ing to censorship records—before arriving at a much-reduced 117-page draft on May 2, 1947. But Breen rejected this rewrite too, complaining that too much criminality still went unpunished. Schnee and Houseman paid a crisis visit to the Production Code office, this time without Ray, to ask about other ways of "strengthening the voice for morality" through the character of Keechie, who in the novel is more complicit in Bowie's actions and who is killed with him by police at the end.

Ray's own radicalism had evanesced, and in his career he was always pragmatic and resourceful about censorship; the team had little choice but to appease the Hollywood censors. At this mid-May meeting, Houseman and Schnee made the unwanted decision to write new dialogue distanc-

ing Keechie from Bowie's crimes. In small ways, they agreed to reinforce her innocence (playing down any hints of a "sex affair" between her and Bowie before their marriage). They agreed to remedy more than thirty other code transgressions: T-Dub's physical brutality, Bowie's indifference to his own misdeeds, the hostile attitude toward police, the actual methods and rewards of crime—all hallmarks of the novel.

Schnee discussed the changes with Ray and Houseman, and their two months of work and diplomacy finally bore fruit when the Breen office tentatively approved Schnee's draft of June 7, 1947, pending resolution of minor problems on three pages. Breen sent the team a special letter of gratitude for the cooperation they showed in taming "this originally very difficult story."

By then, Ray had labored on the script for more than a year—longer than he would work on any other script of his that ended up on the screen. He had benefited from advice and feedback from astute writer friends in New York and Hollywood, and from Houseman and Schnee during every stage of the struggle at RKO. Even during the censorship crunch he had maintained his compass.

Indeed, one could argue that, by some mysterious means, the long development process—and even the censorship concessions—further aligned the film with Ray's psyche. The final script was still relatively faithful to Anderson's tough-minded novel. But the story now was less about the trio of criminals and more about Bowie and Keechie—a fable of their doomed romance. Like the men in many future Ray films, Bowie was depicted as scalded by his upbringing, misunderstood by society, and in the thrall of macho behavior. He was also helplessly, almost haplessly, in love with a blameless girl. But Bowie's fundamental decency was underlined by his ultimate self-sacrifice. The doomed character finally succeeded, it might be said, by failing. These elements were present in the book, but they were protected and enhanced as the script evolved.

And many of Ray's personal touches persisted into the final script—including his unusual title sequence. Schnee honed the final words, but it was Ray who had conceived the film's opening: a tight image of Bowie and Keechie, rapturously entwined, along with a narrative scroll. "This boy and this girl, were never properly introduced to the world we live in . . ." This singular prelude would introduce the film—and establish the unmistakable tone of Ray's vision.

The title itself never stopped being a point of contention. RKO didn't object when the Production Code took issue with Anderson's original title: The studio didn't like "Thieves Like Us" either.\* And when Schnee replaced the Mexican nightclub dancer in Ray's treatment with a jazz singer who entertains Bowie and Keechie on their date night, Ray earmarked the part for another *Lute Song* acquaintance, his rumored lover Marie Bryant. Ray liked a bluesy song in Bryant's repertoire, "Your Red Wagon," a 1930s tune retooled by Hollywood composers and recorded by both Count Basie and Jimmy Witherspoon in 1947. In New Orleans slang, "That's your red wagon" meant "That's your business," and Ray thought it made for a good title.

No one in the studio hierarchy was crazy about its obscure meaning, but that was what was stamped on Schnee's June 26, 1946, shooting script, and in late June "Your Red Wagon" was announced as the working title of the new RKO production based on *Thieves Like Us*.

<div align="center">❋</div>

While Schnee was writing, Ray was organizing the cast and crew and planning the logistics of the production. His biggest concern was casting the two leads, the doomed lovers Bowie and Keechie. Schary had intriguing ideas: Maybe Shirley Temple as Keechie? But the studio boss was willing to let Ray explore other possibilities, reserving the right of final approval.

From the leads to the smallest parts, Ray's search process was unconventional. For him, there was no dividing line between the studio workday and the Hollywood night. The parties he attended became an extension of the casting call. Drink in hand, Ray would stare at guests as if, thinking of Vakhtangov, he was peering into their souls, their essences, searching for signs of the characters in the films he was preparing.

He stared at Farley Granger so long and hard he gave the actor the creeps. Not quite twenty-two, Granger was an epicene Californian with unexpected depths and, in the right role, the pounce of a tiger. In some

---

\* Farley Granger said, later, that when Howard Hughes took over the studio, Hughes reconsidered the book's original title before vetoing it on the grounds the public might misinterpret it as *Thieves* Like *Us*.

ways Ray saw the Edward Anderson novel as a crime-story variation on *Romeo and Juliet*—he joked about borrowing the title—and Granger was Romeo-handsome. Before serving in the military, he had attracted notice in two Lewis Milestone films. Though he was now under contract to Goldwyn, Granger hadn't worked since the war.

At Saul and Ethyl Chaplin's house for a party one night, Ethyl introduced Granger to the tall, older stranger who'd been eyeing him from across the room. "I tried to make conversation," the actor remembered, "but failed miserably. Nick was either shy, or inhibited, or taciturn, or all of the above. After a while I gave up trying to communicate with him and went to get a drink."

No matter how often Granger ran into Ray, they fell into these same stilted conversations. "I actually thought he was drunk all the time," recalled Granger. Nick Ray very well may *be* drunk, Ethyl Chaplin told Granger with a wink, but he's also a new director studying you for a part in the movie he's making. Sure enough, one day soon thereafter Ray and John Houseman summoned Granger to RKO for a meeting.

There the actor met the other side of Ray. "Nick was completely articulate when he talked to me about the part and what he thought I could bring to it," recalled Granger. "John Houseman was charming, and, as I was to learn, more than articulate about everything."

Ray saw Granger as the fugitive Bowie, but in order to convince the studio, they needed Granger to make a screen test, playing a convincing love scene with a Keechie-type actress. Would Granger prefer to test with any particular actress? The actor suggested his friend and fellow Goldwyn player Cathy O'Donnell, a wholesome, ethereal beauty who'd made a touching debut as the wife of armless war hero Harold Russell in *The Best Years of Our Lives*. That was enough for Ray, who tended to build his films around male leads, casting the women almost as afterthoughts. He got in touch with O'Donnell, and the actress rehearsed with Granger over the weekend before their on-camera audition.

The tests went well but Schary wasn't won over. RKO had its own young contract players, and the studio was reluctant to pay Goldwyn for loan-outs. The director and producer dug in their heels, however, and "Houseman, a very canny man, probably let the final casting go until the eleventh hour in order to be able to put that extra bit of pressure on Dore Schary," in Granger's words. The eleventh hour rolled around in June,

when Schnee delivered his final revised script, and then, at last, Schary approved Ray's choices for Bowie and Keechie.

RKO cared mainly about the two leads and left the supporting roles to the director's discretion. Between them, Houseman later wrote, most of their picks were people they already knew and felt comfortable with: "our friends—men and women we had worked with before."

Ray's onetime writing partner, actor Howard Da Silva, seemed born to play the sinister Chickamaw. ("Three-toed Mobley" in the book, in the film Chickamaw acquires a glass eye to become "One-eyed Mobley," playing on Da Silva's trademark glower.) Ray knew Jay C. Flippen from political benefits in New York and a long poker-playing relationship. The craggy-faced, raspy-voiced Flippen was well known as a vaudeville comic, but Ray also recalled him as the shiftless Jeeter Lester in a road show of *Tobacco Road*. More recently Flippen had displayed his menace as a prison guard in Jules Dassin's *Brute Force*. Ray cast his friend as T-Dub, the oldest, most mercurial member of the trio of escaped convicts. And he called on stage actress Helen Craig, from the ill-fated *Lute Song*, to make her memorable screen debut as the hard-bitten, treacherous Mattie, the wife of T-Dub's jailed brother.

Ray gave small parts to Stanley Prager and to his old Theatre of Action friends Will Lee, Curt Conway, and Erskine Sanford, all circulating in Hollywood these days. In the tradition of left-wing theater, he even buttonholed a few nonactors to play their counterparts on the screen. A real Greyhound driver, for example, played the bus driver in the film.

Ray was sentimental about one last piece of casting. One day at RKO he recognized Guy Beach—his boyhood idol, now a character actor—making the studio rounds. Ray greeted him warmly and promptly offered the onetime impresario of the La Crosse stock company a role as the plumber who recognizes Bowie and Keechie from their pictures in the newspapers. A publicity photo of the two old friends reminiscing was promptly dispatched to Wisconsin papers.

The camera, design, and postproduction personnel on the film were all under contract to RKO. Though Ray often claimed to have discovered his cinematographer, in fact George E. Diskant already had solid credits at the studio, including a film noir for Anthony Mann. Ray's editor, Sherman Todd, was among the best on the lot, Oscar-nominated for *The Long Voyage Home* and *For Whom the Bell Tolls*. When Ray told Diskant about his plans

for unusual camerawork, including aerial photography, the cinematographer nodded in agreement; when the director told Todd that he shouldn't expect the standard coverage—establishing shot, medium shot, two-shot, close-up—the veteran editor didn't even blink.

<center>❋</center>

By the time principal photography got under way, John Houseman was noticing a "new balance" in his relationship with the first-time director. All of Ray's background in theater, radio, and television, his time with the WPA and Voice of America—all that he had done in the fifteen years since leaving Wisconsin—had led to this propitious moment. Once Houseman's trusted alter ego, Ray had grown under his friend's sponsorship and emerged as his own man. No longer "ungathered," the novice director had prepared extensively, scribbling notes and ideas all over the novel and script. His experience in broadcasting made him instantly comfortable with the technology of cameras and sound. Full of optimism and energy, "with a style and work patterns that were entirely and fiercely his own," in Houseman's words, Ray took charge—so much so that, one day very early in the filming, he and Houseman had a disagreement and the producer was ordered off the set.

Houseman left willingly. He realized he was no longer needed. Though Ray and he continued to share the same address, and though they stayed the best of friends, the producer was heard and seen less on the set. Houseman already had found a new outlet for his talents, helping to start the Coronet Theatre on La Cienega Boulevard, financed by old New York friends in Hollywood. The Coronet Theatre was just opening up and planning to host the long-awaited American premiere of *Galileo,* directed by Joseph Losey.

Left firmly in command, Ray almost immediately raised eyebrows at the studio—and among journalists—with his maverick techniques. It started with his decision to deploy a helicopter for the opening aerial shots, which was trumpeted as a first in Hollywood and attracted coast-to-coast wire-service coverage during the first week of filming. The studio departments had initially opposed the idea as risky and expensive, but Ray insisted that using overhead shots to photograph the trio of convicts escaping in a speeding car and fleeing through a wheat field would

be a unique way to launch the story and establish the mood. After the first few aerial shots—for which the director climbed in the copter and flew in the air to personally aim the camera lens—Ray giddily ordered fifteen more unplanned aerial setups. Years later, under the influence of auteurist praise, the director would find a deeper significance to the unusual aerial shots, describing them as "intended to represent the long arm of fate, doom."

Yet Ray was a conscious visual artist. He approached a scene the way he examined guests at a party, peering at them from every possible angle, hovering, edging closer, sometimes looming over their heads. His camera made a study of his characters, then sympathetically adopted their point of view. He insisted on handheld photography in some scenes, wedging the camera close to the people trapped inside careening cars. He called for shots that were skewed at an angle, just like in the funny papers. At one point, he even forced a cameraman to dig a hole in a stage floor to get the kind of extreme low angle that would become characteristic in his films. His camerawork forced an intimacy with the characters.

As much as possible, Ray tried to set his scenes outdoors and at night, to heighten the naturalism of the Edward Anderson story. He set up shots with slats, smoke, rain, or waving branches to add texture to the foreground of his compositions. Not for the last time he used mirrors to divide the screen, with one image commenting on another: a last glimpse of the incorrigible Chickamaw in Bowie's rearview mirror as he angrily drives away.

Ray offered constant challenges to RKO's camera and lighting crew, and the same went for the studio sound technicians. With his radio training, Ray was highly attuned to the audio effects for his first film: the wind hissing down wires, the mournful train whistles, and the clamor of cars on the road. The first-time director was bent on "such a thorough and painstaking job that he drove the studio working crews into a frenzy," according to one newspaper account. "There were mutterings of, 'Who does he think he is, another Orson Welles?'"

※

Hollywood directors could be laissez-faire when it came to handling actors; some were sadistic martinets. Here too, on his very first film, Ray set a unique tone with cast members: gentle, whispering, confidential. Drawing

on his years of study and experience, he urged his players to ponder the be-havior of their characters and explore any similarities to themselves.

He used every rehearsal ploy he could think of: sending Cathy O'Donnell to work at a gas station across the street from RKO, for in-stance, to teach her what it was like to pump gas, change oil, and check tires for days on end. When it came time to film, the dirt and grease on her coveralls was real. But Ray was also a good listener. When O'Donnell told him that she'd been born in Alabama and gone to school in Oklahoma, he seized on those details, reminding her that her character was from the same time and place, urging her to absorb and reflect that kinship. He did the same with Jay C. Flippen, an Arkansas native. With certain other per-formers—like Howard Da Silva, a self-starting powerhouse—his direction was more a matter of a wink and a nod.

Ray's biggest roll of the dice was undoubtedly Farley Granger, the actor playing Bowie. Ray and Charles Schnee had strengthened Bowie's position at the center of the story, revising scenes to reflect the character's point of view—staging the first bank robbery, for example, from inside the car through Bowie's eyes. Ray's nurturing began first thing in the morn-ing—most mornings—when the director picked up the young star and gave him a ride to the studio. Yet Ray could be maddeningly uncommunicative in the car, saying almost nothing until they arrived at RKO.

Though Ray was "socially inarticulate, he was the complete opposite when working," Granger recalled. "If he wanted something special from any of the actors in a scene, he would put his arm around your shoulder and walk you away to talk privately about the situation and the character, even if it was for something as simple as wanting me to react differently to the sound of a car approaching."

For Ray, Vakhtangov's dictum to actors—"find yourself within your character"—extended to the director as well. A Nicholas Ray film always worked best when he could explore himself in the main characters. As a onetime delinquent himself who understood intense fears and desires, Bowie was a natural alter ego for him. As closely as Ray observed Granger at parties before, he watched him on the set now, making sure the young actor talked as tough as T-Dub in some scenes and acted as vulnerable as Keechie in others. Granger fulfilled his expectations.

Ray's budget was only $750,000—less than half of the $1.7 million budget for *Mr. Blandings Builds His Dream House,* for instance, produced

by the same studio in the same year (its cost padded by the salaries for three stars: Cary Grant, Myrna Loy, and Melvyn Douglas). Though Ray's unconventional techniques took him $20,000 over budget, he picked up momentum as the filming progressed, and the production was completed on schedule by mid-August. In the last days of shooting Ray celebrated his thirty-sixth birthday. He was the same age as Elia Kazan when he directed *A Tree Grows in Brooklyn*.

<div align="center">✳</div>

Flattering publicity came with the studio contract, and here too, Ray revealed a hidden strength; he knew how to play his salesman part in the Hollywood game. In his earliest interviews, the novice RKO filmmaker took pains to carve a distinct identity for himself, even to the point of disparaging a few other directors by name—veteran old-timers who were born at the end of the nineteenth century, whose first pictures had been silent, and who were now in their fifties.

Interviewers painted Ray as a man with "a tall, athletic body, a handsome, sensitive face, and wavy, slightly graying hair." Ray's youthful looks set him apart from the old guard, and so did his wardrobe: Where they dressed in suits and ties, Ray outfitted himself in "outrageous red, white and blue polka-dot shirts, corduroy pants and Mexican rope sandals," as one reporter noted.

His cinematic ambitions differed from those of the suit-and-tie generation. "Men like Cecil B. DeMille, Alexander Korda and John Ford expertly handle casts of three thousand people, with two thousand animals and massive sets," Ray said in one article. "But in doing so, they have to be more like generals conducting a battle. They must sacrifice intimate, personal details, which make an audience realize there is a relation between what they see on the screen and their own lives."

He added this statement, a kind of declaration of principle: "I believe in stripping away details that are unnecessary or distracting to an audience. Big sets and fancy costumes are so frequently beautiful by themselves that they cause filmgoers to lose sight of the story and people."

"The story and the people": In interviews and at studio meetings Ray floated a fistful of potential new screen stories to follow "Your Red Wagon." Bernard Eisenschitz, in his biography, lists five different projects

Ray registered through his agency, Berg and Allenberg, which also represented John Houseman. None was ever produced or, as far as is known, completed as a script.

For a while, after finishing his first film, he worked on another intimate, troubled-youth project with Esther McCoy, Jean Evans's friend from his early New York days, and McCoy's collaborator, Colorado-born writer Silvia Richards, who had come out of radio. McCoy and Richards were crafting a Bowie-and-Keechie-type tale about two teenagers in love, whose fates are warped by their bad parents. The two writers did the kind of research Ray valued, visiting juvenile courts and reform schools and interviewing parole officers. Their story had one key scene that took place at the Griffith Park Observatory, where an expert gives a lecture about the stars and sky. The lecture scene lent the McCoy-Richards story its title: "Main Street, Heaventown," a phrase from a Joyce Kilmer poem. The authors finished a lengthy treatment, but it wasn't enough to hook RKO.

Ray announced he would stage Shakespeare's *Romeo and Juliet* with Farley Granger and Cathy O'Donnell at the Coronet Theatre for Christmas. Good publicity for *Your Red Wagon*, yet it never happened. The truth was, for whatever he did next, he needed the studio's consent and RKO hadn't decided on his next assignment. But that didn't matter to his feelings of pride and happiness. Even as Ray searched and searched for his next viable property, his future looked bright. His smile was never broader.

✳

By day, during the fall of 1947, Ray oversaw the cutting of "Your Red Wagon," working closely with editor Sherman Todd. Todd, whose own directorial ambitions were never realized, encouraged the director's bolder instincts—cutting from movement into a close-up, for example, or allowing a long uninterrupted glide of the camera. It was Todd, Ray recalled, who suggested "the cut into the trees swaying with the wind that takes Cathy [O'Donnell] into the cabin." Todd would edit two other RKO pictures for Ray: *A Woman's Secret* and *Flying Leathernecks*.

John Houseman returned to the lot to assist with postproduction. With "loving care," the producer remembered, Ray took the lead in shaping a soundtrack of "the characteristic, commonplace, personal and mechanical sounds of American life." Some of it was popular music derived from

radio shows: the chestnut "Comfort and Joy" was heard behind Bowie and Keechie's Christmas argument, and there were snatches of WPA tunes, including one by Ray's old friend Woody Guthrie.* Studio composer Leigh Harline blended it all together.

The excitement around the picture was mounting; the film's "lyricism" (Ray's word) gave it a sensibility uncommon among the typical run of crime dramas. The director's standing rose at the studio and on "the Bel-Air Circuit," the mansion homes of producers and executives who had plush screening rooms for private showings. Dore Schary met with Ray and promised him an "A" budget and stars for his next production.

After his theater and radio careers and other professional detours, the late bloomer had discovered his true calling. "The celluloid strip is a bloodstream for me," Ray proclaimed toward the end of his life, and it was true: It was a job that encompassed all of life, and all the arts, and nearly everything he had absorbed and practiced and dreamed of doing over the years.

For the first time ever he also had money to spare, and he felt so at home in Hollywood he even spoke in interviews of building a house with his newfound affluence. The parties and women were still abundant, but money gave him another way to socialize: high-stakes poker games. Ray quickly became a regular in the big games with producers and executives, and now he could even afford jaunts to Las Vegas. In the hotels and casinos in the gambling capital, he quickly became known as a happy-go-lucky loser who never seemed to mind losing big sums of money.

<div align="center">✳</div>

September 1947 should have been a glorious milestone. Ray's road ahead looked clear and unobstructed. Then something happened to cast a pall over his—and Hollywood's—future.

Years later, writer Gavin Lambert said that Ray's friends privately thought of the director as a little like Joe Btfsplk, the Al Capp comic strip

---

* Though uncredited, Guthrie's version of the song "Going Down the Road Feeling Bad" is faintly excerpted on a car radio in one scene just before the three fugitive criminals abandon the vehicle, with the song still playing, and set it on fire.

character with a permanent dark cloud of bad luck hovering over his head. Lambert was alluding to the series of physical accidents and illnesses that began to plague Ray in the mid-1950s, but he might just as well have been referring to the dramatic setbacks that had marked his life dating back to his father's sudden death, or his banishment from Taliesin.

For a decade, Ray had dodged the rabid anti-Communism hovering over his generation. He had escaped public mention at the congressional hearings that attacked the Federal Theatre Project. He had eluded J. Edgar Hoover's best efforts to classify him as a dangerous subversive. He was openly denounced when working for the Voice of America and lost out on his overseas transfer and passport, but took it all with a blithe shrug of the shoulders. But he must have blanched in September 1947, when the House Committee on Un-American Activities announced that it was subpoenaing thirty Hollywood figures to testify in Washington, D.C.

Nineteen of those subpoenaed were accused of Communist Party membership. Most of the accused were screenwriters, their credits as prominent as their left-wing beliefs. Ray personally knew several of the nineteen: Albert Maltz, who had sat on the board of the Theatre of Action; John Howard Lawson, who'd helped the radical collective with *The Young Go First;* director Edward Dmytryk and producer Adrian Scott, who'd crossed his path at RKO where they too were under contract; Howard Koch, writer of the ballot-box documentary *Tuesday in November.*

Liberals in Hollywood rose to the defense of the "Hollywood Nineteen," forming the Committee for the First Amendment, comprised of top-tier directors like John Huston and William Wyler, and stars such as Gene Kelly, Danny Kaye, Humphrey Bogart, and Lauren Bacall. Members of the Committee for the First Amendment announced that they would accompany the Hollywood Nineteen to the hearings in Washington and speak out against harassment of the industry. Yet Ray's name was absent from the committee's signed public advertisements.

Then, in October, amid sensationalistic press coverage and anti-Communist grandstanding from firm-jawed, conservative-minded stars like Gary Cooper and Robert Taylor, ten of the nineteen were summoned to the witness stand—and stoutly refused to answer hostile questions about their political beliefs. An eleventh, playwright Bertolt Brecht, stymied the committee with his sly, bland responses; after dismissal, Brecht promptly grabbed a taxi to the airport and fled America. The remain-

ing "Hollywood Ten" were cited for contempt of Congress and sentenced to jail terms. They vowed to fight their case all the way to the Supreme Court.

Liberal support for the Ten evaporated almost overnight in Hollywood. The Committee for the First Amendment, divided by the witnesses' sometimes belligerent defiance of HUAC—and taken aback by the unsympathetic press coverage—returned to Hollywood and disbanded.

Dore Schary, an avowed anti-Communist liberal, was one of the witnesses who offered "friendly" testimony to HUAC in Washington. Even after the debacle of the Ten, Schary insisted that studio employees had a right to their political beliefs and "in the absence of company policy he would not refuse to hire Communists," according to a statement he gave to the *New York Times*. But Schary was countermanded one month later by company president Peter Rathvon and chairman of the board Floyd Odlum; and RKO became the first major studio to announce it would no longer hire any known Communist.

A wider blow was struck in early December, when more than fifty film producers and executives held a closed-door meeting at the Waldorf-Astoria Hotel in New York. After two days, they emerged to announce the firing of the Ten and an industry-wide policy that barred the future employment of any known Communists—"an action unprecedented in American industrial fields," as the *New York Times* noted. The moguls who joined in the decision included Columbia's Harry Cohn, MGM's Louis B. Mayer, Jack L. Warner, independent producer Samuel Goldwyn—and RKO's Dore Schary, to the dismay of Hollywood liberals and leftists alike.

Pressed by reporters to explain his actions, Schary said that his opposition to firing Communists had been "my own personal view," but that he would "abide by the decision" reached at the Waldorf-Astoria. Edward Dmytryk and Adrian Scott, the two members of the Hollywood Ten under RKO contract, were the first to be let go—the first to be "blacklisted."

A short time later, in February 1948, a California governmental group, the Senate Fact-Finding Committee on Un-American Activities, took up the gauntlet with a state-based investigation into "Communist front organizations" in the motion picture industry. Many actors once affiliated with the Federal Theatre Project or the Theatre of Action—friends of Ray's— were called to respond to charges against them, including Will Lee, who'd had a small part in Ray's still-unreleased adaptation of *Thieves Like Us*.

Lee was among those who refused to answer whether or not he was ever a Communist, and his screen offers swiftly dried up.[*]

Over the Christmas holiday in 1947, Ray took a brief mountain vacation with Gene Kelly and Stanley Donen (who directed Kelly's MGM musicals), hearing firsthand about the alarming events in D.C. from Kelly, the least repentant of the Committee for the First Amendment delegation. (Kelly's wife, actress Betsy Blair, was close to the Communist Party.) All three knew and admired Schary and hoped he would moderate the impact of HUAC on Hollywood.

For a brief time, Ray attended large meetings designed to map out a legal strategy and raise money to support the jobless Hollywood Ten. When the number of supporters dwindled, though, Ray too stayed away.

In truth, he had long since distanced himself from America's Communist Party. To most people who met Ray for the first time in Hollywood—not New York—he seemed tight-lipped or apolitical about his beliefs. Mickey Knox, a left-winger from New York who played a featured role in *Knock on Any Door,* thought Ray didn't have a political bone in his body. Screenwriter Millard Kaufman, who befriended Ray at parties, said, "I had no awareness of his politics."

Writer Arthur Laurents, who knew Ray during the making of *They Live by Night* (Laurents was Farley Granger's lover and part of the crowd that gathered at the Kellys' and Chaplins'), saw him as a faux-leftist. "I never quite believed Nick had any real convictions," Laurents said, "perhaps because I didn't believe he knew who he was politically, sexually, or otherwise. Or perhaps because, if he wasn't drunk, he always sounded vague, as drunks do."

But in fact Ray had been a Communist for years before, and his left-wing activity in New York was hardly a secret. His name was on HUAC's lists. He couldn't help but feel a stab of foreboding.

<p style="text-align:center">✳</p>

Late in the fall the studio hosted invitation-only screenings of "Your Red Wagon." After John Houseman arranged with his friend Iris Barry, cura-

---

[*]  Later, after years of being blacklisted, Will Lee became well known to younger generations of television watchers as Mr. Hooper on *Sesame Street.*

tor of the film department at the Museum of Modern Art, to have Ray's first picture screened in New York, the buzz was good on both coasts. "Your Red Wagon" was scheduled for an early 1947 release.

The hot new director was privileged to receive an invitation to Sam Spiegel's New Year's Eve celebration, a lavish annual house party attended by all the studio bosses and glamorous stars. Cary Grant could be spotted whispering in the ear of Hedda Hopper. Elia Kazan, in and out of Hollywood, was there, and at midnight, Ray had to pinch himself to find himself standing next to Alfred Hitchcock, discussing the fine points of filmmaking.

Three months after the last day of filming on "Your Red Wagon," however, Ray and RKO still hadn't settled on a subject for his second picture. His fistful of ideas all sounded problematic to RKO, mainly because the studio would have to allot time and money to develop scripts based on any of Ray's original stories. From the studio's point of view, Ray was proven as a director, not yet as a writer. Management preferred literary properties that had a track record with the public.

Shortly after the Waldorf-Astoria conference, Dore Schary called Ray in and asked him to take on an unlikely assignment, a woman's picture based on a 1946 Vicki Baum novel called *Mortgage on Life.* Schary waxed enthusiastic over the Viennese-born Baum, whose *Grand Hotel,* her most famous book, had spawned a memorable movie in 1932 and several spin-offs.* *Mortgage on Life* wasn't Baum's finest creation, Schary conceded; nor did it aspire to any *Thieves Like Us*–type reality. But Ray could show his versatility and loyalty to the studio by taking the job.

Herman Mankiewicz, who had shared the long car ride to the West Coast with Ray and John Houseman in 1946, was already immersed in writing the script. Not only would his involvement guarantee a quality screenplay, Schary said, but for the first time "Mank," as everyone called him, was also in line to produce the film.† Mankiewicz was a master of flashbacks, and *Mortgage on Life* was a novel full of backstory. The drama started with the confessed shooting of a sexy torch singer by her rivalrous

---

* There was even an anti-Nazi version of *Grand Hotel* called *Hotel Berlin* in 1945, incidentally with a script by Alvah Bessie, one of the Hollywood Ten.

† Technically, Mankiewicz had been credited once before, as producer of a W. C. Fields film back in 1932, but he was one of several nominal co-producers then, when perhaps the credit should have been "co-refereeing."

manageress, a talented songstress whose rise in show business has been thwarted by her plain-Jane looks. Scenes from the past reveal the manageress and torch singer locked in a triangle with a debonair piano man.

One big reason the film had to go ahead, Schary explained, was that the project would satisfy a host of commitments from some of Hollywood's leading talent. The dapper, intelligent Melvyn Douglas already had agreed to play the piano man. At the height of his reputation, with a pay scale two or three notches above Farley Granger's, Douglas had romanced Greta Garbo, Joan Crawford, and Merle Oberon in major box-office hits. The decisive factor, however, was that Douglas owed a picture to RKO from an earlier contract.

Casting Maureen O'Hara as the female lead had required Schary's best diplomacy. When she was first asked to play the songstress turned manageress, the fiery, red-haired Irish actress read over the book and announced that it "stank." Besides, her casting was illogical. One of the screen's reigning beauties playing the "plain little frum" who claims to have shot the torch singer? O'Hara declined.

Schary politely reminded O'Hara that she too owed RKO a picture from a previous pact. Although Schary admitted that the Baum film would likely turn out "less than mediocre," O'Hara recalled, he "didn't waver in his commitment to making it. Studio executives had a bit of discretionary leeway to make pictures they wanted from time to time, because they practiced block booking, which meant that RKO would sell its pictures to theater owners in packages."

When Schary asked O'Hara what it would take to gain her goodwill, she suggested signing her husband Will Price to a director-producer contract: done. (Sure enough, the aptly named *Strange Bargain,* Price's first picture, was produced by RKO in 1949.) Then, Schary told Ray, O'Hara requested him as her director, after watching a screening of "Your Red Wagon."

The studio chief saved the best for last. The third lead, the role of the sexy torch singer, was earmarked for Gloria Grahame. One of the industry's hottest newcomers, the blond actress was coming off a Best Supporting Actor Oscar nomination for her role in *Crossfire*. In her meetings with Schary, O'Hara had gotten the distinct impression that the studio boss had a crush on Grahame, who was known to sleep around. O'Hara wondered if Schary was having an affair with Grahame. Ray might have wondered the same, but quite a few things were left unspoken.

If Ray wanted to thrive in Hollywood, he would have to shed his purism as well as his leftism. He had to adapt to a new kind of politics: studio politics. The director couldn't always count on surrounding himself with like-minded collaborators or having producers as compatible as John Houseman. The studios took charge of major production decisions—the story, stars, and budget—and, as Maureen O'Hara rightly noted, often those decisions were made purely for business reasons. Schary made Ray feel like directing the Baum film would amount to a huge favor to him and RKO.

Ray was a nice guy; he liked doing favors. He was already a high roller with a contract and lifestyle to protect. And hadn't he shown a willingness to try almost anything in his career stops? Ray said yes, telling Schary he would try to make the Baum film as interesting as possible.

❄

*Mortgage on Life* wasn't such a great book; it wasn't even a good title for a book. Bad titles followed Ray around like those little dark clouds drifting over his head. The studio borrowed a working title, "The Long Denial," from the *Collier's* serialization, though it wasn't much better.

Since O'Hara was nobody's idea of a "plain little frum," Mankiewicz had to concoct an explanation for why such a ravishingly beautiful singer would have failed to achieve the same success as the torch singer she mentors. Mankiewicz gave the manageress a mysterious throat infection that voided her singing career, turning her vulnerable and jealous. The novel may have been silly, but the throat infection was pure Hollywood. Ray and Mankiewicz talked through the script; the director managed to insert a few ideas of his own: the *Name That Tune* radio show that figures early in the film, and the newly Mexicanized name of the torch singer (Estrellita). But Mankiewicz was a grizzled—some would say cynical—Hollywood expert with limited regard for Ray's storytelling instincts, and Ray was forced to defer to the great "Mank" (as everyone called him), who was after all the producer as well as screenwriter of "The Long Denial."

Mank was at the end of a long, hard-drinking, curmudgeonly life. This was his penultimate script; only one more would bear his name before his death in 1953. Not his finest hour as a writer, "The Long Denial" also called for producing skills with which he wasn't equipped. The patience, mediating ability, and ingenuity of John Houseman, who had again fled to New York, were not part of his makeup.

Ray and Houseman had collaborated on the adventurous casting of "Your Red Wagon," but Douglas, O'Hara, and Grahame were already set in stone for "The Long Denial." Mank let Ray fill in the ensemble: The director tapped Jay C. Flippen again, this time as a wisecracking detective, and gave small parts to Curt Conway, Guy Beach, and ex-revuer Alvin Hammer.

Ray also called back cinematographer George E. Diskant, whose main mission on the new picture was to prettify the leading ladies and make the New York, Paris, and North African sets as convincing as possible. Ray did manage to get RKO to agree to six days of read-throughs and rehearsal time before filming. This was precious time in an otherwise rushed schedule, but it allowed Ray to get to know the actors and agitate their essences. It also marked the moment when the first long looks passed between him and Gloria Grahame.

By mid-February, the principal photography was under way. O'Hara and Douglas would enjoy the most screen time, and their performances cannot be faulted. Even Douglas, lamenting his weak role and the poor script, appreciated Ray as "imaginative, with what material he had."

As filming progressed, however, Douglas wasn't alone in thinking that the director had begun to dote overmuch on his third lead, Gloria Grahame, who was playing the wide-eyed shopgirl from small-town Azuza, California (a running joke in the film: "Everything from A to Z, USA!"), who metamorphoses into the torch singer Estrellita, a bewitching monster. Frankenstein never looked so good.

At twenty-four, the youngest of the three stars and the least seasoned, Grahame gave herself over to Ray's velvet-gloves style of whispered directing. She surrendered to his fussiness over her look, even when he decided to stuff cotton under her lips to exaggerate her poutiness. The director turned Grahame loose for her musical numbers and then tried to balance her shortcomings as a singer with old radio tricks. Ray called in professional dubber Kaye Lorraine to sing her several songs, forcing Grahame to lip-sync the words. The glamorous blond actress "didn't have much of a range, four or five notes, give or take a note," recalled costar Douglas, who resented being upstaged and thought that Ray was proving himself "a neurotic man" in his increasing preoccupation with the actress.

Douglas may have been the last to realize why Grahame held such a special power over the director: They were sleeping together. Soon after

filming began, Ray started to leave the set after work holding hands with the young actress, then showed up with her at late-night parties, where he crawled all over her. As Grahame's rumored lover, Schary was definitely out of the running by late March, when all of America learned that "Gloria Grahame and Nicholas Ray," as Hedda Hopper announced in her syndicated column, "have found each other and don't deny it."

Grahame had been alluring in earlier film appearances, but Ray would make her glow as never before in his new film—and their romance made good publicity for "The Long Denial."

<p style="text-align:center">✳</p>

A native of Los Angeles who had learned her sexy pout from her mother, an actress and acting teacher, Grahame had been performing since high school but in motion pictures for only three years. When MGM couldn't figure out how to exploit her talents, the studio sold her contract to RKO, which promoted her sultrier side. After causing a sensation in a small part in *It's a Wonderful Life,* she'd gone on to earn an Oscar nomination as the B-girl who hides killer Robert Ryan in her apartment in *Crossfire,* a socially conscious picture that both RKO and Ray considered exemplary, even if it was produced by Adrian Scott and directed by Edward Dmytryk—both presently blacklisted. Grahame was "a whirlwind headed for stardom," as columnist Dorothy Manners put it.

Many of the men who stood in Grahame's path were mowed down by that whirlwind. At the time of "The Long Denial," Grahame was still legally married to her first husband, Stanley Clements, an actor who had been one of the East Side Kids—low-budget Monogram Studio's answer to the Dead End Kids. Their divorce was pending, because California's interlocutory decree mandated a waiting period, intended to encourage a reconciliation, before the official breakup.

Grahame was a natural for spitfire roles—in part because they were close enough to the real Grahame. Her sulking sexuality and her lit-fuse personality were no charade: She was a schoolgirl with sorceress eyes, as Cecil B. DeMille once described her. As prolific as he was casual about love affairs, Ray fell hard for Grahame, as was his wont. Much later, though, he admitted that he hadn't given much thought to marrying her—until she became "chubby" with child, as Bowie fondly puts it in Ray's first film (still

unreleased). Grahame decided to have the baby, and that was a problem for RKO, which like all Hollywood studios had morals clauses in its contracts—and a paranoia about public reaction to adulterous behavior.

Already public, the Ray-Grahame romance had to fast-forward after the filming of "The Long Denial." On April 19, 1948, the actress flew to Las Vegas to establish the six-week residency required for a Nevada divorce. Taking breaks from postproduction, Ray made several trips to the gambling capital, which had become one of his favorite places to relax. But six weeks is a long time, and this time it wasn't relaxing. The director spent days on end at the craps tables, drinking, rolling the dice, and losing thousands of dollars. Several times he wired his agency and RKO for emergency advances and more money to lose. He was being pressured into a shotgun marriage, he was piling up debt, and he was obviously feeling the strain.

At one thirty P.M. on June 1, the very day her legal residency concluded, Grahame was granted her divorce. At seven thirty P.M. that same day, Ray and Grahame were scheduled to wed in a small chapel on the grounds of El Rancho Vegas Hotel. When the appointed hour arrived, however, Ray could not be found. His best man, Jay C. Flippen, had to track him down at the craps tables and drag Ray to the hotel barber to clean up a little. The director went into his second marriage the same way he suffered a bad script: silently, his resentment masked with a smile.

Wire service photographers were waiting outside the chapel to capture the image of Ray, "radiant, with his white handkerchief and polka-dot tie; less ravishing, though, than Gloria, in her generously low-cut Mexican dress." The smiling, kissing photograph that splashed across America's newspapers suggested a dewy-eyed wedding, like the one celebrated by Bowie and Keechie in "Your Red Wagon." But it wasn't long before Ray started to behave like one of the angry men in certain films he directed, the ones who shout at ladies and slap them around.

"Gloria said that after the ceremony he went back to the tables," wrote Vincent Curcio in *Suicide Blonde: The Life of Gloria Grahame,* "and left her with one of his close friends, who was especially mean to her. Not a very romantic, or even kind, way to treat his bride."

RKO did its best to disguise the truth, and Hollywood reporters who suspected the reality colluded in keeping the secret. This episode cemented Ray's already developing relationships with Hedda Hopper, Louella Par-

sons, and other Hollywood columnists who traded in "scoops"—like the concurrent announcement that the director had agreed to a multipicture loan-out to Humphrey Bogart's exciting new production company at Columbia. Although it would eventually have quite a downside, for the moment Ray's marriage to the ravishing, pregnant Grahame was contrived by publicity to boost both his name and his manly image.

"Our dull little picture is to be sneak previewed next week," the director wrote Houseman in midsummer about the Mankiewicz-produced "The Long Denial," "so who cares."

\*

All of a sudden, studio boss Dore Schary, out of the running with Gloria Grahame, checked himself out of RKO entirely. Back on May 11, while Ray and Grahame were still biding their time in Las Vegas, Floyd Odlum, chairman of the RKO board, announced the transfer of a 24 percent, controlling bloc of company stock to the aviation pioneer and independent film magnate Howard Hughes. The takeover bid by Hughes, an eccentric outsider, sent another shock wave through the studio, which was already reeling from the HUAC depredations.

Studio employees, from top producers to lowliest sweepers, awaited Hughes's arrival with dread. The new owner made one imperious tour of the RKO premises ("Paint the place!" Hughes is said to have famously declared); then, living up to his oddball reputation, he elected to keep his main offices at Goldwyn Studios about a mile away. Not until late June did Hughes strike his first blow, scuttling four major Schary-approved projects on the eve of filming. Schary resigned in the first week of July to join MGM as its new head of production.

Some, including Ray, thought wistfully of the departing RKO boss as a decent progressive who'd been coerced into the Waldorf-Astoria statement. Schary's hiring by MGM was probably "the one courageous note" Hollywood had trumpeted in months, as Ray wrote in a summer letter to John Houseman. Although he wondered if Ray could survive in the MGM "den of horrors," he felt certain Schary was "aware of the booby traps."

In time, the liberal Schary would further disappoint, but meanwhile the future of RKO belonged to the notoriously quixotic, high-handed Hughes.

As soon as Schary was gone, Hughes overhauled the studio's management, ushered in a new executive team, and began to review all the long-term contracts. He slowed down all production and the release of finished pictures.

Ray's personal, short-term future was safe—he had free and clear permission to work with Bogart on one or more films independent of RKO. But Hughes's arrival jeopardized "Your Red Wagon" just when Ray's first picture was finally due for release. It didn't help that the film was saddled with a title no one liked or could even remember. In early 1948, Schary had tried giving Ray's directing debut a new name: "The Twisted Road." That June—the same month Ray married Grahame, Hughes assumed control of RKO, and Schary left to join MGM—"The Twisted Road" was screened in New York and Los Angeles for the trade press.

*Motion Picture Daily* found Ray's debut unusual, strong, and compelling, "directed with distinction." The *Hollywood Reporter* likewise thought "The Twisted Road" gripping and eloquent, with Ray achieving "an impressive job of direction that is characterized throughout by intelligent understatement and a markedly successful attempt to keep the characterizations credible." *Variety* hailed the picture as honest and moving.

Yet most of the positive reviews commented adversely on the film's downbeat subject matter—which, according to the trade press, augured a "limited" box-office. After watching "The Twisted Road" himself, Howard Hughes agreed: downbeat and limited. Soon thereafter, Ray's first film was put on the studio shelf and indefinitely embargoed. While in time this would add to Ray's mystique, in June 1948 it merely added to his load of troubles.

❋

"The current atmosphere of fear in this town [Hollywood] is much worse," Ray wrote John Houseman as his mood blackened over the summer of 1948, "and all seem to be picking at themselves, as if they had been covered by soot from a passing freight train."

The firing of the Hollywood Ten caused the specter of a wider blacklist to hang over the film industry. Some former or current Communists fled Hollywood for New York and the seeming safety of theater or television. Many chose to stick things out, doubtful that the worst would happen. Most campaigned for Henry Wallace, convinced that a President

Wallace would put an end to the spreading anti-Communist hysteria. Everyone kept their heads down, picking at the soot.

Ray had made small strides in divorcing himself from the idealistic artist and committed Communist he once had been. During the making of his first film, before the advent of the HUAC hearings, Ray had boasted of his "realistic" approach to the material. But these days in Hollywood the term "realism" was a watchword for radicalism, especially among anti-Communist zealots. Now, in interviews, the director made a point of describing his second picture—prosaically retitled *A Woman's Secret*—as "candy-box" entertainment.

Indeed it was. *A Woman's Secret* proved that Ray was willing to go along to get along. So did his next choice of leading man: Humphrey Bogart.

When the HUAC hearings were first called, Bogart had bristled at the conservative political attack on Hollywood. Two of his biggest successes, *Casablanca* and *Action in the North Atlantic,* had been penned by Howard Koch and John Howard Lawson, two of the Hollywood Nineteen. And Bogart had led the Committee for the First Amendment to Washington, D.C., defending the accused Communists.

But after the HUAC hearings, which liberals considered a fiasco, Bogart returned to Hollywood with his fellow First Amendment defenders, and inside the industry the tough-guy star came under intense pressure to clear his skirts of any pro-Communist taint. Bogart did so faster than most, sending a December 1947 letter to right-wing newspaper columnist Sidney Sokolsky in which he admitted that his support of the Nineteen was "ill-advised, even foolish." It was one of a series of humiliating apologies that Bogart made publicly and privately in Hollywood, culminating in his infamous "I was a dope and a dupe" article for *Photoplay* in March 1948.*

The tough-guy hero had turned weak-guy, it appeared; to many people on the Hollywood left, Bogart became a pariah. "No character, nothing. A shit," declared fellow left-liberal actor Paul Henreid, another star of *Casablanca,* himself destined to be graylisted.

Then in late 1947, shortly after the Waldorf-Astoria statement, Bogart broke away from his home studio, Warner Bros., and formed an

---

* Bogart's son Stephen Humphrey Bogart quoted his mother Lauren Bacall about the liberal star's political "change of heart" in his 1995 book *In Search of My Father:* "He [Bogart] felt coerced into it, and he was never proud of it."

independent company named after his sailboat, Santana. Columbia, another Gower Gulch studio, set out the welcome mat for Santana Productions. Though Bogart retained many liberal beliefs, he was urged by close advisers to steer clear of any left-wing associations or controversy in the future—and to clear his name with the movies made by Santana.

The first Santana production, an adaptation of a novel every bit as fraught with dangerous elements as "Thieves Like Us," would present special difficulties in that regard for its director as well as its star-producer.

✳

Predating the Hollywood Ten uproar, Willard Motley's gritty first novel, *Knock on Any Door,* had catapulted the writer from obscurity to fame early in 1947. The episodic life story of a young man, not so unlike Bowie in *Thieves Like Us,* whose criminal character has been forged by the hopelessness of Chicago slum life, the book sold more than a hundred thousand hardcover copies, with a dozen foreign rights sales. The *New York Times* hailed the author as an "extraordinary and powerful" disciple of Theodore Dreiser and James T. Farrell.

"Live fast, die young and have a good-looking corpse!" was the credo of the lead character in Motley's story, Nick Romano, a handsome West Side altar boy whom poverty transforms into a wanton cop-killer, and whose short, violent career ends in the electric chair.

Hollywood had taken quick notice of the book's success, and bidding for the screen rights rose to $125,000. The competition slowed when producers started recognizing the censorship hurdles any screen adaptation would face; they included the pervasive violence of the book's milieu—similar to the complaints about *Thieves Like Us*—and other thorny issues. For example, the Nick Romano character dabbles in bisexuality; he finds homosexuals easy marks for crime but ends up as a kept man for one, rendering him impotent and unable to consummate his relationships with women.

Moreover, while the themes of *Thieves Like Us* were implicitly radical, *Knock on Any Door* was an overtly crusading tale about the negative influences of society. It was unabashedly a New Deal novel, with First Lady Eleanor Roosevelt among its public fans. To drive home his message, the author inserted himself into the story, in the character of a writer who

befriends the former altar boy and comments on the unfolding tragedy.

Born and raised in Chicago, Motley was a rare specimen: a homosexual and a "Negro" (in the terminology of the day) who was openly sympathetic to Communism. So what if the Production Code was dead set "against" his book, as his agent told him? Motley wasn't going to lose any sleep over it. He had little appetite to sell his book to a Hollywood producer likely to gut or conventionalize a story he'd spent years nursing through research and multiple drafts.

Motley thought the only person in Hollywood who might have the courage to film the book truthfully was Mark Hellinger, a former Broadway columnist who had become a high-quality producer—first at Warner Bros., with realistic gangster pictures like *The Roaring Twenties* and *High Sierra,* both watershed vehicles for Humphrey Bogart, and more recently at Universal, where he supervised brutal crime films like *The Killers, Brute Force,* and *Naked City.*

Spurred by instructions from Motley, his agent pursued Hellinger after the other bidders dropped out. In September 1947, the agent finally landed a $50,000 deal with the producer. Closely consulting Motley, Hellinger penciled in writer Albert Maltz and director Jules Dassin, the team behind *Naked City,* to handle the film version. An ecstatic Motley believed Hellinger might even attempt to capture Romano's divided sexuality; after all, he told friends, recent films like Billy Wilder's *The Lost Weekend* had alluded to the subject, long taboo in Hollywood.

Two developments couldn't have been predicted: first, the October 1947 HUAC hearings which, in Motley's word, permanently "furloughed" Maltz, one of the Hollywood Ten. Then, just two months later, a massive coronary struck the forty-four-year-old Hellinger, ending the life of the admired producer.

Hellinger and Bogart had been close friends since their days at Warner's, and Bogart was already in place as a principal stockholder of Mark Hellinger Productions. They had been planning to make several films together before Hellinger died. Now, along with his business partner, A. Morgan Maree, Bogart took over several of the Hellinger properties, drawing his new Santana Productions roster out of the deceased man's story file. The best-known among the properties was *Knock on Any Door,* which Bogart had read and admired.

The success of Motley's book would guarantee audience interest

around the world. While some parts of Motley's story might be tricky to get past the censors—especially given Bogart's HUAC troubles—the star envisioned himself in the role of Nick Romano's lawyer, a part that didn't really exist in the novel. The original story could be reshaped to please the Production Code office, Bogart's part could be padded, and scenes that flirted with bisexuality and left-wing politics could be junked. Otherwise, Santana would never be able to obtain the necessary bank loans to finance such an incendiary film—as Bogart himself conceded to the author months later, apologetically.

✳

Bogart and Ray had met first at Hollywood nightclubs and parties, and their glancing acquaintance had evolved into a chummy friendship. Ever the tough guy, Bogart had seen and liked "The Twisted Road" (as Ray's unreleased first film was now known), and he wanted Ray to direct the first Santana production. Ray was expected to bring the same realism and pictorial expressiveness—not to mention censorship adroitness—to a screen adaptation of Motley's novel. Another old friend of Bogart's was just as important to the partnership: Robert Lord, who had taken Hellinger's place as producer and who would oversee the script.

Lord had been at MGM when the studio had first tried to option *Knock on Any Door.* But he knew Bogart from Warner Bros. and shared Chicago roots with both Ray and Motley. He'd attended the University of Chicago High School before graduating from Harvard, where he was part of George Pierce Baker's renowned Workshop 47 in playwriting. After a brief stint as a *New Yorker* writer, Lord came to Hollywood in the 1920s; he paid his dues writing Tom Mix Westerns before finding his streetwise voice at Warner Bros. Lord won an Academy Award for his story for *One Way Passage* in 1932, and he was nominated again for *Black Legion,* a 1937 drama about a secret vigilante organization starring Bogart. The tough-guy star never forgot the film—an unusual socially conscious drama that had rescued him, early in his career, from routine assignments.

After Hellinger died, Bogart went straight to Lord. Lord's track record as a producer was not as distinguished as Hellinger's, but Bogart liked and trusted him. In early 1948 the writer-producer became Santana's

vice president, and even before Ray was hired, Lord was already shaping the vulgarization of *Knock on Any Door.*

First, Lord commissioned another Warner Bros. veteran—John Monks Jr., whose best-known credit was *Brother Rat,* a 1938 movie based on his Broadway play about life at Virginia Military Institute—to extract a Bogart vehicle from the lengthy, episodic novel. One of Monks's key contributions was rolling Motley's narrative observer from the book into Bogart's lawyer character in the film, making the story less about the sad life of a young hoodlum than about the relationship between the doomed young man and a lawyer with noble intentions. After Monks finished a draft, Lord revised it into a lengthy treatment with dialogue, continuing to bolster Bogart's role.

The novel had unfolded in painstaking fashion, following the course of Romano's life chronologically as society gradually devours him. While discussing the script with a Columbia executive (and former Los Angeles judge) named Lester Roth, however, Lord conceived a new frame-and-flashback structure that would launch the film in a courtroom setting. The film could begin with an opening statement by Andrew Morton, Romano's lawyer and a lifelong friend. (In the novel Morton does not appear in the story until the courtroom climax.) Lord's decision to tell the screen story in flashback altered the way Romano is shaped by the incremental injustices he suffers in Motley's novel. It was Roth who suggested depicting Morton as the idealistic partner in a "plushy law firm" that doesn't appreciate his taking on the cause of a lowlife like Romano—another substantive change that shifted the spotlight further toward Bogart.

In March 1948, Bogart officially hired Ray as the film's director. Though Ray too had admired Motley's novel, he agreed with the necessity of Lord's changes. That same month, the producer also hired Daniel Taradash to write the final screenplay. A Harvard-trained attorney who had never practiced law, Taradash was a literate yet down-to-earth writer who was in good stead at Columbia, where he had adapted Clifford Odets's play *Golden Boy* into a successful film. (Later in his career Taradash would win an Oscar for the studio for *From Here to Eternity.*)

Ray was not only preoccupied with finishing the melodramatic *A Woman's Secret* for RKO, he was busy coping with the personal soap opera of Grahame's pregnancy and the hastily arranged marriage that followed. In the crucial weeks ahead the director would spend a great deal of his time in

Las Vegas—an unfortunate choice that also gave him plausible deniability as the script for *Knock on Any Door* evolved in his absence.

From March through June, Taradash lived in Miami Beach, where he wrote the bulk of the script; Ray met with him only once or twice on his obligatory visits to Hollywood. Even then, Taradash found the director "strange and remote." Ray said little, Taradash recalled, merely handed him some pamphlets on juvenile delinquency and reform school.

At Santana's expense, Taradash made at least one more trip to Los Angeles and another to Chicago to tour the Halstead-Maxwell neighborhood, described in the novel as the milieu of Nick Romano's boyhood ("the housing is as depressing as anything I've ever seen," wrote Taradash), and his West Madison skid row haunts ("as depraved a section as you can find"). The rest of the time he spent in Miami Beach with Robert Lord, the only person in Hollywood with whom he was in regular communication. Taradash tried with limited success to dispense with the producer's old-fashioned Warner Bros. flourishes. "I didn't like his dialogue at all," the screenwriter reflected years later. "When we discussed it in person, he said, 'Dan, I've been in the business for twenty years,' to which I replied, 'So has your dialogue.'"

The dialogue wasn't the least of it. Lord was constantly fretting that "Bogart hasn't enough to do in this picture" and urged Taradash over and over to bolster Bogart's heroic behavior. Bogart had to be "likeable," Lord insisted, and his character should take more "action" in the story. This preoccupation gave rise to the action-lawyer scenes, foreign to the book, in which Morton benevolently takes Nick Romano on a fishing trip in Wisconsin—during which Romano steals money from Morton's stuffy law partner. The Wisconsin crime, in turn, leads to Morton's payback, when he jack-rolls Romano in an alley later in the film.

Perhaps the most egregious change from the book was tying Romano's life of crime into Morton's professional misjudgments. In Motley's novel, Romano's father's untimely death plunges the family into dire poverty; for the film version, Lord insisted that Romano's father be wrongfully imprisoned and later die in jail, and that Morton himself be shown as the father's lawyer. Having failed to defend the father properly, Morton is left with a guilty conscience.

In the book, it didn't matter whether readers liked Romano. But movie audiences *had* to like the hoodlum, according to Lord, who repeatedly asked Taradash to sweeten his characterization. At one point the

frustrated Taradash drew up a list of twenty-five "points in my script cal-
culated to make Nick sympathetic and understandable," citing instances
where Romano showed a sense of humor and even his "use of Latin in the
park scene," so audiences wouldn't forget that he'd been an altar boy once.
Taradash even reminded Lord of a scene in which Romano steals to afford
a bracelet to give his girlfriend—a scene Lord himself had originally pro-
posed and Taradash had complained about as a cliché—before caving in
to write it.

The film's budget, including Bogart's salary, came in at $1.5 million,
twice that of the *Thieves Like Us* adaptation. But Santana was anxious to
pay off its bank loans as fast as possible, to avoid the surcharges that could
be levied on the loan, and Lord was in a hurry for the final script, so sec-
tions were rushed to Lord in Hollywood as soon as they passed through
Taradash's typewriter. "I am going to be awful tough about shooting any-
thing not absolutely necessary," Lord told Taradash. "Production costs are
incredible (and going up) while box-office receipts are dropping."

Under the circumstances, Taradash knew that the pages he mailed
to Hollywood would suffer a final edit from the heavy hand of Lord, the
former scenarist turned producer. When Lord invoked budget concerns to
justify chopping away at scenes that distracted from Bogart's story line—
including a brutal reform-school sequence that was crucial to Romano's
downturn in the novel—Taradash asked plaintively if Ray was still around
and approved of such drastic changes.

He was right to ask: Indeed, Ray was still in Las Vegas, even as the
reform school sequence was being decimated. Whenever in Hollywood
he checked in at Santana, but on script matters Ray tended to support
the star and his partner. "Nick Ray has returned and we are conferring
hourly," Lord reported to Taradash. "I gave him a copy of our notes and he
seems happy about them." When Taradash complained repeatedly about
Lord's revisions, the producer reminded him that "both Bogart and Ray
think I write good, strong dialogue and seem to like it."

Under the shadow of HUAC and preoccupied by his own messy per-
sonal problems, Ray had as little as possible to do with the *Knock on Any
Door* script, an increasingly watered-down adaptation of a book whose
truths were too stark for Hollywood. He would make a few spot contribu-
tions to the script but concentrated instead on his strengths of casting and
camerawork.

Far from the studio-system "victim" that later fans of his films liked

to describe, Nick Ray often showed a brilliant ability to simply play the cards he was dealt.

✳

After finishing the script in late June, Taradash mailed the final pages to Hollywood, then took off for New York to work on a Broadway play. In New York, months later, he was angered to learn he would be sharing screen credit with John Monks Jr., whose draft he had never read. "The funny part of it is that you know at one time I talked about taking my name off the film," he wrote his agent. "Even now, I don't think it's the greatest credit of all time."

As Taradash left for Broadway, Ray finally headed home from Las Vegas. In spite of the behind-the-scenes tensions surrounding his nationally publicized nuptials, he and Grahame had made peace and decided to try to make their marriage work. To all appearances, the director was a happy newlywed. Optimism was his stock in trade, personally as well as professionally.

Now Ray's old dreams of building a real home for himself in Hollywood broadened to include his new wife and expected child. Given his gambling losses and uneasy feelings about Howard Hughes taking over RKO, though, leasing a house seemed the best temporary solution. After closing up John Houseman's estate, Ray and the new Mrs. Ray moved into a grand Tudor cottage–style house on Sunset Boulevard, complete with gated driveway and English gardens.

Ray's marriage to Grahame gave him something else in common with Bogart: Both had young wives expecting their first babies. (Bogart knew about Grahame's pregnancy, and by the end of July the news that the actress was expecting had begun to crop up in Hollywood gossip columns.) Ray had always been socially versatile, and with the atmosphere of fear overshadowing his old left-wing circles, the director began shying away from big parties in favor of smaller dinner affairs with other married couples—a group that often included liberal but anti-Communist power couples such as Bogart and Bacall, writer Nunnally Johnson and his wife, and Romanian-born director Jean Negulesco and his wife.

To all appearances, Ray and Grahame were blissed-out newlyweds, holding hands and smooching in front of others. Both were working on

Gower Gulch projects: On the strength of her performance in *A Woman's Secret,* the blond actress had been offered her first starring role in an RKO Western. In late June, as Ray was conducting screen tests for *Knock on Any Door,* Willard Motley himself was on the set when he was introduced to a famous visitor. "Late in afternoon, Gloria Grahame, Nick Ray's wife, arrives," Motley wrote in his journal. "'Oh, hello Willard!' Takes my hand. She [was] very sweet [and] friendly." Motley was being treated royally by Santana. He had a night on the town with actress Sylvia Sidney and writer Richard Brooks, whom he admired for his Mark Hellinger pictures; a private screening of the film Ray persisted in calling "Your Red Wagon," though RKO was still clinging to "The Twisted Road"; and a night of cocktails and script talk chez Ray on Sunset Boulevard.

On the day of Grahame's visit, Ray was testing actresses for the pivotal role of Emma, Romano's sweetheart, whose pure love cannot save him from his self-destructive habits and who ends up committing suicide in the story. This type of character—like Keechie in *They Live by Night*—echoed other saintly women who would pass through the director's private life (with Grahame a notable exception). Just now Ray was testing Peggy Ann Garner, the young actress whom Kazan propelled to a special Oscar in *A Tree Grows in Brooklyn* ("baby-faced, bunched features," scribbled Motley in his journal). The following day the director spent a long time giving the same chance to a newcomer without credits ("Much prettier than Peggy Ann. Beautiful hair, big green eyes," noted Motley). Dozens of tests followed with other would-be Emmas, along with tests for the parts of Vito, Butch, Juan, and the other members of Romano's skid row gang.

Bogart stopped by to chat with Ray and Motley. According to studio publicity, it was Bogart himself who personally discovered the film's unknown young star while touring an infantry camp during the war. John Derek always insisted he had discovered himself—that he had devoured the novel and doggedly pursued the role, pleading with his agent to arrange a screen test. Either way, Bogart and Lord had to approve the casting, and Santana held off announcing the news until June, although Ray had tested Derek several times and Bogart signed off on him early in May.

Born and raised in Hollywood, the son of silent-era actress Dolores Johnson and writer-director Lawson Harris, Derek had played only a handful of bit parts (under the name Dare Harris) before *Knock on Any*

*Door*. Portraying Nick Romano, the twenty-two-year-old would have more scenes than Bogart, as well as numerous scenes *with* Bogart. There were private concerns about his ability: "Can that Derek boy really play the part of Nick? It's not easy," Taradash warned Lord in a May 22, 1948, letter. But the vital thing was Romano's looks. In the film, as in the book, Romano is nicknamed "Pretty Boy," and pretty-boy Derek would also have to convey a sense of inner torment. This was only Ray's third picture, and already his favorite type of leading man was emerging: a character not unlike himself, a physically dominating, attractive man harboring despair and self-destruction behind his outward beauty.

With his thick dark hair and soulful eyes, John Derek evoked a Greek god. "His looks are wasted on a man," associate producer David Mathias assured the doubtful Motley, before they arrived to watch Derek rehearsing with the Emma candidates. "Then saw him," Motley recorded in his journal. "Very handsome. Mrs. M[athias] introduced us. He shook hands and grinned. 'Action!' and he had to start scene again—saying as he walked away, 'I want to talk to you!'"

Despite his misgivings about the film, and his fish-out-of-water feeling in Hollywood, Motley was momentarily buoyed to meet Derek, whose sculpted visage was matched by a surprising modesty, born of insecurity. "Do you think I'm all right for the part of Nick [Romano]?" was the first question Derek asked, when they ducked inside his trailer for an hour.

But Motley's misgivings about the film grew when the actor started talking about his director. Derek insistently "complained about Nick Ray," according to Motley. "Asked my advice about acting Nick [the character]. Asked if his interpretation of Nick was correct in several scenes. Read one part of the script I hadn't seen . . ."

Derek told Motley that he felt he was being rushed by the filming schedule, that he wasn't yet prepared to do justice to his leading role. The actor yearned to visit Chicago, to "live on the street a while to get the feel of the place," Motley wrote in his journal. "Says he thinks Ray should go too. Asked me to suggest it. Said he was disappointed that they weren't going to shoot some scenes in Chicago."

Derek surprised him further by blurting out how "he wished Hellinger was doing it. Said he'd like to see Ø [homosexual] men in it and other scenes that this outfit feel are too realistic."

Derek echoed the voice inside Motley's head, alarmed at "the Bogart production angle—and how his pictures had to make money," in Motley's

words. The author had read the script with a sinking heart, especially dismayed at the film's new ending—one that Ray himself had brainstormed and described for him over cocktails at his house: a tableau of the lawyer (Bogart) and two of Romano's pals, Juan and Sunshine, striding down Chicago's West Madison Street, "almost like the death march itself," intercut with Romano's walk to the electric chair.

Motley liked Ray, found him a nice man. But he found this new ending a flossy betrayal of the novel. Indeed, he was appalled by the adaptation as a whole, finding it "completely altered to suit Bogart." He'd felt sick to his stomach during his VIP tour of the $75,000 three-block skid row under construction in the San Fernando Valley in lieu of actual Chicago locales. The author tried to be diplomatic, making small suggestions, but he had a hard time connecting with Ray. He found Derek more open to his feedback—indeed, a kindred spirit. Returning to Chicago after his brief stay in Hollywood, Motley privately wrote to Derek, trying to build up Derek's confidence ("You're perfect for the part and know that you will make Nick live on the screen"). He enclosed newspaper clippings from the trial of a Chicago teenage murderer named Bernard Sawicki—"upon whom I based some of the courtroom stuff in my book"—that featured photographs of the convicted young killer.*

"I don't know whether or not Nick Ray will approve of my sending them to you," Motley noted diplomatically in his letter. "I hope he does. At any rate show them to him if you wish to or if you want to substantiate any point as to how an actual killer would act or react."

Motley's advice to Derek could have sprung from Vakhtangov: It was both scene- and character-specific. "Maybe looking at the pictures," the author suggested, "will help give you some of the feelings of a boy on trial for his life. You will notice that the photographer has sometimes caught him sneering but that where he looks most sincere or honest is when he holds his hands in his lap with bowed head or stares straight ahead with his lips slightly parted."

The clippings about the Sawicki case were for Derek's eyes, but Motley also enclosed a September 6, 1947, *Look* magazine layout of scenes from

---

\* Bernard Sawicki was a reform school parolee who made a courtroom confession to killing a policeman during a Chicago crime spree in 1941. His public defender, Morton Anderson, was the model for Nick Romano's lawyer Andrew Morton in Willard Motley's novel.

his novel as imagined by one of the magazine's top photographers, asking Derek to pass it on to Ray so that he might be inspired by the photographer's beautiful visualizations. Motley also wrote Ray directly, exhorting him to make "a real movie" like the ones Mark Hellinger had produced. He implored him to depict poverty truthfully, as had been done in William Wyler's *Dead End* (another Bogart vehicle) or in old-timer John Ford's film of John Steinbeck's *The Grapes of Wrath*.

"Please come to Chicago," Motley begged Ray. Worried that he had "perhaps exaggerated West Madison Street in our discussions," the author had revisited the Chicago neighborhood several times after returning from Hollywood, he said, but was now more convinced than ever that Ray would scrap the Lord-Taradash Hollywood script and make-believe settings if he were to witness the conditions in Chicago firsthand.

"Sunday afternoon," Motley continued. "About two hundred men sitting along the curbstone in an area of three blocks with their feet hanging down in the street. Bottles, full and half empty, sitting alongside of them. In the three blocks distance of at least twenty men stretched across the sidewalk, drunk, sound asleep. One hobo, drunk, with his buddy's head in his legs . . ."

Along with the *Look* layout, Motley offered other specific ideas for camerawork. Ray might shoot scenes on location with a hidden camera, he suggested, as Billy Wilder had while filming *The Lost Weekend*. "If you come to Chicago you will make a great movie," wrote Motley. "Come with some old clothes and let's prowl these streets during the day and at night."

In Motley's voluminous archives there is no evidence of any response from Ray. Producer Robert Lord delivered the official reply from Santana, informing Motley that Chicago was "touchy" about movies displaying the ugly side of the city. The cameras would roll only in Hollywood; the reality would be faked. "Emotional reality" would have to suffice.

✳

Beyond the fact that the film's lead character was named Nick, Ray did have many affinities with Willard Motley's novel. *Knock on Any Door* was set in Chicago, a city he knew well, with a taut narrative set in motion by a father's untimely death, not so different from the one that had crucially influenced the director's life. (Nick Romano was forever after "terribly in

need of the son-father relationship which has been destroyed," as Daniel Taradash noted.) Like Ray, the story's protagonist was handsome, sexually ambiguous, and unlucky in love.

Yet Ray had mixed feelings about the vehicle. Just one year before, starting out in Hollywood with unknown actors and low expectations, he and John Houseman had succeeded in mounting a relatively faithful version of the grimly realistic novel *Thieves Like Us*. But now, with Robert Lord producing and Humphrey Bogart as his star, his hopes were lowered. Done well, this film would take his career to a new level: It was a Bogart film, after all, and an adaptation of a much-talked-about bestseller. But Ray also knew that everyone involved—including himself—had made compromises to get the job done. Some of the decisions—making the star likable, cutting costly scenes—were business as usual in Hollywood. But others were the byproduct of censorship qualms or the HUAC "atmosphere of fear"—and neither Ray nor anyone else saw a way around them.

Ray was going to begin shooting *Knock on Any Door* on August 2, he wrote Houseman, enclosing a copy of the script, "and I wish I could report my enthusiasm is at a new high pitch. I can't."

Bogart was more than a movie star: He was already an icon, his hard-boiled persona honed with increasing authority and popularity over two decades and sixty films. By 1948 the star had amassed credits as stellar as anyone's, including *The Petrified Forest, High Sierra, The Maltese Falcon, Casablanca, The Big Sleep, To Have and Have Not,* and *The Treasure of the Sierra Madre*. His career may have been at a vulnerable crossroads, but the man himself was at the height of his skill and fame.

On the set of *Knock on Any Door,* Bogart appeared relaxed, at ease. But his casual demeanor was deceptive. The star had money as well as his reputation riding on the first Santana production. And, like Ray, Bogart had a dual personality: He could be aloof or volatile, especially when drinking. On the first day of filming, word went around that Bogart was on the wagon; Ray too stopped drinking while filming. Then again, Bogart and Ray both indulged in cycles of bingeing and drying out.

Trained in the theater, Bogart always approached a script diligently. Ray conferred with him about his part, but Bogart didn't require or desire much input. His part wasn't that big a stretch for him, and Bogart was a thoroughgoing professional who'd made his first movie when his director was still in high school.

From the first day of shooting, though, Bogart listened patiently to Ray, nodding even when he disagreed with his suggestions—or was mystified by the director's fuzzy language. Bogart tried to incorporate Ray's ideas, but sometimes "afterwards," as Ray recalled, "Bogie would come to me—as the young director, and he was president of the company and the producer—and he would say, 'Look, Nick, you know, I just don't think that's the best way for me to do it,' in his offhand manner of speaking. But that wasn't necessary because I knew from his tone, and as soon as he put his arm around my shoulder, what to do."

The only scene that gave Bogart any real concern was his last one, his eloquent courtroom summation speech defending Romano—the star's shining moment, and the largest chunk of dialogue and social consciousness to survive intact from the novel.

> Yes, Nick Romano is guilty! But so are we. So is this precious thing called Society. Society is you and I and all of us. We—Society—are hard and selfish and stupid. We are scandalized by environment and call it crime. We denounce crime as if it were a magician's whim—hanging in the air—with no responsibility of our own. Until we do away with the type of neighborhood which produced this boy, ten will spring up to take his place. A hundred. A thousand.
>
> Until we wipe out our slums and rebuild them—knock on any door—and you may find Nick Romano.

Bogart was unaccustomed to marathon speeches. As the scene approached he walked around nervously with the pages in his hand. Ray wanted him to try it in one long take. "It was the only scene about which Bogart and I had an argument," the director said years later. But Ray, telling the star not to worry, convinced Bogart, and the speech was filmed as a master shot, running seven or eight minutes. Then Ray hedged his bets with cutaways and close-ups for coverage.

The director took greater pains with some of the younger players, including the actress who was finally cast as Emma: Allene Roberts, a twenty-one-year-old who had been inconspicuous in movies before *Knock on Any Door*. From Alabama, Roberts was another actress with a soft twang and a spectral beauty: a crushed flower, like Cathy O'Donnell's Keechie. Her delicate love scenes with Derek were close to the book's, and Ray

filmed them simply and naturalistically—composing them, incidentally, as though he'd flipped through Motley's beloved *Look* layout.

When Nick Romano rejects Emma's virtuous influence, she breaks down, committing suicide by shutting the windows of their small apartment, opening the oven door, and turning on the gas. This was one of the toughest scenes in the book and one that eked its way past the Production Code, with a small script adjustment revealing that Emma is pregnant; Nick Romano's return to crime sharpens her motivation for suicide. Ray filmed her tragedy exquisitely, with an extreme close-up that dissolves as she bends toward the oven door.

Ray set the mood, speaking quietly and at length to the actress about her key scene. "I knew that scene was important," remembered Roberts, "and it was important that I do it well. I really thought about it a lot, going over the lines and movements and everything I had to do. Even before getting on the set, that scene was going through my mind."

Ray spent an inordinate amount of time with another actor playing a smaller part. The novel had inveighed against racial discrimination, and it was important to the director—as well as Bogart and Lord—to keep some of that. But the Production Code office kept eliminating references to race in the script, and there wasn't much anyone could do about it. The most prominent black character was a pal of Romano's named Sunshine; Ray gave the part to Davis Roberts from the Actors Lab and rehearsed him as much as Bogart, it seemed, advising him to be wary of the "slight Southern quality" in his voice. When it came time for Roberts's courtroom appearance, he warned him: "Remember you don't like cops. Harden your attitude and your speech!"

Ray also suggested changing one line of Bogart's, having Morton call the character "Jim" rather than "Sunshine" on the witness stand, thereby "making the anti-Negro bias of the prosecuting attorney clearer," in the words of *Ebony,* the largest-circulation magazine for black America.*

More than Davis Roberts, Allene Roberts, or even Humphrey Bogart,

---

* But the writer of the *Ebony* article, comparing the Willard Motley novel to the Hollywood film, complained that the courtroom scene contained the "only mention of racial discrimination in the picture," and that Sunshine, pointedly jobless in the novel, was employed in the film version as a rack boy in a local pool hall, "establishing him in a menial role."

however, the film version of *Knock on Any Door* rode on the shoulders of John Derek, the young discovery playing Nick Romano. Accordingly, Ray paid more attention to Derek than to any other performer. Everyone thought Derek had the look of Romano ("He's the exact-looking person I had in mind," Motley exclaimed), but on camera it was sometimes the look of a marble statue.

There's no question that Derek himself was partly to blame. He was "a reluctant actor," recalled Mickey Knox, the young New York actor playing Romano's pal Vito, "quiet, unassuming." Derek and Allene Roberts practiced their romantic scenes together "a good bit," the actress recalled, and when they were rehearsing their first kiss, Derek told her, "Now when we shoot it, I'm going to *really* kiss you." That piqued her interest—but when Ray called "Action!" and Derek kissed her, she remembered thinking, "Oh my goodness, if that's his idea of a real kiss, I'm sorry." Later she recalled, "It just didn't go."

Derek was an earnest actor, but never a deep-thinking or -feeling one. He lacked the dimensionality, the inner conflict, that the part of Nick Romano called for. Moreover, the first-time star never got over his quibbles with the script, the film's fake skid row settings, or his inability to relate to the director. Try as he might, Ray just couldn't win him over.

Ray's frustration eventually got the better of him. If Derek was going to act like a statue, then maybe Ray should treat him like one. One day, when he couldn't get Derek to strike a particular pose, Ray strode over and grabbed the young star by the head. "With suppressed annoyance," Knox recalled, Ray "turned his [Derek's] head to the left and told him to keep looking in that direction during the scene." Although Ray had a growing reputation as an actor's director, that wasn't the case with every actor—not all the time. When it came to working with Derek, Mickey Knox recalled, "patience and tact were not in Nick Ray's playbook."

Some actors found Ray a profound communicator; to others he was a sphinx. Knox, fresh from the West Coast production of *Galileo,* was just breaking into the movies. But his experience working with studio contract directors had left him hungering for something more. Another left-wing theater refugee, Knox had heard of Ray's reputation, and he arrived on the set full of hope, thinking, "What a break, a real director!" Ray greeted Knox warmly, threw his arms around him, and escorted him on a wide tour of the soundstage, leading with his chin. "I waited for him to speak,

tell me the secret life of the character I was playing," Knox recalled. "But not a word was said. It was a large stage so we must have walked for a full minute. When we got back to the camera position he patted me on the back and said, 'Okay?' I nodded, not knowing what else to say. Another disappointment."

A handful of actors saw both sides of Ray's directing attitude: When he wasn't definite about something, the director could be downright inscrutable, as Farley Granger discovered a few months later.

After their fruitful collaboration on his first film, Granger met up with Ray when RKO loaned the director to producer Samuel Goldwyn to reshoot a handful of scenes for a picture called *Roseanna McCoy*. The filming went on for weeks on location in the Sierra Madre, but "beyond our initial warm hello," recalled Granger, "I couldn't get him to have a conversation with me. It was almost as if he were ashamed to be working as a clean-up director on a lost cause for Goldwyn."

<p align="center">✳</p>

The principal photography of *Knock on Any Door* was finished by the end of September. Less than two months later, on November 12, 1948—"nearly four months before he was expected," studio publicity insisted—Grahame gave birth to Ray's second son, a five-pound baby boy they named Timothy.

According to the Hollywood columnists, Grahame was "happy as a lark," an eager young mother who said she intended to quit acting for at least a year to devote herself to parenthood. Ray's sister Alice, who was living in California and attended the Las Vegas wedding, said that Ray was equally happy. "I had never seen such tenderness in a father," she recalled.

By late November, Ray found himself dandling another unplanned baby on his knee—this one a film project, designed by Howard Hughes to test Ray's politics and loyalty to the studio.

Hughes was warming to his new role as studio chief and making dramatic moves that would affect the entire film industry. Earlier in November, Hughes had decided to submit to the federal government's demand that the studios divest themselves of the theaters they owned—a move that broke the united front of the major studios and launched the dissolution of RKO's theater chain. And now, in another bid to accommodate

himself to the federal government, Hughes announced the industry's first high-profile anti-Communist film project.

Studio publicity described the story, set against the backdrop of a San Francisco waterfront strike,* as the first production to be ordered personally by the owner of the studio, "a special Howard Hughes project." The film, tentatively titled "I Married a Communist," would be overseen by RKO's new head of production, Sid Rogell, a B-unit supervisor with two decades' experience. John Houseman considered Rogell "a competent hack without imagination or courage," but the executive had Hughes's friendship and trust; Rogell and his brother, director Albert Rogell, were both fervent anti-Communists who belonged to Cecil B. DeMille's circle, which proactively targeted suspected Reds or sympathizers in the screen trade.

Federal Bureau of Investigation files make it clear that Hughes intended to use his "special project" to clean house of Reds and fellow travelers at RKO. Indeed, "I Married a Communist," which attracted extensive press coverage, was seen inside the industry as a bellwether for how far the studios would go to cooperate with the growing anti-Communist climate in America.

Hughes's initial target was progressive-minded director John Cromwell—a man whose own films were rarely political but whose wife, actress Ruth Nelson, was on the lists as a onetime pillar of the Group Theatre. In early November, Rogell assigned Cromwell to direct "I Married a Communist." When Cromwell refused, RKO tried to force him out of his contract, but Cromwell was no Communist, and his agents and lawyers dug in their heels. Hughes was stymied.

Next the eccentric studio boss went after Joseph Losey, whose first feature, the unusual antiprejudice fable *The Boy with Green Hair,* was just heading into national release. Losey said that he and Ray, nowadays his colleague at RKO, were acutely aware of the rising tide of anti-Communism and "used to walk in empty lots in order to stay out of offices, not to be seen together and not to be in cars so that we wouldn't incriminate each other." Losey also declined the "special project" and soon after left the studio.

---

\*    The waterfront setting was a clear reference to Australian-born longshoreman Harry Bridges, who led fierce strikes in the Bay Area. Bridges was often accused—though it was never proved conclusively—of being a Communist.

Finally, on Hughes's orders, Rogell offered "I Married a Communist" to Nick Ray.

As Losey remembered, Ray "asked my advice" about taking the job. He and Ray "walked and walked and walked," trying to talk the problem over in privacy. "And then we got into his car and he dropped me at my house. And just a very short time after, he rang me on the phone and said, 'I've had a call from Hughes, who knows I've been talking to you, so for God's sake don't say anything about it.' Even the precautions we took weren't good enough."

Agonizing over the decision, Ray holed up in Indio, in the Southern California desert, where he had gone for Christmas with his wife and baby. Until this time, he had never even met the notoriously aloof, uncommunicative Hughes. On New Year's Eve 1948, however, Ray sent Hughes a telegram: "Believe it will be important we talk before I begin my first assignment for you. Time, place, or manner at your convenience. Am at the La Quinta Hotel for the next few days. Happy New Year."

Ray drove up from the desert for his showdown with Hughes. And then, just a few days later, in the first week of January 1949, the studio made an astonishing announcement: Nicholas Ray had agreed to direct the anti-Communist hot potato. Gloria Grahame was being considered for the film's leading lady, and rehearsals were due to start within days.

His New York friends couldn't believe their ears. "I got calls from my friends on the left: 'Nick, what are you doing? Are you out of your mind?'" he later recalled. "I'd say 'Shut up!' and hang up the phone."

Whether Ray intended to make the film in any way, shape, or form is still debatable. "I thought we might make a comedy out of it," the director boasted later in life. Only a few days after the first announcment, newspapers had begun to report that Ray was balking at the prospective script. The director entered into urgent discussions with Rogell and, again privately, Hughes. What happened between Ray and Hughes is as elliptical as his last encounter with Frank Lloyd Wright. In this case, however, there is no question that Ray and Hughes struck another kind of "strange bargain."

Just one week after announcing that Ray would guide "I Married a Communist" to fruition, the studio backtracked, saying the director had excused himself "for dramatic rather than ideological reasons," according to the January 14, 1949, *New York Times*. When the paper tried to

reach Ray for further explanation, it was told that he was "not available for comment."

His old left-wing friends were left scratching their heads. Ray had apparently declined to direct Howard Hughes's special anti-Communist project—and RKO had accepted his refusal without repercussions, even after two previous directors, John Cromwell and Joseph Losey, had been sent to the studio doghouse for rejecting the same assignment. Ray's agents, Berg and Allenberg, made a show of asking for his release from the studio, but RKO again acted in baffling fashion, announcing that it would prefer to retain his services. The studio then actually renewed Ray's contract, giving him job security with extended terms.

※

Trying to keep the interest rates down on its bank loans, Santana rushed *Knock on Any Door* into release. Although it was the third film he had directed, in late February 1949 the screen adaptation of Willard Motley's bestseller premiered ahead of "The Twisted Road" and *A Woman's Secret,* becoming the first Nicholas Ray picture to reach the American moviegoing public.

In early March the studio held a special premiere in Chicago, the story's setting. Ray had always been fond of Chicago, but he skipped the event, as he was busy with his remedial gig on *Roseanna McCoy,* the first of many cleanup jobs he'd handle for Howard Hughes and RKO in years to come. The studio paid him his regular staff salary on such assignments but made a profit on loaning him out. The red carpets in Chicago were rolled out for Humphrey Bogart, his wife, Lauren Bacall, and a small retinue of publicists. Author Motley set his private reservations aside to greet the stars at the train station.

Bumming a cigarette from the novelist, Bogart immediately tried to dispel the tension between them. "First thing he said, 'I hope you aren't sore at us for what we did to your book!'" recalled Motley. Bogart ruefully admitted that he'd been "crazy" about the novel. "I loved the book too," Bacall agreed. Then the tough-guy star nervously pulled out pamphlets for "a Boy's Town in Italy for which he [was] trying to get donations," charming Motley. "A regular fellow," the author wrote in his journal. The stars and their entourage repaired to the Ambassador East, where columnists,

reviewers, and publicists fraternized, Bogart fielded questions from the press, and the scotch and bourbon flowed. (Bogart "boozed up" quite a bit, Motley noted. The author pleaded for beer—"these people never heard of beer"—and drank several to steel his nerves.)

Motley hadn't yet seen the film, but the publicity staff talked him into piloting a bus down to skid row, filling it up with his own friends and some conspicuous down-and-outers; they were all shuttled to the fancy premiere, followed by Italian cuisine at Riccardo's. When some of the drunks who'd been loaded onto the bus slept through the screening, Motley wryly observed that they probably had the right idea.

In his journal and letters, the author proved an astute critic of the screen adaptation, itemizing its cop-outs and failures:

- Motley found the casting "typical Hollywood with corny touches" and Emma's characterization especially "insipid."
- He recoiled at "the little slap-slap-kiss scene between Nick and Nellie" (another female character, played by Cara Williams), the kind of quick violence women suffered from frustrated men in more than one Ray film, dismissing it as "real burlesque."
- At the sight of Mrs. Romano in a wheelchair, an obvious bid for audience sympathy, Motley "almost puked."

By the time of Bogart's summation in the courtroom, Motley had shrunk down in his seat, despairing over the director's star-oriented staging and grandiose flourishes. "Bogart's body first and then just his head filling two-thirds of the screen when he made his final speech was uncomfortable to me, at least, as a spectator," the author wrote in his journal. "And, my, my, how theatrical they got at the end."

Deciding that he should see the film again before forming a final opinion, Motley sneaked into a Chicago theater and watched *Knock on Any Door* with the general public, studying his beloved creation more closely, with more detachment. This time he was "more conscious than ever of Nick Ray forcing—I suppose forcing, after seeing him work there two days—Derek to overact scenes," he wrote.

When it came to publicity, Motley was all smiles. Privately, however, he was tearing his hair out. "It isn't my kid! It's a bastard!" he wrote his agent, admitting that he'd wept over the botched product. "By the way,"

he added bitterly, "can you tell me what book the movie was taken from anyway?"

The reviews were mixed: some quite good, some bad, some half and half, like the verdict in *Newsweek,* which found the picture intelligent and sincere but full of "situational clichés and preaching." Critics familiar with the novel were more likely to view the film as diluted. Bosley Crowther in the *New York Times* decried the "hokum from the start—a mélange of gangster-film clichés and sentimental romance." *Ebony* said that the outstanding realism of Motley's original story had been "powder-puffed" in the film version.

The reviews were worse when the candy-box *A Woman's Secret* was released soon after. In the *Chicago Daily Tribune,* Mae Tinee found the woman's picture a "silly" waste of time. In the *Washington Post,* Richard L. Coe called the Vicki Baum adaptation "a perfectly terrible movie, well near the top of the year's Worst List." The *New York Times* declined to review it. Few, at least, bothered to mention the director's name.

Meanwhile, Ray's first film—his *Citizen Kane*—still sat on the studio shelf.

# *Mr. Nice Guy*

## 1949–1951

By the beginning of 1949, Ray was stuck in two shotgun marriages, but the one with Howard Hughes may have been the happier of the two. However opportunistic it was, the friendship they developed appears to have been genuine. Both fundamentally lonely, uncommunicative men, Ray and Hughes shared occasional dinners together at the studio chief's mansion, sometimes joined by the director's favorite nephew, his oldest sister Alice's oldest son, Sumner Williams, who had acting ambitions and had played his first bit role in *Knock on Any Door*.

In 1976, in the midst of one last-ditch attempt to craft an autobiography, Ray received word that Howard Hughes had died. The news stopped his writing cold. Ray said he felt "the same block," the same "emptiness," that he had experienced when trying to write about his father. Sometimes, when interviewers asked him about Hughes, Ray would well up with tears, fumbling even worse than usual for the right words. To the end of his days he saw Hughes as someone whom he "admired, respected, may even have loved."

A father substitute for Ray, Hughes was also a manly exemplar. Ray was fond of recalling the older man's stories of his test-pilot heroism and the "battle scars" from his romances with glamorous actresses. The director

acknowledged the "gaping holes" in Hughes's character, excusing his flaws as making him "more real, more touchable, more in common with most of us, more decipherable," and the political divide between them, admitting that he "detested his party politics," even "felt superior to him" in such matters. But Ray didn't linger on Hughes's half-mercenary, half-inept dismantling of RKO, and he rarely commented on Hughes's blacklisting of Ray's "friends on the left."

What was behind this unlikely affinity between the right-wing RKO boss and his left-leaning director? What kind of bargain had they struck?

There's no doubt that Hughes was a fervent anti-Communist. But he was also fiercely independent, and he was paranoid about the U.S. government meddling in his business affairs. He refused to take meetings with FBI men who wanted to discuss Communists in the film industry, finding himself unable to trust the government men (or G-men, as they were known in Hollywood movies). Instead, Hughes wanted to deal with the Communist menace in his own way: RKO would produce the first anti-Communist movies in Hollywood, and Hughes would be the first to sweep his lot clean of suspected Reds.

All but one, at least. With his impeccable patriotic credentials, Hughes was uniquely positioned to shield that one lucky man, Nicholas Ray, through the Sturm und Drang of the blacklist.

Why? Did Ray convince Hughes that he was fed up with Communism? Did he vow to atone for his leftist ways?

Did the angst-ridden Hughes feel an emotional kinship with Ray? Did Ray's anguish strike him more favorably than John Cromwell's intransigence or Joseph Losey's arrogance?

Did Ray plead new marriage and fatherhood? Did he beg for privacy? Or did he simply express his admiration for Hughes so sincerely that the studio boss was moved to help him?

❋

Whatever happened between them, shortly after Ray withdrew from "I Married a Communist" Hughes ordered production head Sid Rogell to remove "all the bugs and harassment" from the director, in Ray's own words. By the early spring of 1949, after six penitential weeks on *Roseanna McCoy*, Ray found himself back in good standing at the studio. He was even given a

new "A" project: a script called *Bed of Roses,* which had more in common with *A Woman's Secret* than *They Live by Night* or *Knock on Any Door.*

In truth, *Bed of Roses* was a musty old project, a women's drama based on Anne Parrish's 1928 novel *All Kneeling,* that a parade of RKO writers had been struggling to adapt since before Dore Schary's tenure.

Parrish's book concerned a ruthless schemer who insinuates her way into high society and marries a deep-pocketed husband, whom she cuckolds for a dissolute writer. The adroit actress Joan Fontaine owned a percentage of the screen rights and had been penciled in as the schemer during Dore Schary's regime. But Fontaine cooled on the prospect when Hughes took over RKO, and the studio boss had to win her back by satisfying her salary and other demands. Quivering with fear in Alfred Hitchcock's *Suspicion* had brought Fontaine an Oscar for Best Actress, and nowadays she had her pick of directors. After watching "The Twisted Road" she chose Ray, who came highly recommended by her old boy-friend John Houseman.

*Bed of Roses,* whose lead character was a lying adulteress, was another project that had long rubbed the Production Code office the wrong way. Fortunately, Charles Schnee, who had adapted *Thieves Like Us,* was back to lend his lawyerly hand to the proceedings, and by June he and Ray had hammered out a new script. (This would be Schnee's last RKO job; he soon followed Schary to MGM, where he would serve, often uncredited, as executive producer and "fixer" for pet Schary projects while writing occasional screenplays of his own. Among the latter was *The Bad and the Beautiful,* a drama exploring the seamy side of Hollywood that domi-nated the 1953 awards season; produced by John Houseman and directed by Vincente Minnelli, the film won Schnee an Oscar for his script—and another for Gloria Grahame as Best Supporting Actress.)

After Joan Fontaine agreed to play the lead in *Bed of Roses*—Christabel, the schemer described by the script as a cross between Lucretia Borgia and Peg O' My Heart—Ray met with Hughes to decide the other leads. The studio boss preferred Robert Young for the leading man, an earthy novelist who has a long-running affair with Christabel, but Ray lobbied for Robert Ryan, the rugged, craggily handsome star of thrillers whose status at RKO was second only to Robert Mitchum's. A Chicago native, Ryan had been a boxing champion at Dartmouth and starred in Clifford Odets's *Clash by Night* on Broadway. Under RKO contract in the postwar years, Ryan had

earned his first (and only) Oscar nomination as the anti-Semitic ex-GI at the center of *Crossfire*. His reputation as an honest, authoritative actor had been enhanced by his lead for Jean Renoir in *The Woman on the Beach* and good parts in Max Ophüls's *Caught* and Joseph Losey's *The Boy with Green Hair*.

Ray convinced Hughes to approve Ryan, and together they settled on Zachary Scott as the wealthy cuckold—a playboy, philanthropist, and aviator (the last a touch that Ray and Schnee added to please Hughes)—and Mel Ferrer as the amusingly pretentious artist of paintings with titles like *Hungry Men Digging Potatoes*. It was also Ray who chose Joan Leslie, James Cagney's wholesome wife in *Yankee Doodle Dandy,* as the decorous fiancée who is backstabbed by Christabel.

After the final script was ready, Ray tried an unusual theatrical exercise with the five principals before the cameras rolled in June 1949: He called Fontaine, Ryan, Scott, Ferrer, and Leslie to a "cold reading" at RKO, with all the top-billed performers handed the shooting script for the first time. Ray told the cast members to invest their lines with as little emotion as possible and concentrate instead on *relating* to each other during the reading.

It was an interesting move, but such stage techniques didn't always work with established screen stars—at least it didn't work in this instance, with a strong-minded actress playing a character who was no wounded doe. Fontaine tried to cooperate with the exercise but she was clearly uncomfortable. At one point, as the actress got carried away by her dialogue, the director stopped her. "Now remember, I don't want any *acting* here, I want a reading of the lines," Ray told Fontaine, "and I want you to look at the person to whom you are speaking—that's all I want now." That got Ray off on a bad footing with the highest-paid person in the room.

Ray worked more comfortably with Ryan, playing another character named Nick, a hard-living scribe trapped in Christabel's web. The strapping, charismatic Ryan would play similar hard-drinking, frustrated womanizers in several Ray pictures—parts that were often, as in this case, surrogates for the director.

The actress who listened most eagerly to Ray's whispered direction was the youngest and lowest-paid in the cast. Twenty-five-year-old Joan Leslie saw her role as an adventurous break from typecasting, and she enthusiastically soaked up his guidance. Studying the actors thoughtfully as they ran through their scenes, Ray's eyes lingered on Leslie. He

took "special pains" with her character, the actress recalled. For one key scene, in which Leslie was called upon to rebuke Christabel (Fontaine) for her cruelty and treachery, the actress thought she might play the scene brimming with tears. But Ray took her aside to warn her against that approach. "Remember," he told her, "you're the only one that gets to tell off Christabel—everybody else plays along with her until the very end when she is exposed, so I want you to play it *hard . . .*"

Then he banished the young actress to an empty, cavernous soundstage where she practiced her dialogue with Rodney Amateau, a New York friend of Ray's from his radio days who often worked as his assistant director. Amateau had Leslie recite her speech over and over, each time more forcefully. "I read the lines louder and then projected them and put anger into my voice and recrimination," she recalled, "and I worked on it until my throat was kind of sore." By the time Ray was ready to shoot, she was ready to play it hard.

"He was absolutely right," Leslie recalled. "I didn't need to have tears in my eyes. I'm so glad he corrected me. I had heard from other people that he was a strong director who knew what he wanted. He'd go along with you and wouldn't fuss with you at all, unless he wanted to correct something and then he'd get right in and correct you."

Leslie felt fulfilled by her interactions with Ray. But Joan Fontaine never felt she established the kind of connection she wanted with a director. "Ray made me terribly nervous," the star recalled. Fontaine was convinced that Ray "was not right for this kind of a picture," which was "a study of a society girl and her machinations. . . . [It] should have been directed by George Cukor," the actress concluded, "who could have lifted it to another plane."

Ray did his best to nudge Fontaine with velvet gloves, but her star power gave her the upper hand, and the director had to be stoic as she brushed his ideas aside. Fontaine was a diva who "prided herself in knowing exactly where her key light was," the director recalled years later, and on "being able to make a wardrobe change in thirty seconds, without causing a moment's delay for the crew. And all her talent dried up in that overawareness."

Fontaine's unhappy memories of collaborating with Ray stayed with her; she even titled her autobiography *No Bed of Roses*. Despite her resistance, though, Ray coaxed a thoughtful performance out of his star, who was excellent playing against her usual nervous-Nellie type. And the film itself—

pulpishly retitled *Born to Be Bad* at the behest of Hughes—wasn't bad either. The director managed to wrest a series of sharp moments from the undistinguished material and bright performances from his ensemble. Salvaging lesser films by coaxing strong performances from his actors in certain scenes was becoming one of Ray's gifts.

\*

Meanwhile, in the spring of 1949, Ray's first film, once known as "Your Red Wagon," now collecting dust as "The Twisted Road," was still unreleased in the United States.

For the third time, the studio tried rechristening the film. Howard Hughes loved tinkering with titles and he himself was rumored to have come up with the noirish *They Live by Night,* under which name the film was offered to exhibitors at trade shows in England. Although the British exhibitors showed little interest in the downbeat Hollywood movie, with its cast of relative nonentities, *They Live by Night* did catch the attention of a young editor and critic for *Sequence,* a film journal emanating from Oxford University.

The young aesthete, Gavin Lambert, responded to the film's remarkable, deeply felt performances, its dark, poetic mood, its meticulously scripted and staged drama, and the feverish quality of its lighting and cinematography and editing. Recognizing that *They Live by Night* was a deeply personal take on the standard Hollywood crime picture, he championed it to high-placed London critics, including Dilys Powell of the *Times,* Virginia Graham of the *Spectator,* and Richard Winnington of the *News Chronicle*.

After another screening was organized, Lambert recalled, their backstage support persuaded "art houses in London and a few other cities" to book the picture. Paired with *The Window,* another low-budget RKO thriller, *They Live by Night* was presented at London's artsy Academy Cinema. There Ray's debut film enjoyed a solid run and garnered almost unanimous praise from the high-placed critics along with reviewers for the *Express, Mail, Herald, Telegraph, Standard, News Star,* and *Dispatch*.

"Every now and again Hollywood produces a film which receives a minimum of advertisement, which is sometimes not shown in the West End at all, and which is worth a dozen of those productions which are put

on with all the flourish of which publicity is capable," wrote Dilys Powell in the *Times*. "It is the custom of the normal Hollywood film to compromise, to make concessions, to force its material into an artificial shape, but *They Live by Night* is content to present a flat and hopeless statement; it achieves its interest by its care for detail and by all that it implies in criticism of certain aspects of the American social system."

Powell did not acknowledge the film's director by name in her notice, but Virginia Graham did, praising Ray's "Gallic approach to an American social problem," adding that "if only he had taken the trouble to be a Frenchman we should be licking his boots in ecstasy." Ray's name also drew mention in *Sequence* and elsewhere. Suddenly, it seemed, good fortune was smiling upon him.

This spontaneous British acclaim for Ray's long-orphaned directing debut triggered a reappraisal of the film's prospects at RKO. Armed with the favorable London notices, studio sales executives were persuaded to give *They Live by Night* another chance with American moviegoers.

When the film was finally released in the United States in late October 1949, more than two years after it had been shot, American critics greeted *They Live by Night* almost as warmly as their British counterparts. The *Los Angeles Times* set the tone, hailing the "depressing" drama as "unquestionably an artistic success" and one of the best films of the year. In the *New York Times,* Bosley Crowther hailed the picture as sensitive and affecting, sharply and vividly staged. While the *New Yorker*'s John McCarten found the story "rather thin," he praised both the "exemplary" acting and Ray's "sure and unobtrusive" guiding hand—one of many reviews that took special notice of the director.

The British reclamation of *They Live by Night* helped to establish the permanent mystique of Nicholas Ray as a filmmaker sinned against and misunderstood by Hollywood, while the film's London art house opening solidified his growing reputation—in Hollywood as well as critical circles—as an "arty" (as opposed to "commercial") filmmaker. And Lambert's beau geste would have a "profound effect," as he put it, on both their futures.

And it all came just in time. As he plunged into preparations for his fourth Hollywood picture—his second with Humphrey Bogart—Ray's spirits needed a lift. His marriage was in a bad state. His recent films had been disappointing. This belated surge of recognition for his first effort

in Hollywood reminded him of his original vision—and his power—as a director.

<center>✳</center>

Ray's marriage to a sexy, Oscar-nominated blond actress, staged for maximum publicity in Las Vegas, raised the director's profile in the press as decisively as the plaudits for *They Live by Night*. But by the first half of 1949 the cracks in Ray's marriage to Gloria Grahame were already common knowledge in Hollywood and staple fodder for columnists. The couple's initial pose as happy newlyweds was followed by "many months of quarrels and misunderstandings," in the words of Louella Parsons, one of the many Tinseltown scribes who tracked the love story on the public record.

Not as gifted at salvaging marriages as he was at salvaging films, Ray couldn't get over the feeling he had been duped somehow. He had always been an impulsive lover; his affairs came and went as dramatically as his drinking binges. But his marriage to Grahame was sobering. "I was infatuated with her," the director mused about his second wife years later, "but I didn't *like* her very much."

He didn't trust her very much either. Even before their vows the director had harbored misgivings about Grahame, and years later he would reflect that his days-long gambling streak before the ceremony had been an instinctually "vindictive" action. "I wanted to be absolutely broke," Ray said. "I didn't want this dame, who later proved to be as shrewd as she had begun to threaten to be, to have anything of mine. I didn't want her to have any money at all."

The public handholding swiftly tapered off in their marriage; Grahame's behavior grew ever more slippery, and that in turn made Ray all the more controlling. At times his distrust verged on paranoia, and his jealousy could take on a threatening edge, just as in his films.

One of Grahame's close friends, fellow RKO actress Jane Greer, said that "Nick had his finger on Gloria," that "there was always a certain tension" between them. Another friend of the sexy blond actress, studio acting coach Lillian Burns Sidney, said that "whenever they were out together Gloria always stood behind him, with her eyes cast on the ground."

One way to avoid problems at home was to make himself scarce, as his own father had done, eluding the trials and responsibilities of family life. Throughout the first half of 1949, Ray found excuses to stay away from

the Sunset Boulevard house he shared with Grahame and his baby son, stealing time gambling at rich producers' houses or, at every available opportunity, in Las Vegas.

Whenever he wasn't actually in production on a film, Ray's drinking and gambling tended to accelerate. In Vegas he sometimes dropped "thirty or forty thousand dollars a night," according to Vincent Curcio's authoritative biography of Gloria Grahame, and during the first year or two of their marriage Ray added marijuana and pharmaceuticals to his list of habitual stimulants. "Gloria and her mother would stay up at nights meticulously opening up capsules to replace the drugs with sugar," according to Curcio.

Their marital troubles were well known to the couple's close friends, and frequently alluded to in the press. Ray made friends with Louella Parsons and Hedda Hopper and other gossip mavens, fielding their phone calls, sweet-talking them, tamping down the rumors when he could. Even so, Parsons was preparing to report a genuinely serious "tiff" between Ray and Grahame in September 1949 when instead, to her astonishment, she received a Santana Pictures publicity release announcing Grahame's postchildbirth comeback—in a film called *In a Lonely Place,* the next Bogart vehicle to be directed by Nicholas Ray.

*

Not everyone had read *Knock on Any Door* or cared whether the film was a faithful rendition of the book, and Bogart's name brought lines of his fans into the theaters. After his initial independent production, the actor had starred in two other Santana productions, both set in the aftermath of World War II: *Tokyo Joe,* an overtly anti-Communist tale situated in Japan, and *Chain Lightning,* a test-pilot drama from which the writing credit of Lester Cole, one of the blacklisted Hollywood Ten, had been removed. Politics aside, after years of servitude at Warner Bros., Bogart had hoped his independent company would produce more distinguished pictures.

Maybe, finally, *In a Lonely Place* would be the one.

The tough-guy star and his wife, Lauren Bacall, still socialized with Ray and Gloria Grahame; the couples both had babies—the Bogarts' baby son, Stephen, was born only two months after Tim Ray—and they swapped child-rearing tips and advice. Bogart didn't blame Ray for any disappointment he might have nursed over *Knock on Any Door;* the star

knew he shared responsibility for the film's shortcomings. The question was never *if* Ray would ever direct Bogart again, but when, and what the right story was for the two of them.

In late 1949, after consulting with Ray, Bogart and producer Robert Lord acquired the rights to *In a Lonely Place,* a novel by Dorothy B. Hughes, and Howard Hughes agreed to let Ray direct a film version for the Santana company. Once again, as with *Knock on Any Door,* the material was anathema to the Production Code, but Hollywood had successfully adapted two of Hughes's previous books, *The Fallen Sparrow* and *Ride the Pink Horse,* and by now Ray had proven nimble with the censors. Everyone was optimistic.

*In a Lonely Place* was a suspenseful crime story about a Los Angeles man who poses as a writer of murder mysteries. His name is Dixon (Dix) Steele, and in reality he is not a writer; he is a sociopath, a serial strangler. City police are stalking the killer, and an old army buddy, now a detective, begins to suspect Dix's guilt, even as he homes in on his next victim, Laurel, a beautiful neighbor and would-be actress.

As happened with *Knock on Any Door,* Lord, the former writer who was Bogart's partner, took the early lead on developing the screenplay and conferring with Production Code officials in the spring of 1950. It was Lord who gave the Bogart character a new career: Taking a cue from Laurel's wishful profession in the novel, he changed Dix from a purported mystery writer to a bona fide Hollywood screenwriter. (In the novel, Dix never did any actual writing.)

In April, Edmund H. North, who played tennis with Lord and badminton with Bogart, was hired to pen a lengthy treatment of the novel, following Lord's guidelines as John Monks Jr. had with *Knock on Any Door.* A hard-nosed professional who'd been around Hollywood since the early 1930s (he'd win his Oscar for *Patton* in 1970), North wrote a version that preserved Steele as a serial strangler, with Laurel as his last victim before he is arrested, while embedding the story (and Bogart's character) more firmly in the Hollywood milieu. North's treatment featured a glamorous, film-colony restaurant (inspired by Romanoff's) and several "Hollywood types," including a dissolute aging actor, and the harried talent agent who represents Dix.

Though he was still working on *Born to Be Bad,* Ray attended the early script meetings for *In a Lonely Place,* but he tended to side with star-producer Bogart—or to say as little as possible. "I found him hard to deal

with," North recalled. "It was hard to draw out of him what he was trying to say. You would ask him something and he would pause; there would be these long stage waits while he pulled his imaginary beard and thought his little dreamy thoughts. This could drive you crazy."

As a matter of routine, Lord submitted North's treatment to the Production Code. The censors predictably objected to having Bogart play a remorseless serial killer, even if the law did nab him in the end. Lord promised he'd find a satisfactory solution—though he knew Bogart relished playing a killer. His solution was to make Dix a suspect in the slaying of a hatcheck girl, who is reading the novel Dix has been hired to adapt into a film; then, in the end, another character would be revealed as the true killer of the hatcheck girl and the other serial victims—but not before Dix's violent side, aroused by the crime script he's writing and by steady police harassment, drives him to murder Laurel. The film would end with Dix's arrest.

The job of converting North's treatment into a full screenplay was handed off to Andrew Solt, who had just finished a well-crafted film noir for Otto Preminger. To ensure the picture's viability, Solt had to jettison almost everything left from the original novel, except for the unsolved serial murders and the names of the main characters. In deference to the Production Code, he toned down the violence and the sexual sparks between Dix and Laurel. To compensate, Solt expanded on the story's Hollywood atmosphere, crafting sharply drawn minor characters like a hotshot producer's boastful son-in-law and Laurel's possessive, mannish masseuse. Bogart himself asked Solt to enlarge the role of the alcoholic thespian who spouts snatches of Shakespeare, setting up the character for an old acquaintance, former Broadway star Robert Warwick, who had befriended the tough-guy star in his salad days.

Most importantly, Solt strengthened and sweetened the romance between Dix and Laurel, giving Bogart more of an opportunity to display his tender side. In the process the writer enhanced the part of Laurel, a onetime B-picture actress (according to the film script) and, until just recently, the kept woman of a real estate magnate who'd built for her a swimming pool "to increase the value of his property." Bogart had been waiting and hoping to cast Bacall as Laurel; she even read the part during a read-through at their house. But Jack Warner, who controlled Bacall's contract, still resented Bogart's decision to abandon Warner Bros., and he ultimately refused to loan her out to Santana and Columbia.

Like Edmund H. North before him, Solt found the director's thoughts

on the script difficult to decipher. During their few conferences Ray was stingy with words, favored ambiguous silences, and when he did "make suggestions," in Solt's words, they emerged "most of the time through his mouthpiece [Rodney] Amateau," who had been engaged again as Ray's assistant on the production.

After the read-through at Bogart's house, the star declared the script perfect and said they would shoot it "without changes." But the part of Laurel remained uncast. Bogart proposed Ginger Rogers, but Ray couldn't imagine the sugary actress in the role. Another obvious candidate was Ray's wife, Gloria Grahame, but she had been unmentionable whenever the subject was aired before. By the late summer of 1950, however, with just a month left before shooting was scheduled to start, a decision had to be made.

Talking it over with Bogart and Lord one day, Ray said, half-jokingly, that he might save his marriage by directing his wife. The columns were drumming up anticipation for her return to the screen after time off for motherhood. Bogart and Lord worried that the obvious fissures in their marriage might make things difficult on the set, but Ray reassured them that he'd directed his wife before without any trouble—and reminded them that the "husband-directs-wife" angle would be a publicity boon for Santana.

Bogart and Lord were game, and Howard Hughes, who tended to be cooperative whenever Ray needed a favor, agreed to loan Grahame out in exchange for compensation. Ray's wife was presented with a unique contract that included the following stipulations: "my husband shall be entitled to direct, control, advise, instruct, and even command my actions during the hours from 9 A.M. to 6 P.M., every day except Sunday, during the filming," with a clause forbidding her to "nag, cajole, tease, or in any other feminine fashion seek to distract or influence him." The "Mr. and Mrs." contract, as it was dubbed, was promptly turned into a publicity release dispatched by Santana to columnists and newspapers around the nation.

✳

Though he had hung back during the script stage, as production approached there were signs that Ray was intent on turning the film into something out of the ordinary, something personal. Besides casting his

wife, Ray gave Art Smith, a founding member of the Group Theatre, a pivotal role as the good-hearted agent Mel, who believes in Dix but is mistreated by him. Partly as a gesture toward Grahame, Ray cast a close friend of hers, the reliable B-western actress Jeff Donnell, as Brub's wife, who is wary of Dix. And he gave his old acting mentor Guy Beach his last bit in a Ray film (Beach would die in 1952). Other parts went to Frank Lovejoy, as the "good cop" named Brub, Dix's former war buddy, and to Carl Benton Reid as the "bad cop" who doesn't believe Dix's alibis. A boogie-woogie pianist and singer Ray had enjoyed around town, Hadda Brooks, was signed for a piano bar sequence.

For the look of the Patio Apartments, where Dix and Laurel live in close proximity, Ray asked Columbia art director Robert Peterson to re-create one of the director's first Hollywood homes, a residence on Harper Avenue in the Fairfax neighborhood where he'd briefly stayed in 1944. Though much of the film would be shot on Columbia soundstages, Ray planned to add location verisimilitude by providing glimpses of Bogart out and about in the city, standing on the street, driving around in his car, or standing in front of area landmarks like the Beverly Hills city hall. (He also slotted cameo appearances by local celebrities like Mike Romanoff, owner of the eponymous Beverly Hills restaurant, a popular hangout for Hollywood folk.)

Bogart was still the supreme boss of the production, and now and then he would step in to override the director. During the piano bar sequence, for instance, Ray wanted Brooks to sing her song in the same "juiced-up" (Ray's words) manner that Marie Bryant had sung "Your Red Wagon" in *They Live by Night*. Brooks resisted the notion, preferring to perform the number *her* way, and Bogart had to break the impasse. "You can't make a Shirley Temple out of a Judy Garland," Bogart snapped, "so let her alone. Let her sing like she wants to sing it."

But the big scenes belonged to Bogart and Grahame. *In a Lonely Place* was crafted as their showcase, the story of their characters' doomed romance. It wasn't hard for the director, with his empathy and admiration for Bogart, to view the tortured writer Dix as a crazy-mirror version of himself. And with Grahame playing Laurel, it would have been impossible for Ray not to see their fragile love story as a twisted commentary on his own marriage.

Where Bogart had strolled through *Knock on Any Door,* this new film

called on him to play certain scenes on the edge of madness—and others in a teasing, tickling, lovey-dovey manner, something that came less easily to the star. It was a more challenging role for Bogart, calling for sudden mood swings and odd, alarming behavior. This time, the actor would have to surrender more trust to Ray and be more responsive to his direction.

And vice versa: The director had to put more faith in his mercurial star, now playing his most mercurial character. "At certain times when I would not drink—when filming, particularly, or in the period of preparation before filming," Ray wrote of Bogart years later, "our relationship would alter. In some ways it became deeper, and in others only more formal."

For emotionally demanding scenes in his films, Ray tended to prefer multiple takes as a form of extended rehearsal. But Bogart went "dry" after six, Ray recalled. By their second film together the director had developed a strategy: stop after the sixth take and "close up for the day; there was no point in trying for more. The next morning I began with an insert as a warm-up, and to get away from anything he might have had a block about from the night before."

The character of Laurel was as changeable as Dix. A vamp with bedroom eyes at the outset, she metamorphoses (thanks to the Production Code) into a burbling girlfriend who is willing to stay up all night to type up Dix's brilliant script—one sign of how Ray preferred to idealize marriage. After witnessing Dix's Jekyll-Hyde transformations, however, Laurel begins to pop pills and becomes a nervous wreck—the director's vision of marriage gone amok.

Held in check by their "Mr. and Mrs." contract, Grahame seemed as eager and responsive as Bogart to her husband's direction. Ray encouraged both his leads to improvise bits of dialogue and stage business, and the actors soon grew so comfortable with their characters that they were giving the kinds of "involuntary" performances the director prized above all.

"After an involuntary performance the actor is kind of stunned and bewildered, he doesn't know what just happened to him," Ray told a class in 1977. "He is in shock at having caught sight of his own evasions, tricks, and clichés, or at sensing something of his own vast and untapped resources, at being forced to question why he became an actor at all. At such moments the director knows he has found something, released something which nobody in the world could have told the actor was there."

That was all on the set, in the studio. At home, of course, there was no audience—just Ray and Grahame, husband and wife, the director and his leading lady who often couldn't stand each other in private. Despite Ray's hopes, filming together didn't save their marriage; rather, it put him and Grahame into round-the-clock contact, with foreseeable results.

Sometime in early November, with production in full swing, the director abruptly moved out of his Sunset Boulevard home and started sleeping in a dressing room on the set, telling Bogart and Lord he needed the extra time and isolation to ponder the script and prepare scenes. Of course everyone understood the truth, but Ray was expert at keeping up appearances.

Around this time, the ending of the film came up on the schedule. (Ray was shooting out of continuity—typical Hollywood practice.) At the end of Andrew Solt's script, Dix turns maniacally possessive, just when Laurel has become convinced the police might be right—that Dix may be a sadistic murderer after all. As the police move in, Dix loses control and strangles Laurel.

By day, Ray insisted on take after take of the emotionally charged material. He pushed the camera close to Bogart and Grahame, heightening Dix's mania and Laurel's trapped feeling. But at night, tucked away in his on-set living quarters, the director scribbled fretful notes to himself in the margins of the script. Unlike Dix, who cheerfully admits he has killed "dozens of people . . . in pictures," Ray fought the urge to kill the fictional character his wife was playing. The idea was all the more unspeakable considering how much he loathed Grahame at the moment. "Shit! I can't do it! I just can't do it!" Ray recalled thinking.

The first time Ray filmed the scene, he shot it just the way Solt had written it. "When Dix realizes that Laurel is about to run away, he pushes her into the bedroom onto the bed," as George E. Turner described it in his definitive article on the making of *In a Lonely Place*. "The next morning Dix is hunched over the typewriter. The cleaning woman, the masseuse and a deliveryman all arrive and go past Dix into the bedroom. Somebody screams. Brub Nicolai and some policeman arrive a bit later. Dix says, 'Just a second, Brub. I'm finished.' Brub finds Laurel's corpse in the bedroom . . .''

But Ray couldn't accept this ending, even after filming it. Talking things over with Bogart and Lord, he got their permission to try to craft an alternative final sequence. Alone at night on the Columbia

soundstages, the director wrote new pages, agonizing over how the story should end.

Ray finally emerged with a new version, in which Dix is interrupted by a phone call just as he is bent over Laurel, choking her. When he hears the ring, Dix grabs the phone, listens, then hands it to Laurel, muttering abjectly, "A man wants to apologize to you." It's Brub on the line, telling Laurel that another man, the hatcheck girl's boyfriend, has confessed to her murder. Dix has been proven innocent after all—the phone call has saved Laurel, yet Dix's vindication has come too late, as Laurel has already seen what he is capable of. "Yesterday this would have meant so much to us," she responds, dazed. "Now it doesn't matter." As Dix staggers away across the courtyard, disconsolate, Laurel murmurs a tearful good-bye and one mournful, memorable phrase: "I lived a few weeks while you loved me . . ."

A line Ray himself wrote, according to many sources: part of the most memorable passage in the film, recited in its entirety by both lead characters in an earlier scene.

> *I was born when she kissed me*
> *I died when she left me*
> *I lived a few weeks while she loved me*

"I want to put it in the script," Dix informs Laurel earlier in the film, "I don't know where." But the best lines sometimes have to wait for the right moment. When Ray conjured up this new ending to *In a Lonely Place*—with this elegiac parting shot, accompanied, ultimately, by George Antheil's throbbing music in the background—he completed the film's transformation from a crime story to that of a glorious romance self-destroyed.

"Lord and Bogart looked at both versions," Turner wrote, "decided they preferred Ray's revised ending, and retained it."

\*

Throughout the filming Grahame rose to the challenges, and Bogart was never better.

Afterward, the director and his leading lady announced that they would travel together as husband and wife at Christmas, visiting Ray's mother and family members in Wisconsin. But Ray couldn't even bring

himself to move back into their Sunset Boulevard home. As Christmas neared, the *Los Angeles Herald Examiner* reran their smiling, kissing wedding photo with the caption "Smiles Have Faded," and the news spread across the wires that Grahame had filed for divorce.

"I am sorry to tell you at this joyous season that the often reported breakup of Gloria Grahame and Nick Ray's marriage has become an actuality," wrote Louella Parsons. Ray, "one of Hollywood's most imaginative directors," according to Parsons, would spend Christmas alone in La Crosse.

Not quite alone: Ray would reunite with his mother and three sisters—Helen, Ruth, and Alice, now Mrs. Ernest Hiegel of La Crosse, Mrs. Stanley Fairweather of Chicago, and Mrs. Porter Williams of Pasadena, California—for the first time since the death of his father in 1926. The *La Crosse Tribune* published a photograph of the Kienzles, together again.

Ray came back to Hollywood in time to toast the New Year—and to clean up a bit of unfinished business for Howard Hughes. While Ray was working on *In a Lonely Place,* Hughes had taken an interest in the Joan Fontaine picture Ray had finished six months before. Not only had the studio boss changed the title—from "Bed of Roses" to *Born to Be Bad*—but now Hughes ordered Ray to reshoot portions of the film, substituting a new, lighter ending.

A pair of married writers, Edith Sommer and Bob Soderberg, hastily supplied new scenes to satisfy Hughes, including a new reconciliation scene between the aviator playboy (Zachary Scott) and his onetime fiancée (Joan Leslie) on an airstrip. Hughes himself is said to have penned the aviator's confessional monologue ("I made a big mistake when I gave up flying . . ."). The film's revamped ending was sprinkled with humor, with Joan Fontaine huffily escorted from Scott's mansion.

Ray was rankled enough by Hughes's tampering that he registered a formal complaint about the changes through his agents. But the director agreed to return to supervise the revised scenes in January. Later still, RKO contract directors Robert Stevenson and Richard Fleischer shot additional retakes for Hughes, who would eventually release multiple versions of *Born to Be Bad* at the end of August 1950, manipulating the footage for different markets.

\*

Permanently vacating his Sunset Boulevard home, Ray moved to a new place in Malibu near his old friend John Houseman, who had come back to Hollywood in late 1949 to supervise Ray's next film for RKO.

Ray never stopped trying to write something worthwhile, but he had a hard time breaking through in Hollywood as a potential writer-director. Studio officials tended to greet his original story ideas with skepticism; most were sketchy, just a few written pages—or, worse from their point of view, intricate and overlong and overambitious. And Ray always seemed to be working on several ideas for scripts at once, rather than concentrating all his resources on the best bet. When he was trying to wriggle out of "I Married a Communist," for example, Ray proposed "two original story ideas"—one "a drama loaded with music and based on the wreck of the old 97,"\* the other "a warmhearted western comedy" from a story by Rod Amateau, his friend and frequent assistant director. Neither made much headway with studio executives.

But there were easier ways to get the studios interested in one of his projects—such as starting with an already published novel or produced play. And so, for his fourth picture for RKO, his sixth overall as director, Ray came up with a book he wanted to film, his own discovery.

A singular book it was: A 1946 novel by Englishman Gerald Butler, *Mad with Much Heart* was not an obvious Hollywood movie. Its story was set almost entirely in the English countryside, and its three main characters included a mentally deficient teenager who kills a young girl; his blind older sister, who hides and protects the teenager; and a hard-bitten London detective who is smitten by the blind sister while tracking the troubled teen.

In 1949, at Ray's urging, the RKO story department took a close look at the book, conceding that the novel was "powerful" but rejecting the story as "unpleasant" art house stuff, unlikely to generate "sizeable box-office

---

\*  The "old 97" was a Southern mail train that jumped a curve while traveling at a high speed and plunged into a ravine near Danville, Virginia, in 1903, killing the crew and mail clerks. The train tragedy had inspired a well-known ballad recorded by many folksingers, including Woody Guthrie.

returns." Head of production Sid Rogell seconded the story department's negative verdict while urging Ray to "keep punching" with his other ideas.

During the making of *In a Lonely Place,* Ray contacted Houseman in New York and asked him to get involved; with Houseman as his producer, RKO might be persuaded to take a chance on the film. Houseman didn't share Ray's enthusiasm for the novel. "I saw what drew him to the story," he said, "but not how he proposed to turn it into a viable movie." But the producer was itching to return to California and take up his RKO commitments, so he agreed.

When Houseman returned, though, he was chagrined by the sweeping changes at the studio since Dore Schary had given way to Howard Hughes. "RKO under Hughes's management was very different from the studio I had known," recalled Houseman. "Hughes himself was never seen, but his influence was pervasive and sinister: he manifested himself through occasional sexual forays (set up by one or another of his personal henchmen) and by influence exerted through his hirelings, who sought to protect their jobs by second-guessing the tastes and caprices of their masters. It was a distasteful and unproductive atmosphere."

Convinced that RKO might greenlight the project if a name writer was committed to the script, Houseman sent the novel to Raymond Chandler, with whom he had worked on *The Blue Dahlia,* his last Paramount production before joining RKO. The dean of hard-boiled crime fiction turned down the job, however. "It has no humor at all which makes it tough for me," Chandler wrote Houseman. "The cop is a ridiculous character. . . . The blind girl is obviously an idiot."

Houseman never showed Chandler's dispiriting letter to Ray. Now the producer turned to A. I. Bezzerides, a half-Greek, half-Armenian novelist from Fresno, who was living with scenarist Silvia Richards, whom Ray had worked with on the unproduced "Main Street, Heaventown." Although not as famous as Chandler, Bezzerides had written several critically acclaimed novels, full of tough, proletarian characters carrying "a grudge against the world," as Lewis Gannett wrote in the *New York Herald Tribune.* In Hollywood Bezzerides had become a noir specialist, most recently writing *Thieves' Highway,* an adaptation of his novel *Thieves' Market* about a vengeful truck driver, directed by Jules Dassin. After reading *Mad with Much Heart,* Bezzerides agreed to write the script.

Together, Ray and Houseman cornered their mutual friend Robert Ryan and sold the top RKO star on playing the lead character, the disillusioned detective whose abusive behavior gets him banished from the city and sent to the countryside to help solve a rural murder. Neither Bezzerides nor Ryan brought enough star power to convince Rogell, however, and Houseman was forced into a personal concession he later regretted. He agreed to produce a lesser studio project, a love story involving a female ex-con, in exchange for the go-ahead on Ray's film. ("Of the two dozen films I have produced," Houseman later wrote, the resulting film—the "silly and bad" *The Company She Keeps*—"is the only one of which I am totally ashamed.")

The deal was finalized by the end of 1950, allowing Ray and Bezzerides to launch their first script conferences early in the new year. Unlike on *They Live by Night,* where he had been integrally involved in the adaptation, this time Houseman left the script entirely to Ray and Bezzerides. The two "seemed to understand each other," the producer recalled, "though I was never quite sure how closely they agreed on the nature of the film we were about to make. They were both great talkers and both combined an almost feminine sensitivity with a strong 'macho' streak."

The first step was to Americanize the novel, which was set mainly in the English countryside. Ray wanted to draw out the city side of the story, showing how the disillusioned cop had been dehumanized by his contacts with low life in the urban jungle. The detective at the center of the novel, Jim Wilson, was a tormented policeman, living "the life of a garbage man, digging and prodding and letting the smell out from human dregs," as Gerald Butler had written. Ray wanted to go deeper in that direction, turning the detective into an angry soul who took sadistic pleasure in beating up crooks, stoolies, and B-girls.

In script conferences, as Bezzerides discovered, Ray could talk like a river or retreat into unfathomable silences, depending on his mood or the problem they were trying to solve. His talk and his silences alike were ripe for interpretation. "He'd say, 'You know, this scene ... uh ... uh ... ?'" Bezzerides recalled. "I'd say, 'I know.' And I'd go off and I'd fix it because I knew exactly what he was talking about, and he'd say, 'Yeah, yeah, that's it!' But he couldn't tell me what *it* was."

Yet Ray and Bezzerides made "slow, garrulous progress," as Houseman recalled, bolstering their work with intensive research into the daily

regimen of policemen. In the increasingly paranoid atmosphere of the time, when accusing fingers were being pointed at realistic, socially conscious films—with so much of the industry on the defensive—backing up even a fictional story with factual research and expert endorsements seemed increasingly important. The research and checking with experts dovetailed with Ray's background in the theater of the left, the Works Progress Administration, and the Voice of America. But now, in the Hollywood of the 1950s, it became almost a mania for him during the preparation stage of a film.

Bezzerides did his part, venturing out at night with Los Angeles cops, taking notes as they drove around their beat. But Ray went further, flying back east to spend time with police in Boston, where he considered setting the city portion of the film, picking up procedural details and vignettes drawn from their daily lives. (The amount of time he spent there varied wildly in his many interviews—from a few days to several weeks.) The second half of the story, the rural half, would take place a long car drive "upstate," where the banished detective joins an ongoing hunt for a teenage killer and meets the blind sister at an isolated farmhouse.

One thing that fueled Ray's enthusiasm for the novel was an intriguing, *Wizard of Oz*–type concept he had for the cinematography: shooting the city half of the film in noirish black and white, with the upstate half gradually unfolding in color. It would be as though the cop—and the audience—would learn to appreciate the beauty of the rural world through the blind woman's eyes.

While Bezzerides wrote, Ray traveled, picking up pointers and scouting locations. His East Coast trips always gave him an excuse to catch up with Broadway plays and friends and family. In New York, he saw Sidney Kingsley's *Detective Story,* another portrayal of the grim routine of a restless cop. (It too was being filmed, over at Paramount.) He also spent time with Jean Evans and his son Tony, just barely a teenager, moody, volatile, at times a hell-raiser but sweet-centered like his father. Tony was always changing private schools and costing Ray more money.

Ray still had a cozy friendship with his ex-wife—warmer, indeed, than his relationship with his current, estranged wife, Gloria Grahame. At *PM,* Evans had evolved from a family-features writer to an interviewer of celebrities like Frank Sinatra and Alfred Stieglitz, and finally to a chronicler of New York subcultures and case histories of troubled people. After *PM*

shut down, Evans had secured a Guggenheim Fellowship to write a book of psychiatric case histories. As usual, her work overlapped with Ray's interests.

As he often did, Ray picked Evans's brain about the script in progress for the new film, which for the moment still carried the novel's title, "Mad with Much Heart." They also talked about an article she had written for *PM* about Gypsy life on the streets of New York, which intrigued Ray as a possible film subject. Evans's friend Esther McCoy was still collaborating on script projects with Silvia Richards, and Ray was still interested in "Main Street, Heaventown," their juvenile delinquency story. On the way back to California, then, Ray stopped in Colorado to scout rural scenery near Denver, a closer outdoors location for the second part of the picture. The director settled on a desirable area in Grand County, Colorado, high in the Rocky Mountains.

Meanwhile, with constant input from Ray, Bezzerides had made progress on the script. The director had continued to push the material away from genre conventions, making it more a character study of the detective, and—as with *They Live by Night* or *In a Lonely Place*—more of a fragile romance. At first the two leads, the detective and the blind sister, would evince an awkward physical attraction, brushing up against each other at odd moments, at one point even stretching out their hands to clasp and console each other—anticipating James Dean's anguished reach for Natalie Wood at the edge of the cliff in *Rebel Without a Cause*. Eventually, their intense feeling for each other would overtake the crime story.

Bezzerides liked and respected Ray, but the director reminded him as much of the blind woman in their story as of the violent cop; the characters were like two sides of the same person. "Nick Ray lived in a sheltered contained world all his own," Bezzerides later reflected. "He was totally isolated."

But when Ray insisted on adding a coda to the script after the story's deadly hilltop climax—with the detective quitting the force and returning upstate to the sightless woman awaiting him in her farmhouse—Bezzerides fought it as sentimental mush. Any hint of a happy ending, he argued, would betray the spirit and letter of the novel, in which the two characters did not end up together. Houseman also found the romantic coda "soft" and embarrassing. But Ray insisted, and he finished what Bezzerides couldn't bear to write. Bezzerides alone would be credited for the screenplay, but for only the second time since *They Live by Night,* Nicholas Ray's

name also appeared on-screen as a writer—sharing an adaptation credit with Bezzerides.

✳

Too often, in Ray's career, he found himself working against the clock. It seems truer of him than some directors, perhaps because he never enjoyed the stature in his industry of directors like Alfred Hitchcock, John Ford, or Howard Hawks, who had the power to dig in their heels when they felt it necessary, to slow things down and clear a path to make the films they wanted to make. Hollywood studios were always in a hurry, and Ray's RKO contract obliged him to keep busy.

His latest production, in Ray's mind, was intertwined with his affection for twenty-two-year-old, blond-haired Sumner Williams, his sister Alice's son. An absentee parent to his own children, Ray felt fatherly toward his nephew, encouraging his acting aspirations with his first small part in *Knock on Any Door*. In Wisconsin at Christmas Ray had spent quality time with Williams, observing him intently. His nephew would serve as a lucky charm behind the scenes of other Ray pictures, but Williams would play his biggest role ever on-screen as the twisted young killer of "Mad with Much Heart."

The part of the blind protectress seemed tailor-made for Ida Lupino, an underrated actress—she jokingly referred to herself as "the poor man's Bette Davis"—who often played hard-shelled women with tender hearts. As Hollywood's only female director, Lupino was acting less frequently by the early 1950s; her scenes had to be crowded together on the schedule, many of them interiors at the studio. (Her company had offices at RKO, which distributed her films.)

A reliable, blustering presence in many John Ford films, Ward Bond was engaged to portray the shotgun-toting father whose determination to avenge his young daughter's slaying, and hostility toward the big-city detective, contributes to the tension of the hunt.

Although the studio ultimately vetoed Ray's hopes for a split personality for the photography—shooting half the picture in black-and-white and the other half in color—the director was able to arrange the valued services of his *They Live by Night* cinematographer, George E. Diskant. For the music he engaged the formidable composer Bernard Herrmann, whose name was to be forever bracketed with his magisterial score for *Cit-*

*izen Kane.* (Herrmann's "violent scherzo" for the manhunt in Ray's film, wrote Steven C. Smith in *A Heart at Fire's Center: The Life and Music of Bernard Herrmann,* would rank among "the most exhilarating pieces of film music ever written.")

The script was finalized, and Ray and company somehow managed to pitch their tents in mountainous Grand County, about four hours by air from Hollywood, by the end of March. Grand County was rugged at any time of year, but late winter guaranteed heavy winds and snowstorms and sunny glare off the snow and ice. The film's protracted chase would be all the more existential for the extreme elements.

The communities of Granby and Tabernash welcomed the Hollywood visitors with buffet suppers. Farmers and residents were rounded up to play the search party, including the rancher who is stabbed in the shoulder by the fugitive teenager when he steals a car. That part was given to Don Yager, the manager of Granby's only movie theater.

It was the first time Ray had ventured away from Hollywood for lengthy location work, and he relished the escape. Shooting in this humble section of America reminded him of his own backstory: hitchhiking to California as a youth, sojourning in Mexico after his bust-up with Frank Lloyd Wright, journeying throughout the South and Midwest on behalf of the WPA. Those were days he spent discovering the artistry of common people, the natural beauty of the land, and himself. To the end of his life Ray would wax nostalgic over this shoot in Grand County, ranking the performances of "some of the farmers of Colorado," in his words, alongside those of Bogart and Grahame in *In a Lonely Place,* Mercedes McCambridge in *Johnny Guitar,* and Sal Mineo in *Rebel Without a Cause.*

In truth, the locals performed only minor parts, nothing consequential. But for the first time since arriving at RKO, Ray was out from under the confinement and prying eyes of the studio executives. He absorbed the harsh Colorado landscape and looked for imaginative ways to use the physical staging to clarify the film's emotional undercurrents. His angles and compositions were fresh, using handheld camerawork to follow the action closely, sometimes shooting the actors as moonlit silhouettes, huffing across frozen ground.

Ray's camera would treat the furtive character of Danny—played by his nephew Sumner Williams, a striking but limited actor—with extra care and sympathy. Danny was another prototype from Ray's psyche, another Bowie or Nick Romano, young and suffering, cause indeterminate.

Like his predecessors, Danny hurts himself above all, making mistakes that prove fatal.

Ida Lupino was expected to sail through her part—and she did. Ray and the actress agreed beforehand to let her "act" the part of a blind woman rather than use special contact lenses to simulate an unseeing stare, as was often done in Hollywood. At the director's suggestion, Lupino logged time dogging the heels of a prominent Los Angeles eye physician, observing his patients. Up in Colorado, the joke on the set was, who was directing whom?

Lupino's character, the sightless sister, had tragic qualities much like those of Keechie or Emma; all three are in some sense blind to reality. The sister instinctively fathoms the cop's inner pain. "Sometimes people who are never alone are the loneliest," she tells him. Lupino delivered a spellbinding performance under Ray's direction.

The detective played by Robert Ryan, whose alienation from himself and the world spills over into abusive behavior, was a different prototype— a stunted, grown-up version of Danny. Ryan excelled at depicting such antisocial characters without surrendering his innate likability. "There was a constant dignity floating around" Ryan, Dore Schary once said, "but like an invisible armor." If Lupino was a poor-man's Bette Davis, Ryan was a poor man's Bogart, and like Bogart he always hit his marks. Ray gave the actor only a "very few suggestions," the self-reliant star recalled. "He took a lot of trouble to get a certain reality. During shooting, he talked to me [about cops] as if he were telling me a story."

Stories revolving around strong, handsome men riven by inner torments stirred Ray's deepest instincts. His films thrust these divided men into hostile environments that tested them and were made haunting by his camerawork. The director knew such male characters too well, and when the leading man was tailored to the part, the emotional effect was doubled.

Off-camera Ray and the leading man of *On Dangerous Ground* were kindred spirits. Besides chain-smoking, heavy drinking, and awkward family relationships, the two shared an eternal desire "to write something." Curiously, during breaks in the making of the taut, suspenseful "Mad with Much Heart," Ray and Ryan scribbled away on a romantic comedy "about an insurance salesman who bets his life savings he can sell a $1,000,000 policy to an heiress."

But comedy was hardly Ryan's strong suit, and Ray was less and less

the young man with a constant grin; after a few pro forma publicity items, their script came to naught.

After the Colorado filming was done, Ray staged the farmhouse interiors, and the first half of the film, at RKO and on the backlot. The director established a bewitched mood for the studio scenes with Ryan and Lupino in her ghostly illuminated farmhouse sanctuary. Night shooting and second-unit work in Los Angeles added dark texture to the city half.

❋

Toward the end of his work on "Mad with Much Heart," the director's personal love story received an injection of hope. According to the Los Angeles papers, Ray reconciled with Gloria Grahame, and the actress and their one-year-old son, Tim, moved into Ray's oceanfront residence in Malibu.

Their reconciliation coincided, ironically, with the nationwide release of *In a Lonely Place,* Ray's gut-wrenching portrait of a destructive relationship wrapped around a crime story. Many critics praised the director's noirish look inside Hollywood, with its unusual blend of suspense, character study, and broken romance. The *New York Times* hailed the film as "a superior cut of melodrama," a verdict echoed by *Variety*, which called it forceful and nail-biting, predicting "a box-office winner." Philip K. Scheuer of the *Los Angeles Times* wrote, "Nicholas Ray's direction is his most meaningful to date." Writing in *The Commonweal,* Philip T. Hartung said that *In a Lonely Place* was "exciting cinema," adding, "Mr. Ray knows how to keep you on edge. . . . The climax is terrific; and the ending, the only one that would make any sense, comes as a complete surprise."

Few realized then how closely the film's bleak, paranoid atmosphere echoed persistent elements of Ray's own domestic life. But over time *In a Lonely Place* has come to be regarded as an emblematic work in his career, described as "one of the most heartbreaking love stories ever committed to film" approaching "the torrents of Camus and Sartre" (Kim Morgan, the Huffington Post) and "the director's most personal Hollywood movie" (J. Hoberman, the *Village Voice*).

In real life, Ray and Grahame—the models for Dix and Laurel—resumed the pretense of a happy home life. In Malibu they set up their new household, hosting other film industry couples for cocktails and dinner. John Houseman, who lived nearby, privately thought their marriage was

an absurdity, yet he and his new spouse (Joan Courtney, a French countess by birth) visited often. The producer courted Grahame about appearing in one of his future projects.

Other frequent guests included director Edward Dmytryk, one of the Hollywood Ten, who was engaged in a losing battle in the courts against his contempt-of-Congress citation, and Dmytryk's young wife, actress Jean Porter. Ray was one of many who admired Dmytryk's *Crossfire* as a seminal postwar social-consciousness picture, and he would borrow three of its four stars—Robert Ryan, Robert Mitchum, and Grahame—again and again for his own films. Dmytryk complained to Ray about his predicament: He and Adrian Scott, *Crossfire*'s producer, had wanted to admit their past Communism in front of HUAC, making it clear they were no longer Party members; instead they were talked into a vow of solidarity with the other Ten. As a group they had defied the Committee, and now as a group they might go to jail.

Although Ray and Grahame put on a good show, the fault lines in their marriage were still there and still obvious to friends. Ray was Mr. Nice Guy, everyone agrees, but Grahame was Mrs. Trouble. Ray wasn't always convincing in the role of the dutiful husband, however, and Grahame didn't care for the role of loving wife. While Mrs. Trouble struggled to impress guests with her cooking, Mr. Nice Guy usually slowly drank himself into a stupor.

Screenwriter Millard Kaufman had known Ray for several years and considered him a friend. Kaufman and his wife came to dinner several times at the Rays' Malibu house. While the director was always "very pleasant, a helluva nice guy," Kaufman recalled, "he lacked the kind of spontaneity that after a while you expect of a friendship." The marriage lacked the same spontaneity. To Kaufman, the couple seemed to have "kind of an adolescent reaction" to hosting visitors: They steered husbands and wives off clumsily into separate rooms—and when Kaufman and his wife compared notes later, they found they themselves had done most of the talking. To Kaufman, it seemed like an empty marriage.

One trait Ray and Grahame definitely shared was the ability to create endless crises out of their own imaginations. Grahame was wrapped up in her own image. Though she tried to be a good mother (rocking a carriage with one hand as she read *How to Raise a Baby* "intently" with the other, according to her biographer), the blond actress, now approaching thirty, was

living in dread of weight and wrinkles and other signs of aging. Convinced that "her chin was too prominent," according to Vincent Curcio, Grahame indulged in a series of plastic surgeries, trying "to get surgeons to give her what nature hadn't." And she was a binge shopper, obsessively anxious about how she looked in clothes, constantly adopting "a new look."

Influenced by Jean Evans's advice, Ray decided that his wife had psychological problems. Although he himself was wary of analysts, Ray insisted that his wife seek healing through therapy. Along with her fear of aging and her shopping sprees, the director felt that Grahame evinced a peculiar intimacy with her girlfriends. She talked on the phone for hours with other actresses, went shopping with her girlfriends, visited them endlessly, sometimes even deciding impulsively to stay with them overnight. Whenever she disappeared for the night, Ray was suspicious.

One reason Grahame may have needed a psychologist was for her apparent addiction to sex. In bed if nowhere else, the couple was still compatible. Sexual chemistry had brought them together, and sexual chemistry reignited the marriage whenever it threatened to die. But Ray's lust for his wife defined the relationship, and the actress delighted in raising the stakes.

According to one of Grahame's friends, *In a Lonely Place* actress Jeff Donnell, quoted in Vincent Curcio's *Suicide Blonde*, "Gloria expected Nick to be like Stanley [her first husband], possessive and temperamental, and when he wasn't [she] created situations to make that happen. She did make him jealous . . . because she was a very sensuous, sexy lady, and, knowing that any man with an excitable temperament could easily react to any provocation with suspicion, deliberately set out to effect it."

Ray lusted after Grahame, but he wondered whether she truly lusted after him, or if he was merely a convenience. Many of those who knew Grahame considered her a nymphomaniac who lusted after multiple sex partners, who—like facial surgery or wardrobe changes—continually validated her youth and attractiveness. She demanded regular sexual activity, and her incessant, sometimes extreme appetites took a toll on Ray. He told one friend that Grahame forced him to escort her to private sex shows whenever they passed through New York. Once, when they got back to their hotel after one such freewheeling event, Grahame demanded sex. When Ray wearily declined, Mrs. Trouble pulled a gun out of her handbag and ordered him to fuck or die.

Alas, such anecdotes are impossible to confirm. But they might help explain why, too soon after publicly resuscitating his marriage, Ray was overcome by ennui and doubt. Many nights the handsome director could be found lingering at Lucy's Cafe across from RKO after work, ordering rounds of drinks and complaining, under his breath, about his famous wife.

✳

Obviously this was not a wonderful time for Ray, personally or professionally.

Or politically: The New Deal was over, and anti-Communism was ascendant.

Even some of Ray's oldest friends would be scarred by the Red-baiting fever that was spreading to all professions—among them his high school and college pal Clarence Sezezechowski, who had shared early theater and journalism adventures and Communist sympathies with Ray. After changing his name to Clarence Hiskey, he had moved from La Crosse to the University of Wisconsin in Madison, after which Hiskey had forged a distinguished career as a scientist. The House Committee on Un-American Activities subpoenaed Hiskey in September 1948, accusing him of being a dedicated Communist who had acted as a Soviet spy during his involvement with the Manhattan Project. Hiskey refused to answer questions and was cited for contempt of Congress in 1950; he was forced to resign his academic posts.

The progressive strain of American politics took blow after blow in the early postwar years. Third-party presidential candidate Henry Wallace was defeated in the 1948 national election. The following year, the fate of the Hollywood Ten was adversely affected by the untimely deaths of two of the U.S. Supreme Court's most liberal justices in 1949. In the spring of 1950, the new court, its number swelled by two conservative jurists appointed by President Harry Truman, declined to hear the cases of John Howard Lawson and Dalton Trumbo. They were the first of the Ten to go to jail. Edward Dmytryk, fresh from the Rays' dinner parties in Malibu, followed in the last days of June.

In February 1950, Wisconsin senator Joseph McCarthy announced that the U.S. State Department had been "infiltrated" by 205 Commu-

nists. On June 25 of that year, North Korea invaded South Korea, instigating the Korean War. In August, Julius and Ethel Rosenberg were jailed for espionage. And when, one by one, the Hollywood Ten trooped off to jail, HUAC announced a fresh wave of hearings probing Communism in the film industry, with the first new round scheduled for early 1951 in Los Angeles itself.

Government investigators had already swarmed Hollywood, collecting the names of left-leaners and Communists throughout the film industry. Anti-Communists in the screen trade were only too happy to help with the list making, and many decided to draw up unofficial lists of their own, making certain anyone too liberal or "pink" was blacklisted from future work in motion pictures.

Actors Ward Bond and John Wayne and director Cecil B. DeMille were among the leading lights of one particularly virulent organization, the Motion Picture Alliance for the Preservation of American Ideals, founded in 1944. The group's leaders had supported the initial HUAC attack on Hollywood in 1947, and now it and other ad hoc groups began to function as clearinghouses for people who wanted to get their names off the swelling lists of probable Reds.

In June 1950, DeMille led the charge at the Directors Guild: He crafted a loyalty oath that he wanted all members to sign attesting to their patriotism and anti-Communism. ("I do not believe in," the loyalty oath stated, "and I am not a member of, nor do I support any organization that believes in or teaches the overthrow of the United States government.") Officers of the guild were already obliged to sign such affidavits, but guild president Joseph L. Mankiewicz, a liberal who recognized DeMille's move as part of a larger right-wing agenda, opposed any mandatory oath-taking for the membership at large. In August, while Mankiewicz was away from Hollywood, DeMille forced a full membership vote on the issue on numbered open ballots — in order to keep tabs on how individuals voted. The "numbered ballots contributed to an atmosphere of fear in which only fourteen directors dared to check the 'no' box under the text of the proposed oath," wrote film historian Joseph McBride. "There were 547 'yes' votes," and 57 abstentions, or ballots not returned."

When Mankiewicz himself refused to sign the new anti-Communist pledge, DeMille tried to have him removed from the presidency as "anti-democratic." In October, Ray joined twenty-five directors on a petition

demanding a full membership meeting to defend Mankiewicz and reconsider the mandatory oath. It would be the last political stand Ray would make for almost twenty years. "Although he signed the petition," wrote Bernard Eisenschitz, Ray "seems not to have attended" the full Directors Guild meeting in late October. (DeMille was rebuked at the meeting, the oath-taking temporarily suspended.)*

The Hollywood blacklist was never official, because the studios had no desire to open themselves up to litigation from complainants. Unofficially, however, thanks not only to HUAC and flag-waving studios like RKO, but to individuals like DeMille and ad hoc groups like the Motion Picture Alliance, the blacklist was going full blast by the late summer of 1950. No Communist in Hollywood, current or former, could hope to fly beneath the anti-Red radar much longer.

<div align="center">❋</div>

That summer, Ray kept his head down. He stayed busy editing "Mad with Much Heart"—retitled *On Dangerous Ground* at the studio's behest—and preparing his next RKO picture: *Flying Leathernecks,* another "special project of Howard Hughes's," an unabashedly patriotic paean to flyers stationed in the Pacific during World War II.

Ray had already given a quiet nod to the bullies in charge of the Hollywood blacklist by handing a pivotal role in *On Dangerous Ground* to Ward Bond, who'd grown as notorious as Cecil B. DeMille for his rabid anti-Communism. Bond was the point man inside the Motion Picture Alliance for clearing former Communists trying to repent their past politics and preserve their film careers; Bond was said to enjoy haranguing his apologetic victims sadistically, sometimes vetting them from his office bathroom while sitting on a toilet with the door open.

Now, in *Flying Leathernecks,* Ray would be directing the figurehead president of the Motion Picture Alliance. John Wayne would get top billing as the commander who always sets personal feelings aside in order to make the hard decisions, playing opposite Robert Ryan as a popular,

---

* A short time later, the liberal, anti-Communist Mankiewicz reversed himself by calling for voluntary signing of the loyalty oath. The oath was resubmitted and approved by the Directors Guild membership on May 27, 1951.

good-hearted officer who bonds with his troops but finds himself in constant conflict with Wayne.

Kenneth Gamet wrote the original script, later polished by other writers, including James Edward Grant, a crony of Wayne's who contributed to several of his films, and Ray's friend Rodney Amateau, who made last-minute fixes on location at Camp Pendleton south of Los Angeles.

Grant and producer Edmund Grainger, who had produced some of Wayne's other war pictures, were also Motion Picture Alliance zealots, helping to hound Ray's "friends on the left" out of show business in their spare time. In case there was any doubt about the message of *Flying Leathernecks,* Grant added a jingoistic prologue and narration to the film.

The story gave Wayne a faithful wife at home (Janis Carter) and Ryan a life-of-the-party brother-in-law (Don Taylor), who would suffer a predictable fate for his callowness. The rest were also stock characters, with Jay C. Flippen—Ray's best man in his marriage to Grahame and a welcome presence in *They Live by Night* and *A Woman's Secret*—back for comic relief as the conniver who could "requisition" any luxury in a pinch.

The film had everything that the younger, more innocent Nicholas Ray had maligned about Hollywood in his earliest interviews: the enormous scale, the army of extras and second-unit crews, the director in supreme military commander mode. In most ways *Flying Leathernecks* was a typical pro-American air force film dominated by the aerial acrobatics. Years later, Ryan told a French admirer that he and the director "often asked ourselves what we were doing on a film like this." But Ray shrugged off his qualms then and later.

The once-left-wing director and the superpatriotic Wayne established a kind of détente on the set, one that even grew into a cautious friendship. "He was a much better actor than most people gave him credit for being," Ray said later, "almost daily full of nice surprises." Wayne gave the director an appropriate gift at the end of filming: an inscribed Marine Corps knife. "Wayne would close all political discussion with 'You're full of shit!' and that was the end of it," recalled Amateau. "Wayne was always a very prudent, careful man. He was kind to everybody. And he felt sorry that Nick made a lot of enemies."

In the critical months of September and October 1950, as the Motion Picture Alliance was demanding fealty from all Hollywood directors, an increasingly vulnerable Nicholas Ray was toiling away at a thankless studio exercise lionizing American war heroes. His first Technicolor film,

*Flying Leathernecks* was touted as realistic, and some critics found the aerial photography, shuffled together deftly with file footage, exciting. Yet ultimately the direction seemed as uninspired as the paint-by-numbers script. It was the antithesis of his greatest work, a personal film only in the sense that he was covering for himself.

❋

Despite Ray's best efforts to separate his personal and professional lives, the two had always intertwined—and never more torturously than now, as HUAC's second round of Hollywood hearings drew closer in March 1951. Yet even as dozens of screen figures, including several of Ray's close friends, began receiving HUAC subpoenas, the real drama was in his own home, where his marriage to Gloria Grahame was approaching a climax.

Though he later claimed to have loathed his actress wife all along, Ray's behavior suggests that his feelings for her were conflicted. Though he himself avoided going home when he could, he fixated on his wife's frequent absences and mysterious "appointments." Better than anyone, the director recognized that Grahame was addicted to sex, destined—like Christabel in *Born to Be Bad*—to cuckold him again and again. Thus his wife must have had a secret lover, but whom?

Although Grahame knew how to incite her husband by flirting with other men in front of him, they weren't necessarily the men she was sleeping with. For a long time, Ray was convinced that his wife was bedding one of the elephant trainers she'd met on the set of Cecil B. DeMille's *The Greatest Show on Earth,* in which she was playing the "elephant girl." All smiles, Ray visited the big-top production one day for a bit of joint publicity. He got so caught up in trying to identify the roustabout in love with Grahame—without success—that he completely missed a fling she was having with one of his own screenwriters. She was also busily engaged in a clandestine affair with Mickey Knox, the handsome actor from Nick Romano's gang in *Knock on Any Door*.

Friends and bystanders were drawn into the couple's web of mutual distrust. Even back during the filming of *In a Lonely Place,* according to Vincent Curcio, Ray pointedly cut back on close-ups of Frank Lovejoy, the actor playing Dix's detective friend Brub, after deciding that Lovejoy had been supporting Grahame with her alibis.

Grahame's friend Jeff Donnell told Curcio about one dinner she and

her husband had with the Rays. "Nick started to question Gloria about where she had been the night before," Curcio wrote. "Gloria said she was with Jeff; Nick said he called Jeff's house and there was no answer, and before Jeff could say a word, Gloria said they had gone to the movies, which wasn't so. Nick became furious with Jeff, badgering her with incisive questions. Did she really go to the movies with Gloria? Why didn't she answer the phone? Since she [Jeff Donnell] was the mother of two small children, when wasn't she at home with them, instead of at the movies? The argument kept escalating, and finally Jeff and her husband couldn't stand it anymore, leaving Gloria and Nick in the middle of a screaming match."

Even as the Red-baiters in Hollywood were dogging Ray's heels, the director put his own wife under surveillance. As angry and paranoid as Bogart at the end of *In a Lonely Place,* Ray hired a detective agency to follow his wife and report on her extramarital conduct. But Grahame soon realized that someone was trailing her and eluded the detectives by slipping in and out of hotels with her lovers in Los Angeles and back east. Thinking that Grahame must be trysting with her lovers in Malibu when Ray was away, the detectives even tried tucking a tape recorder under their living room sofa—but the family dog barked at the machine incessantly, obscuring any other noise in the house.

The detectives were right in a way. The tape recorder wasn't necessary, however. Shortly after Grahame finished *The Greatest Show on Earth,* the Rays' marital suspense built to a catastrophe no one could have foreseen.

The scene: the couple's Malibu home.

The surprising main character: Tony Ray, the director's thirteen-year-old son with Jean Evans. Evans was always fretting that her ex-husband did not spend enough time with his son, and Tony had started making summertime visits to Hollywood. The young teenager and his stepmother had established a warm relationship. When Tony showed up in late May or early June 1951, just after completing his first term in a new prep school, he looked all grown-up, big and strong and handsome like his father. The teenager was prone to the same feelings of arousal Ray had felt for his own father's mistress back in La Crosse. And Grahame was promiscuous.

"Gloria opened the door, and like a scene in a movie, the two of them looked at each other and something instantly passed between them," wrote Curcio. "Gloria was tall and radiant at that time, with reddish-blond

hair, never more beautiful; Tony was dark and attractive, with large liquid eyes and all the touching beauty of the first blush of youth. They did not think of before or after, of proscriptions or consequences . . .

"They made love that afternoon."

According to a detective employed by Ray, the couple's lovemaking continued stealthily for days. But Ray's suspicions were mounting, and one afternoon the director barged in without warning to discover his wife and teenage son in flagrante delicto.

"All hell broke loose," Curcio wrote. Ray stormed around, waving his arms and shouting, smashing everything he could find. Tony was thrown out of the house; he spent the night sleeping under a neighbor's porch.

Grahame later told a friend she merely "swept up the broken records and put the books back in the bookcase, and just sort of tidied up, and made the house look nice again."

A house, but never again any kind of home: Overnight Ray took rooms at the Garden of Allah on Sunset Boulevard, the venerable Hollywood hotel where Kazan had once stayed, nowadays populated by old-time screenwriters and reclusive silent-era stars. A short time later he moved into a separate four-room bungalow adjoining the Clover Club, a private, illicit casino on the Sunset Strip.

By the second week of July the Hollywood columnists, who knew the details of the scandal but kept their published accounts tasteful, reported that the director and sexy blond actress had finally split up for good. "I think we made a good try," Ray told a wire service. "In fact we tried over and over again, but it just didn't come off."

Of all the inexplicable bits of bad luck that could have happened to Ray, this was the worst. His teenage son sleeping with his wife: It was not just a blow to his pride but a stab to his heart and soul—a burden he would carry for the rest of his life and a humiliation he could never hide . . . because everyone already knew.

"In the circle emanating from Houseman's house we all knew," said Norman Lloyd, the onetime Theatre of Action player long since installed in Hollywood.

Ray plunged into a blue funk of heavy drinking. Actress Betsy Blair tried to remember when it was exactly—July 1951, she thought—one morning after a Saturday night party she'd thrown with her husband, Gene Kelly, she woke up to see director sprawled asleep outside their

window. Ray hadn't even made it to his car. He'd passed out on the lawn.

✳

As Ray's personal life was crumbling around him, HUAC investigators were pressuring him to deliver testimony about his years as a Communist, demanding the names of friends and associates who'd been Party members. Ray had been sensitive to the issues of informing as far back as *They Live by Night,* which had been made during the tumult of the first HUAC hearings. In this, his first film—and the one over which he exerted the greatest artistic control—Mattie's "informing" leads to Bowie's death. The film clearly condemns the character's treachery: after being reassured by police who tell her she's doing the right thing, Mattie remarks, "I don't think that's gonna help me sleep nights." By 1951, however, informing was the only clear way to avoid being blacklisted, and in future films involving various acts of betrayal—a surprising number of his films touch on the matter—Ray would be more sympathetic to the betrayer.

In March and April, HUAC convened the new Hollywood hearings, the first to focus on motion pictures since 1947. Widely covered in the press, the hearings riveted the film industry. Subpoenas went out to more writers than actors, and more actors than directors. The Directors Guild was "not a hotbed" of Communism, director Jules Dassin, who was ultimately blacklisted, commented years later, "not even a tepid bed." John Berry, whom John Houseman had launched as a director and who had collaborated with Ray on the documentary *Tuesday in November,* was among those subpoenaed in 1951. But Berry joined Dassin, Joseph Losey, and a burgeoning number of Ray's left-wing friends who evaded their summonses or anticipated them by leaving for New York, Europe, or Mexico.

Dassin, Berry, and Losey, directors all: They were bellwethers for Ray. But more influential, ultimately, was the appearance before HUAC of another colleague: Edward Dmytryk. On April 25, 1951, after having served six months in prison, Dmytryk recanted his "unfriendly" testimony and named himself and twenty-six other former Hollywood Communists. "The philosophical reason for his change of position," reported the *New York Times,* "was the fact that the U.S. was at war with the Communists in Korea. On the personal level, he was faced with the need to support a wife and children." One month later, Dmytryk was hired to direct a Hollywood movie.

After 1947, a handful of important screen figures were permitted to give cooperative testimony at closed-door hearings or in private meetings attended only by lawyers and Committee representatives. These sessions were not reported by the press or in any way made public. It was a strategy designed to let a secretly "friendly" witness preserve his (or her) public image, as well as the confidentiality (and arguable factual nature) of any testimony.

Ray's friend and fellow director Elia Kazan, briefly a Communist Party member in the 1930s, would become a paragon of this strategy. But in mid-1951 Kazan was still trying desperately to squirm away from the clutches of HUAC. (He was temporarily safe in Texas, directing Marlon Brando in *Viva Zapata!*, a picture he later would cite as proof of his anti-Communist values.) Although Ray wasn't as prominent in Hollywood as Kazan, they were in a mutual quandary and talked the dilemma over by phone.

Ray had a lot to lose. Not for nothing does his alter ego Dix (Bogart) in *In a Lonely Place,* complain about women whose expertise is limited to the fine points of community property. Ray was facing a second divorce, and he would have two ex-wives and children to support. The director had "a deep-seated suspicion that Gloria was after his money," wrote Vincent Curcio, and "years later, near death, he continued to allude to her avariciousness." Not to mention that Ray had a gambling habit and an expensive Hollywood lifestyle to protect.

It was no longer enough that Ray had associated himself with Bogart at the very moment when the star had publicly repudiated Hollywood Communists. It wasn't enough to be protected by his mysterious handshake agreement with Howard Hughes, or to have given up his early social-consciousness inclinations in favor of candy-box women's pictures and the emotional reality of domestic melodramas. It wasn't even enough to have worked with Ward Bond and John Wayne, or to have grit his teeth and ground out a pledge-of-allegiance film like *Flying Leathernecks.*

Ray was no different than anyone else on the Committee's endless lists. He would have to cooperate with HUAC, explain and atone for his Communism, and name names—or else.

"A posse is like an animal," comments Sterling Hayden in *Johnny Guitar,* "moves like one, and thinks like one."

"They're men with itchy fingers and a coil of rope around their saddle horns," replies Joan Crawford, "looking for somebody to hang."

"Either you side with them or us," barks a leading citizen of the town, the spokesman for the posse, played again by none other than Ward Bond.

✳

Why would Ray cooperate with HUAC? Why would he secretly aid the inquisitors and facilitate the efforts of people like Bond and Wayne, who were out to destroy his old friends? Was he moved by a heightened skepticism toward the Soviet Union? By a fresh surge of anti-Communist feeling engendered by the Korean War? Had Ray become a sincere anti-Communist, as some informers claimed in explaining their decision?

Or was Ray compelled by other, less defensible motives? Had he become the "materialistic American" he once had scorned? Was he afraid that his conflicted sexual identity might be revealed? Congressional investigators had been known to blackmail homosexual leftists, threatening to expose their private lives unless they cooperated.

What Ray told the House Committee on Un-American Activities— what names he named, what rationale he gave for doing so—remains conjecture. His Freedom of Information Act files are voluminous up to 1948 and the "I Married a Communist" incident; the file is then suspended and does not resume until 1963. No other records are known to exist. Ray protected many secrets in his life, and thus far he has protected this secret— better even than Elia Kazan, the transcript of whose 1952 executive-session HUAC testimony was withheld from film historians until 2005, two years after Kazan's death.

What is known is that Ray did meet with HUAC behind closed doors, as Bernard Eisenschitz first reported, quoting a "curious admission" the director made to his beloved ex-wife Jean Evans. "He told me that when he had to testify [before HUAC]," Evans reportedly said, "he said I was the one who brought him to the Communist Youth League, which wasn't true at all."

This is the one astonishing detail known about his testimony: that Ray "named" his first wife, lying that she had recruited him to the Party (he'd been a Young Communist back in La Crosse). "*Naming Names* [Victor Navasky's book about the moral terrain of blacklisting] spoke of how you could arrange, off the record, to go before the Committee and not have any publicity," Evans explained. "I think that is what Nick did."

Ray may have offered his secret testimony in the late winter of 1950 or in early 1951, after completing his John Wayne film. It might have been in May 1951, when Ray traveled to the East Coast to visit Grahame in Phila-

delphia on the set of *The Greatest Show on Earth*. It may have been midsummer, after the new Los Angeles hearings coughed up a slew of eminent informers—including actors Larry Parks and Sterling Hayden, as well as Dmytryk—and pressure on others intensified. It could even have been as late as the autumn of 1951, when Ray made a quiet trip east, stopping in La Crosse to lead a parade of dignitaries, Marine Corps color guard, and drum and bugle corps marchers—leading not as young George Washington this time, but as the director of the patriotic new film *Flying Leathernecks,* opening at the downtown Rivoli.

Unlike those of more famous informers, Ray's capitulation never made headlines or mention in the show business columns. Ray never had to admit or defend his testimony publicly. There is no evidence that he ever told anyone but Jean Evans. (She herself appears to have escaped any HUAC harassment.)

Only a few people, then and later, wondered how Ray had managed to elude the blacklist. *Rebel Without a Cause* screenwriter Stewart Stern said he "heard from passionate, political theatre friends over the years, that Nick seemed not to know what morality was when it came to the politics of the blacklist days and his part, or partlessness, in it." Most preferred not to know the tawdry details of this latest self-inflicted harm to a man who usually—though not this time—hurt only himself.

<p align="center">✳</p>

Nineteen fifty-one was the least productive, most ruinous year of Ray's career. Though the director could not salvage his marriage or his political ideals, he continued to earn his salary and prove his value to Howard Hughes by shooting retakes and performing repair jobs.

For a while he concentrated on mending a pair of films that were left unfinished by Josef von Sternberg, a living legend who had become a cropper at RKO. Von Sternberg, who'd guided Marlene Dietrich to iconic status in elegant pictures in the 1920s and 1930s, had been virtually inactive since the early 1940s, until Howard Hughes lured him back to work in 1950. In a comeback blaze of glory, von Sternberg mounted two RKO pictures in a year's time. But Hughes found fault with both films and was holding them back until they could be "fixed."

The first, *Jet Pilot,* was another anti-Communist aerial potboiler with John Wayne, this time costarring Janet Leigh. According to Ray, he shot

scenes for this film, as did almost every other director on the RKO lot, though *Jet Pilot* wouldn't slink into theaters until 1957.

The second, *Macao,* followed the exploits of an undercover crime fighter in the South China Sea port city of *Macao.* Von Sternberg's autocratic methods had alienated most of the cast and crew during the actual filming, and RKO's editors couldn't find a way to splice the footage together into a logical story line. "I was meeting myself coming through doors," leading man Robert Mitchum later cracked.

The reigning box-office king of RKO, Mitchum was one of three *Macao* stars—along with Jane Russell and Ray's estranged wife, Gloria Grahame. The director was gradually becoming the studio's Mitchum expert, having shot a series of fix-it scenes earlier that year for *His Kind of Woman,* another Mitchum-Russell vehicle about a deported gang boss in Mexico. Starting in late May, according to the *New York Times,* Ray launched "extensive retakes and added scenes" for von Sternberg's muddled *Macao.*

But he was no longer the Grahame expert. Ray and his wife were up to their necks in divorce lawyers; there was no hope this time for a "Mr. and Mrs." contract. "Howard Hughes had to fly Mel Ferrer in from La Jolla [a San Diego resort community] to direct" new footage with Grahame, wrote Hedda Hopper. But Mitchum and Russell were the real stars, and Grahame's part in the film continued to shrink.

Mitchum and Russell were compatible with Ray. The film's original script was useless, according to Mitchum, who claimed to have written most of the new scenes with input from Russell and the resourceful fix-it director. "My dressing room was being repainted," Mitchum claimed, "so I used Victor Mature's and wrote the day's work and gave it to the secretary to type up. We shot it in the afternoon. Did that for almost ten days. At least they could release it. Before that it was a flat impossibility.'"

That made for a good anecdote, but production records show that

---

\*   Naming names for HUAC was a betrayal of ideals, in the view of some; doing Hughes's dirty work of retakes on another director's picture was another form of betrayal, in the view of Josef von Sternberg. Ray claimed to have asked the legendary director's permission to tinker with his unreleased films, but whether he did or not, von Sternberg did not appreciate the result. "Nicholas Ray is an idiot," von Sternberg later told film historian Kevin Brownlow. "He did terrible things to *Macao,* he cut it and ruined it. His name did not appear but mine did. It was a great injustice."

producer Jerry Wald, ensconced on the RKO lot with his partner, writer Norman Krasna, worked with Ray and two young scenarists—Norman Katkov and Walter Newman—refining the scenes. It was Ray's introduction to Wald and Newman, both of whom would loom in his future.

"They said the picture needed three days' work," Mitchum also said, "but they didn't say *what* three days." It took more than three days—more than ten, actually—but Ray strengthened the byplay between the leads, tightened plot points, and added humor to the troubled film.

After *Macao,* Ray moved on to another flawed law-and-order vehicle from RKO: *The Racket.* Earlier in 1951, director John Cromwell had finished shooting this remake of a Bartlett Cormack play about gangsters and corruption, already filmed once before in the silent era. Howard Hughes still had Cromwell in his anti-Communist sights, though, and the studio boss refused to approve *The Racket* without remedial enhancements from Ray. (Later graylisted, Cromwell wouldn't direct another feature film for five years.)

If there was any high point in this year of lows, it was working with Robert Mitchum. Ray had known Mitchum socially for years and had tried to cast the beefy, sleepy-eyed star in earlier pictures, as far back as *They Live by Night;* now the two developed a close friendship based on Ray's rescues of *His Kind of Woman, Macao,* and *The Racket.* They stuck around late at night after everyone else had gone home, drinking and smoking marijuana and talking.

But on every other level, 1951 was a washout—a year in which Ray, who had completed six pictures during his first four years in Hollywood, didn't finish a single movie in its entirety.

❋

Ray's bitter divorce and the grubby HUAC business dragged him through the year.

According to Gloria Grahame's biographer Vincent Curcio, Ray was so afraid he was being set up for a high alimony that he behaved in an extremely vindictive fashion once Grahame filed for divorce.

With his longtime involvement with radio broadcasting and archival recordings, Ray had taken to tape-recording script conferences, wiring himself with a lapel mike and recording his sessions with writers and

producers to make sure he registered all the important details. Many of the tape recordings were never listened to or transcribed, however. Now, Curcio writes, Ray "forced" his son Tony "to make a recording of what had passed between him and Gloria, and was threatening to use it in court against her in their divorce trial." According to Grahame's biographer, John Houseman felt that, regardless of what had transpired between the blond actress and Tony, Ray acted neurotically and horribly toward his son. His old friend and most supportive producer was infuriated, and Houseman and Ray drifted apart. "Where his son was concerned," said another longtime Ray friend, Rodney Amateau, "Nick was a dedicated prick."

It would take a year for the director's divorce to become official—a miserable year in which Ray alternately blamed Tony, the remorseless Grahame, or himself.

On August 14, 1952, Grahame arrived in court "in a black dress as low cut as anyone could recall," the Associated Press reported. "Over it she wore an unbuttoned white sweater, which concealed none of her charms." (A revealing photograph of Grahame was transmitted with the report to hundreds of American newspapers.)

As Ray looked on miserably, the actress testified that her husband "hit me twice, once at a party without provocation, and once at our home when I locked my bedroom door"—an account suggesting that the sado-masochistic relationship between Robert Ryan and a B-girl in *On Dangerous Ground*—or the sex games hinted at between Bogart and a former girlfriend in *In a Lonely Place*—weren't entirely fictional. The director was frequently "sullen and morose" during their four-year marriage, Grahame, continued, "and would go into another room when my friends came to the house. This made me so unhappy I lost weight and it hurt my acting."

In the end, though, like his HUAC testimony, Ray's secret recording of Tony was never aired in public. A settlement was worked out in advance: Grahame asked for not a penny of alimony, only a modest $300 monthly support payment for the couple's four-year-old son, Tim. Ray could afford it: Even treading water at RKO, he was still making several times that amount every week.

# Bread and Taxes

## 1951–1954

Ray would never again work with John Houseman after *On Dangerous Ground,* nor with any producer as sympathetic to his artistic goals. He sorely wanted to produce his own films, but Howard Hughes was not ready to allow that step. For the moment, Ray needed to forge a constructive relationship with another intelligent producer, and perhaps the best candidate at RKO was a newcomer to the studio who claimed some autonomy: Jerry Wald.

Hughes had lured Wald and his partner, Norman Krasna, to the studio early in 1951, promising them financial incentives and creative control of their projects. Krasna was the invisible partner of the team, a successful screenwriter (with four Best Screenplay nominations and one Oscar win by the early 1950s) but also a playwright who often contrived to be away in New York, on Broadway jobs, or in Europe, where he took long vacations to refresh his creativity. Wald was more the Hollywood creature, a writer-turned-producer and demon of energy who thrived on studio pressures and power games. The duo's deal with Hughes included a side agreement to fix any studio pictures that required reshooting or reediting. Wald had fallen in with Ray while they were both doing repair work for Hughes early in 1951.

While he was overseeing repairs on *Macao*—and then fiddling with Ray's *On Dangerous Ground* after mixed previews made Hughes demand retakes and recutting—Wald realized that the head of the studio had a genuine affection for the director. Wald couldn't get Hughes to approve any of his numerous pending projects, and it occurred to him that folding Ray into his unit might help. Wald gave the director his choice of their backlog of properties, and Ray chose the long-gestating "Cowpoke," a script about a broken-down rodeo contestant.

"Cowpoke" was one of several projects the Wald-Krasna team had ready to go when they arrived at RKO. The story derived from a May 1946 *Life* magazine article about a colorful rodeo performer named Bob Crosby, known as the "King of the Cowboys." After reading the article, Wald had commissioned a lengthy treatment of Crosby's life from the *Life* author, Claude Stanush, a Texan who had just started in the magazine's Los Angeles bureau. Stanush, who had grown up on a ranch, was a knowledgeable fan of the rodeo world, and he completed both a treatment and a full script under Wald's supervision before the project got stalled.

Stanush moved to *Life*'s Washington, D.C., bureau, but Wald remained interested in the rodeo project, and some time later he asked Stanush to collaborate on a new draft with director Robert Parrish and David Dortort, a young New York novelist without any screen credits.* Stanush, Dortort, and Parrish met up at Madison Square Garden, where a second unit was shooting rodeo footage for Wald; afterward they repaired to Hollywood, carving out an improved script that moved away from Crosby's true story into a fictionalized drama about an aging bronco-riding champ who befriends a young ranch hand aspiring to rodeo fame. The older champion, who's nursing a crush on the rancher's wife, ultimately sacrifices his life to save his protégé from death in the arena.

Parrish soon departed for another job, however, and Wald jumped to RKO. There "Cowpoke" was stalled. Even though Hughes had pursued Wald and Krasna, he was maddeningly evasive and indecisive about their properties once they were ensconced at his studio. Wald would send Hughes urgent questions about his plans and have to wait days or even weeks for a response—unless it concerned one of the studio chief's pet projects or a sexy actress with big breasts.

---

* David Dortort would go on to create and produce the iconic Western television series *Bonanza*.

Wald had submitted a first draft of "Cowpoke" to RKO as early as January 1951, but Hughes took his time critiquing it. Even as Wald and Ray met with a succession of writers to craft a final script, Hughes's enthusiasm lagged—no matter that his favorite director was on board, excited about a story that put him back in the scratch-a-living world of loners and ramblers.

One problem was that Hughes didn't like the title, and when he didn't like a title it bothered him, coloring his view of the whole enterprise. And the studio boss didn't like to be rushed on the casting of stars, which he considered his prerogative. Ray and Wald had penciled in Robert Mitchum as the broken-down rodeo champion, but Hughes had gotten the idea that Ray and Mitchum had a conspiratorial friendship that excluded him. Throughout 1951, as he took his time weighing the script, Hughes urged Wald to look for a bigger star: Gary Cooper, John Wayne, Burt Lancaster. And he changed the title: "Cowpoke" became "Rough Company."

Wald was a driven man, accustomed to frenetic speed and productivity. His motto, according to writer David Dortort, was "Do a dozen pictures, and if one turns out to be a money-maker that'll take care of the other eleven." By the end of the summer Wald had been at the studio for four months, but all of his production unit's ideas and scripts were still in limbo. He hadn't done a dozen; he hadn't gone into production on a single Wald-Krasna picture for RKO. All his valuable time had been taken up critiquing and polishing RKO scripts and mending unfinished RKO films.

Another factor in the delay may have been Ray's brush with HUAC. If Ray was not thoroughly cleared of any Communist taint, even Hughes wouldn't be able to emblazon his name on a film, lest he incur the wrath of the anti-Commie special interest groups. Himself an anti-Communist liberal, Wald had turned his company into an informal refuge for cooperative HUAC witnesses. One Wald-Krasna employee was writer George Beck, who named names in September 1951 and shortly thereafter directed his only film for Wald-Krasna and RKO. Another was German émigré filmmaker Fritz Lang, who was desperately trying to clear himself of any left-wing stigma; Lang was no Communist, but he had many acquaintances who might qualify, including his former girlfriend and amanuensis Silvia Richards, a onetime Communist who eventually surrendered to HUAC. Lang was busy preparing a Wald-Krasna film of the play *Clash by Night* by former Group Theatre playwright Clifford Odets, who would also turn informer, shortly after Elia Kazan in 1952.

One day, late that summer, Wald got a visit from a Syracuse supermarket tycoon named Lawrence A. Johnson. A one-man crusader against Hollywood Reds, Johnson wielded his chain of stores like a dripping ax, using them to promote boycotts of theaters that dared to book pictures with cast or crew members he suspected of Communist ties. The studios were terrified of Johnson and businessmen like him, who claimed to represent a wide constituency.

Wald banished his staff and met with Johnson alone, patiently reviewing a list of people active on the Wald-Krasna projects that were awaiting Hughes's go-ahead. Around this time, the studio logjam finally broke, and Hughes grudgingly approved Mitchum as the star of "Rough Company." In early September Ray was given permission and the necessary budget to travel with a small crew to Oregon to shoot some background footage at the Pendleton Round-Up, one of the oldest and largest annual frontier celebrations in America.

Years before, during summers growing up in La Crosse, Ray had fallen in love with the rodeo; during his WPA days, he began to see the cowboy competitions as a sort of Western people's theater. The director envisioned the Pendleton Round-Up as the setting for the final rodeo scenes in the film. He was joined on the trip by cinematographer George E. Diskant and writer Horace McCoy, the latest contributor to the ongoing script progress. Ray deployed twelve cameras to capture the opening parade of the roundup, the small-town and rodeo atmosphere, and cowboy contestants. Ray also brought along stuntmen to double for Mitchum, who was busy elsewhere.

As happy as he was to be shooting the rodeo footage, the extra salary he was picking up for supervising the second unit was also a welcome boon for a director worried about divorce costs. And after the Pendleton shoot Ray took a brief vacation, visiting his mother in Wisconsin; there he could store up thoughts for the rodeo film's early, poignant homecoming scenes.

Meanwhile, back in Hollywood, Ray's Pendleton footage won Hughes over. The excited studio boss finally okayed the production and even came up with a new title that might help lasso a leading lady for the project: "This Man Is Mine."

<p style="text-align:center">✳</p>

Although Ray boasted later that they "actually had almost thirty pages" before filming started, and Robert Mitchum claimed, "Nick and I, both

stoned, worked out the script," the rodeo film had a succession of capable writers and a series of complete drafts.

By the time Ray became immersed in the project, sometime after he finally signed off on *Macao* in August, Wald had recruited Niven Busch, initially, followed by Horace McCoy, to revise the Stanush-Parrish-Dortort draft.* Although Ray participated in the conferences with McCoy, the film's final writer, their personalities never really jibed.

A former Texas newspaper man steeped in cowboy lore, McCoy had been called in to reinforce the lingo and authenticity of the script. After starting out as a sports and crime reporter, McCoy had penned pulp fiction for *Black Mask* magazine in the late 1920s; eventually he made a double life for himself as a novelist and screenwriter, publishing hard-boiled novels including *They Shoot Horses, Don't They?,* a slice of life about marathon dancers in the Depression, and *Kiss Tomorrow Goodbye,* a gangster story that had just been produced as a film with James Cagney. But his macho credits didn't prepare one for the real McCoy, a courtly, soft-spoken southerner (born in Tennessee) who preferred to write in longhand with a quill pen while standing at a lectern.

Wald himself was a caricature of a cigar-chomping Hollywood producer, with a surplus of secretaries always trailing after him to take down the ideas spewing from both sides of his mouth. Every night before falling asleep the producer made wire recordings of the fresh ideas he'd brainstormed after office hours, and every morning he brought the recordings to script meetings. Ray didn't mind Wald's recording regimen—he'd been known to tape his own late-night musings—but Wald's ideas were neverending, and the producer needed help distinguishing the good ideas from the bad and cutting off the flow.

The two had gotten along well when they were fixing other people's pictures. Wald was giving the orders then, and Ray seemed to take orders cheerfully enough. Now, however, a new, more swaggering Ray was emerging from the aftermath of his divorce and HUAC difficulties. Despite all the humiliating drama in his private life, which people knew about, Ray came to the office with his coat thrown over his shoulder, with the air of some kind of genius. In meetings Ray paused in long, pregnant silences before agreeing, disagreeing, or commenting noncommittally.

---

* Only McCoy and Dortort would be credited for the script on-screen, not Parrish, with Stanush alone credited for the story.

The normally unflappable Wald was not exactly cowed but he was confounded.

Ray seemed mainly interested in Mitchum's part: the aging, limping rodeo headliner who mentors a younger, ambitious ranch hand. Ray flaunted his chummy relationship with Mitchum, and soon Wald was feeling as excluded as Hughes from their two-man club. The script talks among Ray, Wald, and McCoy became like a weak game of billiards, with the balls caroming around the table but rarely connecting.

Ray's difficulty articulating his ideas—and his silences—were real, but sometimes they were also a stalling tactic, especially where the script was concerned. The struggle for self-expression was at the core of his personality, and his art. And wasn't it the most poignant handicap an expressive artist can have—the inability or powerlessness to express himself, to realize his art fully?

Wald had other projects to juggle, and eventually he handed matters to McCoy, who would try his best to follow his dictums. McCoy knew the terminology and milieu of the rodeo world, and he did his utmost with the script. "Typical of McCoy's best work in Hollywood," wrote Mitchum biographer Lee Server, the final screenplay "blended strong, flavorful writing with backlot clichés." By the time he had finished, however, McCoy had a feeling that a dissatisfied Ray was going to potchky the pages on the set.

✳

Trying to make up for lost time, Wald wanted to start filming by the end of 1951. By early December they'd made definite progress casting the other two principals.

The casting was a delicate three-way negotiation with Wald and Hughes. Everyone wanted Ray to be happy with the stars, but the final decision was up to the producer and the studio chief. With Wald feeling flummoxed by the director, he distrusted Ray's casting impulses all the more.

"Please be sure that I okay everybody that Nick Ray okays for 'This Man Is Mine,'" Wald wrote, addressing a memo to the RKO casting department. "In other words, it is most important to me that I have the final approval on these castings. I would also like to know what each person costs, too. Let's be careful on any bit players especially that we try to make

deals where we can get them a little cheaper. I'm sure you've worked with Nick Ray before and you know better than I do how to handle him."

Initially, for the part of Mitchum's protégé, Wald tried to whip up a general enthusiasm for Ben Johnson, a genuine ex–rodeo man who'd done impressive work in John Ford pictures. But Ray argued for his own personal discovery, twenty-two-year-old Casey Tibbs, a fast-rising bronco rider he'd befriended at Pendleton. Tibbs, from South Dakota, would win the first of two World All-Around Rodeo Champion titles in 1951 and decorate the cover of *Life*.

Like many directors, Ray liked the idea of discovering unknowns and launching their careers in film. He brought Tibbs to Hollywood, screen-tested him at RKO, and wangled items for the young rodeo star in Hedda Hopper's column. Tagged "the male Katharine Hepburn" by Hopper, the tall, lanky Tibbs made for good press, driving around Hollywood with Ray in his fuchsia-colored Cadillac. But Wald couldn't see an amateur in the part, and he vetoed Tibbs after viewing his camera test. Tibbs ended up with a walk-on.

When RKO passed on Tibbs, a disappointed Ray switched to lobbying for the more cerebral Arthur Kennedy, arguing that the stage-trained actor would make an intriguing contrast with the manlier Mitchum. Kennedy was a former Federal Theatre actor who'd starred on Broadway in two Arthur Miller plays for Elia Kazan; in 1949 he had collected his first Oscar nomination playing Kirk Douglas's hobbled brother in the boxing movie *Champion*. This time Ray got his way: Wald said yes to Kennedy. Kennedy himself played hard to get, though, and Ray had to lure him to a long drinkathon at Lucy's and conquer his doubts before he agreed.

Hughes and Wald were more interested in the actress who would play the ranch hand's wife. Ray tried to interest Lauren Bacall in the female lead, but he never was able to nurture the kinds of long-term ties with stars that gave other top directors leverage with the studios. Again and again, for example, Ray and Bogart announced projects, but they never made another film together after *In a Lonely Place*. Except for Bogart, Mitchum (counting the repair jobs), and two lesser names—Robert Ryan and Gloria Grahame—Ray never worked with the same star twice.

Hughes and Wald wanted the sexiest possible leading lady, someone with obvious va-va-voom. Wald made overtures to Darryl Zanuck of 20th Century-Fox, who was willing to loan out his studio's prize actress, Susan

Hayward. The red-haired former fashion model, who'd originally come to Hollywood to audition for Scarlett O'Hara in *Gone with the Wind,* had matured into a serious, admired performer with three Oscar nominations to date.

Yet Hayward was tricky to persuade; she was reluctant to join Mitchum and Kennedy in "This Man Is Mine," fearing that her character would inevitably be overshadowed by the two leading men and the rodeo setting. Wald tried to assuage Hayward's concerns by promising to stoke her scenes in the eleventh-hour rewrites, and RKO agreed to give her top billing, above Mitchum and Kennedy. The actress met with Hughes himself, who could be charming when necessary; evidently the charm offensive was mutual, for reportedly, the studio boss and the star would later embark on an affair.

Hayward then met with the two-man club of Ray and Mitchum, knitting as she listened to their pitch. Ray painted a glorious vision of the rodeo film in his halting, not entirely coherent manner—"a bit like a librarian," Mitchum recalled, "a bit cerebral." After a while Hayward lost patience and threw down her knitting. "Hey, I'm from Brooklyn," she said. "What's the *story*?" The director turned to Mitchum and said, "Tell her, Bob."

The first day of photography was scheduled for the week before Christmas. Ray immersed himself in last-minute cast and crew decisions and planning. Folksy Arthur Hunnicutt was added to the cast, fourth-billed as Mitchum's sidekick, an addled ex-rodeo performer. Although the rodeo world was dominated by men, and as full of drinking, gambling, and partying as the life of a Hollywood director's, Ray cast several lesser-known actresses in vivid small parts, including Maria Hart as a trick rider and Lorna Thayer as an ill-fated wife. Their performances would add to the film's rich tapestry.

After shooting valuable second-unit footage at Pendleton, cinematographer George E. Diskant had taken another assignment; he would never again work directly with Ray. But Diskant was replaced by another strong choice, Lee Garmes, a veteran visual experimenter with first-rate credits dating back to 1916; his moodily lit compositions were influenced by his worship of Rembrandt.

Ray insisted that the final script still needed touching up, and he and Mitchum may have brainstormed a few bits, especially for Mitchum's scenes, but studio records show that Andrew Solt, Alfred Hayes, and Norman Krasna also churned out last-minute rewrites during filming.

If the director wrote his best stuff for Mitchum, the professionals had their hands full trying to please the leading lady. Hayward balked at her sketchy, one-dimensional character. "I went down on the set where sat, pouting, Susan Hayward," Solt recalled. "This woman had the foulest mouth that I've ever heard in my life. She sat there and said, 'No, I'm not going to say these lines, they insult me.' And there sat Mr. Mitchum, who couldn't care less, and Nick blowing his top."

With so many cooks in the kitchen, the scenes featuring both Hayward and Mitchum were scripted to a fault. Never mind that Hayward defied credulity as a wife faithful to her stolid husband, cooking pot roast and saving money to buy a house while fending off repeated advances from the more magnetic Mitchum. Implausible it may have been, but the recently cuckolded Ray made the sanctity of marriage a theme in this film and several others.

Prickly about the script, Hayward was also resistant to Ray's directing style—another leading lady, like Joan Fontaine, who didn't go in for too much deep thinking. Her scenes with Kennedy were undemanding, but she may have been right to suspect that Ray and Mitchum were somehow allied against her. With his practiced diffidence and yen for practical jokes, the beefy star kept Hayward off-balance in their important scenes together. "Mitchum would bare his stomach just as we were about to shoot and he'd growl and Susan—a delicate young thing at that time—would get upset," Ray recalled. "It did Mitchum's heart good."

Hayward's schedule was tight—she was booked to go to work immediately after the rodeo film in *The Snows at Kilimanjaro* for 20th Century-Fox—so Ray had to shoot her scenes first. And soon after Hayward finished her part, Ray himself was unexpectedly sidelined: His Sunset Strip bungalow caught fire, and as he was coming down a ladder carrying his pet boxer, Ray missed the last three rungs and stepped on junk and glass in his bare feet. "The injury has been growing worse rather than better," wrote Hedda Hopper. The film's original director, Robert Parrish, filled in for a few days as Ray went to the hospital for tetanus treatments—the first hint of a physical jinx in this strapping man's career.

When he returned to the job, Ray finished up the studio interiors and then took the remaining cast and crew on the road for two weeks, chasing rodeos around the South and West.

*

In its final form, Ray's rodeo picture would combine documentary-style glimpses of actual rodeo life with graceful, naturalistically photographed drama. The rodeo footage was matter-of-fact, but the emotionalism of the staged scenes was high-pitched, at times even overheated. As with Ray's finest films, the end result was a unique blend. Plot and genre conventions had gradually been shaved away in the scripting process; the episodic nature of the story reflected Ray's ruminative personality, its plotting was secondary to the character studies and emotional landscape.

In the story, the amiable ranch hand played by Arthur Kennedy is transformed by success into a hard-drinking rodeo headliner with a rampant ego. In the film's later scenes, where he clashed with Mitchum, his mentor turned rival, Kennedy was at his best. Although Ray later listed Kennedy, along with Bogart and James Dean, among the true "naturals" who understood his directing "shorthand," Kennedy himself wasn't quite so sure.

"A strange guy," Kennedy recalled of Ray in one interview. "Had a most peculiar way of giving direction. I could never quite grasp his meaning. I'd agree to everything, then try to figure out what the hell he meant."

At Hughes's behest, RKO had tried to mold the project into more of a woman's picture (hence the title: "This Man Is Mine"). But from the start Ray saw the picture as Mitchum's showcase. The aging rodeo star, Jeff McCloud, was clearly the director's favorite character: his surrogate, a nomadic loser, wounded physically and psychically. In an early scene, filmed just after Christmas, McCloud returns to his childhood home. When the old-timer living there says that marriage is lousy and coming home is like visiting a graveyard, the cowboy nods knowingly.

Once upon a time, McCloud muses, he had fame and money. He didn't throw the money away, he reflects; "it just sort of floated." When Kennedy's character, Wes, asks if he was ever scared riding in the rodeo, he replies cryptically: "I've been scared and I've been not scared . . ."

Some of this muttered brilliance might have come from Ray, or Mitchum, or both. Stoned or sober, they decided every issue together. Ray made small gestures to please his friend—having Jimmie Dodd sing "The Chilly Winds," one of the star's favorite old-time songs, in a raucous rodeo party scene, for instance. Their two-man club grew stronger during the

filming. Mitchum didn't have the producer or star power of a Bogart; he was more like the director, a rogue and rapscallion and skirt chaser; a lush and a dope smoker. (Mitchum had famously been arrested for marijuana use; Ray once claimed to have briefly shared a jail cell with him.) A hugely gifted artist, Mitchum prided himself on walking through certain films just for the money: not this one, though.

As Ray had learned on their earlier pictures, Mitchum was like Bogart in at least one respect. "Both were genuine sight readers," Lee Server noted in his Mitchum biography, "both were good for up to six takes only and then would stray or dry up. If there was still a problem or a technical mistake with the sixth take, Ray would go to something else and come back to it later."

The director's oddball side wasn't entirely lost on his sympathetic leading man. Mitchum and his brother John (who had a bit role in the rodeo film, as he had in *Knock on Any Door*) dubbed Ray "the Mystic" for his habit of roaming the set restlessly, as though he were questing for hidden treasure, then plunking himself down in his chair "in such deep concentration that nothing would penetrate it"—before suddenly coming to an epiphany and leaping up to give a command.

Ray prompted Mitchum at length, according to Server, "craftily connecting the washed-up, drifting character of Jeff McCloud to things he knew of Mitchum's personal history and inner life. Mitchum thought Ray sounded like a screw-loose prophet when he got going on a subject, but Ray had pushed the right buttons—Mitchum's fondness for losers and outsiders, his memories of Depression wandering and homelessness."

Despite his genuine affinity for Ray, however, Mitchum could only take so much of Vakhtangov and Stanislavski. "When I act, I come in and say, 'What page is it and where are the marks?' But Nick is a fellow who likes to discuss the scenes with the actors . . . what my background was, what the background of the rodeo bulls and horses was . . ."

As another actor, Robert Wagner, who worked with Ray later on, said, "Nick was all about conflict. That's all he cared about. He was always after you to pull things out that were about conflict. You can't live like that all the time, except I think Nick did."

Mitchum took what worked; the rest went in one ear, out the other. Ever the diffident antihero, he compelled more than one producer in his career to worry over whether the beefy star was showing *enough* energy

in his pictures. Early on during the making of the rodeo film, Wald, who religiously watchdogged the dailies—dashing off memo after memo insisting on this angle or that line of dialogue—sent Ray a note: "We should be most careful in avoiding Mitchum walking through scenes sleepy-eyed."

Once they got away from the studio, the two-man club romped through the rest of the scenes on the schedule. The director was thrilled about the rodeo scenes. He loved rubbing elbows with the rodeo journeymen playing fleeting parts. "He was happiest when the rodeo stars themselves were around," said Richard Baer, a young assistant to Wald. "They were men's men, and I think Nick [himself] was coming across that way. I always heard rumors to the contrary, in terms of his sexual preferences. [But] he certainly had a lot of swagger to him."

Out on the road, the director strapped sixteen-millimeter cameras on the chests of riders; both Mitchum and Kennedy defied studio insurance policies to get up on the bucking horses and Brahma bulls, capturing one-of-a-kind imagery from their precarious perches. "Even Ray felt compelled to show he had what it took," wrote Server, "hopping aboard a bucking bronco at the San Francisco Cow Palace."

As he watched the accumulating footage in the screening room, Wald soon realized that this time Mitchum wasn't sleepwalking—and neither was Ray. Something else was happening on the screen. Between Ray, Mitchum, and cinematographer Lee Garmes, the scenes added up to a visual tone poem, a paean to the harsh, lonely rodeo life and ruined male ethos embodied by Mitchum and his character. As with Bogart in *In a Lonely Place*—or, for that matter, Farley Granger in *They Live by Night*—Ray had crafted a heart-on-the-sleeve portrait of a noble outsider whose glory lies in his vulnerability and impotence. "The most poignant drama in the lives of rodeo riders was portrayed by Mitchum walking across an empty rodeo arena," one critic later wrote, "the wind blowing rubbish behind him." The dailies, with their melancholy, tragic quality, were a great improvement on a script that had never quite seemed to come together.

Mitchum liked to give the impression that he was trying to finish each day as soon as possible in order to disappear inside a trailer and break out the booze. Ray was more the patient, brooding type on the set. But under Wald's prodding the director was never as efficient, finishing "This Man Is Mine" before Valentine's Day 1952. Then Ray, Wald, and three-time-Oscar-winning editor Ralph Dawson went to work organizing the foot-

age, melding the Hollywood scenes with the reels and reels of second-unit and stock footage. Mitchum rarely watched his own pictures, but he was intrigued by Ray's passion and questing, and when the footage was about two-thirds assembled he asked for a private screening. Mitchum watched the film alone in the projection room; afterward, Ray recalled, the normally diffident star floated out of the room "walking about ten feet high." They celebrated by drinking too much at Lucy's, the Mexican restaurant across from RKO.

Howard Hughes also viewed an assemblage and liked the footage so much he decided to improve on his own title. Demanding a new list of suggestions, he circled one: *The Lusty Men*. Wald and Krasna, half-amused, thought he might have misread it as *The Busty Men*.

<p style="text-align:center">⁂</p>

Ray and Mitchum took fishing trips to La Paz, and they got together now and then for dinner, always conspiratorial in their friendship, sometimes inviting Jane Russell along to join in the laughs. They mused about forming an independent film company with money from a wealthy Texas buddy of Mitchum's. But somehow—despite their fruitful collaboration on *The Lusty Men*—none of these future projects ever materialized. Ray and Mitchum never made another film together.

While Ray was busy with this picture about a man who sacrifices his life for a friend, his own mentor Elia Kazan was standing before the House Committee on Un-American Activities faced with a dilemma: name names or sacrifice his skyrocketing career.

When Kazan made his first, confidential appearance before HUAC, on January 12, 1952, he admitted to having belonged to the Communist Party in the mid-1930s, but he refused to name any fellow comrades. Before that executive session, Kazan held a late-morning meeting with Raphael I. Nixon,* an ex-FBI man who headed research for the Committee. Trying to convince Kazan to cooperate, Nixon handed over the "friendly" testimonies of writers Budd Schulberg and Richard Collins and director Edward Dmytryk (all from the 1951 hearings), urging Kazan to read and be guided by their repentant transcripts.

---

\*   No relation to future president Richard M. Nixon.

In his forty-five-minute afternoon session, Kazan readily confessed his own Communist activities. When he was pressed for the identities of others in the Group Theatre cell, though, Kazan would not budge, insisting it was a matter of "personal conscience" to hold his tongue. He declined to comment on the politics of other people—including even John Howard Lawson, who had already been branded a Communist and served jail time.

At the time, the congressmen appeared satisfied by the humble tone of Kazan's limited testimony. "There was no question of Kazan being cited for contempt," wrote film historian Brian Neve, "despite his refusal to give names." And the matter might have died there—if "the fact of Kazan's appearance, and crucially, his unwillingness to give names," in Neve's words, hadn't been leaked to the press by Representative Harold H. Velde, a Republican congressman from Illinois. Right-wing journalists and an anti-Communist with a *Hollywood Reporter* column led an attack on Kazan, and 20th Century-Fox began to exert pressures on the director. Kazan's film of Tennessee Williams's *A Streetcar Named Desire* was contending for Oscars in 1952, and his latest picture, *Viva Zapata!,* was a 20th Century-Fox investment just heading into national release.

Kazan was Zanuck's star director, and the mogul pleaded with him to stop shielding others and to stand up and protect himself and his career. Higher up the ladder, company president Spyros Skouras called Kazan in and had a sympathetic talk with the director, but according to Kazan, the studio executive "implied I couldn't work in pictures anymore if I didn't name the other lefties in the Group." Kazan agonized over what to do, consulting with longtime friends across the political spectrum. The author of *Viva Zapata!,* novelist John Steinbeck—once a leftist himself, now a dedicated anti-Communist—advised him to heed Zanuck. Playwrights Arthur Miller and Lillian Hellman urged him to hold firm. Kazan's wife, Molly Day Thacher—"a guide, a critic, a mentor, a constant advisor," in Kazan's words—had converted to anti-Communism and felt it was her husband's patriotic duty to make a clean break with the past and name names.

Finally, Kazan later recalled in his autobiography, "I began to measure the weight and the worth of what I was giving up, my career in films," in his words "surrendering" his profession and livelihood "for a cause I didn't believe in" any longer. The stage and screen director requested a new executive hearing, and on April 10, 1952, he delivered a prepared public statement and sworn affidavit to HUAC representatives. As prearranged, the Committee did not cross-examine Kazan, and "no doubt," as historian

Eric Bentley later wrote, the closed-door session preserved Kazan "from hecklers in the audience."

In his statement, Kazan noted his participation in the Theatre of Action, where there was "Communist thought and behavior and control," in his words. "But," Kazan added, explaining why he balked at identifying the Communist controlmongers of the Theatre of Action (thus sparing Ray any identification), "I did not attend their political meetings, so I cannot tell which of the actors were Party members and which were not."

Besides identifying a number of New York functionaries in the Party, Kazan narrowed his list to seven actors in the Group Theatre, along with playwright Clifford Odets, who had agreed with Kazan that they could point accusing fingers at each other. One of the seven actors was Art Smith, who had portrayed the dutiful Hollywood agent in Ray's film *In a Lonely Place*. Smith's career in motion pictures was effectively terminated.

Most of Kazan's old friends on the left were appalled, if not entirely surprised, by his about-face. Many turned their backs forever on the director. One who immediately phoned Kazan afterward to commiserate was the director of *In a Lonely Place*.

Whether it was Kazan who showed Ray the way, or vice versa, is not known. But when it came to HUAC, Ray probably had more in common with Odets, who indeed named Kazan in his own "friendly" (though actually quite testy) testimony the following month. The leading playwright of the left, whom Ray deeply admired, cut himself off permanently from his political friends, and tarnished his reputation forever, by cooperating with the anti-Red inquisitors. Perhaps most damaging for Odets, though, was his own guilt and mortification. "The sad fact," Kazan wrote years later, "is that what was possible for me hurt Clifford mortally."

Kazan was able to turn his personal trauma into drama. Always "tough as nails," in the words of John Houseman, the stage and screen director rebounded vengefully from the controversy of his testimony. The hate mail and hostility of his enemies empowered him, Kazan wrote later; after the first storm of reproach—and after slogging through the anti-Communist *Man on a Tightrope* for 20th Century-Fox and Zanuck—"something mysterious had happened. I found I was the possessor of a new degree of energy, one that would send me spinning through ten years of unremitting work."

Kazan's film energy peaked in the 1950s, and he continued to enjoy success on Broadway. In spite of his many sputtering enemies, Kazan also preserved key professional relationships. He had a gift for communing with

writers as well as actors, and his most famous 1950s films were indebted to close collaborations with friends who shared his anti-Communist fervor, Steinbeck and Schulberg among them. Kazan started producing his own pictures after the blacklist, eventually writing the scripts as well. For Kazan, cooperation was an act of self-preservation and growth.

For Ray, like Odets, the blacklist became another means of self-destruction. A man who had thrived on community and collaboration, Ray operated best within a circle of trust among friends. By the end of 1952, that circle was dwindling in show business.

Rather than kowtow to HUAC, for example, Ray's old Theatre of Action pal, composer Earl Robinson, returned to New York, leaving behind a lucrative niche in film music (he'd scored Frank Sinatra's Oscar-winning 1945 short *The House I Live In*). Ray's folklorist blood brother, Alan Lomax, fled to England to escape the witch hunt. Willard Motley, author of *Knock on Any Door,* chose exile in Mexico. Woody Guthrie and most of the other Almanac Singers, with whom Ray once lived, had been blackballed by 1951. Two of Ray's musician friends, Burl Ives and Josh White, gave "friendly" testimony, and many in the folk and blues community never forgave them.

Anyone who'd been connected with the Theatre of Action or Federal Theatre or left-wing benefits came under suspicion. Alvin Hammer of the Revuers was shut out of show business. Judy Holliday had to fight false accusations of Communism, and many believe she was graylisted during the 1950s. Among the many other actors driven from Hollywood were Howard Da Silva, Mickey Knox, and Stanley Prager, all veterans of Ray's films; when they refused to appease HUAC their work dried up.

The narrowing of the circle was reflected in a dramatic change in social life in Hollywood too. Ray lost many personal friends, including Ethyl Chaplin, who had hosted house parties when he was new to Hollywood, and Decla Dunning, who had leased him her house on Sunset Boulevard, both of them now blacklisted and driven from the film capital. And there was one other consequence of the blacklist era, often overlooked: Any creative artist who went on to make films in Hollywood in the 1950s found that their choices of subject matter were severely constrained. The era of socially conscious picture-making had come to an end.

In some ways, Nicholas Ray was lucky. He avoided the kind of public ordeal Odets was subjected to and he kept the secret of his HUAC capitu-

lation closely guarded. But neither did he feel the sense of empowerment Kazan derived from the experience. Like Odets, who was almost visibly burdened by his guilt and shame, Ray must have been tormented by his decision to testify—in ways that were invisible to most but that doubtless wounded and weakened him.

<div align="center">✳</div>

*On Dangerous Ground* was released in February, the same month Ray completed *The Lusty Men*. Critics saw the Robert Ryan–Ida Lupino picture as an ambitious mingling of genres that reached for greatness and almost attained it. In the *New York Times,* Bosley Crowther described the film as an intelligent attempt "to get something more than sheer melodrama on the screen—something pictorially reflective of the emotional confusion of a man." Despite Ray's sincere, shrewd direction, though, Crowther found the story "flimsy," the explanation for the cop's pathology superficial, and the romance between the cop and blind woman mawkish.

"You won't find it all too bad—particularly the first half," agreed Philip K. Scheuer, the often discerning first-string reviewer for the *Los Angeles Times,* "if you regard it as an action yarn and don't let the 'metaphysical' overtones depress you unduly." *Newsweek* too found the film likable, plausible, effective, while never quite achieving "the dramatic intensity to match its good purposes."

To boost the picture's earning potential, RKO released *On Dangerous Ground* in many cities on a double bill with the B Western *Indian Uprising.* Regardless of that gambit, Ray's film performed only modestly at the box office. Among Ray's credits, only the two Bogart vehicles had been clear moneymakers, and more than ever RKO saw him internally as an "arty" director.

Overseas "arty" was a compliment, and that had been Ray's reputation ever since the London debut of *They Live by Night. Knock on Any Door* and *In a Lonely Place* confirmed the director's "very remarkable talent," according to *Sequence,* though the slick studio assignments of *A Woman's Secret, Born to Be Bad,* and *Flying Leathernecks* hurt Ray's aura. The last issue in 1951 of Gavin Lambert's magazine *Sequence* harshly ranked the director, along with inactive filmmakers like V. I. Pudovkin and Erich von Stroheim, among the "Goners—No longer, in any vital sense, with us."

The French came along in time to give Ray a needed boost. Although they prided themselves on making Hollywood discoveries, Parisian cinephiles initially missed out on *They Live by Night*. The first Ray film to be widely shown in the French capital was *Knock on Any Door* in 1950, with the magic of Bogart overshadowing that of the unknown director. While the screen adaptation of Willard Motley's novel was well received, the praise mostly went to Bogart, with Ray barely mentioned.

Not until the following year was *They Live by Night* screened as part of the Biarritz Festival du Film Maudit—"a kind of anti-Cannes fest," in the words of film historian Jean-Pierre Coursodon. The festival was sponsored by Objectif 49, a cine club whose doyens included André Bazin, the father of a new school of criticism that was beginning to extol directors as the dominant "auteurs" of motion pictures—as authors who "wrote with the camera." In fact, many auteurist critics treated the actual screenplay with faint scorn, and if anything Hollywood filmmakers who were *not* writers—whose lively camerawork lent humanity even to dull material—got extra credit.

Not all the budding auteurists appreciated Ray's debut picture, not right away. Some left the screening telling those outside to go home. Ray's first picture, *They Live by Night*, had a brief, subsequent run in Paris in 1951, but it wasn't until its third booking that lines began to form.

In the pages of *Cahiers du Cinéma*, which soon became the Paris auteurists' house journal after its first issue in 1951, Francois Truffaut was to hail Ray's first picture, *They Live by Night*, as a "dazzling confirmation" of the promise of *Knock on Any Door*. Truffaut even compared the Hollywood director to Robert Bresson, who was emerging as the patron saint of French art cinema. Jean-Luc Godard was no less enthusiastic about Ray's directing debut; later, Godard would make a point of including beloved shot sequences from *They Live by Night* in his *Histoires* series of documentaries, including "four shots of Cathy O'Donnell standing up from a kneeling position, they're not quite centered frontal shots, and then they are, and you could say that this is a true beginning of artistic montage."

*In a Lonely Place* made its way to Paris not long after *They Live by Night*, becoming another beloved Bogart film and a fresh affirmation of Ray's artistry. To some extent, Bazin's young disciples found in this and other early Ray films a mirror of themselves: Like them and at the same time as them, he was starting out in his career. His unusual camera moves, intimate close-ups, odd angles, unconventional editing, and taste for location

work amounted to an anti-traditional aesthetic. His vision was seen, from the earliest prescient reviews, as a struggle against forces (both exterior and interior) more powerful than his own artistic stamina. In "the youth of the heroes" of *They Live by Night,* in "their stubborn intensity" (as Eric Rohmer wrote later), these young iconoclasts of film theory saw nothing less than an allegory of themselves as young rebels pitted against the out-side world, the establishment, the crass commerical cinema.

By the time of *On Dangerous Ground,* Ray's "greatness"—already the operative word among the Parisian cineastes—was reflexively assumed. Indeed, Jacques Rivette, struck by the "wonderful progression" of ideas and style in Ray's 1952 release, raised the stakes in his appraisal, grouping the Hollywood director, with only six pictures to his name, among "the masters" who saw even "the most simple mistakes turn out to their advan-tage, rather than diminishing their stature."

Ray's British admirers had been more circumspect. Gavin Lambert's language was measured (he found Ray's direction of *They Live by Night* "striking," for instance, "swift, compact, tense, with many expressive and appropriate angles"), and *Sequence* preferred to ignore the Ray films it didn't like rather than finding hidden genius in their flaws.

The French had lagged behind the British; the first major appreciation of Ray did not appear in *Cahiers* until 1953. But now they grabbed the lead, hailing Ray as a master of the cinema whose stature was enhanced even by his mistakes. First as critics, later as filmmakers, Truffaut, Godard, Rohmer, Rivette, and others in the *Cahiers* group saw themselves as Ray's spiritual children. And their exuberant, flowery, militant praise began to spread around the world and influence other critics.

<p style="text-align:center">✳</p>

Within Hollywood, Ray struggled for projects worthy of his growing French mystique. During the making of *The Lusty Men* he announced he was leaving RKO, despite the two years remaining on his current contract. The public statements were actually intended as a negotiating wedge; behind the scenes, Ray's agents were discussing an improved one-year con-tract for the director, raising his salary to $1,500 weekly. The new RKO contract also promised Ray opportunities to write scripts and produce his own films.

The contract was an expedient move for RKO, and it was also a bit

of a ruse. For Ray, the writing and producing provisions were intended to extend his creative authority from the blank page to the final cut, while the extra money would boost his bank account. Later in life, Ray even suggested that Howard Hughes had asked him to help run the studio during the second half of 1952. In truth, what the contract had was a "Jerry Wald clause" obliging him to work without credit on problematic RKO scripts and releases. Even as the French were celebrating him as an artist unfettered by commercial motives, Ray was encumbered by financial worries. As part of his new contract he talked Hughes into a $15,000 advance for divorce-related fees and lifestyle expenses.

To RKO, the writer-producer provisions in his contract were a sop to Ray's ambitions. The studio put a little seed money into development of Ray's projected film about Gypsy life on New York streets, based on Jean Evans's research into the Gypsy subculture. The director's dream casting of Marlon Brando and Jane Russell briefly tantalized Hughes, but when Brando began to look impossible and the casting switched to Robert Mitchum and Jane Russell the momentum slowed to a turtle's pace.

And there were other problems: By the early 1950s, Hughes had become all but dysfunctional, and RKO was distributing more pictures than it was producing. The studio's annual output would dwindle from a peak of fifty-three films released in 1940 to only thirteen by 1955. Everyone at the studio, Ray included, wondered not if, but when Hughes would sell the studio.

Working closely with producer Jerry Wald during the spring and summer, Ray conferred over the postproduction of *The Lusty Men* while repairing RKO scripts and films. The highest-profile project on the endangered list was *Androcles and the Lion,* an adaptation of the George Bernard Shaw play about an escaped slave and a noble lion, set in ancient Rome. The RKO coproduction had fallen behind under writer-director Chester Erskine.

Ray got together with producer Gabriel Pascal to speed up the remaining scenes and cut corners on costs. As usual, Hughes wanted to make everything sexier, and Ray was drafted to stage an elaborate interlude with women dancing around in flesh-colored leotards. This peculiar fantasia wasn't so far from Ray's cabaret experience, and the several days' work he did on the picture in August would scarcely merit mention if the director hadn't met a seventeen-year-old blonde named Betty Utey, a dancer in Spanish choreographer Carmelita Maracci's troupe.

"Hughes wanted more sex," Utey recalled. "The whole troupe of us were told to wear bikinis and report to RKO. I'd never worn a bikini before and I felt really funked out. I stood there in this line-up, and Nick selected very voluptuous kinds of bodies. I wanted to run off the sound stage, because he was a very piercing personality and I felt like a fool. He walked over to me and he said, 'What's your favorite fruit?' I told him I liked peaches. So a prop man appeared with a peach and I ate it full out, it dripped all over me. He featured me in the scene."

The expensive sequence, directed by Ray, was later cut after the film's original director, Erskine, complained that it was "vulgar, inaccurate and clumsily incorporated." But Utey would crop up again in Ray's life.

Over the summer, however, Wald had developed a grudging respect for Ray. The two shared long phone calls, lunches, and meetings, with Wald bending over backward to include Ray on every aspect of the post-production on *The Lusty Men,* even bringing him in on plans for the publicity and advertising. Together the producer and director kvetched about all the other RKO emergencies that vied for their attention.

At one point it looked like Wald himself might take over RKO. The producer complained incessantly about how "discouraging, disconcerting and just plain bad for our morale" it was to be constantly overruled by Hughes, and in June 1952 he was called to a secret meeting with Hughes's top business adviser, Noah Dietrich, for a surprising offer. Hughes wanted to shed the albatross of RKO, and Wald could have the studio if he could rally a group of investors willing to pay $6.50 a share for Hughes's one-million-plus shares. Wald spent a week on the phone with Louis B. Mayer, David O. Selznick, New York banker Serge Semenenko, and other nabobs, but all considered RKO a sinking ship, its stock already devalued by Hughes's mismanagement, and the takeover idea fizzled.

Soon Wald himself was looking to get out, maybe take Ray with him. In August, the producer, increasingly proud of *The Lusty Men,* finagled a bonus for the director to supervise a new, happier ending to the rodeo picture. The pathos that concluded *They Live by Night* and *In a Lonely Place* reflected the tone Ray favored for his endings, but more than once in his career he'd be forced to accept a little Hollywood uplift.

Ray's original ending showed Jeff McCloud (Mitchum) curled into the arms of Louise (Hayward) after being fatally wounded during his last rodeo ride. His dying words: "Guys like me last forever." McCloud's death finally causes Wes (Arthur Kennedy) to heed his wife Louise's pleas and

quit the circuit. As he walks away arm-in-arm with Louise, Wes hears his name called out by an announcer. "Pass!" he shouts, striding away from the rodeo as another first-time bronco rider charges into the arena.

Convinced the ending was too dire, Wald brainstormed a rose-colored finish with Jeff surviving his brush with death and walking off into the sunset with an ex-girlfriend. Ray shot it for a paycheck bonus, arguing with Wald all the way.

Wald considered the clash of endings a minor difference of opinion, and he slapped the new finish on the version he previewed at the studio in September. One of the guests was David Dortort, the original screenwriter, who met Ray there for the first time; when the preview was over, he recalled, the director and producer had "one hell of an argument." Ray insisted that the ending of a film belonged to its director. Wald waved him off: Even the illustrious Fritz Lang, making another picture for the Wald-Krasna unit, didn't have final cut. The producer was not about to give Ray the last word on a film he'd practically conjured out of nothing. Wald stood his ground, but he was taken aback at Ray's vehemence and felt wounded by the incident.

Later, Wald reconsidered and restored Ray's ending, which made more sense and which everyone liked better anyway. But the incident soured relations between Wald and Ray, and the producer dropped his bid to sign the director for another picture. Not long after, Wald would depart RKO for offices at Columbia, leaving Ray behind.

＊

What Ray was going to do after RKO remained up in the air. He and Humphrey Bogart continued to indulge in "moon talk," as grandiose ambitions are derisively described in *The Lusty Men,* announcing plans to film Ernest Hemingway's *The Old Man and the Sea* or W. R. Burnett's *Little Men, Big World.* Ray got Bogart briefly excited about an original story he brainstormed over drinks called "Round Trip," but the idea never advanced to the script stage.

Their most intriguing prospect was another story of Ray's, entitled "Passport," about a man without a passport living on a tourist ship that shuttles between Italy and France. Bogart wanted to work in Italy, and this was the first hint in Ray's career of his own fixation with Europe. Louella Parsons reported that the director had hired Italian writer Pier

Pasinetti, who was teaching world literature at the University of California–Los Angeles (UCLA), to collaborate with him. But "Passport" was abandoned when Santana went out of business, and Bogart booked himself up with writer-directors John Huston and Richard Brooks, who came equipped with full scripts they had written themselves.

Brooks was close to Ray's age, and Ray regarded him as something of a rival in Bogart's circle. One of the movies they all admired, *Crossfire,* had been adapted from Brooks's first novel; more important to Bogart, Brooks had helped John Huston with the script for *Key Largo.* A hot up-and-comer, Brooks was announcing future projects left and right, and his rapid rise as a writer-director seemed to put Ray to shame. It wasn't like Ray to grouse about a colleague, but he complained that Brooks got ahead by "singing for his ego" at Bogart's house, and that in his first films Brooks showed "no talent" as a director. One day, spotting Brooks at the racetrack, Ray boasted, he got a "vicious pleasure out of returning his pleasant greeting by yelling from the box: 'Hi, WRITER!'"

By the end of 1952, Ray had at least one completed script that he could carry around with him to meetings. Under his new, improved contract with Howard Hughes, Ray and a collaborator, Walter Newman, had fashioned a love story set in the New York Gypsy subculture Jean Evans had written about for *PM*. Ray's original two-page synopsis of the story evolved into a 130-page screenplay after long hours spent with Newman, a former radio dramatist who'd been nominated for an Oscar for writing Billy Wilder's *Ace in the Hole.* Ray still couldn't nail down a leading man, but Jane Russell had committed herself to the female lead and they had tailored the script for her. The well-endowed RKO actress was a personal favorite of Hughes's, but even that wasn't enough for Ray or Russell to convince the studio boss to approve the project.

The RKO story executives heaped praise on the Ray-Newman script. But after they warned production officials that it might be too much of an "arthouse" project the Gypsy film got stalled. When Walter Newman moved on to other assignments, Ray was left to fitfully revise the script, in between remedial chores on RKO films considered to have better profit potential.

---

\* Pasinetti later returned to Italy and worked several times as a scenarist with Michelangelo Antonioni.

❋

By the end of the summer of 1952, Ray's days at RKO were coming to a close.

Though the details were still being arranged, Howard Hughes had found another buyer for the studio. When Ray's last RKO picture, *The Lusty Men,* was released in October, American critics saw in it many of the same virtues that characterized *On Dangerous Ground:* an ambitious over-lap of genres, a dreamlike pictorial quality, and a brooding, fatalistic view of life. The wayward script (which too quickly "develops a limp," as the *Time* reviewer noted) attracted its share of complaints, but the director got credit for all that was different and unusual about the rodeo-world film. "The situation is worked out melodramatically, but it is director Nicholas Ray's surrounding atmosphere that counts most," *Newsweek* wrote. "The rodeo as an institution, human and geographic, comes to intimate life."

Over time, *The Lusty Men* has soared in reputation and has come to be regarded as one of the director's triumphs. For fans of Mitchum, it boasts one of the actor's standout performances. "A masterpiece by Nicholas Ray—perhaps the most melancholy and reflective of his films," Dave Kehr declared unreservedly in 2000 in the *Chicago Reader.* "Ray creates an un-stable atmosphere of dust and despair—trailer camps and broken-down ranches—that expresses the contradictory impulses of his characters: a lust for freedom balanced by a quest for security."

Yet the film's downbeat storyline conspired to keep *The Lusty Men* from doing well in theaters at the time of its release—a now-familiar failure that only added to Ray's pigeonholing in Hollywood as an "arty" director. And RKO's collapsing distribution and exhibition network left him little reason to continue his career there.

❋

An entire year would elapse between the release of *The Lusty Men* and the moment Nick Ray called the first take on his next picture. It was a tran-sitional year for Ray professionally, one in which he forged a new image for himself in Hollywood. He had started out in the industry hailed as a wunderkind director of realistic human drama. His RKO studio handouts

then reframed him as a "melodrama specialist." His marriage to Gloria Grahame gave him another fresh hook as a ladies' man with a knack for working fruitfully with glamorous actresses, on-screen and off. After his HUAC clearance and messy divorce from Grahame, Ray worked extra hard at polishing this ladies'-man image; it gave him political cover while alleviating the private and public embarrassment of his divorce (which was swiftly followed by Grahame's third marriage).

Ray's divorce was officially granted in August 1952, but well before then the director had recovered from his marital disaster enough to advertise himself as "a well-known movie colony heartbreaker," in the words of columnist Dorothy Kilgallen, "the darling of so many Hollywood glamour girls." Kilgallen was an old New York acquaintance who may have known Ray's charms firsthand, but Ray also cultivated his friendships with Hedda Hopper and Louella Parsons, trading items about his romantic affairs for items promoting his various projects.

Ray's serial womanizing ate up almost as much time, energy, and money as his drinking. Hopper and Parsons both covered Ray's love life and career with equal avidity. Hopper was a rabid anti-Communist who complained incessantly in her column about Reds and pinkos hanging on by their fingernails at some studios, but Ray often sat next to her at Hollywood premieres, and she never so much as hinted at Ray's past politics. The director strengthened his ties with Parsons in similar fashion, occasionally escorting her divorced daughter Harriet, a Paramount producer—one of the few women in that position—to industry functions.

Gossip items can be wishful, but Ray himself boasted about his female conquests, to columnists and friends alike—and many of the star romances can be corroborated. Ray was always beguiling to women, and never more so than at this vulnerable time of his life. Some believed that Ray's high rate of success with women was aided by the impression that he was "a potential homosexual with a deep, passionate and constant need for female love in his life," as his friend, producer John Houseman, wrote sympathetically. "This made him attractive to women, for whom the chance to save him from his own self-destructive habits proved an irresistible attraction of which Nick took full advantage and for which he rarely forgave them."

Atop the list of glamour girls romantically linked to the director was Marilyn Monroe. One of Hollywood's rising stars, just starting to get good parts, Monroe shared a flat with Shelley Winters, who blew hot and cold

on Ray over the years. Winters and Monroe passed Ray back and forth in the early 1950s, but Winters later reflected that the very things about Ray that daunted her—his age and intelligence—were the traits that turned Monroe on.

While Ray was working on *The Lusty Men,* Monroe was filming *Clash by Night,* the Fritz Lang film of Clifford Odets's play that Jerry Wald was producing for RKO. Ray had known Monroe for a while by then, escorting her to Gene Kelly and Betsy Blair's parties more than once. He had a real crush on Monroe and often talked about working with the actress on a film one day, but Monroe always kept a few steps ahead of him. Whether Ray and Monroe were in Wald's office or out on a date, the director "monopolized" her, as one columnist put it, fluttering around the sexy blonde as if she were a personal trophy. Monroe sincerely liked Ray, but her interest in him ebbed and flowed, not always coinciding with his interest in her.

Richard Baer, Wald's young assistant, was also pining for Monroe and kept trying to finagle a date with the actress. Monroe loathed watching dailies but insisted that Baer phone her nightly to report on her scenes in *Clash by Night*—how she performed, how her hair and costume looked. Baer kept hinting that it would be easier if he just could come to her place in person. "Over the phone is just fine," Monroe always replied sweetly.

Finally, Baer coaxed Monroe into a lunch date at Lucy's. They were just getting settled when Ray swept in, wearing some kind of cape, and headed straight for their table. The director plunked himself down in their booth, fawning over Monroe, stroking her arms and patting her thighs. Balefully eyeing Baer, Ray kissed Monroe good-bye on the cheek before making a grand exit. The actress waited until Ray was out of sight, then gave Baer a look and murmured dolefully, "I never knew a man with such terrible teeth."

Another object of Ray's affection during this time was Joan Crawford, an older and more established Hollywood glamour girl—six years older than Ray himself. A steely-eyed diva who had reigned over both MGM and Warner Bros. in her heyday, Crawford had won an Oscar at the latter studio for her title role in *Mildred Pierce*. By the early 1950s, when the studios could no longer afford long-term contracts with high-paid stars, Crawford was forced into freelancing.

As often happened with Ray, his romantic partnership with Crawford had a professional component. The couple first made news together

early in 1952, as they planned a big-budget Cold War suspense drama for Paramount called *Lisbon,* which Ray hoped to shoot partly on location in Europe. The gossip columnists were terrified of Crawford and treated her private life with kid gloves; the fact that they reported on her off-and-on affair with the director—including their late-night rendezvous and many long-distance phone calls when they were apart—suggests that their affair was genuine, or at least that Crawford approved the items.

When his high-profile affairs waxed and waned, Ray dallied with lesser lights—the blond Hungarian personality Zsa Zsa Gabor, who was between marriages and just starting out in Hollywood; or the beautiful starlet Natalie Thompson, who had just left Clark Gable. The director had a regular table at the Mocambo nightclub and flaunted his eligibility.

He was an expert at juggling his women. One woman heading out Ray's door rarely met the next one coming in, in part because he arranged some of his trysts during the day. Whenever the women did meet, Ray usually got a referral. "He was known to be great in the sack," said Gavin Lambert, who later was Ray's lover for a brief time, "which surprised me, given how much he drank."

The closest of the director's girlfriends may have been the least-known in Hollywood. A German redhead who was raised a Catholic but was Jewish by birth, Hannelore Axmann had come to the United States after spending the last year of World War II eluding the Gestapo in her native Munich. A woman whose "beauty," rhapsodized her friend, poet Arthur Gregor, was "not only of a perfection of features but of a subtle, mesmerizing mysteriousness," Hanne Axmann was a gifted painter who was trying for a career as an actress in Hollywood; though Michael Curtiz agreed to give her a screen test, only a few walk-ons came of it. Much later in life she would she appear in a number of Das Neue Kino films in Germany.

Axmann's real talent lay in her humaneness and generous spirit, friends said, which drew her to troubled men. A brief marriage to actor Edward Tierney—the youngest of three Tierney actor brothers and the one with the meanest streak—ended around the time he was arrested for statutory rape. Her separation and subsequent divorce drove her into the arms of Ray.

Axmann once estimated that she spent "hundreds of nights" drinking with the director, often staying up all night long talking blue streaks with him before dozing off; after Ray's morning visit to a psychoanalyst,

they would resume their drinking in the afternoon. Sometimes Ray would freshen up and head off to a studio appointment; sometimes he'd disappear for days. Whether she knew or cared about his other girlfriends, Axmann waited for him to come home, as patient and tolerant as a wife, sister, or mother.

Compartmentalized, like the other women in Ray's life, the beautiful, nurturing Axmann "met nobody through Nick," she later told Bernard Eisenschitz. But Axmann didn't mind their nonexclusive, intermittent relationship, and she would remain his friend for a long time.

✳

Ray had avoided professional therapy during the crises of his first marriage, but he had begun seeing a psychoanalyst several times a week under court order as part of his California divorce process. Besides discussing the love affair between his wife Gloria Grahame and his teenage son Tony, he may even have discussed his cooperation with HUAC; many other "friendly" witnesses later admitted to exploring their burdens of guilt with therapists.

His appointments were with Carel Van der Heide, a favorite of the Hollywood show business crowd, whose offices were on Wilshire Boulevard in Beverly Hills. His first sessions with a therapist, back in 1941, had ended with Ray losing his voice from the stress. But often with Ray, silences had to be decoded.

Dr. Van der Heide was an expert in Freudian dream analysis and the author of influential articles like "Blank Silence and the Dream Screen," published in 1961, which reads as though it was inspired by his visits with Ray. Van der Heide observed that chronically silent patients, or those who resort to unintelligible speech, believed they were sharing "blank dreams" as though from a sleepless dream. At times now, Ray opened up to the psychoanalyst, and he found he almost enjoyed the ritual of talking to someone who was paid to listen to his miseries.

Regardless of the many newspaper items he planted about his projects, his career had bogged down. The Gypsy love story Ray had developed with Walter Newman seemed moribund. Ray had his heart set on the project, even investing his own money to bring a young man he had spotted in Luis Buñuel's *Los Olvidados* to Hollywood from Mexico, touring

him around town and touting him for the lead he had once envisioned for Marlon Brando. No one nibbled, however—and in any event the Gypsy script was still owned by RKO, now nearly defunct.

There was one bright light during this lost year, however. Ray got himself a powerful new agent: Lew Wasserman of the Music Corporation of America (MCA).

Wasserman had risen up from music and nightclub booking to become president of the Hollywood division of MCA, and after Ray's RKO contract finally ran out, he became the director's agent. Wasserman was a pioneer at bundling actor clients along with writer and director clients into "package" deals for the major studios, although once he had packaged the elements of a film, his subordinates usually stepped in to negotiate the details. In Ray's case, the fine print usually fell to Herman Citron, dubbed "Lemon Citron" by some, "the Iceman" by others, because he was such a sour, tough negotiator.

Wasserman, a supercharged workaholic, was one of Ray's card-playing buddies—and like Ray, he was another habitual loser at gambling, alleged to have lost his own house, twice, on bad bets. They had a real affection for each other. Wasserman didn't even seem to mind it when Ray began a protracted affair with the agent's wife, Edie Wasserman. The petite, vivacious Edie was known to sleep around, but Gavin Lambert, who knew them both, insisted that Ray was one of her true loves. "Absolutely," Lambert is quoted as saying in a joint biography of the Wassermans. "There was something masculine about her manner and voice" when Edie was among other people, but she turned "soft and feminine" around Ray. Ray and Edie trysted regularly after his divorce from Gloria Grahame, and at one point their affair became so "intense" that Edie considered leaving her husband, according to Lambert. That prompted Ray to cool it.

The tall, gentlemanly Wasserman, Hollywood's ultimate power broker, spent most of his time on his A-list clients, including Alfred Hitchcock, James Stewart, and Bette Davis. Ray was not on the A-list; nor was he an easy sell. The studios were cutting back on production while looking for potential blockbusters—and, apart from his two Bogart pictures, the director didn't have a very impressive box-office track record.

Everyone seemed to know Ray's personal backstory—his actress wife's affair with his teenage son, which led to their divorce; his left-wing ties and narrow brush with HUAC. But Ray was still winning in meetings:

Talking to producers, he radiated energy, confidence, and likability. Wasserman got the director a few promising deals in the last half of 1952 and the first half of 1953—although none of these "packages" actually made it in front of the cameras.

The one that came closest—and ultimately bore ancillary fruit—was *Lisbon,* the lavish thriller Ray prepared for Paramount. Joan Crawford was the star, and she and Ray went around town nuzzling for the columnists. The director had just gotten medical shots to head overseas and scout locations in Portugal when Paramount balked at the escalating budget and postponed the production. (It would eventually be produced by Republic in 1956, shot almost entirely on soundstages, with Ray Milland directing and starring opposite Maureen O'Hara.)

Crawford was incensed. The steely-eyed diva had been nursing along another project at Republic, the cheapest, least prestigious studio in Hollywood, and early in the summer she announced that she would take her marquee name over to Republic and star in her first Western since the forgotten *Montana Moon* in 1930. Ray would join her as her director.

The Hollywood press reported that the Western would have a $2 million budget, unusually lavish for Republic. Besides a salary commensurate with her billing, the star would participate in the film's profits, because she owned the screen rights to *Johnny Guitar,* the novel on which the picture would be based. Ray's salary would be a mere $75,000 covering the preproduction and filming schedule, yet it was his biggest paycheck to date for a single film.

Crawford was considered the picture's de facto producer. For Ray, an important part of the *Johnny Guitar* package was that, for the first time, he would also get a producer title—"associate producer," actually, according to publicity announcements. But after nearly a year spent squiring glamour girls around Hollywood—and watching his quixotic projects fall to the wayside at studio after studio—Ray was grateful for the opportunity.

❋

There are many versions of how *Johnny Guitar*—that "bold excursion into camp," in the words of David Thomson—came into being. Most versions burnish Ray's mystique at the expense of others. One way in which Hollywood tradition and auteurist theory overlap is by underplaying or dismiss-

ing the contribution of the writer of a film—in this case Roy Chanslor, author of the novel and script, sometimes described by zealous Ray admirers as a journeyman or "hack" writer.

Born in Missouri in 1899, Chanslor attended the University of California–Berkeley, becoming editor of the student newspaper. Ambitious and versatile, Chanslor started out as a beat reporter for California newspapers but wrote his first stage play in 1929. In 1931, he began alternating novels and film scripts, and over the next thirty years he amassed sixty Hollywood credits, mostly contract pictures for B stars and directors, including installments in the Tarzan and Sherlock Holmes series.

During his career in Hollywood's basement, however, Chanslor built a reputation for talent and integrity. He had a social conscience too, once going public to condemn a studio for turning a Negro character in one of his films into a demeaning stereotype in order to accommodate southern censors. He was known in the industry for plots involving brash women and breezy dialogue (with "a high quotient of smartness and toughness," as one *New York Times* critic noted of a Chanslor novel). As far back as *Front Page Woman*, a 1935 Bette Davis programmer for Warner Bros., Chanslor had made a specialty of strong, eccentric female characters who invaded male professions.

Another of his niches was Westerns. A few years before *Johnny Guitar*, Chanslor had worked without credit on *Rancho Notorious*, an offbeat Fritz Lang Western with Marlene Dietrich as an aging saloon singer. A few years after, he would pen an even loopier feminist sagebrush novel, *The Ballad of Cat Ballou*. (*Cat Ballou* would be made into a 1965 film with Jane Fonda and Lee Marvin that was nominated for five Oscars —almost two years after Chanslor died of a heart attack while working on the script in a rented flat in Encino.)

Chanslor and his wife, award-winning children's illustrator and mystery novelist Torrey (Marjorie) Chanslor, were old friends with Joan Crawford. Their friendship peaked in 1953, when Chanslor published two novels linked to the star. The first, *The Naked I,* was a roman à clef about Hollywood, featuring a novelist moonlighting as a screenwriter who frets about selling his soul to the movie industry, even as he falls in love with a glamorous actress. The second, *Johnny Guitar,* was a film about rival gun-toting women, which he dedicated to Crawford.

The main character in Chanslor's novel is a beautiful woman named

Vienna who runs a saloon on the outskirts of a Wyoming town. A puritanical townswoman named Emma, who detests Vienna, is looking for excuses to agitate against her. Vienna may or may not have had a past romance with an outlaw called the Dancing Kid (he likes to dance with himself). Trouble breaks out when the Dancing Kid's gang robs a stage and a handsome enigmatic stranger carrying a guitar steps off a train and takes a fancy to Vienna.

Crawford bought the rights to *Johnny Guitar* before publication. She may indeed have commissioned the novel, with Chanslor first writing it as a lengthy treatment, a common practice for Hollywood screenwriters. The film of *Johnny Guitar* was announced in the late spring of 1953; the book wouldn't appear in print until September, when the *New York Times* hailed it as "one of the best [Westerns] in a long time."

The novel's four main characters—Vienna, Johnny Guitar, Emma, and the Dancing Kid—closely resemble their namesakes in the final film. Emma in the book is just as ornery a character, just as obsessed with Vienna, just as determined to seal Vienna's death. In both the book and the film, Emma organizes a mob that tries to lynch Vienna; in both the book and film, Emma shotguns a chandelier, starting the bonfire that burns Vienna's saloon. The novel does insert a third female character into the story's climactic shootout: Elsa, the Dancing Kid's girlfriend. But press announcements suggest that Elsa was eliminated from the movie story line before filming, and the gunfight duel to the death—a memorable sequence in the picture—already had been narrowed down to Emma and Vienna.

Ray and the film's writer had all summer and much of the fall to adapt the novel and sculpt the script. But who was that writer? And to what extent was Ray involved? This is one of the enduring mysteries of *Johnny Guitar*—one that has fascinated Ray's French devotees in particular.

The film's only credited writer is Philip Yordan, who is believed to have added finishing touches to the script on location. Yordan always insisted that he joined the production after Chanslor's own draft had been written and accepted and after the filming started. But Yordan had a shadowy background that casts doubt on his claims. Before Hollywood, he admittedly paid someone to attend law school and take the bar exams in his name. On Broadway, his first hit play, *Anna Lucasta,* was the subject of a bitter lawsuit, with a closet collaborator suing Yordan and successfully claiming the lion's share of authorship. A screenwriter since 1940,

Yordan had amassed credits on about twenty films before *Johnny Guitar;* a few dozen more would follow, including other collaborations with Ray.

But Yordan's checkered history makes it difficult to confirm how much actual writing—if any—he did on any one script. He was perfectly capable of spitballing clever ideas and snappy dialogue, but sometimes (if not frequently) he left the actual writing to others. Yordan had a longtime secretary who worked over several of his early scripts without credit, and he confessed to hiring other "surrogates" over the years—a few blacklisted writers—to pen the numerous films bearing his name.

In one interview, blacklisted writer Ben Maddow said he helped Yordan with *Johnny Guitar*—a service that Maddow performed, without credit, on several Yordan pictures in the 1950s. But Maddow conceded that he'd ghostwritten so many Yordan scripts that he couldn't always keep track, and he later retreated from the claim, saying that *Johnny Guitar* wasn't a job he especially remembered, so probably he didn't write it. If a blacklistee did help with the script in the summer of 1953, that might explain why Ray himself, who was inclined to take inordinate credit for scripts—as with *The Lusty Men,* for example, or *Rebel Without a Cause* later on—never once boasted of writing *Johnny Guitar:* He couldn't have easily admitted the involvement of a blacklistee.

Chanslor undoubtedly wrote a first draft, consulting with Ray and surely Crawford herself. It may be that Chanslor was the sole writer of the first draft: He was certainly capable, and whoever penned the adaptation carefully preserved the novel's extremes and peculiarities while reorganizing the story more tightly around the four main characters. In the film, Johnny Guitar would become a more enigmatic, more conflicted character, while Vienna became angrier, at once more mannish and more feminist, quite unlike the stand-by-your-man women and mothers and housekeepers in other Nicholas Ray films. "A man can lie, steal, and even kill, but as long as he hangs on to his pride he's still a man," Vienna sneers at one point after Johnny boasts that he still has his pride. "All a woman has to do is slip once and she's a tramp. It must be a great comfort for you to be a man."

The script changed the setting to Arizona, while adding an intriguingly vague romantic backstory between Johnny Guitar and Vienna. (In the novel, the two meet for the first time in the town bank shortly after Johnny Guitar's arrival; in fact, Vienna takes an instinctive dislike to the

guitar man.) Nearly every line of dialogue in the book was tossed out and written anew. One notable exception, interestingly, was Johnny Guitar's self-introductory line, "I'm a stranger here . . . ," which is in the novel and which, later in life, Ray adopted as a kind of personal motto.

Over the summer of 1953, Chanslor's exceptional novel became an even better script—with improvements still to come—taking *Johnny Guitar* further down its bold, distinctive path.

<p align="center">✳</p>

Ray assembled the rest of the cast with Joan Crawford and Republic studio head Herbert J. Yates looking over his shoulder. Crawford, a brunette, wanted a blond actress to play Emma, which would offer a visual contrast in their scenes together, but Ray talked her into the brown-haired spitfire Mercedes McCambridge. Trained as a classical actress, a veteran of Orson Welles's Mercury Theatre, McCambridge was already typed in Hollywood as a female heavy after winning an Oscar for her tough-talking debut in *All the King's Men* in 1949.

Early on, the studio announced that Robert Mitchum would play the title role, but "previous commitments" kept him away. Ray tried to borrow Jeff Chandler, then gravitated to Sterling Hayden, the leader of the heist-gone-wrong in 1950's *The Asphalt Jungle*. Hayden had confessed his ties to the Communist Party before HUAC in 1951, and he saw *Johnny Guitar* as belonging to the "morass" of B pictures he was condemned to make after selling his soul. (He never changed his opinion.) Ray and Hayden not only shared HUAC scars, they shared the same business manager, and Ray knew that Hayden—like him—needed the money.

Scott Brady—a Tierney behind his stage name, and the former brother-in-law of Ray's lover Hanne Axmann—would play the Dancing Kid. Ernest Borgnine, Royal Dano, and Ben Cooper were cast as Bart, Corey, and Turkey, members of the Kid's gang, clearly outlaws in the novel, law-abiding silver miners in the film, before they are falsely accused of a stage holdup and decide they may as well rob a bank. The supporting cast also included well-traveled character actor John Carradine as Vienna's loyal vassal Old Tom, and Ward Bond—the only featured player who'd acted before for Ray—as John McIvers, a civic figure leading the mob.

Like everyone else in the film, the outlaws got bits of dialogue or stage

business sketching in their character types. Dano plays a tubercular who reads a book to pass the time during his lookout stint on a knoll. When the Dancing Kid asks Bart, the meanest member of the gang, if he likes anything or anyone, he spits, "Me? I like me! And I'm taking good care of me." Turkey shouts, "You talk like I'm a boy! I'm a man!" before demonstrating his shooting prowess to Vienna, and just before Johnny Guitar shoots the gun out of his hands. (Turkey is a different character in the book; in the movie he becomes a descendant of Bowie and a precursor of Plato, among other febrile young men in Nicholas Ray films. His scenes—his crush on and piteous betrayal of Vienna, leading to his hanging—have a special tenderness and emotional gravity.)

*Flying Leathernecks* had been Ray's first exercise in Technicolor, but everything about that film had been subject to Howard Hughes's whim. (The color was in full bloom only when John Wayne was furloughed home into a radiantly designed family living room.) Ray would have more freedom with the look of *Johnny Guitar,* and he worked closely with art director James W. Sullivan and cinematographer Harry Stradling (nominated for fourteen Oscars in his long career), marrying the surpassing natural beauty of the outdoor vistas with the coded, sometimes voluptuous colors of the characters' attire.

Ray's "provocative flair in handling color," as film scholar Peter Wollen described it, would come to be recognized by academics and auteurists as one of his trademarks. "Like Bakst for Diaghilev," Wollen effused, "he [Ray] would use daring, often lurid combinations: red on red, green on green, or, as Godard described it, 'barley-sugar orange shirts, acid-green dresses, violet cars, blue and pink carpets.'"

Ray took his cues on color dynamics from Chanslor's novel, which depicted Vienna as a "fine bold woman in black pants and red silk shirt," who wore "boyish riding breeches" when she wasn't gliding around in revealing peignoirs. The director jotted endless notes in the margins of the book and script, building on Chanslor's descriptions. When Crawford, in the film, wasn't dressed in gunslinger black, she was sporting violent red blouses or blinding white dresses, "her lips, full and red, bold red, painted" (as Chanslor wrote), her witchy eyebrows dark and theatrical.

Alternatively, Emma is dressed in emerald-green togs when she first appears, like a crazed Dorothy fresh from the color half of *The Wizard of Oz.* The posse coming for Vienna arrives from Emma's brother's funeral in

blacks and whites, like MCA agents, as Ray once said. (Emma, in the same colors, looks like a nun.) Johnny Guitar is garbed in tangerine, the Dancing Kid in key lime, and his gang in similarly fruity colors, with young Turkey in banana yellow.

Filming in color was still new to Ray, and he promoted his theories in numerous interviews. "I've always felt that the psychology of color is overlooked," the director explained on one occasion, "not just in motion pictures but in numerous situations. I've discovered that there is a definite audience reaction to the repeated use of certain shades. This also involves color identification with a character, and this particular mental process is grasped unconsciously by an audience." For a man who often felt boxed out of the script, color was another way of stamping his signature on his films—adding an emotional energy and a further layer of interpretation to the scenes.

Once again, as with *They Live by Night,* having the clear structure of an established novel—and a long period of scriptwork and planning—worked to Ray's advantage. By the time he launched the photography of *Johnny Guitar* in Sedona, Arizona, in the third week of October 1953, Ray had not been behind the camera for an entire year.

＊

About thirty miles south of Flagstaff, Sedona is a town in an area of high desert, its canyons and massive red rock formations a favorite location for Hollywood Westerns. If Ray had been hoping for a Grand County or rodeo-circuit location experience, however, he was sadly mistaken.

Ray's off-and-on fling with Joan Crawford had ended for good over the summer, and by the time they arrived in Sedona there was a distinct unease between them. Neither pretended to be monogamous, and either one may have ended the affair, though with Ray it was usually the women who did. But the timing was bad for the director, as it had been when he fired Libby Holman, a star of *Beggar's Holiday,* just after sleeping with her.

Like Bogart in *Knock on Any Door* and *In a Lonely Place,* Crawford was the star *and* producer of *Johnny Guitar;* she outranked the director in billing, salary, and actual power.

Crawford arrived in Sedona already feeling defensive. Perhaps she was just getting into character, but it soon became clear that she felt

Roy Chanslor had double-crossed her, writing the character of Emma to upstage her Vienna. Crawford couldn't forget that Mercedes McCambridge had been Ray's casting brainstorm; she was infuriated when the younger actress resisted dyeing her hair blond, and even more so when Ray defended her.

Sets for the film were built on the outskirts of Sedona: Vienna's saloon, the Dancing Kid's hideout atop a knoll, the façades of the town's buildings. Before they were even completed, however, Ray first shot one of the film's dramatic action scenes, with Vienna submerging herself in icy river waters and clinging to Johnny Guitar while escaping from the lynch mob. Afterward, the director thanked both players for their professionalism, according to Bob Thomas's authoritative biography of Crawford, ceremonially bestowing a bottle of brandy on each of the performers and telling Crawford and Hayden to take the rest of the day off.

Ray turned his attentions to the younger actress who still proudly wore her theater background on her sleeve. The next shots involved Emma and the vigilante posse. When Ray called action, McCambridge expertly spat her lines while keeping her poise on a fidgeting horse. "Beautifully done!" proclaimed Ray. But the director "immediately felt he was being watched," according to Thomas's book; glancing over his shoulder, Ray spied Crawford watching from a nearby hill, trembling with fury. "She turned on her heel and disappeared beyond the hill," wrote Thomas. A "feud" between the actresses "exploded when the company applauded the McCambridge gal," wrote Hollywood columnist Harrison Carroll at the time.

It probably didn't help that costar Scott Brady passed Crawford's room later that day and shouted to the actress, "Hey, you should have seen McCambridge work today! I wouldn't be surprised if that dame won another Oscar."

Crawford had brought cases of vodka on location, and although some of it was for entertaining those cast members she liked, she drank her quota. That night, as he roamed the grounds of the Cedar Motel, Ray spotted a drunken Crawford lurching along the nearby highway, strewing objects that "he recognized upon close examination as Mercedes' costumes for the movie," according to Thomas's book. In the morning Ray vacated his private cabin so that McCambridge could move out of the motel and live a safe distance from Crawford. That only looked like more favoritism to Crawford, who demanded an afternoon meeting with the director and

insisted on rewrites to enhance some of her scenes. Ray tried to talk her out of expensive script delays, but the star was "sober and adamant," wrote Thomas.

Late that night, Philip Yordan got a call from Lew Wasserman of MCA, which represented him as well as Ray and Crawford (Chanslor and McCambridge too, for that matter). Yordan was known inside the industry as an unflappable emergency script doctor, and Crawford wanted someone new—not Roy Chanslor—to make changes. Wasserman asked Yordan to step in, and the next day Yordan and Arthur Park, a senior MCA agent, flew to Sedona.

A Chicago native, Yordan was balding, hawk nosed, with black goggle glasses that advertised his bookishness. (For all that, he was catnip to ladies.) The writer had met Ray only a few times in passing. Both were friends with Anthony Mann, who'd directed several Yordan scripts. Ray and Yordan had been thrown together at a Hollywood party one night when Frank Lovejoy, who'd gotten on Ray's bad side while playing the detective Brub in *In a Lonely Place*, picked a drunken argument with Yordan. "He got very aggressive," recalled Yordan, "and Nick, who was a very big man, defended me. I didn't know him then, but I knew of him."

In Sedona—and often enough in the future—Yordan would repay the favor. Wearing his pained, drained look, Ray waited for him in his motel room. "I need this picture," he told Yordan, "but I can't talk to Miss Crawford anymore. Please do something with her."

Yordan met with Crawford, who complained vociferously about her scenes and Vienna's characterization. "I have no part. I just stand around with boots on and have a few stupid scenes. I want to play the man. I want to shoot it out in the end with Mercedes McCambridge and instead of me playing with myself in a corner. Let Sterling play with himself in the corner . . ."

Crawford insisted that Ray had "betrayed" her, favoring McCambridge over her, and that certain cast members were conspiring against her. No one treated her with respect. She was the star, she was taking the most risks, it was her movie, and she wanted her scenes boosted.

Yordan talked it over with Ray in his motel room. It was the beginning of a long, mutually profitable relationship—Yordan would write and produce more Ray films than any other person—though never a very talkative one. "Nick didn't hardly ever say anything," Yordan explained. "In

fact, he would sit with his back to you when you talked to him. Look out a window, even if it's night. And I would say something and wait fifteen minutes, then Nick would turn around and he still wouldn't say anything."

Yordan said he could revise Crawford's dialogue to give it more of an edge and he would rework the ending to contrive a more cathartic show-down between the star and McCambridge. Bob Thomas reported that Yordan revised exactly three scenes and no more. No script drafts exist to confirm any of the details, but it may be that Chanslor had given Johnny Guitar too much action at the climax. The on-the-spot changes would leave Johnny out of the showdown entirely, giving Vienna and Emma the death duel that became the film's cult-favorite finale.

When Ray grew morose about all the infighting, Yordan tried to cheer him up. "When you get up in the morning, when you are shaving and look-ing into the mirror, say to yourself, 'I'll *never* work with Joan Crawford again,' and then in eight weeks it'll all be over." Yordan waited forever for Ray to say something, until finally the director spoke: "Never is a long time."

The location rewrites gave an added smartness and toughness to Crawford's dialogue. The romantic repartee between Vienna and Johnny Guitar, in particular, was at times like screwball comedy delivered with solemn faces.

JOHNNY: How many men have you forgotten?
VIENNA: As many women as you've remembered.
JOHNNY: Don't go away.
VIENNA: I haven't moved.
JOHNNY: Tell me something nice.
VIENNA: Sure, what do you want to hear?
JOHNNY: Lie to me. Tell me all those years you've waited. Tell me.
VIENNA: All those years I've waited.
JOHNNY: Tell me you'd have died if I hadn't come back.
VIENNA: I would have died if you hadn't come back.
JOHNNY: Tell me you still love me like I love you.
VIENNA: I still love you like you love me.
JOHNNY: Thanks. Thanks a lot.

It wasn't hard to rewrite Chanslor, Yordan recalled; the whole script was "nonsense" anyway. "I think it took me about a week," he recalled. But Wasserman informed the writer, "You're on payroll for the whole picture,

so you'd better stay on." Yordan remained on the payroll as the studio's liaison on the set, in effect taking over from Ray as the "acting producer" of *Johnny Guitar*. To the already grueling daily schedule of seven A.M. calls were now added nightly script conferences, with Yordan and Ray and Crawford sitting in and going over the next day's pages.

For Ray, losing this standoff with Crawford meant losing one more recognition he sorely wanted. He wouldn't see his name up on the screen as producer—now or ever.

<center>✳</center>

Filming resumed after Yordan had sufficiently massaged the script, but Crawford—whom Ray later called "one of the worst human beings" he'd ever encountered—never stopped treating the director like a Judas. Making *Johnny Guitar,* first in Sedona and later on soundstages in Hollywood, was an "appalling" experience, Ray told Gavin Lambert a few years later. "Quite a few times I would have to stop the car and vomit before I got to work in the morning," he recalled.

Ray tried forging a bond of solidarity with Sterling Hayden, but the actor playing Johnny Guitar wasn't enjoying himself either. Hayden recalled it as "an extremely difficult time for me." He was haunted by his HUAC testimony. His marriage was on the rocks, yet his wife insisted on keeping him company on location. (The couple would marry and divorce three times.) He felt foolish toting around a guitar. "I can't play guitar and I can't sing," Hayden said in one interview. "They put twine on the guitar so, in case I hit it, it wouldn't go 'plunk.'"

The director connected deeply with only one of the four leads: the stage-trained Mercedes McCambridge. In his novel Chanslor had described Emma's "hate-mottled face," and Ray exhorted McCambridge to become "straight sulphuric acid," in his words. The actress exulted in the part of the unhinged rabble-rouser. There is no more riled-up woman in any Western.

Crawford never stopped treating her costar like her real-life enemy. The rivalry between Crawford and McCambridge, real enough behind the scenes, fueled their animosity on-screen. Cast members were forced to choose sides, and most chose McCambridge. Crawford told friends and reporters, in late-night drunken phone calls, that the younger actress was a "witch" trying to lay a curse on her. Their feud, initially reported in Arizona newspapers, traveled with the company back to Hollywood and filled

show business columns in the *Los Angeles Herald Examiner,* the *Los Angeles Mirror, Confidential,* and many other publications.

"I wouldn't trust McCambridge as far as I could throw a battleship," Crawford told the press.

"I tried to talk to Joan—to reason with her, but she turned her back on me," rejoined McCambridge, a strong-willed woman who didn't surrender easily.

Hayden chimed in: "There is not enough money in Hollywood to lure me into making another picture with Joan Crawford. Her treatment of Mercedes was a shameful thing."

"If I ever see her [Crawford] again," said Hayden's wife, who had also clashed with the steely-eyed diva, "I'll probably strike her in the face."

The director stood by, wringing his velvet-gloved hands, saying almost nothing on the record (though later he was a source for Bob Thomas's Crawford biography). The iron fist was not an option when your leading lady was also the producer. Later, rehashing events in her memoir, Crawford didn't admit her affair with Ray and refused even to mention McCambridge by name. She did suggest, however, that the director may have connived and rejoiced in the feud.

At one point, according to Crawford, she was speaking by phone to an old journalist friend, the columnist Harrison Carroll, urging Carroll to stop covering the on-set bickering, when the director happened by and grabbed the phone out of her hand. "Keep it going, Harrison! It's good for the picture!" Ray bellowed into the phone, according to Crawford.

He was right: The feud *was* good for the picture—both for its publicity value and for the tension it lent to the actresses' performances. For that matter, Ray's breakup with Crawford may have been good for the picture too. "Whatever works, works," as Kazan had said. Crawford had been playing steel-plated ladies for two decades; she didn't really need a director to tell her what to do. Her persona was as well defined as Bogart's or Mitchum's. But her furious, glint-eyed performance was one of the best any actress ever gave in a Nicholas Ray film and never did she seem as tortured a romantic as she did in this picture, under her former lover's direction.

At Republic, the interior shooting for the Western wound down in early December, and then Ray plunged into the editing room with one of the studio's expert editors, Richard L. Van Enger, who'd won an Oscar for *Sands of Iwo Jima.* They stuck a Peggy Lee ballad on the end of the film, and the release of *Johnny Guitar* was scheduled for May 1954.

✳

Once again, regardless of all the offscreen drama, Ray had proven his mettle with a touchy star. He had taken a well-worn genre, imbued it with his personality and style, and extracted a final result that pleased the studio. The nasty gossip about the Joan Crawford Western, as everyone in Hollywood understood, was icing on the cake. Ray's name suddenly seemed to be on every producer's lips, and MCA's Herman Citron was quickly able to shuttle Ray into another Western with another ex-Warners' star.

This time the suitor was a major studio, Paramount, which had been tempted by a relationship with Ray one year earlier before pulling the plug on the expensive *Lisbon*. The producers were William H. Pine and William C. Thomas, the so-called Dollar Bills who ran the studio's B unit with a knack for thriftily accounted pictures that always made money.

James Cagney was the star of the new Western, called *Run for Cover*. Although Cagney's involvement gave the project a "shaky A" status, the Paramount Western still had a smaller budget than *Johnny Guitar;* Ray's salary would also be smaller, because the script was ready to go when he signed his deal. MCA got him three thousand dollars weekly for ten weeks of preproduction and filming, starting in mid-March 1954.

Like Crawford, Cagney had come to the end of a long-running obligation to Warner Bros. Earlier in 1954, he had folded the separate independent company he ran with his younger brother William. After nearly a quarter century as a reliable box-office icon whose tough-guy veneer rivaled Humphrey Bogart's, Cagney was freelancing for the first time.

Though Cagney was a horse lover and outdoors enthusiast, his Hell's Kitchen accent made him an unlikely candidate for Westerns; his only previous attempt, 1939's *The Oklahoma Kid,* had been a send-up of the genre costarring Bogart. Though Cagney was considering retirement, he was enticed into *Run for Cover* by an original story that let him play the rare good guy, and by the Dollar Bills' agreement to shoot at least 30 percent of the film out of doors in the real West.

Cagney's part was tailored for the actor; he would play Matt Dow, a gentle man, capable of violence, who was trying to leave behind a mysterious past including a wrongful conviction and prison term. Cagney had approval over the studio's choice of director, but he was won over first

by Ray's reputation for working with actors and then, in person, by the man, as pensive and enigmatic as Cagney himself. Having spent much of his career working with studio contract directors, the star was hoping for something unusual, even offbeat, with Ray at the helm.

By the time Ray was hired, Irving Ravetch and Harriet Frank Jr. had turned in their story treatment, and Winston Miller was putting the finishing touches on the screenplay. Miller, who helped write John Ford's *My Darling Clementine,* among other solid credits, said that Cagney himself had a hand in the script. "I was in my office one day when he appeared at the door and introduced himself, said 'I'm Jim Cagney,'" recalled Miller. "I said, 'I know.' He said he liked the script and would I mind if he made a suggestion. I said, 'Of course not.' He said this had nothing to do with his part, and he was so humble, almost, so considerate of the way you wrote something . . .

"His suggestion was that if I built up the part of the heavy it would help the whole picture. He was quite right. But he was so modest about wanting to make a suggestion."

Miller never even met Ray. By the time the director took charge of the Western, the schedule had been set, the sequences broken down for costs, and the start date was coming up fast. The director concentrated on organizing the cast and crew and planning the photography.

The second lead in *Run for Cover* was a character named Davey, a young man befriended by Matt Dow. On the trail together, Matt and Davey both get caught up as innocent bystanders in a train robbery. The two men are mistaken for robbers, and Davey suffers crippling injuries at the hands of a rabid posse. When Matt becomes sheriff of the local town, he makes Davey his deputy, but the injured young man remains resentful and turns to crime.

For the part of Davey, the director thought right away of John Derek. The young star of *Knock on Any Door* had made strides in his career since they'd worked together, and Ray thought he could improve on Derek's inhibited performance in their first film—an opportunity to correct a failure that had stuck in Ray's craw. The character Derek would play was another tough kid desperate to prove his manhood—like Bowie from *They Live by Night,* Turkey in *Johnny Guitar,* or Nick Romano, Derek's earlier role in *Knock on Any Door.*

For Cagney's love interest, the Swedish rancher's daughter who falls

in love with Matt Dow, Ray picked the Swedish-born actress Viveca Lind-
fors. He cast Grant Withers as the heavy and called back Ernest Borgnine,
from *Johnny Guitar,* as an auxiliary bad guy. The other billed actors were
all new to his pictures.

<div align="center">*</div>

Sentimental about Colorado, which had served him well during the
making of *On Dangerous Ground,* Ray scouted out a patch of high country
on the edge of the San Juan National Forest, and by the last week of May
the *Run for Cover* company was deployed above Durango near the small
town of Silverton, whose streets and buildings could be tricked up to look
like the Old West.

The director and his simpatico star tried to make a few changes to
Winston Miller's script, at one point devising an episode with Indians
playing a game Ray had researched—a sort of horse polo with hats—which
was intended as a departure from standard Hollywood Westerns. ("What
do they do," Ray mused, "when they're *not* being Indians?") But the omni-
present Dollar Bills frowned on departures from the officially approved
pages, and their tinkering was constrained.

Try as he might, Ray still couldn't find the key to unlocking John
Derek. The handsome young actor wasn't as stiff this time as he had been
in *Knock on Any Door,* but neither was his character as well-rounded, or
sympathetic, as Nick Romano. And Derek still couldn't deliver on his big
emotional scenes. One person who knew them both thought that Derek
was nervous because he believed that Ray nursed a platonic crush on him.

Viveca Lindfors, the female lead, found Ray ambiguous, an insecure
man who hid behind his image as a "controlling" genius. Like Joan Fon-
taine, Susan Hayward, and Joan Crawford, the actress listened to the di-
rector, then went her own way. "He's a talented man, a combination of big
shot ... I mean, he really thinks of himself as a very brilliant human being,
right?" Lindfors said later, but "on the other hand, there's a fragility there
that makes him protect something, so it's very difficult to be open with
Nicholas . . .

"In my estimation," the actress continued, Ray didn't "know how to
meet anybody on equal ground. It didn't bother me at all in those days. I sort
of even was seduced by his soft-spoken, kind of sensitive" directing style.

In Cagney, however, Ray found another champion. Most directors stood back a safe distance from the self-made, instinctual actor. Cagney wasn't accustomed to intelligent counsel from directors, but he welcomed it. Cagney was never much of a parent figure or sex symbol, but Ray ushered him ably through surrogate-father scenes with Derek and graceful romantic ones with Lindfors. Cagney's standout scene was a most anguished moment at the end of the film when he believes he has no choice but to kill the treacherous Davey; then, realizing too late that Davey had been about to repent, he weeps, abjectly, before the camera.

The director said later that he tried to draw on the star's natural "serenity," his "great love of the earth" and "understanding of loneliness." The result was a heartfelt performance. But Ray himself later admitted that "the vehicle itself wasn't strong enough" to support the performances and complained that he "didn't have enough time" to be inventive. Cagney would always hail Ray as "a good man" who tried hard to make *Run for Cover* a good film, and to the end of his life the star remained furious about bits that Ray shot that were left on the cutting room floor.

"Both Nick Ray and I had put in some ingenious touches," Cagney complained to biographer John McCabe. "Offbeat stuff. But the assholes who cut the picture were unhappy with anything they hadn't seen before, and when the things we put in would come up—because they were too new to the boys who were sitting in judgment on what should have been in the picture—anything that was novel was out.

"It became just another programmer."

❖

In late April 1954, just before Ray started filming *Run for Cover,* Republic studio chief Herbert J. Yates tried to organize a premiere party for *Johnny Guitar* for "live" broadcast on KTTV in Los Angeles. But the event fizzled when Sterling Hayden declined to attend, Mercedes McCambridge claimed her invitation never arrived, and Joan Crawford contrived to be somewhere else that day. The bad blood lingered. "I should have had my head examined," Crawford told an interviewer years later. "No excuse for a picture being this bad or for me making it."

Many American critics agreed at the time. The *Hollywood Reporter* described the Joan Crawford Western as "one of the most confused and

garrulous outdoors films to hit the screen for some time," while Bosley Crowther in the *New York Times* pilloried it as "a fiasco . . . a flat walk-through—or occasional ride-through—of western clichés." Mae Tinee in the *Chicago Daily Tribune* thought it was preposterous, self-conscious, and "just plain pathetic."

While a few U.S. critics found the film superficially entertaining, reviewers in England and France, where Ray continued to boast an auteurist cachet, saw it as something else altogether: a film with hidden delights. Though she decried the film's dialogue, which "never strays a syllable from the intense," the *London Spectator*'s Virginia Graham was among the first to notice that *Johnny Guitar* may be "all hopelessly unconvincing and foolish, but because it is acted with such dedicated earnestness, and is, in a sense, a parody of itself, it gives a perverted pleasure."

Francois Truffaut reached deep into his bag of superlatives to praise the new Western. "The realism of words and poetic insights," the *Cahiers du Cinéma* auteurist rhapsodized, is "much like Cocteau. This film is a string of preciosity, truer than the truth. . . . It is dreamed, a fairy tale, a hallucinatory Western. . . . *Johnny Guitar* is the *Beauty and the Beast* of Westerns, a Western dream. The cowboys vanish and die with the grace of ballerinas. The bold, violent color (by TruColor) contributes to the sense of strangeness; the hues are vivid, sometimes very beautiful, always unexpected."*

Besides noting the strangeness of the characters, the "hallucinatory" colors, and the "emotional quality" of the camerawork ("Crawford often appears from above on her balcony, worshipped by the camera in low-angle," as fellow critic Roger Ebert wrote years later), Truffaut saw three distinct levels to the Western: Freudian, political, personal. The last was the most important for the *Cahiers* group, which was largely apolitical or moderate politically (except for Godard). Above all, according to Truffaut, *Johnny Guitar* should be recognized as an allegory of the director's life story, with a link to certain life-story allegories that Ray previously had directed. "Bazin agrees with me here—how much Ray's life resembles his films," Truffaut observed. In his view, the director's tumultuous divorce from Gloria Grahame suggested a link between Ray's *In a Lonely Place*—with Bogart almost strangling Grahame's character—and the Joan

---

\*    Even so, Truffaut, at this juncture, considered Ray's *They Live by Night* to be "still his best film."

Crawford Western. "One can imagine," wrote Truffaut, "our lovers meeting again six years later. He has become a guitarist, she runs a gambling-joint out West, and here is the end of *In a Lonely Place* running neatly into the beginning of *Johnny Guitar,* with Crawford replacing Gloria."

There were so many allegorical meanings tucked inside *Johnny Guitar,* Truffaut conceded, that ordinary moviegoers shouldn't be expected to fathom them all, at least not at first. "The public on the Champs-Elysées wasn't mistaken to snicker at *Johnny Guitar,*" the auteurist and Ray admirer admitted. But Truffaut went on to make a bold prediction. "In five years," he wrote, "they'll be crowding into the Cinema d'Essai to applaud it."*

Truffaut was right about one thing certainly: *Johnny Guitar* had a crowd-pleasing future. Over time it has become a particular cult favorite, especially for gay viewers. (The documentary *The Celluloid Closet* notes, for example, how Ray's costuming for Crawford—her black gunslinger apparel—sent signals that straight audiences didn't always notice.) And audiences may have taken longer to catch on to the film in Europe, but in the United States it happened right away in 1954. The Joan Crawford vehicle became a surprise modest hit for Republic, aided by its pairing in many cities with an "added first run attraction"—John Ford's *The Sun Shines Bright*. Ticket sales stretched out over the summer. Though not quite a blockbuster, *Johnny Guitar* helped Ray turn a corner in his career, proving he could thrive outside of RKO and put his distinctive stamp on a Western.

---

\* The Cinema d'Essai was on the Right Bank on the Avenue des Ternes. It was not exactly a revival house. Originally it was intended to show "difficult" films of all sorts.

CHAPTER EIGHT

# *The Golden World*

## 1954–1955

For once, during the summer of 1954, Nicholas Ray could bask in the sun. *Johnny Guitar* was running up ticket sales, and his next Western, starring James Cagney, was well along in postproduction. The director's "Hollywood dinner dates, which had been cancelled after the bad reviews of *Johnny Guitar*," according to the *New York Times,* reporting Ray's own recollections, "were reinstated when the film became a big money-maker."

In July, Ray traveled to Wisconsin to visit his mother and his sister Helen's family and go boating on the Mississippi. "Wisconsin has never been so beautiful," Ray told the local press. "I flew in from Chicago, and I've seen the state from the air, the land, and the water. There's a lovely warmth and a special quality in the landscape."

In August, Ray earned a bit of easy, if not big, money staging a half-hour television episode of *General Electric Theater* called "The High Green Wall." Broadcast later in October, the show, starring Joseph Cotten, was based on an Evelyn Waugh story. Besides *Sorry, Wrong Number* in 1946, it was the only television show he ever directed.

For once, Ray had plenty of job offers. One place where he commanded special attention was Warner Bros., tightly run by the youngest brother, monomaniacal Jack, whose nerves twitched to think of his former con-

tract players Cagney, Humphrey Bogart, and Joan Crawford now flourishing independently under Ray.

In September 1954, after a Paramount rough-cut screening of *Run for Cover,* Ray invited Lew and Edie Wasserman home with him for dinner. He was living these days at the Chateau Marmont, a sprawling, castle-like complex of buildings towering over Sunset Boulevard west of Crescent Heights. Ray occupied Bungalow 2, a large, free-standing three-bedroom unit just inside the gates of the compound. The swimming pool ran along the back. The Chateau's elite clientele included Marlon Brando, playwright Clifford Odets, and the up-and-coming writer Gore Vidal.

After dinner, Ray and the Wassermans sat down to watch *Dragnet,* the popular true-crime show, on the director's giant black-and-white Madman Muntz TV set. Ray was in a sour mood, after having just watched the producers' businesslike cut of the Cagney Western, with many of his personal touches—like the polo-playing Indians—excised from the film. Ray cleared his throat, warming up to make a point. Wasserman knew better than to hurry his ruminative client. Finally, the director spoke.

"I'm tired of doing films for the bread and taxes," Ray said. Wasserman raised an eyebrow. "I want to make a film that I love," the director continued. "I have to believe in the next one or feel that it's important."

"What's important to you?" the head of MCA asked.

"Well, there are about six productions of *War and Peace* scheduled around town, so I've given that one up," Ray joked. "Kids," he finally added, wearing a somber expression. "I want to do a film about kids growing up, the young people next door, middle-class kids. Their problems."

He had been thinking about juvenile delinquency all his life. He could even be considered something of an expert, Ray said with a slight smile, considering his own misspent youth. He admired the Spanish-born surrealist Luis Buñuel, whose 1950 film *Los Olvidados,* about the violent, criminal life of Mexico City slum youth, Ray had watched repeatedly. *Los Olvidados,* he thought, was *Knock on Any Door* done right. Ray didn't want to try to improve on Buñuel; he was through with the slum approach. But what about *middle-class* delinquents? Didn't ordinary American teenagers have a story worth telling?

"I've done my share of films about the depressed areas of society," the director continued, referring to *They Live by Night* and *Knock on Any Door.*

"The misfits. Now I want to do a film about the kid next door, like he could be one of my sons."

Ray's agent nodded thoughtfully. He wasn't sure what Ray had in mind, but he knew the studios lusted after the burgeoning teenage market. He knew that Warner Bros. had been asking about Ray's availability and that the director yearned to work for the studio, which was known for its hard-hitting, topical, populist pictures—"an adventurous studio in different periods," in Ray's words. Wasserman told Ray he'd see what he could do.

Shortly thereafter, Wasserman phoned Steve Trilling, Jack Warner's chief lieutenant, and told him that Ray wanted to make a definitive film about teenage delinquency. Warner had a grudging respect for Wasserman, a respect that bordered on fear; a few years earlier, he had actually banned the agent and his "MCA blackbirds" (as he called them, for their standard wardrobe) after they provoked too many stars into declaring their freedom from his term contracts. But Wasserman had a reputation for being ahead of the curve, and Trilling told him that Warner would be interested in Ray's pitch.

Trilling asked the story department to messenger over a couple of youth-oriented scripts the studio owned, along with a 1944 nonfiction book by psychiatrist Robert Lindner. The book had a good title, *Rebel Without a Cause,* and a long, forgettable subtitle (*The Hypno-Analysis of a Criminal Psychopath*). Employing hypnosis and analysis, Lindner had investigated the troubled childhood and antisocial impulses of one particular career criminal in a federal penitentiary, a subject identified only by his first name, "Harold."

As a director who'd been saddled, often at the eleventh hour, with lusty, dangerous, born-to-be-bad titles circled off a list by Howard Hughes, Ray was instantly drawn to Lindner's evocative title. Ray actually knew of Lindner's work already, through Jean Evans, but he rejected the psychiatrist's book and the other Warner's scripts, saying that "it was neither the psychopath nor the son of a poor family I was interested in now."

The director was sent over to the studio to meet with Trilling. The tall, square-shouldered, handsome forty-three-year-old director, his hair now flecked with gray, was in his best salesman mode, passionately assuring the portly, poker-faced, cigar-smoking executive that he could make the best teenage delinquent picture Hollywood had ever seen. Ray told Trilling that he liked the title of the Lindner book but that he didn't need

the rest of it, the medical-analytical business. He wanted to get inside teenagers' heads and hearts.

What kind of story was he thinking about? Trilling asked. The director winged his answer, calling up a number of anecdotes from his own life and others he'd read in the papers. For the next forty-five minutes, he talked easily through the story elements he wanted to explore.

Trilling was intrigued. He asked the director to put something down on paper so he could show it to Jack Warner. Ray stayed up all night with his secretary, pouring out his thoughts on the theme, which had preoccupied him all his life, personally and professionally. The result was a seventeen-page treatment he called "The Blind Run." After they finished, at seven A.M., Wasserman had the treatment rush-delivered to the studio. Trilling read it and passed it on to the studio kingpin.

Ray's seventeen pages began with a series of "searingly graphic images," as Lawrence Frascella and Al Weisel noted in their authoritative book *Live Fast, Die Young: The Wild Ride of Making "Rebel Without a Cause,"* including "a man aflame" hurtling toward the camera and "a nearly pornographic scene of a sixteen-year-old girl, stripped to the waist, being whipped by three teenagers." Warner Bros. could hardly be expected to allow such shocking images in a finished film, but no matter: "The Blind Run" was intended as an attention grabber, not a final product.

Some of the material in "The Blind Run" was disposable, but the treatment also contained a number of "key concepts" that helped shape the eventual film, according to Frascella and Weisel. Chief among them was the film's "teenage trinity," including "a heroic boy (who would grow into the iconic figure of Jim Stark), a girl named Eve (who would lose her biblical overtones to become Judy) and Demo (a teenage psychotic who would eventually evolve into the groundbreaking figure of Plato)."

Besides the "teenage trinity," the treatment also featured a knife fight and a suicidal car contest—the "blind run" of the title, a daredevil game in which two cars charged toward each other in a dark tunnel. Perhaps the crucial distinction of Ray's seventeen pages, wrote Frascella and Weisel, was the author's proclamation that "youth is always in the foreground, and adults are for the most part only to be seen as the kids see them."

Ray's first treatment was sketchy, light on plot and heavy on sensationalism. But Warner's interest was piqued, and by the end of the day Wasserman had a deal. Not only did the agent arrange for the director's

biggest salary to date—three thousand dollars per week for the duration of an "A" production—but he also got Ray five thousand dollars for "The Blind Run" as the story basis of the film-to-be with added compensation for his participation in development of the script.

Despite paying extra for "The Blind Run," Warner Bros. was skeptical of Ray's writing ability and insisted on enlisting a professional to craft the script under the supervision of an in-house producer. Even so, Wasserman scored one all-important guarantee: Regardless of how many writers followed him, sole credit for the story would go to Nicholas Ray.

<p style="text-align:center">✳</p>

"Like he could be one of my sons": After the filming was over and Oscars were in the offing, the successive writers of *Rebel Without a Cause* would disagree about who had invented each of the film's memorable scenes. But no one could dispute that, emotionally at least, Ray saw himself as a hapless parent like the ones depicted in the film.

He felt like a bad father to Tony and Tim, and from all accounts he was not a very good one. Gloria Grahame had primary custody of Tim, and Ray tried to preserve a civil relationship with his ex-wife—even moving back into the couple's old Malibu house to take care of his young son when the actress traveled overseas to star in Elia Kazan's anti-Communist potboiler *Man on a Tightrope*. (Like so much of Ray's personal life, it seemed, this cozy arrangement was covered in the gossip columns, although in fact Ray arranged for his older son, Tony, to do most of the actual babysitting.) But it was never easy for Ray to get along with his self-absorbed ex-wife, and he threw up his hands after her August 1954 marriage to scenarist Cy Howard and the weird public announcement that his son Tim Ray had been renamed David Cyrus Howard.

Ray had time and money for girlfriends, parties, and all-night poker games, but he didn't have much time or money for Tim, six years old in 1954. In March 1958, in fact, Grahame filed suit against her former husband, claiming that Ray had fallen fifty months and $15,000 behind in child support payments, dating back to the time when he was planning *Rebel Without a Cause*. It was hardly a unique situation: All of Ray's wives chased him for support money, although the 1958 case was eventually dropped.

Sweet, volatile Tony, who turned seventeen in 1954, dreamed of becoming an actor, and his father was an expert on acting. After discovering the teenager in bed with his wife, however, Ray struggled to connect with Tony. In the best of times their relationship always had been fragile, with Ray mostly absent from his son's upbringing. "I think he hated himself to a large degree for failing as a father," mused Gavin Lambert. "He should never have had kids. . . . He should never have been married. Nick had quite a few guilts. This was one of them. And it influenced his approach to [*Rebel Without a Cause*]."

<p style="text-align:center">⁕</p>

Warner Bros. gave Ray his pick of staff producers, and he chose David Weisbart—because, as he often noted, Weisbart was the youngest producer on the lot (not quite forty), and he had two teenage children of his own. A top editor at the studio throughout the 1940s, Weisbart had been nominated for an Oscar for 1949's *Johnny Belinda;* more important, his last editing job before turning producer was for Elia Kazan on *A Streetcar Named Desire.*

In many ways, Kazan cast a long shadow over *Rebel Without a Cause.* Ray's old lefty theater colleague had offices at Warner's now, where he was immersed in postproduction for *East of Eden,* the first picture to star a young sensation named James Dean. Ray acquired a suite of offices nearby, and he and his onetime mentor drew closer as friends if not quite equals. They were united by their shared HUAC ordeal and by Kazan's experience directing Gloria Grahame in *Man on a Tightrope.* Kazan found the actress a spoiled child, and it ratcheted up his respect and empathy for Ray that he could have stayed married to such a woman for even five minutes. Although Kazan was never very effusive about Ray's films in public, he also had a growing, if grudging, regard for him as a fellow director.

As Kazan was finishing *Eden* and Ray was starting work on *Rebel,* the two found rare free time to socialize. The two directors got together with Clifford Odets, and also with writer Budd Schulberg, another tough guy who had turned "friendly" for HUAC. Schulberg, a boxing fan, was trailed by boxer friends wherever he roamed. He talked about writing the life story of a New York boxer, a onetime undefeated middleweight named Roger Donoghue who had quit boxing after his knockout punch killed a

foe at Madison Square Garden. Seeing the idea as a possible film project, Ray collected sixteen-millimeter newsreel footage of bouts he watched late at night when others dropped off to sleep.

Ray befriended the twenty-four-year-old Donoghue and hired him as an adviser on his upcoming film. Tall and handsome, with curly hair, twinkling eyes, and an Irish capacity for drink, Donoghue had showed Brando boxing moves for *On the Waterfront;* for *Rebel Without a Cause* he would teach James Dean how to duck and glide.

Weisbart, a modest, diplomatic man who knew the ins and outs of production, came highly recommended by Kazan. Ray felt he had had bad luck with producers; he considered them a breed apart, loyal first and always to money and management. (The producers in *In a Lonely Place* are repugnant characters, hotshots and blowhards.) Thanks to Kazan, Ray would have good luck with Weisbart, the only producer besides John Houseman whom Ray called "outstanding," by which he meant standing behind him.

Weisbart was deferential when it came to finalizing the script, which was one weakness of his résumé. Ray's first challenge was resolving the Robert Lindner situation. According to Frascella and Weisel, the studio "insisted" that the director accept Lindner's title, *Rebel Without a Cause,* as the title of his film-to-be, since the studio had paid the sum of five thousand dollars for the rights to Lindner's book—the same amount they'd paid Ray for "The Blind Run." But they couldn't have had to fight very hard: Ray coveted that title, and there were also some ideas in Lindner's book he was happy to borrow as he shaped the story.

A Baltimore native, Lindner had been widely hailed as a leading authority in his field—as well as "a fine storyteller"—by Ray's ex-wife Jean Evans, who reviewed one of his books for the *New York Times.* Lindner was one of many authors trading on the public fascination with Freudian theories during this era; his 1955 book *The Fifty-Minute Hour,* comprised of case studies of individual patients—including a chapter called "The Jet-Propelled Couch," about a brilliant physicist who created and inhabited an imaginary science-fictional world—is still considered a classic in the profession. Another of Lindner's fans was producer Jerry Wald, who had brought *Rebel Without a Cause* to Warner's in the late 1940s and oversaw several script versions of the book, including an early one penned by Lindner himself.

Ray made a point of meeting Lindner when the psychologist came to Los Angeles in November 1954 as part of a national lecture tour. Ray listened to Lindner's talk, which defended middle-class teenage delinquents as rebels against insidious social conformity, and afterward attended a cocktail party in his honor at the Beverly Hills Hotel. Ray introduced himself to the psychologist as the director of the Warner's film that would take its title from his book. When Lindner pleaded to be hired as a consultant on the project, however, Ray rebuffed him—much to his astonishment—and shut the psychologist out of any future participation.* Lindner later threatened legal action against Warner Bros., but the studio adopted the legal position that it owned the film rights to his book free and clear, and that included the right to use his title as they saw fit.

<center>✳</center>

More than ever Ray was determined to go out on a limb and make a film that was entirely his own. From the very beginning of the process, he committed himself as never before. He was determined, this time, to avoid unseemly compromises, to fight every battle—to subsume all ideas and influences and collaborators under his own banner.

Ray borrowed at least one core concept from Lindner's book: that psychopathic criminal behavior was often reflected in an alienated or deviant sexuality. This was also a central motif of *Knock on Any Door*—the novel, not the tame film version. Back then, Ray had distanced himself from the subtext, which may have struck too close to home. But time, and the power handed to him by Warner Bros., emboldened him now, and as the script evolved, the character of Plato, youngest of the "teenage trinity," inched toward a conflicted or closeted sexuality.

Who should write the screenplay? That was the next battle Ray had to fight. The appointed writer had to harmonize with the director, who had written "The Blind Run" in an all-night sleepless dream state. He would have to create a through-line with the main characters of "The Blind Run" that satisfied the studio executives, censorship officials, and especially the director—and in order to please Ray, the writer would have to learn

---

\* In 1956, a year after *Rebel Without a Cause* was released, Lindner died of a heart ailment at the age of forty-one.

to interpret his frequently abstruse ideas and cryptic silences. "Are you a mind reader?" hatcheck girl Martha Stewart asks Humphrey Bogart in *In a Lonely Place*. "Most writers like to think they are," Bogart replies.

Establishing a relationship with a compatible writer was almost as formidable a problem in the director's career as finding a sympathetic producer. Charles Schnee had been an effective collaborator at RKO, but no other writer had worked subsequently with Ray more than once. The foundational work on the Bogart films, flaws and all, was Robert Lord's and done largely without Ray's involvement—although he could claim yeoman service on the final act of *In a Lonely Place*. He had left the heavy lifting on *The Lusty Men* to another writer-producer, Jerry Wald, though Ray made equally vital on-the-spot contributions to Robert Mitchum's scenes. Ray had allowed Philip Yordan (or one of his "surrogates") to sprinkle fairy dust on *Johnny Guitar* and had never even met the scenarist of *Run for Cover,* his latest picture.

Working with friends or acquaintances on his own time and dime, Ray hadn't yet gotten any of his original ideas made into films. Although studio professionals had worked on all his produced pictures, over time the director had come to view Hollywood writers as compromised, conflicted creatures, like Dix in *In a Lonely Place*. Playwrights (they always stank of the gallows) or literary novelists (not the bestselling variety) were more legitimate; they worked from scratch, originating stories that were unconstrained by movie conventions or censorship. Ray had once aspired to be a poet or real writer, like his early mentor Thornton Wilder, someone whose work was worthwhile and enduring. Saddled too often with contract writers, Ray yearned for outsiders with blue-ribbon names.

First Ray bid for the services of Clifford Odets, lately his neighbor at the Chateau Marmont. Ray had worshipped Odets since the 1930s; besides their onetime left-wing beliefs, the two shared a taste for drinking and womanizing, and during the mid-1950s they bonded as never before. But it had been ten years since Odets had written an original motion picture. His plays, while enshrined in the culture, were seen as left-wing or highbrow. Hollywood viewed Odets as more of a script doctor, and that would become his circumscribed role on *Rebel Without a Cause*. David Weisbart nixed Odets as the lead writer, but the playwright stayed on call as the director's muse, making suggestions big and small. As Odets worked with Ray to define the character of Jim Stark (James Dean), for example, the

playwright urged the director to "find the keg of dynamite he's sitting on," obscure advice, perhaps, but as Ray later recalled, "That one single concept helped me tremendously in building the character."

Weisbart and Warner Bros. preferred a writer already on the lot, which was better for the budget and for supervisory purposes. From a list of available names, Ray and the producer gravitated to Leon Uris, who'd just finished a script based on his semiautobiographical novel *Battle Cry,* about the love lives and battle sacrifices of young marines in the Pacific during World War II. Like A. I. Bezzerides, who had written *On Dangerous Ground,* Uris was a legitimate novelist, and after meeting with Ray and Weisbart he warmed to the idea of a bellwether film about lawbreaking middle-class teenagers.

Uris was known for his research methods, and Ray maintained his fondness for factual research as background in preparing a film. "Documentation" helped to preempt any criticism of socially edgy films. Reading authoritative sources, consulting specialists, mingling with real-life counterparts of screen characters—increasingly, this had become Ray's methodology, one way to invest his vaunted "emotional reality" with genuine reality.

For *Rebel Without a Cause,* Ray, joined by Weisbart and Uris, lined up judges, social workers, child psychologists, and police officials to shed light on the roots of juvenile delinquency. The director himself spent "sixty five hours in a juvenile division police patrol car, gathering data and impressions," according to later studio publicity. He drew on his meetings with these authorities in shaping the story, and—just as important—secured their official declarations of support. Such official endorsements allowed the studio to plan an unusual "exploitation campaign," as Ray forecast in a studio memo, "forthcoming on a national scale," delineating his film as being "fresh, different and as realistic as the headlines."

Ray added actual teenage youth gang members to his list of preferred "experts" and even asked the studio for permission to arrange the pretend arrest of his nephew, Sumner Williams, so that he could mingle with juvenile offenders and report back. "He's 25, looks 28, ex-G.I., so can handle himself, knows what we're looking for, etc.," Ray wrote to Weisbart. "I think it's a good idea."

Uris's hiring appears to have short-circuited the fake-arrest idea, and the new writer took up the research gauntlet, riding around in police cars,

attending juvenile court sessions, apprenticing for ten days as a social worker at the juvenile hall of the downtown Los Angeles Police Department. By October 7, the director was able to send Weisbart an upbeat report on Uris's progress, noting that he "is not only gaining insight to the problems and characters, but is already beginning to talk story characters and scenes. In other words, the excitement gathers."

That was before Uris had put anything down on paper, however. When the writer submitted his first take on the prospective film, a five-page sketch of an imaginary town faced with a teenage crime wave, dated October 14, 1954, Ray's gathering excitement deflated. Uris's treatment offered a too "intellectual approach," Ray felt, and the writer's subsequent twenty-four-page treatment and revision, dated October 20 and November 1, were pocked with "tedious, clichéd descriptions of adults' petty, quotidian small-town lives," in the words of Frascella and Weisel, while neglecting Ray's chief goal: capturing the inner angst of the teenagers.

Uris had dubbed his treatment "Rayfield," as a humorous nod to the director. But the title alone "made me vomit," Ray said later, ungenerously. Uris had failed to divine and interpret Ray's secret thoughts. "It was like an eye test at the optician's," as Ray explained later. "Could he read the characters in my mind as he might a chart on the wall?"

Weisbart agreed with Ray. Uris was summarily discharged. According to Frascella and Weisel, though, the writer's work wasn't entirely discarded. In his treatment, Uris "did create a tender image that survives into the final film—Jimmy protectively covering his sleeping friend Plato with his jacket. Uris also depicted Amy—who would become Judy, the Natalie Wood role—as starving for her father's affection. Uris wrote that she 'tries to replace her mother . . . become the wife of her father.'" The members of Ray's teenage trinity all had inadequate parents, but the fathers were especially hapless.

<p style="text-align:center">✳</p>

Although East of Eden would not be released until March 1955, Hollywood wags were already touting its debuting star, James Dean, as the new Marlon Brando. Ray first heard about Dean from Elia Kazan and his wife, Molly, at a dinner where Kazan inveighed angrily against the impossible young actor. Ray crossed paths with Dean at rough-cut screenings of the

Kazan picture, but Dean was "aloof and solitary," as Ray recalled. "We hardly exchanged a word. It didn't occur to me that he was the ideal actor for my film."

Ray pined to work with Brando, the most compelling actor in postwar Hollywood, but after his triumph in Kazan's *A Streetcar Named Desire* Brando had shot into the sky like a nova; for the foreseeable future he was booked up with the most prestigious first-tier directors. Kazan didn't think that Dean, "a far, far sicker kid," unruly, undisciplined, and solipsistic, merited the comparisons to Brando. Directing Dean had been a struggle; Kazan had had to resort to flattery and insults, coaxing and bullying. But Dean was right for *Rebel Without a Cause,* and Kazan thought Ray could handle him.

Twenty-three in the fall of 1954, Dean was hardly a teenager. And he was an unknown quantity to the general public, which knew him only from "live" television. In person the young actor was a slight, almost fragile-looking man-child, always mumbling about fast cars and jazz when he wasn't mumbling about truth and art. Uncombed and sleepy-eyed, dressed in T-shirt and jeans and cowboy boots, faintly bored with everything, he was the most charismatic person in the room, wherever he happened to be. He sought truth in acting but also, he made it clear, he was looking for truth in living. Though he was capable of both wit and warmth, he was haunted by deep-seated loneliness, anger, and pain.

Like Ray, Dean was a displaced midwesterner, born in small-town Indiana. Both had lost a parent in youth (Dean's mother had died of cancer when he was nine; "he could never quite forgive her for that," Ray recalled). In most ways, the two men made a sublime mirror image. Yet at first they circled each other noncommittally. Everyone knew that Ray was planning a major film about teenage rebels; everyone knew that Dean, under contract to the same studio, Warner Bros., might or might not be interested in the gig. Many who were there have described how their initially cautious relationship evolved, over several months, from a steady courtship and mutual seduction into a slow dreamy tango.

Dean started dropping by Ray's office, acting "warily interested" in the teenage delinquency film, in Ray's words. Then, one night, the actor dropped by Ray's bungalow at the Chateau Marmont. Upon entering, Dean turned a back somersault, bringing a smile to Ray's face. "Are you middle-aged?" Dean teased the director, who was old enough to be his

father. Dean had brought along an entourage—including actor Jack Simmons and the local television horror show hostess known as Vampira—and coaxed Ray to tell them the story of his escape from the Clover Club fire, delighting in his story of walking over glass shards carrying his pet dog.

Later, Ray said that Dean was probably more cat than dog. "Maybe a Siamese," the director mused on one occasion. "The only thing to do with a Siamese cat is to let it take its own time. It will come up to you, walk around you, smell you. If it doesn't like you, it will go away again. If it does, it will stay."

When Dean headed to New York for a television appearance in the fall, the director followed in his tracks, ostensibly to visit the Actors Studio, whose cofounders included Kazan, and to interview budding young thespians studying the Method under Lee Strasberg. Along with a Warner Bros. talent executive, William T. Orr, Ray met or auditioned several dozen East Coast actors and actresses during the trip.

The director checked in with Jean Evans and his teenage son Tony but kept his eye on the main chance, sniffing Dean out at his East Sixty-eighth Street fifth-floor walkup, full of books and records (jazz, classical, African tribal, Afro-Cuban song and dance); racing, bullfighting, and sailing posters; and bongo drums. On a music stand was the score of Berlioz's *Harold in Italy,* which Dean was "studying assiduously," in Ray's words, at the recommendation of composer Leonard Rosenman, who was finishing the score for *East of Eden.* Dean played his favorite records for Ray, changing them excitedly midsong.

Together Ray and Dean went to see *Jour de fête,* Jacques Tati's 1949 comedy. The actor was "morose as he entered the theater," Ray remembered, but was so overcome by wild laughter at the French comedy that the two were asked to leave. The director introduced Dean to his son Tony, and Dean invited the aspiring actor to the all-night bongo parties that Dean thrived on. "I put him together with my son, who was Sal [Mineo]'s age," Ray explained later, "to see how he reacted to a youth of that age. And it was wonderful." In a small way, Tony helped his father win over Dean.

The conversations between Ray and Dean revealed a curious coincidence: They shared the same psychiatrist, Dr. Van der Heide in Beverly Hills. And by the end of their time together in New York, Dean had decided he trusted Ray enough "to impart a confidence," in the director's words, confessing that he had crabs and asking what he should do. Ray

took him to a drugstore. "I want to do your film," the grateful actor told him. "But don't let *them* know it." It would be "us vs. them," i.e., Warner Bros., all the way. The two shook hands on it.

Their sniffing courtship continued, though, as there were various snags that had to be overcome. For one thing, a number of other, more luminous directors were wooing the new Brando, including George Stevens, who was fresh off the Western *Shane* and the Montgomery Clift–Elizabeth Taylor drama *A Place in the Sun*. Dean's schedule after *East of Eden* was still up in the air, and after the young star's tussles with Kazan, Warner Bros. had adopted a wait-and-see attitude. Dean himself felt "unsure about Ray's ability to pull off the kind of top-line movie with which he wanted to be associated," in the words of Frascella and Weisel.

Ray, however, was sanguine. He had achieved his best films when he was able to work at a slow, leisurely pace, an opportunity Hollywood had rarely afforded him. Writing a story or script, preparing a film, he was more comfortable taking time to ponder and study the subject, get to know people, store up thoughts and observations and ideas. Ray looked forward to spending time with Dean and studying the human being as a means of building the characterization of Jim Stark.

"To work with Jimmy meant exploring his nature," Ray wrote later. "He wanted to make films in which he could personally believe, but it was never easy for him. Between belief and action lay the obstacle of his own deep, obscure uncertainty." The same might have been said of the director.

Until he had a script in hand, Ray could afford to wait and watch. Ray had two aces up his sleeve—cards a less mellow, more controlling director, like Kazan, would not have condoned. The first was the age gap between Ray and Dean, with all its father-son implications. Like Ray, Dean yearned for a loving relationship with his father, who'd abandoned him after the death of his mother—a man Dean considered "a monster, a person without any kind of sensitivity," as Dean's friend Leonard Rosenman recalled. (Ray soon enlisted Rosenman to write the music for *Rebel Without a Cause*.)

In his own reckless youth, Ray had assiduously sought out role models and mentors. In many ways he himself would fail as a parent. But in middle age, ironically, he had begun to transform himself into a father figure for numerous young people.

As time went on, and word spread that he was developing a film about teenage rebels, Ray's bungalow at the Chateau Marmont filled up with a

host of starry-eyed young hopefuls. The director was "enthroned," writer Stewart Stern recalled, "as guru." The youngsters mingled with Ray's contemporaries, like his friend Odets, and usually an assortment of ex-boxers, some, like Roger Donoghue, also young enough to be Ray's son. Ray held regular gatherings on Sunday afternoons that were reminiscent of Taliesin or Almanack House Sundays. But other parties and get-togethers ignited spontaneously. One Hollywood columnist wrote that Ray's parties tended to start at one P.M. with bop and end at one A.M. with Bach, the music blasting continually from Ray's hi-fi. Lit by red lanterns and scented by night-blooming jasmines, Ray's bungalow became a haven for aspiring young actors flocking there from all around town.

That was Ray's first ace: Young people trusted him as a father figure. His second was that he too was a bohemian, a self-styled outsider. Where Kazan was a lordly director, Ray saw himself as one of the gang, an eternal delinquent. His club was privileged but never elitist. Ray's doors opened to a circle of trust.

While Dean in time became a regular at the director's bungalow, mingling with other young people, he was as much the star of the gatherings as Ray. And at first, Dean was slippery to lure inside the circle of trust. The troubled actor wanted a father but he didn't want to be eclipsed. He was "intensely determined," Ray said later, "not to be loved or to love."

Ray gave him trust and approval, watching and waiting. Even before Dean was official, even before an acceptable script existed, Ray had begun to absorb the actor into *Rebel Without a Cause*. "He wanted to belong and I made him feel that he did," wrote Ray later.

✳

In November, Ray and David Weisbart agreed on another writer: Irving Shulman, a novelist whose 1947 bestseller *The Amboy Dukes* realistically depicted youth gangs rampaging through Brooklyn streets. Universal had adapted the novel into a taut film, *City Across the River,* and though Shulman continued to write novels about crime and society, he had since moved to Hollywood and written scripts for a couple of gritty boxing pictures.

Ray was won over when Shulman professed his belief that adults, not teenagers, were the real delinquents in society. Shulman wasn't a researcher like Uris, but "his talent for inventing or remembering incidents

led us quickly forward," according to the director. It was Shulman, then, who recalled an item in the papers about a gang of kids staging a "chickie run," a rite of passage in which two teenagers in separate cars raced toward a precipice, seeing which of them would "chicken out" first before applying the brakes. The "chickie run" would replace Ray's "blind run," becoming a memorable highlight of *Rebel Without a Cause*.

Between them, Ray and Shulman made strides in the evolving portrait of Plato, who'd been a flat-out psychopath in "The Blind Run." In Shulman's draft, Plato would still be depicted as "a ticking time bomb," in the words of Frascella and Weisel, but with an empty home life that explained his explosiveness. Building on that idea, Shulman gave Plato a nanny, standing in for a negligent mother, and a father whose only contact with his son was his child support payments. The studio thought the absentee father was a little harsh, according to Ray, but he insisted on it "as I have two sons in that situation, and it was an idea drawn only too directly from personal experience."

Shulman's draft introduced the idea that the teenage trinity should meet on a class field trip to Griffith Park's planetarium, a local landmark and tourist attraction overlooking the city of Los Angeles. ("Confronted with a giant replica of the sky, pinpointed planets and constellations glittering on it," as Ray put it later, "they listen to a dry cosmic lecture.") Ray later claimed that he and Weisbart brainstormed this memorable set piece, but in fact he had copped it from "Main Street, Heaventown," the teenage-delinquency script he had worked on years earlier with Esther McCoy and Silvia Richards. The director "lifted it either consciously or unconsciously," Richards told Bernard Eisenschitz. "He didn't deny it when I accused him."

Shulman finished his 164-page draft on January 26, 1955. His version "has much in common with the final film," wrote Frascella and Weisel, who analyzed all the drafts, "although it reads like a distorted mirror image." One big difference was the climax, which Shulman envisioned taking place at Plato's home, surrounded by police. Ray and Shulman disagreed strongly about the location of the climax: The director wanted Plato back at the planetarium, "seeking shelter under its great dome and artificial sky," in his words, but Shulman insisted that the ending would be played better at Plato's house. "The issue made me decide that our points of view were essentially different," Ray said later.

It didn't help matters when Dean met the screenwriter one day at Ray's bungalow and the two butted heads in an exchange about cars. "Dean was disappointed to discover that Shulman's car, an MG, had neither special carburetors for racing nor wire wheels," wrote Frascella and Weisel. "Shulman, meanwhile, resented the fact that Dean wanted to buy a German-made Porsche so soon after World War II. It wasn't long before their conversation sputtered to a halt."

Like Ray, Dean held a special reverence for "important" writers: He was awestruck to meet Clifford Odets on another occasion at Ray's bungalow, considering the former Group Theatre playwright comparable to Ibsen or Shaw. Shulman didn't inspire the same warmth or respect, and eventually he, like Uris, was shown the door. Not that he minded: "I didn't like working with Ray," recalled Shulman, "and the whole project took on a nightmarish quality."

His replacement was ready and waiting in the wings.

❋

Accompanied by a clinging Marilyn Monroe, Ray came to Gene Kelly and Betsy Blair's house for their annual Christmas party in 1954, playing volleyball before dinner and charades after. The other guests included Arthur Loew Jr., grandson of Marcus Loew, the theater chain magnate and a founder of MGM, and his cousin, Stewart Stern, a balding thirty-two-year-old with the feverish look of a beat poet, who was visiting from New York.

Loew had produced and Stern had written the 1951 film *Teresa,* directed by Fred Zinnemann, a "problem drama" with a neorealist aesthetic concerning a young World War II veteran and his Italian bride. Stern had been Oscar-nominated with Alfred Hayes for the screen story (separate from the script, which Stern wrote alone). Ray told Stern how much he'd admired the movie, and a short time later Stern's agent, Clancy Sigal, phoned to say that Ray wanted to talk with Stern about a script job.

The invitation might never have been made if Stern hadn't met Ray at Gene Kelly's party, but the writer already had passed muster with Dean and Leonard Rosenman, who were guests at Loew's house that same Christmas season. After failing at small talk, Stern and Dean had plopped down into big revolving armchairs and spun around making farm-animal

noises—cows especially. "His 'moo' in *Rebel* is a souvenir of that," Stern recalled, "a kind of private hello to me."*

Despite his Oscar nomination, Stern had been fired from MGM amid a general studio housecleaning after *Teresa*. Disillusioned by Hollywood, he'd gone back to his native New York, where he was prospering in live television. The writer wasn't sure he wanted to have anything more to do with the motion picture industry.

Ray met with Stern at Warner Bros., first in his office and continuing over lunch in the commissary. The director explained he wanted to do a movie about middle-class kids who clashed with the law because of their need to act out "the emotional strivings, longings and horrors caused by terrible family relationships," Stern recalled. "He was passionate about bringing to public notice his discovery that the alienation that brought on this 'delinquent behavior' was not restricted to what were called 'ghetto families' then, but also by deep maladjustments in typical middle class families who provided no economic reason to steal, maraud, plunder or deface but every emotional reason to rebel." Emotional deprivation was just as critical as economic deprivation, Ray insisted.

The director supplied Stern with a pile of newspaper clippings, including accounts of "chickie runs" and articles depicting the lives of troubled teenagers and their families. He also gave Stern the Shulman script, without mentioning that he himself had written the treatment that was its basis.

Captivated by Ray's ambitions for the film, Stern felt his resistance to Hollywood gradually melting away. He and Ray were on the same wavelength, he felt, both soul-searching creative types. "Nick was in agony, a kind of private hell, at that time," recalled Stern. "He had a concept and a vision of what he wanted to say, but he had not found a way to say it through the writers he had had. He was almost inarticulate about what he wanted."

When Stern's turn to talk came, Ray listened intently. The writer made a powerful impression. His sincere wariness about the studio system, coupled with his preference for living in New York, endeared him to the director. Stern revealed that he was deeply involved in therapy, trying to

---

\* Jim Stark's impulsive mooing during the Taurus the Bull part of the planetarium lecture is partly what gets him into trouble with Buzz and his gang.

understand himself; that resonated with Ray, who also kept regular appointments with a "head-shrinker," to borrow Plato's terminology. Stern had to connect with a subject emotionally in order to write about it; Ray felt the same way about writing and directing. Stern was almost painfully honest, his flights of eloquence leavened with wry humor.

The two men found common ground discussing their personal family backgrounds. "Nick confided that part of his passion for the subject came from the guilt he felt about the ways he was handling his own fatherhood," Stern said, "and I confided to him the resentment, loneliness and blame I felt about my parents' relationship with each other and with me."

A fan of *Peter Pan* since childhood, Stern said he could envision the script taking on the fairy-tale mood of a "modern version" of the J. M. Barrie play, with Dean's character as a variation on Peter, and Judy and Plato, the other two members of the teenage trinity, as a Wendy stolen away from her family and a Lost Boy respectively. Ray countered with one of his own favorite sources of inspiration, saying he thought the romance of Jim and Judy ought to have a *Romeo and Juliet*–type quality. They agreed that elements of both could be woven into the final film.

By the end of the day, Ray and Stern had reached a "profound emotional agreement," the writer recalled. "Nick and I knew that we both had deep personal statements to make through the vehicle of whatever story I came up with based in part on his ideas," said Stern, though Ray agreed that he "should be freed to start from scratch."

Their financial agreement was just as profound: four figures weekly, more than Stern had ever earned. Ray urged the writer to adopt some of the same research habits as his predecessors on the script, posting him to the Los Angeles Juvenile Division. Said Stern, "I proceeded to spend many nights with its personnel there, posing, at their suggestion, as a social worker from Wisconsin, so I could witness at first hand how kids arrested that night were brought in and interviewed, sometimes with the parents summoned to meet them.

"I was allowed to have any 'inmate' brought before me for a private interview, sometimes late into the night, and as more trust was built between the officers and myself, was granted permission to read the intake reports, psychological workups and social workers' family-visit assessments of any child whose experience attracted me."

Stern's Juvenile Division notes helped flesh out the teenage trinity,

whom Shulman had named Jim, Judy, and Plato. In Judy's case, Stern noticed one girl "who was having a terrible time with her father, but she was too young to understand any of the sexual connotations. She only knew that he was constantly rejecting her. She wasn't allowed to wear lipstick—or do anything to make herself look more feminine—even though her father allowed her younger sister to do it. And that became a kind of signal for the relationship between Judy and her father."

Under Stern, the teenage trinity—and their families—began to spring to life. Plato acquired the caring middle-aged black woman who acts as his nanny (the film's only African American character). Stern saw Judy as being "in a panic of frustration regarding her father—needing his love and suffering when it's denied. This forces her to invite the attention of other men in order to punish him." He derived Jim Stark's parents from his own upbringing: a domineering mom and a submissive dad who was known to wear an apron—a burning image from Stern's youth.

Between Ray and Stern—though later they disputed the origin of certain ideas—they established the sequence of the narrative. Ray wanted a juvenile hall opening that would introduce the audience to the teenage trinity, though the three would not actually meet in the scene. Stern wrote the scene with Jim, Judy, and Plato being booked for arrest, "visible to each other through the glass walls of their interviewing rooms" in the police station. It was Ray's idea for Judy to leave her compact on the chair at juvenile hall, an item Jim then pockets as a souvenir, showing it to Judy after Buzz has been killed—"an inspired director's invention of an 'object track,'" recalled Stern. Another object track, the coat Jim is always offering to the shivering Plato, was also planted in the opening.

In subsequent meetings, Ray and Stern pinged off each other beautifully. When the director said he wanted the three teenagers to enjoy "a wonderful kind of crazy Walpurgis Night celebration" in a deserted mansion, Stern brainstormed a kind of Never-Never Land interlude, with Jim, Judy, and Plato hiding from Buzz's gang and spending time as an "idealized family," in Stern's words. Plato would pretend to be a real estate agent showing the empty house to potential buyers Jim and Judy; all three would lark about in an empty swimming pool.

Stern went along with Ray's idea that Plato should meet his fate back at the planetarium ("a sacrifice on the steps of the temple," in the writer's words). But through the years Stern always insisted that he came up with the

idea to link the rotation of the solar system to the film's circadian plot structure, with the story unfolding within a strict twenty-four-hour time frame—a crucial bit of structure as well as a nod to classical dramatic unities.

The director encouraged Stern to meet with Dean, listening to the young actor's ideas, observing his tics and traits. Stern and the young star started hanging out often at his cousin's house, talking and trading ideas on an informal basis. "Without meaning to use specific aspects of Jimmy's personality, I became infected by it," recalled Stern.

<center>✳</center>

Ray gave Stern total freedom, and if the director had an idea he didn't like, he felt free to reject it. "Nick was superb when he was superb," according to Stern.

They had only one serious disagreement before filming. Ray had been chewing over his dreams with Dr. Van der Heide; enamored of Luis Buñuel and his surrealistic approach—and worried, according to Stern, about "being able to fill up the Cinemascope screen"—the director proposed a series of split-screen fantasy sequences in the film, with one half of the screen depicting the Freudian dreams or daydreams of the teenage trinity as the real action was staged on the other half.

For example, Plato might have a dream where he imagined himself "inside a crayon drawing, singing to himself about being alone," according to film historian Douglas L. Rathgeb in his book *The Making of* Rebel Without a Cause. "A crayon car arrives with his father, who wears a naval officer's uniform. The father hugs Plato. Plato's mother appears, smiling. Plato and his father walk down the crayon road and go fishing. They sit on the bank of a blue crayon lake under the yellow stars of a crayon sky. Plato shivers. His father offers him his uniform jacket. The father has Jim Stark's face."

Or, while his mother and father argue over him, Jim might withdraw into a daydream at a shooting gallery, where he aims a .22 rifle at moving metal ducks. Three large balloons with bull's-eyes would then appear above the ducks, bearing the faces of his mother, father, and grandmother. After he shoots each balloon he runs to a service station and tries in vain to reinflate the balloons. When Jim returns to the shooting gallery, he takes aim at a new balloon decorated with his own face. Jim pleads for punishment, a shot rings out, and in the words of the script, "a look of relief passes over his face."

Ray also wanted to make Jim Stark's inner thoughts explicit by adding voice-over narration. Narration had been a routine storytelling device in Ray's radio career, and as a man fueled by inner voices, desperate to break Hollywood conventions, Ray used different types of narration as often as he could in his films.

The director had forced some of these ideas into Shulman's draft. Now he urged Stern to keep them and expand upon them. The writer dug in his heels, finding many of the conceits "pretentious and intrusive." Weisbart quietly sided with Stern, but Ray defended his experimental ideas stubbornly. He had used mirrors to similar effect, as far back as *They Live by Night*. Having been denied his split-photography experiment with *On Dangerous Ground,* he was adamant about the fantasy/reality scenes he envisioned for *Rebel*.

Ray did have one group on his side: the experts he courted during his research. Dr. Douglas Kelley, head of the criminology department at University of California–Berkeley, was one of the most prestigious consultants on *Rebel Without a Cause* (he'd been chief psychiatrist during the Nuremberg Nazi war crimes trial), and Kelley voted with the director, saying that such daydreams could accurately depict troubled minds.

Feeling pressed, Stern did write a few split-screen surrealistic scenes for Ray. But Weisbart contrived to have them rejected by the studio, and ultimately the scenes—along with the voice-over idea—were winnowed from the shooting script. Ray was disappointed; he would have to wait fifteen years, and leave Hollywood far behind, before he had another opportunity to indulge in the kinds of surrealist images, multiple voices, and technological experimentation he never managed to pull off within the studio system.

The script evolved gradually, then, over the course of months. Although Stern tried to write every day, at first he made painfully slow progress, until he too came under the influence of Elia Kazan. One day, wandering into a theater to watch *On the Waterfront,* the writer found himself thunderstruck by the natural poetry of Kazan's film, by the way it spread a "layer of myth over something so real." The writing began to move for him.

Throughout February and March 1955, Stern wrote and rewrote. He met with Ray only when necessary. Ray trusted Stern and believed the script was in loving hands. The three pillars of *Rebel Without a Cause* were finally in place: a sensitive, questing writer; an actor who embodied the

torments of the lead character; and a director resolved to fulfill his lifelong desire to create something entertaining, artistic, and worthwhile.

✳

With Stewart Stern busy on the script and James Dean deep-thinking his part, Ray began to assemble the rest of the cast. The official readings and auditions were held at the studio, but as usual with Ray the process spilled over into restaurants, parties, and his home.

Members of an actual middle-class youth gang from Hollywood High, whose jackets identified them as "Athenians," had begun showing up at the Chateau Marmont shortly after Ray met their leader, former child actor Frank Mazzola, at a studio casting call. The director cultivated a close friendship with Mazzola, and the Athenians mingled at his house with young performers who were angling to play characters just like them.

In turn, Mazzola invited the director to attend the gang's own meetings and to hang out with its members, observing their behavior and recording their slang from "a portable miniature wire recorder inside his breast pocket," according to studio publicity. (Later, in a televised interview, Ray said he was also wired with mikes on his wristwatch and tie clasp.) He even went along with them to supposed rumbles. The Hollywood gang eschewed guns, booze, and pot, but they were tough, fighting it out with tire chains, according to Ray.

In time, the mutual attraction between Ray and some of his young acolytes breached the bedroom. Ray was a father figure, but one who gave off a pronounced sexual vibe. "There seemed to be a musky sexual readiness when he moved through a crowded room making deep, searching connections with the eyes of the young," Stern recalled, "as if his message to them was, 'I see you, I love your specialness which nobody else remarks, I will never seduce you, but in time you'll realize that I know you better than anyone else does and I am the safety you need.'

"Then he'd move on, leaving them gawping with their cokes going warm in their hands. There was simply too much of him for most people to resist. And nothing turned him off."

The leading female character in the film-to-be was Judy, and many young actresses coveted the part, but none more so than one sixteen-year-old nervy brunette who was halfway through her senior year at Van Nuys

High School. A former child actress whose increasingly unhappy home life was dominated by a cold, alcoholic father and a fiercely protective stage mother, Natalia Zakharenko—or Natalie Wood, as she was known—had been named the "Most Talented Juvenile Picture Star" for her endearing performance in 1947's *Miracle on 34th Street,* a Christmas story about a little girl who doesn't believe in Santa Claus. Now, seven years later, Wood had grown into a ripe teenager itching to be noticed. Hollywood had her stuck playing sweet young girls in Rock Hudson vehicles. Once in a while she got an interesting part in live television.

One of those interesting parts was playing a crush of James Dean's in "I'm a Fool," a half-hour drama based on a Sherwood Anderson short story, aired live on *General Electric Theater* in November 1954. Wood's role was minor, but after briefly sharing the stage with Dean, she felt anointed. A diligent student of her own profession, she read all the trade papers and gossip columns and looked forward to Elia Kazan's film of *East of Eden.* She knew that Kazan was celebrated for his handling of actors like Marlon Brando, and when *East of Eden* was released early in 1955, Wood saw the film ten, twenty, thirty times—losing count.

All of Wood's friends and acquaintances were former child performers, now teenagers seeking to break away from their own adolescent straitjackets, and by January 1955 she'd learned through the grapevine that Dean's next project was a film about teenage rebels directed by Nicholas Ray—a protégé of Kazan's and a man attuned to young people. Finagling a copy of the Irving Shulman script from an agent, she saw herself instantly as Judy.

"I felt exactly the way the girl did in the picture toward her parents," Wood recalled. "It was about a high school girl rebelling, and it was very close to home." Wood told her friends she would do anything to get the female lead opposite Dean. The young actress often voiced her ambitions of being taken seriously and winning an Oscar.

Aiming to look older and sexier, the sixteen-year-old showed up at the Warner Bros. casting department one day dressed to kill, sporting opera pumps, a tight black dress, and a black-veiled hat. Admitted to Ray's office, she pounded on his desk, insisting on a screen test. He interviewed her—he spent all day interviewing and auditioning young actors—but then showed her the door, still seeing Wood as a child actress. Outside his office, however, he noticed a friend of hers waiting, "this kid with a fresh

scar on his face," and Ray thought twice. Maybe this girl was on some kind of rebel trip after all. "Let's talk again," the director told her.

Was Ray thinking something else too? Wood definitely was. She was in awe of the director, but she was also physically attracted to him. Though Ray was old enough to be her father, he seemed "mysterious, laconic and powerful, like an aging Heathcliff," in the words of Gavin Lambert, who also fell in love with the director one year later. Ray's charisma had its fatherly side, but he was also Romeo-handsome, and the women in his life trended younger as he grew older; the father-daughter angle was already a factor in his active love life.

In fact, Ray had been interviewing many other former child actresses, including Margaret O'Brien, who had been cute in *Meet Me in St. Louis* but was too cute for Judy, as things turned out. Ray himself might have preferred to discover a newcomer for the film, but Jack Warner insisted on a marquee name—or, at the very least, a discovery Warner felt he could build into a marquee name. Some days Ray would see fifty young men and women; Wood was only one of many begging for his attention.

But he had noticed her now, and after Wood and a girlfriend started hanging out in the studio commissary, trying to bump into Ray "accidentally," he noticed her again. At first her outfits were wrong: Wood had misread Ray's vision for the part, dressing up in high heels and expensive jewelry. But soon after she switched to flats, a sweater, and a ponytail, the director stopped by her table to say hello. He told the maître d' to add the two pretty young girls to his tab and invited them to lunch the next day.

Ray immediately began treating Wood and her friend like experts on teenage life, peering at them as intently as if he was holding a lens in his hands, earnestly asking their opinions of his script ideas, then listening just as seriously to their teenage views and problems. Ray was the first director "who wanted *my* ideas," Wood said later. Their commissary lunch led to a dinner invitation, and Wood tricked her parents to sneak out of the house and meet Ray at the Chateau Marmont. He took her to the Luau, his favorite watering hole, and ordered drinks for his underage companion. Other dinners ensued, with candlelight and champagne.

In Ray, the teenager had found a one-man Fellowship. The director was her father surrogate, intellectual guru, and, soon enough, partner in love. Wood eagerly soaked up his observations on acting, his takes on Vakhtangov and Stanislavski. Ray spoke knowledgeably about literature;

he seemed to know all about F. Scott Fitzgerald, and in his thrall Wood fancied herself as Zelda to Ray's Scott. One of Ray's favorite books was *The Little Prince,* and soon the children's fable about a golden-haired prince who lives on an asteroid became one of hers. The teenage actress felt as though she'd been admitted into a "golden world," in her words.

Only a few days passed before they slept together. "That [first] interview took place in the first week of February," wrote Gavin Lambert, who later shared the confidences of both, "and by the time she made her first test ten days later, they were lovers."

After Ray gave Wood a key to his bungalow, she started making the scene at the Chateau Marmont too, mingling at his drop-in parties whenever she could elude her parents, lounging around in her leopard bikini at the swimming pool in the late afternoons, desperate for glimpses of Brando. When Ray came home from the studio, they'd make love. "I'd like to make love with you," he'd say, the word *with* setting Ray apart from the other lovers the teenager had already known. "All the other guys just want to screw me," she confided to a friend. "He wants to make love *with* me."

Ray enjoyed making love in the afternoons, according to Lambert—possibly because he had other bookings late at night, when Wood found it difficult to slip away from home. According to several accounts, at this heady point the director was juggling concurrent affairs with several women—among them the French actress Geneviève Aumont and his intermittent paramour Shelley Winters (who told columnists that Ray was not only good-looking but also "very adept at discussion on any subject"). When Winters was off duty, Marilyn Monroe was on, and Edie Wasserman was always hovering in reserve.

Ray also pursued another young hopeful he screen-tested for the part of Judy: busty platinum blonde Jayne Mansfield. Ray later claimed the Mansfield screen test was "an hallucination" of the casting department, that he "didn't even put any film in the camera," but Leonard Rosenman and actor Dennis Hopper, who read James Dean's lines with Mansfield, insisted it was a real test, film and all. Ray recommended Mansfield to director Frank Tashlin, whom he knew from RKO and who gave Mansfield her big break a short time later in *The Girl Can't Help It.*

As Lambert pointed out in his detailed biography of Wood, it took quite a while, after the actress started sleeping with Ray, before she secured the part of Judy. Her first camera test was only adequate. Ray ticked

the issues off to her, one by one (it was unclear whether they were *his* issues or the studio's). Her figure was petite, not curvaceous. She was too thin. Her walk wasn't sexy enough. Her hair wasn't right. Her voice was too girlish. This was their pillow talk, and Wood listened, determined to become the Judy Ray wanted.

Dennis Hopper, who'd been firmly cast in *Rebel Without a Cause* according to studio publicity releases authorized by Ray, didn't know yet what role he'd be playing. (For one thing, the script was still being written.) When Dean was out of town, or couldn't be bothered, Hopper read his part with many actresses. On the day of Wood's first test, he stood in for Dean with ten actresses. A native of Dodge City, Kansas, the eighteen-year-old Hopper was raised in San Diego and studied acting at the Old Globe Theatre there. Warner Bros. had signed him after two television appearances in December 1954 and January 1955. After Wood's test, Ray raved about the young San Diegan's glittering future and handed Wood five hundred dollars to show him around Hollywood.

If that was a hint, Wood took it. She asked Hopper out on a date after their test and "planned their assignation like an experienced conspirator," according to Lambert, "asking him to wait outside in his car at five o'clock when she'd be leaving Nick's bungalow." After they drove up to Lover's Lane on Mulholland Drive and parked, Wood aroused Hopper by telling him that she'd just left the director's bed. The two young actors made love in the car.

Ray and Wood remained lovers, but so did Wood and Hopper. Ray also promoted Wood's later, well-publicized dates with Nick Adams, another young actor signed for an undetermined role in *Rebel Without a Cause*. Sometimes the relationship between Wood and Hopper seemed to irritate Ray; other times it had the effect of alleviating the pressure he was feeling from the lovestruck teenage actress. Ray "accepted the three-some," according to Lambert, and once in a while the trio even dined out together.

All the while, Ray was privately coaching Wood for her all-important second camera test, scheduled for the end of February. Trying to act above it all, the director claimed that Steve Trilling and Jack Warner were the vacillators holding up the decision. (For a while, the studio wanted Debbie Reynolds as Judy.) But many people felt that Ray himself was leaning seriously toward Carroll Baker, a young actress who was a protegée of Elia

Kazan's. Wood remained optimistic, a true believer in Ray but also—just as crucial—a believer in herself.

Ray assured Wood that her physical limitations weren't the real hurdle. Physical problems were technical problems, and those the director could fix. After all, he said, it was he who'd enhanced Gloria Grahame's sexy pout by ordering cotton stuffed under her top lip. What Ray was really looking for was truthful acting. He urged Wood to look inward and find aspects of her own personality to transfer to Judy. They talked through the part over and over again, reviewing key aspects of the role.

By her second camera test, Wood was up to the challenge. Whether Ray had finally convinced himself is unclear. He was maddeningly evasive with Wood, telling her that he had to wait on word from the studio bigwigs. Even after her second test, the director kept auditioning potential Judys, with Hopper standing in for Dean. Not until March 1 did Ray write a forceful memo declaring, "We just spent three days testing 32 kids. There is only one girl that has shown the capacity to play Judy and that is Natalie Wood."

But there was still no decision from on high, and Wood's nerves were fraying. Around this time a dangerous incident occurred: Wood and Hopper and one of the actress's girlfriends started drinking at lunch; they drank wine all afternoon, switched to whiskey after dinner, and then drove in Hopper's car to the top of Laurel Canyon to gaze at the night stars. The friend passed out. Wood vomited. As Hopper drove them home down a long, twisty road, he steered head-on into an oncoming automobile, flipping his car and tossing Wood from the vehicle with a concussion. An ambulance rushed her to an emergency room.

"Nick Ray," Wood kept murmuring when she was asked her parents' phone number. "Call Nick Ray . . ." The director arrived in a fury, slamming Hopper up against a wall—not the first flicker of tension between them—and blaming the young actor for what had happened. When one of the hospital staff allegedly called Wood a juvenile delinquent, according to Suzanne Finstad's biography of Wood, the actress pulled Ray close and hissed, "Nick! They called me a goddamn juvenile delinquent! *Now* do I get the part?"

Lambert dismissed this anecdote as a press agent's invention, but either way, as Hopper later said, "She wanted him to see her—not like a Hollywood type, but really in trouble." And it worked. On the way

out of her hospital room after consoling Wood, Ray told the supervising doctor, "Take good care of this young lady. She's the *star* of my next movie." Driving her home from the hospital a day or two later, Ray officially confirmed the news: Trilling had phoned to say that Jack Warner had finally approved her as Judy.

When Ray had time and a willing vessel, he went the extra mile. In the two months before the start of filming, while constantly urging Wood to be herself, the director engaged Robert Ryan's voice coach to help her develop a more expressive timbre; he gave instructions for Wood's makeup to be toned down and her hair darkened and shortened, so that it would hang just below her ears in flip waves; he had a special bra designed to lift up and accent her breasts; he ordered up hip pads to give her more of an hourglass figure; and he hired movement instructors to teach her a sexier way to walk.

In such ways he never stopped second-guessing himself.

✳

Now Wood joined Ray, James Dean, and sometimes Leonard Rosenman in meetings with Stewart Stern, who was pushing to finish the script. Dean was officially announced as the star of *Rebel Without a Cause* early in 1955, but Warner Bros. also had scheduled him to star in George Stevens's adaptation of Edna Ferber's epic novel *Giant,* a bigger-budgeted extravaganza that was due to start filming in Texas in late May or early June. Dean would have to squeeze in Ray's film before then.

The team finalized certain key scenes in meetings at the studio, but sometimes they were refined during spontaneous late-night rehearsals at the Chateau Marmont. One night, in the director's bungalow, Ray and Dean were mulling over the scene where Jim Stark returns home in the dead of night after Buzz has been killed during the chickie run. Ray thought the scene, originally written to take place in Jim's mother's bedroom, was "too claustrophobic" and might be more effective in showing Jim's "turmoil" if it was shifted to a different setting.

He asked Dean to act out his entrance in his living room with "two contradictory actions," namely "you want to get upstairs without being seen, without being heard, without a confrontation, but yet you've got to spill your guts out to somebody."

Playing Jim's father, Ray turned his TV set on to a "dead channel" and pretended to be asleep on the couch, watching "with one eye open" as Dean crept into the kitchen for a bottle of milk, then sprawled at a skewed angle on the couch, his head flopping upside down, almost to the floor. During the rehearsal Dean improvised swigging the milk and rubbing the bottle across his burning forehead (perfectly capturing "the sensibility of the milk-fed American teen, caught between maturity and childhood," in the words of Frascella and Weisel). In the script, the next thing that happens is that Jim's mother cries out his name from the top of the stairs. When Ray gave the cue, in a mother's voice, Dean turned his head toward where his mother would be—and "gave me the idea of the 180 degree turn of the camera," Ray recalled. The director devised an extraordinary shot in which the camera follows Jim's point of view as he gradually rights himself, his mother rushing down the steps toward him. "The shot came to express my feeling toward the entire scene," as Ray explained later. "Here was a house in danger of tipping from side to side. It felt organic to the scene."

Just as he had when making *In a Lonely Place,* Ray talked his ideas over with the studio art director, Malcolm C. Bert, asking him to scrap the mother's-bedroom set and redesign the living room and staircase to match the layout of Ray's bungalow. He would direct the scene as they had rehearsed it. "It was all based on the improvisation at my home," Ray said later. Ray's camera adopted a nightmarish tilt at several points during the confrontation between Dean and his parents, and then later echoed the tilt, fast like a tremor, when Plato is shot. Spending so much time with Dean and the others paid off in a thousand ways. Ray's script and settings and camerawork would never be as organic, as yoked to the psychologies and emotions of the actors, as in *Rebel Without a Cause.*

✳

Young people by the hundreds swarmed the casting department. Often the candidates for parts were handed a couple of script pages to study for improvisational purposes, but sometimes they were simply invited to sit around and talk informally with the director. "What do you think about what's going on in the world today?" Ray liked to ask.

"He just wanted to talk with everybody," recalled actor Ken Miller, who was cast in a small part among the many that would end up on the

cutting-room floor. "That's how he figured out if people would be right or wrong. He just became one of the gang."

One of the film's pivotal characters was Buzz, the leader of the gang harassing Jim Stark. It is Buzz who challenges Jim to the chickie run but who also befriends him before the event, as they gaze over the cliff where the run will end and one of them will die.

> BUZZ (quietly): That's the edge. The end.
> JIM: Yeah. Certainly is.
> BUZZ: You know something? I like you. You know that?
> JIM: Why do we do this?
> BUZZ (still quiet): You got to do *something*!

UCLA theater graduate Corey Allen, who appeared frequently in local plays, came to the studio backlot one day along with a hundred and fifty other young actors, where they were told to gather on a set of bleachers for the audition. A young New York actor named Perry Lopez, a friend of Dean's who was assisting Ray, blew a whistle, signaling the assembled aspirants to climb up to the top rows, then turn around and descend, as the director watched. While the others stampeded by him, Allen took his time climbing up and down, puzzled by the exercise. He got the part.

For weeks, other prospective members of Buzz's gang went through similarly peculiar improvisations. Night after night Ray took a bunch of performers out onto a floodlit wooden platform in the studio parking lot, encouraging them to crawl around the superstructure and improvise "until he had winnowed out the few from the many and was left with a tribe that belonged together and could never be pried apart," in Stewart Stern's words.

By late February, Ray had settled on most of the tribe, which began to collect more purposefully at his bungalow for nightly talks and rehearsals. Casual visitors or bystanders like Ray's son Tony were quietly sent away. The lucky ones stayed. Ray talked with them about sense and emotion memory, entreating the young actors to seek the truth of their characters deep inside themselves. The cast members all carried around dog-eared copies of Michael Chekhov's book *To the Actor,* which covered Stanislavskian theories and techniques.

Dean was one of the tribe but also the leader of the tribe. Over the

months of getting to know Ray and preparing for his role, he had transformed himself gradually into Jim Stark, until he was truly living Jim's emotional reality. Dean rarely stepped out of character; he was self-absorbed, sometimes surly, never cuddly. The others admired him, but they were also intimidated by his persona. And whatever his mood—or the mood of the scene they were playing—Ray gave his star the room he needed.

"Read and see what you can do," Ray gently urged the young actors as he handed out pages of the working drafts for their use in read-throughs and improvisations. "Take it easy and explore." Rehearsing the scenes repeatedly, trying out inflections, movements, and gestures, the actors developed a closeness and shorthand they would carry over into the film.

With his lifelong penchant for capturing sound, Ray recorded many of the rehearsals and improvisations, then played them back for the young performers so they could hear and critique themselves. Ray urged them to analyze and discuss the scenes at length. Time was forgotten. The discussion and critiquing seemed endless. "He [Ray] would encourage me," recalled Wood, "and get annoyed if I didn't bring in lots of notes or ideas, or even changes of dialogue, or if I didn't challenge certain scenes."

A couple of weeks before principal photography was supposed to start, key cast members gathered for the first full read-through at Ray's bungalow. All but one: Ray still had not chosen the film's Plato, so Dean's friend Jack Simmons, who'd end up playing a member of Buzz's gang, read the part. Stewart Stern was present to participate and take notes for final revisions. Photographer Dennis Stock, another friend of Dean's, recorded the session on Ray's reel-to-reel machine.

A photograph exists of the cast sitting in a circle of chairs in Ray's living room, heads bent over their scripts. The adult actors playing the parents were almost an add-on to the read-through; when the two portraying Dean's parents arrived at the Chateau for the first time, they soon realized that the younger performers had formed an intense bond with each other—and with Dean and Ray—from which they were excluded. The adults did not belong to the same golden world.

For the part of Jim's father, Ray had cast against type, hiring Jim Backus, known as the voice of the myopic cartoon character Mr. Magoo. Dean had suggested Backus to Ray after meeting him at a Thanksgiving dinner hosted by Keenan Wynn. Buffoonery was Backus's forte, and his casting completed the impression of a weak-willed father.

Ray had chosen veteran actress Marsha Hunt to play Mrs. Stark, Dean's mother. The actress recalled the Chateau read-through as an especially "weird night" for the more seasoned players, who weren't accustomed to such deeply introspective interpretations. "The cast sat around and mumbled," Hunt remembered. "Nobody was audible but me." Hunt would later be dropped from the cast and replaced by Ann Doran, who was just as seasoned, though in lesser roles.

Hunt wasn't the only actor dropped at the eleventh hour; several parts were recast before filming. The studio claimed that scheduling delays forced Hunt's replacement, as the actress was obliged to honor a prior stage contract. But the suspicion has never been dismissed that Hunt didn't fit into the circle of trust—or that someone at Warner Bros. may have noticed her mention as a Communist sympathizer in *Red Channels,* the 1950 booklet that listed suspected Communists in the media and entertainment industries. Though she was never a Communist, Hunt had been a left-liberal activist in Hollywood causes, and her career suffered for it in the 1950s. "All these years later," wrote Frascella and Weisel, "Hunt still cannot deny that the blacklist may have played a role."

✳

The last member of the teenage trinity, the part of Plato, was still up in the air two weeks before the first day of filming. At Dean's urging, Ray tested Jack Simmons, the star's friend and personal assistant, while also looking closely at Billy Gray, who played Bud on TV's *Father Knows Best.* Ray couldn't make up his mind. Then one day he spotted a baby-faced actor with an olive complexion answering a general casting call for the film. The actor looked "more like a Plato than a Billy Gray," Ray noticed, while also reminding him of his son Tony, whom he regarded as "a Plato of sorts," though the actor was "prettier."

An impish fifteen-year-old with doe eyes, Sal Mineo was an alumnus of the original Broadway production of *The King and I.* Like so many other child performers, he was seeking a fresh start in Hollywood, yet had snagged only minor television and film roles to date. Ray called Corey Allen over and asked him to improvise with Mineo. Then he invited Mineo to the Chateau Marmont on Sunday afternoon to read with Dean.

"I thought I dressed pretty sharp for those days in pegged pants,

skinny tie, jacket—until Jimmy Dean walked in with his tee shirt and blue jeans," recalled Mineo in a subsequent interview. "We went through a scene and nothing happened between us. Nick Ray finally walked over and suggested we sit and talk for a while."

The informal "talking" worked to open both of them up, as Ray had guessed it would. "When Jimmy found out I was from the Bronx," Mineo said, "we started gabbing about New York, and then progressed to cars, and before we knew it, we were buddies. . . . Then we went back to the script, and this time it went off like clockwork. When we reached a part where we were to laugh hysterically, Jimmy let out a giggle, and I couldn't help but follow along. Pretty soon we just couldn't stop laughing."

Mineo's camera test took place a few days later, on March 16, with Dean, Wood, and Mineo feeling their way through the deserted mansion sequence, using a set left over from Kazan's film of *A Streetcar Named Desire*. After touring the mansion as pretend buyers in the scene, and fooling around in an empty swimming pool, Judy hums a lullaby as Plato falls asleep. Jim and Judy kiss. Then Buzz's gang swarms vengefully.

The director tested another young prospect, Richard Beymer, the very same day, but clearly the chemistry wasn't there: Beymer found Ray "gruffly unhelpful," and he felt as excluded as Marsha Hunt from the playful, giggling repartee among the other actors.

After summoning him, Ray waited for Mineo at his office a day or two later. Wearing a frown, the director took a long time to get words out of his mouth. "Sal," Ray said finally. "Every once in a while, a director has to gamble. I'm going to take a chance. You're Plato."

The character of the psychopathic criminal can be traced all the way back to Robert Lindner's book, and Plato is definitely a psychopath in the film. (In the first scene, at juvenile hall, the police are grilling him for shooting puppies.) But Mineo had another unspoken qualification for the role: his homosexuality. The director knowingly cast other young homosexual or bisexual actors in the picture as well, and of course most accounts agree that Dean himself was bisexual. "Jimmy himself said more than once that he swung both ways," the director affirmed in 1977.

Plato's sexuality in the film is latent, but the signals are clear, right down to the pinup of Alan Ladd in his school locker. The decisive factor in the casting was Mineo's natural chemistry with Dean. On the set, according to several accounts, Mineo developed a crush on Dean that echoed

Plato's painful attraction to Jim Stark. Ray's own dual sexuality made him the rare Hollywood director attuned to such subtexts, and even as he was fighting off studio and Production Code concerns about homosexual inferences in the scenes between Jim and Plato, he urged the actors themselves to explore those implications. When Mineo told Ray that he really wanted his driver's license, the director advised him to look at Dean "as if *he* is your driver's license." In the same vein, Dean urged Mineo, "Look at me the way I look at Natalie."

Years later, Mineo would boast that he'd played "the first gay teenager in films."

<p style="text-align:center">✳</p>

Just as Ray was ready to start filming, the industry was abuzz about another juvenile delinquency picture opening in theaters. *Blackboard Jungle,* an MGM picture, was written and directed by Ray's professional nemesis, Richard Brooks, whom Ray still resented for cozying up to Bogart a few years before. Speaking with the press as *Rebel Without a Cause* was hitting theaters, Ray later took pains to differentiate his film from Brooks's, which he described as sensationalistic. But early acclaim for *Blackboard Jungle* drove up expectations for Ray's entry into the teenage rebel sweepstakes, and an anxious Jack Warner urged Ray to hurry and seize the moment.

Writing feverishly, Stewart Stern finished the final draft of the script about a week before the official start date of March 25. He had spent part of the time working in New York, where he kept an apartment. Elia Kazan also lived in New York part of the time, and Ray insisted that Stern get Kazan's opinion of the script. Feeling "very uncomfortable" with the errand, Stern took the script over to Kazan's place on the East Side, just down the block from John Steinbeck's.

Kazan graciously welcomed Stern, offering the writer a sandwich before disappearing into his study with the script. Stern said, "Nick insisted that I wait there while Kazan read it," so he sat and twiddled his thumbs, watching Steinbeck out the back window, "about two gardens away, sitting in his backyard typing."

Kazan returned, handed the script to Stern, and shook his hand politely, without saying anything that lingered in Stern's memory. Kazan

phoned Ray later with his reaction, but nothing he said ever reached the screenwriter.

<p style="text-align:center">✳</p>

Just before photography began, Ray brought the teenage trinity back to Warner Bros. for another stab at the deserted mansion sequence, filming their performances as a dress rehearsal so the young actors could study themselves afterward—a highly unusual practice at the time. Their movements, body language, and byplay would be recycled almost verbatim during later filming, though some felt the dress rehearsal was even better.

The rehearsal was also a chance for the director and cameraman to familiarize themselves with CinemaScope, the wide-screen process Warner had licensed from 20th Century-Fox. This was the first excursion into CinemaScope for both Ray and Ernest Haller, who'd shared an Oscar (in a career of seven nominations) for the photography of *Gone With the Wind*. At first both were somewhat nervous about the oblong shape of the CinemaScope image, and the director made more notes to himself, sketched more shots, and ordered more storyboard art than was his custom.

Unlike some Hollywood directors, though, Ray would quickly grow accustomed to the brand-new format, which complemented his personal aesthetic. "Remember I worked with Frank Lloyd Wright?" Ray liked to remind interviewers. "The horizontal line. I felt at home with Scope." He would shoot all his future films except one in wide-screen, and in Europe— where the beauty of his compositions was particularly celebrated—he would be dubbed "Mr. CinemaScope."

A few days after the dress rehearsal, James Dean suffered a panic attack. After racing his Porsche Speedster in a Palm Springs competition, the star disappeared from his usual Hollywood haunts. Dean had gone to ground somewhere, perhaps New York. The studio was "frantic," Stewart Stern recalled. Busy with last-minute work on sets and organizing the crew at the studio, the director dismissed everyone's apprehensions. Dean would show up when the time came.

That weekend, Stern answered the phone to hear mooing on the other end. He mooed back. It was Dean, calling to say he couldn't shake his qualms about Ray, who didn't instill the same confidence in him as Kazan. Kazan was firm, decisive; Ray kept tinkering with the tone and staging

of important scenes like the one in the deserted mansion. "I'm not sure I should do this movie," he told Stern, "because I'm not sure I can trust Nick." Stern, who was beginning to have his own trust issues with Ray, talked it over with Dean but ultimately said the decision was up to the actor.

But Stern told no one about Dean's phone call. Reluctant to mediate between the star and director, he then decided to sit out the filming in New York. "Ray promised to call Stern in New York if he decided to change anything in the script," wrote Frascella and Weisel, "a promise that Ray would break many times over."

<div align="center">✳</div>

The filming started with background and location shots on Wednesday, March 25. The teenage trinity wasn't on call until March 30, when the schedule called for Ray to stage the knife fight between Jim Stark and Buzz at the observatory.

Dean's disappearing act didn't last long; when Monday came, Ray was right—the star showed up on time. But Dean still harbored doubts about Ray—doubts that were exposed in the very first scene of his that Ray directed. For the knife fight between Jim Stark and Buzz, Dean and Corey Allen had decided to use real switchblades with dulled edges. They wore chest protectors but still risked injuring themselves. Ray's boxers had choreographed all their moves, but the two actors warily twirled away from each other during the first few takes. It was a crucial scene, which also involved Natalie Wood, Sal Mineo, and the rest of the tribe, and it took two days before Dean and Allen began to lose themselves in the moment. Then, at one point, Allen lunged at Dean, accidentally nicking the star's ear and causing a spurt of blood.

Alarmed, Ray shouted, "Cut!" and requested first aid.

Dean had been momentarily elated with the scene. Now he turned furious. "Goddamn it, Nick!" cried the star. "What the fuck are you doing? Can't you see this is a real moment? Don't you ever cut a scene while I'm having a real moment! That's what I'm here for!"

People on the set were astonished. They waited for Ray to defend himself, but the velvet-gloved director stepped back, saying nothing while the medic fussed over Dean's minor injury. That incident set the pattern: When Dean was in a scene—and he was in the bulk of them—Ray patiently indulged his star's instincts. The director and star interacted with

such seeming parity that the other actors and onlookers weren't always sure who was in charge.

The knife fight had been shot in black and white, but then Jack Warner took a look at the first week of dailies and was riveted by what he saw—the balletically staged confrontation between Dean and Allen, with the rebel girls standing on the sideline, turned on by the violence. On the second Saturday, the studio head made a bold decision: to start the filming over in color.[*]

By mid-March, *East of Eden,* a CinemaScope film shot in color, had opened in New York and Los Angeles, drawing praise and filling theaters. Dean was a winner with critics and audiences alike; *Rebel Without a Cause* would disappoint his swelling number of fans if it wasn't also in color.

A last-minute switch to color was a gamble, as Ray the gambler knew. But the director's artistic instincts were also aroused by color, and he welcomed the edict from the studio boss, although it entailed many hurried adjustments. A handful of scenes would have to be refilmed and a number of script details adjusted. For example, the story had originally been set during Christmas (with Buzz and his gang accosting a shopper on Christmas Eve); now the time frame was moved to Easter, which made more sense because of the springtime weather.[†]

The outlaw gang in Ray's last color film, *Johnny Guitar,* had looked like they were dressed for an MGM musical. The Western possessed all the emotionalism of a Nicholas Ray film but little of the realism he was also known for. For *Rebel,* he wanted the color to be more natural. As a color consultant, Ray engaged John Hambleton, an old New York drinking buddy who had started out in the left-wing theater movement before doing the costumes for top-drawer Broadway plays. Showing the designer a layout of college students from *Life,* Ray told Hambleton he wanted the teenagers to be dressed like them—as realistically as possible.

---

[*] Ray later claimed that Jack Warner suffered an anxiety attack about making *Rebel Without a Cause* early in the shooting, threatening to shut the production down. According to Ray, when he learned of the imminent shutdown he contacted his business manager and tried to buy the film away from Warner Bros., before wiser heads reassured the head of the studio. This made for a fascinating anecdote—told by Ray on several occasions, including to Cliff Jahr on television—for which there is no proof.

[†] The season in which the story takes place is virtually irrelevant, however, in the film as it exists.

As with *Johnny Guitar,* however, Ray opted to dress the main characters, the trinity of Jim, Judy, and Plato, in coded colors. Dropping the horn-rim glasses and black leather jacket he had been wearing for black-and-white photography, Dean donned a red nylon windbreaker to contrast with his white T-shirt and blue jeans. The customized black 1949 Mercury his character drives completed the star's iconic look. "When you first see Jimmy in his red jacket against his black Mercury," Ray said later, "it's not a pose. It's a warning."

In her early scenes, Natalie Wood would wear a bright red Easter coat, her lips a "gauche red," almost as garish as Joan Crawford's in *Johnny Guitar.* Later, her character graduated to nonthreatening greens and "soft fluffy pink." (The 1950s were a "pink world," according to color-film scholar Patti Bellantoni, with "bright and iconoclastic" shades signaling "danger, rage, torment, and courage.")

The sexually conflicted, violence-prone Plato was intentionally dressed as a "square," wearing tweed jackets, sweaters, a white shirt and tie. In the deserted mansion scene, it's revealed that he's wearing mismatched socks, one red and one blue. ("That helps in the most external way to say to the audience quickly," according to Ray, "that he's had a pretty confused day.")

The colors of the teenage trinity stood out in an otherwise saturated wide-screen palette. CinemaScope was still new, the rules staid. Ray broke them with his lustrous colors, and in other ways—with his insistence on complicated boom and crane shots, tilts and angles (the low-to-the-ground lens often peering up adoringly at Dean), the tight close-ups and quick shots of people in motion. All this would add to the film's visual turbulence.

✳

The star took his sweet time working himself into a mood for major scenes. Dean's moodiness didn't make him dark or unpleasant, Ray insisted later. "Beautiful moods, wonderful moods, gay joyous happy moods," the director recalled. "He had temperament. He was never temperamentally irresponsible. It was very workable temperament."

Ray worked with his star in deceptive ways, whispering, brainstorming together, and waiting for Dean to react to alternative suggestions. Unlike Natalie Wood, Dean didn't need any physical modification (although Ray later claimed, "I taught him how to walk!"). The actor also knew how to

agitate his own essence: Squirreled away for prolonged periods in his dressing room, Dean played his bongos, or drank from a jug of red wine, or listened to recordings of Wagner's *Ride of the Valkyries* before appearing on the set and humming the same music on camera. Between takes he'd curl into himself, deep in preparation while Ray stalled on his behalf.

The older cast and crew members were skeptical of Dean's extreme modus operandi. One day, Ann Doran recalled, she and Jim Backus crept up from "way, way behind the camera" to watch Dean mired on concentration. "All of a sudden everything got quiet and Dean got down in this fetal position. We waited, and waited. *Finally,* he stood up, and they said, 'Action!' Jim and I practically fell on the floor laughing. We had never seen such a bunch of crap in our lives. We snuck out."

The camera crew were cautioned never to disturb Dean's intense concentration by calling out the customary cues of "Speed!" or "Roll 'em!" "Nick wouldn't go until Jimmy said so," recalled Corey Allen. "And all Jimmy would ever do was nod his head; sometimes he wouldn't go, with the crew standing around, maybe becoming angry."

Sometimes Dean would explode on camera in startling ways, smashing his hand so badly on the desk of a police officer when they shot the first scene of the picture that he had to be treated at the hospital. In the family living room scene, where Jim Stark argues with his parents over whether to tell the police about Buzz's death, Dean leaped up the stairs to grab Jim Backus, pulling the middle-aged actor down the steps and dragging him across the living room, then hurling him over a chair and trying to choke him. Only the attempted choking was in the script. ("Welcome to the Elia Kazan hour!" Backus quipped later.)

Dean was just as unpredictable in his quieter, more vulnerable scenes. He improvised his bit in the opening credits where he drunkenly lies down on a street with a mechanical monkey, cradling the toy. (The inspiration came at the end of a longer sequence in which Buzz's gang attacked a stranger returning to his family with an armful of holiday gifts, including the monkey. Only Dean's final improvisation remains in the film.)

He turned his nervous laughing with Plato, in an alley outside the Starks' garage after Buzz has died, into an erotically charged moment. And he unexpectedly prolonged his first kiss with Judy. Ray didn't always know in advance what Dean was going to do. Sometimes Dean himself didn't know.

"Very often," recalled Natalie Wood, "he [Dean] would kind of take over and almost say fuck off to Nick Ray."

"In my opinion," said Dennis Hopper, "James Dean directed *Rebel Without a Cause,* from blocking all the scenes, setting the camera, starting the scene and saying 'cut.' Nicholas Ray intelligently allowed him to do this."

Dean was "practically a codirector," Jim Backus said later. ("Jim Backus is an asshole," Ray barked when asked about his comment.)

It wasn't the first time that Ray had formed a close partnership with his male lead. On *Knock on Any Door* and *In a Lonely Place,* it was Bogart and him. *The Lusty Men,* one of Ray's proudest accomplishments to the end of his life, was shaped by the two-man club of Robert Mitchum and Ray. On *Rebel Without a Cause* the director drew his youthful cast into a circle of trust, but inside that circle there was the best two-man club of all: Ray and Dean. Sometimes Ray acted paternally toward the star. Other times he treated him like a brother, almost as though he were Dean's twin. Some days he even dressed like Dean, in T-shirt and jeans and—an indulgence no Hollywood director had ever ventured before—bare feet. He treated Dean like an echo of himself.

Ray and his star drew even closer as the filming progressed. They spent hours together on weekends, talking about forming an independent production company. The two of them stole time together in Mexico, watching road races they might incorporate into one of their future projects. When Dean decided he wanted to start seeing another psychiatrist besides Dr. Van der Heide he consulted Ray about who it should be.

Together, they decided, they would produce films, even entire television series. Dean would direct some of the projects himself, drawing on the notes he was making while watching Ray shoot *Rebel Without a Cause.*

\*

Of all the unorthodox behavior Ray was known to have indulged in during the making of *Rebel Without a Cause*—holding auditions and rehearsals at home, directing in Levi's and bare feet, plying underage teenagers with alcohol, smoking dope with James Dean—his "secret" romance with Natalie Wood was the least defensible. Today such behavior would invite charges of sexual harassment. Then, as now, it qualified as felony statutory rape.

Though everyone pretended ignorance, the studio and most of the

principal cast and crew knew, or suspected, that the director was carrying on an affair with his underage lead actress. "We all knew," said Ann Doran in 1999. "Jim [Backus] and I talked about it."

Even Ray's friends and supporters were discomfited by the affair. Increasingly, they felt, the director blurred the lines of morality if it was personally convenient. "I liked Nick," said Leonard Rosenman years later, "but I *didn't* like him. He was a weird guy."

Although Ray had a dozen roses delivered to Wood on the first day of filming, at times he treated the teenage actress inconsiderately in front of others—as though he were trying to distance himself or heighten her insecurity as she played her first romantic lead opposite America's most celebrated rising star.

One of Wood's hallmarks as a child performer had been her uncanny ability to shed tears on cue. In her very first scene for *Rebel Without a Cause*, she was called upon to break down weeping, but Ray insisted on multiple takes and berated her efforts as inadequate, according to eyewitnesses. The director complained openly about Wood's fake histrionics and insisted on more truthful emotions. "How did I ever hire her?" he grumbled aloud.

Dean himself, the other member of the two-man club, played his share of mind games with his young leading lady. Although Wood revered Dean and longed to impress him, the star was stingy with pleasantries—except where Sal Mineo was concerned. "On the set Sal seemed always to be under Jimmy's protective arm," remembered Dennis Hopper, "which was the relationship that Jimmy created and that their parts demanded."

As the filming progressed, however, Ray and Dean both seemed to soften toward Wood. This dovetailed with the story line and corresponded with scenes in which the seemingly cold, brittle Judy is gradually won over to Jim Stark's side. When Ray shot the mansion sequence—with Dean giving Wood her first big-screen kiss*—the set was cleared of nonessential personnel. All of a sudden, it seemed, Ray and Dean were both alert to Wood's jitteriness. Dean treated his costar sweetly while shooting the scene, and afterward Ray congratulated her on giving the sort of "involuntary performance" he prized above all.

---

\* Dean and Wood had actually shared a long smooch in the small-screen "I'm a Fool," televised the previous November.

Whether he was scolding or applauding Wood, Ray maintained his furtive romantic relationship with the teenage actress throughout the filming, even though a studio-appointed guardian was supposedly supervising her and Mineo during their time at the studio. Both she and Mineo were underage minors; both had to sit for school lessons for three hours daily.

Ray and Wood had to be careful about their time alone, however, and that may have prompted a flare-up of jealousy on the director's part. One day, the director buttonholed Wood's mother and "snitched" to her, to use Dennis Hopper's word, that Hopper was engaging in sexual relations with her daughter. Wood's mother knew about her daughter's ongoing affair with Ray (she had spied on them from her parked car outside the Chateau), but she never interfered. After talking with Ray, though, Wood's mother marched off to Warner's executive offices and complained—about the nineteen-year-old Hopper, not the forty-three-year-old Ray. Hopper was warned away from Wood, though he insisted later their relationship continued in secret.

The secret couldn't be kept from Ray, though, and he began to harp on Hopper's shortcomings, trimming his action and lines. After feeling maltreated during one scene, Hopper stormed into Ray's trailer, demanding that they duke it out like men. Ray peered at the young man scornfully, telling him to grow up and start using his brains instead of his fists.

One day, Hopper and another young player left the set during a break and missed their next call. Ray made a show of angrily shutting down the production. Though he pardoned the second actor, the director insisted that Warner Bros. should fire Hopper. Steve Trilling met with Ray and told him such a rash decision was precluded by Hopper's contract. Hopper stayed on, but his role continued to shrink.

He wasn't alone. Others in Buzz's gang faded into the background, becoming less individual characters than a Greek chorus responding to the events of the story with cries and echoes of dialogue, and with the restless choreography that sent them swirling and scattering in ceaseless motion, then swarming back to rejoin the main body. Ray added extras for certain scenes, then dropped them from retakes. Actors were filmed in small parts, later cut. Scenes were lengthened, or shortened, depending chiefly on Dean's improvisations, which Ray relished from behind the camera.

Some people behind the scenes felt that Ray acted indecisively at

times, reassessing scenes and changing his mind at the last moment about what the actors should do, or how to frame or where to move the camera. The schedule lost a little time when the film switched to color, and the production kept falling further behind as staging and dialogue were tinkered with, the camerawork grew more elaborate, and Wood and Mineo became unavailable because of restrictions on the work hours for minors.

Ray prided himself on adapting well to production pressures, but in this case the constant changes did affect the timetable—and his originally planned ending for *Rebel Without a Cause*. The director had envisioned a climax in which the panicked Plato climbs atop the planetarium dome, causing the alarmed police to shoot him down.* One problem was getting the actor up there safely; an expensive replica would have to be constructed in the studio. Ray showed makeshift coverage of the scene to studio officials on May 23, just a few days before the last scheduled day of photography. But the studio fretted about the extra cost and time involved, and producer David Weisbart agreed. Ray's ending had to be scaled back.

Stewart Stern devised a compromise, with Plato waving his empty gun at police from the steps of the planetarium. As the police mow Plato down, Jim shouts out desperately: "I got the bullets! Look!" It was a line Ray insisted was written by Odets and paid for out of the director's own pocket.

Bereft, Jim zippers the jacket Plato is wearing—his jacket, which he'd given to him inside the planetarium—murmuring a line with a hint of Wisconsin: "He was always cold . . ."

After that, however, came an unusual postscript: Ray gave himself a Hitchcock-type cameo at the very end of the picture. Stern fought the idea of a cameo tooth and nail, but the director insisted on the moment. As the ambulance carrying Plato's body leaves and the police cars drive away, a trenchcoated figure toting a briefcase is glimpsed from high overhead, walking through the crime scene toward the planetarium as the sun rises.

"He was determined to do it," recalled Stern. "You can see it in his very determined walk." The figure's identity is never explained, but it was

---

\* This sequence evoked the ending to a film by one of Ray's favorite directors, Alfred Hitchcock's *Blackmail,* which climaxes with a criminal chased by police perishing atop the British Museum.

Nicholas Ray, the director, putting his stamp on the final shot of the film, the one that would become his lasting testament.

<div align="center">✳</div>

After a handful of inserts and retakes, the filming of *Rebel Without a Cause* ended at two forty-five A.M. on May 27, 1955. The shoot had taken two months and forty-seven shooting days. "We didn't really want to admit it was all over," the director recalled years later. Ray, Natalie Wood, and Dennis Hopper piled into Ray's Cadillac with two of his assistants and followed James Dean on his motorcycle from Burbank to Googi's, a deli kitty-corner from the Chateau Marmont, where they enjoyed a late-night celebratory feast.

During the last days of filming, Warner Bros. had circulated a list of the tentative credits to principal cast members and personnel. The result shocked Stewart Stern. The screenwriter had been hearing reports from the set that the director was encouraging Dean and the other young actors to stray from the script when the spirit moved them. At one point during the production Stern even wrote a formal letter of protest to Steve Trilling, complaining about the "bit by bit emasculation" of his work.

Many of Dean's impromptu touches invaluably enriched the film (such as his side-of-the-mouth crack about children in the deserted mansion sequence—"Drown 'em like puppies!"—a nod to both Jim Backus's character Mr. Magoo and Plato's puppy-killing spree). But other additions or subtractions sanctioned by Ray were "inappropriate," according to Stern, including a number of too-explicit "on-the-nose lines and some so sentimental that they wrecked the scenes they occurred in and pulled the audience right off the screen."

Stern hated it when Plato's kindly black housekeeper explained to the intake officer in the juvenile hall opening that "Plato was a Greek philosopher" because it was "wildly out of character for that woman." He hated it just as much when Plato blurted to Jim Stark, "Gee . . . if only you could have been my father . . . ," in the garage alley scene, or when Mrs. Stark stares into the camera from the backseat of a police car and utters lines cribbed directly from a *Los Angeles Times* article about a failed chickie run that Ray carried around in his pocket. "I don't understand," Jim's mother says. "You pray for your children. You read about things like this happen-

ing to other families, but you never dream it could happen to yours." ("*Rebel*'s most hackneyed moment," according to Frascella and Weisel.)

Even worse, Stern felt, was "Nick's assault on the dignity of the picture's ending by filling the father's mouth with treacle so he can burble out lines of repentance like 'Stand up, son, and I'll stand up with you. Let me try to be as strong as you want me to be . . .'"

Now, in late May, Stern learned for the first time Ray would be taking sole story credit. Stern would be credited only with the screenplay. Stern was astonished to learn that Ray had written anything at all for the film. He had never read Ray's treatment, "The Blind Run," or even been informed about its existence. On *Teresa,* Stern's first film, he'd been dismayed to be nominated for his costory but not his solo script; now he worried that the same thing would happen with *Rebel*—that the story would be honored while the script was dismissed as cut-and-paste.

Moreover, Irving Shulman's name had been entirely left off the proposed credits. From Stern's point of view, "Irving first, and then I, had, in that order, created the story line, the personalities of all the characters and all the incidents in the script."

Rather than "leave to chance, or nervousness," the way he presented his case, the scenarist sat down and wrote a three-page letter to Ray, taking it to a private meeting with the director at the Chateau Marmont. Stern read the letter aloud to Ray and then handed it to him.

Ray became "very silent and very glum," according to Stern, "and then told me about his 'secret' deal with Warner's: that upon submitting the 'treatment' to them he would be guaranteed solo story credit and that now that was part of his contract. I told him that I hadn't even known there had been a treatment, or certainly what was in it."

Stern asked to see Ray's treatment, but the director refused to hand over the seventeen pages. At the very least, Stern argued, Shulman deserved an adaptation credit, and Ray agreed to support that change.[*] But Ray still refused to share the story credit.

"He then asked me what story ideas I considered myself to have contributed to the screenplay and I went through the list," Stern said. "He

---

[*] While accepting his adaptation credit, Shulman later filed a grievance with the Writers Guild contesting Ray's sole story credit and vigorously protested that credit to Warner Bros.

dismissed each in turn and professed to have dated notes that proved that each had been his idea first."

One particular bone of contention was the story's twenty-four-hour time-structure, which Stern claimed as his brainstorm. The writer could pinpoint the very day when he first had raised the idea. "I was glad that you finally realized what I had on my mind," Ray answered flatly.

Finally, Ray said, if Stern was permitted to share his story credit, he should be allowed to share the screenplay credit. Stern angrily rejected that suggestion, telling Ray that he'd never written a line of the script. "Then no deal," said Ray. "The credits stay as they are."

They shook hands and parted, leaving Stern forever outraged at what he deemed a moral and professional betrayal—but also forever grateful, as he wrote in his letter to Ray, for "one of the happiest and most challenging episodes of my creative life."

<p style="text-align:center">✳</p>

Pleased that Ray had finished *Rebel Without a Cause* in time for James Dean to report on schedule for *Giant,* Warner Bros. bestowed a sizable bonus on the director. Perhaps inspired by Dean, Ray splurged on a Mercedes 300 SL. He certainly had Dean in his thoughts when he spent the rest of his bonus, optioning the rights to a story called "Heroic Love" and putting a little money into another story "about a Mexican road race," which topped the long list of projects he and his *Rebel* partner envisioned in their future.

*Giant* had started ahead of Dean, but director George Stevens was waiting on location in Marfa, Texas, for the star and two of his *Rebel* buddies, Dennis Hopper and Sal Mineo. Natalie Wood was due in Monument Valley, where she would play a young girl kidnapped by Indians in John Ford's *The Searchers.* As Gavin Lambert pointed out, by the time John Wayne picked Wood up in his arms and said, "Let's go home, Debbie," the company had returned to Los Angeles, shooting the scene in a Griffith Park canyon a few miles away from the observatory.

Incredibly, Ray himself was due to start directing another film by early July: "Tambourine," the new working title of the Gypsy love story that had been Ray's pet unfulfilled project at RKO. The *Rebel Without a Cause* delays had shoved the two production schedules up against one another, and Ray should have postponed "Tambourine." But for the last nine

months he had been spending exhorbitantly, throwing parties and spreading cash around to young people—lavish gestures he couldn't afford.

Too soon, he would sorely need money. One contract clause Lew Wasserman hadn't wangled was keeping Ray on salary for the postproduction of *Rebel Without a Cause*. This is where it hurt him not to be a producer, or even coproducer, of the film. Although he worked closely with David Weisbart and editor William H. Ziegler, a veteran of several Hitchcock movies, certain scenes in the script had stretched out during the filming, and the picture was going to run long. The cutting involved subtle as well as obvious choices, weighing numerous alternate takes and multiple versions of scenes, deciding which privileged moments would be saved or dropped. Moreover, countless lines of dialogue had been lost or mumbled by the cast, and the dubbing and looping chores ahead were prodigious.

Panicked, Ray asked for more time and pay. He wanted more power over the rough cut, which Jack Warner was demanding to see as soon as possible in order to push *Rebel* into theaters while the excitement over *East of Eden* was still fresh. Warner's reply didn't come fast enough, though, and on June 7 Ray dashed off an ill-advised "Dear Jack" letter that didn't endear him to the top man.

"My name is Nick Ray," the letter stated, "and I just finished making a picture for you called *Rebel Without a Cause*. I thought maybe you'd forgotten my name because the last time we met any closer than bowing distance was in your office late at night and you wished you'd never met me and I thought you should have felt just the opposite."

More tactfully, Ray said he remembered "every important frame" of *Rebel Without a Cause* "as if it had been printed on my skin," and he promised a "wonderful show" for Warner if only he could get a "limited" extension on the editing schedule.

Warner stood firm, however. He didn't want to extend Ray's time or salary. In addition to commercial pressures to release the picture, the mogul was now facing political pressures: In the third week of June, Warner was due in Washington, D.C., to testify before a subcommittee chaired by U.S. Senator Estes Kefauver, who was leading a crusade against violent films about juvenile delinquency.

"We've had some calls on *Rebel Without a Cause*," Kefauver told the studio chief.

"Whoever called must be working with radar," Warner said. "I haven't seen it myself yet."

That was true. With a host of important editing and postproduction decisions yet to be made, Warner's private memos to Weisbart show that he was pressing his staff producer to stem Ray's "arty" impulses where necessary. Weisbart did his best to mediate; he also did his best to incorporate Ray's "cutting notes." While the director sneaked time in the editing room, he was also holding script and casting meetings for "Tambourine," aiming for a delayed July start at Columbia.

Warner sat for the rough cut on June 30 and pronounced it "excellent," with "Dean beyond comprehension." By that date, however, with editing and postproduction touches still to come, Ray was forced to move on to "Tambourine." Leonard Rosenman was busy working on the music, fusing classical themes with jazz in a memorable score that would anticipate *West Side Story*.

<p style="text-align:center">✳</p>

Only a contradictory personality like Ray could have followed the budding personal triumph of *Rebel Without a Cause* with the near-total disaster of the Gypsy love story.

Lew Wasserman had organized a lucrative package, with Ray as director; Jane Russell as the star; her husband, football player Bob Waterfield, as executive producer; and former MCA agent Harry Tatelman as producer of the film. Perhaps the only excuse for junking Walter Newman's script, which had been praised in the past by everybody who had read it, was to boost the package with a new writer, another MCA-Wasserman client.

The new writer, Jesse Lasky Jr., was a veteran of Alfred Hitchcock and Cecil B. DeMille films, and the son of silent-era pioneer Jesse Lasky, a cofounder of Paramount Pictures. Lasky had an unforgettable first appointment with Ray at the Chateau Marmont. "I heard jazz coming out as I approached the door," Lasky remembered. "I went in, and the first time I saw Nick he was dancing with another man. The other man was a young prizefighter, and the two of them were dancing cheek-to-cheek around the room to jazz. Nick waved me to sit down and waved the servant with a drink, and I sat there and watched the two of them dance.... They danced beautifully, very graceful guys."

When the director finished his cheek-to-cheek, he and Lasky shared

drinks and a long, digressive conversation about "Tambourine." Ray saw the film as a semimusical: Gypsy guys dancing with other Gypsy guys. Lasky didn't blink at this; nor did he hesitate when Ray told him he could start work on the revised script tomorrow. "I knew the minute you sat down in that chair," explained Ray, "that you were the right writer for me."

Without a Dean to partner with, however, the new picture didn't really engage the director's imagination. Though he kept up an ebullient façade, after *Rebel Without a Cause* fell behind him, Ray slipped into a sort of postpartum depression. The director worked as if by rote, and the results were largely uninspired.

Ray delegated to others what he might have done himself under less hectic circumstances. He dispatched Lasky to meet the king of the Gypsies in Los Angeles. ("Talk to him, get all those ideas, watch what you see, make your mental notes . . .") He sent Roger Donoghue to New York on a similar errand, asking him to brief (and be briefed by) Jean Evans and tape-record a few street Gypsies. Later the charming former boxer actually pitched in on the screenplay, collaborating with the director on the elaborate, pivotal "whip dance" wedding scene.

But Evans's vaunted research, and Ray's endless study of Gypsy-ceremony photographs, fell by the wayside in the rush to get the script and cast and crew ready for the cameras. The revised script moved the story from New York City to a nondescript urban locale, with most of the film to be shot on artificial sets in the studio.

Later, Ray said that he went ahead with the Gypsy film out of loyalty to Russell, who had long ago agreed to play the hot-blooded lass forced into an arranged marriage with the footloose brother of the king of the Gypsies. It was also loyalty to Jean Evans; his first wife got story credit and her only Hollywood paycheck.

Ray had originally touted Marlon Brando as the brother of the Gypsy king, a free-spirited itinerant dancer. Then when Brando became untouchable, the director pursued Robert Mitchum. Ultimately Ray had to settle for Cornel Wilde, with Luther Adler, formerly of the Group Theatre, as the king contriving to enthrone his brother before his death.

Although Ray tried holding a freewheeling rehearsal in his bungalow, à la *Rebel Without a Cause*, he couldn't cast the same golden spell over these nonteenagers. The James Dean film had been a watershed for him in many ways—not least because he started to break his own rules of not drink-

ing or taking drugs while on the job. Working at home at the Chateau Marmont had blurred the line. Now Wilde, for one, was thrown by Ray's often "broken and slurred" speech. "A lot of what he said was incomprehensible, or at least it was way up on cloud nine as far as I was concerned," said Wilde, who had just, for the first time, directed one of his own films. "I know Nick drank some but I think he was on something else too. His expressions were so vague that frequently I didn't know what he was getting at."

The photography finally got going on July 25. It was another Cinema-Scope venture, with an explosion of color in the costuming and decor compensating for the drab script. While Ray guided Russell and Wilde through their Gypsy paces, Leonard Rosenman scored the music for *Rebel Without a Cause* and David Weisbart, consulting with Ray, polished the Dean picture to a gloss.

A week or two later, as the director was still guiding song-and-dance numbers for the Gypsy love story, Natalie Wood ended her work for John Ford—and, around the same time, her romance with Ray. According to Gavin Lambert, the final blow to their waning relationship came when the teenager missed her menstrual period. Wood placed a urine sample in the refrigerator of the director's Chateau Marmont bungalow one night before a pregnancy test; stumbling about in the wee hours, Ray mistook her urine for a glass of fruit juice, thirstily gulping it down. The actress, who had just celebrated her seventeenth birthday, took the opportunity to break off their months-long affair. Fortunately, it turned out Wood wasn't pregnant.

✳

In spite of his mild friction with the studio boss, Ray's special relationship with James Dean gave him the upper hand with Jack Warner. In just a few months' time, Dean had catapulted from unknown quantity to star with an unlimited future; the studio was hoping that Dean would cooperate with the publicity campaign and appear in future Warner Bros. pictures.

The studio was also aware of Ray's rising reputation in Europe and of his ease with the press. The director had been trying to get overseas for several years, planning ill-destined film projects set in Italy with Humphrey Bogart and in Portugal with Joan Crawford. Now Warner's

arranged for him to travel first-class to Europe, to screen *Rebel Without a Cause* for European censors and distributors and promote the film in interviews. He was scheduled to leave days after calling the last take on "Tambourine."

By late August, Dean had finished most of his work on *Giant,* just as Ray was about to depart for New York. The two met for dinner. The star complained about director George Stevens's old-fashioned methods, saying how much he missed the creative flow, the circle of trust, that Ray had engendered during the making of *Rebel Without a Cause.* For several hours they talked over their future projects: They thought they might start with "Heroic Love," a story by an Arizona English professor, Edward Loomis, revolving around a *Lusty Men*–type triangle of an older judge, the judge's younger wife, and a lawyer.

A few hours after they'd said good-bye, Dean turned up again, at three in the morning, at the Chateau Marmont. Elizabeth Taylor had given her costar a Siamese cat as a parting gift, and he wanted to borrow one of Ray's books about cats. After *Rebel Without a Cause* was released, Ray and Dean planned a much-needed vacation. "We had our holiday place to stay in Nicaragua all picked out," Ray told a film journal years later.

The first preview of *Rebel Without a Cause,* which Dean attended and Ray missed because of a trip, was set for September 1 in Huntington Park, a suburb of Los Angeles south of downtown. The world premiere was scheduled for late October in New York.

# Circle of Isolation

## 1955–1957

Just as Ray once turned his eyes from New York to Hollywood, he now began to pivot toward Europe. Clippings of his overseas coverage kept him apprised of his growing stature in France as a major screen artist who could do no wrong. The director consciously sprinkled a little French into *Rebel Without a Cause,* and after shooting the erotically charged alley exchange between Jim Stark and Plato—where Plato invites Jim to stay overnight at his house ("we could talk in the morning and we could have breakfast") and gushes that he wishes Jim could be his father—Ray told James Dean that he'd handcrafted the scene to titillate his Parisian admirers. "I didn't think anyone would pick up on it in the States," the director said in an interview years later.

France beckoned, and in early September Ray took passage on a transatlantic ocean liner that would give him several days of needed rest during the crossing. Once in Paris he checked into the luxurious Prince de Galles Hotel on Avenue George V just off the Champs-Elysées, an establishment favored by Hollywood visitors. Though he distanced himself from "Tambourine," leaving the Gypsy film behind for postproduction, Ray threw himself into selling *Rebel Without a Cause,* which he foresaw as his signature work.

In Paris, Ray felt buoyant, mixing invisibly with the boulevardiers while holding court with cinephiles at Les Deux Magots. The director was their auteurist rebel, his films their cause. Though he had a sense of what to expect, Ray was nonetheless taken aback by their seemingly bottomless praise. When one Frenchman raved to him about *Johnny Guitar*—which Ray himself considered a troublesome career blip he would rather have forgotten—he was stunned. "He almost persuaded me it was a great movie," he joked with Gavin Lambert a few months later.

Back in California, *Rebel Without a Cause* aced its first previews, meeting the studio's highest expectations. Jack Warner, Steve Trilling, and producer David Weisbart sent telegrams to Ray reporting the positive audience response cards and the mounting anticipation for the film. Without Ray, they made final trims in precious sections the director had obsessed over, including the knife-fight sequence and the sexually inflected alley scene, but they did so, as Trilling insisted in his communications with Ray, for length and "without losing any scenes or values."

After a brief stay in Paris, Ray flew to London to meet with Arthur Abeles of the London office of Warner Bros. The United Kingdom was the single most lucrative foreign territory for Hollywood, but British censors were strict about films that mixed violence and young people. *Blackboard Jungle* had preceded *Rebel Without a Cause* in England, stirring controversy and losing footage to the censors. Ray had no qualms about bad-mouthing Richard Brooks's more realistic take on juvenile delinquency, helping the London team craft a strategy touting *Rebel* as "sincere and intelligent" compared to the MGM film. While in London, Ray also made a round of the British studios, already thinking of making a picture in Europe someday soon.

Ray was still visiting London on September 30, 1955, when James Dean, chain-smoking Chesterfields as he sped down the highway in his new silver Porsche 550 Spyder, smashed into a 1950 Ford turning left into his path at the intersection of routes 466 and 41 near Cholame, California. Rushed by ambulance to a Paso Robles hospital, Dean was officially pronounced dead at six twenty P.M. In the predawn hours, the telephone rang in Ray's room at the Savoy Hotel. It was Roger Donoghue in America.

"Jimmy's dead," Donoghue told the director.

There was a long, heavy pause. "Are you sure?" Ray finally responded.

Donoghue said that he'd double-checked with the wire services before calling. The charismatic twenty-four-year-old star of *Rebel Without a Cause,*

upon whom Ray had pinned so many hopes, had been crushed beneath his steering wheel, suffering a broken neck, multiple fractures, and internal injuries. He was dead on the scene. The sole passenger in Dean's car, and the driver of the Ford, both survived their injuries.

"I'll talk to you tomorrow," Ray said before hanging up.

Ray fled to Frankfurt, where he met up with Hanne Axmann, who'd moved back to Germany. "Hi, darling," he said, getting off the plane, "Jimmy's dead." He broke down weeping, and he sobbed on and off throughout the day as they drove to Axmann's country house, stopping along the way at "every inn" for "a Steinhager or something to drink," in her words.

He tried a little sightseeing and visited Göttingen University to meet the writer of a book he expressed interest in filming. Mostly, however, he spent two weeks in drink and tears.

One day, Ray and Axmann drove to the eastern border to watch the first trainload of repatriated German prisoners returning home from ten years of slave labor in Russia—men whose trials had left them looking "older than their parents." Impulsively Ray spent two days photographing the ex-soldiers and interviewing them, with Axmann as his interpreter. "If I can think of a constructive way of handling the material so it will fit into a picture, it's certainly a stark background," the director informed Hedda Hopper in an exclusive for her column, already spinning future plans and keeping his name in the limelight. "I feel there's something to say about it."

Returning by plane to London, the director sat through *Rebel Without a Cause* with the top British censorship official, Arthur Watkins. "Much as I love the picture," Ray scribbled on a Lufthansa postcard to Trilling, "it's a little like going to a funeral, as you can imagine."

Dean's abrupt death did not stop Warner Bros.'s plans for the film's elaborate October 26 world premiere in New York City. "Possibly if the timing had been different we could have held back the release," Trilling wrote sympathetically to Ray, "but publicity had already been planted and it was impossible to stop the forward movement without creating comment."

The director arrived in New York on the Sunday before the occasion. He was booked into the St. Moritz overlooking Central Park. Roger Donoghue picked him up at the airport at ten A.M., but Ray had drank steadily all during the flight and was thoroughly soused. Donoghue had seen the director stumbling and slurring before, but this time was different. "I think it was all over on that September night of 1955," Donoghue said later, meaning the momentum, or perhaps pleasure, of Ray's career.

The premiere went smoothly, although the big-city critics were divided over Ray's teenage delinquent manifesto. With its fervent emotionalism, *Rebel* defied easy categorization, and some of its moments bordered on camp or soap opera. Wanda Hale of the New York *Daily News* hedged her three-star review with complaints about the cardboard adult characters. Alton Cook of the *New York World-Telegram* described the acting of the teenage trinity as outstanding but said the story went to "unacceptable extremes." Despite memorable performances, wrote Archer Winsten in the *New York Post,* the film was studded with clichés. William Zinsser of the *New York Herald Tribune* called Dean the saving grace of a "turgid melodrama."

Good, bad, or mixed, the reviews would not matter to the extraordinary reception accorded the film by the public. Ray saw his usual equation reversed: Critics may have been underwhelmed, but ordinary people took the film to heart. Capitalizing on the surge of interest in Dean after his death, *Rebel Without a Cause* was the rare Nicholas Ray film to spread like a wave among audiences across America. The film became the eleventh-biggest moneymaker of 1956 and Warner's highest-grossing picture of the year. No other picture Ray directed had scored such a bull's-eye with audiences.

Indeed, no other film he directed was ever rated so highly among his film industry peers. Early in 1956, when the Oscar nominations were announced, *Rebel Without a Cause* became the only film Ray directed to be nominated for any major Academy Awards.[*] Lew Wasserman's foresight—and Stewart Stern's apprehensions—were confirmed when the film drew a Best Motion Picture Story nomination, based on Ray's seventeen-page treatment, "The Blind Run." The film's screenplay, by contrast, was overlooked.

Disappointingly, Dean's performance in *Rebel* was slighted in the Best Actor category; instead he was nominated for his breakthrough under Elia Kazan in *East of Eden.* But a Best Supporting Actress nomination for Natalie Wood validated Ray's stewardship—and manipulation—of the young actress, while a Best Supporting Actor nomination for Sal Mineo affirmed Ray's discovery and sensitive handling of a prior unknown.

Dean lost to Ernest Borgnine in his category[†] and *Rebel* didn't win

---

[*]   Only one other Nicholas Ray film contended for *any* Academy Awards. *55 Days at Peking,* his last picture, was nominated (but didn't win) for Best Original Song and Best Score.

[†]   Also Oscar-nominated for Best Actor, one year later for *Giant,* Dean lost again.

a single award on Oscar night, but the three nominations stamped the picture within the trade as Ray's highest achievement. That is also the view of posterity. Today, *Rebel Without a Cause* continues to entertain, fascinate, and inspire. The film that best captures Dean's tormented sensibility, it endures as a unique touchstone of its era. And for Ray himself, inarguably, it was the rare moment in his career when everything had come together.

The director didn't think the film was perfect. It had nagging faults. "I didn't like the way Nick Ray treated the parents in *Rebel Without a Cause*," Elia Kazan wrote in his memoir. "I get angry just thinking about that film," Orson Welles once declared, believing the picture had been overpraised.

And the French, perversely, tended to rank it lower than some other Ray films, the underdog movies that must beg for attention. (*Rebel Without a Cause* is "more explicit, less mysterious" than these films, in Bernard Eisenschitz's words.) But as Ray himself often said, it was his most satisfying film, his favorite.

✳

"We deem Nicholas Ray to be one of the greatest—[Jacques] Rivette would say *the* greatest, and I would willingly endorse that—of the new generation of American filmmakers, the generation which only came on the scene after the war," rhapsodized Eric Rohmer in his lengthy appreciation of *Rebel Without a Cause* in *Cahiers du Cinéma*. "In spite of his obvious lack of pretensions, he is one of the few to possess his own style, his own vision of the world, his own poetry; he is an auteur, a great auteur."

Fate robbed the "great auteur" of immediate pride in his greatness, however. His pride was tempered by what-ifs. He tasted more bile than pleasure. Ray could think only of the fallen star, the dead man-child, his almost-son, blood brother, twin, his echo, the cat man.

Every interviewer asked him about James Dean, and the publicity never stopped. While on the East Coast, Ray was comforted by Jean Evans and Connie Ernst (now married and known as Connie Bessie) before returning briefly to Los Angeles and the Chateau Marmont to lease his bungalow to an actor for several months. He told people he was returning to Europe on behalf of Warner Bros. but intended to stay there for an ex-

tended period. He met with actor James Mason, who had a project at 20th Century-Fox that he wanted Ray to direct, but Ray wasn't sure; despite his familiar smile, he went about in a blue-funk daze.

In Hollywood he sold the Mercedes that he'd bought to use touring around Mexico with Dean ("never drove it") and checked in on post-production for the Gypsy love story, which had suffered another generic retitling and become *Hot Blood*. ("What a title!" he exclaimed to *Movie* magazine in 1963. "It's hard for me to say it.") It was nearly Christmas, but any joy of the season had been drained out of him—and out of *Hot Blood*.

Then he headed back to New York, where he tried disporting, by turns, with Shelley Winters and Jayne Mansfield. When Ray departed by ocean liner again for Europe, Mansfield was there to see him off at the dock, later telling a columnist that she rated the "tall, attractive" director among America's ten most fascinating bachelors, for his "rare combination of brawn, brains and achievement." (The others on the actress's list, including heartthrob singer Johnny Ray and fashion designer Oleg Cassini, were no slouches.)

Back in Europe, Ray spent two weeks with the loving and sympathetic Hanne Axmann in a Munich hotel. But there was also work to be done, and he once again put his salesmanship at the disposal of Warner Bros., helping to plan the Paris and London openings of *Rebel*. In London, Ray failed at one important mission: The British censor, Arthur Watkins, insisted on snipping six minutes out of the Dean film, including bits from the knife-fight scene and the scene where Jim Stark throttles his father—and even then granted the film an "X" certificate, for over-sixteen moviegoers only. Warner's London emissary, Arthur Abeles, blamed himself for relying too much on Ray, who "cut absolutely no ice" with Watkins while also making impolitic statements about censorship to the British press.

Ray did score a direct hit on another target, however. The director went to a New Year's Eve party hoping to meet Gavin Lambert, the young critic who'd rescued *They Live by Night* from oblivion, now the editor of *Sight and Sound,* the prestigious journal of the British Film Institute. Just before midnight, Lambert arrived to be ushered into the presence of "a man with powerful shoulders, a leonine head and graying blond hair, very handsome but gloomy," standing alone in a far corner of the crowded room, seeming "to create a circle of isolation around himself." Lambert instantly recognized Ray from photographs.

"I am a new director of very remarkable talent," Ray said, introducing himself jocularly with words quoted from Lambert's own review of his debut film—and taking a long look at the thin, ascetic scribe, with his rooster's tuft of hair. After singing "Auld Lang Syne" with the other guests, Ray said, "Let's get out of here," and escorted Lambert to a chauffeured limousine. At the Hyde Park Hotel they settled in the sitting room of Ray's suite, drinking vodka and discussing Ray's films, especially *Rebel Without a Cause* (which Lambert had seen at an advance screening and liked) and James Dean.

"You can imagine how I felt . . . ," Ray said, groping to express his grief over Dean's death, pouring himself another vodka. He never did finish the sentence.

Changing the subject, Ray asked if Lambert had seen and enjoyed *In a Lonely Place*. Yes, the Englishman said, and he appreciated "its ambiguity, the way it left you wondering how the Bogart character was going to spend the rest of his life."

Ray perked up at this discerning appraisal of the Bogart film. "Exactly," he replied. "Will he become a hopeless drunk, or kill himself, or seek psychiatric help? Those have always been my personal options, by the way."

Before Lambert could digest this unsettling remark, Ray switched subjects again. He started talking about *Johnny Guitar,* the ordeal of making that movie, what a monster Joan Crawford was—and how amusing the French were, praising the film to the skies.

Then Ray wanted to hear about *Another Sky,* a low-budget love story, set partly in Morocco, that Lambert himself had written and directed a year before. Ray wanted a screening arranged for him right away—the next day. The director had meetings all morning, followed by a lunch date, so three o'clock would be optimal, Ray said. "Then he got up, rifled through various scripts and papers on a table," according to Lambert, "and handed me a photocopy of a *New Yorker* article," a story that was the basis of the picture James Mason wanted him to direct.

"I want you to read this and tell me what you think about it at the screening tomorrow," Ray said, heading for the bathroom that adjoined the bedroom in his suite.

He paused at the door, almost as an afterthought, and turned to ask, "How old are you?"

Thirty-one, answered Lambert.

"I'm forty-four," Ray mused. "Not quite old enough to be your father."

"What was that supposed to mean?" wondered Lambert, who was homosexual and comfortable with his sexuality. Ever since Ray's teasing opening remark at the New Year's party, Lambert had been trying to decide if Ray was homosexual; the director seemed to be striking an intentionally "flirtatious note" with him. Ten minutes later he looked at his watch; hours had passed, it was three thirty A.M., and Lambert began to wonder something else: "Why hadn't Ray come back from the bathroom?"

Perhaps he'd fallen asleep. Lambert peered into the bathroom, but it was vacant. Then he peeked through the bedroom door, which was not quite closed.

"As I reached it," wrote Lambert years later, "the door opened further and I collided with Nick on his way back, naked except for his underpants." They fell into each other's arms and made love.

Afterward, Ray was talkative. "An hour or so later," recalled Lambert, "he said that he wasn't really homosexual, not really even bisexual, as he'd been to bed with a great many women in his life, but only two or three men."

That would make Lambert number three or four but the only one whose identity is definite, because he wrote extensively about his relationship with Ray in his autobiographical book *Mainly About Lindsay Anderson*.

Near dawn, the Englishman stumbled home to the flat he shared with fellow critic and budding filmmaker Lindsay Anderson. After catching a few hours of sleep, Lambert went off to work at the British Film Institute, only pretending to busy himself at his editor's job. "All I could think about was the fact that I'd fallen deeply in love with Nick," he wrote. "So, as I discovered later, had scores of other people."

To Lambert's relief, Ray praised *Another Sky* after the screening—"it's got a strange kind of concentration"—and back they went the next day by limousine to the Hyde Park Hotel. En route they discussed the *New Yorker* article "Ten Feet Tall," a nonfiction account of a New York history teacher, suffering from a degenerative artery disease, who is treated with the new drug cortisone. The drug alleviates his symptoms but transforms the history teacher into a manic-depressive whose aberrant behavior wreaks havoc on his family.

Ray said he'd just signed a two-picture contract with 20th Century-Fox. A film based on "Ten Feet Tall" was slated to be the first of the two.

Ray had signed the contract only after the studio included, as part of the deal, a first-class return ticket to Europe after the two pictures were completed. "I want you to come out to Hollywood and work with me on it," the director told Lambert in his suite, pouring himself a generous glass of vodka.

Before Lambert could recover from his astonishment, Ray said that the next day he had to dash off to Paris, where *Rebel Without a Cause* was going to be shown to journalists under its French title, *La fureur de vivre* ("The Fury to Live"), and thence to Berlin for similar events and publicity interviews covering the German market. He said he'd return to London for the official press screening of *Rebel Without a Cause* in a week's time. After hugging Lambert, the director ambled into his bedroom and closed the door: No lovemaking this time.

From Paris, he phoned to tell Lambert that the French were cooing over the James Dean picture, with one critic comparing it to the "masterful" *Johnny Guitar*. Lambert admitted that he, like Ray, could never understand why *Cahiers du Cinéma* critics took the Joan Crawford Western so seriously. "Something about inner solitude," Ray explained wryly, adding, "I miss you."

Lambert heard nothing more from Ray until his rendezvous with the director at the London screening. Again, Ray told him that he would be "leaving tomorrow," but this time he asked Lambert to drive him to the airport, where he was due to catch a flight to America en route to Hollywood.

The London screening had gone well, though the atmosphere was more restrained than in Paris. "The British critics had been very polite," recalled Lambert. "He [Ray] wondered if they really liked the film. Some of them told me they did, I assured him, but critics here feel they have to safeguard their integrity by keeping a distance from filmmakers."

"A virginity complex . . . ?" Ray asked mischievously.

On the way to the airport the next day, Ray talked enthusiastically about "Ten Feet Tall" and assured Lambert that he was going to like California a lot after he moved there. The director said he'd already asked 20th Century-Fox to prepare a green card for his new assistant. Ray offered Lambert advice on filling out his visa application. Then he shifted to personal ground. "He gave me a lecture on the need to disguise my homosexuality in Hollywood," recalled Lambert. "A butch handshake, he said,

is very important, then demonstrated a bone-crushing one, and gave his startling smile."

The director told Lambert he didn't need to see him to the gate. The two said a hurried good-bye, then Ray turned to go. Before he disappeared he called out to Lambert: "Will you bring me a couple of bottles of marc de Bourgogne?" he asked plaintively. "I can't get it out there."

❋

Medical correspondent Berton Rouche's case study of cortisone treatment gone amok, "Ten Feet Tall," ran over twenty magazine pages in the September 10, 1955, issue of the *New Yorker*.

After receiving a Best Oscar nomination for playing Judy Garland's alcoholic has-been husband in *A Star Is Born,* the debonair, mellifluous-voiced British actor James Mason had been wooed by 20th Century-Fox to produce and direct his own pictures. The actor had invested months in diligently preparing a remake of *Jane Eyre,* but the studio canceled the project at the eleventh hour. Mason was eager to get something produced; he didn't care about directing. After reading "Ten Feet Tall," Mason seized on the article and got permission from the studio to purchase the screen rights. He worked closely with Cyril Hume and Richard Maibaum on a first-draft script written without Ray's direct involvement; it was completed before Christmas 1955.

The senior partner of the writing team, in age and reputation, Hume was a former New York reporter who had written his first, acclaimed novel at the age of twenty-three. He'd logged much of the 1920s in England and Italy writing lost-generation novels that earned him comparisons to F. Scott Fitzgerald, before moving to Hollywood with the explosion of "talkies" in 1930. His best-known credits were on Astaire-Rogers and Tarzan vehicles before MGM teamed him with Maibaum, a newly arrived playwright from New York, in 1936. The two had worked intermittently together since then, their scripts including a 1949 version of *The Great Gatsby* for Paramount.

Hume and Maibaum took the true-life husband and wife interviews that shaped "Ten Feet Tall" and created a drama about a fictional family. In the original article, the schoolteacher, his wife, and their eleven-year-old son had lived in Queens; the writers moved the family to a suburb in

a small, unidentified American city. But the planned community in their script bore a distinct resemblance to New Rochelle, where Hume had been born and raised: "a huge residential housing development," in the words of their script, "the individual houses" opposing "the vast, underlying uniformity by being bright, modern, attractive, and superficially varied in design."

Besides creating the main characters, Hume and Maibaum established the story premise (the spells of pain suffered by the teacher, which prompt doctors to diagnose him with a rare inflammation of the arteries and prescribe cortisone) and the sequence of events that ensues: the mood swings and the downward spiral of the narrative. Their script even included some of the film's most memorable dialogue. When the teacher suffers his worst psychotic meltdown and decides to kill his own son, for example, he recites from the Bible the story of God asking Abraham to sacrifice his only child, Isaac, as a "burnt offering." But God stopped Abraham, his wife tearfully reminds him. Ed's blasphemous rejoinder—"God was wrong!"—is in the Hume-Maibaum draft.

Production Code officials approved the Hume-Maibaum script with only minor quibbles, which were easily resolved in later versions. The studio then made a halfhearted effort to recruit an American type to play Ed, the schoolteacher, briefly pursuing Richard Widmark for the part. But Mason had grown attached to the story, working closely with Hume and Maibaum, and he thought he might play the teacher after all, finessing the American accent. If Mason was going to produce the film, the studio was more than happy to have him star in it as well.

After screening *Rebel Without a Cause,* Mason picked Ray from a list of director candidates supplied by 20th Century-Fox. Darryl Zanuck, the studio's longtime chief, had just handed over the reins of production to a group of executives led by Buddy Adler, an old card-playing confederate of Ray's. One of Adler's right-hand men was Sid Rogell, once Ray's nemesis at RKO, now the 20th Century-Fox studio manager. Rogell could attest that Ray had done everything and more asked of a contract director for Howard Hughes.

Twentieth Century-Fox was one of Hollywood's venerable studios, with a long track record of quality and success under Zanuck, who tightly controlled the final product. By the time the director had signed his contract, the Hume-Maibaum script of "Ten Feet Tall" had been approved

by Mason, the Production Code, and the studio officials substituting for Zanuck, with a start date for filming firmly on the calendar, two months hence.

<p style="text-align:center">✳</p>

Arriving back in Hollywood in early January, Ray met with Mason and told him that he wanted to improve the script as much as possible in the time remaining. "Would he like to meet the writers Cyril Hume and Richard Maibaum and brief them about the improvements that he had in mind?" Mason recalled asking. "No, he definitely did not."

In that case, Mason suggested that he and Ray could collaborate on the revisions, because "we both had experience," in the star's words.* The director said no, he preferred to hire his friend Clifford Odets, whose name would lend distinction to the film. (Ray had moved back into his bungalow at the Chateau Marmont, where Odets still lived.) But Mason was wary of the ex–Group Theatre playwright, who might be tempted to do too much, maybe start over from scratch. The star said no. Ray went over Mason's head to Buddy Adler, but Adler also said no. Having lost that gambit, Ray plunged into script sessions with Mason.

Their script work was congenial enough but filled with "pause play," in Mason's words, and not always conclusive. The third star-producer Ray had worked with, after Humphrey Bogart and Joan Crawford, Mason joined another growing list: collaborators of Ray's who found it challenging to decipher his pauses and silences. "Nick was not too sure about the script but he couldn't really pinpoint it," Mason recalled some years later. "He is a person who can't express himself in words very well. He's a man who holds long, inarticulate pauses and during these early stages it was really quite frustrating because he wanted rewriting to be done, but he couldn't say exactly what it was."

As usual, Ray sought to bolster the authenticity of his approach by consulting medical authorities for their expertise. He arranged to speak to Dr. Philip S. Hench, a shared winner of the 1950 Nobel Prize for Medicine for his part in treating rheumatoid arthritis with injections of cortisone. Dr. Hench was willing to answer Ray's questions but uninterested in any

---

* Mason had writing credits on several films co-written with his wife, Pamela.

close association with a Hollywood movie; the Nobel Prize–winner was wrapped up in his work at the Mayo Clinic in Rochester, Minnesota. For that reason, in part, Ray's ardor for realism was dampened.

Yet Ray and Mason made progress enhancing the Hume-Maibaum draft. Much of the revision went toward strengthening Mason's school-teacher character, Ed, as had happened before when Ray formed two-man clubs with other stars—Bogart, Mitchum, James Dean. For example, Ray and Mason gave the script a new beginning, in which the dedicated teacher fights off mysterious stabs of pain after a hard day at school, then heads to a second, nighttime job as a taxi dispatcher (a secret sideline he keeps from his family). Ray later took credit for the taxi-moonlighting idea himself, saying it arose from his indignation that American teachers were such "poorly paid professionals." Teachers often held second jobs in order "to keep up with the Joneses," in his words, "the false central idea of much of the activity of this country [the United States]."

"Revisions in this version by James Mason and Nick Ray" was inscribed on the drafts that followed Hume and Maibaum's, suggesting that Ray was angling for another writing credit like the one that had brought him an Oscar nomination for *Rebel Without a Cause*. But this time the director had no such guarantee in his contract, and ultimately Hume and Maibaum alone would be credited on-screen with the story and script.

Even as Ray and Mason came to the end of their work, however, the director still wasn't satisfied, and he revived the idea of engaging Odets for a final swipe at the script. "He wanted the confidence which would be given him by the cooperation of someone like Clifford Odets," according to Mason. But Mason still demurred, and the star recalled that a "barrier" sprang up between him and the director then, which might have worsened if Gavin Lambert hadn't arrived on the scene in early March.

❋

Officially, 20th Century-Fox had hired Ray's protégé as a dialogue director—the same way Ray had started out in Hollywood. But Ray made it clear to James Mason that Lambert was a multitalent: a discriminating critic, writer, and budding filmmaker. Ray told the star that "as a younger man," Mason recalled, "he had been taken on as an apprentice and enormously helped by Elia Kazan and as a result he had always felt it was his duty, in the event of finding someone with outstanding talent, to help him in a similar way."

"Your first Hollywood set," the director said, gesturing grandly, escorting Lambert to dinner at fashionable Chasen's just hours after the Englishman had arrived by plane, been chauffeured to the Chateau Marmont, and been handed a key to the bungalow he'd share with Ray. At dinner that night, they discussed the Mason picture, soon to be retitled *Bigger Than Life*. Though they'd made some improvements, Ray said, the script was still inadequate. The relationship between the husband and wife was superficial, the dramatization of medical procedures old-fashioned. Lambert would surely agree, Ray said, after reading it.

On the way back to the Chateau, they stopped at Judy Holliday's house in Beverly Hills, where they socialized with the blond comedienne, whose career had slowed down as a result of her hostile cross-examination by the House Un-American Activities Committee in 1952. Holliday and Ray were both in a low mood, troubled by radio accounts of U.S. hydrogen bomb tests in the Pacific. "Some time after one o'clock in the morning," Lambert recalled, "they both ran out of angst."

Returning to the Chateau, Ray handed Lambert the latest draft of the script; then, saying he was tired, the director trudged upstairs to his bedroom and closed the door. "Nick's way of telling me, I supposed, that what had happened once in London might or might not happen again," Lambert recalled, "and it was up to him to decide. I was not too tired to feel disappointed and confused."

Lambert's spirits lifted, however, upon meeting the star and producer of the film. He felt an instant rapport with fellow Englishman James Mason, who was much admired as a silky-smooth actor. Mason liked Lambert too: Besides being bright and articulate, Lambert was "a young man," Mason realized, "and Nick communicates with young men much better than he does with people of his own age, so it seems." Mason and Ray's assistant went to work trying to inject some vitality into the script's domestic and medical scenes, while Ray supervised preproduction.

✻

Ray was still yearning for input from Clifford Odets, however, and again he went over Mason's head, pleading with Buddy Adler to let Odets critique their final draft. Odets had offered his services for free; the studio wouldn't even have to pay. Adler prevailed upon Mason to let Ray go ahead; the critique couldn't hurt and it might serve some purpose.

Ray and Lambert crept across the Chateau grounds one night for a late-hour appointment with Odets. The director carried a tiny portable tape recorder in his vest pocket so he could document the eminent playwright's advice. Yet Odets gave them only a few specific pointers, Lambert recalled, including suggesting they ought to blame the teacher's financial pressures on the "social ambitions" of the wife.* Mostly Odets expressed himself in somewhat vague terms, at one point delivering "a long, mournful aria on 'the loss of belief as we all grow older,' 'the shrinkage of idealism,' and 'the death of hope,'" according to Lambert. "Although it was supposedly a lament for American life in general, to me it sounded more like Odets's song of himself."

Leaving Odets's place, Lambert was at a loss for words. "It's fascinating in a way, but we can't do it," he finally muttered, meeting a glance from Ray that seemed to concur.

Ray plowed ahead with casting. As Mason's wife, the director picked Barbara Rush, an elegant actress under contract to Universal; for the young son he chose Christopher Olsen, who had recently appeared in Hitchcock's remake of *The Man Who Knew Too Much*. Walter Matthau landed an early, unlikely role as a high school gym teacher who looks out for his friend Ed.

Ray also hired a prominent informer, composer David Raksin, who wrote evocative music for many motion pictures (including the famous theme to *Laura*) and whose career continued to soar after his 1951 HUAC appearance, in which he named eleven former Communist comrades—all, he later rationalized, dead or previously identified.

The studio had slated the film as a CinemaScope color production, with Mexican-born Joseph MacDonald behind the lens. One of the studio's stellar cinematographers, MacDonald had photographed John Ford's *My Darling Clementine* and Elia Kazan's *Viva Zapata!* Working with MacDonald and studio art directors Jack Martin Smith and Lyle R. Wheeler, while nursing drinks with his production-design friend John Hambleton, Ray ordered up another color scheme that was encrypted with meaning. The natural earth tones and outdoors scenes would be "indicative of life," as Ray later explained, while more garish colors, like the expensive Christian

---

* This was a tip they ignored, and the wife character in the film remained relatively blameless.

Dior orange dress the manic teacher buys for his wife, represented alarm-bell "intrusions." The household would grow darker and more shadowed as the teacher's psychosis progressed and the family entered its nightmare.

Again, defying the conservative rules that guided most CinemaScope productions, Ray planned for close-ups, unusual angles, and elaborate camera movements (the camera racing with the boy to catch his father's foot-ball pass) whenever he felt the scene required a visual kick. For the picture's climax, the violent struggle between the psychotic teacher and his friend, Ray set up multiple cameras to run without a break for several minutes.

Mason insisted on adhering closely to the script, and all page changes had to go through him and the studio. As Lambert noticed during the film-ing, however, Ray prided himself on using the camera to impose his will on scenes where he found the script, or the scene's emotional content, lacking. "How I shoot depends on what I want to get away with—to fool the censor, the front office, whoever," the director confided to Lambert during the production, "or how confident I feel about the scene as written."

One example: Ray wanted to add "some dialogue about the medical profession's carelessness in prescribing new 'wonder drugs' whose side effects had not been thoroughly monitored," Lambert recalled. Mason thought that was fine, but the studio rejected Ray's lines, apprehensive about the reaction from the American Medical Association. So the direc-tor cast "tough-looking actors" as physicians and "shot them nearly always on the move, in dark-suited gangsterish cabals of two or three," in Lam-bert's words. Like the teacher's financial woes, the sinister doctors gave the film a mild edge of social criticism.

Again and again, whenever the director was "forbidden to make a point verbally," Lambert recalled admiringly, "Nick had an extraordinary flair for making it visually."

❋

The photography got under way at the studio in the last week of March 1956.

Behind the camera, Gavin Lambert wore several hats. Besides re-hearsing lines with the actors before each scene, the director's assistant watched the actual filming carefully to make sure there were no continuity gaps. Whenever a script fix was needed, it was Lambert's job to supply it.

Besides interpreting Ray's silences for Mason, he also decoded him for studio officials. "I remember one of the executives at Fox saying to me quite early on, 'Well, you know Nick Ray very well. We don't understand his silences, we're so intimidated by them,'" the director's assistant and lover recalled. "I'd tell people, 'Don't be intimidated. When Nick is silent it means he's got nothing to say. It's really as simple as that.'"

Privately, though, it was not as simple as that. From late March through early May, during six weeks of principal photography (and while living together at the Chateau), Lambert increasingly saw Ray as a flawed human being who was at a professional and personal crossroads. While Ray wore a mask of steadiness and good humor, and talked about using the camera as a means of controlling the film, inside the armored façade he was a weak man plagued by self-doubt.

Taking a sip of Ray's glass of orange juice by accident one morning, Lambert realized the director's serving was spiked with vodka. The director was desperately hiding his alcoholism from people, in the same way that James Mason's character was concealing his cortisone addiction in the film they were making. Ray was "not the falling-down drunk kind," Lambert said, "but some days his usually acute responses were blurred."

Like the cabinet in the teacher's bathroom in *Bigger Than Life,* Ray's was filled with medicine vials. Some days, the director also kept quick appointments with the studio doctor for supposed vitamin B-12 shots. The injections "very quickly" energized him, as well they should, Lambert discovered eventually, for they contained "a dash of amphetamine."

Most days, Lambert insisted, Ray was on point. The director communed easily with Barbara Rush, a sensitive actress playing Ray's usual type of self-sacrificing wife, but despite their mutual regard, he never established a profound kinship with Mason, who felt uncomfortable with his own performance and noticed the days when Ray seemed fuzzy. "When Nick wasn't on his best form," Lambert wrote in *Mainly About Lindsay Anderson,* "James Mason reacted with the puzzled, uncertain look that often crossed his face, so different from the strength and occasional menace he conveyed on the screen."

If the camerawork excited Ray, the script inadequacies continued to bother him, and he spent most nights after filming working over the upcoming scenes with Lambert. "Every day or so he would come in with a few new sheets of paper which were submitted through the proper channels," Mason said, "just small dialogue improvements mostly."

Secretly too, the director kept up his midnight appointments with Clifford Odets. Ray was shooting more in sequence than usual, with the last scenes of the script coming up toward the end of May. The story ended with the teacher hospitalized after his worst breakdown. How could that be rounded off cathartically (and optimistically) for audiences? As usual for Ray, who'd fought for his bleak endings to *In a Lonely Place, The Lusty Men,* and *Rebel Without a Cause,* the ending was a sore point.

Mason was just as unhappy with the film's scripted ending, but he despaired of a wholly satisfactory solution. One night, toward the end of the schedule, Mason got together with Lambert for one last whack at the final scene; meanwhile, unbeknownst to Mason, Ray brought the same issue to Odets, who had swallowed a sleeping pill and had to force himself awake to hear the director outline the circumstances of the scene. After some drowsy gabble, the playwright agreed to come to the studio the next day and try to solve the problem.

Ray smuggled Odets onto the lot and stashed him in the back of a property truck to cogitate and scribble. Mason was astonished when Ray told him he'd brought Odets to the lot ("The man is talking to me," the star recalled thinking, "as if I am a party to the midnight script conferences that have been going on"), but he agreed to listen to Odets's recommendations at lunchtime.

At the end of the script, the teacher's psychosis takes a murderous turn. He stalks his young son with a scissors, and when the gym teacher intervenes, a fight ensues. The two crash through a banister, smashing up the hallway and living room (as circus music blasts from the nearby TV) before the teacher ends up unconscious and sedated in a hospital room that's lit like a prison cell. As his doctor and family gather around his bed, it's unclear whether the teacher's mind will ever recover.

What should happen next? Should the family—the audience—be given false hope, when cortisone, with its dangerous side effects, has already been described as the last resort for his illness? That was the dilemma for Odets, for Ray, for the film.

The writer's writer presented his ideas. The doctor should tell the wife that she must have faith in the future, Odets said. Then the teacher should wake up from a feverish dream. He recalls walking along with Abraham Lincoln in the dream, "as big, as ugly, and as beautiful as he is in life." But then speaking the name "Abraham" gives the teacher a start, and he remembers the Bible story that drove him to try to murder his own son.

With eyes misting over, the teacher struggles to remember the horri-
fying details—everything that has happened, all he has done to endanger
his family. The doctor urges him to hold onto the memory, telling him how
important it is never to forget. The teacher is filled with contrition, but
also a hopeful feeling of renewal. He draws his wife and son to him in bed,
murmuring, "Come closer, closer . . ."

Ray nodded approvingly. Mason too was thrilled, despite his previ-
ous misgivings about Odets. "This was the first indication that I had had
that Nick was going and checking with Clifford in the evenings," the star-
producer reflected years later, "and in fact this is probably what gave some
quality to the film. Without Clifford's help maybe it wouldn't have had that
quality which brought it to the attention of some of the French critics."

Later in life, Ray described Mason as a "wonderful producer" who
gave him nothing but support and encouragement while they were making
*Bigger Than Life*. But Mason had wanted to make a realistic film, "very
close to a documentary film," and any hopes for realism were dashed—
first by CinemaScope, he said later, whose wide-screen color image made
"all films look like very cheap color advertisements from magazines," and
second by his own performance. Mason felt he had been implausible as an
American schoolteacher, with the slightest of Yank accents. The film had
emotional realism, to be sure, but not enough of the kind of realism Mason
would have preferred.

In his best of moods, however, Mason looked back on *Bigger Than Life*
as "a great adventure." Though he found Ray a "neurotic man" who "wanted
the kind of big brother I was not," as the star explained in one interview,
Mason was tempted to work with the director again. The two talked about
reuniting and even had a few near misses later in the early 1960s. "I could
tell you many conversations about Nick Ray," Mason once mused sympa-
thetically, "and mostly they're an exchange about Nick's strange conduct
in one way or another. They all seem to end up with someone saying, 'Mark
you, Nick is not without talent!'"

✳

One weekend, during the filming of *Bigger Than Life,* the restless Ray
woke Gavin Lambert up at around two in the morning and led him to
his bedroom. They made love. Ray quickly fell asleep afterward, the fra-
grance of a perfume he occasionally used lingering in the air.

Their lovemaking was infrequent because Ray stayed "sexually very active" with a number of women during this time. "Some weekends," Lambert wrote, "Nick arranged for a girlfriend to come over in the late afternoon, and asked me to stay out of the bungalow for 'a couple of hours.' The girlfriend was usually one of several young unknown actresses, very occasionally she was Marilyn Monroe, and in any case [she] never stayed the night."

Divorced from baseball star Joe DiMaggio, Monroe was dating Ray again when convenient. She remained one of his deepest crushes, although he could never quite promote himself into the role of her steady "beau" (as Hedda Hopper was encouraged to describe their relationship). He couldn't quite promote her into any film he was directing either.

Once, when Monroe visited the set of *Bigger Than Life* at the end of the day—she was finishing *Bus Stop* for 20th Century-Fox on a nearby soundstage—Ray tried coaxing the actress into a cameo appearance. Staging cutaways for a hospital scene, Ray talked Monroe into donning a nurse's costume and carrying two lamps into camera range. "Carry them on the set," Ray advised her, "put them down, walk over to this desk, sit down and look at the star, who's gone slightly off his nut."

According to Mason, who was in the scene, the cameo was intended as a laugh for studio executives at dailies, not for actual use in the film, but Monroe lost her nerve anyway. Ray couldn't shoo away her anxiety. "Oh Nick," she said, "tell me what you want me to do! I can't do it, Nick!" Finally Ray called cut, according to Mason, giving Monroe a comforting embrace before announcing "that he did not think it was such a funny idea after all, so let's not do it. 'Come on, Marilyn, what do you want to drink?'" Ray later fed the item to Hedda Hopper, who ran it straight: "Marilyn Does Bit in Nick Ray's Film," her column declared in May 1956, reporting that Marilyn had played her cameo role "like a lamb." Yet Monroe cannot be glimpsed in *Bigger Than Life*—nor in any other Nick Ray film.

Observing the director more critically as time passed, Lambert began to see Ray as fundamentally a misogynist who resented needing women in his life. ("Do you look down on all women?" Dixon Steele's old flame asks, challenging him, in *In a Lonely Place,* "or just the ones you know?") Lambert wondered if Ray resented needing men too. One day, when Ray pointedly told his protégé, "I'm afraid that sex destroys intimacy more often than it creates it," the Englishman wondered, "A reference to all the women he

had never felt truly happy with, or to me?" Lambert asked; the director clammed up.

"Although Nick rarely wanted to make love," wrote Lambert, "he behaved like a possessive lover, expecting me to be always here on call, to talk about projects (he had several he wanted us to work on together), to listen to music together (American folk songs, the blues, Schoenberg's spine-chilling *Erwartung,* a melodrama about a woman stumbling on the dead body of her lover at night), or simply to share one of his long, impenetrable silences, when he seemed to be struggling to confide some deeply buried emotion.

"At first I used to ask what was wrong," Lambert continued, "but instead of answering he would get up abruptly and leave the room."

Many of their late-night conversations circled back to James Dean. Ray couldn't shake off the deceased star's haunting memory; indeed, he didn't want to. The first anniversary of Dean's death was coming up in September 1956, and many of those who'd been touched by the star wrote letters to the director of *Rebel Without a Cause.* Journalists lined up for another round of interviews with Ray. "I think within two years," Ray told the press, "Jim would have taken his place with Laurence Olivier, Gérard Philipe and Marlon Brando as one of the great actors of modern times."*

An editor at *Harper's* magazine had asked Ray to keep a diary when making *Rebel Without a Cause* and afterward write an article about the film. The diary foundered during the filming, but now the material was located and dusted off for a book. A series of items in the Hollywood columns reported Ray had started on a book to commemorate Dean's greatness. One excerpt was eventually published in *Sight and Sound,* another in *Variety.*

The *Variety* excerpt, in which Ray describes his first encounters with Dean, remains one of the most perceptive pieces ever written about the enigmatic star. The work in progress had a title (*Rebel—The Life Story of a Film*) and a publication date timed to capitalize on the fanfare surrounding the anniversary of Dean's death. What it didn't have was a writer to take the manuscript to fruition. Lambert had to help with the excerpts, and the full book never came to be.

---

\*   Interesting that Ray, at this juncture, ranked Gérard Philipe alongside Olivier and Brando. Not as well remembered today, Philipe was a handsome, serious actor in quality French films, dead of liver cancer in 1959 before the age of thirty-seven.

✳

After finishing *Bigger Than Life,* Ray announced that he was forming a new independent production company, Rexray, in partnership with his business manager Rex Cole and a lawyer, Lawrence Beilenson, who had started out as a Screen Actors Guild attorney before joining MCA and swinging politically to the right, in the 1950s, along with one of his close friends, Ronald Reagan.

A flurry of press releases detailed the company's ambitious agenda, with most of the projects, including a film of "Heroic Love," left over from the plans Ray had made with James Dean. Ray talked to 20th Century-Fox about "Heroic Love," but the studio wasn't interested in a partnership with Rexray, and Ray, Cole, and Beilenson had to shop their slate to other studios around Hollywood. None was tempted by the projects, however; Ray was still no one's idea of a producer.

Twenteith Century-Fox was perfectly happy with *Bigger Than Life,* however, and Spyros Skouras talked to Ray about extending his two-picture contract, making one film a year for the next seven years for the studio. First, however, the director had to fulfill his current deal, and late in the spring Ray halfheartedly agreed to mount a remake of Henry King's 1939 film *Jesse James,* about the outlaw and his brother, Frank. Buddy Adler and Sid Rogell pitched it to the director as *"Rebel Without a Cause* out West," with the James brothers as "misunderstood teenagers," as Ray later recalled.

After finishing *Bigger than Life,* however, Ray felt a distinct letdown when he and the Jesse James project were assigned to a staff producer. Despite the problems he'd encountered while making the James Mason picture, the story had been in Ray's comfort zone, with its middle-class milieu, alienated protagonist, drug-addiction theme, manic father-son relationship, and tinge of social critique. Besides, he'd had power and influence while making the film; he'd shared the trust of star-producer Mason—they were almost a two-man club—and all their fights were good fights.

He didn't feel the same kinship with the 20th Century-Fox staff producer, Herbert Bayard Swope Jr., and it was clear from the start that he wouldn't be granted the same leeway on the Jesse James film. The studio hovered over the script and pushed its own contract players as the leads.

Long before filming began, the director saw disappointment written on the wall—and his own actions helped make it so.

The Jesse James remake had begun taking shape in the spring of 1956, when Ray was still deeply immersed in *Bigger Than Life*. Buddy Adler bought a first draft from Russell Hughes, a Western specialist who had been assigned to write a faithful adaptation of Nunnally Johnson's script for the 1939 Tyrone Power–Henry Fonda version. A revered figure within the industry, Johnson had turned director and producer of his pictures; he was still a luminary on the 20th Century-Fox lot, and the studio had no intentions of straying very far from the original.

Ray came along with a loftier notion. "My preliminary production scheme," he explained some years later, "was to do the whole film on stage as a legend, with people coming in and out of areas of light, making it a period study of the behavior of young people, but doing it as if it were all a ballad. It meant never doing anything for realism, putting the psychological, but not the real, within a stylistic form to make a unified piece of work."

Studio officials put the kibosh on his ballad-of-a-legend idea early in the summer. Even so, Ray went to work on the script with Walter Newman, a writer whose friendly relationship with the director dated back to their mutually hectic RKO days, when they'd doctored a few films for Howard Hughes and collaborated on the Gypsy love story that ultimately morphed into *Hot Blood*. Ray told Newman he wanted to nudge the Jesse James story down an unconventional path—he wanted a more psychological and less romantic treatment of the folk hero, as compared to the earlier film—and he thought he could fend off some of the studio's objections to his approach. He intended to salvage some aspects of the ballad idea with a theme song and flashbacks from the memory perspective of different characters. Jesse James himself would narrate the film at points.

As Ray envisioned James, the notorious outlaw was as troubled as he was troublemaker; he was another confused, overwrought youth in the Bowie–Nick Romano–Jim Stark vein. "We had great hopes for [the film] because we were trying to do a few things far ahead of its time," Newman recalled. "For one thing, both Nick and I were psychoanalytically oriented and in doing research were struck by the fact that Jesse was unmistakably self-destructive. His exploits were increasingly more hazardous and—surely it was unconscious on his part—he kept making disastrous mistakes.

"For example, he gave the man who killed him the gun with which it

was done as a gift—like an invitation to murder him," Newman said. "And to make it easier, he turned his back on the man to straighten a 'God Bless Our Home' chromo on the wall."

Ray and Newman didn't have very much time, however; the studio wanted to start photography by September. The two of them embarked on the usual frenzy of research and fact-finding, trying, as was Ray's wont, to plant the fiction in authenticity. They came up with a number of interesting details—Frank James was known to carry a pocket volume of Shakespeare—but just as with *Hot Blood,* another film Ray ultimately shrugged off, most of the research got left behind or was reduced to fleeting embellishments.

Still, Newman enjoyed their collaboration. He belonged to the rare group of writers who felt he *almost* could read Ray's mind. "I very seldom understood a single thing that Nick *said,*" Newman recalled. "Nick mumbled a great deal, leaving sentences unfinished and hanging in the air and starting many of them in the middle. Something like the interior monologues in *Ulysses.* But his tone of voice was expressive and he used his hands, his body and his face a great deal and once you crack his code there's great clarity and wild originality—he wasn't afraid to leave the ground in a balloon and then cut all the ropes anchoring him to earth."

※

With Rexray finding no takers for its wishful projects, Ray realized that he wasn't going to be able to launch his own independant production company in Hollywood. He talked over the frustrations of his career with Gavin Lambert. For the first time the director began to muse about escaping the prison walls of American film and finding true creative freedom in Europe. He had long wanted to shoot a picture overseas, and he'd enjoyed his taste of Europe during his two trips promoting *Rebel Without a Cause.* Now Ray began to talk of living abroad permanently. After all, he still had a first-class ticket in his back pocket, courtesy of 20th Century-Fox.

Using his overseas contacts, the director tried to set up an international project. He tried in vain to interest producers in a film of Alan Paton's *Too Late the Phalarope,* a South African novel about the racial divide with rugby as a backdrop. The Roger Donoghue story belonged to Budd Schulberg, but for a while Ray tried to promote his own boxing film about

early-twentieth-century French champion Georges Carpentier, nick-
named the "Orchid Man," but that too went nowhere.

Finally, a promising manuscript he'd chased for some time came to
him via a Paris-based producer who thought he could set up an interna-
tional coproduction using Hollywood connections. This was *Bitter Vic-
tory,* a forthcoming English translation of the novel *Amère victoire* by René
Hardy, a French author Ray had met in Paris.

Hardy's novel had won the Prix des Deux Magots in France, and the
author had a curious life story. A center-right resistance fighter during
World War II, Hardy had been a pivotal figure in the notorious Caluire
affair (named for the Lyons suburb where it occurred), which involved
the betrayal of leading comrades to the Gestapo. Twice tried as a traitor,
Hardy was first acquitted and then technically found guilty but spared the
actual verdict and death sentence on a procedural point. Hardy lived with
fame and success but also the widespread public belief that he'd been a
traitor.

Set in World War II, Hardy's novel told the story of a crack commando
unit led by two officers—one a coward, the other an admirable man who's
fallen for the coward's wife. After being parachuted behind enemy lines in
Libya on a mission to obtain secret battle plans, the unit makes a daring
raid on German headquarters. Afterward, however, the soldiers miss their
rescue rendezvous and are forced to strike out across hostile desert ter-
rain, facing desperate thirst, poisonous scorpions, and a deadly sandstorm.

One intriguing element of the novel was the homoerotic attraction
of Leith, the admirable officer, to his longtime Arab guide, Mokrane.
This echoed the subtext of "homosocial desire," as film scholar Anna
Phelan-Cox has written, that is "played out through Oedipal love trian-
gles" in other Ray films like *Rebel Without a Cause* or *The Lusty Men.* Often
these were father-son relationships ("whether literal or figurative filial,"
in Phelan-Cox's words) found within an "erotic triangle," in which the
"threat" of mutual desire is "usually eradicated by the death of one of the
dueling men." As Hardy wrote of Leith in the novel, when the officer gazes
at his faithful guide, "a strange uneasiness, centering on the Arab, stirred
him with an unknown emotion, a sort of weakness."

Ray and Gavin Lambert hoped to preserve the Leith-Mokrane rela-
tionship in the screen adaptation. Ray wanted to film scenes on location
in North Africa, a prospect as daunting as it was exciting. "We both saw

possibilities in the story," Lambert recalled. MCA agent Herman Citron worked out a deal for Ray to direct *Bitter Victory,* with Lambert writing the script.

The French novelist came to Hollywood for talks with Ray and his assistant. Lambert was a helpful liaison between Ray and the Frenchman, who spoke stilted English but nonetheless assisted with the script. The director wanted to eliminate the flashback structure of the novel, putting the action into logical sequence; he also wanted to build the coward's wife into more of a star part and to create more of an aching romance between her and Leith.

The producer also came to Hollywood: German-born Paul Graetz. Graetz discussed the production with Ray and Lambert but also visited Columbia to arrange $1.5 million in financing from the studio that knew Ray from Santana/Bogart films and *Hot Blood.* In the summer of 1956, Lambert worked minimally with Ray on *The True Story of Jesse James* (as the 20th Century-Fox remake would be known) and maximally on *Bitter Victory.*

❋

One Nicholas Ray picture that wasn't overlooked by critics at the time of its release was *Bigger Than Life,* which was rushed into U.S. theaters in early August in order to capitalize on the anniversary of James Dean's death. Anticipation ran high for the new offering from the director of *Rebel Without a Cause,* and the notices were as positive as any in Ray's career. James Mason's performance was generally applauded—despite the star's own reservations—and although audiences found the grim drama problematic, Mason's popularity gave the film a brief opening lift at the box office.

"A first-rate thriller," exclaimed *Time,* saying the lead role had been "superbly acted" by Mason and the picture "hair-raisingly directed by Nicholas Ray." "Taut" and "tingling," enthused the *Washington Star.* "An engrossing drama which builds to a climax of almost unbearable excitement and suspense," rhapsodized Kay Proctor in the *Los Angeles Examiner.* "A brilliant triumph for its director."

The film encountered much the same reception overseas. Selling *Rebel Without a Cause* in Europe had made Ray aware of the importance of film festivals, and it was his idea for 20th Century-Fox to submit *Bigger Than Life* to the end-of-summer Venice Film Festival. In its early years Holly-

wood had not paid much attention to the Venice event, since Americans rarely won the top awards, but that had begun to change in 1951, when Elia Kazan was awarded a Special Jury Prize for *A Streetcar Named Desire.* Ray knew that French periodicals closely covered the Venice screenings. Mason appeared at the festival, giving many interviews, and *Bigger Than Life* was nominated for the top prize, the Leone d'Oro, or Golden Lion. But two other films tied for that honor, and because of the tie, the Golden Lion was not awarded in 1956.

Still, Ray was right about the festival's prestige value. Simone Dubreuilh, who wrote for *Liberación* but also was affiliated with *Cahiers du Cinéma,* saw the James Mason picture at the Venice festival and wrote, in advance of its European bookings, that Ray's latest film cemented his stature as one of the revolutionaries of the American cinema. Jean-Luc Godard also acclaimed it, later listing *Bigger Than Life* as one of the ten best American sound films ever.

Today, Ray's legion of admirers regard *Bigger Than Life* as a near masterwork, a personal allegory of the director's own fight against addiction and depression and his aversion to family, as well as a social allegory about the fragility of the American nuclear family in the 1950s. David Thomson, one of the best-known U.S. critics, named it among the one thousand essential films he'd urge upon friends. "One of Ray's most important and dynamic films," Thomson declared in his book *Have You Seen . . . ?* "Both *Rebel* and *Bigger Than Life* show how plainly he saw manias building in America."

Ray could join in his own hero worship, or he could beg to differ. *Bigger Than Life* would be his last fond memory of Hollywood, and years later the director told the Canadian film journal *Take One* that he was "satisfied" with the film—a strong word for him—adding, "The ending is a little bit corny and embarrassing. . . . The unrealness of it embarrasses me at times."

✳

Following Ray's guidance, Walter Newman wrote as swiftly as possible over the summer of 1956. His late summer draft for *The True Story of Jesse James* might have reflected the dangling conversations he had with the director. When Darryl F. Zanuck's longtime assistant Molly Mandaville read the draft, she complained in a memo that she couldn't make heads or tails of it.

"This is an awfully difficult script to read," Mandaville wrote on the last day of August, a week before filming was scheduled to start. "Time after time I had to refer back several pages in the script in order to get the thread of what had happened before, and connect it up with what I was reading at the time. It's possible that when we see this on the screen this confusion won't develop. But reading it in black and white is pretty tough going."

One difficulty, as Mandaville noted, was the "peculiar flashback style" of the script. The many flashbacks from shifting perspectives alarmed everyone at the studio. After receiving Mandaville's memo, Adler convened an emergency meeting in his office to go over the script line by line with Ray, studio story editor David Brown, and producer Herbert Bayard Swope Jr. Adler asked for fewer flashbacks, less of the first-person narration Ray always loved, fewer long speeches pouring out of the mouths of major characters, and a reduction in the number of minor characters. The director reluctantly agreed to the less-is-more consensus in the room, and Newman went back to work, now doing more cutting and rearranging than writing.

A few days later, Adler reread the script more closely and dictated a detailed critique. He just couldn't fathom some of the psychologizing—as when the character Remington (played by Alan Baxter) reminisces about Jesse James, using words drawn from William Wordsworth: "The child is father to the man." ("I do not understand this quotation, and neither do several other people," wrote Adler. "Please delete it.") Baffled by the convoluted "pattern of the story," Adler itemized page-by-page dialogue trims and clarifications that would help simplify the script.

Newman continued to cut and revise until his contract ran out. Adler then brought another writer in for remedial revisions, which continued throughout September even as the cameras rolled. As studio memos make clear, when Ray was faced with a roomful of people finding flaws in the script, he meekly acquiesced to the chorus. His heart wasn't in it—the script or the film—and Lambert confirms that the director was drinking and popping pills like crazy to get through that summer.

Believing that his camerawork would ultimately triumph over the weakened script, Ray told Newman he intended to shoot *The True Story of Jesse James* in sequential fashion to satisfy the studio, but then he would try to restore some of the flashback structure in the editing room. Newman wondered if that was even possible but thought, more power to him.

Among Ray's illusory hopes for *The True Story of Jesse James* was that the rock and roll star Elvis Presley might be recruited to portray Jesse James. Elvis, whom Ray regarded as "another kind of James Dean," in Gavin Lambert's words, was an unabashed fan of *Rebel Without a Cause,* able to recite swaths of dialogue from the film from memory. David Weisbart had produced Elvis's first picture for 20th Century-Fox, earlier in 1956, and could make the introductions. But Presley had been spirited away to Paramount by producer Hal Wallis, and 20th Century-Fox fixated on one of its own contract players, handsome Robert Wagner—"an all-American laughing boy," as Ray later described the star with faint scorn. ("I'm sure he knew every possible mechanical gimmick," the director also said uncharitably. "He just didn't know how to act.")

In 1956, however, Ray was okay with Wagner, who was dating Natalie Wood; he was equally comfortable with the actor he cast as Frank James, Jeffrey Hunter, who had been married to Barbara Rush. Both were young smoothies, not as complicated as Farley Granger or James Dean, but under the right circumstances both could be quite good. Nor was there anything amiss with the rest of the cast: Mercury Theatre and *Citizen Kane* alumnus Agnes Moorehead was the James boys' mother, and Jesse's sweetheart was played by Hope Lange, a television actress crossing over to film. (*The True Story of Jesse James* was only her second feature, after a prominent debut in *Bus Stop*.) The director happily stuck with studio cinematographer Joseph MacDonald, who had handled the beautiful camerawork for *Bigger Than Life*.

But over the summer Ray increasingly regarded the Jesse James remake as a "potboiler" belonging to the studio, not to him. Studio officials seemed to fight all of his best instincts, right down to insisting on rehabbing old sets and filming at the 20th Century-Fox ranch in the Santa Monica Mountains, when Ray had hoped to photograph some scenes on location in Missouri and Minnesota—the James Gang's real stomping grounds. One sequence in the script depicted a famous bank robbery in Northfield, Minnesota, only a little more than a hundred miles from where Ray grew up, and it gnawed on him to re-create that outlaw raid in Hollywood.

"The real reason they made it [*The True Story of Jesse James*] was because some genius at Fox had figured out a way of reprocessing old footage into [Cinema]Scope," Ray complained in a later interview. "Fortunately,"

the studio had had "the foresight" to make the original *Jesse James* in color. "Now, if you've ever seen it, the one scene that you'll recall is this incredible stunt where Jesse and Frank elude the posse by riding through a plate glass window, down the streets out of town, and over a huge cliff into a river. Well, since the picture had been made, the ASPCA [American Society for the Prevention of Cruelty to Animals] cracked down on abuse to horses in movies. I mean those animals really took a fall. So basically, that whole picture was made to use that scene again. We matched the clothing and everything. A lot of the same buildings and props were still around."

Ray would do his duty and shoot the film, bolstered by drink and drugs to dull the pain. His self-medicating had begun to creep into working hours during the filming of *Rebel Without a Cause,* and Gavin Lambert had noted mounting evidence of the director's various addictions during the making of *Bigger Than Life*. In a 1976 journal entry, Ray admitted that he'd existed in an almost "continuous blackout between 1957 or earlier until now."

Just before launching photography, the director took a drunken tumble down the stairs of his bungalow, spraining his ankle—the same bad foot he'd had since *The Lusty Men*. Most days Lambert had to chauffeur the director to the set. Ray's mood was strained, even his characteristic smile barely manifested. His pain gave him an excuse to sip from his thermos of spiked orange juice, while the cast made sense of his foggy bidding.

Marian Seldes was playing Hope Lange's sister; it was her first credited screen role. One day, she recalled, Ray gave the actress advice in such a low whispered tone it was as though he was mumbling to himself. After the scene, he called Seldes over, acting hurt. "Didn't you like what I suggested?" She couldn't say—she hadn't understood a word of his mumbling.

"He hardly ever gave you a physical direction," recalled Robert Wagner. "It was all about emotions, and that's what he tried to put into the movie." But the director's drinking and drug dependencies were obvious to the film's star, contributing to "a very confused and convoluted personality, even for a director," as Wagner wrote in his memoir, *Pieces of My Heart*. "The problem was that Nick was always anesthetized; he'd stare off into space and then he'd say, 'Try this. No. Wait. Don't.' He liked acolytes; I have this mental snapshot of him wearing cowboy boots, surrounded by actors sitting around him on the ground. I remember thinking that he looked a little too comfortable. He was terribly enamored of [Elia] Kazan,

but he completely lacked Gadge's focus. Every morning we'd all wonder how Nick was going to be today, which is no way to make a movie."

Producer Herbert B. Swope Jr. was an admirer of *Rebel Without a Cause,* and he had looked forward to getting to know the director. "But he was not an easy man to know," said Swope. "He'd just sit in a big easy chair by the window and look forlornly out the window as you came into his office to talk. He didn't make contact directly too much. He was inhibited in some ways, and there was a kind of air of defeat about him."

Yet Swope was open to Ray's flashback ideas and prevailed upon the studio to screen two different rough cut versions in early November: the director's cut, with a number of flashbacks wrapped around a Jesse James ballad sung by George Comfort Sr., and a second, more straightforward, conventional version. The executives who assembled to watch the competing cuts included the West Coast studio boss Buddy Adler and East Coast company president Spyros Skouras. Afterward, Adler took the floor, saying that he thought both versions fell short, but the flashback variation was as impossible to follow as Walter Newman's convoluted script had been. The film would have to be recut in a more linear fashion, Adler said.

Swope agreed. This betrayal (as Ray saw it) prompted a repeat of what happened at the first screening of *The Lusty Men;* now, however, the stakes were not as high and Ray was playing with a losing hand. The director exploded, shouting at the producer, calling him a traitor and worse, hurling abuse at him in front of the shocked studio executives. After the dust settled, Ray did handle some of the refilming, while contract directors steered a few other scenes. In the final film, the flashbacks and narration and music—the ballad threading the story—were all cut back.

In later interviews, Ray preferred to blame the studio's stupidity. "I think some of the best scenes I ever directed were in that film but were cut out," the director ruefully recalled years later. "One was the fight between Frank and Jesse in the cave with very straight dialogue in a good heavy sense. The action was also a little too violent. For taste, I reshot it." But Lambert recalled pleading with his mentor to fight harder for the film in the last weeks before Ray left for Europe and *Bitter Victory*. "We could do this, we could do that—that would be a little better, don't you think?" Drink in hand, Ray answered him, "Yeah, but why bother?"

Swope took over the reediting after Ray left, following Adler's memos. Walter Newman did a little more writing at the end; Ray blamed the sce-

narist for being overly cooperative with the producer and refused ever to speak to him again. Of course the multipicture contract Skouras had offered Ray was out of the question now. Yet Ray had his ticket back to Europe, which he insisted on, and the studio delivered, even though officials were disappointed in his half measures.

Thanks to its handsome stars, *The True Story of Jesse James* did fair business when it was finally released in March 1957. Today, though, the picture looks lackluster; whatever gold flecks may be buried in his final Western, even Ray cultists find them deeply hidden. "I've only seen the film once in projection," Ray boasted to *Movie* in 1963.

<p style="text-align:center">❋</p>

Ray did have at least one excuse for never seeing the finished film: In mid-November, the director went into St. John's Hospital for foot surgery. By the time of his discharge, Paul Graetz had phoned to accept Gavin Lambert's draft of *Bitter Victory*. The producer wanted Ray to come to Paris as soon as possible to work on the final script, casting, and scouting locations.

Humphrey Bogart was in a different hospital, and Lauren Bacall called Ray to let him know the tough-guy star was gravely ill without long to live. Ray was in a hurry to leave and didn't have time to visit his onetime pal; Bogart died at home a short time later, in January 1957, with Ray overseas. The Golden Age of Hollywood was dying all around. The old studio system was in on its last legs. General Tire, which now owned RKO, shut down production at the studio the same month that Bogart died, and the other once-robust major studios seemed to exist on life support.

Ray went almost straight from the hospital to New York, wearing his bandages, though before he left America he flirted publicly with Shelley Winters, who always seemed to rebound into his life whenever Marilyn Monroe slipped away. The director even appeared in the audience of a broadcast of *What's My Line?*, Dorothy Kilgallen's show, as the "mystery guest" of Winters. The actress had a "long-time crush" on Ray, wrote Kilgallen, his loyal chronicler.

This time he traveled by plane to Paris, looking not over his shoulder at the botched and misguided *Jesse James* but forward with hopefulness to *Bitter Victory*. In prospect the latter appealed to him more, with its aching

romance and failed heroics and rival leaders Brand and Leith—the former a hollow man with a feeble military résumé, the latter an intellectual with a death wish, both of them typical of Ray's vying "male antagonists who achieve a kind of mystical equality," as critic Jonathan Rosenbaum has noted.

In their script sessions, Ray and Lambert had "talked mainly about the conflict between the two principal characters, something he felt very close to," as Lambert wrote, "because . . . basically he was both of them. And I think that was the mainspring of the film for him. It wasn't a war film, nor was it an anti-war film; it was a private psychological duel."

As the script evolved, however, the duel became more one-sided, with Ray favoring the braver Leith, who is not too proud to admit his fear ("All men are cowards . . . in some things") and other weaknesses. Although a man of action when necessary, Leith is "lonelier than any man had ever been," in the words of René Hardy's novel.

Curiously, Ray originally envisioned the Welsh actor Richard Burton as Brand, the hollow superior, while hoping for Montgomery Clift as Leith, the archaeologist and Orientalist. But in Paris, without consulting his director, the producer cast German actor Curd Jürgens as Brand. Jürgens had just catapulted to international recognition opposite Brigitte Bardot in *And God Created Woman,* and he was certainly a capable actor, but his German accent made him just as unlikely a British officer as James Mason was an American schoolteacher.

"Just add a line that he's South African," Graetz told Ray, "a Boer." Ray threatened to walk off the picture; Graetz threatened to sue. The director backed down. He had staked too much on *Bitter Victory,* and he was already drinking heavily by the time Lambert arrived in Paris, two weeks after his sponsor. The producer informed Lambert that he had to take some responsibility for Ray's drinking, or the writer would have his contract canceled once filming started, when Ray was bound to need him most. "I know *exactly* how much you mean to him, and how upset he'll be," Graetz told Lambert with a sleazy smile.

The director did need Lambert—for his French—and, as always with Ray, for the script, whose inadequacies gnawed harder at him as the start date neared. Ray and Lambert plunged into revisions, but the company was scheduled to travel to Libyan desert locations in February, and under the drink and duress Ray showed "signs of compulsive indecision," in

Lambert's words. The director seemed unable to pinpoint what was wrong with the script or how to make it better. "Something's missing," Ray kept repeating, "I don't know what it is, but I know it isn't there."

Maybe a more experienced writer could suss it out. Born in France, Vladimir Pozner was a former Hollywood scribe with an Oscar nomination in 1946 for *The Dark Mirror* among his handful of prestigious credits. (He'd also been one of the writers for the Hollywood all-star FDR memorial Ray had worked on behind the scenes.) The blacklist had sent Pozner back to Paris. In Hollywood, Ray avoided blacklistees like the plague (most had vacated anyway). But Europe was different, and Pozner wouldn't have known anything about Ray's closed-doors cooperation with HUAC.

Ray and Lambert met with Pozner, talking through numerous improvements that "seemed to satisfy Nick for the moment," in Lambert's words. Of course, Pozner would get no screen credit; he came at a bargain price, and moreover had to be paid off the books. The director insisted on keeping the blacklistee's participation secret even from Graetz. "I was a mechanic repairing a broken-down car," Pozner said later.

For Ray, working with Graetz was a horror; he was less cooperative and more meddling than the worst Hollywood producer. Graetz closely monitored every script change and surprised Ray again by announcing that he'd cast an American, Hollywood actress Ruth Roman, as Brand's wife Jane, who is secretly in love with Leith. The producer harbored "a pathological hatred of directors," according to Lambert, and enjoyed lording his arbitrary decisions over Ray. In most power struggles, Ray the nice guy, the patient whisperer, the velvet-gloves director, was the natural patsy, and the tension grew between him and Graetz. Once again—far from the American studio system—Ray would have to resort to stealth and duplicity in order to win the day.

In January, Ray and Lambert took a scouting trip to Libya that gave both of them a happy breather. Graetz, who was Jewish, felt he might be subject to possible kidnapping risks in the predominantly Islamic nation, and the producer chose to stay in Paris when the director and his writer-lover flew to Tripoli, checking into a deluxe hotel. Ray had made earlier trips to Libya with the camera and design team but this was more of a last idyll for the two of them. The desert had attracted and beguiled Ray ever since he'd screened Lambert's directing debut, which was set in Morocco. In 1957, before the discovery of oil reserves and revolution, Libya was a

constitutional monarchy, a paradise of ancient sights whose government was trying to boost tourism.

The two visited the unspoiled Roman ruins of Leptis Magna, where the Wadi Lebda meets the Mediterranean near Egypt, and toured the huge amphitheater at the port of Sabratha. Standing on the highest tier, staring out over ten thousand seats and the sparkling blue sea, with yellow and blue wildflowers blooming all around, the director felt exultant. "Do you realize the Romans built in CinemaScope?" he asked Lambert gleefully.

Suddenly, seized by a vision, Ray grabbed Lambert and tugged him down to the arena. The amphitheater would be the perfect site for a production of Sophocles's Athenian tragedy *Oedipus Rex,* the director declared, with "masked and robed figures performing in front of the circle of archways" and "the sea as a backdrop." His arms flung wide, Ray declaimed from memory the last line of Yeats's translation: "Call no man happy till he is dead."

"I never saw him happier," Lambert recalled.

Inevitable lows followed the highs. Lambert could do nothing about Ray's persistent drinking, nor his reckless gambling at the casino that was attached to their hotel. The director haunted the casino every night, "seemingly indifferent to the large sums he lost," wrote Lambert, adding that he finally realized why Ray "understood so well the character of the teacher addicted to cortisone in *Bigger Than Life,* and how (with the help of James Mason's fine performance) he could make the scenes of personality disorder so compelling."

Returning to Paris with Ray, Lambert resumed his problematic script work. At one point Graetz buttonholed him, demanding confidential reports on Ray's drinking and gambling; when he refused, the producer threatened to fire him. Lambert told Ray about Graetz; the director went to the producer and threatened to quit. Another stalemate, but Lambert soldiered on.

Just as Graetz relished such power games, Lambert felt that Ray enjoyed conjuring up endless crises. Although Ray defended his assistant professionally, he left Lambert confused about where they stood on a personal level—especially after one night when the director brought back to their hotel a young woman he'd picked up in a St. Germain bar. The woman, who went by the name Manon, claimed to be a "Moroccan Sherifian" descended from nobility, according to Lambert. "About eighteen years old,"

she had dyed blond hair, "manic eyes," and a "violent temper." She was also a heroin addict—an Arabian nightmare, from Lambert's perspective. But Ray, for some reason, began to dote on Manon. The director pretended to be rescuing his discovery from the depths of depravity, but in truth Manon was leading him down. He treated her as his latest protégée, but in the category of depravity they were competitors.

As Lambert and the script faded into the background, the Hollywood director and the teenage heroin addict plunged into a weird folie à deux. "What I understood," recalled Lambert, "was that his impulse to self-destruction had grown too powerful for anyone to deflect." After Lambert completed the shooting script, Ray flew off to Libya with cast and crew—and Manon—leaving his scenarist and spurned lover behind. The writer begged Graetz for his last payment. The producer refused to pay until Ray was done with the filming.

Lambert lingered in Paris.

<p style="text-align:center">✳</p>

With the typical logic of international coproductions, the producer had cast a German and an American in two of the film's three main roles, both playing English characters. Ray finally acquired the genuine article, Richard Burton—not for the role of Brand, but as Leith. Already reigning over epics like *The Robe,* and destined for a career of messy greatness, Burton was persuaded to play the sensitive, brooding hero whose fate is entwined with a deadly scorpion and an apocalyptic sandstorm. Brand was the better role for him in the end.

The rest of the ensemble was ordered up from England, with a sprinkling from France. The supporting roles were subordinate, not deeply characterized, almost interchangeable. Actor Christopher Lee arrived from London with no idea of what role he would be playing. "We were ferried out to the Marcus Aurelius ruins," Lee wrote later, "and there the dramatis personae were apportioned with the same casual optimism by the director as if the clock had been turned back fifteen years and we'd all been in fact doing a skit for the camp entertainment. All but the stars took part in this lottery. Everybody got a part they either did not want, or somebody else coveted more than they did."

French actor Raymond Pelligrin, Sacha Guitry's Napoleon, was upset,

according to Lee, "because he'd drawn the short straw in the casting and had only four lines as an Arab guide."* Lee also found himself in "none too agreeable a mood after being told, as Sergeant Barney of the Guards, 'not to bring all this British Army nonsense into it,' which I thought was an odd direction in a story supposed to be about the British army."

The scouting trips had been quixotic and optimistic. The actual filming, in contrast, seemed a depressing ordeal. Ray stayed in the fashionable hotel with attached casino, but most of the troupe bunked at a lower-cost venue, with tiny rooms and narrow beds. Cast and crew rose as one body before dawn to be shuttled off to locations sometimes over one hundred miles away, first forming a line of cars, and then switching to jeeps, driving for hours before arriving at dunes that stretched to infinity. They were usually in for a long day of breathing the sand, with rainy weather and freezing temperatures at sundown; the company often didn't get back to Tripoli until ten at night.

By now, it was standard practice for Ray to fiddle with unsatisfactory scripts during actual filming as a means of imposing his vision on a picture. He did this with little regard for the ellipses in characterization or continuity that could result; indeed, one could argue that ellipses were his hallmark, with his gnomic personality and questing artistry the only glue binding them together.

As usual, his on-the-spot changes tended to privilege the character he preferred (Leith) along with the actor that was closest to being his soul mate (Burton). Ray drew Burton out between setups, talking about art, music, theater, and literature; on camera, he turned the actor into another brooding, sensitive James Dean. (Burton was even photographed to look like Dean, with the wind tousling his fine hair.) The actor was rewarded with the film's bones-of-war speeches ("The fine line between murder and war is distance"), philosophical musings ("I wonder why people have short memories—do they forget what they want to forget or don't they care?"), and borrowings from Walt Whitman ("I contradict myself!").

Although Graetz again elected to stay in Paris, the producer wouldn't let go of the script, which symbolized the continuing battle between him and Ray. The producer regularly telexed new pages he was extracting from an established American short-story writer and novelist, Paul Gallico,

---

* To be fair, Pelligrin was playing *the* Arab guide—Mokrane.

who lived in Paris. Ray had reluctantly gone along with the eleventh-hour hiring of Gallico, seeing him as a writer's writer whose ideas and critiques might be useful. But the stream of telexed pages tended to conflict with Ray's own drift, plumping up the roles played by Jürgens or Roman, the producer's favorites. (Jürgens, in particular, complained that his character had been weakened and demonized in Lambert's script.)*

Sometimes, though, Gallico sided with the director. Especially with his knowledge of the relationship between Lambert and Ray, Graetz never had liked the subtext of the scenes between Leith and Mokrane. Stung by a scorpion, Leith is lovingly attended to by his Arab guide, who first attempts to suck out the scorpion's venom with his own mouth and then cuts into the stomach of the expedition's only camel to retrieve its bladder and medicinal viscera. The provocative scenes hinted at another dimension to Mokrane's devotion. After revising these scenes one last time for Graetz, Gallico told the producer that the scenes were fine, that they could be carried off with subtle direction, and that Ray was up to the job. And he was.

Phoning Lambert regularly, Ray boasted that he was ignoring most of Gallico's revisions while introducing "quite a few changes of his own." This, over time, had become his signature approach, grabbing from here and there, zigging and zagging, assembling a film out of the ideas and influences and experts and collaborators he collected as he thought and planned and ultimately filmed. Such a process didn't bear imitation, and it didn't always work; it simply reflected the director's variegated personality. But Ray's buffet approach to the script, which had hardened into a default methodology, endeared him to neither producers nor writers.

Concerned that Graetz might be eavesdropping on the phones at the hotel where both of them were staying, Lambert took Ray's calls at the Champs-Elysées post office. The director said he was sure Lambert would approve his on-the-spot emendations and the final form of the script. "I'm sure I will," Lambert told Ray stoically, telling himself, however, "It no longer mattered what I said because the film was a lost cause."

Some in the cast and crew felt the same way. The logistics were grueling, and Ray's tentativeness and second-guessing were beginning to get

---

* Jürgens wrote later in his autobiography that, on location, the ministrations of the executive producer, Graetz's "pretty blonde wife" Janine, were his consolation prize.

the better of him. On the set, sometimes, he rehearsed and rehearsed, stalling his camera decisions. He had an adaptable cinematographer in Frenchman Michel Kelber, a veteran of Jean Renoir and René Clair films who wasn't cowed by the desert, but Ray had to call the shots, and sometimes he couldn't decide. He weighed choices, waited for inspiration, shot and reshot.

His deliberative method could produce extraordinary results. "Nick would choose what he wanted, and he had plenty to choose from," insisted Renée Lichtig, one of the editors of *Bitter Victory*. "If it wasn't there in one setup, it would be there in another. But he didn't take what he wanted just from the angle he wanted. Because it wasn't the angle that interested him, it was the performance. There was always a take which contained the phrase, the little bit he wanted. And that was his strength; even while filming, he could see that this line had something he needed."

Still, the overtime costs inched up. The budget swelled. The filming fell behind schedule—not drastically, but enough to tighten the screws on Ray above all.

Every day the company returned to Tripoli, drained and cursing their misfortune. No matter how hard the day had been, Ray couldn't sleep. Until midnight the director was up hacking at the script. He quarreled fiercely with Manon, then hit the casino, "betting on all the numbers at roulette," according to cinematographer Kelber, "forgetting what numbers he was playing, losing everything; the croupiers soon tumbled to him and pocketed everything." The next morning, en route to the set, Ray would doze in the jeep.

One of the actors tried to slit his wrists—for "private domestic reasons," recalled Christopher Lee, "bad news from home, but as I said to him rather tartly, we all of us had plenty of good justification for suicide in the circumstances all around us. He lived. We all did, and parted after six weeks in the certain knowledge of having shared in a failure."

Or was it? As with *The Lusty Men* or *Bigger Than Life*, perhaps only cultists would call the film a masterpiece. But the cultists say so, loudly and insistently.

In the end the script was a mash, however, with both flat scenes and moments of transcendence. This was Ray in his glory, failing gloriously, trying to bend chaos partly of his own making to his will. The location scenes were worth it, the desert photographed in black and white as eerily, as beautifully, as rolling Wisconsin hills in the winter. Off-camera and on,

the physical struggles of the characters paralleled their emotional and psychological trials.

In late March, Paul Graetz finally pulled the plug, calling Ray back to Nice to finish the remaining scenes in a studio.

※

Among the last interior scenes to be filmed was the ending. Ray kept changing his mind about exactly how the story should end. In the novel, Leith shoots himself to end his suffering; Brand is disgraced by his actions. In the film, Leith sacrifices himself to cover Brand during the terrible sandstorm, while Brand survives, only to be given a medal for his lies and cowardice and murder. Thus the film ends with a hollow award for treachery—a possible guilty allusion to the blacklist, and certainly Ray's bleakest ending. Feeling alone and defeated, his marriage ruined, Brand sticks his prize on a training dummy as the closing credits roll.

Ray had returned from Libya "a wreck," recalled Gavin Lambert, "ravaged, traumatized" from the pressures of filming. The director was drinking around the clock and had fallen "seriously into drugs" with his heroin-addict girlfriend, Manon. At the Victorine Studios in Nice, Ray spent several weeks completing the relationship and soundstage scenes by day while debauching himself with Manon and frequenting the baccarat tables in Monte Carlo after hours. One night the director is said to have lost sixty thousand dollars. Sumner Williams, playing a minor role in his fifth or sixth Nick Ray film, kept his uncle company and somberly wrote out the checks.

"It's true that I lost all my money gambling," Ray told Vincent Canby a decade later. "The only time Graetz wouldn't bother me was when I was playing chemin de fer. To find some peace, I just continued to play chemin de fer until I ran out of money."

Williams was an undemanding Sancho Panza, but Lambert was through. Barred from Nice by Paul Graetz, Lambert was paid his last five thousand dollars in Paris after filming finally wrapped down south; the producer then ordered the writer to vacate his hotel room.

Ray summoned him to a Champs-Elysées nightclub, where he waited with a frantic-looking Manon. The director "seemed to have aged ten years in two months," Lambert recalled. Ray limped and used a cane. It wasn't the old foot injury, Ray explained, but a new, mysterious one in his leg. Michel Kelber believed that Ray's illnesses were induced by various

"psychoses." If not the leg and his cane, then "he'd lose his voice, open his mouth and be unable to speak."

Ray said he was experiencing a temporary cash shortfall because of his gambling losses, but that Manon, who looked shell-shocked, needed "help right now." What sort of help was not specified. Lambert returned to the hotel where he'd been packing, counted out one thousand dollars from his stash, returned to the club, handed Ray the money, and then left without another word.

"He didn't try to stop me," Lambert wrote. The writer sat at a nearby café, his eyes filling with tears, thinking "how Nick had come into my life at a crucial moment and transformed it irrevocably. I wanted to go back and tell him I would always love him for that."

Instead, the next day, Lambert flew to London and thence to Los Angeles, where he moved out of the Chateau Marmont and started over in Hollywood as a screenwriter and novelist of distinction. Lambert would remain cordial with Ray in years to come, talking to the director by phone now and then but seeing him rarely.

✳

In Paris, the director found time to tell columnist Dorothy Kilgallen about his romance with a "lush beauty" named Manon (no last name reported) whom he was escorting to Paris "hot spots." Manon was described as the "script girl" for *Bitter Victory,* which she was not. Eventually, to recover from the tribulations of *Bitter Victory,* the director checked into a hospital, as much for exhaustion as for his chronic leg pain.

He was visited there by Stewart Stern, the scenarist of *Rebel Without a Cause,* who was passing through Paris when he discovered a just-published French novelization of the film called *La fureur du vivre,* complete with scenes and dialogue from Stern's script but bearing only Ray's byline. Ray insisted it was merely a publicity device, and Stern backed off with regrets for his illness. Ray wouldn't say how much he had been paid: pocket money for his lifestyle.

His hospital stay was brief, and afterward Ray plunged into work with a French team preparing a rough cut of *Bitter Victory* to show the organizers of the Cannes Film Festival in May. But the director was becoming dilatory about his editing decisions too, coming in after the main editors had

gone home and then working all night with their young assistants, play-
ing with established sequences, changing the order of pieces of film, later
changing them back. Eventually a score by Maurice Le Roux was added
to the print, and the real premiere of *Bitter Victory* was scheduled for the
Venice Film Festival in early September.

At the time, the correspondent covering the festival for the *Times* of
London wrote that *Bitter Victory* "startled" discerning critics "and at times
divided them into two hostile camps." The London correspondent found
the film's plotting disorganized, the skulduggery unsuspenseful. Even Eric
Rohmer, one of Ray's longtime admirers, confessed to being "somewhat
disconcerted," though he added that *Bitter Victory* was "the only intelligent
film shown at the festival," a backhanded compliment. Later, Jean-Luc
Godard would hail the film with a famous trumpet blast: "The cinema is
Nicholas Ray." (Godard ranked the Ray film at the top of his personal ten
best of 1957, ahead of films by Hitchcock, Buñuel, and Ingmar Bergman.)

Although *Bitter Victory* became the second Nicholas Ray picture to be
nominated for the Golden Lion at the Venice festival, it still won no major
prizes. Not surprisingly, the grim World War II picture then struggled
at the box office. It probably didn't help that the producer and censors
cut the film significantly for public exhibition, presumably to curtail its
bleakness. Originally 102 minutes, *Bitter Victory* was ninety when shown
in England and eighty-two when finally released in the United States in
March 1958, a year after it was completed.

Perhaps Lambert, ultimately shouldered aside by his own mentor on
the script (he shared screen credit with Ray, René Hardy, and Paul Gal-
lico), was its most discerning viewer. *Bitter Victory* had "some powerfully
staged scenes," Lambert wrote years later, but "too many others that were
muddled or inconclusive, the truth of Richard Burton's performance un-
dermined by the falsity of [Curd] Jurgens's."

Their lover-protégé-collaborator relationship was over in a year's
time, but like many people burned by the sweet man, Lambert thought of
Ray only sympathetically.

CHAPTER TEN

# Lost Causes

1957–1959

Paul Graetz blamed Ray for everything that had gone wrong on *Bitter Victory,* and afterward the producer busied himself writing letters to studio officials he knew in Hollywood, warning them not to hire Ray because the director was an irresponsible drunk.

After the double whammy of *Hot Blood* and *Bitter Victory,* Columbia didn't need any further warnings about Ray's misconduct or weak box-office record. Twentieth Century-Fox was no longer in Ray's corner, after the director had given a less-than-sterling effort on *The Return of Jesse James* and scuttled a multiple-picture contract. RKO, his long-ago sanctuary, was defunct. The number of studios where Ray might be welcome was dwindling.

In Paris, Ray announced various "personal projects," including a series of Grand Guignol horror plays, but none of them would ever materialize, for lack of an actual script, viable producer, or financing. His journey to Europe had not set him free, at least not yet. He really had little immediate choice but to sift through his remaining U.S. options.

One American who believed in Ray was the writer Budd Schulberg, who had been Elia Kazan's creative partner on the multiple-Oscar-winning *On the Waterfront.* Schulberg had known Ray for years, primarily through Kazan, and always liked him personally, though he was nagged by the feeling that there was "always something of the poseur about him."

Budd and his younger brother Stuart, who had been producing films in Germany, were organizing an independent company to make their own movies. Producing was a family tradition. Their father, B. P. Schulberg, who died early in 1957, had produced *Wings,* the winner of the first Oscar for Best Picture, and the paterfamilias ran Paramount in the 1930s. Seeing Ray as a natural ally, Stuart Schulberg had arranged to meet with him in New York in late 1956 before the director left for Paris to start work on *Bitter Victory.*

One Hollywood studio that might overlook disparaging reports from the producer of *Bitter Victory* was Warner Bros., where Jack Warner—and his right-hand man Steve Trilling—still reigned. Not so long ago, despite his unorthodox habits and methods, Ray had taken a sketchy story of seventeen pages and transformed it into the triumphant *Rebel Without a Cause* for the studio. In a sense, Ray stood as a testament to Jack Warner's own good judgment.

Stuart Schulberg's older brother, Budd, was also a desirable risk for the studio. Budd had just finished a job for Warner Bros. writing *A Face in the Crowd,* another Kazan film. Even before Kazan, Schulberg had been a voluntary cooperative witness in front of the House Committee on Un-American Activities in May 1951, taking pleasure in decrying his past Communist ties and equal pride, later, in insisting that the Communists he fingered had all been exposed to light long before he named them.* The film that he and Kazan subsequently made together, *On the Waterfront,* had showcased Marlon Brando as a longshoreman willing to stand up to corrupt union bosses; many people saw Schulberg's script as an allegorical defense of informing, with the Communist Party disguised as the corrupt union.

Now the Schulbergs wanted to make a film about the Florida Everglades. Over time Budd had grown fascinated with the story of the forgotten, sometimes deadly turn-of-the-century war between pioneering Audubon Society agents and primitive Everglades squatters, who slaughtered egrets, blue herons, and flamingos to supply milliners with feathers for high-fashion hats.

---

* Cooperative witnesses who supplied names to HUAC typically adopted this rationale in defense of their actions. However, as Victor S. Navasky wrote in his book *Naming Names,* scolding Schulberg and others like him, "The 'I didn't hurt anybody' argument a) turns out to be not true and b) in any event seems to go more to what lawyers call mitigation of damages than to be a real defense of naming names."

The writer had sketched out enough of a story treatment to hook Warner Bros., combining action, adventure, and "the urgent theme of conservation," in Schulberg's words. Coincidentally, just as with *Bitter Victory,* the two main characters of his story were mortal enemies: Cottonmouth, a plume hunter who is king of the Everglades lowlifes, and Walt Murdock, an English teacher and naturalist who is opposed to the slaughter. The antagonists would lock horns throughout the film, eventually perishing at each other's hands, according to Schulberg's first treatment—though this nihilistic ending was quickly rejected by the Production Code office.

A lengthier treatment was in motion when Stuart Schulberg met with Ray at New York's Plaza Hotel in December 1956. *Bitter Victory* was weighing on the director's mind, but an alliance with the Schulbergs seemed propitious down the road. Budd was a pedigreed writer, and besides Kazan's friendship and cooperation with HUAC, they had a common interest in boxing and a mutual friend in Roger Donoghue. Indeed, after the prospect of casting James Dean in a Donoghue biopic evaporated, the Schulbergs had begun talking about having Donoghue play himself in a film. Ray could maybe direct the Donoghue movie after the Everglades picture; it was all between friends, all in the family. They shook hands on a two-picture deal.

Warner Bros. signed a two-picture contract with the brothers, and Budd Schulberg got busy writing, while Stuart brokered arrangements with the studio and MCA, which still represented Ray. Warner's was happy to have Ray as the director, but once Ray was off in France and Libya, he began playing hard to get. He demanded a "right of first cut" and a salary of $75,000, with a badly needed cash advance upon signing. The Schulbergs countered with $50,000 and 5 percent of the producer's profits, no advance.

His Oscar nomination and the box-office sensation of *Rebel Without a Cause* were only two years in the past. Ray should have been at the height of his bargaining power. But he had never made as much money as the most trusted first-echelon names: Alfred Hitchcock was getting $150,000 per picture with a long list of perks and profit clauses by the 1950s. George Cukor, long a contract director at MGM, had a new arrangement promising him $4,000 weekly on a year-round basis.

*Bigger Than Life* may have been a success d'estime, but *Hot Blood, The True Story of Jesse James,* and *Bitter Victory* had cost Ray. After overseeing

the director's two-picture deal at 20th Century-Fox, which had ended so badly, Lew Wasserman and Herman Citron had passed Ray on to lesser lights in the agency. Now Mort Viner tried to mediate Ray's needs on behalf of MCA, but by midwinter the Schulbergs were growing anxious for the director's formal commitment. They sent treatment pages to Paris, asking for Ray's comments and suggestions. Viner sent telegrams to Ray, trying to sort out Ray's salary and the other contract issues. Neither party heard back.

The business-minded brother, Stuart, was less personally friendly with Ray, and he advised Budd to forget the uncommunicative director. "I will check once more with MCA," Stuart wrote to Budd in Sarasota, Florida, in February, where the writer was hunkered down with the script, "but with little hope since MCA itself confesses Nick has been incommunicado for a month. He has failed to answer two letters from me and never acknowledged the Christmas cable we sent him. This is worrisome behavior."

Though initially enthusiastic, Warner's also grew increasingly wary. When Stuart Schulberg asked Steve Trilling if the brothers might switch to Robert Parrish as director, Trilling—whose skepticism about Ray would catch up to and surpass Jack Warner's—gave a fast reply: "He's first-rate. Skilled, solid, cooperative. You can't go wrong with Parrish. Get him!"

It was Budd who preferred to give Ray the benefit of the doubt. The director was understandably preoccupied, shooting on location in Libya, for God's sake, Budd said. Warner's could be stalled. Budd had plenty of writing to do. The brothers could afford to be patient.

In the meantime, the Schulbergs thought ahead to the casting. On Broadway they had recently seen *The Lark,* a drama by Jean Anouilh about Joan of Arc, and they were excited by Canadian-born Christopher Plummer, a commanding young actor who played the Earl of Warwick. They penciled in Plummer for Walt while targeting Ray's old folksinging buddy Burl Ives, whose acting career had blossomed after his "friendly" HUAC testimony and his colorful, fourth-billed turn as Sam the Sheriff in Kazan's *East of Eden,* as natural casting for Cottonmouth. Stuart Schulberg knew that Ray and Ives went way back and thought the folksinger's involvement would add to the family spirit of the enterprise for the director.

Not until mid-March did Ray finally send a telegram from his temporary address in the Hotel Negresco in Nice, explaining that he was still "winding" *Bitter Victory* and wouldn't become available until June.

Relieved, Stuart Schulberg replied immediately that "for a number of reasons—not the least of them some uncertainty as to your availability" the brothers had already decided to postpone the start of photography until August or September. The summer heat and hurricane season would be over by then, everyone hoped; they planned to spend two months on Florida locations and finish interiors in New York studios by Christmas.

Still, to the Schulbergs' dismay, Ray offered scant feedback on the script or casting ideas, and he kept throwing up roadblocks over his contract. Warner's and the Schulbergs readily agreed to give Ray right of first cut, which they viewed as nothing more than an intermediate stage of the final assembly. But the studio was adamant about keeping the budget below $1.1 million and did not want to pay Ray a penny until he reported for duty in the United States. Both the studio and the Schulbergs opposed his $75,000 salary. Indicating his weak leverage, Ray finally dropped to $60,000 and 5 percent of the producer's profits.

By the end of May, with Ray still at a geographical and emotional distance from the project, his contract still unsigned, the leads had been tentatively cast and some locations preliminarily scouted around Everglades City off the coast of the Gulf of Mexico in southwest Florida. Budd had delivered his first expanded treatment to the studio, which the Warner's story department found talky and downbeat. In a confidential June 7 memo to Jack Warner, Trilling warned that the Schulbergs might stubbornly resist the needed script changes—making the studio executive all the more nervous about placing their friend Ray in charge, because Trilling felt sure the director would take the brothers' side in any disagreement.

Budd cranked out pages as the summer flew by. At first Ray was mired in postproduction for *Bitter Victory;* then he advised the Schulbergs that his doctor had ordered him to take a month's vacation after his hospital stay. Yet the brothers suspected that the real reason Ray was still in Europe was that he was in no hurry to leave and was casting about for other prospects. They had heard gossip about his wild times overseas—about drugs and drinking and gambling. The director's bad habits were no secret: A mutual friend, the poet and screenwriter Alfred Hayes, who had helped out writing *The Lusty Men,* would later mention Ray in a poem, portraying him as a chic drunkard, living at the Hotel Raphael near the Champs-Elysées.

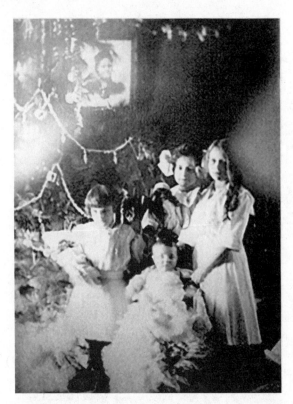

Raymond Nicholas Kienzle Jr. with his three sisters. Christmas, 1911.

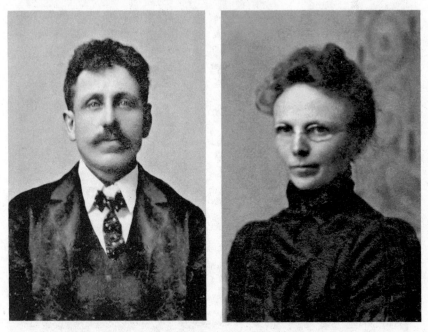

Ray's parents, Raymond Kienzle Sr. and Lena Kienzle.

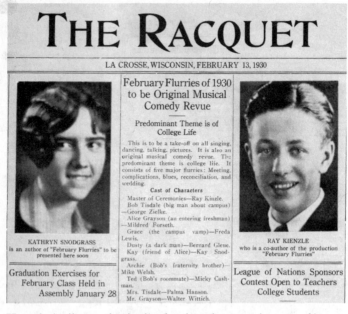

# THE RACQUET

LA CROSSE, WISCONSIN, FEBRUARY 13, 1930

### February Flurries of 1930 to be Original Musical Comedy Revue

#### Predominant Theme is of College Life

This is to be a take-off on all singing, dancing, talking, pictures. It is also an original musical comedy revue. The predominant theme is college life. It consists of five major flurries: Meeting, complications, blues, reconciliation, and wedding.

#### Cast of Characters

Master of Ceremonies—Ray Kinzle.
Bob Tisdale (big man about campus)—George Zielke.
Alice Grayson (an entering freshman)—Mildred Forseth.
Grace (the campus vamp)—Freda Lewis.
Dusty (a dark man)—Bernard Gleue.
Kay (friend of Alice)—Kay Snodgrass.
Archie (Bob's fraternity brother)—Mike Welsh.
Ted (Bob's roommate)—Micky Cashman.
Mrs. Tisdale—Palma Hanson.
Mr. Grayson—Walter Wittich.

**KATHRYN SNODGRASS**
is an author of "February Flurries" to be presented here soon

**RAY KIENZLE**
who is a co-author of the production "February Flurries"

Graduation Exercises for February Class Held in Assembly January 28

League of Nations Sponsors Contest Open to Teachers College Students

Kienzle (still using his high school graduation photograph) makes a triumphant splash across the front page of the *Racquet*, the student newspaper of La Crosse Teachers College, 1930.

"Struggle is grand": Ray with girlfriend Jean Evans, soon to become his first wife.

The cast of *The Young Go First,* the Theatre of Action's only Broadway play, codirected by Elia Kazan. *Left to right:* unidentified actor, Earl Robinson, Perry Bruskin, Ben Berenberg, Will Lee, Harry Lessin, and Curt Conway. "Nik Ray" stares down from atop the mound of dirt.

Ray, seen here motivating performers in a local community theater, traveled widely on behalf of the Works Progress Administration (WPA).

Farley Granger and Cathy O'Donnell, the ill-fated Romeo and Juliet of *They Live by Night*. Ray's directing debut would sit on the RKO shelf for two years.

The director seems at ease with John Derek and Allene Roberts on the set of *Knock on Any Door*, but Derek was not putty in his hands.

Ray's second marriage was to actress Gloria Grahame in 1948. Blissful photographs of the Las Vegas ceremony flooded America's newspapers.

Ray rehearses Gloria Grahame in a love scene with Humphrey Bogart for *In a Lonely Place,* a romantic thriller that many critics rank among his personal best. The husband-directs-wife angle made for good publicity, but off-camera their marriage was fraying.

The director was inspired by the Colorado locations for *On Dangerous Ground*, an unusual, gripping film noir that Ray steered past studio skepticism. Star Robert Ryan, a soulmate for the director in several productions, stands at left.

The close, conspiratorial two-man club of Ray and Robert Mitchum elevated *The Lusty Men* into a tone poem celebrating rodeo life and losers.

Following his divorce from Gloria Grahame and after his troubles with the House Un-American Activities Committee (HUAC) were over, Ray developed a useful ladies'-man image in the Hollywood press. Among his many fleeting conquests were (*top to bottom*): Shelley Winters, *Johnny Guitar* star Joan Crawford, and Marilyn Monroe.

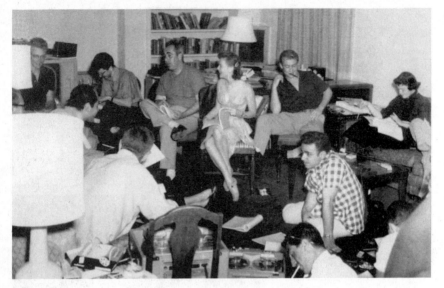

Ray's door opened to a "golden world" for the cast of *Rebel Without a Cause*, seen here during the first full reading of the script in the director's Chateau Marmont bungalow. *Clockwise from center:* Natalie Wood, Nick Adams, actress Mitzi McCall, Frank Mazzola, unidentified actor, Dennis Stock (*manning the tape recorder*), Ray (*back to camera*), Stewart Stern, James Dean, Dean's friend Jack Simmons (*reading the role of Plato*), and Jim Backus.

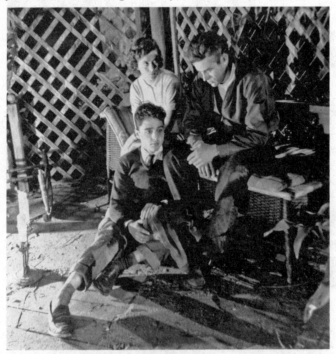

Perfect casting for the teenage trinity: James Dean, Natalie Wood, and Sal Mineo in a publicity shot for *Rebel Without a Cause*.

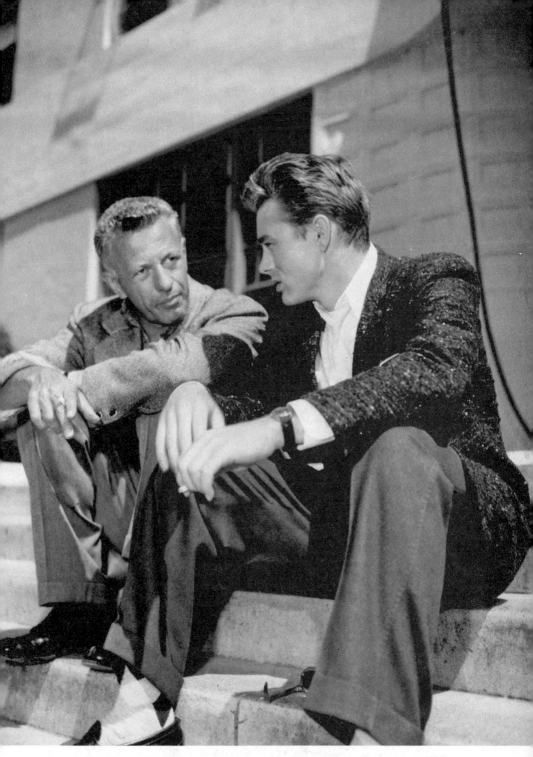
Ray and Dean had a profound kinship and ambitious plans for what they would do after *Rebel Without a Cause*. The star's car-crash death on September 30, 1955, changed everything.

Ray's affair with the then-teenage Natalie Wood (here at the New York premiere of *The Court-Martial of Billy Mitchell*) only lasted a few months after the filming of *Rebel Without a Cause*—though their friendship endured.

The American dream on drugs: James Mason, playing the manic schoolteacher, telling Barbara Rush, his dutiful wife, that "God was wrong!" in *Bigger Than Life*.

Showing signs of dissolution, the director is captured in the 20th Century-Fox commissary with Elvis Presley; Robert Wagner, the star of *The True Story of Jesse James;* and actor Alan Hale Jr., who played Cole Younger in Ray's 1957 film, among the group.

With *Bitter Victory,* Ray began to make a specialty of grueling location experiences whose ordeals were mirrored in the finished films. He is seen here in the Libyan desert with Lucie Lichtig (*holding the script*).

Rome, 1960. Mr. and Mrs. Ray, the former dancer Betty Utey, and daughter Julie Christina, their firstborn. As with Jean Evans and Gloria Grahame, Ray also began to depend on his third wife professionally.

Madrid, 1960. Ray with writer-producer Philip Yordan, who had helped to rescue *Johnny Guitar* and now became his partner (and boss) on two extravagant Samuel Bronston epics filmed in Spain.

Ray in deep-think mode with Rip Torn, who was playing Judas in *King of Kings*. As with many of Ray's post-HUAC films, the director found ways to be sympathetic to the character of the betrayer.

The onetime actor had performed cameos in his first Hollywood picture (while assistant directing for Elia Kazan) and in the last moments of his signature work, *Rebel Without a Cause*. For *55 Days at Peking*, destined to be his last feature film, Ray donned a beard and costume to play an American diplomat—a brief scene that survived the emergency change of directors and final cut. Standing behind Ray is Lucy Lichtig and assistant director José Lopez Rodero.

Ray chats with Charlton Heston at the London premiere of *55 Days at Peking*, which was completed without his input. Betty Utey is seated next to the director. They would separate within the year.

Ray with his young acolytes and keeper of the flame Susan Schwartz (*cradling the director in her lap*). They worked day and night on the student-professor film *We Can't Go Home Again*. Harpur College, 1971–73.

Ray had launched Dennis Hopper's career in *Rebel Without a Cause,* but they clashed over Natalie Wood and other issues. Ray had a rapprochement with Hopper after he returned to America in 1969, appearing with him in Wim Wenders's film *An American Friend*. Here they are seen during an appearance by Hopper at Harpur College.

The director and his German admirer Wim Wenders at work on *Lightning Over Water,* the semi-fictionalized homage to Ray's life. They finished shooting "Nick's Movie" just a few weeks before his death in 1979.

Ray and Susan Schwartz Ray—the fourth Mrs. Ray, although they may never have formally married. Forty years younger than the director, she stayed by his side through the worst of times. Thirty years after his death, she worked to complete a final version of *We Can't Go Home Again*.

In August, Stuart Schulberg took it upon himself to organize ten days of second-unit work at Duck Rock sanctuary off the tip of southern Florida, photographing thousands of nesting egrets, herons, and flamingos. Ray had urged the Schulbergs to hire Paris-born cinematographer Joseph C. Brun, and the absentee director passed on filming instructions for the second unit, but it was Stuart who led the expedition that captured the breathtaking wildlife footage, pleasing everyone who viewed it and reassuring jittery Warner's executives.

"I know you will be as thrilled by it [the footage] as all of us here," Stuart Schulberg wrote to Ray at his Hotel Raphael address, where the director was ensconced, on August 22. "We got much closer to the birds than we expected and were able to shoot them in every conceivable light and position, from close-ups of baby birds in the nest to mass shots of mature birds streaking across the sunset skies. Joe Brun did a magnificent job. No picture postcard gaudiness, but soft half-tones and pastels."

Not until late August was Ray officially contracted to helm the first two Schulberg productions, the one now called *Wind Across the Everglades,* and a second project, tentatively slated to be the Roger Donoghue story. MCA used the two-picture commitment to carve out future guarantees and options for Ray, tied to the expected success of the first picture.

The Schulberg brothers had not laid eyes on Ray for almost nine months when they greeted him at the Plaza Hotel upon his arrival back from Europe at the end of the first week of September. Ray came straight from the Venice Film Festival, where he'd appeared in support of *Bitter Victory.* Its failure to win the Golden Lion sorely disappointed him. The brothers' first glance told them the whispers were true: This was not the same man who had directed *Rebel Without a Cause,* not even the same person they had conferred with in New York last December. Ray had obviously been living rough and drinking hard. The director was dressed poorly. His attention drifted. And he looked unhealthy.

They could barely conceal their astonishment when Manon strolled out of the bedroom in Ray's suite, wearing only a bra on top, and "flopped in his lap during our first conversation about the picture," according to Schulberg. Ray listened to the brothers with a dreamy expression, stroking Manon's hair, as they discussed the work ahead of them. If the Schulbergs were feeling apprehensive before, the sight of their director, obviously in the thrall of a young drug addict, triggered serious alarm bells.

Though they were shaken by the encounter, the brothers talked it over afterward, reassuring each other that, when the time for filming began, the old Nick Ray would bob to the surface and reassert himself.

✳

The casting plans had fluctuated over the summer. Christopher Plummer had been signed to make his screen debut in *Stage Struck,* detracting from his allure as the Schulbergs' "discovery." For a while the brothers pursued Paul Newman, another new Brando, whom the Schulbergs saw as a sexier candidate for Walt. Intriguingly, Ray countered by suggesting the chiseled star of *The Ten Commandments,* Charlton Heston, but the brothers diplomatically dismissed that notion. Heston "seemed to us too physically magnificent, too obviously competent, to create any suspense about his survival in the Glades," Stuart Schulberg wrote to Ray.

Ives proposed Ben Gazzara, an Actors Studio discovery, his costar on Broadway in Tennessee Williams's *Cat on a Hot Tin Roof,* directed by Elia Kazan. Ives felt a special chemistry with Gazzara, who was marked down for the part of Walt. But then Ives's own participation became doubtful; he had a supporting role in William Wyler's *The Big Country,* and the filming was going to take longer than anticipated, putting the folksinger out of reach until mid-October at the earliest. Warner's wanted to replace Ives, but the Schulbergs were convinced Ives would make the perfect Cottonmouth, and they preferred to shoot around him until he finished the Wyler film. In the way it often happens, then, Gazzara abruptly dropped out of the project, and Plummer dropped back in as Walt.

The continual delays added to the budget, and Warner's pressured the Schulbergs into cutting a number of backstory scenes, set in New York and Boston. This would save production time and money while anchoring the story and filming almost entirely in the Everglades. The changes gave the script focus but diminished its scope and breadth. Ray, who'd been looking forward to shooting in East Coast locations for the first time, was dismayed by the forced changes, but he lagged behind the decision-making and nursed his resentments as the planning sped along.

In mid-September the Schulbergs tried to revive the family spirit with a little togetherness. Ray, the brothers, and the production team— which included many veterans of Elia Kazan films—took a scouting trip

to Everglades City in Florida. Ray and the brothers agreed on Duck Rock for a primary location and Chokoloskee Island for the wetlands portions of the story, and they interviewed local fishermen and citizens for small parts.

The Schulbergs were hoping for an early November start date, but now it was the writing that fell behind. Budd had to keep going back and revising the earliest scenes on the schedule to keep up with studio dictates. He did most of his writing in Florida, limiting Ray's input.

Trying for his own circle of trust, however meager, Ray convinced the Schulbergs to add color consultant J. Edward Hambleton to the *Wind Across the Everglades* payroll. The director also found small parts for his old New York friends Curt Conway (from the Theatre of Action days) and George Voskovec (the refugee comedian from Prague who'd performed on Office of War Information broadcasts). As usual, Ray's nephew Sumner Williams would act a minor part, but Williams also graduated to a behind-the-scenes role as "dialogue supervisor."

Yet Ray seemed to be having a hard time clicking into gear, becoming inspired by the material or committing to the experience. The signs disturbed the Schulbergs. They were no strangers to heavy drinking. But outside their purview, it was obvious—even to straight arrows like them—that Ray was indulging in assorted drugs, perhaps including heroin. "He was in a way a distortion of the Nick that we had known," recalled Budd Schulberg. "He was in a cloud, he just wasn't clear, he didn't know what the story was. It's true that our relationship flip-flopped almost overnight from one of being friends to being almost adversaries."

One of the worst things, from the brothers' viewpoint, was the constant presence of Manon. Ray seemed umbilically attached to the young woman, who was constantly hovering nearby him, monopolizing him with her always-urgent needs. One day, Budd asked Ray if he loved Manon. Ray quickly said no. Then, later, he vacillated, explaining that he'd found a relationship "strangely easy with this strange woman" and "maybe it makes for loving."

In mid-October, the Schulbergs conspired to organize another boys' night out, luring the director away from Manon on a leisure trip to Florida with a small group of their friends. They arranged to tour the Everglades with the film's technical adviser, a professional guide, and a local friend of Budd Schulberg's, a well-known Florida abstract artist named

Syd Solomon. For several days they would do nothing but "sop up the atmosphere," in Budd's words. If the brothers hoped to make the trip a restorative for Ray, however, it had the opposite effect. Away from Manon and drugs, Ray plunged into a blue funk. One morning, the director refused even to come out of his cabin; Schulberg found him sitting inside, holding his head in his hands.

"His attitude was, 'When can we go back? When you've seen one Glade, you've seen them all.' He was just not in a frame of mind to do this picture," recalled Schulberg.

There was no uptick in goodwill or confidence after their return to New York. As the endlessly delayed November launch of photography approached and the brothers organized for the big move to Florida, the Schulbergs privately chewed the matter over again. Ray was acting crazy; Manon was at best a distraction, at worst a conduit to hard drugs. The brothers arranged a face-to-face with Ray, laying down the law: His girlfriend shouldn't go on location with him. Everglades City was a provincial place, one that wouldn't embrace someone like Manon.

Thus confronted, Ray reluctantly agreed. Then, however, the director went back to the hotel room he shared with his young inamorata and wrote a remarkable letter in which he revealed his innermost feelings— and reversed his decision about Manon. "My very dear Budd," Ray wrote, "I will go with you unqualifiedly to the end of life against any opposition and toward any goal. I beg an understanding, a tolerance of others and yourself. That you feed on hatreds as well as loves is common to us both— but I believe they should be deeply and justly founded and have a purity that cannot be associated with the festering of rumor or second and third hand reports, the motivations of which we can only guess at this time . . .

"You or Gadj [Kazan], my two kids and a few others may ask anything of me at any time," Ray wrote—except for banning Manon from the Florida shoot. That was too much to ask.

"Until now an early anger towards women has marred my march thru hundreds of women and a couple marriages," his letter continued. "And now I feel protective and giving toward one woman on a scale which I can no more understand than the abstraction of love."

Ray's struggle to express himself was never more apparent, but his resolution was unmistakable. "Somehow I feel that behind your allowance of a festering anger toward Manon is a protective feeling toward me,"

Ray's missive concluded. "I appreciate that but become concerned with your inner burn because you let it get too hot before you loose it on her, or me. My feelings for you should be clear enough for you to know that nothing need be withheld beyond the moment of the thought itself. I will accept, reject, but consider and honor whatever it may be, and with this declaration I take Manon to Sarasota to clear the atmosphere of the shack for work."

Sidelined and impotent when it came to key filmmaking decisions, the director put his foot down on this issue. When the cast and crew arrived in Everglades City, Manon was at Ray's side.

<center>✳</center>

Thus far the Schulbergs had taken the lead on their first production. Budd Schulberg, who was also the producer of *Wind Across the Everglades,* had followed his own muse on the script. His brother and coproducer Stuart guided the second-unit photography, which would lend flavor and authenticity to the film. The Schulbergs also arranged much of the casting.

A "motlier" cast, wrote Christopher Plummer in his memoir, never existed. The former stripper and *litterateur* Gypsy Rose Lee was recruited to play the madam of the local brothel. The Schulbergs gave speaking parts to jockey and broadcaster Sam Renick and boxer "Two Ton" Tony Galento, who had once fought Joe Louis. The sad-faced circus clown Emmett Kelly agreed to a rare screen appearance, mainly for publicity's sake, and other pugilists and circus types acquainted with the Schulbergs were awarded walk-ons. Bits went to cronies and relatives. One of Ray's choices was an offbeat Actors Studio alumnus named Peter Falk, who was making his first movie. Falk was one of the "only actual actors in the film," Plummer joked.

The leading lady, Plummer's love interest, was also a newcomer. The Schulbergs bestowed this plum part on their personal discovery, a former Israeli airline hostess named Chana Eden, whom Stuart had spotted when making the rounds of New York acting classes. (Stuart later admitted that her rash casting didn't improve the film.)

Another novice actor unwittingly exacerbated the growing rift between Ray and the Schulbergs. Author MacKinlay Kantor, who had won a Pulitzer Prize the previous year for his Civil War novel *Andersonville,* was a Sarasota resident and a mutual friend of Budd Schulberg's and Ray's.

(Kantor had mingled with the director during the Hollywood phase of his career.) He was the consensus choice to play the judge in the picture.

But when Kantor came to the hotel where they all were staying to meet with Ray in his suite, Budd waited for his invitation to join them. "I thought we'd all get together more or less socially," recalled Schulberg. After Budd had waited "maybe two hours," Ray suddenly "burst" into his room, waving a copy of the script and saying excitedly, "Budd, Mac and I have been working on the script, and I think we've made some marvelous improvements." Schulberg angrily remembered his astonishment decades later. "He had it all written down in the margins. I said, 'Nick . . .'—I was shaking, I was so angry—'Nick, I want you to get away from me, just get away from me.' He said, 'But please, look at this . . .' He didn't seem to understand what he and Mac had done."

Schulberg rushed off to find his brother. Ray had lost touch with reality, Budd warned Stuart. The director was a deluded man, acting as though the script were a blueprint for his own genius. The brothers were debating whether to fire Ray—and whether Warner's would accept such a last-minute shock without pulling the plug on the production—when they were interrupted by a phone call from the hotel owner, who was also a physician. Manon had just taken an overdose of sleeping pills in the bathroom of Ray's suite. "It was the first of three so-called attempts" at suicide by the director's girlfriend during the filming, according to Schulberg.

Good timing: Manon was saved from the brink, and her failed suicide changed the crisis. Schulberg mended fences with Ray and Kantor, and the brothers set aside the idea of firing the director.

❈

The first day of filming was November 5, 1957. The night before, Ray convened the entire cast for a read-through of the script. That was his cherished method, studying the actors as they grappled for the first time with their lines and characterizations. It was a throwback to his theater training, though it didn't always work for motion pictures.

The night was a travesty of the unifying event that had hypnotized the young cast of *Rebel Without a Cause*. Burl Ives, one of the major players, couldn't be present; his lines had to be read by someone else. On the other hand, even the "bit players" were invited, recalled Budd Schulberg, "like the manager of the Everglades Hotel Rod and Gun Club. He shouldn't

have been at such a reading anyway, but as he read his lines, Nick stopped him and said, 'Now, do you understand your motivation for this?' Nick was talking Stanislavski to this poor little man who was just thinking it would be fun to dress up and be in a movie."

Other advice Ray proffered that night struck even some of the professional actors as "incoherent," according to Budd Schulberg. After the reading, Plummer made a beeline for the writer-producer and yanked him aside. "You do realize, don't you, Budd," hissed the leading man, "that this man is stark, raving mad?"

Ray and Plummer never really hit it off, and the read-through did nothing to improve their relationship. The read-through was intended to foster a communal spirit, but as Ray would demonstrate in various ways on location—offending some in the cast and crew by insisting on special meals rather than standing in line; dining alone with Manon rather than communally—such gestures were merely a pretense. Plummer was the kind of theater-trained actor Ray normally favored, but the Canadian-born thespian was not Ray's casting, and he symbolized a creative process dominated by the Schulbergs. Furthermore, Plummer was playing "the somewhat colorless leading juvenile of this fated film," in the actor's own words. Ray looked more fondly on the rapscallion parts, especially the chief outlaw, the hard-boozing gambling man Cottonmouth, the role earmarked for his old folksinging buddy Ives.

After Plummer finished his confab with Schulberg, Ray, who had been eyeing them suspiciously, grabbed Budd for another earful. "I can't handle Chris," the director announced. "So what if I direct Burl and I let you direct Chris?"

Was Ray joking? Schulberg couldn't believe what he was hearing. Later, he and his brother had another "serious discussion" about firing Ray, rehashing the pros and cons. Warner's might cancel the picture or impose its own crappy director. Ray boasted a fine body of work; keeping him was preferable to scaring the studio. For all his faults, they still held out hope that Ray would get back on track once filming started. The Schulbergs chose to wait and see.

✳

The Schulberg brothers were novice film producers, and they were gradually becoming overwhelmed by a critical mass of problems and emergen-

cies. Most of the time, Budd Schulberg was just as pickled in alcohol as Ray, though some felt that the writer-producer held his liquor better. (The older Schulberg brother "started on the vodka at ten in the morning and by late afternoon was still standing, believe it or not, quite sober, even when writing copious pages of new dialogue," recalled Plummer. "What a constitution!")

The hellishness of the location couldn't be blamed on Ray. First the cast and crew experienced miserable heat and humidity and mosquitoes and snakes; then the weather switched to thunderstorms and the coldest, wettest winter in decades. Filming in the Everglades was as arduous as working in the Libyan desert. Everyone took to bed with ailments.

Everyone but Ray: Once again the director's physical courage impressed people, even when his psychological state gave them cause for alarm. One day, Ray fell thirty-five feet from a gangplank into the Barron River and had to be fished out by an electrician; he went straight back to work on the scene in progress. At one point, the Schulbergs reported to Steve Trilling, "Ives and Plummer both bedridden . . . Nick also sick but still on his feet." *Variety* ran a publicity item describing Ray as "a hero to his colleagues on location scouting expeditions." Unafraid of the rampant snakes, Ray took the lead on treks into the wetlands and told a reporter, "Those rattlers never strike the first person in line, always the second or third."

Budd Schulberg frightened Ray more than pneumonia or snakes. Early in the filming, Budd tapped Ray on the shoulder to make a suggestion and the director jumped ten feet. From then on Ray ordered Budd to keep his distance—the opposite of how Schulberg had worked with Elia Kazan, and this time Schulberg was not only the writer but also the producer! Nevertheless, Budd bit his tongue and vowed to tread cautiously.

Ray spent the first month shooting every possible scene that didn't involve Burl Ives, while waiting for William Wyler to release the big fellow from *The Big Country*. That meant, primarily, agitating the essence of Christopher Plummer. Just before an important scene, he'd take Plummer on one of his characteristically long strolls, whispering and gesturing ambiguously. "On these instances," Plummer said, "he could be at his most pretentious. Only too occasionally would flashes of talent show through, and then he was both lucid and helpful."

One time, just before a key close-up, Ray elaborately threw his arm

around the actor and took him on the grand tour of the set, expounding on the complexity of the role he was playing and comparing his character, Walt Murdock, to "Hamlet or Oedipus," in Plummer's words, "favored slightly with a touch of Kraft-Ebbing and Kierkegaard."

Another time, before another close-up, Ray walked Plummer around for a long, long time—maybe ten minutes, maybe four hundred yards. As the crew waited and waited, director and actor walked and walked—and Ray never uttered a single word. Finally, he stopped, turned to Plummer, and asked, "See what I mean?"

"Things are getting a little scary," Plummer thought. The actor chalked it up to dope, or whatever other influence was emanating from Manon. "If she didn't push dope," recalled Plummer, she "pushed just about everything else. She was certainly feeding Nick with something, for to those on board who had known and respected this gifted man he most certainly was not himself. His eyes were always running, the pupils strangely dilated—he would stare vacantly into space. Half aware of this he began to wear a black patch over one eye so that he resembled that famed rebel director from the recent past Andre de Toth.

"Nick and his girl were never apart. She stood close to him on the set, never took her eyes off him. One could sense there wasn't much tenderness there; they seemed shackled together in a love-hate bondage that could only end in despair."

Ray had threatened to leave the direction of Plummer to Budd Schulberg, and "in a sense that is what happened," said Schulberg. "He simply wouldn't communicate with Chris at all, and we just tried to work out together how to adjust to that situation."

Plummer wasn't alone in wondering if he was trapped in some kind of swamp horror flick. He and Peter Falk and a few others formed an "anti–Nick Ray" clique, privately referring to the film as "Wind Breaking Across the Everglades."

When Ives finally arrived on location, however, everyone's spirits lifted a little. The burly folksinger serenaded everyone at night, taking up his guitar and singing favorite songs from the balcony of his room. Ray too sprang back to life. The director threw himself wholeheartedly into his old cohort's scenes, most of which involved singing and drinking and gambling. He and Ives spoke the same language of macho bluff, and Ives's scenes played as warmly and slyly menacing as Plummer's were cold and

devoid of charm. Ray also gave privileged moments to other friends playing minor characters, like George Voskovec. Convinced that the thirteenth-billed Voskovec added texture to the film, Ray gave inordinate screen time to the former Prague comedian.

"Screen time" was a mounting issue as Ray repeatedly sank into his chair, deep-thinking the next shot. While filming, the director called for constant last-minute changes in camera setups and numerous alternative shots. At night, unable as ever to sleep, Ray would feverishly compile notes and sketch shots, but by day he insisted on filming the same scene through numerous similar angles, with only slight adjustments in the coverage.

Undoubtedly, Ray did manage to capture some picturesque images on film. ("Some of his photographic setups and angles," Plummer wrote, "were most interestingly conceived.") But both Jack Warner and Steve Trilling sent telegrams complaining about Ray's endless minute variations, nearly all of which were destined for the cutting room floor. "Time, effort and cost," they wrote, "unnecessarily expended."

Privately, the Schulbergs concurred. But the brothers were doing their best to control Ray without triggering panic in Hollywood or an explosion in the Everglades. "Methods of director unexpectedly intricate and expensive," Stuart Schulberg reported politely to the studio. "We have pressed for simplification to maximum extent possible without destroying his effectiveness. Of course controlling him is our responsibility but as you know a difficult problem to be handled on the scene and on Day to Day basis."

For all these unpleasant reasons, the filming fell behind schedule and budget. The scenes and footage kept elongating, and Warner Bros. kept insisting on making cuts in the script to compensate. Already feeling under the gun, Budd Schulberg trimmed scenes further, blaming the need for the trims on Ray. The director, in turn, grew irritated by the constant flow of revisions, over which he exerted zero influence, and which, he later claimed, jettisoned some of the very elements in the script that had drawn him to the story in the first place.

The atmosphere on location had become one of permanent crisis.

<center>✳</center>

The Schulbergs had been fearing some kind of explosion, and it came, literally, in mid-January.

After failing three times to kill herself, one night Manon made a game attempt at murdering someone else. "In the dead of night she had left their bed, Nick still sleeping," Plummer wrote in his memoir, "got into the big Cadillac convertible, backed up several yards then gunned it at full speed straight through the wall of their bedroom. If, seconds before, Nick hadn't got up to pee, he would surely have been a dead man. We saw the cabin the next morning which looked like a collapsed accordion."

Ray was "badly shaken" by the incident, according to Plummer, and Manon was briefly spirited away somewhere. But the mysterious young French woman didn't go very far; she would be glimpsed at least twice more, several days later.

Some of the film's crucial scenes were coming up, including the late passages in which Walt Murdock confronts Cottonmouth in his lair and force-marches him to justice through an alligator-infested swamp. The ending had been the subject of much internal debate: The script had originally concluded with both the protagonist and villain dying, but Schulberg changed it at the behest of Warner Bros. so that Cottonmouth would acquiesce in his own death by snakebite, almost as a noble gesture. Though the change was Schulberg's decision, it bore an almost eerie similarity to what happens between Leith and Brand at the end of *Bitter Victory*.

The director felt he had been working well with Ives, building his characterization and performance, and Ray was looking forward to the death march as an opportunity to clinch an Oscar for his old friend. But it was not to be: Before Ives could die on camera, a second, less violent but even more disastrous blowup took place that derailed the picture altogether.

It happened not long after Manon's car crash—on January 13, 1958, according to Bernard Eisenschitz—the fifty-eighth day of photography, with about two and a half weeks of filming left.

After supervising a brief shot involving a minor character, Ray told the man to quit the scene by exiting to his left. His continuity girl, Roberta Hodes, checked her notes and told the director the shot wouldn't match with the editing unless the performer exited to the right. Ray said that the editing matchup didn't matter to him and repeated his direction to exit left. Hodes spoke up again, in a small voice, warning that the shot might cause confusion in the editing room. Loudly, Ray said he didn't care. Finally, assistant director Charlie Maguire chimed in, agreeing with Hodes. Maguire "was disciplined, knows his place as an assistant director, never

talks back to directors," Hodes recalled, "but he [Maguire] said, 'Nick, Roberta's right, it won't match, it'll look as if instead of following up, he's going in the opposite direction.'"

Ray waxed indignant. "I will not have this kind of insubordination on my set!" he protested. Then cinematographer Joe Brun—"a gentle artistic soul, he would never intervene, but finally he did," as Hodes noted—spoke up, siding with the continuity girl and assistant director. Furious, Ray demanded the take he wanted, the one everyone warned him wouldn't be suitable.

Watching from the sidelines with mounting exasperation, Budd Schulberg finally let loose, upbraiding Ray and heatedly telling him he ought to thank three knowledgeable people who'd tried so hard to assist him with good advice. The director stood his ground, rebuking Schulberg angrily. "I cannot and will not work with this sort of interference!"

"Well," said Schulberg, "maybe we had better stop right now."

The filming halted, and everyone sheepishly returned to the hotel. The Schulberg brothers met one last time to debate what to do. Budd insisted that Ray was physically incapable of directing the picture, that he was "not really coherent." The cast and crew were demoralized by his erratic behavior. Budd felt they had no choice but to fire him.

But who would take over for the remaining two and a half weeks, Stuart asked, including the climax of Cottonmouth's death? Budd said he could direct the remainder himself, with the help of the cinematographer and assistant director. "It can only be better," he argued, "it can't be worse."

Years later, Ray would strike two blows to Budd's solar plexus, telling friendly interviewers that Schulberg had a ghostwriter on the set (i.e., his brother?) and that Budd had secretly wanted to direct the picture all along (i.e., that Budd was a faux writer *and* director). "Schulberg refused to allow a range of respect among men," Ray said, defending himself abstrusely.

But the truth is that the Schulbergs had given Ray plenty of charitable reprieves. Now they felt forced to dismiss him, banishing him from his own set and ordering him to stay in his hotel room while Schulberg, assistant director Charlie Maguire, and director of photography Joseph Brun finished the filming. In exchange for staying out of sight, the Schulbergs agreed not to announce publicly that Ray had been discharged. The director insisted on his contractual right of first cut and his directing credit. The Schulbergs readily agreed. He demanded the remainder of his salary; that too was granted. Warner's had to be apprised of the change (Jack

Warner and Steve Trilling were frankly relieved), but the studio would keep the secret to avoid negative publicity.

But Ray couldn't bear his dismissal and confinement. Not long after his firing, Budd Schulberg glimpsed the director crouched low in the back of a rental car lurking on the perimeter of the set, watching the filming from the stipulated distance with Manon behind the wheel. A few days later, Plummer spotted the director in the same furtive position in the back of the same rental car; this time, however, Manon was driving the couple to the airport.

\*

Privately Ray may have been deflated, but only briefly was he cowed. He believed his own defense and rationalized what had happened. His hubris remained intact—helped by the fact that, as often happened in his life, only a handful inside the film industry knew of his secret firing and the whole shameful episode.

Besides, Ray had a ready fallback. The director had been talking to Charles Schnee about directing a Roaring Twenties quasi-musical for MGM. The dependable writer of *They Live by Night* and *Born to Be Bad* had supervised a script called *Party Girl,* slated to be the last picture he would produce for MGM before leaving the studio. (Schnee's booster, Dore Schary, had been ousted as production chief in late November 1956.) Ray's contract for *Party Girl* was being finalized the very week of the Everglades standoff.

MGM was one of the last major studios in Hollywood where Ray hadn't worked. The studio insisted on a "morality clause" in his contract, penalizing the director in the event of indecent or illegal deportment—a clause that, while pro forma in many contracts, hinted at whispers about his drinking and drug use. Ray swiftly dropped his initial resistance to the morality clause after the Schulbergs fired him, and there is no evidence MGM was informed about what happened in Florida. Just as swiftly, Ray agreed to $3,750 weekly for twenty weeks. That added up to $75,000, the very salary he had been unsuccessful in obtaining for *Wind Across the Everglades.*

Pressured by Warner's, meanwhile, the Schulbergs rushed to assemble a rough cut of the Everglades picture. Although Ray was in New York for the rough-cut editing, he deliberately absented himself. Editors Joe Zigman and George Klotz were urged to let Ray view the rushes "on that part of the

picture completed after his departure," according to Stuart Schulberg, and to let him advise and consult on the overall editing, but the director never showed for the screenings scheduled to accommodate his input. Despite "repeated efforts by telephone to arrange other dates for him to screen the material, he never returned their calls or made any effort, as far as they could discover, to meet with them," recalled Stuart Schulberg.

Ray was pointedly invited to the rough-cut showing attended by Jack Warner himself in New York. He didn't respond to the invitation. After viewing the assembly, the studio mogul wrote an April 22, 1957, memo to Steve Trilling: "Just saw picture . . . about 100% better than we thought it would be . . . needs editing but doesn't need any retakes . . . all we need is some stock shots of animal life . . . Editing can be done between you, me, Rudy [Rudi] Fehr." The latter was a Warner Bros. official, formerly a top editor, who specialized in tidying up messy pictures.

Ray left for California, and the editing of *Wind Across the Everglades* soon moved there also, so that Warner Bros. could closely guard the final form of the film. Fehr, Zigman, and Klotz worked with the Schulberg brothers on the Warner's lot. Feeling obliged to keep Ray apprised because of his "contractual right of first cut," the Schulbergs persisted in their efforts to reach the director at his new MGM offices, but he refused even to return their phone calls. Stuart Schulberg tried calling Ray's new MCA agent, Herb Brenner—one more rung down the agency's ladder— but Brenner was having no better luck communicating with Ray.

The Everglades film progressed through postproduction. Actors flew in for dubbing. Warner Bros. approved a final cut. Canned music was added after a musician's strike hit Hollywood, though more goodwill with the studio might have stalled that unwise decision. A July 9 preview was slated, with Ray the only name on the guest list without an escort and the name Manon conspicuously missing.

Ray still hadn't seen *Wind Across the Everglades*. Still worried about the director's right-of-first-cut clause, Stuart Schulberg made one last-ditch effort to contact him. Ray's secretary told him the director had been ill, but that he would phone him shortly. It wasn't until the last week of June that the director finally did, however. Schulberg told Ray that he was free to see the film at any mutually agreeable time. Yet more days went by without Ray specifying a date.

After reading all this in a June 30 memo, with the studio preview just one week away, Steve Trilling dictated a blunt memo: "Forget the whole

matter." The Schulbergs and Warner's had done everything possible to honor Ray's contract. Now it was "his problem," Trilling said.

Defying expectations, then, Ray showed up at the preview. Afterward, the director dashed off a memo to the Schulbergs and George Klotz (the French editor Ray himself had hired), reporting "my reaction to the film." The memo, which appears personally typed, rather than dictated, revealed a mind still at times lucid, other times groping for clarity.

"The story line is unclear," Ray began. "Therefore, to say that unity is lost is redundant." He mourned the loss of favorite scenes, many involving fringe characters such as the one played by Voskovec, and especially the "largely improvisatory" moments—his own contributions, that is, not those scripted by Schulberg. "I find angles used differently than their intention," he pointed out—their intended use, of course, known only to him.

"The academics of repetition to make historic or folkloreistic [*sic*] points, annoyed me and the audience," he wrote in a particularly obscure passage, "because, no matter what our sentiments might be, the interference with entertainment is on film."

Ray found the preview version to be hobbled by "almost ludicrous" scene transitions, and he felt compelled to make suggestions for cuts and resequencing, even singling out certain lines of dialogue for clarification, deletion, or translation into the Seminole language. "This is not creative cutting," he said of the preview version, "but I am not in a position to do more than challenge it."

The dubbing was "atrocious," Ray added almost as an afterthought, "and the canned score, of course is impossible. But I'm certain you entertain no thoughts of releasing the film this way."

By the end of the three-page memo, his bitterness had built to a howl of outrage. "I'm sure that my name means very little to the box-office revenue for this film except in Europe," Ray declared, "but unless the final scene shot after my departure from Florida is reshot, I would be most acquiescent to having my name removed from the film. I cannot allow it to be associated with the style of acting employed by Burl, in the death scene.

"The film has a potential of being interesting," he concluded, "but not in its present state."

The "death scene" to which Ray referred was supposed to have been the cathartic high point of *Wind Across the Everglades*. If Ray himself had shot it, the director believed, it would have clinched a Best Actor Oscar for Burl Ives. And Ray wasn't alone: No one was satisfied with the ending

as it was filmed by the makeshift trio of Budd Schulberg, cinematographer Joseph Brun, and assistant director Charles Maguire. Ives himself remained sympathetic to Ray, and during his trip to Hollywood for dubbing, he volunteered to redo several scenes including his death on studio soundstages. By that time, however, Jack Warner was through adding to the production budget. He wanted to cut his losses and move on.

"Good luck," Ray signed his impolitic memo, which he copied to Trilling and Warner. But the director's suggestions were ignored, the canned music was preserved, and *Wind Across the Everglades* was released in September to tepid box office and reviews that tended to damn with faint praise. ("Moderately interesting," wrote John L. Scott in the *Los Angeles Times*.) Ironically, Ives did win an acting Oscar that year—not for *Everglades,* but for his supporting role in *The Big Country*.

There would be no second Schulberg brothers' project for Ray—or for Budd and Stuart, for that matter. (It was actually the last motion picture either Schulberg would make.) Jack Warner scoffed at striking the director's name from the credits, but for the foreseeable future Ray was persona non grata at the studio that had gambled so successfully on him with *Rebel Without a Cause*. This was one blacklisting that had nothing to do with politics.

※

Charles Schnee didn't last very long without Dore Schary. After MGM's new management restricted his freedom with the *Party Girl* script and dictated leads that appalled him, the writer-producer fled to Columbia. The Roaring Twenties musical was bequeathed to Joseph Pasternak, who'd been producing light entertainment for three decades, including many musicals, first in Germany, then for Universal and MGM in Hollywood.

*Party Girl* was set in a time and place Ray knew firsthand: Chicago in the era of Prohibition and gangland violence. The story wasn't much, a romance between a nightclub performer and a crippled mob lawyer whose sole client, a boyhood friend turned brutal criminal, has begun to question the lawyer's loyalty. The formula was old-fashioned, like a Warner Bros. gangster film of the 1930s, only with singing and dancing instead of a social conscience.

After Schnee's departure, several writers tried to pump life into the script. The last of these was George Wells, who'd won an Oscar for writing

*Designing Woman,* an MGM picture Vincente Minnelli had directed the year before. Before Ray came on board, Wells's final script had been approved by MGM officials and budgeted by the departments. Though the major roles had been cast, Ray sprinkled in a handful of old acquaintances in minor roles: Corey Allen from *Rebel Without a Cause* and Rusty Lane, one of the judges of the radio contest he had won, long ago in Wisconsin. The director had time and opportunity for only trivial script changes. "I don't know whether he didn't like my work or I didn't like his," recalled Wells. "I do not know. I did not do well with him."

The two leads, whose casting Schnee had fought unsuccessfully, were set in concrete: Robert Taylor and Cyd Charisse, two aging, fading stars making their last MGM pictures under cushy contracts that had to be paid. Both were cast somewhat against type: Charisse was supposed to play a common showgirl—"no background, no breeding," in Wells's words—yet most moviegoers knew that the silky dancer, trained as a ballerina, was a "highly talented woman, beautiful, refined, everything wrong for the part." The same went for Taylor, in real life "a smooth, wonderful nice guy," as Wells noted, whom the front office insisted on casting as a tainted lawyer with a limp, the only person willing to stand up to a sadistic gang lord.

There was a third lead, the gang lord Rico, even his name a Hollywood cliché. For that role the studio had cast Lee J. Cobb, a Group Theatre veteran who'd been directed by Elia Kazan onstage (in *Death of a Salesman*) and on-screen (picking up an Oscar nomination for playing the corrupt union boss—i.e., tyrannical Communist leader—in *On the Waterfront*). Dogged by his many left-wing associations, Cobb had been hounded by HUAC into naming twenty Communists in a 1952 executive session, suffering a massive coronary shortly thereafter. In keeping with the times, and with Ray's own retreat from his leftist roots, Cobb would be playing a no-good character, undeserving of sympathy or understanding, regardless of how unfortunately his environment shaped him.

Cobb had nothing on Robert Taylor, who had appeared as a "friendly witness" for HUAC in 1947, saying he didn't know for sure who in Hollywood was Communist but offering to "name a few who seem to sort of disrupt things once in a while." "Whether or not they are Communists," Taylor testified, "I don't know. One chap we have currently, I think, is Mr. Howard Da Silva. He always seems to have something to say at the wrong time."

A character who always had something to say at the wrong time: That was the role Da Silva had played in *They Live by Night,* Nicholas Ray's first film, in which he was unforgettable as the loudmouthed Chickamaw. After the Hollywood Ten went to jail in 1950, and the new rounds of hearings were launched, Da Silva had been among the first unfriendly witnesses— "belligerently uncooperative," as Victor Navasky put it. RKO decided to make a "symbolic example" of Da Silva, splicing him out of a leading role in a Western and then reshooting his part with Brian Donlevy. Once a friend of Ray's, Da Silva found himself blacklisted thanks to people like Taylor; for the next decade he'd miss out on a host of choice movie roles—including the gang lord in *Party Girl,* for which he would have been perfect.

<div align="center">✳</div>

The studio vetoed any location work in Chicago, instead re-dressing standing sets for the filming. The cinematographer, Robert J. Bronner, specialized in MGM musicals highlighting the beauty of Cyd Charisse. But Ray found consolation in CinemaScope and color, and some consider *Party Girl* his most exquisitely beautiful picture.

John Hambleton was around for drinks and brainstorming, and once again Ray resorted to "the psychology of color" in costuming the main characters. Charisse would appear in "a film wardrobe restricted to shades of coral or flame," the director informed the press. Taylor, "a well-educated, sharp-shooting gangster attorney," would wear "nothing but businesslike grey and shades of grey." Gangster boss Lee J. Cobb would be dressed in "conservative black clothing" that set him apart from young, ambitious underlings like his lieutenant, played by John Ireland, who had seven wardrobe changes in varieties of green—i.e., callowness, envy, money, etc. ("The color just goes with the part he represents," said Ray.)

Only one color was banned from the set: blue. Ray regarded blue as a "scene-stealer," the director told journalists, distracting from the main action. The only exception to the ban was Ray himself, who now abandoned his jeans and sandals for a blue sport coat, hinting at a jaunty attitude.

And yet, during the principal photography, which ran from late March until early May, Ray seemed a wounded, diminished figure. Some days the director deliberately absented himself from the set. Ray had always said he wanted to stage a Hollywood musical, and along with *Hot Blood* this was

the closest he came. But he delegated the handling of all the musical numbers to choreographer Robert Sidney, who rehearsed the singing and dancing and then guided the camerawork, ostensibly under Ray's supervision. The filming halted during the musicians' dispute in May and then didn't resume until early July, but most of what remained were song-and-dance numbers that were mapped out for Sidney. Ray soon left the lot, and MGM staffers supervised the editing and musical scoring.

Characteristically, Ray worked best with Taylor, the male lead, insisting in a later interview that the sometimes colorless star worked for him "like a true Method actor." ("I took him to the greatest bone specialist in southern California," Ray told *Take One,* "and we spent hours going over hip dislocations, and what would cause that kind of limp.") The director failed to obtain the same agitation of essence from Charisse, who was mystified when Ray suggested, during one scene, that she take a handful of roses and inhale deeply "as though you were smoking a joint," as she told French author Jean-Claude Missiaen. Charisse was frankly relieved when Ray left the song-and-dance routines to her favorite choreographer. "Ray didn't have a clue about the [musical] numbers," the actress recalled years later.

Was Ray himself smoking joints, drinking heavily, or trying to wean himself off his dependencies? Was he plagued by illness, as his secretary had informed the Schulbergs? Or was he burned out?

"He was in an unhappy frame of mind," recalled Wells. "I don't know what was bothering him."

And whatever happened to Manon, the "one woman" for whom Ray had declared his true love or something "almost" like it? There are unsubstantiated rumors that the French North African heroin addict was arrested and deported in Florida—and other rumors suggesting she lingered with Ray in Hollywood. No one has ever reported Manon's last name or even confirmed that she had one.

Ray found Manon's replacement on the set of *Party Girl,* however, when dancer Betty Utey roared back into his life like a blood transfusion. At twenty-three, from a Michigan family, Utey (born Uitti) was half Ray's age. Blond and vivacious, with a sweet come-hither smile, she resembled Carroll Baker, the star of Elia Kazan's *Baby Doll.* Bright and bursting with energy, she was dying to prove she was more than a chorus girl.

Utey had been a chorine for nearly a decade: training with the Ballet Russe, dancing behind Jimmy Durante in nightclubs, doing chorus work in *Pal Joey,* and twirling on Fred Astaire's arm briefly in *Silk Stockings* (another

Cyd Charisse vehicle). Ray had met her as a teenager at RKO, and they may have had an affair back then. Now she was one of the billed "party girls" dressing up the background of his MGM musical.

As soon as he drew his last paycheck, the director declared that he needed a long vacation from Hollywood—maybe a permanent vacation. Hollywood was killing him. Utey, who fell in love with him during the filming, was a sunny optimist who believed that all Ray really needed was to stop drinking and taking drugs. They left together in a car heading east, stopping in Wisconsin, to visit Ray's mother, and in Michigan, where Utey had relatives. They took their time, and Ray began to decompress. Their summer vacation became an extended sabbatical, and for months Ray barely kept in touch with his Hollywood agents. By the fall they had worked their way north to Maine, where they took a cabin and did little every day but hunt, fish, and make love.

Once again Ray had fallen hard for a woman, and this one, like Jean Evans, was determined to uplift him. On October 13, 1958, the two exchanged wedding vows at a United Methodist church in Kingfield, Maine, near Sugarloaf Mountain, not far from the Canadian border. Bursting with happiness, Ray himself phoned Hedda Hopper from nearby Quebec and told her he was in love and newly married for the third time.

He had had time to rest and time to reflect on recent disappointments. The old ambivalence he felt toward Hollywood had reasserted itself. Setting aside his own mistakes, had he tried hard enough? Did the very nature of film and the money-grubbing of the industry make it impossible for him to pursue idiosyncratic, personal motion pictures? Was any and every attempt at artistic glory doomed to failure?

Ray's call to Hopper was the first sign that he wasn't through directing. Not long thereafter, he exchanged wires with MCA, and the agency started putting out feelers on his behalf. All the rumors about his behavior had hurt his reputation, and producers were wary, but there were always second and third chances in the film business. "He couldn't get insured," Betty Utey said later, "because of his alcoholism. To prove that he wasn't drinking was the big thing."

The newlyweds left Maine with two beagle puppies, stopping in New York to visit the Museum of Modern Art, then driving all the way back to Los Angeles, arriving in late November and renting a home on Miller Drive in Beverly Hills. Ray made sure Hopper's column was up-to-date. "He's reading scripts like mad," the columnist reported.

Lew and Edie Wasserman revived their friendship with the director, and the department store magnate Alfred S. Bloomingdale, another high-stakes-card-playing muckamuck friendly with Ronald Reagan, helped Ray set up a story development company. "There were people in high places who believed in him," recalled Utey, "especially if he wasn't drinking."

The drinking had tapered off, though it's unclear whether the director had stopped altogether. "At that time in my life I thought vodka was men's cologne," explained Utey. "I thought he'd stopped using whatever cologne he was using, so I was pretty innocent."

As before, Ray found it impossible to achieve a breakthrough on his own. Without the umbrella of a studio, his efforts at story development went nowhere. Ray may have spent weeks reading "like mad" but he fielded few actual offers. The deal MCA finally came up with had little to do with Hollywood: a new project that was backed by British, French, and Italian money, with as yet no commitments from any American studio.

The project's Rome-based producer, Maleno Malenotti, had put together the financing for previous pictures by maverick Italian filmmakers like Gillo Pontecorvo and American blacklistees like Jules Dassin. Malenotti wanted to film an acclaimed novel by Hans Ruesch called *The Top of the World,* published in 1950. Ruesch's story revolved around the primitive existence of an Inuit Eskimo named Ernenek; the film would call him Inuk. After Inuk accidentally kills a Christian missionary who has refused the sexual "loan" of his wife—an Eskimo courtesy—two Javert-like police troopers hunt him down across miles and years to bring the Eskimo to justice.

The novel's setting appealed to Ray at least as much as its plot: It would be an Arctic adventure for him. The director was a fan of the documentarian and ethnographer Robert Flaherty, and *The Top of the World* bore similarities to Flaherty's pioneering *Nanook of the North,* which Ray first saw at Taliesin, along with Rockwell Kent's footage of Greenland. For Ray, this new project was a chance to return to the purism of his past, to ideas born at Taliesin, but also to his own happy days as an ethnographer, traveling on behalf of the Works Progress Administration.

✳

Now, over Christmas 1958, Ray wrote like mad, working on a script draft he could take to the next stage of casting and location scouting. Ray

boasted later that it was "the first major script I wrote all by myself"—a sole credit he'd long craved as a badge of honor.

But as usual he had unsung assistance, including a secretary and a supportive new wife, to help him conduct a flurry of research into Eskimo life. Over time, his attitude toward scripts—his sometimes poor relationship with Hollywood professionals and his frustration with projects that came to him with ready-made, inferior scripts already stamped with final approval by studio executives—had converged and hardened into a cynicism. Scripts were something to be improved upon during production—if not by more scribbling, then by ingenious camerawork. Paradoxically, perhaps, Ray enjoyed writing and was always happy writing.

"There was a need for Nick to be in control, which he never was," said producer Jud Kinberg, an associate of John Houseman's and a friend of Ray's in Hollywood and Rome, "and I think writing gave you the most control you can get, because until somebody else stepped in you were the one who made all the decisions. And it never happened down the line. It didn't even happen to the writer, but for the time that it was being written you were the producer, the director, the actors. You were everything."

By February 26, 1959, Ray had completed a draft, carrying only his own name and a new title: *The Savage Innocents.* "I took more from the Archives of Copenhagen and a book by Peter Freuchen* than I did from the novel," Ray later boasted to interviewers, sounding a little like Dix (Bogart) in *In a Lonely Place,* who stoutly refuses to read the bestseller he is adapting. ("It's not the book," Dix's agent complains after the script is done. "The book was trash," Dix retorts.)

In fact Ray borrowed heavily from the first half of Ruesch's story, while skipping the second half. His script also benefitted from work by several other writers who either preceded him or later overlapped him on final revisions: novelist Hans Ruesch, Italian scenarist Franco Solinas, and, curiously, Ray's eventual assistant and second-unit director, Baccio Bandini. All were credited with "adaptation" for the European release.

Yet once again, Ray was determined to make the Eskimo film his

---

* Freuchen was a Danish explorer who wrote definitive books about Eskimos and the Arctic and who worked as an adviser to some Hollywood films, including MGM's extraordinary *Eskimo,* a.k.a. *Mala the Magnificent,* starring the half-Inupiat Ray Mala, in 1933.

own. He saw *The Savage Innocents* as a chance to redeem himself after *Bitter Victory* and *Wind Across the Everglades*. He believed he had failed to bring those subjects to life in a glorious manner. *The Savage Innocents* was his third topographical film set in a foreign culture: the tarantulas and sandstorms of *Bitter Victory*—and the gator-infested swamplands of *Wind Across the Everglades*—would comprise an informal trilogy with the arctic wilderness and dangers of *The Savage Innocents*.

Indeed, scene after scene of Ray's new project echoed the images and themes of the earlier films. In *Bitter Victory,* the Arab guide carves into the stomach of a camel in order to extract the juices of its bladder and prolong the life of Leith; in *The Savage Innocents,* Inuk would gut a dog and thrust the frozen hands of a trooper into its warm belly. One trooper perishes in *The Savage Innocents,* but the other persists in his determination to capture Inuk; their long slog toward justice would eerily evoke the tropical death march shared by Walt Murdock and Cottonmouth at the end of *Wind Across the Everglades.*

The Italian producer liked Ray's draft enough to approve funds for the scouting and planning to begin in earnest in March 1959. The director planned a trip to Ottawa, where he met up with a Canadian wilderness adviser, Douglas Wilkinson, assistant director Bandini, a close associate of Malenotti's, and the Italian cinematographer Aldo Tonti. This would be the first of Ray's films in the new seventy-millimeter format, and Tonti, whose background included shooting *Nights of Cabiria* for Federico Fellini, would ensure its visual grandeur. After ten days spent touring the rugged north, Ray settled on a group of sites near the town of Churchill on Hudson Bay and nearby Baffin Island, not far from Greenland and the Arctic Circle.

Though Ray seemed ebullient while scouting in Canada, he acted "tired, gloomy and irritable" upon returning to Hollywood, according to an assistant director, Jacques Giraldeau. "He had lost his enthusiasm. I've always felt that the discrepancy between the reality and what he had imagined from his desk in California was the cause of his change in attitude."

The script remained fluid, a work in progress. Malenotti was anxious to sign a marquee name for Inuk, in order to lock in the financing, so Ray went after Anthony Quinn, the flamboyant, Mexican-born actor, who specialized in ethnic leads. Quinn was at the height of his popularity and transition to stardom: He would win Academy Awards for Best Support-

ing Actor in 1953 and 1957, and garner nominations for Best Actor in 1958 and 1965. Quinn was amenable to playing the Eskimo, but he vigorously critiqued his scenes, adding his own rewrite demands to those of the producer and irritating Ray, who hadn't expected quite so much feedback.

Much preparing remained. Ray embarked on a flurry of trips: first to Wisconsin, where he and Betty Utey stood in the harsh cold over his mother's grave (she had died in March 1959), and then to Europe. He met with the producer in Rome, discussed studio interiors in London to follow the location work in Canada, went to Paris to cast the French-born Japanese actress Yoko Tani as Quinn's Eskimo wife,* and made quick stops in Berlin and Copenhagen to conduct research and scout secondary locations (later abandoned). In Copenhagen too, he rendezvoused with Quinn and Tani and reviewed the schedule, discussing Eskimo customs and listening to Eskimo music.

While in London, Ray also sought an actor to play the First Trooper, who suffers frozen hands and has his life saved by Inuk during the long trek. Peter O'Toole, then a twenty-six-year-old thespian unknown to moviegoers, and his wife, actress Sian Phillips, were excited to meet the great man who'd directed the famous *Rebel Without a Cause*. But the reality dismayed them. "He was oddly disappointing: distracted and unfocused," Phillips recalled. "But he wasn't drunk—maybe he was ill?"

O'Toole had a previous stage commitment, but Ray decided to work around his schedule, using a local double for the actor in Canada. Bandini and Tonti and a small crew traveled to Churchill ahead of the main company, shooting second-unit footage, with the director and cast members arriving in the wilds in mid-May. The weather was still subzero, and the wind was a shrill and freezing menace. Again—as with those other "adventures," *Bitter Victory* and *Wind Across the Everglades*—the isolation cast a spell of gloom over the production.

If Ray had hopes of fostering another two-man club with Quinn—who'd won his first Oscar under Elia Kazan's tutelage in *Viva Zapata!*—he was in for a letdown. The punishing location discomfited the star, and Quinn kept forcing changes in the script. Ray had written "all the Eskimo

---

\*   Publicity for the film defended Tani's casting by insisting that there were cultural similarities between Japan and the Eskimos, including physical resemblances and a common tone and accent in the languages.

dialogue in beautiful, fluent, poetic language," for example, as the director insisted later. "But when they began playing, Quinn found that he couldn't adjust to Yoko's rhythm without using pidgin English. I should have recast, or at least determined to dub."

Quinn's performance was his business, and sometimes the camera-work too. Later, referring to "terrible problems" with the star, Ray said that he'd had to compromise and allow Quinn to step in as a kind of co-director—much as he had, to better results, with James Dean. "On one or two occasions I even had to shoot scenes in two different ways," recalled Ray, "as Quinn saw it and as I wanted it."

Whether fueled by drink, drugs, or gritty resolve, Ray's physical stamina won over the cast and crew—and finally, grudgingly, Quinn himself. As an Eskimo stood nearby, Winchester at the ready, Ray captured footage of bears as they emerged from hibernation. The director was "ready to work twenty-four hours a day," remembered cinematographer Tonti, and exulted in the extreme conditions. A Canadian journalist visiting the location reported that he was impressed to see Hollywood folks roughing it as if they were natives. "The cameramen are constantly on the move," he wrote in his chronicle, "disregarding wind and cold. Once during a minor blizzard they took shelter behind a canvas windbreak, but only until Mr. Ray decided it was a good opportunity to catch a storm scene. Then they shot film."

The director stayed up all night, making notes and sketching shots. By day he raced ahead of the camera crew across sheets of ice. "The landscape, truth to tell," recalled Tonti, "looked much the same all over, but the director went on rambling imperturbably around, as though strolling through summer meadows. . . . He used to stride around on the ice as though he'd done it all his life."

One day, as he marched around, Ray suddenly dropped from sight. Everyone thought he'd fallen through the ice. The cameraman rushed forward, calling out his name. "I found him," Tonti remembered, "kneeling on the ground. He had one hand held to his brow, staring intently off into the infinite. Thinking he was praying, I was going to withdraw, but my modest shadow made him turn around. He looked at me with an air of inspiration. 'I want the camera always to be this high!' he decreed, getting up and casting a shadow twice the length of mine. I remained puzzled. 'The important thing is to get out of here alive,' I stammered. And we went on."

Early on, Ray's young wife came along for the adventure. Eventually,

though, she was sent ahead to London, and for good reason: The third Mrs. Ray was pregnant with the couple's first child. The director gave Hedda Hopper the exclusive on the story, sending her a telegram from the northern clime. A month later, Betty Utey rejoined her husband and the crew in London for soundstage scenes at Pinewood Studios.

Yet the director was still Joe Btfsplk, trailed too often by a little cloud of bad luck. Disaster struck *The Savage Innocents* when a Beechcraft airplane leaving the Canadian location belly-dived into an ice heap during takeoff; no one was killed, but much of Ray's hard-won documentary footage was destroyed. In London, Ray had to scramble to rent circus animals and conjure up seal fights, blinding snowstorms, and plausible igloos and icy terrain inside studio soundstages. Special effects matte shots would complete the half-real, half-fake Arctic.

The script had originally included a third act set in the courtroom, just like Reusch's novel. But time and budget forced Ray to sacrifice those scenes in London. In interviews at the time, the director professed high spirits over the many challenges. "I suppose I should be tired," Ray told the *Times* of London, "but I don't feel at all tired. I always find working hard on a film which interests me has a tonic effect. Since we started location shooting, I've lost two stone and seldom felt better."

After the London interiors he was off to Rome, where postproduction would take most of his time until the end of the year. There Ray would have inevitable disagreements with Maleno Malenotti, however. The Italian producer felt that the film belonged to him, financially and otherwise; behind Ray's back he ordered recutting and the dubbing of Peter O'Toole's English voice with an Italian actor's—a particularly bitter pill for the director, as Ray had bonded with O'Toole during the filming in London. (Together they had gone to see Laurence Olivier's *Coriolanus* at Stratford-on-Avon.) O'Toole took it badly; unhappy with the whole business, he insisted on removing his name from the English prints.

The Italian market, where the film was called *Ombre bianche* (literally, "White Shadows"), took precedence over all others. As Ray later bitterly told *Sight and Sound,* "The score had an Italian flavor; the jokes were a bit broader than they need be, to meet the Italian sense of humor; there was rather more emphasis on blood and slaughter in the cutting." Malenotti struck the final blow, in Italy, giving Baccio Bandini equal billing as "co-director."

After filming was completed in London, nearly a year would pass before *The Savage Innocents* was unveiled to audiences. In June 1960, the Eskimo film competed unsuccessfully for the Golden Palm at the Cannes Film Festival, once again sharply dividing general attendees and the sophisticated critics who awaited the latest film from Nicholas Ray.

Even admirers had to concede that *The Savage Innocents* was stubbornly peculiar—an acquired taste, like the blubber devoured by the Eskimos in the picture. Quinn's central performance was dubious, and in any case the director had sublimated the human drama to the spectacularly harsh vistas and wilderness imagery—some of it real, some of it not. Ray's Disney *True-Life Adventures*–style narration encouraged unflattering comparisons to Robert Flaherty.

Never widely released in the United States, *The Savage Innocents* would not be shown in New York until one year after its screening at Cannes, and only then in "badly cut form as a neighborhood theatre second feature," in the words of Eugene Archer, the *New York Times*'s second-string critic. Yet Archer liked the film, hailing Ray's "highly individualistic preoccupation with moral tensions," and praising the filmmaker's visual style, "emphasizing violent eruptive motion rather than smoother, more graceful techniques." Archer apprised viewers that the director had concealed "symbolic meanings beneath the bewildering surface level of his plot."

Archer was uniquely positioned to view the latest Ray film sympathetically. Fluent in French, he'd studied film at the Sorbonne; he was friendly with Truffaut and Godard and shared the general *Cahiers du Cinema* reverence for Ray. (Godard again listed *The Savage Innocents* among his top ten films of the year.) Along with Andrew Sarris, who had just started writing regularly for the *Village Voice,* and Peter Bogdanovich, just beginning to line up films and write program notes for the New Yorker Theater, Archer represented the first real stirrings of American auteurism.

In favoring symbolism over plot, Archer wrote, Ray had "simultaneously sacrificed his chances for popular acceptance and allied himself with such difficult and controversial European filmmakers" as Michelangelo Antonioni in Italy and Godard in France. Just as *The Savage Innocents* split Cannes sophisticates into camps, Ray's film would divide its prospective audience in the United States, Archer predicted. "His strange, disturbing drama will leave most of its viewers dissatisfied and some outraged," Archer wrote.

Most people would never have the chance to see the Eskimo drama, however, to be dissatisfied or outraged by Ray's film. Even today, *The Savage Innocents* is probably the director's least-seen film in the United States, unavailable at this writing on videotape or DVD (though parts can be viewed on YouTube). In Europe, where it's more readily available, it is regarded by Ray enthusiasts as probably his last pure film, the defining testament to his questing artistry, a film in which he succeeded in bending a stubborn cast, a ticklish script, and harsh external elements to his glorious vision, rebounding from banishment to thumb his nose at Hollywood, triumphing over daunting obstacles to create a sublimely personal work.

\*

The director did not spend all of the latter half of 1959 in the editing room, or even in Rome.

Avoiding Hollywood, where he was not very employable, Ray traveled widely, floating ideas and flirting with producers hoping to mount various projects with him in France, Switzerland, and Israel. Encouraged by his young wife, he talked about directing "simple," noncommercial stories, nothing as searching or grueling as *The Savage Innocents*. They shared the bliss of her pregnancy and took long motoring trips through Italy.

In Rome one day, Ray met with a one-of-a-kind producer named Samuel Bronston. Born in Bessarabia (then part of Russia, today Moldova) three years before Ray, in 1908, Bronston was Jewish by birth, Napoleonic in height. Not a creative producer per se, he was more of an extraordinary salesman, a man of monumental ideas who could make pitches to backers in any number of languages. Soft-spoken but feisty, always elegantly dressed, Bronston was a gentleman who sometimes seemed to adhere to an extinct code of chivalry. Ray liked him—not always an auspicious sign in his career. Liking people was one of his Achilles' heels.

Though his track record was hardly dazzling, Bronston also harbored Napoleonic ambitions. He was launching a series of big-budget international coproductions, historical spectacles to be filmed under less-than-ideal conditions in Spain, and he needed a director who could handle the scope and logistical pressures of a bona fide epic. (An epic, as Mildred the hatcheck girl explains in *In a Lonely Place,* is "a picture that's real long and has lots of things going on.")

Bronston was cobbling together a colossal bankroll from investors

around the world, including Pierre du Pont, the American heir to the multinational chemical company. Bronston's superspectacles would all be shot in Spain, because most of Bronston's investors—individuals, banks, and other companies—had funds in Spanish banks that had been restricted by the country's fascist dictator, Francisco Franco, limiting the money to local Spanish use. Cheap nonunion crews and extras would lower the costs of production.

Bronston's superspectacles, dotted with internationally recognized marquee names, were intended for the widest possible audience. The producer had worked hard to endear himself to the Vatican, to Spanish Catholics, and to the Franco regime, pledging to make historical, religious, and patriotic sagas "for families, for everyone to see." (The Vatican newspaper *L'osservatore romano* described Bronston as the screen producer whose intentions and principles were "nearest to our point of view.")

Thus far, Bronston had managed to produce only one of these superspectacles, and *John Paul Jones,* released earlier in 1959, wasn't quite the launching pad he had envisioned. The American military saga, starring Robert Stack, had bombed at the box office. Bronston had lined up the film's Australian-born director, John Farrow, for another superspectacle, his second, but that faltered when the pressures of epic-making sent Farrow's health into a tailspin from which he never recovered. (Farrow died in 1963 without making another film.)

Farrow's dream project had been to shoot a film about the life of Jesus Christ. Bronston had underwritten several script drafts on the subject, all thus far unsatisfactory. "Son of Man" was the tentative title of the dream project. Would Ray like to direct a film about the life of Christ?

A subject neither personal nor small, in most ways an epic life of Christ was the complete opposite of everything Ray had been saying he'd rather do. In his *New York Times* review of *The Savage Innocents,* Eugene Archer had construed the Eskimo film as Ray's brave artistic rejection of commercial moviemaking. Now, here was Samuel Bronston, talking about reaching a worldwide audience with a lavishly budgeted, seventy-millimeter, road-show-length adaptation of the New Testament.

At best, moreover, Ray's association with religion had always been arm's length. He hadn't been a churchgoer since his Wisconsin childhood. True, *Bigger Than Life* had pivoted on a Bible lesson, and Betty Utey had brought the director back to his mother's religion for their wedding (his first two were civil ceremonies). And Bronston kept talking about portray-

ing the historical Jesus, satisfying all faiths (and ticket buyers). That was tempting. So was the money.

Over the course of several meetings with Bronston, Ray got down to brass tacks. Could he also write the script? Bronston was skeptical. Would Ray even have the time, much less the inclination, to wear two hats on such a massive operation? Ray wondered then if he might protect himself, fulfill a career dream, and add to his paycheck by serving as coproducer of the life-of-Christ epic. Bronston didn't want to encourage that ambition either.

Bronston himself had little patience for the details of producing. He had a staff of highly qualified people to handle the day-to-day issues. It was true that the life of Christ needed a new script as well as a hands-on producer. But Bronston wanted to hire Ray only as the director. Down the road, if their partnership worked out, Bronston promised, Ray could write and produce other Bronston superspectacles. Right now, though, Ray could help Bronston find the right writer and producer to join in a collaboration with them, someone who would be a boon to both of them.

Ray knew the right man, a writer who was also a producer: Philip Yordan, who had salvaged *Johnny Guitar,* the Joan Crawford Western. Bronston knew Yordan's reputation as a Hollywood insider who knew all the other insiders, a consummate writer and businessman, the ultimate problem solver. That was just the kind of man he needed in his operation.

By late November, Ray and Bronston were down to contract clauses. The director stalled until he was offered $3,125 weekly for twenty-four weeks: six months of preproduction and filming for a total of $75,000. That was the same money he had made in the past, and for more weeks of work, but Bronston also tempted Ray with promises of bonuses and profit points and a long-term future of other projects stretching ahead. When the producer threw in a new car and a mink coat for Utey, Ray finally signed on.

Apart from his usual desperate desire for cash, Ray had new household responsibilities. On January 10, 1960, soon after he agreed to film the life of Jesus, Betty Utey gave birth to their first daughter, Julie Christina, in a Rome hospital. The director's old friend actress Jane Russell, in Italy for nightclub dates, visited Rome with her husband to help Ray celebrate his new fatherhood. Soon after, Ray and Bronston flew to Madrid to meet up with Yordan.

# The Martyrlogue

## 1960–1963

Madrid was the production headquarters of Samuel Bronston's budding empire. The sets for his life-of-Christ epic were already under construction at Estudios Chamartín, north of the city center, and Sevilla Studios in the same vicinity, where Bronston was also leasing space. Reached in New York, Philip Yordan said that filming the life of Christ didn't much interest him, but Ray pleaded with Yordan to join them in Madrid, if only for a weekend. Bronston offered him first-class airplane tickets and accommodations at a deluxe hotel. When Bronston and Ray met him on the runway and whisked him through the airport—bypassing Spanish customs officials—Yordan realized that Bronston must have extraordinary influence with the Franco government.

Yordan liked Bronston instantly, but as a producer—judging by his list of credits, which included *John Paul Jones,* an obscure Jack London biopic from the 1940s, and several documentaries produced for the Vatican—well, he "knew shit about movies."

But Bronston knew he knew shit. That's why he needed a smooth operator like Yordan, who understood the creative side but also the dollars and cents of moviemaking.

Bronston presented Yordan with a stack of rejected "Son of Man" scripts, including a draft by John Farrow that had been rewritten by Alan

Brown, a Bronston associate, and revisions of same by the veteran MGM scenarist Sonya Levien. Yordan sat in a suite at the Castellana Hilton, where Bronston maintained an open account, dully turning the pages of the latest version. "The script consisted of two hundred pages of excerpts from the New Testament," remembered Yordan. "No continuity. No characterizations. No dialogue or description other than direct lifting of passages from the biblical text."

Bronston and Ray took Yordan on a "depressing" tour of Estudios Chamartín, grandly revealing the sets in progress, which the writer privately scoffed at as "so small only several actors could play on each set—like a high school drama." Over dinner, Yordan told Bronston and Ray that the working script was worthless; he'd have to start over on a blank page. He advised Bronston to stop, dismantle all sets, and furlough any personnel ensconced at the Hilton. "My every command was obeyed without question," Yordan recalled wonderingly, though Bronston was desperate and "Nick's acquiescence was no surprise."

Yordan signed his contract less than a week after Ray, accepting the same $75,000 salary for only twelve weeks of work. (MCA coordinated the deal.) Aware that Bronston was flirting with bankruptcy after *John Paul Jones*, Yordan demanded two weeks' pay in advance and insisted on being allowed to write the script on his own in California.

All agreed they needed a fresh title for the life-of-Christ epic. Yordan, who prided himself on snappy titles, began earning his salary with his idea: *King of Kings*, which was actually a title Cecil DeMille had used for his silent-era life of Christ back in 1927. Ray, who wasn't always fortunate with titles, beamed to hear the suggestion. "The title was magic," boasted Yordan. "Probably the greatest single title in the history of the cinema." After finding out that DeMille had never bothered to renew his registration of the title with the Motion Picture Association of America, Yordan bought a four-cent postage stamp and registered *King of Kings* on behalf of the Bronston organization. DeMille's estate filed suit (he had died in 1959), but Yordan, a lawyer, prevailed.

✳

While Ray returned to Rome, Yordan hied to Hollywood to write *King of Kings*.

When Philip Yordan was involved, who actually did the writing was

murky as ever. Yordan rarely if ever worked alone, preferring to employ ghostwriters (often, these days, blacklisted screenwriters) who were paid to take down his stream of ideas and organize them on paper as coherent narrative.

Ray and Yordan agreed that the script couldn't be sermon-like, and that the drama needed a through-line, giving the audience other characters—besides the Son of God—to relate to. The two shared a passion for research, and Yordan stocked his shelves with all sorts of history books and reference aids. According to Yordan, he launched into a frenetic skim of the scholarship, searching for a character whose story might run parallel to that of Jesus's, and discovered the solution "in a passage by some obscure British historian in the eighteenth century" that presented Barabbas as a revolutionary who saw the savior as someone like himself, a rebel helping to destroy the Romans and free the Jews of Caesar's tyranny.

Jesus as a rebel: Ray liked that. Barabbas the revolutionary would become one of the principal through-line characters in Yordan's script. When Christ preaches nonviolence, the disaffected Barabbas launches a violent uprising; his arrest brings him in front of the Passover crowds in Jerusalem at the same time as Jesus. When asked by Pontius Pilate to choose which of them should be freed, the multitude picks Barabbas.

As Yordan (and/or his surrogates) wrote, Ray divided his time between his office in Rome, decorated with photographs of James Dean, and appointments in Paris and London, where he met with possible cast, crew, and religious experts. In early February, Ray wrote to Bronston that "For the first time since I completed the script of *Savage Innocents* I feel like writing again." By then, however, most of the Jesus script had been finished in Hollywood, beyond his reach. Yet Ray and Yordan kept in close touch, and Yordan, under the gun to finish, welcomed the director's contributions. Ray liaised with the experts to hone the accuracy of key sequences.

Ray's penchant for authenticity never met a greater test. How should Christ be baptized? Forehead only, or full immersion? Did ancient Jews wear skullcaps? Was the traitor Judas wholly evil, or could he have been sincere but misguided, as Ray was inclined to believe of turncoats?

Jesus—especially his trial and crucifixion—had to be depicted in a way that would not offend Jews, Catholics, or any Christian denomination, much less censorship groups or critics. That was crucial to Bronston's entire sales approach. In London, Ray called on the Reverend George D. Kilpatrick, an Oxford professor who was a foremost authority on the relations between

Judaism and early Christianity, the historical Jesus and his disciples, and the known facts and context of Jesus's era. Kilpatrick was hired as a consultant, serving much the same purpose on *King of Kings* as the many juvenile delinquency experts who had vetted *Rebel Without a Cause*.

In Rome, Ray forged a relationship with the equally useful Diego Fabbri, one of Italy's preeminent playwrights (his plays were regarded as profound examinations of Catholic dilemmas) and screenwriters (he collaborated frequently with Roberto Rossellini and served on the Cannes Film Festival jury in 1960). Though a leftist, Fabbri had worked closely for many years with the Catholic Film Center, Italy's version of the Legion of Decency, on liberalizing the church's attitude toward motion pictures. Fabbri could anticipate doctrinal issues in the script and work to secure the blessing of the Holy See.

As grueling as it had been to film in the Libyan desert, the Florida Everglades, and the Canadian wilds, *King of Kings* was an undertaking on a far more massive scale, calling as never before upon Ray's ability to absorb a crushing workload and juggle and delegate endless tasks. Although Bronston had a large, capable staff ready to assist him, Ray was being put in charge of an enormous chain-reaction machine. And time was money: Bronston wanted Ray to start the filming by April.

As Ray and Yordan doubled up on the script, the producer flitted around Europe and America, trying to raise the five or six million dollars he needed for filming. After Yordan coughed up his first draft, Ray and Bronston flew to Hollywood, where MGM had always been interested in the life-of-Jesus project. Yordan accompanied them to a meeting with Sol C. Siegel, MGM's head of production, and Joseph R. Vogel, East Coast president of MGM's parent company, Loews Inc.

Siegel had taken the reins at MGM after Dore Schary when *Party Girl* was already underway with Ray directing. Although that film had cost and paid out pretty much as expected, Siegel was "worried" about Ray taking charge of a biblical epic like *King of Kings,* according to Yordan. He also took a "dim view" of Bronston. But Siegel and Yordan were old friends who trusted each other from Siegel's days as an independent producer at 20th Century-Fox, when they worked together on films like *House of Strangers* and *Broken Lance*. (Siegel had protected Yordan's original-story credit for *House of Strangers,* then recycled the same story into a Western that was made as *Broken Lance,* garnering Yordan his only Academy Award—Best

Original Story for *Broken Lance,* a picture for which he hadn't written a word.)

Bronston let Ray and Yordan do most of the talking. Ray outlined his vision for the film, his intention to aim for a historical truthfulness never before achieved in telling the life of Christ, and to cast actors as youthful as the characters they were playing. Still best known as the director of *Rebel Without a Cause,* Ray hammered his points home with his fresh research: Salome had been a mere teenager, he informed the MGM brass; John the apostle was also underage. Many of Jesus's most fervent disciples had been young rebels in their twenties or early thirties.

Yordan talked through the nuts and bolts of his script, still a labor in progress. Siegel praised Yordan's first draft and said that Barabbas served a good purpose as a continuing character and the other elements of the story seemed to be falling into place, but the studio might have criticisms and suggestions after the final script was ready.

When the discussion turned to financing and terms, Vogel took over. Loews was willing to offer Bronston a $5.5 million pickup, which meant "no money in advance but when the completed film is delivered the money would be paid," in Yordan's words. The contract between MGM and Bronston would not even be signed until the cameras rolled on the first day of photography. And the studio insisted on controlling the final cut. But the money was the important thing, and Bronston was delighted about the offer, knowing that he could borrow the necessary operating capital from different banks based on the MGM guarantee.

Finally, because of studio concerns about Bronston and Ray, neither of whom inspired much confidence, according to Yordan, "it was stipulated that I was to supervise the production in Madrid until delivery." Bronston agreed without missing a beat. As with *Johnny Guitar,* Yordan had smoothly engineered a role for himself as producer as well as writer of the project. He was amazed at how grateful Bronston and Ray appeared—how relieved, almost. Later, back at the hotel where they were all staying, Bronston and Yordan talked it over. Obviously his old contract had to be torn up in favor of a new one. Bronston offered Yordan $400,000 for writing and producing *King of Kings,* "plus an unlimited expense account," in Yordan's words. "Everything with Bronston was always 'unlimited.'"

Within days, Yordan had vacated his Hollywood premises and moved to Paris, finding a new place to live in his favorite European city. Ray and

396 <em>Nicholas Ray</em>

Bronston shot back to Italy, where the director gathered up his family and relocated them to a Madrid villa. Yordan hurried from Paris to Madrid, where he took a long-term suite at the Castellana Hilton. Work on the final script would have to compete with the countdown to readiness for the first day of filming.

Bronston lingered in Rome for a "private audience" with Pope John XXIII, according to *Variety,* sliding the final piece of his master plan into place. The page-one story in the show business weekly, headlined "Pope Direct OK Simplifies 'Kings' Coin Problems," broke the news that "the Phil Yordan–Diego Fabri [*sic*] screenplay was read and accepted by highest New Testament authorities. The Pope blessed the production and urged Catholic support" for *King of Kings.*\* No less important than MGM's backing, the Vatican endorsement "eliminated ministerial obstacles to clearance of import licenses for a reported $4,000,000 of U.S. agricultural machinery and manufactured equipment 'blocked funds'" for Bronston to spend in Spain.

<p style="text-align:center">✳</p>

In Madrid, preproduction shifted into high gear. A babel of languages was spoken at the daily project meetings, but these days Ray felt more at home in Europe than in Hollywood, and his meager Spanish was enough to get by. When Philip Yordan arrived, he and the writer-producer settled into a comfortable working rhythm. They had friendship and a mutual respect. Ray brimmed with energy and optimism, exulting in the obstacles and hurdles ahead. The walls of the villa where he lived with his family were covered with sketches of sets and costumes; books about Jesus crowded the shelves of his home and office.

"If you sit down to a big dinner," Robert Mitchum advises Susan Hayward in *The Lusty Men,* "just loosen your belt." It was a matter of pride for Bronston to pay out huge sums of money for everything, and *King of Kings* was looking to be a very big dinner indeed. The creditors were usually close behind the producer, however. No one kept accurate track of the fluid ex-

---

\*   Yordan was the only scriptwriter who would see his name up on the screen as writer of *King of Kings*—except in Italy, where Diego Fabbri, the consummate writer of religious drama, was included.

change rate—the dollars converted into pesetas—or of the accounting, which overlapped several different Bronston productions. "There was an endless chain paying off old bills," recalled Yordan. "Over a hundred thousand to TWA airlines. Over two hundred thousand to the Madrid Hilton Hotel. Over half a million to unpaid debts incurred on *John Paul Jones* . . . countless obligations to private lenders."

The result was a budget, originally estimated at $4.5 million, that rose daily with the sun. Bronston ordered costumes with real silk, rather than imitation, and twenty-four-carat gold leaf to adorn the legs of chairs in minor scenes. But he also took curious austerity measures, balking at paying for "a cast of star name actors," Yordan recalled. Bronston, who'd hired the dependable but low-cost Robert Stack to carry his first super-spectacle, still had learning curve when it came to big-name stars.

Ray and Yordan had to scrounge for their stars for *King of Kings* and for the money to pay them. They decided that one marquee attraction might serve as "a Judas goat" (Yordan's words) to lure others to the slaughter. Ray fixated on Richard Burton to play Lucius, a centurion who was another of their key characters threading through the life of Christ. Yordan knew the Welshman from *The Bramble Bush,* the last film he'd written, and of course Ray remembered him fondly from *Bitter Victory*.

Ray and Yordan put full effort into courting Burton, promising to build up his part, give him top billing and limit his involvement to a ten-week schedule. Burton was interested, but it came down to money. Burton's agent wanted $200,000, about as much as Bronston had set aside for the entire billed cast. Yordan angrily wrote Burton off.

Ray was disappointed—Burton was another soul mate with whom he would never be reunited—but Yordan decided the Welshman was only a "semi-name" anyway. He started over with Robert Ryan, a longtime friend of his and Ray's, who agreed to $50,000, less than his customary fee, to play John the Baptist. Though Ryan was likewise a semi-name, the well-regarded actor instantly gave *King of Kings* "respectability," in Yordan's view.

Yordan later boasted that he spent all of one day at MCA's offices in New York collecting the rest of the supporting cast at a bargain group rate. "Spain" and "Jesus" were the magic words. Instead of Burton as Lucius, he dickered for the Australian-born Ron Randell, a onetime Bulldog Drummond in Hollywood B pictures: Asking price: $10,000. For his Herod, the lesser-known Australian Frank Thring, Yordan paid even less.

Hurd Hatfield, the titular star of *The Picture of Dorian Gray,* agreed to play Pontius Pilate for $13,000. Viveca Lindfors, whom Ray had directed in *Run for Cover,* would portray Pilate's wife for $10,000. Actors Studio alumnus Rita Gam as Herod's wife came aboard for $8,000. The Irish actress and Abbey Players luminary Siobhan McKenna agreed to play Mary, the mother of Jesus, for $15,000. The Spanish actress Carmen Sevilla, also paid $15,000, would portray Mary Magdalene. Two Actors Studio up-and-comers, Rip Torn (who'd been directed on Broadway by Elia Kazan) and Harry Guardino (he'd be Tony-nominated for his role in *One More River,* which had just closed) were signed for the vital jobs of Judas Iscariot and Barabbas respectively for $1,000 per week.

The only role that really mattered, of course, was Jesus. Ray was determined to cast the perfect Jesus, and he and Yordan had their only real casting dispute over the part. Ray considered unknown stage actors from London and better-known thespians like Max von Sydow, already famous in Europe from Ingmar Bergman films; when Yordan stumbled into *Molokai, la isla maldita* in a Madrid movie house, he was moved by the lead performance of Javier Escrivá, a Spaniard making his first appearance on the screen as Father Damien, the leper priest.

The man who played Jesus had to be "the greatest actor alive, or an unknown," Ray told journalists, and Yordan felt that Escrivá was that great unknown. Yordan leaked Escrivá's name to *Variety,* but Ray had to be convinced even to give the Spaniard a screen test. Yordan felt the test was "magnificent." Ray did not. Escrivá knew only Spanish, and his English would have to be fluent for scenes like the Sermon on the Mount, which Ray envisioned as one of the high points of *King of Kings.* Ray foresaw dubbing others in the international cast, and he didn't want to have to dub Jesus.

Bronston was torn by the decision, recalled Yordan. The top boss was "terribly impressed by this obscure Spanish actor's performance but nervous over Nick's apprehension." Bronston and Yordan ultimately deferred to Ray, though the director's final decision in early April was neither an unknown nor the greatest actor alive: Jeffrey Hunter from *The True Story of Jesse James.* Yordan professed skepticism, but Ray liked Hunter personally and thought he had the acting chops to play Jesus. Ray didn't even bother testing Hunter, saying he recalled "the quality of genuine gentleness in his conduct with people" from his earlier filming experience with him.

Hunter had been threatening to become a major star for a decade. A

graduate of Northwestern University, the intelligent, thoughtful Hunter lived "a quiet and peaceful life," Bronston proclaimed after investigating him. The film's Jesus had no skeletons in his closet. MGM approved of his casting. And, above all, Hunter had the look: He was the right age for Jesus, thirty-three, and strikingly handsome, with pale blue eyes and a Christlike serenity. (Indeed, Hunter bore a distinct resemblance to Ray himself as a younger man.)

Whatever else they got wrong, Ray kept telling Yordan, they had to get Jesus right. At first, Ray had seen the life-of-Christ project as merely a well-paying job. Like Robert Ryan in *On Dangerous Ground,* Ray had squirreled his Bible away; he didn't necessarily believe in the divinity of Jesus. But the man and the myth grew on Ray, working on his imagination. The director decided that he truly admired Jesus as a genuine rebel, and the film would treat him like one, with the savior's "flaming red garments and rebellious stances," as critic Jonathan Rosenbaum wrote some years later, taking viewers "right back to James Dean in his zipper jacket."

<p style="text-align:center">✳</p>

Just before filming was set to start, the press began reporting on a renewed relationship between Ray's son Tony and actress Gloria Grahame, Ray's second wife. As a young teenager, Tony had helped to precipitate his father's divorce after Ray discovered him in bed with Grahame. Now twenty-three years old, tall and striking like his father, Tony had appeared without credit as Bob Younger in *The True Story of Jesse James* and had a small billed role in an Anthony Mann film the same year; he also had understudied for a William Inge play on Broadway. But Tony's thespian career had sputtered, and these days, according to New York columnists, he and Grahame were taking classes together at the Actors Studio. Though Tony denied rumors of any romance between them, the subject was painful and humiliating to Ray, who knew better. Everyone tiptoed around the news in his presence.

The painful rumors made it all the more essential that Ray's new family succeed. Ray had bounced back from the overindulgences of his Manon period; these days he stemmed his drinking until after dark. He showed little interest in other women and always seemed energized and happier with Betty Utey by his side. Though "every place he lived seemed

like a hotel suite, never a home," recalled Gavin Lambert, who visited him
and his family in Madrid, the director seemed "more settled, more at peace
with himself" in his luxury villa in La Florida, a section of Madrid on the
outskirts of the city and reachable only by taxi or car—the kind of place you
might find in the Los Angeles hills, with a beautiful lawn flecked with trees.

The couple doted on their infant daughter, and everyone felt that
the third Mrs. Ray exerted an enormously positive influence on her hus-
band. Utey was not shy about proffering forceful opinions and advice,
and her behind-the-scenes role would grow over time. As with Jean Evans
and Gloria Grahame, there was a professional component to Ray's third
marriage; the director went to bat for Betty, a trained dancer, and got
her the job of choreographing Salome's sinuous dance for King Herod.
Though Utey would not receive screen credit, the married-director-and-
choreographer angle made for good publicity.

One of the dark jokes of *Sunset Boulevard* is the prospect of the wrin-
kled old silent star, Gloria Swanson, planning her comeback as a teenage
Salome. For his Salome, Ray made a more age-appropriate choice: sixteen-
year-old, dark-haired Brigid Bazlen, a Wisconsin native known mainly for
her gig in Chicago as a fairy who flew across the stage on a wire at the
beginning of a weekly children's television show.*

Imagining Salome as "a rebellious teenager," Utey applied her modern-
dance techniques to Bazlen's hyperkinetic solo in the film, hoping the wild
wiggling and hip-tossing might disguise the fact that Bazlen was really "a
little girl who could not dance," in Utey's words. (Ray's solemn direction
made it even more bizarre, like the Gypsy dances in *Hot Blood*.) Filmed at
Sevilla Studios, like many of the interiors, Salome's dance received almost
as much press coverage as the Sermon on the Mount or the Crucifixion.

※

Unlike other directors, Ray never managed to collect much of a "filmmaking
family" to follow him from job to job. In the Bronston company Ray counted

---

* Excited about Bazlen, MGM put the attractive young actress under contract.
She played Steve McQueen's girlfriend in *The Honeymoon Machine,* filmed after
*King of Kings* but released before the life of Jesus in the same year, 1961. Bazlen
starred in one more important MGM film, *How the West Was Won,* before her
career tapered off. She died from cancer in 1989 at age forty-four.

only a handful of friends or supporters among his personal circle of trust, including the French editor of *King of Kings,* Renée Lichtig, whom Ray had gotten to know and trust during his *Bitter Victory* ordeal, and his nephew Sumner Williams, who was serving as one of several second-unit directors.

Ray did manage to line up the Hollywood cinematographer he wanted: Franz Planer, who had experience in Spain filming *The Pride and the Passion.* Planer, in turn, brought on Manuel Berenguer, a Spanish veteran who'd been his operator on the earlier film, to handle the European camera crew. MGM wanted its very best composer, and Miklós Rózsa, a specialist in historical spectacles who'd just won the Oscar for *Ben-Hur,* would compose some of the music in Madrid; in the spirit of truth-seeking, Rózsa visited several other "European ecclesiastical centers to find authentic musical themes for the score," according to MGM publicity.

Top studio officials were on hand for the late-April start date, with Sol Siegel and Joseph Vogel flying in from New York to watch Ray stage a spectacular scene that encouraged MGM to sign the official papers. The scene showed Pompey leading hundreds of legionaries into the temple of Jerusalem, where they massacre the Jewish defenders and rabbis, setting up the Roman conquest of Judaea before Christ's birth. After that first day of filming, the money started to flow—although months later Ray would reshoot the entire scene, this time with upgraded sets and costumes.

Never mind that, too often, the money ebbed. Bronston sometimes vanished for days while people waited for their paychecks. The trickle turned gusher in surprising ways. "One day he showed up on the set with an enormous carpetbag full of exotic currencies—pfennigs, pesetas, francs, lira and a variety of others," recalled Robert Stack, the star of *John Paul Jones,* "announcing that the currency represented my week's salary."

The financial shortfalls and chicanery were almost a joke. But the logistics of the production—the constantly revolving cast, everyone speaking different languages; the huge crowd scenes, requiring thousands of extras; the intricate scheduling and rescheduling of scenes—were more a nightmare. Early scenes were planned meticulously and came off well enough, but as the script and preparation dragged, the schedule began to unravel and the budget to soar.

Though in many ways they were running a race in which they were joined at the hip, Ray and Yordan soon found themselves in a power struggle, aggravated by time and economic pressures and, as usual with Ray, eleventh-hour disagreements over the script. Since taking charge as pro-

ducer, Yordan had been preoccupied with money and casting and prepro-
duction decisions. The script that he (and, possibly, his team) had written
in Hollywood had been neglected. Subsequent drafts had been written
mainly to satisfy MGM demands—often deletions to save on length and
costs. There was never a true "final script" before filming began.

Ray found inadequacies in the best scripts, and even under prime
conditions he was inclined to rework the pages of key scenes up until the
moment of filming. Yordan had a lot on his mind, and he wasn't a polisher.
But he didn't enjoy pounding the typewriter every night, then consulting
with Ray about the new pages every morning—only to find, while watch-
ing dailies, that the director had continued to weave his own ideas into the
scenes even on the set.

"Yordan and his people are reporting back to Bronston on every move
I make," Ray boasted to Gavin Lambert, who visited the location one day
in Madrid. "But I'm sneaking in quite a few changes, and we're so over-
budget they daren't make me reshoot." Watching the director set up an
elaborate Pontius Pilate scene, Lambert noted "two widely separated
groups" standing at opposite ends of the set, staring hard at each other
"like the headquarters of opposing armies." Commanding one army was
Ray, the other Yordan, "and they communicated only through their as-
sistants by walkie-talkie."

Yordan didn't care about the camerawork; that was Ray's bailiwick.
But script disputes were another matter. It was one thing for Ray and
Yordan to have collaborated amicably on an emergency injection to Roy
Chanslor's script for *Johnny Guitar*. It was another thing for Ray to be re-
writing Yordan insistently behind his back. Ray was a fine director, and
Yordan liked him personally. But Ray was the director, not the writer, not
the producer. And this was *King of Kings,* a multimillion-dollar superspec-
tacle, not a penny-ante Western for Republic. Yordan was answerable to
Bronston and MGM. The life of Christ was only the first of a full program
of superspectacles he was planning with Bronston. If they pulled this one
off, it was only the beginning of their glorious future together.

So the stakes were high—and that very fact preserved a tense truce on
the set. For the moment, Yordan needed Ray, and vice versa. Yordan had
films of his own that he had earmarked for Ray to direct. He had plenty
of ideas for films, and the ones that didn't suit Bronston would be chan-
neled into Yordan's own independent company, Security Pictures, which

followed him wherever he roamed. Soon enough, the writer-producer announced a separate lineup of Security projects under the aegis of the Rank Organization in England. Ray could write as many scripts and direct as many films as he liked—as long as he did his job on *King of Kings*.

<div align="center">✳</div>

What ultimately brought the two men back together was MGM's meddling.

By early June, the budget for *King of Kings* had risen to an estimated $7.5 million, and a studio production manager was dispatched overseas to clamp down on costs. The MGM man calculated that thus far only 20 percent of the script had been photographed. The stately quality of the footage pleased everyone at MGM, but the pace of production was equally stately. Yordan's script revisions barely kept pace with the filming, and the lack of a bona fide shooting script made it impossible to get a reliable estimate of budget and schedule. At this rate, the production manager guessed, Ray would still be filming *King of Kings* in December.

The production manager's memo to higher-ups triggered alarm bells in Hollywood. Yordan dove back into the script, cutting and trimming, while Ray picked up speed to make up for lost time.

Later in June, another emissary from MGM arrived in Madrid. Bernard Smith, the head of the story department and the studio's senior creative executive, had been studying the footage forwarded from Spain. So far, he informed Ray and Yordan, *King of Kings* was adding up to a series of beautiful tableaux; beautiful to behold, but the story badly required more narrative drive and human drama. The audience would never identify with Christ, Smith explained, who was an invulnerable deity after all. The script cried out for a fresh character, a Romanized Jew drawn to Christ, who could move through the film and present a mortal point of view. Neither Barabbas nor the centurion Lucius would suffice. A Romanized Jew had to be inserted into the script, with his life story crisscrossing the main events of Christ's. Ray and Yordan would have to go back and interject this new character into the film, almost scene by scene.

After weeks of mutual hostility, Ray and Yordan shared an empathetic glance. Smith's idea suspiciously evoked *Ben-Hur*, another MGM road-show picture—with Charlton Heston as just such a Romanized Jew—

which had enthralled millions and dominated the season of awards the previous year.

Exasperated, Ray pointed out that Lucius the centurion had been created for that express purpose. The director had expended almost as much effort and focus on Ron Randell, who was playing the centurion, as he had on Jeffrey Hunter's Jesus. Too bad, Smith replied, because thus far Randell was "virtually deadpan, inarticulate and remote."

Yordan phoned Siegel in Hollywood to convey their unhappiness. Siegel told Yordan that his position at MGM had become untenable and that others at the studio were siding with Smith. Don't make waves, Siegel implored the writer-producer, for old times' sake. Siegel suggested that Yordan hire an English actor and then cleverly craft the character so that he could be integrated into the footage with a minimum of refilming. Siegel would consider it a personal favor.

Now Ray and Yordan were thrown into a conspiracy to mollify Smith, who lingered on location in Madrid for a month and watched the footage like a hawk once he was back in Hollywood. While Ray continued shooting, Yordan immersed himself in conferences with the MGM official, ripping out chunks of the old script and minting fresh sections revolving around the brainstormed character of David, a Roman Jew intrigued by Jesus. Yordan flew to London and returned with an all-purpose stage actor, Richard Johnson, to play the part.

The showdown with MGM clarified the relationship between Ray and Yordan. When MGM forced an unwanted character into Yordan's script, it brought the writer and director back together against a common foe. It also clarified Yordan's supremacy as producer; on vital script and production matters MGM dealt directly with Yordan, while Bronston also deferred to him.

Ray had never proved himself as a writer or producer, a weakness that had hampered his career. He often resorted to tinkering with scripts behind producers' backs, and Yordan conceded that much of his tinkering was for the good. The director was sincere when he told the press he wanted *King of Kings* to be "the greatest film of my career." The scenes were turning out as well as could be expected, and Yordan appreciated Ray's diligence, even if Yordan himself was a pragmatist with no illusion that *King of Kings* would be the greatest film of *his* career.

For the remainder of the production the script would remain as fluid and volatile as the budget. Yordan gave Ray leeway in shooting pages

that may have been hastily conceived at night. The variations in scenes were almost as hard to track as the fluctuations of cash. Throughout the filming, Ray dropped scenes that had been carefully planned and shot rewrites that hadn't been shown to MGM, improvising "questionable bits," as Smith complained in one studio memo. "No doubt some of them will never even appear in the final cut."

<center>✳</center>

But Ray's tableaux were exceedingly beautiful, pleasing the apprehensive studio executives who gathered to watch the accumulating footage in MGM screening rooms back in Hollywood.

In July, the director filmed the Sermon on the Mount with more than five thousand extras in the Chinchón hills, southeast of Madrid. In paintings and films, Jesus was usually depicted standing and lecturing in front of a vast crowd. Ray's research told him the sermon probably followed "the teaching method used in the synagogues at the time," in his words, "a dialogue comprising question and answer." To that end, he recalled, "We constructed what, according to my crew, was the longest track ever built, from the top of a hill to the bottom, with a track counterbalancing it on the opposite slope, as the cables wound round a pair of olive trees, and we followed Jesus as he moved through the crowd, answering questions as he was asked." The scene, which took several weeks to photograph and lasted eleven minutes on the screen, riveted everyone who viewed it in Hollywood.

Ray also lent his visual flair to the Last Supper, departing from the familiar Leonardo da Vinci depiction of Christ seated at the center of a long table. After vetoing a long or crucifix-shaped table as ahistorical, the director settled on "a Y-shaped grouping of small tables," in his words, "from the head of which Jesus could easily pass the bread and wine to each of his devoted followers." The unusual design and simplicity of his staging took his officials at MGM by pleasant surprise.

As the weeks passed, however, the filming, like that of *Bitter Victory, Wind Across the Everglades,* and *The Savage Innocents,* became another marathon endurance test. The company shuttled between Chamartín and Sevilla Studios, but also journeyed to other locations, including Alicante, on the Mediterranean coast, for the desert-fasting scenes, and a craggy peak above the ski-resort town of Navacerrada, for the Crucifixion. Now

and then, one of the crew or the extras keeled over from heatstroke after standing out too long in the oppressive Spanish sun. Harry Guardino, who was playing Barabbas, was injured in a car accident that killed another member of the production team. And at one point, Franz Planer fell ill and was forced to leave the job; another Hollywood cinematographer, Milton Krasner, came to Madrid, seamlessly making the join.

Though Ray had a reputation for stamina, he also had a history of physical breakdowns dating back to *The Lusty Men,* and at one point during the filming of *King of Kings* he had to be replaced for several days by Charles Walters, an MGM contract director better known for comedies and musicals. Emergencies came and went with each new day. If, as Gavin Lambert believed, the atmosphere of crisis on a Ray film was often "self-created" by the director, this time Ray had plenty of help from God and nature. Yet Ray made it to the celebration of his forty-ninth birthday on the set in August, with gifts piled high and Cava and cake for five hundred cast and crew and spouses, government officials, and Spanish nobility.

"Isn't it great?" the sunburned director exclaimed to visiting Hollywood correspondent Erskine Johnson later that same month, standing like a king on a mountaintop overlooking camera platforms, scaffolding and generators, and thousands of actors and extras. "The enthusiasm of Ray oozes out with his perspiration," wrote Johnson.

The very bigness of it all, the thousands of day extras delegated to assistant directors, seemed a contradiction for this man who had begun his career as director whispering to small ensembles of kindred souls. Ray still prided himself on forging a confidence with his principals, getting to know the lead players inside and out, agitating their essences. But there were so many actors in *King of Kings,* and by necessity some had to be abandoned to their own resources. The director wasn't the only one carrying around history books for reference, and the twelve apostles formed their own study group with a Spanish priest.

These days Ray was more likely to be found squinting through a viewfinder, huddling with a camera squad, discussing the merits of different lenses and filters. He spent much of his time with design staff, or setting up unusual shots and camera moves. The actors were artfully arranged and treated kindly, but there was less time, and perhaps need, for whispered advice.

Jeffrey Hunter would do his best for Ray, but it was hard to be the

perfect Jesus. Between Ray and MGM, his physical appearance was under
constant scrutiny. Once again, as with Gloria Grahame in *In a Lonely Place*
and Natalie Wood in *Rebel Without a Cause,* Ray prepared his actor by first
sandpapering his look—arranging for Hunter to get a nose job (replacing
his button nose with an aquiline profile) and ordering him to shave his
armpits for the Crucifixion.

Even after the look was right, the voice was wrong. Ray kept trying
to dial down Hunter's American accent, at one point sending him to the
same voice coach who'd helped Natalie Wood. Ray filmed and refilmed
the actor's sermonizing so often that Jesus developed laryngitis. Later,
after the main photography was over, the MGM executives decided that
some of Jesus's lines sounded too tough-spoken, and the star endured ex-
tensive redubbing to restore what the studio described as "the traditional,
religious quietness of Christ."

Ray had more hands-on participation in the editing room than on
most previous Hollywood films, because the MGM contract required
delivery of a complete assembly of *King of Kings.* At every stage, the pro-
duction team spliced together completed sequences in Madrid before
shipping them to Hollywood. Ray and Yordan wrangled over the edit-
ing, and Yordan brought in one of his longtime associates, editor Irving
Lerner, to second-guess Ray's cutter, Renée Lichtig. According to Bernard
Eisenschitz, it was only after viewing Lerner's more conventional version
that the director started drinking heavily again—whether because he'd re-
alized that Lerner had superseded Lichtig, or that Yordan had once again
managed to overrule him—or, perhaps, above all, that *King of Kings* was
falling short of greatness.

Sol Siegel flew in to watch Lerner's version, however, and his nonen-
dorsement convinced Yordan that Ray knew best. The buck was passed
back to Ray and Lichtig, and it was their three-and-a-half-hour rendition
of *King of Kings* that was handed over to MGM on October 11 in exchange
for a $6 million check. Bronston and Yordan desperately needed the
money to launch *El Cid,* slated for a real star this time, Charlton Heston,
and to be directed by Ray's old Federal Theatre Project friend Anthony
Mann. *El Cid* was due to go before the cameras one month later at Sevilla
Studios.

*El Cid* was about the eleventh-century hero who drove the Moors
from Spain. It was Yordan's idea that Ray and Mann could alternate the

directing of Bronston productions and Security pictures. Heston was the
man of the hour—he had just picked up the 1959 Best Actor Oscar for *Ben-
Hur*—and Bronston had finally ponied up the required bucks to purchase
a marquee name of his magnitude. Heston was in and out of Madrid, and
Ray arranged a lunch with the chiseled star, asking if he'd consider starring
in the director's next picture, for either Bronston or Yordan. Heston was
intrigued but noncommittal.

After ten nonstop months working on *King of Kings,* Ray finally went
for a medical checkup. As Hedda Hopper's column reported, he was sent
shortly thereafter to "a Swiss sanitarium for total fatigue."

<center>✳</center>

MGM viewed Ray's version of *King of Kings* as the director's obligatory
"first cut," and the studio brought in Margaret Booth, the editing wizard
who oversaw and approved the final form of every major studio release.
She would supervise staff cutter Harold F. Kress in reshaping the length
and continuity of the biblical epic. After his stay in the Swiss sanitarium,
Ray rushed to Hollywood. Busy with *El Cid,* Yordan trusted Ray to serve
as liaison with MGM. Bronston promised to pay Ray's bills even if MGM
did not.

Long fond of radio-style narrative voice-over as a storytelling device,
the director busied himself arranging the narration for the film, which
Yordan needed to fob off on another writer. The best man for the task in
Hollywood was Ray Bradbury, well-known for science fantasy but a multi-
faceted novelist and short-story writer who also dabbled in screenplays. "I
had lunch with Nicholas Ray," Bradbury recalled, "and he says, 'We're in
the last days of making the film, but we need a narration. Will you write
a narration for us?' I said, 'I certainly will, because I love the Bible.' And
he said, 'We need an ending for the film, we don't know what the ending
should be.' I said, 'Have you tried the Bible?'"

Bradbury wrote one possible ending for Ray, but it was rejected as
"too expensive," the writer recalled. Otherwise, the narration was all his.
Yordan refused to cede any credit to Bradbury, however, "because he was
jealous of my doing the narration," as Bradbury recalled. Orson Welles
agreed to lend his majestic voice to the proceedings, but then refused to
let MGM use his name on the screen unless he was paid more money, so
neither was listed on the screen.

MGM, never enthusiastic about Ray's involvement, discouraged the director from entering the editing room. The studio ordered retakes and filming of new scenes on soundstages—some of which Ray directed, some of which he knew nothing about. After about a month in Hollywood, according to Bernard Eisenschitz, he was probably "sacked" or barred from the studio. The extra filming, dubbing, scoring, and postproduction persisted for months, with Ray reduced to pleading from afar. The elusive ending he was still agonizing over in December was ultimately conjured by MGM from available footage.

In the end, the editing team of Booth and Kress obliterated Renée Lichtig's version so thoroughly that Ray's editor was credited only on the French release. By shaving subplots and trimming scenes, the road-show film was brought down to 168 minutes. One element that was deleted entirely, ironically, was Richard Johnson's character—the Romanized Jew originally shoehorned into the film at MGM's behest.

Long after its release, Ray would tell *Movie* magazine that the film had been "atrociously edited." And yet, despite these affronts, Ray remained loyal to *King of Kings*. Dating back to *The True Story of Jesse James,* this was the sixth picture in a row from which he had been discharged, left early, or was sabotaged by producers—the sixth in a row that, strictly speaking, did not represent his final vision. By Christmas the director had left Hollywood for his home in Rome, dejected, but with his smile fixed to celebrate the New Year.

❋

In early 1961, Ray's wife became pregnant again. The director moved his growing family into a house on the Appia Antica. Though happily married, the director found many reasons to stay away from home, with business and pleasure often taking him to the city center.

Since the early 1950s, the ancient city had become a mecca for U.S. film producers fleeing bloated Hollywood budgets (hence the term "runaway productions"). Italian studio space and personnel were cheap, and the exchange rate and lack of union surcharges made things cheaper still. American visitors were part of the food, glamour, and all-night bacchanalia of La Dolce Vita. "Hollywood on the Tiber," the Americans called Rome.

The budding catastrophe of *Cleopatra,* with Richard Burton seducing

Elizabeth Taylor on-camera and off-, drew most of the attention, but all or part of numerous Hollywood films were shot in Rome in 1961, including *Two Weeks in Another Town,* another MGM production, with a final script by Charles Schnee* and Ray's old friend John Houseman as its producer. After years of polite communication, Ray and Houseman now enjoyed a warm rapprochement.

Ray saw old friends and made many new ones among the English-speaking community in Italy. Yordan was trailed to Rome and Paris by the string of blacklistees who pitched in on the many scripts that were credited only to him. Yordan's reputation for hiring former Hollywood Communists was well-known, and now the Yordan-Bronston-Security operation became a mother lode for refugees living in England, France, and Italy. People even had a nickname for them in Madrid: "Los Negroes," or the Black Ones.

Safely away from America, and from the waning years of McCarthyism, Ray was thrown back into the company of onetime political compatriots. Los Negroes included Bernard Gordon, who had just come from America and was writing his first script, a schlock horror film, for Yordan; Julian Halevy, a writer friend of Gordon's from college days, now blacklisted and living in Rome; and former Hollywood scenarist Leonardo Bercovici, another blacklistee gone Italian. These and other Los Negroes were Yordan's troubleshooters. He always had "a half dozen other stories he wanted written by some of the poorly paid slaves he kept in his basement rooms" in Paris, recalled Gordon. And Yordan employed nonwriter blacklistees too, including his frequent production manager Lou Brandt.

Ray had a beach house in Sabaudia that became a warm-weather magnet for Americans in Rome, including several of Los Negroes. (Bercovici also had a summer place in the coastal town.) These days, the group talked more about film than politics; for a while Ray contemplated adapting Halevy's 1955 novel *The Young Lovers,* about a bittersweet college romance.

For the first time in a decade, in private conversations with Los Negroes, Ray defined himself as a kindred radical. That was news to Gordon, a younger New Yorker who hadn't known the director in Hollywood before the blacklist but warmed to him nowadays as a friend. Ray was not really one of Los Negroes, thought Gordon; for one thing, he was paid better and

---

* Schnee died of a heart attack at age forty-six in 1962.

worked under his own name. But they were all in the same boat, Gordon reasoned, victims of the blacklist and dubious beneficiaries of Yordan.

✳

For Ray, much of 1961 was leisurely and recuperative. The director stayed on retainer for Bronston's superspectacles, but Yordan also paid him to develop subjects for his Security Pictures. Ray spent part of the year making notes for his planned adaptation of a favorite book, British author Nicholas Monsarrat's well-known novel *The Tribe That Lost Its Head,* which involved political intrigue and violence on a jungle island off the coast of Africa.

The Monsarrat adaptation was an unlikely Bronston or Yordan project, however, and not much actual money got paid out for the activity. Script development was Ray's alone to pursue. He traced and retraced a path from Paris to London, Madrid, New York, and Hollywood, talking up *The Tribe That Lost Its Head* and other film ideas with writers and producers. Some of his projects were tied to Yordan's sponsorship; others were more or less independent, and more or less illusory, without a star or financing.

Ray set no limits on the type or range of film material that interested him. One project, for example, was about Cyrus the Great; another, the adaptation of a novel by Yael Dayan (the young daughter of Israeli military leader Moshe Dayan). The director toyed with the idea of a French Revolution epic, which intrigued both Bronston and Yordan; an adaptation of Aldous Huxley's futuristic *Brave New World;* even a film based on Rimbaud's nineteenth-century prose poem *Une Saison en Enfer.*

He dashed off a passionate fan letter to Clifford Odets, whom he had last seen at a party at Danny Kaye's house, pleading for the rights to what would turn out to be Odets's final play, *The Flowering Peach,* a comedy about Noah building the ark. One last time he hoped to collaborate with his friend, still a paragon of writers in Ray's mind. He asked for the playwright's permission to write a treatment of *The Flowering Peach,* demonstrating how it might be adapted into a film, "and [if] you like these plans well enough to either give me an option, or use the ideas and develop it yourself (and I don't understand why you haven't done so already)—any one of these things singly or in combination would be acceptable to me."

Every time Charlton Heston met with the director, it seemed, Ray was talking up a different way forward. Late in 1960 Ray claimed he would forge ahead immediately with the Nicholas Monsarrat novel, if only Heston would agree to star in the picture. In another meeting with Heston, Ray touted William McGivern's 1961 novel *The Road to the Snail,* about the building of a local road in southern Spain that led to a mountain-top villa dubbed "the Snail." (McGivern was the uncle of Brigid Bazlen, and Ray's Salome, he mentioned, was penciled in for a suitable role.)

Early in the year, Heston was preoccupied in Spain with *El Cid,* but in April he and Yordan passed through Rome as guests of honor at a lavish cocktail party for Bronston investors. Over a long lunch at Ray's house, the director made one last appeal on behalf of *The Tribe That Lost Its Head.* Ray said he and Heston might team up on two projects—*The Tribe* and then a new, tantalizing possibility, a film based on a true-history children's novel by Henry Treece about a medieval army of children marching to the Holy Land through Italy, peacefully converting Muslims en route. Heston could "act in one film [*The Tribe*] for him, then coproduce, codirect another one on the Children's Crusade," Ray explained enthusiastically. "I must look into this," Heston wrote in his journal, unconvinced that either was feasible or real.

Ray was hardly alone in pursuing Heston. The Oscar winner was arguably the most bankable actor in the world, and Bronston and Yordan wanted him to star in all of their next pictures. Bronston could raise money purely on Heston's name, which was gold at the box office. Yordan and Ray spent a lot of time together in Rome and Paris, and although Yordan was faintly encouraging about Ray's quixotic projects, their conversations inevitably swirled around the subjects that would be most appealing to Heston.

Yordan had a catchphrase—"The Fall of the Roman Empire"—and he and Ray began to brainstorm another superspectacle with that title and Ray as the director. Bronston liked the phrase enough to authorize a little money for a script and preliminary planning. The script was farmed out to one of Los Negroes, Joseph Losey's close collaborator Ben Barzman, who was living in Paris, where Yordan and Ray could easily confer with him. Barzman had written the bulk of *El Cid* (although Yordan got the credit). Heston was initially noncommittal about "The Fall of the Roman Empire," but Yordan felt increasingly confident about its allurement. He

thought that the star would eventually succumb to any good script involving the Roman Empire, with its obvious overlap with *Ben-Hur.*

\*

Regardless of how the director or broader public might have felt about them, Ray's recent, problem-plagued films had been greeted with rapturous praise by French cinephiles. The French were not monolithic: The Paris-based *Cahiers du Cinéma* group was arguably more fervent than its left-wing rival *Positif,* based in Lyons, which had published its first issue in 1952. But in general *Bitter Victory, Party Girl, The Savage Innocents,* and even *Hot Blood* and *Wind Across the Everglades* were seen in France as personal artistic triumphs over the Hollywood factory system. "To remain insensitive to the thousand beauties of Nicholas Ray's *Party Girl,*" read the famously extravagant verdict of *Cahiers*'s Fereydoun Hoveyda, "is to turn one's back resolutely on the modern cinema, to reject the cinema as an autonomous art."

Around this time, a new generation of Oxonians emerged to ratchet up the "egghead praise" of Ray, as it was dubbed in London's *Guardian.* Ray reached out to the new Oxonians, as he had to Gavin Lambert and the earliest proponents of auteurism in France. The director believed in meeting and "educating the critics" about the "dark ways of the film industry," as W. J. Weatherby wrote in the *Guardian.* Ray liked to discuss with his admirers their theories about his films, mingling his ideas with theirs and cross-fertilizing. At one point Ray even proposed "a mammoth conference at which about ten leading directors," himself included, "would show what they thought was their best film," according to Weatherby, "then would argue over it with a group of leading critics."

On one trip to London, the director accepted a speaking engagement at the Oxford Film Society, meeting one of his leading admirers among the new generation of English critics, V. F. Perkins, who exchanged "a few over-awed fan-like words" with the director, according to Perkins. Perkins's subsequent encomium in the *Oxford Opinion* compared Ray favorably with Orson Welles and Alfred Hitchcock, extolling his "quest for lucidity" in storytelling, his brilliance with actors, and his "outstandingly beautiful" use of design and camerawork. The director's methods, Perkins wrote, resulted in "the subjection of a frequently banal narrative to an idiosyncratic mise-en-scene."

Penelope Houston, editor of the older, wiser *Sight and Sound,* was one of the original Oxonians, along with Lambert, to have discovered Ray with *They Live by Night,* and she reminded readers of those credentials while taking exception to the *Oxford Opinion*'s "extreme" new brand of auteurism, which carried with it "vague hints and indications" that anyone who disputed their criteria was some kind of fuddy-duddy. Citing cult Oxonian films directed by Sam Fuller and Douglas Sirk, as well as the Cyd Charisse–Robert Taylor film of Ray's that was such a French favorite, she wrote, "A theory of criticism constructed around an appreciation of *Crimson Kimono* [Fuller] or *Party Girl* [Ray], or *Written on the Wind* [Sirk], seems to me a distinctly barren one."

Richard Roud, an American serving as the London correspondent for *Cahiers,* weighed in on Houston's side but tried to occupy a thoughtful middle ground with an essay explaining why "old fogies" preferred pictures that evince "a fusion of significant form with literary or humanistic content." Roud made light of the French adoration of *Party Girl* and the emerging *critique des beautés,* a critical approach concentrating "entirely on the beauties of a work of art rather than attempting impartially to point out both the good and the bad elements." The *critique des beautés,* Roud wrote, increasingly formed a questionable adjunct to the *politique des auteurs,* with its guiding principle of choosing "those you are for and those you are against."

This argument preoccupied important English and French film critics alike—that is, primarily *Sight and Sound, Cahiers du Cinéma,* and *Positif*—and, although it is hard to explain why exactly, Ray more than any other director found himself positioned at its center. In part this was because, earlier than most American filmmakers, Ray had taken an activist role in forming alliances with young adherents and in making appearances at film festivals and retrospectives of his films in Europe.

For the first time, during the long postproduction of *King of Kings,* Ray was a guest of honor at a major festival, screening *Rebel Without a Cause* and *The Savage Innocents* in Barcelona, Spain. In March of the same year, 1961, the director was on hand for his first *en bloc* retrospective at the Cinémathèque Française, in Paris, with cofounder Henri Langlois introducing *Bitter Victory* as a masterwork. Bronston's publicity apparatus also helped to organize a mini-retrospective of Ray's films at the National Film Theatre (NFT) in London still later in 1961, coinciding with the British

premiere of *King of Kings*. (Joseph Losey shared the program, but the pairing had nothing to do with their La Crosse connection. According to the program director, "We were planning to do a series on Losey anyway and decided to give the other half to Ray when we found out he was coming through London.") The NFT program opened with *They Live by Night,* the Ray film that had been rescued from oblivion by local critics more than a decade before.

Wherever Ray traveled, he encouraged the enthusiasm of young critics and influenced the "reading" of his films. These days Philip Yordan often accompanied him, adding his own voice to the mix. Yordan's body of work gave him an independent cachet with the French, and Yordan too hobnobbed with auteurists, giving interviews that tended to echo, complement, or augment Ray's. For example, the writer spoke at length to Bertrand Tavernier for *Cahiers du Cinéma,* explaining *Johnny Guitar* as a conscious attack on puritanism and McCarthyism. Yordan said almost nothing about Ray's contribution to the script, yet this was the first time anyone had defined the Joan Crawford Western in an anti-McCarthyist vein. No one, when *Johnny Guitar* was initially released, had written about the lynch mob as stand-ins for the House Un-American Activities Committee, or Ward Bond as a caricature of an anti-Communist vigilante, or Joan Crawford as a falsely fingered Red. Yordan's anti-McCarthyist explanation stuck, however, and is routinely cited by many contemporary critics writing about *Johnny Guitar*. "I was gullible and told what I wanted to hear," Tavernier now says decades later, although he isn't certain the film isn't an anti-McCarthyist parable anyway.

Similarly, when *In a Lonely Place* was first shown, the French described the film as an allegory treating Ray's marriage to Gloria Grahame; only later would some describe it as a political parable depicting Dix (Bogart), the wrongly accused screenwriter, as a sort of blacklist victim. Ray himself, speaking to V. F. Perkins for his new magazine *Movie* in 1961, described Dix as being "under the pressure of society," while saying nothing specific about those pressures, nothing about the blacklist. Yet, as his films were revived in the early 1960s, as Ray traveled throughout Europe and gave interviews, these dubious ideas about his films would grow and solidify.

Ray benefited from his proximity to the European auteurists, just as their reverential view of him was bolstered by the fact that he lived in Europe. They saw him as a filmmaker, like D. W. Griffith or Orson

416 <em>Nicholas Ray</em>

Welles, whose instincts were too "arty" for the Hollywood system. In their view, after all, Hollywood tried to kill many of its greatest artists. Ray, Griffith, Welles, and a few others belonged to Hollywood's long shameful "martyrlogue"—a word coined by Serge Daney, an assertive French critic who later became an editor of *Cahiers du Cinéma*.

At least one who shared that category resented the fact that Ray had risen so fast and high in the French martyrlogue. Gore Vidal savored the punch line of this anecdote, which he told often: "Orson Welles, a very funny man, once said to me, 'You know the French ruin everything. They come up to you and say, "You are one of the three great directors of the cinema." I nod, I nod. "There is D. W. Griffith. There is Orson Welles. And there is Nicholas Ray." ' He said, 'There is always that third name that crushes you.'"

In common with Welles, however, Ray saw the "egghead praise" as free publicity and salve to his wounds. Not always lucky in life or career, Ray recognized his status among auteurists as a rare stroke of good fortune. The adoration of English and French critics—now spreading to America—not only rescued the director at low points in his career, but increasingly posited a munificent view of his career that brooked no argument. Appreciation for Nicholas Ray became a cornerstone of auteurist film criticism, from which there was no backing down.

✳

Thinking highly of Ray's salesmanship, Samuel Bronston dispatched the director to premieres and events launching *King of Kings* in cities around the world. In Hollywood, Ray was all smiles at a bountiful press luncheon hosted by MGM at Perino's. Afterward he traveled with the film's Salome, Brigid Bazlen, to Tokyo, Hong Kong, Bangkok, and Manila. Everywhere he went, regardless of the fact that MGM had kept him at arm's length while crafting the film's final form, Ray fiercely defended his life of Christ against skeptical or negative reviews.

Major U.S. theaters welcomed *King of Kings* in early November 1961, well in advance of the religious holiday season that was approaching. A number of the American reviews were scornful, but the notices in Hollywood, where multimillion-dollar products of the hometown industry were generally supported on principle, were not as harsh as those in New York.

Ray had a "belligerent" reaction, in his own words, to Bosley Crowther's harsh pan in the *New York Times,* which derided *King of Kings* as an "illustrated lecture" that was "peculiarly impersonal" and sluggish and tedious besides. The director told a friendlier journalist from the *Los Angeles Mirror* that Crowther's review "was generated by areas of ill-meaning and of questionable motivation. It was not genuine film criticism."

Then Ray was asked about Moira Walsh, who had described *King of Kings,* in the Catholic national weekly *America,* as "a gigantic fraud perpetrated by the film industry on the movie going public" without "substantial religious or at least edifying qualities."

Ray pulled out a clipping from *L'osservatore romano,* the Vatican newspaper, extolling the director's courage, his careful portrait of Jesus, his commendable objectives, "even if his picture is . . . much more impressive from a point of form, than contents."

Again and again in similar interviews the director hit on a theme that had preoccupied much of his career, from *They Live by Night* through to *Rebel Without a Cause* and *The True Story of Jesse James.* "I have always been concerned with youth and their struggle for belief and understanding," the director told the press. "And I will be personally satisfied if our film can establish the fact that the story of Jesus and the men and women who were first attracted to His teachings is essentially a story about, and for, young people."

Although *King of Kings* opened with all the promotional hoopla MGM could muster, the 168-minute superspectacle was slow to attract an audience—and at first appeared to sell a disappointing number of tickets. But the Bronston organization files confirm that Ray's life of Christ steadily built a following in America and throughout the world. "The wild expectations that were dreamt up by publicity men should never have been taken too seriously," writer-producer Yordan wrote to reassure one nervous Bronston investor. "But by solid theatre men, *Kings* is a hit film. The picture will not only recoup its negative, but remain and continue its exhibition for the remainder of our life span."

In terms of dollars earned, *King of Kings* was actually more successful than *Rebel Without a Cause.* It scored higher in the annual box-office ratings, ending up in the top ten of 1962. Not only that: If the Ray cult was initially fazed by the picture, which was unlike any other the director had made—a stately biblical epic targeting all religions and audiences—many

gradually swung around. In 2002, Jonathan Rosenbaum, one of the elder statesmen of American auteurism, pointed out "potent stretches" in one of Ray's least-praised pictures. Indeed, Rosenbaum said that all of Ray's twenty completed features "could plausibly be called masterpieces of one kind or another." *King of Kings* was the nineteenth.

✳

By the time Betty Utey gave birth to their second daughter, Nicca, on October 1, 1961, just before the *King of Kings* premiere, Ray knew what his twentieth film would be. After signing a new contract with Samuel Bronston and Philip Yordan to direct three pictures for an aggregate of $1 million, Ray boasted of being "the highest paid director in the American cinema." However, the aggregate included unearned bonuses and profit percentages. (Perhaps he should have added "living in Europe.")

After *El Cid* moved on to postproduction, Yordan and Ray were able to spend concerted time together, sifting through all the potential projects and lining them up in future order for the Bronston organization and Security Pictures.

Ray probably wasn't surprised when Yordan definitively passed on *The Tribe That Lost Its Head, The Road to the Snail,* the Children's Crusade film, and the other "moon talk" that had occupied his time in the six months since completing *King of Kings.* More to Yordan's taste was Ray's ambition to craft a blockbuster about circus life—another borrowing from Cecil B. DeMille. Caught up in the superspectacle mania, Ray pitched a big-top film that would out-DeMille DeMille. It would be a travelogue of world circuses, hopping from location to location in Europe and the Far East. Major international stars would play key as well as cameo roles, à la *Around the World in 80 Days.* The all-encompassing script would offer "an accurate and penetrating panorama of circus life, its people and the traditional trained animals in both historic and modern perspective," according to advance publicity. Ray's circus-world extravaganza was penciled in for Security Pictures somewhere down the line—after he directed everybody's first choice, "The Fall of the Roman Empire," for Bronston.

Between Ray, Yordan, Paris blacklistee Ben Barzman, and Italian writer-director Basilio Franchina, a "Roman Empire" script had been rushed into existence that numbered about one hundred pages. But after

reading this first draft, Charlton Heston couldn't get very excited about the prospects. Heston had been unhappy with his experience on *El Cid,* where he had been beguiled by Yordan and his smooth talk, but never got the "honest script" he was promised, in Heston's words. The actor was flooded with offers these days and thought perhaps he should make his next vehicle a contemporary drama, for variety's sake, not another sweeping historical saga like *Ben-Hur* or *El Cid.* But Ray as his director continued to intrigue him. Heston refused to say yes or no; he kept bouncing the project back to his agent—Ray's old agent Herman Citron—demanding various guarantees.

Meanwhile, for several months over the summer of 1961, the script writing and preproduction moved along. Trying to stay one step ahead of Heston's psychology, Yordan decided it would be good to have a fallback project to offer to the star if he kept stonewalling them on "The Fall of the Roman Empire." Bernard Gordon, toiling away in Yordan's cubicles in Paris, pitched the idea of a superspectacle involving the Boxer Rebellion in Peking in 1900, telling Yordan about an "unusual, pictorial and filmic" stage play he recalled on the subject from his days as a lowly reader at Paramount back in the 1940s. Stuck in Paris, Gordon couldn't recall the title or author, and Yordan "never sparked" to his idea anyway.

Not, at least, until one day when Yordan took a trip to London, where he went cruising the book stalls with his wife. Mrs. Yordan picked up one of the books for sale and opened it to a chapter titled "Fifty-five Days at Peking." "That clicked," Yordan told Gordon.

Nothing better than a snappy title. Right then and there at the book stalls, Yordan told Gordon, he'd been inspired to make a film about the 1900 uprising in Peking, with the anti-Christian, anti-imperialist Boxers, egged on by the royal dynasty in the imperial palace of the Forbidden City, declaring war on foreign nationals. Americans—Charlton Heston!—could ride to the rescue for fifty-five days, heroically defending men and women from eleven foreign legations occupying a few acres of a walled compound. In short, "a Chinese Alamo." Gordon tried reminding Yordan that he'd been pushing the Boxer Rebellion for months, but Yordan insisted it was the London book stalls, and his wife's stumbling upon the chapter title, that galvanized him.

With a great title—but "no story, no plot ideas, no characters and only the sketchiest notion of what the Boxer Rebellion had ever been about," in

Gordon's words—Yordan and Gordon dove into crafting a "presentable" story treatment to hook Heston. At the Madrid preview of *El Cid* in late November, while touring the elaborate sets for the Roman Empire film that a gung-ho Bronston was busily erecting, Heston stood his ground: He would not be starring in Bronston's Roman Empire epic. He was surprised by how unfazed everyone was.

Traveling by jet to Los Angeles the next morning, however, Heston was astonished to discover Yordan in the seat next to him and Ray smiling at him across the aisle. The two started in on him, talking about the Boxer Rebellion and *55 Days in Peking*. The actor felt cornered, trapped for hours on the transoceanic flight. All three drank liberally from a bottle of thirty-year-old single-malt that Yordan and Ray had managed to smuggle on board. "Phil [Yordan] was matchless in this situation," as Heston recalled. "He outlined the history of the attack on the foreign legations in Peking by a bizarre bunch of Chinese fanatics, secretly supported by the Dowager Empress, the last woman in history to hold absolute dictatorial power in any government."

Somewhere over Greenland or Iceland—he could never remember where exactly—Heston surrendered, saying that after the Bronston organization had finished "The Fall of the Roman Empire" Heston would star in *55 Days at Peking*. Then Yordan really amazed the actor by announcing that they'd decided to postpone the Roman Empire superspectacle, pushing it back a year or two in order to shoot *55 Days in Peking* next summer with Heston instead. "I was stunned, impressed and flattered in about equal measure," the Oscar-winning star recalled.

Heston made a "semi-commitment," in his words, "pending my approval of script and casting," but Yordan knew a dodge when he heard one. ("It's been observed in Hollywood that a semi-commitment is about as reliable as a semi-erection," as Heston wrote in his autobiography.) In late December, again in Madrid, Yordan and Ray tag-teamed the star, holding an all-day meeting that ended with Yordan threatening to throw himself out a hotel room window if Heston wouldn't sign a contract to star in *55 Days at Peking*—one that offered Heston "a unique deal for a percentage of the producer's share," in Gordon's words. Ray was the closer, driving Heston to the airport the next morning.

"I feel uneasy," Heston told himself. But he decided that he trusted "the director's talent," even without a script in hand. "I think I'll do it," he scribbled in his journal.

✳

Like the old film montages, the calendar pages were already flying away, as *55 Days at Peking* was already slotted to begin shooting in the summer of 1962. Samuel Bronston was determined to churn out one superspectacle a year, and already they were behind schedule. "The Bronston studio in Madrid had to keep operating with a new picture, a new budget, and financing in place to pay the overhead and substantial salaries of many people, including Yordan," recalled Bernard Gordon.

Ray began to meet with art directors Veniero Colasanti and John Moore, an Italian and Englishman who together had designed *El Cid* and now had the daunting task of building the residence of the Dowager Empress, the Forbidden City, and the surrounding Great Wall on a backlot outside Madrid. The sets alone would cost nearly $1 million.

Yordan, preoccupied with business meetings and other planning, left the heavy lifting on the script to Bernard Gordon. "Yordan tried to work closely with me," the blacklisted writer recalled. "A great deal was at stake. He was good at coming up with an idea for a spectacular scene or situation, [and] he had a good feel for what would sell the picture, but I had to go back to my office and try to sweat these ideas into a plot and into personal stories."

The goal was to have the first third of the script ready by February 1, the day Ray was scheduled to move back to Madrid to take charge of preproduction. Indeed, Gordon sweated—he was suffering from the flu, but he was also drawing blanks on major characters and scenes. When Gordon faltered, Yordan sent him to Madrid to confer directly with Ray. "Yordan was hoping and praying that, working together, Nick and I would solve the script problems," remembered Gordon, "and leave him free for all his other machinations."

Ensconced at the Castellana Hilton, Gordon plunged into four weeks of intensive sessions with Ray. They worked well together, the writer felt, and made decent progress. Ray wanted to take the script down a venturesome path; he was back in the mode of *On Dangerous Ground,* where he'd argued unsuccessfully for a split black and white/color visual scheme, or *Rebel Without a Cause,* where he'd tried for "dream bubbles" portraying the subconscious lives of the teenage trinity. For *55 Days at Peking* he wanted to divide the screen with multiple images that showed simultaneously

unfolding planes of action. Gordon found Ray's ideas novel and stimulating; the director commissioned Spanish and Chinese artists to create renderings of the split-screen images, and put special effects wizard Linwood Dunn, who had worked on *Androcles and the Lion* with Ray at RKO, on salary as a consultant. (Dunn's career as the studio's effects expert stretched back to the original *King Kong*.)

Then Yordan arrived in Madrid, read the venturesome scenes the two had devised, and tossed them into the circular file. "I was disheartened," Gordon said. "I don't believe Nick ever regained his confidence in me. He needed someone like Yordan to tell him what to do. From this point on he went along with all Yordan's opinions. In other ways, so did I."

With extravagant sets under construction and the start date encroaching, Yordan insisted that the blacklisted screenwriter "go back to square one and write the kind of clumsy, impersonal, fat historical opus," in Gordon's words, that "international distributors, who catered to the lowest common denominator, wanted." With sinking spirits, Gordon started over, this time with decidedly less input from the director of *55 Days at Peking*.

<p style="text-align:center">✳</p>

Ray took the defeat placidly, thought Bernard Gordon; with plenty of other problems, he seemed relieved to be rid of script responsibility.

Around this time, in May, columnists reported that the director's son Tony had married Ray's ex-wife Gloria Grahame in Mexico, adding a new chapter to the love affair that had begun between them in Malibu when Tony was a teenager. Ray rarely mentioned the union between his oldest child and his second wife, which lasted fourteen years and produced two children, but the news must have pierced his heart, and it further colored his relationships with Tony and Tim, Ray's son with Grahame.

He lost himself in the endless details and problems of preproduction. As he had armed himself with clippings and books and tape recordings and official endorsements while preparing *Rebel Without a Cause,* and with all manner of references and expert advice and official approval in the making of *King of Kings,* the director now surrounded himself with artwork and volumes of history and professorial experts on the Boxer Rebellion.

Every day he held meetings with roomfuls of associate producers and department heads on the Bronston payroll. The staff debated at length what kind of horse Heston should ride, what kind of equipment should be leased

from *Lawrence of Arabia* (also shooting in Spain), how the different national uniforms and armaments should look, how much water would have to be ferried to remote exterior locations for drinking and bathing and potential fire prevention (a real concern in the hot summers), the number and ethnicity of extras (they had endless trouble finding Chinese people in Spain and had to import the majority from London). On days when Ray could not be present, script supervisor and director's assistant Lucie Lichtig—sister of editor Renée Lichtig—represented him faithfully and took notes.

Bronston had refused to rehire Renée Lichtig, who'd been superseded by MGM on *King of Kings,* but her sister Lucie joined Ray's narrowing circle of trust. Bronston also balked at hiring Sumner Williams as a second-unit director again, and Ray's nephew chose to sit out *55 Days in Peking.* But Ray engaged a likable production manager, whom he knew from Hollywood, and a young assistant director, José Lopez Rodero from *King of Kings,* whom he regarded as his latest protégé.

There were circles within circles at the Bronston offices; visitors had to walk through the big office of Ray's trusted production manager to gain access to the director's inner, more spacious office, as though one were guarding the entrance to the other. To his bewilderment, Rodero found himself installed *inside* Ray's large office at a small desk facing the director and his huge Hollywood-style desk. When he wasn't meeting with someone or talking on the phone, which was most of the time, Ray kept busy shuffling papers and turning the pages of books or the slowly burgeoning script, making notes to himself. "What do you think?" he'd ask the young Spaniard from time to time, indicating the script open on his desk. Taken aback, the young assistant director would stammer, "Well, I haven't really had a chance to read it thoroughly . . .

"I had to look directly at him all day and exchange looks," Rodero recalled. "He had reading glasses and sometimes he'd look at me over his glasses and I'd wait, expecting a question or something. Many times, nothing would come out. I had to make something up, obviously, now and then, because this went on hour after hour after hour."

It occurred to Rodero that Ray had barricaded himself deep inside the Bronston machine against the outside world. Betty Utey was in and out of the office with their two young children in tow. The family was back living at the La Florida villa, and Utey was at the center of Ray's circle of trust. She was vocal and articulate, and he listened to her.

Gordon saw Ray most days and some nights. The director did not

seem to be drinking in the office, but Ray was clever at fooling people, and at night he sipped steadily, during their long talks, from a bottle of Fernet Branca, a potent Italian digestif he claimed aided him in his battle against alcohol dependency. But the drink was eighty proof, and Gordon noticed that Ray could polish off a liter or one-quart bottle easily in a sitting.

Still, Ray was calm and smiling much of the time. How could he look and act so normal, Gordon wondered, while downing an entire bottle of Fernet Branca? Appalled at the high-velocity plans that were already in motion for an epic that lacked a coherent script—a script for which he was responsible—Gordon himself felt on the verge of a breakdown. When he joined Ray at the studio one day to inspect small-scale models for the sets, Gordon worried aloud about the way the Great Wall, the embattled compound, and the Forbidden City had been laid out, saying there didn't seem to be enough space for the rousing scenes he had yet to cogitate.

No, no, Ray assured Gordon with his easy smile, don't worry—everything will turn out fine. That was his mantra, part of the unflappable persona long worn by the strong, handsome man, and it certainly convinced many people. But Gordon, overwhelmed by the scale of the undertaking, decided that Ray was "just as frightened as I."

※

Before flying to Madrid in the third week of May, Charlton Heston had been unnerved by a chance conversation he had with his longstanding, trusted publicist, Bill Blowitz. Blowitz said he knew Ray from a weekly poker game with the director in Hollywood. "Let me tell you something, Chuck," said Blowitz. "He's a gifted guy, but he's a loser."

Heston's misgivings mounted when, upon arrival, he was handed a 140-page draft of the script that was "unfinished," with many scenes only summarized or sketched in. "Not pleased," the actor jotted in his journal. "The love story is very arbitrary, I think; the dialogue primitive. Lunch with Nick and Phil filled me with apprehension."

With Bernard Gordon dragging his feet, Philip Yordan called in reinforcements. David Niven had been signed to play the British ambassador, but the dapper veteran insisted on meatier scenes for his character. Robert Hamer of *Kind Hearts and Coronets* fame was express-delivered from London to pad Niven's part with a number of stiff-upper-lip speeches. Un-

fortunately, Hamer did more drinking than writing, and another London writer, Welshman Jon Manchip White, was rushed to Madrid as his replacement.

Heston's love interest was a Russian countess, her character somewhat adrift in the story. Ray and Heston both wanted to cast a European actress for the role, while Yordan and Bronston leaned toward a Hollywood commodity like Ava Gardner. Gardner was living, conveniently, in Madrid, making her practically a European. Still, Ray tried lobbying for Greek actress Melina Mercouri, and Heston made a quick trip to Rome to watch a screening of *Phaedra,* starring Mercouri and directed by American blacklistee Jules Dassin (who later became her husband). Though Heston felt unable to endorse Mercouri wholeheartedly—the print he'd seen in Rome was dubbed in Italian, which was Greek to him—he stood nobly with Ray against the Bronston brass in a heated meeting, insisting on a European personality. By the end of June, though, Gardner was cast.

When Gardner came aboard, it was her turn to inspect the script. Invited with Heston to Ray's villa late one night, she delivered a vitriolic rant against its flaws—especially those in her character's scenes. Ray listened stoically. Heston sneaked out after about forty minutes. "A macabre evening," the star wrote in his journal. "Oddly, her rejection of the script has the curious effect of throwing me into support of it." One of the most dependable of Yordan's Los Negroes, Arnaud d'Usseau—a former Broadway playwright and Hollywood scenarist—was then ferried to Madrid to plump up Gardner's scenes as fast as they flew out of Gordon's typewriter.

After the roles played by Heston, Gardner, and Niven, the most important characters were the evil prime minister and Empress Dowager, and those parts were offered to former Australian ballet star Robert Helpmann and longtime versatile character actress Flora Robson. But Robson was of such regal stature (she was named a dame commander of the British Empire in 1962) that the team felt compelled to build up her scenes too, and Gordon's friend and fellow blacklistee Julian Halevy was parachuted in from Italy to do the honors.

Meanwhile Gordon scurried about, trying to keep track of the ever-changing continuity issues while superintending Los Negroes, who were working on all of the subplots and tailoring character-specific scenes.

With emergency writers arriving right and left, Heston realized that Yordan had snookered him again. As with *King of Kings,* there would never

be a final script before the cameras rolled on *55 Days at Peking*. The script would be written and rewritten during filming. Since everyone else was busy making egoistic demands, Heston decided he might as well insist on a few award-caliber scenes of his own. He talked it over with Gordon, insisting on a soul-baring moment for his hero character. Gordon brought the matter to Ray and Yordan, rolling his eyes as he did.

One of Heston's marines in the story is a guilty father—a familiar character in Ray's work—who has abandoned his young half-Chinese daughter. Heston had a scene in which he gave the marine a little morale-boosting pep talk. "You're better than most fathers," Heston says to reassure the marine. "At least you try to see her when you can." But there was no payoff for this motif in the script thus far, and so now Ray got together with Gordon and Yordan and spitballed a clever expedient. They would write another scene for Heston and the little Chinese girl, with him comforting her after the marine's death. In the scene the gruff officer is forced into tenderness, taking over for the dead marine and becoming, in effect, her surrogate father. Heston was thrilled, and it became a strong scene in the film.

Even the Italian cinematographer the director had hired blinked when he arrived in Madrid to find the same half-baked 140-page draft that troubled Heston. Aldo Tonti, who had signed a contract for *55 Days at Peking* after working so well with Ray on *The Savage Innocents,* couldn't be reassured. Yet Ray was able to replace him at the eleventh hour with British ace Jack Hildyard, who had just won the Oscar for *The Bridge on the River Kwai.*

The scene with the Chinese girl appeased Heston, but the star still couldn't shake his publicist's distressing warning. After discussing his role with the director "at length, but to no great purpose," Heston wrote, "I can't put my finger on the lack of contact I feel there. He's intelligent, articulate, and committed, but I feel a barrier . . ." He felt as if Ray were giving "a performance somehow."

The first day of photography approached: July 2, 1962. The cast was a bouillabaisse, representing every nation where Bronston and Yordan hoped to sell the film, and most of the performers arrived barely in time to squeeze in their costume fittings. The script was full of holes and Band-Aids and scenes marked for revision or late-schedule filming. "I start this picture with more misgivings than I remember about a film," Heston wrote in his journal.

*

Ray had also kept a journal, erratically, for years. He scratched notes to himself on scrap paper and napkins too. The running words in his head were another form of journal.

The director might well have stared in the mirror, as the start date approached, and wondered if he was gazing at an impostor, giving the kind of "performance" that ran counter to his own principles. It might be said that, as in *Bigger than Life,* the image staring back at him was broken in shards.

As a young man in La Crosse, Ray had worried about prostituting himself as an artist; publicly he had declared his purity. At Taliesin he had reinforced his credo that art should aspire to organic truth and beauty. In New York and Washington, D.C., working onstage and in radio with left-wing idealists and ideologues, he had tried to celebrate the lives of ordinary people and grassroots culture.

Early in his Hollywood career, he had denounced directors like Cecil B. DeMille, whose swollen epics, intended for maximum box office, lacked the intimacy and humanity of the type of stories Ray preferred. He had never really meshed with the commercial system in Hollywood, but in desperation (and thrall to his addictions) he had grasped at more and more lucrative yet less and less malleable material.

His last picture, *King of Kings,* had been a virtual DeMille remake. Now Ray found himself immersed in another, even more bloated superspectacle. The stars, not all of his choosing, came equipped with myriad accents and chips on their shoulders. Thousands of anonymous extras and necessary and unnecessary crew workers waited his call to action. Journalists were flooding in from all over the world to describe his every move. Enormous sets were poised for his staging; all manner of machinery and technology and devices stood ready, waiting for the agitation of his essence.

As a young man, moved by the imprecations of Thornton Wilder, Ray had sworn never to become a materialistic American. Now every day his job revolved around money: his blockbuster-in-the-making, with its supersize budget and expected worldwide profits; his own salary, his highest ever, with perks he'd come to enjoy and rely on; his very lifestyle, once lived cheaply, now padded with luxury.

"One of Nick's troubles," mused Gavin Lambert, "was that he always wanted to be a sort of avant-garde, independent moviemaker and do daring things on a low budget. At the same time, he wanted the five-star hotel and the limo at his beck and call."

Away from the studio or office, drinking got him through the job. Few knew the full extent of his intake. And few suspected that, supposedly to cure his alcoholism, Ray had begun crystal methamphetamine injections from a nurse who visited the family villa—a place where he spent less and less time. Work was paramount. Rest and sleep were enemies. When not in the office, he contrived to be out and about, taking meetings and short trips, finding ways to gamble, though it was illegal in Franco's Spain. "My mother said he was more excited about losing than he was about winning," said his daughter Nicca.

Ray was a loner who hated to be alone, and he coaxed Lucie Lichtig or Bernard Gordon or his young Spanish assistant, José Lopez Rodero, into many a dinner with him, calling them working dinners when he really just wanted some company. Yet the director was "difficult" to communicate with "even alone," recalled Rodero, always taking an extraordinarily long time to digest whatever he was thinking or about to say.

Regardless of external pressures, in spite of internal doubts, Ray maintained his composure. The press clippings almost uniformly describe him as tall, strong, and handsome, as positive minded and healthy looking as could be. "I never noticed any evidence of Ray's dismay," said the Spanish filmmaker and critic Juan Cobos, who visited the set of *55 Days at Peking* as a young man. "Even in those days he always defended the idea that a movie director has to arrive at the film studio every morning firmly believing he was making a very good picture, the best picture ever made."

Years later, Ray liked to say that he awoke one night, shortly before filming began, and told his wife he'd just dreamed that *55 Days at Peking* would be his last movie. It's hard to know whether to believe the story— among other things, it would have required Ray to be at home, sleeping soundly—but it made a good anecdote and no one doubts the premonition.

✳

Bernard Gordon thought that anyone would have cracked under the pressures of making *55 Days at Peking*. From the outset, the project was a paradigm of waste, mismanagement, lunacy.

The first day of filming, "the height of that really wild year," in Gordon's words, arrived with a trumpet blast. Bronston threw an impossibly exorbitant party, chauffeuring all the guests—Franco officials, the mayor of Madrid, press correspondents from around the world—to the old-Peking set, arranged on a leased portion of the fifty-thousand-acre estate known as Las Matas (the Shrubs), home to the Marques de Villabragima, about sixteen miles outside Madrid. The golden spire of the Temple of Heaven, the towering Chien Mien Gate, and one hundred other buildings were in various stages of completion.

The event was planned for maximum publicity value. Ray would shoot from inside the Forbidden City "toward the great Temple of Heaven, a round building that had actually been constructed full-scale and half-round," Gordon recalled. The scenarist was ceremonially "greeted by Nick, who took me with him in the basket of the crane that lifted us both high above the action." Cinematographer Jack Hildyard "had gathered every 5,000-watt brute in Spain and some from France to light this huge exterior night scene. When the lights went on, it was impressive, seeing the great set illuminated for the first time."

The speeches and champagne toasts went on far too long, however. The director had to delay the first take until after dusk, and then the footage was worthless. In the darkness, the round Temple of Heaven looked "flat, a two-dimensional fake," said Gordon. The shot had to be redone later, at great expense, though the journalists were none the wiser.

Not that Bronston cared about the mounting expense. He was at the height of his delusions of grandeur. The wheeler-dealer was then negotiating to buy the Chamartín Studio, which he would rename the Samuel Bronston Studios. Bronston wanted everything on a Bronston production, on- or offscreen, "to be real, only the best," in Gordon's words. The Castellana Hilton filled up with Bronston dependents. "People came and went from Hollywood and London to be consulted, at Bronston's expense, on foolish, doomed schemes for original ways to photograph the action sequences (pace Nick Ray)," according to Gordon. "Expensive talent was hired and then dismissed and paid off on a whim. Personal expenses were unrestrained and had to come out of the budget."

Every day, Bronston's publicity staff offered reporters privileged glimpses of the director at work on the magnificent sets. But while the journalists stared and scribbled, Ray scrounged for scenes to shoot, as much as possible working around the highest-paid stars. Gordon and Los Negroes

scurried around in the background, trying to keep ahead of the filming. As the journalists oohed and aahed, Ray made slow, painful progress.

July was painfully hot besides. The first week of August brought the bulletin that Ray's old flame Marilyn Monroe had been found dead in the bedroom of her Brentwood home. More than Humphrey Bogart's death, Monroe's sudden passing, at thirty-six, seemed a personal augury to Ray. He had loved the blond sex symbol, for her obvious qualities but all the more for her elusiveness; now he would never have the chance to direct her in a motion picture. Monroe's death left Ray "deeply shocked and grieved," according to news accounts, but the director could not leave the high-pressure filming in Spain and had to content himself with sending a floral display to her funeral.

Gradually, Ray moved the stars in front of the camera for the film's more intimate scenes. He always had worked famously well with actors but not always as smoothly with self-important stars. His usual thing was to ask the actors what they wanted to do in a scene and then play with their ideas, but there wasn't always time to do that now, and it was next to impossible with three marquee names—Charlton Heston, Ava Gardner, and David Niven—maneuvering for advantage.

As usual, the director had better luck with the men. Ray had been friendly with the easygoing Niven in Hollywood for years, and once the actor's scenes were properly aligned for his character the Englishman made effortless work of his role.

Heston, of course, was the main attraction for investors and audiences, and Ray would have to spend most of his quality time with the chiseled star. Heston felt constrained by his one-dimensional drinking, womanizing, warrior-hero character, but as he worked closely with the director, he began to invest his scenes with swagger and feeling.

Ray couldn't seem to strike the right note with his leading lady, however. As had happened before—with other female stars in Ray films—Gardner felt like a mere adornment, a bauble, in a man's world. Insecurity about the character she was playing translated into insecurity over her performance. Ray had to treat her gingerly. The actress had a temper; she drank, she swore. Ray feared her disapproval, at first treating her misbehavior with velvet gloves.

They were shooting "French hours" most of the time, starting at eleven in the morning and continuing until eight at night. Gardner was "most reliable" in the mornings, recalled Heston, but French mornings

were only about one hour long, and it took time to set up each new shot. Gardner was habitually late, and often hungover, and she liked to hide out in her trailer until she felt presentable. When she was hiding out she inevitably resumed drinking, a glass of wine followed by tequila or vodka, until by late afternoon she often couldn't remember her lines or slurred them.

"September 1, Las Matas," Heston recorded in his journal after two months of his costar's lateness and drinking and sulking and tantrums. "Today marked the worst behavior I've yet seen from that curious breed I make my living opposite. Ava showed up for a late call, did one shot (with the usual incredible delay in coming to the set), and then walked off just before lunch when some Chinese extra took a still of her. She came back after a painful three-hour lunch break . . . only to walk off again, for the same reason (this time untrue; the Chinese extra did *not* take a still of her). Great day."

Ray suffered a public humiliation that day, and some—Heston for one—thought the director himself was partly to blame. One time, José Lopez Rodero witnessed a nasty exchange in Gardner's dressing room, with Ray angrily summoning Gardner to the set and Gardner telling the director to fuck off—and getting away with it. Would Ava Gardner have dared tell John Ford to fuck off?

Bronston and Yordan couldn't cope with Gardner either, however. Yordan contacted Ben Barzman in Paris, asking him to read the script and find ways to minimize the actress's remaining time on the shoot. Barzman scratched his head sagely and said the solution was obvious: Kill her character off. Yordan thought that was brilliant. Deleting the countess after a certain point could be done without damaging the rest of the structure, and with the help of Barzman and Gordon he concocted a scene in which she would be struck by Boxer shrapnel as she nobly tends the wounded.

A death scene is a gift to any actor, and Gardner was flattered. When it came time to film the scene, though, Ray made a mistake. "The previous day's scene had slopped over," wrote Heston. "Nick didn't wrap the other set till midafternoon. By the time he had Ava's death scene lit, she couldn't do it."

The staging was simple enough: Gardner lying in a hospital bed, with Paul Lukas playing the surgeon hovering over her, listening sympathetically as her last words tie up her backstory with Heston's character. But Gardner was too drunk to perform the lines.

Ray saved the day, coming up with the inspired idea of handing her

lines to Lukas—which took "surprisingly little rewriting," in Heston's words. ("I'm still amazed we got away with this," Heston wrote, "but the dialogue worked quite well, largely because of Paul's skill.") In Heston's view, though, Ray had been "badly at fault" for having procrastinated in the first instance. Already suspicious that her character was being winnowed from the picture, Gardner had been forced into a position of "unspeakable humiliation," according to Heston, having to surrender her valedictory to another, more clear-headed actor. "I've never before seen someone literally writhe in frustration and shame," wrote Heston. "Poor, sad lady."

For Heston, the incident only confirmed his publicist's dim view of Ray as a loser. "He was a sensitive and intelligent man," the star wrote. "When he was talking about a scene, or an acting problem, you saw a quick creative mind at work. *Shooting* the scene, you saw something quite different. He wasn't so much directing as acting the role of director. He was surely not a good captain. Whatever his talents, a director must, *must* be a captain."

✳

The leading lady in Ray's personal life—Betty Utey, his wife—also began to cause problems. The director had been married to Utey for three years, about as long as he'd managed to stay with both Jean Evans and Gloria Grahame. "For three years all Jeff had to do was whistle," the lady trick rider in *The Lusty Men* confesses, "and I came running." Why did she stop running? "He quit whistling."

Ray's third wife had shored him up after *Party Girl,* supported and assisted him during the endurance tests of *The Savage Innocents* and *King of Kings.* Ray saw himself as Utey's mentor, but Utey was a dominating character who asserted herself as his equal. She kept pushing for equality, and Ray kept ceding ground.

To some extent, within the Bronston company, Utey was regarded as Ray's compass and muse. Often close at hand, in the office and on the set, she'd pass him scribbled notes or lean over and whisper suggestions. Sometimes, when his wife made a surprise appearance during filming, he'd grow visibly tense to see her. At the same time, the director continued to need her, lean on her, and involve her in many aspects of the production.

When Ben Barzman flew in from Paris to write Ava Gardner out of 55 *Days at Peking*—the fifth or sixth of Los Negros to contribute to the script—he was chauffeured by limousine to the Rays' villa to discuss the various options with the director. There, to the writer's amazement, it was Utey, not Ray, who delivered a summary of the script issues as they stood. "It was a scene right out of *Sunset Boulevard*," Barzman recalled.

It became increasingly clear to some in the Bronston operation that Ray was actually farming out some of the last-minute remedial revisions to his young wife. "We managed once again to resurrect an ill-written scene into some semblance of life," Charlton Heston wrote in his journal on August 18. "Curiously overwritten lines seem to keep popping into the script every day or so on new pages. I'm drawn inescapably to the conclusion that these are from the nimble typewriter of Nick's wife Betty. This will not do . . ."

When Yordan found out, he exploded. This was worse than the director tinkering with Yordan's pages behind his back. Mrs. Ray was not even a writer. Yordan had a sharp confrontation with Ray—the kind both usually avoided—and told him it had to stop.

Humiliated, Ray blew up at his wife, banning her from the office and the set. Now Utey's absence—and that of their two young daughters, Julie and Nicca, who had delighted everyone and cast a charm on the production—left a regrettable void, though it was unremarked upon as Ray walked round and round the set, chain-smoking, slowly setting up his shots.

❊

The shots seemed to take longer and longer to set up. A man so highly praised for his visual compositions now began to falter at the greatness expected of him. After Ava Gardner's botched death scene—which happened not long after Ray had banished his own wife from the office and set, and not so very long after the director's fiftieth birthday—came the last straw.

Not all directors, especially not very many of the old-fashioned boys, carried around a viewfinder the way Ray did. He enjoyed putting the lens up to his eye and walking around a scene, crouching down or standing on a rise, contemplating unusual angles. He enjoyed chewing the shots over with his cameramen, talking lenses and lighting options.

The camera crews were paid to listen to him, almost like psychoanalysts, and they had all the time in the world. Ray devoted more and more time to the camerawork, hoping it might rescue this leviathan of a film, with its grudging actors and spotty script.

Yet with so much effort being put into the staging and setups, Ray fell farther and farther behind schedule. The birthday watch his wife gave to him became, for some members of the company, an echo of the Bowie-Keechie object tracks of *They Live by Night* and a symbol of the general *mishegas* of the film. It was a newfangled watch with a little alarm, which more than once went off right in the middle of a take, causing Ray to grunt an apology and order a retake. Oddly, however, this happened several times, until some began to wonder if it was planned, if the director himself kept setting the alarm, perversely enjoying everyone's discomfort.

Normally, it was the job of Ray himself to dispel people's discomfort. At his best, especially in his early days, he could be endlessly tolerant with his actors, always pleasant and agreeable, but now he was "running out of steam and becoming more irritable," as Bernard Gordon recalled. Worse yet, often Ray couldn't make up his mind about a shot. The production lost more and more time as he walked around and around, thinking and thinking, slow to come to any decision.

"Eventually" one day, wrote Gordon in his autobiography, Ray "froze up and was unable to decide where to put the camera to start a simple scene. Yordan was sent for."

It was another scene on the hospital set, with Paul Lukas examining Ava Gardner just after her injury. Yordan raced to the set wearing a diplomatic face. "Prudently," said Gordon, "Yordan acted as though he had to give this matter serious consideration, then turned to Nick with a tentative suggestion. 'Maybe you could have the doctor hold a watch in one hand and take the patient's pulse with the other. Then start with the camera in close on the watch, pull back and go on with the scene.' After Yordan's profound suggestion, Nick gave this his usual protracted and thoughtful consideration. 'Good idea,' he eventually agreed. The shooting resumed."

But it was a dire portent, and there was worse to come. A few days later, on September 11, Ray "finally caved in," Heston wrote, "collapsing on the set this morning as we waited for the first set-up. They bundled him into a car, white-faced and sweating." Years later, Heston added this brack-

eted note to his original journal entry: "A major coronary."

Louella Parsons, a confidante of Ray's, reported contemporaneously that the "so-called heart attack" was nothing of the sort. It was a "warning attack," she wrote.

Betty Utey told Bernard Eisenschitz that the incident was a tachycardia—not technically a heart attack but an irregular, fast-beating heart rhythm caused by stress or other factors.

Heston did not say he actually witnessed Ray's collapse, nor his rush to the hospital, nor even his physical presence on the set that day. Assistant director José Lopez Rodero, who was at Ray's side whenever he was on the job, said the director simply did not show up at the studio that morning. The first thing Rodero heard was that Ray was in the hospital.

Years later, Yordan told anyone who would listen that Ray hadn't suffered any heart attack. He just quit. An ambulance was called to make it look good for people on the set.

Was it, indeed, a heart attack or tachycardia? Was it brought on by stress, or by Ray's various bad habits, his sleepless nights, the endless tensions and pressures of the shoot? Had Ava Gardner threatened to quit the film, as some believe, if Ray was not replaced? Or had Bronston and Yordan simply fired the director, fed up with his inability to control Gardner, his fussing with the script, his procrastination with the camera, his drinking and drug use?

And was the illness "staged" by Ray and Yordan to disguise the firing, much as the Schulbergs had protected the secret of his firing on *Wind Across the Everglades*?

Something happened in private between Ray and Yordan, and like other crucial episodes in Ray's life, many versions have been reported, none of them quite conclusive.

After four days, Heston visited the director in the hospital. He noted in his journal, "[Ray] looks . . . not bad, really, but *quelled,* somehow. Apparently he has accepted the fact that he dare not work again on *55 Days at Peking,* though we didn't speak of it." James Cagney, vacationing in Spain with one of his brothers, heard that the director of *Run for Cover* had been hospitalized and also paid him a visit, holding the hand of one of the few men of his profession whom he liked and admired. Most other visitors Ray turned away. When José Lopez Rodero phoned his room, the nurse told him Ray was taking no calls.

*

Ray's production manager and script assistant, the Spanish and Chinese artists working on sketches for split-screen images, and the RKO effects specialist—all were quickly let go. Only Rodero, Ray's assistant director, remained to bridge the transition.

Andrew Marton, a well-respected second-unit director who'd staged the chariot races for *Ben-Hur,* rushed to Madrid to take the reins of command. An Englishman with whom Heston felt comfortable, Guy Green, flew in to handle an emotional scene between Heston and Gardner. Everyone felt sorry about Ray, but the production picked up energy and finally seemed to get on track.

When Heston visited Ray in the hospital a second time at the end of September, the star was appalled to discover that the sidelined director, who was looking "better and better," was talking "of coming back to the film next week." Heston noted in his journal, "I can't believe this is a good idea . . . either for him or for us. It's a horrifying thing to say, but maybe the best contribution he made to our enterprise was falling ill when he did."

Bronston and Yordan couldn't believe it either. They had no intention of enabling Ray's return. Marton's no-nonsense approach was refreshing, his early footage fine.

The two producers had negotiated the terms of Ray's surrender, and as with *Wind Across the Everglades* his contract would be honored only if he stayed away. Ray would receive his contractual salary and director's credit. He'd also receive generous compensation and a story credit for the still-sketchy *Circus World.* No heart attack, quitting, or firing would be confirmed, only a vague "illness" requiring his hospitalization.

Some scenes Ray had finished would be rewritten and reshot, including a few with Heston and Gardner. "I threw out sequence after sequence," Marton said insistently later. The principal photography would persist for almost three months, until December; some days two units toiled simultaneously, one headed by Marton, the other by second-unit director Noel Howard under Marton's supervision. Although Ray was discharged from the hospital after three weeks, he was not welcomed in the Bronston offices or on the set. He tried to view the new footage, but one day, after Ray snuck into an assembly preview for investors and exhibitors only, editor Robert Lawrence warned him away.

Ultimately, Marton believed, he directed at least as much of the final footage of *55 Days of Peking* as Ray. Indeed, Marton estimated that his scenes comprised 65 percent of the film, which eventually would run nearly three hours. Even as he was still shooting, Marton began to lobby for the main directing credit. Bronston and Yordan sympathized with Marton and thought they might persuade Ray to share the director's credit—a rare solution, but one the lawyers and guilds would accept if both parties did. Ray demanded to see an assembly in order to address the issue, and Bronston decided that was only fair.

One day in November Ray came to a projection room to watch the work in progress with Bronston, Yordan, and a handful of others in the organization. "I wasn't there," said Marton, "but my spies told me he was so abusive and so critical of the first part of the picture, which was my part, that they stopped and went out to lunch."

Ray returned after lunch, only to be informed by the projectionist that Bronston had ordered the screening halted. Ray was forbidden to watch and comment on the rest. The director waited around for an hour or so before he realized Bronston wasn't going to budge and then he left quietly. Ray later sent memos urging that several scenes be reedited or reshot, but his advice was politely ignored.

Marton wanted the directing credit so badly he threatened legal action and guild arbitration, but Bronston assuaged him with money and flattery, and finally Marton let the matter drop in the interest of goodwill. But there is no question that Marton directed most of *55 Days at Peking*. Grateful for his intercession, Bronston and Yordan thanked him with an unusual separate screen card crediting him as "director of second unit operations." Marton would go on to work on several additional projects for Security Pictures, including a few as director. Yordan, ruefully and without bitterness, would wash his hands of Nick Ray.

✳

As Ray's health rebounded, so did his optimism. The director tried to repair his marriage to Betty Utey, and the family began to divide their time between Rome and Madrid. When Ray wasn't with the family, he was traveling and meeting with producers.

Mr. and Mrs. Ray were together at the world premiere of *55 Days in Peking* in London in May 1963. The program read "directed by Nicholas

Ray," and some of it clearly was: the anguished faces in close-up, spilling out of the frame; the unconventional framing and cutting of action; the dark, swirling colors; the film's marked empathy with fearful men.

One scene Ray certainly directed involved his own cameo appearance. Ray had given audiences a glimpse of himself at the very beginning of his career in Hollywood, in Elia Kazan's *A Tree Grows in Brooklyn,* and he had contrived an enigmatic moment of recognition for himself at the end of *Rebel Without a Cause.* Now, his oeuvre was bookended with a scene that couldn't easily be reshot or taken out of the picture.

According to official accounts, an actor with a small part had dropped out at the last moment, and the director was forced to step in, portraying an ailing U.S. official who announces at a high-level meeting that "the United States has no territorial concession in China." Ray performed his brief scene as the official with a heavy beard, swaddled in a wheelchair.

*55 Days at Peking* did surprisingly well at the box office, slipping into the top twenty of 1963. Ray always boasted that none of his pictures lost money, but the truth is that *Rebel Without a Cause* and his two Bronston productions, which were heavily promoted and widely distributed around the world, were his only big commercial hits—and the Bronston super-spectacles outstripped even the James Dean film.

✳

Six months after the *55 Days* premiere, Ray and Utey separated. She moved back to America, taking a house with her two children in Malibu, soon filing for divorce.

By then Madrid was Ray's de facto home, and for a while he seemed to put as much energy into being a public figure in the Spanish capital as he did toward his next film project. He kept in the spotlight by opening a restaurant and cocktail lounge called Nikka's, between Avenida de America and Cartagena Street. The name of the place was a contraction of Nick's name and his daughter Nicca's—although for the next decade his daughters would barely see him. Sumner Williams—his own film career kaput—became Nikka's manager.

Ray's *Flying Leathernecks* star John Wayne, in Europe for *The Longest Day,* was a VIP guest for the opening night of Nikka's. Ray dutifully talked Wayne up as the prospective star of *Circus World,* Ray's big-top

story, now taken over completely by Yordan. The director's friends were always comped at the nightspot—including Yordan and Samuel Bronston, though they rarely came. With a small parade of American celebrities passing through, Nikka's—a small tunnel-shaped basement restaurant by day, a club with a stage for shows at night—became the place in Madrid to see and be seen.

Actor Mickey Knox, who had appeared in *Knock on Any Door* before being blacklisted, stopped at Nikka's one night during a trip to Madrid. Ray strode up to him, coldly declaring that he'd had his detectives follow Knox back when the actor was having an affair with his wife Gloria Grahame. Ray said he had evidence they were lovers. Knox brazenly lied to Ray, insisting it wasn't true. Ray glowered at the actor but slowly stepped away. Knox was not comped.

Besides its well-stocked bar, Nikka's was known for its cabaret and jazz performers, American musicians touring Europe, and emerging Spanish personalities like the singer Marisol, for whom the place was a stepping-stone in their careers. Ray worked closely with some of the younger, novice entertainers, helping to choreograph their acts and advising them on proper stage behavior, throwing himself into producing their shows.

Early on, Ray made himself conspicuous, sitting at the bar, greeting guests, dressed to the nines like Humphrey Bogart, the lord of Rick's Café Americain in *Casablanca*. The Spanish journalists who encountered the director there found him unusually gracious and intimate compared to other Hollywood filmmakers who flocked to Spain in that era.

A chunk of Ray's Bronston-Yordan contract buyout, reportedly around $1 million, was poured down the drain of Nikka's. It was an expensive hobby, and in time the crowds diminished. Eventually, whenever he was in Madrid, Ray the insomniac could be found there late at night, alone at the bar with a bottle, reluctant to go home. When the director started traveling nonstop, Ray bequeathed the place to Sumner Williams for a short time; after being dunned for debts and taxes, then, Nikka's was closed down. Everyone remembers it fondly as a glorious failure.

CHAPTER TWELVE

# *Project X*

### 1963–1979

One day in Madrid, back during the making of *King of Kings,* Ray crossed paths with one of his cinema idols, Luis Buñuel, who had returned to Madrid after years of forced exile. Generalissimo Franco had brought the surrealist filmmaker back to Spain amid huge fanfare, arranging government financing for his new project, *Viridiana.* (The fascist regime would later condemn *Viridiana* and expel the subversive once more from his native land.)

Ray—the highest-paid director in Hollywood, according to his own overblown publicity—invited one of the lowest-paid to dinner, along with Buñuel's son, Juan Luis. "Buñuel, out of all the directors I know," Ray said, "you're the only one who does what he wants. What is your secret?"

"I ask for less than fifty thousand dollars per film," Buñuel replied proudly. He adjusted his stories to small budgets, Buñuel explained, and then filmed them as he liked.

"You're a famous director," Buñuel told Ray. "Why not try an experiment? You've just finished a picture that cost five million dollars. Why not try one for four hundred thousand dollars and see for yourself how much freer you are?"

Ray looked aghast. "You don't understand!" he protested. "If I did

that in Hollywood, everyone would think I was going to pieces. They'd say I was on the skids, and I'd never make another movie." The dinner talk moved on politely.

"A sad conversation," Buñuel reflected later, "because he was absolutely serious."

<center>✳</center>

By the end of 1963, Ray's hair was whitening, and he was starting to grow it long. Though his face was increasingly furrowed, he somehow appeared even more handsome, and he still radiated energy and enthusiasm. He was still the nice guy, welcome everywhere he went.

Ray spent the rest of the 1960s plotting a glorious comeback. At first he stayed in Madrid, making it the main hub of his activity; later he would move to London and Paris and other European cities. When traveling, Ray often had to crash with friends and borrow money. Yet he was determined to restart the career he had frittered away, not in Buñuel fashion, but in the magnificent high style to which he had grown accustomed: hot properties, writers' writers, top stars, plush budgets, first-class hotels.

Shortly after he and his wife separated, Ray struck up a collaboration with James Jones, the author of *From Here to Eternity*. The two had much in common: Both were midwesterners in Europe, boozers, chain-smokers, self-styled macho men. Ray had the idea of making a sprawling Western, set in the late nineteenth century, and Jones liked his idea. In the fall of 1963, Ray moved in with Jones and his wife and two children in their Ile St.-Louis home in Paris. But the director couldn't raise money on the story, Jones had other work and interruptions, and the Western was deferred.

For several years, the Jones residence was Ray's refuge whenever he passed through Paris. Jones's secretary recalled fondly how the director hurtled through their lives, arriving and departing in puffs of Gitanes, leaving behind suitcases and books and wallets and piles of files and swirling scraps of paper. He also left behind astronomical telephone bills: Though he could be maddeningly uncommunicative in person, these days Ray seemed to be perpetually on the phone trying to conjure financing or to coax stars of his earlier films—Anthony Quinn among them—to star in his increasingly chimerical projects.

His son Tim was at Cambridge in England, and Ray visited the young

man and sometimes crashed with him and his friends. In London, Ray made the rounds of American blacklistees; they were usually happy to see him, though inevitably he got around to asking for a handout. ("Can I borrow a hundred pounds? Do you know any producers?") He picked up pocket change from old friends and seed money from producers willing to shell out for a synopsis or treatment, though wary of heavy investment.

While touring Europe for a *Redbook* assignment in the summer of 1963, Jean Evans visited her ex-husband in Madrid. Alarmed by his habits—insomnia, chain-smoking, drinking, and drugs—she talked with Joseph Losey, who operated out of London. Losey's main interest was Losey, and despite the blacklist his own career was going gangbusters; Losey still considered Ray a friend, but he was more disposed to his fellow La Crossian in the abstract than in the flesh. When Ray turned up on his doorstep, Losey passed him on to an acquaintance, Dr. Barrington Cooper.

Cooper was a fatherly physician and psychiatrist who was renowned in London for treating prominent English politicians, intellectuals, artists, and entertainers. "An intuitive and calming man," the *Times* wrote of the admired doctor, "Cooper divided his practice equally between the cure of the body and the mind. To be received in his consulting room was to encounter tact, extreme discretion, imagination and sympathy."

As he added more and more screen figures to his clientele, Cooper acquired ambitions to become a motion picture producer. One of his patients had been Dylan Thomas, and after Thomas's death in 1953, Cooper had secured the rights to one of the Welsh poet's few film treatments, called *The Doctor and the Devils*. Set in nineteenth-century Edinburgh, the story drew on the exploits of a real-life surgeon, Dr. Robert Knox, who had employed two Irish immigrants to rob graves (and kill people) to supply bodies for his anatomy classes. The mystique of Dylan Thomas made the property potentially valuable, although his musical prose made it seem unfilmable to most who read it.

In Cooper, Ray had stumbled upon a physician and coproducer all in one—complete with precious film material. The director moved in with the doctor, living in his London mews for several months. The shared residency was a form of "occupational therapy," as Cooper recalled. The physician in him tried to cure Ray of his amphetamine and other dependencies; his aspiring-producer side joined Ray in forming Emerald Films, buying stories or scripts on which the partners collaborated, then selling

the improved drafts to other producers. Sometimes there was more reliable money to be made in script speculation than in iffy film ventures that took forever to become realized. "We edited and cowrote," Cooper said, and Ray was "an extraordinarily effective script editor."

They made decent money at it, shuffling their scripts and dealing them out like cards. They held on to two high cards for themselves: *The Doctor and the Devils* and another project, an adaptation of Dave Wallis's futurist novel *Only Lovers Left Alive,* which Ray intended to direct after they filmed the Dylan Thomas script.

Ray met several times with James Mason, who was intrigued by the prospect of the Dr. Knox character, though he weighed the risks of reuniting with the director of *Bigger Than Life.* Ray also met with Yugoslavian businessmen and producers who were interested in creating a "Hollywood on the river Sava" in Zagreb. Ray's leftist credentials and positive experience in Spain under the Franco regime made him seem a plausible bet to thrive under the Communist rule of Marshal Tito.

Although Ray and Cooper flogged the script of "The Doctor and the Devils" for a while, they decided they needed an established writer to give it polish and add another name for investors. The director journeyed to Paris to interview candidates, engaging as his assistant a young American, Frawley Becker, who had come recommended by Robert Parrish. Fluent in several languages, Becker was expected to help round up French writer candidates and prospective actors and crew while serving as intermediary in Paris-based meetings with possible financiers. In Zagreb, when they got around to filming, Becker would serve as Ray's dialogue coach.

Ray waved the most recent draft of the Dylan Thomas script in front of his new assistant as though it were an aphrodisiac. "It's Gothic, even a bit macabre, set in Victorian England. And full of dark poetry," Ray explained.

"Who adapted it?" Becker asked.

"The latest revisions are mine," the director replied ambiguously.

The script was still incomplete, Ray admitted, because he was still debating the ending. The script Becker read ended with a fade-out on the main character, with these teasing words: "We do, indeed, see him again, one last time, but perhaps not in the place or the time we expect."

The involvement of the Yugoslavians and the prospect of filming in Zagreb spurred the director into a wholesale rethinking of the script. He

decided to transpose much of it to the Austro-Hungarian empire, with glimpses of the field of battle at Waterloo, where Dr. Knox first crosses paths with one of the body snatchers. Aghast at how far the idea was straying from Dylan Thomas's original (with Edinburgh passed over in favor of Vienna and so on), James Mason begged off. Ray began talking up Laurence Harvey as a potential lead, surrounded by a cast of international names.

"I was with Nick almost daily, with night and day bleeding into each other," recalled Becker. "He never seemed to sleep, this man. Not conventionally. He would work on well into the night, hold long, late interviews with French writers to whom he would pose the question, 'What is this film about?' Then the writer would answer by narrating the incidents in the screenplay, while Nick closed his eyes and listened . . .

"Then there would be an interminable silence during which nothing happened and we were sure he'd fallen asleep. Finally he would open his eyes and through his drifting Gitanes smoke say, 'No, no, not the plot. I know the plot. What is this *about?*'"

Most of 1964 went by in whiskey-soaked, Gitanes-smoke-wreathed slow motion. Ray kept trying to figure out what "The Doctor and the Devils" was *about,* never mind the ending. Ray couldn't find the right writer on his shoestring advances, and the Yugoslavs added a caveat: They would invest up to $600,000, ultimately, but only if the director found matching funds from U.S. producers and forged ties with a Hollywood studio for Western-world distribution.

As usual, the director distracted himself with half a dozen other possible projects, which tumbled from his mouth as easily as bumming a cigarette. At one point Ray was on the verge of launching a production of Henrik Ibsen's *The Lady from the Sea,* with Ingrid Bergman and Laurence Olivier as his stars and a $2.5 million budget from MGM, until someone at MGM looked over the prospectus and thought twice.

The director also toiled briefly on an adaptation of *Next Stop, Paradise,* a Polish novel by Marek Hlasko about the hard lives of truck drivers in the mountain forests of the Carpathians. Another *Ben-Hur* alumnus, Stephen Boyd, was announced as the star after meeting with Ray. The director decided he would shoot the picture in Poland or Alaska, making it another ethnographic adventure like *Bitter Victory, Wind Across the Everglades,* and *The Savage Innocents*—until one night he fell into a drunken quarrel with the author in Stockholm and learned that Hlasko had slept with his ex-

wife Betty in Hollywood, and, worse, that he'd already sold the book to another producer.

Now and then, Ray put in some time on the James Jones Western, while crashing with Jones and family on the Ile St.-Louis, running up phone bills before rushing out the door to an urgent meeting with another backer in another country. Ray became extremely proficient at extracting installments from deep-pocketed producers, and every once in a while he used his salesmanship and contacts to broker a deal for another colleague. According to Bernard Eisenschitz, for example, Ray handled the sale of German director Volker Schlöndorff's second film to Universal for American distribution, pocketing $50,000 of the $173,000 deal plus $10,000 for expenses.

But the Yugoslavs were purposeful, and 1965 loomed as the make-or-break year for "The Doctor and the Devils." After visiting Zagreb and Belgrade, Ray was convinced that the time had come. By now he was a familiar figure at European film festivals, sometimes as a juror, other times just there to see films and dole out interviews. At Cannes in 1965, Ray met with John Fowles, a writer's writer, trying to convince Fowles to take the Dylan Thomas gamble.

Fowles, who'd come to Cannes to promote William Wyler's film of his novel *The Collector,* regarded Ray warily. He found the director "atrociously hesitant and uncommunicative" in person, Fowles wrote in his journal. "After his first 'good films' he has had a decade of bad ones. He explains, with nervous drawings that mean nothing, his idea of mixed shots in one frame, to tell, say, three stages of a story simultaneously. But he is vague, so vague. . . . I have glimpses of what he intends—something Expressionist, historical, Bergman-like," Fowles added. "But his sentences taper off into silence."

Overnight Fowles dutifully read the latest version of the script, which, he said "plunges from good to bad and back again. I can't decide, it is so far from decency." Before Fowles met with Ray again, he had a sobering word with Jud Kinberg, the producer of *The Collector,* who had known Ray in Hollywood and in Rome. "He's a difficult man to work with," Kinberg told him. Fowles's second meeting with Ray was comprised of "more indecision, more silences." Fowles backed off; Kinberg's cautionary words had struck a nerve, like the advice Charlton Heston got from his publicist.

Eventually, Ray's eyes turned to Rome. The ancient city had been

lucky for Ray, and he still had many connections there. The director flew to Rome to meet with Gore Vidal, an old friend from his Chateau Marmont days, now an author of distinction (of mainly novels and plays, though he had doctored *Ben-Hur*) who didn't cavil about money. Ray prevailed upon his old acquaintance, and in a Rome hotel room he and Vidal wrestled the script into a condition meant to impress American investors.

"He was a big con man, as all successful directors are," Vidal recalled cheerfully, "And I suppose we had enough past in common. Anyway, he didn't bore me, which most movie directors do. But he was quite crazy.

"The first sign when I realized you could perhaps institutionalize him: he came to my flat in khaki trousers with one leg torn to shreds. I said, 'What the hell did you do?' He said, 'Well, I went to the zoo, where there's a new lion cub. I held it, then it fell and cut my trousers; but I want to own a lion cub and I'm going to buy it.' I said, 'Where are you going to keep it?'—'Oh, I have a little flat in Paris.' I said, 'But you're always away, how are you going to keep the lion?'—'Oh, it's not difficult, I'll find somebody to look after him.' That was when I realized I was dealing with a madman."

Everything about the project ballooned as the director kept raising the stakes on the story and budget. The script Ray and Vidal wrote together ran to 152 pages, which would augur nearly three hours on-screen. The official projected cost of the production was $2.5 million, but everyone who read the script viewed that as a deliberate underestimate.

More intriguingly, Ray—a onetime actor who had squeezed himself into several pictures in his career—had conceived a new framing device for the Dylan Thomas story, giving himself an on-screen role as director of "a film company shooting a picture and we dissolve from the director commenting on the film to the story itself," in the words of one précis. Besides the autobiographical elements, "The Doctor and the Devils" also was intended to make good on long-standing Ray artistic ambitions: dabbling in divided screens that would show parallel action unfolding in multiple story lines.

Laurence Harvey was no longer the definite lead; the star would probably be Maximilian Schell (or "an equivalent," as Ray explained in meetings), with Susannah York as a love interest added for commerciality (the story reaches a crisis point when her body is delivered to the doctor), and/or Geraldine Chaplin and/or Ava Gardner, with whom Ray had been trying to mend fences. (As a juror at the 1964 San Sebastián International Film Festival,

according to Bernard Eisenschitz, Ray campaigned strenuously for Gardner to win Best Actress for her role in *The Night of the Iguana*.) The "devils" of Dylan Thomas's story—the two drunken thieves who lure and strangle people to provide the dead bodies—had become less important as the script evolved, as did the simarily shifting names of the actors playing the roles.

Vidal's rewrite gave Ray a fresh jolt of optimism, and the director moved "permanently" to Zagreb, setting a start date of October 21, 1965. Ray grandly announced a $14 million slate of eight or more international coproductions to be produced under his own banner: basically his personal file of script ideas, including the James Jones Western. For all his troubles, the name Nicholas Ray still resonated in Hollywood, and the news made all the trade papers.

With his Yugoslav start-up money in hand, Ray contracted a capable cinematographer and art director from Prague; he hired the faithful Hanne Axmann to design the costumes, Renée Lichtig as his editor, and her sister Lucie as script girl. In a Zagreb hotel suite the director presided over a staff of several dozen. It wasn't quite the lap of luxury, but it was a fair imitation of Bronston and Yordan, with government vouchers and civic support. "Nick thought and spoke in English," recalled Cooper, "the Yugoslavs thought and spoke in Serbo-Croat, and their Ministry of Culture thought and spoke in French. So the script meetings were just a little complicated."

Ray sketched shots even as he rewrote the scenes to change them utterly. The latest version of the script was dispatched to America. The director was still anathema at the major Hollywood studios, where he had crossed the line too often in too many ways. But Ray knew people in high places in New York, bankers and lawyers who had taken management positions with the small independent film production companies that proliferated now that most of the West Coast goliaths were floundering.

After Vidal's script bounced around New York offices over the summer of 1965, Ray pinned his hopes on Seven Arts Pictures, a thriving Park Avenue enterprise headed by Ray Stark and Eliot Hyman. Seven Arts financed films and then sold them to the major studios, gradually becoming equity investors. (In 1967, the company finally merged with Warner Bros.) Stark was a former hard-charging Hollywood agent who steered West Coast affairs; Hyman, the lower-profile partner, came from wholesale tires, microfilm, and TV programming. Both had played gin rummy with Ray back in the day.

Seven Arts was asked to invest $750,000 in the Dylan Thomas film; in return the company would get all world distribution rights to the picture, except for Italy and the Eastern Bloc countries. (Those were set aside for the Yugoslav film companies Avila and Pol.) At least one-third of the $2.5 million had to come from Spanish investors and other sources yet to be determined. The director requested a $225,000 salary, down from his supposed high of $1 million, but with a share of anticipated profits.

Seven Arts remained undecided about the Gore Vidal script, even as casting was being finalized and the sets were going up in Zagreb. In this way too, Ray was following the Bronston-Yordan model, viewing the script as a fluid entity, more a selling tool than a final blueprint. A few weeks before the shooting was set to begin, as Ray made another round of changes—turning a boy character into a girl, flipping settings and time periods, and so forth—Vidal finally threw up his hands. The director also hurt himself by informing Seven Arts that he was still "working on the script daily" and that it was "much better than the first draft" he had delivered to America. "Sounds like a few other directors I know," a company story analyst commented smarmily in a private memo.

It fell to longtime story editor and script consultant William J. Fadiman—ironically, the very man who had once read a book called *Thieves Like Us* and urged RKO to option it for the screen—to summarize the risks of Ray's project. "The total cost of this picture—two to two and a half million dollars—is staggering, but there are reasons for it," Fadiman wrote. "There is a huge fiesta-pageant, there are numerous scenes of crowds; the final trial scene has many people—but none of these elements aid the story one single bit."

Despite Vidal's sparkling writing, Fadiman said, the story never really jelled. "The dialogue—Vidal cannot write bad prose—is literate and clear; but it is not outstanding and I have the impression that Vidal did this job very hurriedly..."

The director was another issue. "I would certainly not think of Nick Ray for this even if it were contemplated (as it is) on a high budget. This is the kind of shock material that could be done best by an [Henri-Georges] Clouzot or a Carol Reed or even a Hitchcock."

As the first cast members landed at the Zagreb airport, they might have waved to Ray, who was boarding his own flight to New York for an eleventh-hour summit with Seven Arts executives. The director was

counting on winning over key people in person with the likability that had always been his calling card. Although Ray made a solid pitch, the rumors about his lifestyle, which had followed him for years in Hollywood, didn't help his cause. The director hadn't visited New York for a few years, and his aging appearance startled company representatives. Seven Arts accepted Fadiman's negative report. No U.S. money was promised.

What happened next is cloudy; over the years Ray offered conflicting accounts. The start of filming was officially postponed several times, until one day it could be delayed no longer and the actors assembled to start work. They were amazed to learn their director was still in New York, foraging for the matching funds he needed to save the film. Ray ordered assistant director Lou Brandt—one of Los Negroes—to call the first take in his absence. After a day or two of this, even the truest believers drifted home. "The Doctor and the Devils" was abandoned, although the stink of litigation would linger for years.* Nobody even knows for sure whether Ray ever even returned to Zagreb.

"He'd had a year or two of living as a great man in a small, unsophisticated community, and he liked that very much," Cooper explained. "He had done what came easily to him, which was storytelling and directing preproduction, when he would be a great man. But I think that he was terrified of fucking it up on the floor."

"Nick was a Titanic, an ocean liner, a sinking one," Hanne Axmann said more bluntly.

Within the film industry, Ray's breakdown during *55 Days at Peking*—and the stories of his erractic behavior on earlier films—represented a stain on his reputation that would never wash away.

✳

"The Doctor and the Devils" was Ray's last real chance at a Bronston-type comeback. He made other attempts at launching grand-scale projects, but they were even less in line with reality. In May 1966, for example, the Rolling Stones announced that the director of *Rebel Without a Cause* would

---

* Mel Brooks finally produced a film of *The Doctor and the Devils,* based on the Dylan Thomas script and having nothing to do with the Nick Ray version, ten years later, in 1985.

guide their first motion picture, *Only Lovers Left Alive,* with the Stones as the youth gang of Dave Wallis's novel battling for survival in a postapocalyptic world. Ray was flown back and forth across the Atlantic to hotels and press conferences, but as Betty Utey said, it was all a "total fantasy," lasting only a few weeks before it evaporated. (Though not before the director got some money out of it.)

More typical, in these years, was what happened when Frawley Becker ran into Ray on the Champs-Elysées a few months after the Rolling Stones nonstarter. The director started telling his former assistant about his plans to remake *Gosta Berling,* based on the classic Swedish novel by Selma Lagerlöf, which as a silent picture had helped to introduce Greta Garbo to audiences. Ray claimed that Ingrid Thulin, an ice-blond Swedish actress who had risen to international prominence in several of Ingmar Bergman's stark masterpieces, had expressed definite interest in playing the lead.

The Swedish actress wanted script approval, as Ray explained, and he hadn't yet put together a proper script. He had always alternated famous writers with novice ones he tried to mentor, and this chance meeting spurred a surprising offer. Ray asked Becker if he wanted to try collaborating. Becker was flattered enough to accept, even though he realized that Ray was "debt-ridden at this point, and so had no money to pay me."

The new partners plunged into hard work "every day, long, long hours," as Becker remembered, "writing a narrative treatment, but animating it with great spurts of dialogue that flowed out of Nick easily. Of the character Gosta Berling, a minister with earthly desires, he wrote, 'Just because a man's collar is on backwards doesn't mean his pants are buttoned up.' I was in love, totally in love, with Nick's creativity, and what we were doing together. Yet I was not blind to the fact that he was broke and that I was buying almost all our lunches or dinners. I didn't care. I considered it tuition to school. And I didn't care when he spoke of his gambling debts at some of the clubs, and I lent him several hundred dollars that he probably used to go to other clubs, drink, and lose still more. I didn't care that I would never see that money again."

After they banked about twenty-five pages, Ray announced that he had enough material to fly to Sweden to meet with Thulin and her husband, Harry Schein, a founder of the Swedish Film Institute, who advised the actress on her career choices. The director told Becker to continue on in his absence. "The very name of Nicholas Ray opened any door in

Europe," Becker believed, "including the one to Thulin's home, which was where their meeting was to be."

The director raced off to the airport, leaving behind his debts, his personal belongings, and the unfinished script. Becker dutifully carried on with the writing—until a few days later, when Ray phoned from Sweden, sounding rueful. The Thulins had surprised him with a piece of news: The screen rights to Selma Lagerlöf's novel were tied up with another producer. But "they both *loved* the idea of Thulin doing the role," Ray told Becker, trying to put a good face on the situation.

Overnight, *Gosta Berling* was dropped, Becker's long, long hours with Ray all wasted. The protégé never saw or heard from his mentor again. Like many others momentarily seduced by one of the director's enticing pipe dreams, however, Becker considered the whole episode one of the charmed moments in his life.

✳

After "The Doctor and the Devils" imploded, Ray fled to Munich. He lived with Hanne Axmann for a spell, until she couldn't stand his all-day, all-night routine any longer and kicked him out. From there he moved to Sylt, the largest of a group of islands in the Wadden Sea, a part of the North Sea, off the western coast of Schleswig-Holstein, Germany, near Denmark. Ray had briefly vacationed on Sylt in 1964 and was drawn to the island's Wisconsin-like winters and warm, pleasant summers. A year-round retreat for affluent retirees, Sylt was also a longtime retreat for homosexuals and a popular spot for vacationers who prized the sea air, water sports, and nude beaches.

Ray lived first in a guesthouse in the village of Braderup near Westerland, the island's largest town. The landlady thought her new tenant resembled a gnarled lumberjack, with his deeply lined face and astonishingly low but cultivated voice. The American told her proudly that he was a Hollywood movie director, but that his real last name was Kienzle, and he was descended from the German Kienzles, whose patriarch had founded a quality clock-making firm in 1822 that was still in business a century and a half later.

Sylt was connected to the mainland by a causeway, allowing the director to make rapid trips to an airport that offered excursions to London,

Paris, Madrid, Rome, and elsewhere. He encouraged friends and potential producers to visit him on Sylt, where he delighted in taking them to the nude beaches, stripping off his clothes and stretching out naked on the sand to brainstorm his latest project. As usual, his residence was more a launching pad than a permanent settlement, but the island felt like a real home to Ray. "I love the panorama of change," the director told an island publication. "I had to live where the leaves turn and where they fall, where the trees return to green, where it storms and then becomes sunny afterwards."

Raving about the climate and topography while ignoring the practical realities, Ray began to envision film stories that he could shoot entirely on the island, simulating nearly every kind of landscape in the world. "Here one could realize things that were impossible elsewhere," he rhapsodized in interviews. At one point, Ray outlined a project that would bring Jane Fonda and Paul Newman, along with two thousand extras, to the island. This project even had an intriguing title: "Go Where You Want, Die as You Must." Ray made tireless scouting trips around the island, filming screen tests of local residents, even talking about constructing a soundstage—out of driftwood!—on the island. Municipal authorities convened meetings about how to serve his needs.

One local paper, *Sylter rundschau,* sent a photographer to shoot the director feeding white paper into a typewriter, supposedly working on the Fonda-Newman script, a cigarette dangling from his mouth. Many other would-be scripts would pass through the same typewriter over the next three years—one intended for Brigitte Bardot, another about an escaped convict on an island with a lighthouse. But none ever quite got the ending it needed, and none was ever filmed.

Ray entertained an incessant stream of ever-younger admirers on the island, who came and went as he did. He had girlfriends aplenty, an endless number; some of them he referred to, jokingly, as his "nurses," because part of their responsibility was to keep him regular with his vitamins, including booster injections in the backside. (Ray liked to boast that one girlfriend was a granddaughter of composer Richard Wagner, whose music James Dean had hummed in *Rebel Without a Cause.*) Perhaps there were boyfriends too; no one is sure. The visitors and lovers and crashers piled up indistinguishably.

The visitors included supportive critics like V. F. Perkins, who arrived from London one day to film Ray for a BBC television show, and Ray's son

Tim, who also came from England. Tim had been trailing his father for a few years, usually accompanied by a gaggle of chums. But on the island he and his father developed a closer relationship, and the director encouraged Tim to become a cameraman.

Ray's projects kept falling by the wayside, however, and his trips away from Sylt waned. Few American producers had any idea where he was living. Even Philip Yordan, asked by an acquaintance why he didn't hire Ray to direct one of his many productions in the 1960s, said he wouldn't know how to contact him if he wanted to. (As usual with Yordan, who spent the decade in Europe making his own pictures, it's unclear whether that was entirely true.) There were a number of Europe-based producers who did make the effort to visit Sylt, but they left after finding Ray unable to talk for long about a film idea without multiplying the story lines and stars, subdividing the imagery on-screen, and doubling and tripling the anticipated budget.

By the late 1960s, not for the first time, the director's finances had reached a dire state. He had surprising resources—paintings he bought and sold along the way, small bank accounts and investments—but some days the well ran dry. Ray sent a begging telegram to studio head Darryl F. Zanuck, who had resumed control of 20th Century-Fox after some years away. Apart from Howard Hughes and, to a lesser extent, Jack Warner, Ray had had only glancing contact with the legendary moguls of Hollywood. Zanuck was absent from Fox when Ray directed *Bigger Than Life* and *The True Story of Jesse James,* and he barely knew Ray, but out of fondness for Elia Kazan and James Jones—both of whom urged him to help— he responded with a check.

Ray sold his Mercedes, which he had been parading around the island. ("He made one's ability to tolerate his reckless driving a kind of loyalty test," recalled V. F. Perkins.) He moved to increasingly smaller houses, leaving behind unfinished scripts, personal mementos, heaps of refuse, and, always, unpaid bills. The director drank to stay awake and drank to fall asleep; he took any drugs on offer, in this era when the variety of available stimulants snowballed; he carried around a doctor's bag with his vitamins and amphetamines and other anonymous uppers and downers. Whenever he felt the urge, if one of his "nurses" wasn't available, the ex– Hollywood director happily dropped his trousers, no matter whom he was speaking with, and unselfconsciously injected himself in the buttocks.

Unable to make the big films, Ray began making small ones, returning

to adolescence as a theme but also in his methods. He launched a "student film" with his son Tim as the cameraman and Tim's schoolmates as performers—a sketchy story called *The Scene* about private school students revolting against their privileges. Jean-Luc Godard loaned him sixteen-millimeter cameras and a cameraman, and they collected a bunch of footage that included boys poring over sexually explicit magazines and "one of the most lyrical, poetic expressions of masturbation I've ever seen," as Ray later told Vincent Canby of the *New York Times*.

Living on Sylt might have made him elusive to producers, but Ray was easily sought out by cinephiles, who flew him to the burgeoning number of retrospectives in his honor throughout Europe. One of those occasions was May 1968, when a Paris theater made Ray and his son Tim special guests at a joint screening of *Johnny Guitar* and *They Live by Night*. Students rioted in the Latin Quarter that night, and after the double feature Ray rushed to the melee in the streets, camera in hand, and father and son shot footage they intended to incorporate into their Sylt film. (A third segment was later shot in London with stock and crew left over from a Godard production.)

There are many legends about Ray during May 1968; the unsubstantiated report that the director of *Rebel Without a Cause* handed a gun over to militants that he claimed had been bequeathed to him by James Dean is the most famous.* But there is no question that the tall, striking man strode through tear gas and milling crowds, calling out shots for a film taking shape in his head. Paris was still the home of his most fervent cult, and Ray could always find lodging with one of his followers; he would always borrow money and whip up excitement among the Nouvelle Vague critics, many filmmakers now, who'd championed him from the first.

The late 1960s were hopscotching years for the director. Perversely, his inactivity—as well as his bizarre activity—only served to solidify his place in the martyrlogue. Throughout the decade auteurism spread across America, gradually becoming as pervasive and deeply embedded a critical theory as it had been in England or France in the 1950s. Along with Eugene

---

* The director always insisted that Dean slept with a gun under his pillow during the making of *Rebel Without a Cause*. When Warner Bros. took the gun away from him, the star acquired another, according to Ray. Dean had several guns, one of which he bestowed as a gift on the director after the filming, Ray said. That, presumably, was the gun handed to Paris militants—which has never been traced.

Archer in the *New York Times,* and Peter Bogdanovich as a programmer of
New York retrospectives (along with his film journalism and criticism),
the leading voice was Andrew Sarris, who'd begun his career as an editor of
the short-lived English-language edition of *Cahiers du Cinéma.*

As early as 1961, commenting on the *Oxford Opinion–Sight and Sound*
dust-up, Sarris had defended *Party Girl,* the film that separated the men
from the boys—the auteurists from "old fogies." The film's acting, script,
and subject matter may be "beneath contempt," Sarris maintained, but
"in Ray's wild exaggerations of decor and action, there arises an anarchic
spirit which infects the entertainment and preserves the interior continu-
ity of the director's work." Sarris ended his appraisal of the Robert Taylor–
Cyd Charisse quasi musical by re-hurling the French gauntlet: "One may
choose to confront or to ignore the disturbing implications of *Party Girl,*
but the choice involves more than one film and one director. It involves
the entire cinema, past, present and future."

Sarris launched a widely read column in New York's alternative weekly
the *Village Voice* in 1960 and wrote prolifically for this and other venues
about Ray's work, finding merit in the least of the director's films when-
ever he had cause to mention them. Sarris's aggressive auteurism sparked
a notorious response from old-fogy critic Dwight Macdonald in *Esquire,*
who called Sarris a "Godzilla monster" that was "clambering up from the
primeval swamps" of small publications to champion the pretentious *poli-
tique des auteurs.*

Macdonald didn't mention Nicholas Ray, but Pauline Kael did, in pass-
ing, when she joined the attack on Sarris. In "Circles and Squares," pub-
lished in the spring 1963 *Film Quarterly,* she denounced auteurists as silly
and dangerous ("they're not critics, they're inside dopesters"). Kael never
wrote very much about Ray (he was basically done directing by the time she
started reviewing), but her hostility to the celebrated auteur and his films
became well-known among her acolytes, who were as numerous as Sarris's.

Not until 1970 did Kael get an opportunity to harangue Ray—in
person, over lunch at a Chinese restaurant. "Pauline, vexed by his recent
critical deification, went through his films one by one," recalled *New York*
critic David Denby, who was present at the Chinese lunch. "This movie
twenty years earlier had a few good shots, another one had been over-
praised, a third was terrible and so on. And Ray, his face cast down into his
shrimp and rice, said hardly a word."

The Sarris-Kael feud would rage and simmer until Kael's death in 2001, a conflict dividing American film critics between those who generally sided with Sarris, in one corner, and the so-called Paulettes, who refused to wholeheartedly embrace auteurism, in the other. It was a complex argument with many underlying causes and disagreements. But over time Ray became "the cause célèbre of the auteur theory," as Sarris proclaimed, a thunderclap that left little room for middle ground. In other words, one could not be a serious film critic without admiring Nicholas Ray.

Sarris outlasted Kael, but perhaps his enduring contribution to film culture came early in the debate: his seminal 1968 book *The American Cinema: Directors and Directions, 1929–1968,* which expanded upon a hierarchal categorization of filmmakers first aired in *Film Culture.* Sarris did not rank Ray in his "Pantheon" of the fourteen greatest American directors, but the hero of the auteurists made the second grouping of twenty, dubbed "the Far Side of Paradise"—ahead of John Huston, Billy Wilder, and Ray's friend Elia Kazan, among many others. (Sarris's full list ranked more than two hundred directors, grouped in eleven categories.)

Sarris's summary of Ray's career hailed "the indisputable records of a very personal anguish that found artistic expression" for too short a time. Sarris found merit in the most tenuous of Ray films, among them *Wind Across the Everglades.* (Years later, irked by one of Sarris's routine references to *Everglades* as a Nicholas Ray film, an outraged Budd Schulberg wrote Sarris privately to complain that Ray got too much credit for the film. Schulberg, after all, had notched many years vacationing in and absorbing the Everglades culture; he had written the script, overseen the casting, actually directed part of the film, and sat in on all of the editing. Ray, meanwhile, had been fired from the production. How, then, was this a Nicholas Ray film?)

As ever, all the critical wrangling added luster Ray's name. Yet it did nothing for his career: He remained out of action for most of the 1960s. Yet whether his inactivity was perceived as bad luck or artistic rejection by the establishment, whether he was seen as a reclusive eccentric or substance abuser, Ray's unfortunate circumstances lent him a distinct tarnished glory and lodged him still deeper in the martyrlogue.

❋

The French auteurists also paid tribute to their idol in their own films. In *Pierrot le fou,* Jean-Luc Godard chose *Johnny Guitar* as the film to which Jean-Paul Belmondo sends his nanny to improve her mind. In *Mississippi Mermaid,* Francois Truffaut shows Belmondo and Catherine Deneuve the same film to kindle their love.

In Hollywood itself, Ray was increasingly forgotten. By the end of the 1960s, few studio executives or producers from his heyday held on to power. Many in his peer group—crusty old directors who'd survived decades of studio dictates and their own difficult career struggles—didn't think much of Ray, if they thought of him at all.

In interviews, Ray himself tended to denigrate certain filmmakers by name. Though, for example, he praised Marilyn Monroe's last picture, *The Misfits,* directed by John Huston, Ray said it was "not as good as *The Lusty Men," his* rodeo film. He made disparaging remarks about Alfred Hitchcock, once a personal favorite, now a shockmeister in Ray's opinion. He made dubious, sweeping pronouncements that couldn't have endeared him to many in his profession: "Directors who have not had the experience of acting are crippled to some degree," or "I started out as an actor, so did Elia Kazan. That's why we're two of the greatest movie directors in the world."

His onetime collaborator and lover Gavin Lambert met John Ford in the mid-1960s. When the great American director asked Lambert how he had come to live in Hollywood, the Englishman replied that he'd been engaged to work on a Nicholas Ray film. "Never heard of him," snapped Ford. (Although, with Ford, one never knew; years earlier, he might have heard the young Nick Ray group him with Cecil B. DeMille and other "old-fashioned boys.") Around the same time, Serge Daney and a *Cahiers du Cinéma* colleague were interviewing George Cukor, still active as a director in Hollywood after over thirty years on the job. They made the mistake of fleetingly praising *Wind Across the Everglades.* "Hearing this," Daney said later, "Cukor started howling, the laugh of a mean and sour old lady, crying to the others, 'Come here, come here! You know which film they like? *Wind Across the Everglades*! The film that Jack Warner didn't even dare release!"

A few years later, Ray appeared at a University of Chicago film society event with Fritz Lang, who had worked for producer Jerry Wald at the time Ray was directing *The Lusty Men.* "I was just coming out of the men's room with Lang," Terry Curtis Fox reported with astonishment after Ray's death, "and he turned to me and asked who was this guy with the eye-patch. He didn't know who Nick was." Of course Lang might have been jealous to share the stage with someone he considered a lesser mortal; and by that time Lang might not have recognized Ray—who in those days sported an eye patch eerily like Lang's own accessory—as the strong, handsome, smiling paragon of the craft that he'd been in 1952.

✳

As the heady summer of 1968 passed, Ray carried on. He undertook more low-budget shoots and started new scripts; he indulged in further debauchery and suffered more downsizing. Finally, he moved to a smaller house on the east side of Sylt, close to the Wadden Sea. A crazy-mirror Almanac House, Ray's place became a commune for momentary friends, hippies, and drug addicts, strewn with litter, empty champagne bottles, and used hypodermic needles.

Helped by his son Tim, Ray delved into an autobiography, making long tape recordings for Tim to transcribe preparatory to polishing. Ray persuaded a publisher to give him a little advance money, but it was difficult to organize the scattershot material and fill in the vast blank spaces—some memories permanently lost, others secret, known only to Ray. The writing changed and improved certain memories. He could never decide whether to tell some of the secrets. Ray wrote pages and pages of stream-of-consciousness memories, hoping almost to the end to finish an autobiography, leaving notes and pages behind whenever he moved on.

In the fall of 1969 two young visitors arrived. A pair of independent filmmakers from America, Bill Desloge and Ellen Ray (no relation), had brought their first movie, a sex, drugs, and rock 'n' roll Western called *Gold,* to Cannes. Now they were making the pilgrimage to Sylt, inspired by Ray's empathy for delinquents and the courtroom theatrics of *Knock on Any Door.* They thought they might coax the living legend back to the United States to direct their second planned film, about a young man on trial for possession of marijuana.

Ray had been absent from his native land for most of the 1960s, a decade in which America had undergone seismic upheavals: the assassinations of John F. Kennedy, Martin Luther King Jr., and Robert F. Kennedy; the civil rights movement and the war in Vietnam; protests, demonstrations, riots, shootings, bombings; the woman's movement, gay liberation, and the spread of the young scofflaw counterculture. But Ray had been energized by the spectacle of May 1968 in Paris, and the director felt in tune with the new rebels and their causes. When the young Americans offered him a plane ticket and the promise of a crusading film project, he declared himself ready to abandon the island of Sylt.

Leaving practically overnight, he stored his paintings on Sylt and in other European cities—paintings he later claimed were worth $1 million—while defaulting on many of his island debts, including his massive phone bills. When his last landlady tracked him down by phone and pleaded with him to return his missing house keys, Ray returned one last time, grandly handing her a bag full of several hundred keys, telling his landlady she could hunt for hers among them. As if he were declaring, "Such incidentals do not concern me . . . I am not a materialistic American."

<p style="text-align:center">✳</p>

The director flew straight from Europe to Washington, D.C., arriving on Saturday, November 15, 1969, as thousands of demonstrators from all around America gathered in the nation's capital to protest the escalating war in Vietnam. Though thousands were there to protest peacefully, one more militant antiwar group tried to march on the South Vietnam embassy before being repelled by riot policemen.

"An hour" after disembarking, Ray later said, "I was in Dupont Circle, with a camera in my hand, for the first gassing" of the radicals. Camera crews organized by Ellen Ray accompanied him throughout the chaotic weekend as the director weaved through the streets—à la Paris '68—chasing the left-wing agitators. The battle escalated on Sunday, November 16, when store windows were smashed, police cars damaged, and rocks and bottles tossed at government buildings. Dozens of arrests and injuries were reported.

Ray felt invigorated, feeding as ever off the energies of those around him. He talked about adding the footage of antiwar rioting to the unfin-

ished films he'd been creating on Sylt, then integrating all of that and more into the marijuana-defendant film, precise form and content to be determined later. While on the East Coast, his young producers set the director up with deep-pocketed liberals in D.C. and New York, and Ray found that antiwar sentiment had loosened up the flow of money. He caught up with Jean Evans and Connie Ernst Bessie and other friends from the past who were glad to see him, hopeful the new film was real and willing to cheer him on.

Many of the D.C. radicals bore banners supporting the Chicago Seven, a group of movement leaders who had been charged with conspiracy and inciting to riot during the 1968 Democratic National Convention. During his first weekend back in America, Ray met and filmed two of the Seven: the Youth International Party (Yippie) leaders Jerry Rubin and Abbie Hoffman. (Ray was especially proud of a shot of "Abbie lifting his shirt to expose his tummy in the L.B.J. gall bladder pose," as Roger Ebert later wrote.)

The "Chicago Conspiracy" trial had riveted the nation's attention since September, and now it riveted Ray's. Chicago—the city he'd known well since high school and his one-semester matriculation at the University of Chicago—was the next stop in his homecoming. *Knock on Any Door* and *Party Girl* had both featured Chicago locales and courtroom showdowns; now the Chicago Seven trial would become part of his new film project, whose layers and scope were expanding daily in his imagination.

\*

Originally there had been eight members of the Chicago Conspiracy, until the hostile judge, Julius Hoffman, bound and gagged Black Panther Bobby Seale in the courtroom, severing him from the case and sentencing Seale to jail on contempt-of-court charges. For three months the remaining Chicago Seven had bitterly mocked the judge, the judge had shouted down the defendants, and demonstrations against the case had swirled outside the courtroom. At one point the National Guard was called in to control the protests.

Many commentators described the trial as a circus. Judge Hoffman would not allow cameras inside the courtroom, but Ray's legend preceded him, and the defendants embraced the director of *Rebel Without a Cause,*

admitting him and his crew into their strategy and rap sessions and crash pads. "Anybody who'd met Jimmy Dean," Abbie Hoffman exclaimed, "what the hell, gonna let him in the door!"

Arriving as the prosecution wound up its case, just two weeks after the Washington, D.C., riots on December 3, Ray collected the Chicago Seven for a freewheeling night of improvisation, including the filming of an "absurdist version" of the trial, in the words of defendant Tom Hayden. "I played the role of Judge Hoffman," Hayden recalled, "sitting on a platform elevated twenty-five feet in the air. Afterward, we stayed out drinking and clowning around." Early in the morning of December 4, when the group learned that a murderous police raid had just taken place at the home of Chicago Black Panther leader Fred Hampton, Ray and his crew rushed to the blood-spattered scene, photographing the dead bodies of Hampton and Mark Clark, another Panther.

Ray fit right in with the sixties rebels, taking over a cheap Orchard Street apartment, sleeping on a mattress on the floor. He was surrounded by film equipment, piles of relevant reading matter, and ashtrays filled with French cigarette stubs. Ray drank his breakfast from a bottle of wine ("a source of Vitamin C," he liked to aver) and carried an omnipresent briefcase filled with "needles, ampules of methedrine and B-complex, mysterious pills, bags of grass," in the words of defense committee volunteer Susan Schwartz, not to mention "blocks of hash."

Using an assortment of low-millimeter cameras and recording paraphernalia, Ray followed around the accused conspirators, their star witnesses, and their team of lawyers for two months. He was assisted by a few professionals who still thought he was devoted to their marijuana-court-case movie, and by a small army of film-crazy college students and defense committee members acting as unpaid volunteers.

As the project ballooned, so did the costs. The Chicago Seven were uncanny fund-raisers, and the money spilled over to Ray from donations to their case. The filmmaker also forged promising links with *Playboy* founder Hugh Hefner, *Hair* producer Michael Butler, and Grove Press editor in chief Barney Rosset, a sponsor of the English-language version of *Cahiers du Cinéma* and distributor of controversial films like the sexually explicit *I Am Curious (Yellow)*. All were sympathetic to the defense and opposed to the war.

Ray was still adept at self-publicity. In the nation's capital, even amid

the chaos in the streets, he had found time to talk to the *Washington Star,* and in Chicago he gave interviews freely, appearing on local television's *The Maggie Daly Show,* whose eponymous hostess was the mother of Brigid Bazlen, the Salome of *King of Kings.* One day Roger Ebert recognized Ray as he strode "through the crowd of demonstrators around the Federal Building, a tall, lean striking man with a shock of white hair and an eye patch . . . carrying a small movie camera." Ebert, then a young journalist, later to become one of America's leading film critics, profiled the director for the *Los Angeles Times.*

By the time of Ebert's published interview, in February 1970, Ray's plan for the would-be film had evolved into a restaging of the courtroom proceedings, mixed with newsreel and documentary footage and interviews and whatever else he might decide. He envisioned multiple film gauges and a subdivided screen. Ray and volunteers were working tirelessly to shape the thousands of pages of court transcripts into a dramatic script, though it was a little like wrestling a phone book.

Financiers as well as journalists were titillated when Ray floated his casting ideas: Groucho Marx, or James Cagney, or, perhaps most curiously, Dustin Hoffman playing Judge Hoffman. According to Bernard Eisenschitz, Abbie Hoffman actually cajoled Ray into phoning Groucho on one occasion. But Cagney and Groucho said no; in the end it was all "moon talk," and no big names were landed.

"His idea is to have the defendants play themselves," Ebert explained in the *Los Angeles Times* article. "All of the action will take place on a courtroom set now under construction in a Chicago studio. The dialogue will be drawn largely from the trial transcript itself. But the words in the courtroom will occasionally be illustrated by scenes from other places. Vietnam, possibly, or ancient Rome . . ."

Ray showed some of the footage to Ebert, including a scene he had shot during a rabble-rousing trip that Abbie Hoffman and Rennie Davis (another of the Seven) made to Washington, D.C. "There was one, long Godardian sequence in the airplane where Abbie and Rennie talked and kidded each other while a girl in the window seat pretended to be asleep," Ebert wrote. "Every once in a while, the girl would open an eye."

Undoubtedly the material was of historical value, but Ray repelled some people as much as he attracted others. Still highly functional as a filmmaker in some ways, especially when he was behind the camera, in

other ways he was at a loss without the Oscar-winning cameramen, sound crew, and editors who'd been at his beck and call in Hollywood. Physically, his addiction to methedrine (supposedly to treat his alcoholism) was driving him to new depths of dysfunctionality. In meetings he'd act bored or listless one moment, then sometimes erupt the next in a fury of paranoia, vehemence, or recrimination.

At one point, Yippie leader Abbie Hoffman tangled with Ray over Elia Kazan's decision to name names to the House Committee on Un-American Activities. Ray argued that Kazan had given only "dead names," people who were dead or already had been named.* Hoffman dismissed the argument, maintaining that Kazan's connivance was indefensible. Hoffman ultimately saw Ray as "a somewhat sad figure," in his words, "a very desperate person," with Ellen Ray and her group "babysitting for him; I don't think he could have survived alone at that period."

By late February, when the Chicago Seven case was decided (with guilty verdicts for five of the seven, all ultimately reversed on appeal), Ellen Ray and her team had begun to suspect that they'd thrown away a lot of money bringing Ray back to America for a film project that no longer interested him very much. They were right. Likewise, the Chicago Seven followers developed the queasy feeling Ray was never going to finish the semidocumentary film about their cause. They were right too.

As Ray devolved personally, his hopes of financing evaporated in kind. He continued to write, to film, to edit; in many ways, on some days, he seemed competent. Yet the Chicago Seven script would never be written, the film never finished, despite Ray's customary vows of completion. ("I can promise you this film will be made!")

The most important thing that happened to Ray during his brief sojourn in Chicago, however, was probably not his failure to complete any film work but his introduction to the young college student who was destined to become his last life partner. A dark-haired beauty in her first semester as a freshman at the University of Chicago, Susan Schwartz was a volunteer with

---

* This wasn't true, of course. Besides Clifford Odets, who had agreed to be identified by him, Kazan in his prepared April 10, 1952, written statement gave the names of seven members of the Group Theatre and a handful of Party functionaries, including low-level officials. What he said off the record, before or later, when being debriefed privately by HUAC representatives or anti-Communist crusaders, has never been disclosed.

the Chicago Seven's defense committee when the group's attorney, William Kunstler, introduced her to Ray outside the courtroom one day. The college freshman had just turned eighteen. The director was fifty-eight.

Although the titles of his films didn't mean much to Schwartz when the ex-Hollywood director mentioned a few of them, the college student did recognize Ray as "the coolest of cats" with an "auric field" that "crackled with high-voltage charge."

Toward the end of the trial, Schwartz offered to help out on his film project. When a taxi brought her from her college dorm to his house, Ray looked just as cool in his eye patch and leopard-spotted bikini underwear, a cigarette dangling from his lips, surrounded by film reels and machines and minions. After a long day, in which she proved herself by washing dishes and answering phones while Ray and his crew were out filming, he handed her a stack of court transcripts and asked for her advice and assistance on the unwieldy script.

"I told him I had not seen a film script before," the new volunteer recalled in her collection of Ray's writings and musings, *I Was Interrupted: Nicholas Ray on Making Movies*. "He told me I would figure it out but offered a hint, like a trick to opening the cap on a jar: I should look for events that advanced the action."

Gradually the college freshman surrendered herself almost entirely to Ray and the project. "He felt at home with me," Schwartz recalled. "I would not go away." In early May, when Ray lit out for New York to scrounge money for the Chicago Seven film, he invited her to come along, to be his apprentice. She would linger a while in Chicago, trying to finish her studies, before finally dropping out and following—an event that advanced the action.

First, Ray traveled to La Crosse to visit with his favorite sister, Helen—Mrs. Ernest Hiegel. While there, he gave an interview to the *La Crosse Tribune*. He mentioned the Chicago Seven film, to be called either "Conspiracy" or "Before the Fall" (he was still deciding). He also told the paper that he was assembling a bunch of hometown footage for a new "Project X," starring his boyhood friend Russell Huber, now a local radio and television music director. Ray invited a *Tribune* reporter along to observe the filming, which started under the Losey Memorial Arch at the entrance to the Oak Grove Cemetery.

Wielding a fifty-pound camera—worth ten thousand dollars, as Ray

pointed out—the director told his old Central High School classmate to walk out from beneath the arch. "Ray shot the scene twice, then directed Huber to walk back through the arch and disappear into some spruce trees," according to the *Tribune*. "He next directed a bewildered Huber to face the camera while standing in the same grove of trees, glance skyward, carefully comb his hair and then walk off."

Hurriedly setting up another scene in front of gawking bystanders, Ray told the local journalist, "More than any other quality a director needs imagination." Then the director ushered Huber into a greenhouse to conjure one last scene starring his old friend. "Here an amused Huber was instructed to walk down an aisle between some plants, stop suddenly, turn to the camera and say, 'You're pretty disgusting.'" The hometown success said a hurried good-bye to Huber and the journalist and then departed La Crosse—for the last time, as far as anyone recalls.

Was Ray really planning a "Project X"? Did he intend to sandwich the footage into the Chicago Seven film, or one of his growing number of home movies? Or was this merely a flattering gesture to an old friend, who like Ray had long ago dreamed of stardom?

✳

About that intriguing eye patch: Toward the end of January 1970, Ray claimed, the director "fell asleep at the editing table" one late night and woke up with an embolism. After being hospitalized for a week, he said, he started wearing a black patch over his right eye.

As Bernard Eisenschitz has observed, though, "the loss of sight in his right eye remained a mystery which he fostered." As far back as 1954, according to news items, a special effects explosion on the Colorado location of *Run for Cover* had hurled a small piece of glass into Ray's eye, forcing him to wear dark glasses for a time. Actor Christopher Plummer also remembered the director flaunting an eye patch now and then while filming *Wind Across the Everglades*. In his autobiography, Elia Kazan insisted that his old friend had lost his eye "in a bar fight in Madrid" in the early 1960s. Film critic Myron Meisel, who once in the 1970s spent a night with Ray in Boston looking for an all-night store that carried a fresh supply of patches, said he saw Ray wear the patch "over each of his eyes in turn." And the director stopped wearing the patch entirely during his last few years of life.

For the sixties radicals, the eye patch helped confirm Ray as one of them: an adventurer, an outlaw, a buccaneer. For film aficionados, it evoked an elite club of one-eyed directors with similar patches: André De Toth, Fritz Lang, Raoul Walsh, John Ford. Ray's looks had always been a deceptive part of his appeal. For a man who cut a romantic, bigger-than-life figure—though "with a crucifixion in his face," as Melville described Ahab—the eye patch was the perfect adornment, the advertisement of a flaw.

<p align="center">✳</p>

In New York, in the summer of 1970, Ray and his new college-dropout acolyte crashed around, often at the home of either Connie Ernst Bessie or Alan Lomax, who was back living in New York. The director commuted between the two, "depending on how pissed off he was with me at the time," according to Schwartz, "or how pissed off with Connie." Sometimes the director and Schwartz stayed at the same place, sometimes separately. Connie's house in the Village was close to Bob Dylan's, and Ray tried without success to interest Dylan, the new Woody Guthrie, in supporting his film with music, money, or a cameo.

This was the rocking, reeling, rolling New York of Dylan and Andy Warhol and *Midnight Cowboy* and the Weather Underground, even wilder than New York in the 1930s. Acquaintances old and new greeted the former Hollywood director—a sight to behold, with his unruly white mane, his characteristic garb of black Levi's, turtleneck, and cowboy boots—as a returning conqueror. "All of a sudden," Perry Bruskin said, "Nick found himself very radical again."

While toiling away obsessively on the Chicago Seven footage, Ray attended plays and films and concerts and parties and hung out at the Village Vanguard. He liked to stay out on the streets all night, "trading insults with winos, drinking at local bars, playing cribbage, pool, poker and endless rounds of bingo at Fascination on 48th Street," according to Schwartz. He started drinking wine as soon as he rolled out of bed, switching over to gin and beer later in the day. He shot speed and gave himself intramuscular injections. Friends kept him well supplied with pot, hash, cocaine, and LSD. For food, he relied heavily on Mars bars.

By summer, the Chicago Seven were yesterday's headlines, and the

money for that project had dried up. "Nick talked about a multi-media road show going round the campus circuit," recalled film scholar James Leahy, who was working with Ray on the Chicago Seven film. "This would use drawings, water colors, stock footage, scenes extracted from the transcript of the trial. There would be dramatic re-enactments improvised under Nick's direction by actors drawn from the audience."

With the Chicago Seven project in limbo, the director found other outlets for his boundlessness. He was invited to sit in on rehearsals of a Sam Shepard play, offering tips. As he had back in the 1950s, he started talking about filming another Alan Paton novel set in South Africa. He got a nibble from Mike Myerberg, the producer of *Lute Song,* who installed Ray in an office above the Princess Theater on Forty-seventh Street and Seventh Avenue. Actors were interviewed, screen tests conducted before there was a completed script. Another urgent project always came along just as the money ran out for the preceding one. Each new possibility tended to first overlap and then override the last.

More than ever, the projects were overtly autobiographical. One the director toiled on during this period was called "New York After Midnight." Based on an original story by Ray, it tracked the nighttime wanderings of a character dubbed "Eyepatch" who has returned to New York after years of absence "to encounter loose ends from his past among present more savage despairs," in Schwartz's words. According to Bernard Eisenschitz's book, this self-exploratory exercise was doomed, despite voluminous notes and several drafts for "scenes, often repeated (with elements of science fiction), some of them dazzling (in particular a dramatization of the death of Ray's father)."

Nineteen-seventy went by in a blur of hyperactivity and substance abuse and blue funks. Schwartz held down a job to make ends meet; though they were sometimes at odds, the couple enjoyed moments of peaceful togetherness, such as the morning they spent watching *They Live by Night* on TV. "Nick nodded and rambled on for a while about the first shots ever made from a helicopter," Schwartz recalled, "but by the end of the film he was weeping."

Trying to throw him a lifeline, Elia Kazan recommended Ray for a teaching stint at Brandeis University, but the school rejected him, plunging Ray into the bluest of funks. Then, one night at a Grateful Dead concert at the Fillmore, Ray bumped into Dennis Hopper, now a director

himself. With their old misunderstandings behind them, Hopper offered to fly Ray to his ranch in Taos, New Mexico, where the actor-director was fitfully editing *The Last Movie,* an arty movie-within-a-movie shot in Peru (and written, incidentally, by another *Rebel Without a Cause* alumnus, Stewart Stern). Ray jumped at the chance. Leaving more debt and unfinished business behind, he traded New York for Taos—one adult Disneyland for another. There he sat in on the cutting of *The Last Movie,* while finding "shelter, food, drink, entertainment, new faces, wide vistas, guns, horses" and more, Schwartz recalled, in the "deluxe outlaw's den" hosted by Hopper.

After putting her New York job on hold, Schwartz followed the director to Taos. "When he met me at the airport I could see right away that he'd gotten wilder, gone over the edge he'd held back from before. He was acting a caricature of himself, a limping one-eyed satyr, and for the first time he seemed to think himself old. He had grown a beard and a surplus of paranoia and had taken to wearing a gun in a holster."

When not busy at target practice, "or out god knows where with the boys," Ray was fooling around with a Western script "about kids who seize control of the town from their parents," Schwartz recalled. He phoned old friends and collaborators in Hollywood and Europe, talking up his future plans. Out of the blue, one day, Ray called Jon Manchip White, a writer acquaintance from the Bronston days, who was teaching at a Texas university, and asked him if he had any interesting scripts sitting around that he might care to submit for his consideration. The director ran up tens of thousands of dollars in phone bills.

Though Ray and his Taos boys' club were ingesting "ounces of coke a day," the director was trying to withdraw from his ruinous speed habit—"if nothing else," as Schwartz recalled. "One night between moans he asked me to marry him. Since by then I knew I would be with him at least until one of us died I told him we could consider it done. Nick gave me his ring, I gave him a pearl."

Ray was rescued by a feeler from Harpur College in upstate New York, inviting him to make a guest appearance there in the spring of 1971. Mustering his discipline, Ray rose to the occasion, staging audience members in filmed reminiscences of their May Day experiences as protesters battling police. The event's success prompted the college to offer the director a real lifeline: a two-year contract as a visiting professor. Ray's onetime

RKO colleague Robert Wise loaned him money to make the move from Taos, another auspicious cross-country drive like so many he had made in the past.

<center>✳</center>

A New York State public college, which had been separated from nearby Binghamton University in 1950, Harpur College of Arts and Sciences was located in the town of Vestal, just south of the Susquehanna River and north of the Pennsylvania border. The school was two hundred miles upstate from New York City or, for that matter, the town of Katonah, where Ray had briefly tried teaching at Brookwood Labor College thirty-five years before.

"The hell with a lecture!" the former Hollywood director told his students on the first day of class, "You'll learn by doing." Although he did assign some reading—including Albert Camus's *The Myth of Sisyphus* and Henri-Louis Bergson on the corrective value of laughter—the new professor let his students know from the outset that his course would be unconventional. That first night, Ray and his students set up lights and cameras and sound machines and shot the first scenes of a communal film they would make together, starting from pages of a script he'd scribbled that very afternoon with the working title "The Gun Under My Pillow."

Officially headquartered in the basement of a college building, the class quickly spread outside. Though at first they met at the appointed day and time, the official timetable soon became irrelevant; the class dug in at Ray's rented farmhouse off campus for filming sessions that tended to start late in the afternoons and become long days' journeys into night.

The students served as actors but also as the production crew, and everyone was expected to try both sides of the camera. Ray's original idea for "The Gun Under My Pillow" swiftly fell by the wayside; he assured the students that the final script would evolve as they evolved. He urged his students to deep-think their roles, to turn trauma into drama, to use whatever works. He taught them mantras about action and motivation. In hours of freewheeling rap sessions and improvisations and rehearsals, he encouraged them to unbosom themselves when speaking to the professor-director and the camera alike—to speak as though addressing a mirror. Their personal revelations would be incorporated into the film.

The class was unorthodox and demanding, and the faint of heart dropped out. Others dropped out of the college altogether yet continued to show up for the communal filmmaking. A handful pledged themselves to Ray and his rolling film production for the entire two years the director spent at Harpur, finding in the experience a surrogate family, a brother-hood like Taliesin, a defining life passage. "He was more than a teacher," one student, Tom Farrell, wrote later. Ray "was a father confessor. We were more than students; we were his children."

The onetime Hollywood filmmaker regaled the students with anec-dotes about Bogart and Dean, showed his famous movies on a sheet stuck to his bedroom wall, lent them his marine corps knife, inscribed by Duke Wayne. (They spent hours in the barn throwing it until it fell apart.)

Of course, this wasn't Hollywood in the Golden Age; the conditions were hardly optimal, the students were amateurs, the budget was nickel-and-dime. During the actual photography, Ray shot infinite takes and variations, encountered endless glitches, lost time and footage. He told his students they could make a virtue of the low budget by embracing the snafus and temperamental equipment. They would end up deploying a va-riety of millimeter gauges (eight millimeter, Super 8, sixteen millimeter, Super 16, and thirty-five millimeter), using the different formats to add an-other level of complexity to Ray's treasured notion of multiple story lines depicted in a split-screen format.

In one sense Ray had finally broken free. He had always been, at least potentially, an avant-garde, "arty" filmmaker, but perhaps one who had followed the wrong muse and ended up mismatched in the Hollywood factory. Although he found fleeting connections with individuals in the film industry, he fell into conflict with many more. He found the deepest connection with this latest tribe of young people and felt renewed as the questing, passionate, risk-taking director he believed himself to be.

Drinking and taking all manner of drugs round the clock, Ray was still prone to interminable, unfathomable silences, but now, unlike in Hol-lywood, they were sometimes punctuated by tantrums and rages. Once known for his velvet-gloves treatment, the director was now capable of screaming at an undergraduate coed to impose his message on the wide-eyed actress—or at his own son Tim, who was in and out as a cameraman.

Again and again, however, the professor brought his admiring stu-dents back from the brink of frustration and despair. He won them over

with his boundless optimism, his sincerity and generosity. Although the course picked up an arts grant or two, Ray poured his entire Harpur salary into the communal student film—$850,000, the director boasted in one article, though he undercut his credibility on that point by adding that in the meantime he'd turned down a Hollywood contract offering him 50 percent ownership of a $2.5 million Victor Hugo screen adaptation.

✳

While Ray lived and taught at Harpur College, Susan Schwartz maintained her day job in New York City, commuting to the college to help out. Time and again she stepped in with vital advice or participation that kept the communal film going.

During the first year, word spread that Nick Ray was teaching at Harpur and directing his first motion picture in a decade. Auteurist journalists and film critics flocked to upstate New York to meet the living legend. The publicity the director of *Rebel Without a Cause* had engendered in D.C. and Chicago became a small tidal wave.

The first-string reviewer for the *New York Times*—and probably the single most powerful critic in America—Vincent Canby had written admiringly about the director during his sixties hiatus. In September 1972, Canby visited the college to interview Ray about the avant-garde student film he was making, its methods as newfangled as its narrative—"an adventure in time and space," Ray kept saying.

Canby was given the red-carpet treatment, such as it was. In a screening room with a dripping ceiling, he watched advance footage of the student production projected by four sixteen-millimeter projectors and one Super 8, with one or more of the machines breaking down every few minutes. "If things work out," Canby reported in knotty technical terms that might have baffled ordinary newpaper readers, the student film "will consist of a 35mm frame into which 16mm and super-8 images will be set, not optically in the lab, but via a videotape synthesizer."

"As I sat in the leaky screening-room," Canby's decidedly sunny account continued, "the people in the movie sat there too, passing around a large bottle of beer and a large bottle of white wine.... I was more aware of the time-space adventure than I'd thought would be possible, for the film, even though unfinished, breaking down, acted by non-pros, every now and

then recalls the controlled, melodramatic density and sheer technique of *They Live by Night* and *Rebel Without a Cause*."

The niche film fan journals were even more excited. "This film, if Ray ever finishes it," reported Jeff Greenberg in *Filmmakers Newsletter,* "will be bolder and more revolutionary than any film he has ever made before. He is creating a new reality on film: the scene being filmed and the act of filming that scene are no longer separate." Niceties like "follow focus and balanced lighting" no longer mattered, Greenberg explained; the "hurried, careless filming" was part of Ray's revolutionary approach.

Filmmakers visited Harpur, eager to capture Ray for documentaries of their own. Half a year after Canby's visit, in mid-February 1973, a Boston crew photographed the director and his core tribe as they staged student-film scenes over the course of a long, frigid night. The footage would be tucked into an approving documentary about Ray's life and career, including interviews with François Truffaut and Natalie Wood. (Ray negotiated an honorarium, and a percentage of the producer's profits, in exchange for his cooperation.) The Boston team called their documentary *I'm a Stranger Here Myself,* which was "the working title of nearly every poem, play, short story, any screenplay I've ever written," as Ray often said. ("I'm a stranger here myself" was a line delivered by Sterling Hayden in *Johnny Guitar,* virtually identical to a line in the Roy Chanslor novel.)

Though administrators at Harpur were initially proud to have snagged the living legend as a faculty member, they had to wonder if the beer-and-wine-drinking young filmmakers that Canby described in the *New York Times* ultimately reflected well on the college. The reality was even worse, according to the rumor mill, and college officials worried increasingly that Ray's class had become a hero-worshipping cult.

Some students admittedly embraced their father confessor's lifestyle. "We would all drink together," recalled student Danny Fisher, "but I never did drugs with him, like some of the others. He was very giving that way! He would shoot up and his line was that amphetamines were his vitamins, and I accepted that. We were like a commune, all sleeping and breakfasting at his house. I thought, 'Is this a film school?'"

The student film underwent a series of title changes, reflecting the group journey. Ray inevitably became a main character in the story, speaking up from behind the camera and eventually stepping in front of the lens. For example, when a local poet who appeared in a few scenes was run over by a truck while hitchhiking—dressed, according to several accounts, as

Santa Claus—Ray restaged the incident, playing the dead Santa himself. The two roles, actor and director, would eventually merge toward the end of the film's story, when, "after a confrontation with the students in which he is accused of exploiting them," wrote Bill Krohn, a U.S. correspondent for *Cahiers du Cinéma,* "the director fashions a noose and hangs himself; the students decide to let him die."

The student film inevitably became a student-professor film. And though the onetime actor was using it as an opportunity to stage his own death, the project had undeniably given Ray new life. Indeed the project had evolved into a kind of collage of his life, with bits from many of his autobiographical scripts and unfinished stuff. But the student-professor film had to be finished by the end of the spring term of 1973. Many of the young people had burned out by then, and it became clear that the unorthodox visiting professor would not see his contract renewed in the fall.

As time ran out, so did the money necessary to put the student-professor film through proper postproduction. Ray tried to contact rich friends like Howard Hughes, now a reclusive billionaire, but without success. Mike Frankovich, "a producer for whom Nick claimed he had made millions," in the words of Myron Meisel, took the director's phone call from a Boston hotel. Ray pleaded with the producer "to let some of the student film be processed with the rushes from Frankovich's film then in production," Meisel recalled. The answer was no.

"Nick's personality on the phone was quite different than I had become used to," Meisel remembered. "With his kids, he was hip, and affected the mannerisms of the counterculture of the day. With Frankovich, he was bluff, cocky, transformed into a firmly remembered Hollywood persona. It was a humiliating conversation."

Ray set up a Hail Mary screening at Movielab in New York for possible investors like David Picker of United Artists and former associates like Dore Schary, the onetime studio chief of RKO and MGM, who'd given Ray his start as a director. "The film they see," reported Joseph Lederer in *American Film,* "is a rough cut without dubbing, dissolves, fadeouts, or music, to say nothing of certain crucial scenes . . ." "It's exciting," Schary murmured as he left the screening. Picker concurred: "Some beautiful things . . ." Nevertheless, United Artists declined to underwrite the completion of the student-professor film.

The director then made a dash to Europe and convinced Cannes officials to allow the student-professor film into the annual festival without

first seeing it in polished final form. Ray's goal was to screen a temporary version at the festival and to use the inevitable acclaim to raise the necessary funds to finish the production. Ray also screened excerpts for select friends at the Cinémathèque Française. "The predominant reaction was puzzlement," wrote Bernard Eisenschitz.

The Cannes officials agreed to host the work in progress, and the visiting professor packed and left Harpur College, never to return. He headed to an American Film Institute lecture in California, where he also expected to arrange cheap editing facilities. A handful of his students loaded the hard-won footage into a drive-away car and followed after him. At least by now the student-professor film had a title that would stick, the Thomas Wolfe–like *We Can't Go Home Again*.

<p style="text-align:center">✳</p>

"The main task now," Bernard Eisenschitz wrote very precisely, "was to combine the various images (including those produced by the synthesizer, which had been transferred to 16 mm) on the same piece of film. An optical process would have been too costly and the results too inflexible. So the film had to be projected (using five projectors in all), and filmed in 35 mm, on a transparent screen, sequence by sequence."

At first Ray wangled the use of an AFI editing room for the purpose, but then he and his students got thrown out. The same thing happened a short time later at another facility. Finally he and they ended up back at the Chateau Marmont, his 1950s digs, where the director threw an elaborate buffet-lunch fund-raiser for the unfinished student-professor picture. Among the stars and producers who attended were Natalie Wood and Robert Wagner, a scenarist and his wife Ray knew from his RKO days, and a former Howard Hughes secretary he'd once dated.

But "very few people" in total came to the event, recalled one of the ex-Harpur students who had trailed after Ray, helping with the editing and reshooting of the student-professor film, "and we were starving, faced by all that food we couldn't touch! We ended up eating the leftovers. It ended as always with Nick getting out his address book, full of numbers that had probably been out of date since forever."

With the Cannes deadline looming, Ray and his cohorts assembled the best material into a ninety-minute version. One student, Tom Farrell, recorded a narration for the film, intended partly to compensate for its in-

termittently faulty sound. Susan Schwartz went to bat, raising the several thousand dollars necessary for the director to make the trip to France. Carrying the film cans with him, Ray met his sweetheart in New York and they continued on to Cannes.

*We Can't Go Home Again*, the first new Nick Ray film unveiled to the public since *55 Days at Peking* ten years before—albeit a temporary version—had its world premiere on the afternoon of their arrival. The sleep-deprived director dozed during the screening. Sterling Hayden, one of the guests, was seated next to Schwartz. "Shit!" the *Johnny Guitar* star exclaimed. "Was Nick on psychedelics when he made this?" The answer was yes, perhaps, some of the time; Hayden and Schwartz themselves were stoned on hash at the Cannes premiere.

Accounts differ as to its reception. Some insist the film earned a standing ovation; in contrast, Ray's French biographer Bernard Eisenschitz reported that "the film went unnoticed, even by the few people who might have been expected to acknowledge it."

Sunning himself on the beach in front of the Carlton Hotel afterward, Ray gave expansive interviews about the student-professor film, linking his modernist techniques to those used by Frank Zappa in *200 Motels* and by the Korean avant-garde video artist Nam June Paik. "Video creates a Socratic relationship," the ex–Hollywood director declared. "I'd like the people to take over all the open access channels in the world. They need the means of communication at their disposal."

Then, having "lost or gambled away" what little money he'd brought with him, according to Eisenschitz, the director decamped to Paris, crashing at the homes of various acquaintances. He spent time on a houseboat Sterling Hayden kept moored on the Seine and ran up high bills that were eventually paid by novelist Françoise Sagan and filmmaker François Truffaut.

Ray had been among the international filmmakers who flocked to the defense of Cinémathèque Française founder Henri Langlois, when French culture minister Andre Malraux tried to fire Langlois in 1968. Now Langlois repaid the favor by putting the American director in touch with an Amsterdam producer who was making an artistic/pornographic anthology film, and who sought to hire Ray to contribute a segment. Ray, who badly needed the money and work, arranged to fly through the Dutch capital on his way back to the States.

He arrived with vision in hand: a short story he'd hastily written, titled

"Wet Dreams," that might be right for the unlikely project. Ray's story involved a preacher who discovers the joys of sex, and a janitor of his church who is his doppelgänger. Besides directing, Ray would play the preacher, who engages in oral sex and incest with his own underage daughter, as well as the janitor, who puts his broom to unspeakable uses. Once again, Ray would stage his own death on camera, when the janitor kills the preacher at the end.

"Wet Dreams" was "a personal film from the word go," wrote Eisenschitz. Ray shot it "almost entirely in close-ups, giving an astonishing sense of brooding re-examination, or mirror effect." Directing himself, "complete with eye-patch, missing tooth, and socks tumbling about his ankles," Ray delivered an orgy-inducing sermon, to which several figures respond by performing fellatio on him: "a bespectacled woman with large teeth, a black woman, and finally his daughter." The Amsterdam producer found a genuine underage girl for the daughter (who, like the others, reportedly performed actual fellatio on the director). Ray kept his erection for hours during the all-night filming, the producer proudly boasted.

Though most of "Wet Dreams" was filmed after Cannes, Ray would return to Amsterdam at least once for additional shooting and editing. Now, however, he had to scurry back to America after receiving a hard-cash offer to film country-and-western singer Willie Nelson's July Fourth picnic in Texas. Like "Wet Dreams," and the Sylt films, and any of the other short movies Ray is supposed to have made in the years after *55 Days at Peking,* Ray's Willie Nelson footage has been confirmed by only a privileged few. "These films are like flying saucers," wrote Bill Krohn, a staunch Ray defender, "you catch glimpses of them or hear about them from people who've seen one."

<center>✳</center>

Especially after its underwhelming reception at Cannes, Ray viewed the temporary 1973 version of *We Can't Go Home Again* as more a tribal student work than a professor's intended masterpiece, and for the next three years the director would feed his sleepless energy into creating a definitive final version that would stand as his magnum opus.

Ray returned to Los Angeles. He crashed with his ex-wife Betty Utey, now an ABC-TV staffer with access to editing rooms and equipment. Ray

reunited awkwardly with his daughters, now teenagers, and plunged into reediting the copious footage with a team of former Harpur College students and assistants, often working through the day to assemble a version or brainstorm new scenes only to tear everything up overnight.

Though Utey welcomed Ray for a while, she eventually realized that the director was "too alcoholic and too full of drugs" to keep on indefinitely and showed him the door. His other Hollywood friends were equally appalled. Hoping to spur investment, he showed his student-professor film to a select few, like Philip Yordan. "It was something that somebody would do in a crazy house," Yordan thought.

Surprised to receive an invitation, Stewart Stern attended one L.A. screening. He was taken aback by the jumbled work in progress and even more flabbergasted when Ray—looking like "the ghost of Beethoven," all bones—jumped up after the showing to give him a hug and kiss. "Nothing made sense," the writer of *Rebel Without a Cause* recalled, "not the rough cut—not the hug—not the sudden jump cut [in my life] to this wreckage of one of the most gifted men I had known."

In March 1974, Ray made his way from Los Angeles north to Berkeley, where Tom Luddy had arranged a retrospective at the Pacific Film Archives. While there he was invited to use the Zoetrope editing rooms, where Francis Coppola was busy editing *The Conversation*. Coppola and his team worked by day, Ray and his by night. Between sleeping on the premises amid empty bottles ("He'd be zonked out with a gallon of white Almaden Mountain Rhine wine," recalled Luddy) and his astronomical phone bill, the director was prodded to move on. Ray first went to a filmmaking collective at another building and finally to a factory warehouse in Sausalito, where his refrigerator, couch, editing table, and film cans shared space with sewing machines and seamstresses.

For nearly three years after his Harpur College experiment, Ray marched ahead, filming new sequences for the film with dedicated former students in several American and European locales while shuttling between editing quarters in Los Angeles and the Bay Area. Now and then, Ray would host other showings of the film in progress, including a packed unveiling at the First Avenue Screening Room in New York in the fall of 1974. True believers felt that *We Can't Go Home Again* was unfolding toward a great destiny, while others tended to agree with Yordan and Stern. "Elia Kazan and Nick's old producer John Houseman [were] there" at the First

Avenue screening, wrote Bill Krohn, the American correspondent for *Cahiers du Cinéma,* "along with a number of backers who were considering investing in the film."

But Krohn and the others "were all disappointed" when "the screening lasted only a few minutes" before the projector suffered a "mysterious breakdown." With an auteurist's faith, though, Krohn reported "the few minutes we saw were worth the price of admission." In his view, Ray's last picture was finally shaping up as "a radically experimental work," integrating documentary, dramatized scenes, multiple formats, and interwoven story lines.

✳

Crisscrossing America in the early 1970s, sandwiching in several trips to Europe (including a disastrous stint as president of the jury of the 1974 San Sebastien Film Festival), Ray took a victory lap celebrating his career even as it reached its all-time nadir.

Colleges, museums, revival theaters, and film festivals offered him well-paid speaking engagements, and wherever he touched down the director gave interviews about his student-professor film project while reflecting on the highs and lows of his filmography. He still did homework on his admirers and could anticipate many of the questions. "I like the piece you did for the *Voice,*" the director told Cliff Jahr at the start of their televised interview, adding pointedly, "The *last* one."

Pressed by one interviewer as to whether he would like to go back in time and improve any of his twenty features, Ray was mildly irritated. "There were times I could have extended myself more," he said. "All the films made money, so why [be]labor it?"

Sometimes Ray was a self-important dissembler; other times he blurted blunt truths. "My father told a great many lies in his life," Nicca Ray conceded. "He was a great liar," agreed producer Chris Sievernich, who worked with Ray and German filmmaker Wim Wenders in the final months of the director's life. Indeed, at times Ray was an incorrigible "con artist," according to former Harpur student Tom Farrell—but then again that might be a vital ingredient in a film director's makeup.

Now and then Ray managed both truth-telling and -dodging simultaneously, as when he declared, "I am the best damn filmmaker in the world who has never made one entirely good, entirely satisfactory film."

He had a sense of humor about his own failures, saying of *Born to be Bad:* "It sure was!"

Few cared anymore whether *Knock on Any Door* or *Johnny Guitar*—not to mention *In a Lonely Place* or *Bitter Victory*—had been strong or weak novels; the books were long out of print or hard to find, and permanently supplanted in the culture by the Bogart films and Ray's version of *Johnny Guitar* (if not by Ray's version of *Bitter Victory*). The director introduced a number of *Johnny Guitar* screenings—over time he had grown almost as fond of the film as his admirers—and even showed his first, uneven Bogart picture to his Harpur College class. ("Although the film was a huge success, it never gave me any satisfaction or feeling of accomplishment.")

*Party Girl* may have been the second-greatest Ray film of all time, as a 1999 poll of ninety Spanish film scholars and critics decided. (A special issue of the journal *Nickel Odeon* tallied eighty-four "favorite" votes for *Chicago año 30,* as Ray's MGM musical was known in Spain, eclipsed only by *Johnny Guitar* with eighty-seven votes; *Rebelde sin causa* came in third.) But Ray, in one interview, said it was "just another MGM straight-to-the-nabe picture. No one thought much of it. [Robert] Taylor considered it a punishment picture; something the front office had thrown him into to help use up his contract. He was probably right."

*On Dangerous Ground:* "A failure, unsuccessful in achieving what I wanted."

*King of Kings:* "A piece of shit."

Though the French auteurists insisted that Ray was a genius, unable to err without being interesting, to his adoring questioners Ray repeatedly said, "In Hollywood about one out of every four films I made was a film I liked," adding, "That's a damn high average."

He'd directed only twenty Hollywood films, and if his math was right that meant he only liked about five. One perpetual favorite was his first, *They Live by Night.* Another was *Rebel Without a Cause. The Lusty Men* may have been the third. The other two were up for debate, largely dependent on his mood or the questioner. *In a Lonely Place? Bigger Than Life?*

On college campuses, leftists and counterculturists greeted him as a Hollywood rebel. Curiously, Ray reinforced this impression by telling people that his generation had disappointed him by "betraying" their values. "Nick told me that one out of every ten people on the left were informers at one time or another," recalled Leslie Levinson, a student actor in *We Can't Go Home Again.* Rarely interrogated about the blacklist, the

director more than once defended Kazan's decision to name Communists "on the grounds that these names were already known," according to more than one published account. His own accommodation with the McCarthy era was never suspected.

Even a first-rate left-wing journalist like Andrew Kopkind, who interviewed Ray sympathetically, found the director "politically right-on," writing in 1976 that "for some unknown reason" Ray had "escaped most of the horrors of McCarthyism in the mid-50s, although many of his comrades on the Left were denounced and blacklisted." Somehow, Ray's reputation survived even the publication of Bernard Eisenschitz's biography, with its clear evidence of HUAC cooperation. Nearly two decades after its publication (in Europe, with spotty distribution in the United States), respected critic Emmanuel Levy could note on his blog that Ray "left the U.S. on a self-exile as a protest against the McCarthy witch-hunt," while the avowedly left-wing J. Hoberman still could describe Ray in the *Village Voice* as "an ex-Communist who was never persecuted and must have wondered why."

※

Although the experience of meeting the great man was always memorable, many felt—as Kazan once did—that Ray was terribly "ungathered."

In March 1973, the former Hollywood director turned up in his old stomping ground of Madison, Wisconsin, where graduate student Gerald Peary, who later became a Boston film critic, was a teaching assistant at the University of Wisconsin. After a screening of *Johnny Guitar,* Ray took questions and taught a practicum for film students. An auteurist who carried around a thumb-worn copy of Andrew Sarris's *American Directors,* Peary was among the throngs who attended Ray's events.

One day Peary and other students assembled eagerly for the director's workshop in an empty classroom set aside for that purpose. Ray divided the group up into a crew ready to work behind the camera, using sixteen-millimeter equipment, and others who were willing to perform improvised scenes. Whenever he was asked a question, Ray took a long time before responding in his weary, often incoherent way. "What was wrong with him?" Peary wondered.

"Perhaps recalling vaguely some paranoid moment crossing a border at an airport (because he was carrying drugs?), Ray broke the actors down

into opposing groups," recalled Peary. "One group was passengers trying to get into the U.S., being stopped at the border. The other group was government agents checking passports, looking for suspicious people trying to wiggle into the country.

"The two thespian groups huddled there, waiting for directions from Ray. The crew waited for directions from Ray. And my memory is that *nothing* happened. Ray stumbled about in private thought, private conversation, and all those people kept waiting. For a few hours. Finally, everyone dispersed. Ray himself didn't seem to notice the hours passing, and that he never got around to directing."

The next day, a privileged group of film-crazy students were invited to a lunch with Ray. Peary ended up sitting next to the director. Ray was quiet, "pretty uncommunicative." Peary tried to engage him, asking him what had happened during the production to mar his vision of *King of Kings*. "Ray had no answer. Instead he gasped around, and began seriously trembling and trembling . . . never saying anything."

Lunch continued awkwardly. An hour later, it was time for Ray to say his good-byes. "And this weird thing happened," Peary continued. "Nick Ray sought me out, walked up to me, and said this cryptic sentence . . . 'This summer . . . Some of us . . . are coming through here in a van.' Did he mean that, *On the Road*–fashion, he was crossing America and that, *Electric Kool Aid Acid*–fashion, he had chosen me, me alone of all his UW contacts, to be On the Bus? I'll never know . . ."

Regardless, the *Velvet Light Trap,* the left-wing, auteurist campus film journal, published a lengthy, reverential interview with the director, who was often able to recount, in loving detail, shots or highlights from his beloved Hollywood movies, but who in other respects behaved like a regrettable wreck of a human being.

✳

After Madison, the director was invited to Portland, Oregon, by the Northwest Film Student Center for a screening of *They Live by Night*. Ray attended a reception at a private home that drew a local crowd, including Ted Mahar, a film critic and entertainment writer for the *Portland Oregonian. Rebel Without a Cause* had been "one of the major cinema events" in Mahar's life, and for weeks he had been looking forward to meeting

Ray. Mahar arrived bristling with questions about James Dean, Bogart, Mitchum, and all the rest.

Mahar instantly recognized that his auteurist hero had seen better days. "His physical body was horribly present, but he was so blotto that he had trouble standing and focusing," Mahar recalled. "Might as well have chatted up the family pooch." Mahar gamely flipped open his journalist's notebook, and the partying stopped all around as Ray "struggled manfully to perform well for the audience," answering Mahar's questions.

Ray seemed oddly belligerent, not toward Mahar personally, but toward "the Establishment." And he couldn't concentrate on the questions. "He literally seemed unable to get me into focus," Mahar recalled. "His brows were like cartoon slashes as he faced me, leaned forward, and tried to stare at me intently. After about fifteen minutes of this, his eyes began to close involuntarily. He never actually nodded off, but the pattern was clear. He was becoming incommunicado.

"The experience saddened me tremendously," the journalist remembered. It was "the major reason I chose to write nothing" in the *Oregonian* about Ray's visit.

✳

Auteurists generally looked past the man to his films, but many were also smitten with the man regardless of his flaws, above and beyond his accomplishments. One day, during a visit to Hollywood, Myron Meisel took an emergency telephone call in his hotel room from the director, who was also passing through Los Angeles. Ray explained that he'd gotten himself "pinned under a large metal standing shelf that had fallen on him" in an editing room at F & B CECO, an independent production company, where he was toiling away on his student-professor film.

"It seemed an odd situation," recalled the former Boston film critic, who'd helped craft the *I'm A Stranger Here Myself* documentary about Ray, "but I rushed over in a cab to pull it off. There I saw this plaintive man, terrible as Lear, submerged in spools of film, literally drowning in the issue of his compulsive drive to glory and failure. If you committed a scene like that to film, no one would believe it. He slept that night in my bed and in the morning put the bite on me for practically everything in my wallet."

Regardless, "I cherished every minute of it," Meisel recalled a few years later, "even unto watching *My Darling Clementine* at 4 A.M. with the

sound off. He had dozed off claiming that he never slept more than two or three hours at a time, hadn't for years. He was out for nine. I don't think I had ever before seen him asleep."

<p style="text-align:center">❊</p>

By early 1976, having burned too many bridges on the West Coast, Ray decided to return to live in New York. One of the last things he did before leaving Los Angeles was attend the funeral of Sal Mineo, the young actor who had soared to fame and success in *Rebel Without a Cause*. In February, Mineo had been murdered by a drifter near his home in West Hollywood.

Ray brought *We Can't Go Home Again* back to New York with him, aiming to polish up the latest version to show to Don Rugoff, whose company Cinema 5 owned a small chain of New York theaters showing art house films. The director had been working on his student-professor film fitfully for years, between his crises and meltdowns, shaping and reshaping the material. The 1976 version was significantly altered from its 1973 predecessor, with footage from his Chicago Seven and flying-saucer projects woven into the Harpur College material, along with cameo interviews with counterculture celebrities and Jimi Hendrix on the soundtrack. Ray had written new narration to replace Tom Farrell's 1973 voice-over, and this time he recorded the narration himself, rising to the occasion in a San Francisco recording studio with eloquent voice-over work that helped focus the film.

"I stayed to the end of the [Chicago Seven] trial," Ray explains in his narration. "Most people began to disappear. Which really made me wonder—where is everybody? So I thought I'd try to find them someplace else. Fortunately, I was offered a job in an upstate New York university. Hell, I decided I'd buy a crooked cane, grow a goatee, wear a crooked smile and impress them with my rhetoric, rebellion, and ponderosity."

In many ways, though, *We Can't Go Home Again* remained a stubborn hodgepodge in need of cohesion. As the Cinema 5 screening date neared, Ray drank "heavily," in the words of Susan Schwartz, becoming "almost useless." All along Schwartz had been helping Ray in ways small and large, and now she stepped in to give the film a more coherent structure. "I had a lot to do with that work print. For one thing, I outlined it, I established the order of the scenes," Schwartz said later. "I also did the music."

The distributor was insufficiently impressed, however, and *We Can't*

*Go Home Again* lost its final bid for public bookings. At first, though, that didn't crush Ray—because, in the spring of 1976, largely as a result of all the attention he'd received for his student-professor film project, along with his many personal appearances and laudatory interviews, the director appeared to have landed one last chance to mount a theatrical feature.

\*

"NICK RAY BACK: LEAD *IS PORNO QUEEN*" screamed the April 21, 1976, headline in *Variety.* The article described plans for a screen story involving a young hooker defended by a seedy lawyer. Blending courtroom drama (one of Ray's specialties) with a porno slant (a more recent feature of his career), the project would star Marilyn Chambers of the scandalous X-rated blockbuster *Behind the Green Door.* The lawyer was to be played by Rip Torn, whom Ray had directed before in *King of Kings.*

If the name Nick Ray still stirred excitement in film circles, the real attention-grabber was the casting of Chambers, a blond hard-core actress then at the peak of her notoriety. The director said that he hadn't seen *Behind the Green Door,* nor attended Chambers's "Le Bellybutton" cabaret show currently running in a Manhattan hotel. For that matter, he hadn't even screen-tested the actress. Rather, Ray had simply talked and walked with Chambers. "I have a camera in my head," Ray declared, then undercut this pronouncement by adding, more dubiously, that Chambers would "eventually be able to handle anything that the young Katie Hepburn or Bette Davis could."

The script was by a writer named William Maidment; the ostensible producer was Jan Pieter Welt, who had photographed, acted in, and helped edit author Norman Mailer's film projects. Mailer himself was said to have signed on for a supporting role, and Ray's old boxing pal Roger Donoghue—a friend of Mailer's too—would pitch in on the script.

An ebullient Ray took an office and a cutting room in a house at the corner of Broadway and Canal. Meeting with Chambers, Ray was informed by the performer that blue was the best color to flatter her looks. He was momentarily disconcerted, having long inveighed against that color. But rules were made to be broken, and Ray announced that he would shoot the film entirely in shades of blue and call it "City Blues."

It was all a glorious delusion, and not everyone noticed that Ray

started drinking at breakfast and tended to fall asleep in his soup at lunch-time. "With some change in his pocket," as Susan Schwartz chronicled later, "Nick easily found all the herbs, liquids and powders he claimed he wanted to quit and he went for them all; but he stayed on the job rewriting the script in three days, scouting locations, talking with actors, abounding with visions and plans." The starting date of "City Blues" kept getting postponed, and within two months, changing tax shelter laws halted the shaky financing.

One day, Ray ran into British film critic V. F. Perkins in Greenwich Village. In the course of their conversation, Perkins told him he had an idea for a horror film. Ray thought it sounded like a good idea and asked if his auteurist champion would like a partner on the script. Perkins was taken aback; he hadn't thought of Nick Ray as a horror filmmaker, much less a potential collaborator. Yet they plunged into the partnership routine, never getting beyond a first draft—another on the pile of unfinished Ray scripts.

"The horror was not just on paper," recalled Schwartz, who was at her wit's end. When the director refused to moderate his self-destructive habits, she left him. "Nick was no longer able to be a cool drunk," according to Schwartz. "He looked like an asshole when drunk. Plus which he was constantly in and out of hospitals with a series of ailments, from pneumonia to infected bruises, all of them the result of his alcoholism. Plus which he had worn out most of his friends now; he had no place to go."

A week later, in early September 1976, Ray fell down a flight of stairs and injured himself. He had been checking into hospitals with regularity for years, for illnesses or falls aggravated by his addictions—including one stint, while filming a student workshop in Minneapolis, that briefly aggravated his old foot problems and forced him onto crutches. But this new injury, along with Schwartz's desertion and his deteriorating professional fortunes, was one wake-up call that penetrated. Ray checked himself into Roosevelt Hospital and spent two months in the detox unit there.

Released in November, he vowed to stay sober. He moved into a new home with Schwartz, "finally a place big enough for us both," she said. The two went job-hunting by day, then "joined other couples for bridge and quiet evenings at home." Ray also attended daily Alcoholics Anonymous meetings. "I believe he felt a new peace at this time," she wrote later.

*

Teaching and acting rejuvenated Ray. Old colleagues Elia Kazan and John Houseman arranged for him to host acting-directing workshops at the Lee Strasberg Institute, part of the Actors Studio, where he gave talks and assigned texts on Vakhtangov and Stanislavski as well as Robert M. Pirsig's *Zen and the Art of Motorcycle Maintenance.*

"That insanity is over," Ray told Cliff Jahr during his *Camera Three* interview in 1977. He was referring to his lost European years in the 1960s, though he could have meant all his insanities through all the years. In this appearance the director looked none the worse for wear, wearing a fashionable seventies-style suit. He didn't hem or haw; he seemed more focused than he had in years, without the extended silences or unfinished sentences he was known for. "I like myself better now," Ray declared.

Late that winter, the New German Cinema filmmaker Wim Wenders came to New York to shoot scenes for a movie based on Patricia Highsmith's Ripley novels. The cast of Wenders's picture, called *The American Friend* in English, included Dennis Hopper and Hollywood B director Sam Fuller. Wenders had never met Ray—neither, for that matter, had Fuller— but they were brought together by the French production manager and hit it off. One night, during an all-night game of backgammon, Wenders told Ray the story of Ripley (a series of books), and Ray expressed interest in playing one of Highsmith's characters: the small role of a painter who keeps producing art after faking his death. (His paintings become more valuable after his death.)

Wenders had left that character out of his movie, but now, with Ray's help, the character was written into the script. The German filmmaker directed Ray in a few cryptic, self-referential scenes in the spring, including brief scenes with Hopper. "It was the first time they had worked together for twenty years," Wenders recalled. "Dennis was very moved. And Nick was nervous."

Ray continued to be in demand as a speaker on the college circuit, although he confined most of his appearances to the East Coast because of his teaching responsibilities. He had quit alcohol so thoroughly that he would not even taste a dessert flavored with brandy, according to friends; he attended his AA meetings faithfully, sometimes twice a day. These days

he seemed almost like a traditional professor in his workshops for budding actors and directors. "With his new glasses," wrote Bill Krohn, who observed a Strasberg Institute session, "Nick looks a little bit like Barry Goldwater, and what he seems to be teaching, apart from the time-tested precepts of the Method, is discipline, orderliness, and professionalism. A far cry from the wild tales of the Harpur days."

The Strasberg Institute classes were regarded as a personal vindication for Ray, and in the summer Laszlo Benedek—the director of *The Wild One* with Marlon Brando, now head of the New York University (NYU) film department—invited him to host a summer workshop for advanced students. That too was considered successful, so much so that the director was asked to teach a regular class at NYU in the fall of 1977.

Too soon however everything changed. After checking into a New York hospital for tests, Ray was diagnosed with lung cancer. Exploratory surgery indicated the cancer had surrounded his aorta and invaded his bloodstream. The doctors gave him two difficult years at most. Among his visitors was Kazan, who found Ray looking healthy and in good spirits. Ray took off his pajama top and proudly "exhibited a long red scar diagonally across his back," Kazan recalled, then put his top back on, sat down, and lit a cigarette. "I wondered if he was doing that for my benefit—or for his own," Kazan wrote later. "I figured that it was his way. He was challenging death."

✳

Writer Michael Weller, who joined in a weekly poker game with Ray, thought the director might play the small role of the General in Miloš Forman's film of *Hair*, for which Weller had written the screenplay. The offer was appreciated, and by February 1978 Ray was on location in Barstow, California, playing a general sternly addressing Vietnam-bound troops with a wind machine blowing black smoke around him. Forman later said that he had no idea of Ray's cancerous condition, or he wouldn't have called for repeated takes for several days. "He never once complained," said Forman. But Ray had always been a trouper, and the worst was yet to come.

Wim Wenders and Dennis Hopper came up from Hollywood to spend a little time with Ray, and the director traveled to Malibu to visit the Housemans. When his son Tim escorted him to an AA meeting in the

area one day, he encountered Edith Soderberg, "an old friend from Garden of Allah and RKO days," in Ray's words, one of the screenwriters who'd done repair work on *Born to Be Bad,* now honoring the pledge along with Ray. Later the director took the bus to Las Vegas for one last gambling splurge—as usual, losing more than he won.

Returning to New York after the filming, Ray continued to teach sporadically at NYU and the Strasberg Institute. His interaction with Wenders, Forman, and other filmmakers, and his stimulating exchanges with students, renewed the old itch to direct one last picture. He began to generate fresh ideas for film projects, taking stabs at various scripts (among them the story of the founder of Alcoholics Anonymous). The unorthodox professor reemerged—"No lectures! Just do it!" The former Hollywood director even launched a couple of short film projects with his students.

*Cahiers du Cinéma* correspondent Bill Krohn returned to the Strasberg Institute and watched Ray as he directed a few days' worth of *Marco,* an eleven-minute sixteen-millimeter short film with his students playing criminals caught in a police dragnet. "The first day of shooting," Krohn wrote, "is devoted to booking the students, each of whom has been assigned a crime as the basis for his improvisation.

"But because of the inadequate wiring at the Institute, the lights keep blowing every three minutes, and shooting conditions on the cramped stairway outside the Marilyn Monroe Room are difficult . . .

"By six o'clock the shooting is already half a day behind schedule; Nick makes a stern speech berating the students for their habitual lateness and enjoins them to report in at twelve o'clock sharp the next day.

"Assuming that the injunction does not apply to journalists I come at four o'clock and Nick shows up after me. By this time most of the class has gone home."

\*

At the recommendation of his longtime friend Connie Ernst Bessie, by then a cancer survivor herself, Ray entered the Memorial Sloan-Kettering Cancer Center in early April 1978 for experimental treatments that involved the implantation of radioactive particles in his lungs. In May he had a brain operation to remove a tumor.

Somehow, through the years—regardless of his soiled shirts, his

nicotine-stained and burned fingers, his wine-blotched lips, his stub-
born, phlegmy cough; regardless of how addled with drink or drugs he
became—the director had always retained his rugged, vulnerable beauty.

Now his look changed dramatically, though it was still charismatic.
When film critic David Thomson met Ray at Dartmouth College in mid-
summer 1978, after his surgery and radiation treatments, he thought the
director resembled "Max Schreck's vampire in Murnau's *Nosferatu,* for he
was utterly bald and the head was a glaring, eerie dome."

Wenders had vowed to make another film with Ray, this time with
the ailing director as its star. In a sense they would be codirectors. By now
Ray knew he would never finish *We Can't Go Home Again* to his own sat-
isfaction. Wenders's offer was his last chance to be involved in a motion
picture that might actually come to fruition. Ray suggested that he might
again play the painter character from *The American Friend* "as a point of
departure," in Wenders's words, with the painter learning that he's dying
for real this time—of cancer.

Ray dashed off a number of script pages about "a man sick with cancer
who wanted 'to bring himself altogether' before he died," in Schwartz's
words. The project gained momentum with European financing in late
1978, though Ray had lost weight due to his illness and become frail and
depressed. "His body shrank down and everything extra burned away with
disease," Schwartz recounted. "What was left was essence of life which in
Nick's face took on a look of such pure sweet sadness it was transfixing."

The photography started in New York in late March 1979, with a
screening of *The Lusty Men* and a talk-back at Vassar College. His mood
elevated by cocaine, Ray showed fits of energy in the first week of film-
ing. But the script quickly faltered, Ray's health declined further, and the
part-fiction, part-documentary idea began to morph. Soon the production
was being improvised around Ray's bedside at the Spring Street home he
shared with Schwartz, becoming primarily a colloquy between the two
filmmakers, interspersed with glimpses of visitors and friends and family
sometimes playing themselves, sometimes fictional characters.

"Look, everybody's looking at me!" says Old Tom as he lies dying in
*Johnny Guitar,* a good line that might have been written by Ray. "It's the
first time I felt important."

Schwartz was conflicted—sometimes "in an extreme state of rage"—
over the production, which increasingly intruded on her home and her

beloved's obvious suffering. Wenders liked to call it "Nick's Movie," but the two filmmakers were at constant loggerheads over how to shape the scenes, and Ray wasn't up to challenging Wenders: It was really "Wim's Movie." Ray felt his German colleague was "lost, both behind and before the camera," Schwartz wrote later, and what he saw of the dailies he didn't particularly like.

The first round of photography had to be interrupted in early April when Wenders was summoned to California for talks with the screenwriter of *Hammett,* a feature film about the crime novelist Dashiell Hammett that he was preparing for Francis Coppola. With Wenders gone, Ray was admitted to Sloan-Kettering for subsistence treatments. When the German filmmaker returned, he was told that Ray's days were numbered. Wenders's producer asked Ray's physician if the dying man could be kept alive for at least the handful of days that were needed to finish the film. "Lest it be considered cold-blooded," Dr. William G. Cahan later wrote, "I should say that Nick desperately wanted this. However, in spite of vitamin shots, stimulants, exhortations to eat, he kept steadily wasting away.

"In his late stages, he had completely lost his appetite," continued Cahan, "and his esophagus was so narrowed by the cancer that it was impossible for him to swallow. To delay this race with death, we fed him food concentrates intravenously. On this routine, the reverse of a crash diet, he gained a pound a day, [and] for a short time, renewed vigor."

Ray's hospital room was flooded by his circle of old trusted friends, some of them dating back to the early 1930s—Connie Bessie, Alan Lomax, Jean Evans. The hospital welcomed Ray's students from Harpur College and other young people from the Strasberg Institute and NYU. Ray's son Tim, who was involved in the Wenders production, both behind and in front of the camera, was often at his father's bedside and tried to teach him meditation exercises to ease the constant pain.

Elia Kazan hurried to the hospital one day and found Ray being pushed down a corridor in a wheelchair by a nurse. At first he didn't recognize the man he'd met some thirty-five years earlier at the Theatre of Action compound, and when he did, he thought, "He'll look better in his coffin." One side of Ray's head was shaved, he recalled, "and there was a target mark indicating where the X-ray should be aimed."

When Kazan said hello, Ray's response was "less cordial than usual, not unfriendly but distracted." Kazan walked along with Ray's wheelchair,

"asking a few questions, getting uncertain and brief answers. He seemed in a hurry as if he was late for an appointment."

As they entered his hospital room, Ray called out "Wim!" and Kazan noticed several men busy setting up camera and sound equipment. He was taken aback to realize that his old friend was devoting his final days to a film capturing his own life and imminent death. "Just like him," Kazan thought as Ray left, "Nick is like an actor preparing to play his most important scene.

"I thought about what was going on and found it grotesque: a man cooperating in putting his own death on film. Walking home, I thought more about what I'd seen. I thought Wenders ghoulish, but I also thought that this might be what Nick himself would most wish to do: dramatize himself as he was dying, make that his last act on earth. What kind of man would do that?"

Years later, as Kazan was working on his autobiography and reflecting on that last encounter with Ray, he worked up the nerve to watch the Wenders film, eventually titled *Lightning over Water,* which he'd "vowed not to see." "Much of it," Kazan wrote, was "clumsy and tedious. But then came an extraordinary long close-up of Nick near the end. The dying director, who knows he's dying, looks straight into the camera's lens and directs his last scene, which is his death. Nick looked unbelievably exhausted. There could be no doubt that he had only a few days to live. But there was also no doubt that, with those last hours of his life, this was precisely what he wanted to do.

"A director when he watches a scene and has what he wants calls out, 'Cut!' But sometimes, when the scene is going surprisingly well and is providing some astonishing things, he will whisper to his cameraman, 'Don't cut,' and allow the scene to continue past where he'd rehearsed it. Nick Ray was directing his own last close-up. Toward the end of the shot and of what he had to say in the shot, he called out, 'Cut!' Then, 'Don't cut!' What Nick was calling out was something more than an instruction to a cameraman. He was prolonging his life where he'd most lived his life—on film.

"Nick didn't want to die. He wanted to go on. He didn't give in, not a minute, not on an inch of film. Even in his last terrible misery, he clung to every 'foot' of life, the film on which his living was being preserved. You may call it phony, and I will understand why. But I call it heroic."

✳

The last take of Wenders's film was recorded on May 3. A few days later, Ray attended a Museum of Modern Art screening of *They Live by Night* and *On Dangerous Ground,* answering audience questions though he stood at death's door. ("We lifted him on stage in a wheelchair," wrote Tom Farrell.) He hung on for another month and was in his hospital bed on June 11 when visitors told him that John Wayne had passed away. Wayne's death struck an unexpected blow: The director tried to tell a fond anecdote about Wayne, but words failed him.

Ray enjoyed telling friends and interviewers that one day his headstone might read "I Was Interrupted." European cinephiles might prefer "Mr. CinemaScope." Fans of *Johnny Guitar* would suggest "I'm a stranger here myself."

He was two months short of his seventy-eighth year when his life was interrupted in the night of June 16, 1979. According to his last wishes, Ray was interred in section 53, lot 248 of the Oak Grove Cemetery in La Crosse, Wisconsin, in the same section as his parents. His grave is only numbered, with no inscription.

✳

Thirty years after his death, as the centennial of Ray's birth approaches in August 2011, his auteurist mystique endures. Although the older European critics who first trumpeted Ray's greatness sixty years ago are a dying breed, they have left their mark on Ray's status in film history and in the renewable ardor of younger critics.

In America, Andrew Sarris is still alive and well and writing about film, and although he has modified his views about many things over the years, his auteurist treatise and early pronouncements were accepted as gospel, sometimes without nuance, by the next generation of American film critics. The best of these include the most constant Ray admirers: Jonathan Rosenbaum—another Francophile—and David Thomson, a transplant from England and *Sight and Sound*. In his 2009 book *Have You Seen . . . ?* Thomson lists seven favorite Nick Ray films—more than one-third of Ray's total output—out of the one thousand he recommends as

vital filmgoing experiences.* Rosenbaum and Thomson, prolific and eloquent, alone could hold the Alamo.

In Europe, as in America, Ray's films have been revived almost nonstop on cable television and in museum and art house retrospectives over the thirty years since the director's death. Though several of his films remain unavailable in the United States, some have been belatedly restored and made available on DVD: the original, 102-minute version of *Bitter Victory* was offered to the public in 2005, and a special edition of *Bigger Than Life,* "now recognized as one of the great American films of the 1950s," according to company publicity, was released as part of the Criterion Collection in 2010, the first of several Nicholas Ray films Criterion plans to resuscitate and market worldwide.

In death Ray remains very much alive—so much so that in 2011, his centennial year, the Venice Film Festival has announced that will finally unveil a definitive version of *We Can't Go Home Again.* Incomplete for thirty years, Ray's 1976 edition of the student-professor film has undergone a $500,000 restoration and finally been finished by his widow, Susan Schwartz Ray.

This, at long last, is the Nicholas Ray film the purists have been waiting for. Susan Ray is the former Susan Schwartz, who seems never to have been formally married to the director or to have been known as "Mrs. Ray" during his lifetime. But Ray was lucky in love with the college student he met in Chicago nine years before his death. She was steadfast during his last years and kept the flame burning after he passed away, launching a foundation to uphold his legacy and tirelessly raising money to restore his last acheivement. Like so many, she believes in Ray's greatness, and she believed all along in his student-professor film. The final cut is hers. However it is received, auteurists might well call it *"un film de* Mr. and Mrs. Ray."

---

* Thomson lists *They Live by Night, In a Lonely Place, The Lusty Men, Johnny Guitar, Rebel Without a Cause, Bigger Than Life,* and *Bitter Victory.* For comparison's sake, his book lists 14 each by John Ford (out of 137 feature films plus 24 short films or television programs) and Howard Hawks (out of 41 credited features), and 17 (out of 53) directed by Alfred Hitchcock.

# Filmography

Cast and crew are identified and listed in the order of the original credits, as the names appeared on the screen at the time of the film's initial release. Various websites—including the Internet Movie Database (www.imdb.com)—feature more complete lists of cast and crew, including "unbilled" players and personnel and spelling variations.

## 1948
### THEY LIVE BY NIGHT

*As director.* Sc: Charles Schnee, adaptation by Ray based on the novel *Thieves Like Us* by Edward Anderson. Ph: George E. Diskant.

Cast: Cathy O'Donnell (Keechie), Farley Granger (Bowie), Howard Da Silva (Chickamaw), Jay C. Flippen (T-Dub), Helen Craig (Mattie), Will Wright (Mobley), William Phipps (Young Farmer), Ian Wolfe (Hawkins), Harry Harvey (Hagenheimer), Marie Bryant (Singer), Will Lee (Jeweller), Jim Nolan (Schreiber), Charles Meredith (Commissioner Hubbell), Teddy Infuhr (Alvin), Byron Foulger (Lambert), Guy L. Beach (Plumber).

(B & W, John Houseman for RKO Pictures, 95 mins.)

> *The most romantic and haunting young-criminals-on-the-run movie ever made.*
> —Filmmaker Jim Jarmusch

## 1949
### A WOMAN'S SECRET

*As director.* Sc: Herman J. Mankiewicz, based on the novel *Mortgage on Life* by Vicki Baum. Ph: George E. Diskant.

Cast: Maureen O'Hara (Marian Washburn), Melvyn Douglas (Luke Jordan), Gloria Grahame (Susan Caldwell/Estrellita), Bill Williams (Lee Crenshaw), Victor Jory (Brook Matthews), Mary Philips (Mrs. Mary Fowler), Jay C. Flippen (Police Inspector Jim Fowler), Robert Warwick (Assistant District Attorney Roberts), Curt Conway (Doctor), Anne Shoemaker (Mrs. Matthews, Brook's Mother), Virginia Farmer (Mollie the Washburn Maid), Ellen Corby (Nurse), Emory Parnell (Police Lieutenant).

(B & W, Herman J. Mankiewicz for RKO Pictures, 84 mins.)

> *Drawing on* Citizen Kane *and prefiguring* All About Eve, *Herman J. Mankiewicz's script for* A Woman's Secret *spins a twisty tale, told in a series of overlapping, sometimes contradictory flashbacks so that the past becomes a shifting chimera of unreliable accounts . . . [Ray] managed to bring crackling cynicism to the studio gloss.*
>
> —James Quandt, program notes, Pacific Film Archives retrospective

## KNOCK ON ANY DOOR

*As director.* Sc: Daniel Taradash and John Monks Jr., from the novel by Willard Motley. Ph: Burnett Guffey.

Cast: Humphrey Bogart (Andrew Morton), John Derek (Nick Romano), George Macready (District Attorney Kerman), Allene Roberts (Emma), Susan Perry (Adele), Mickey Knox (Vito), Barry Kelley (Judge Drake).

(B & W, Robert Lord for Santana Productions/Columbia, 100 mins.)

> *A fascinating, slightly askew mix of social document and romantic agony. The basic material may be determinist melodrama—slum boy with deck stacked against him winds up on Death Row despite the efforts of a liberal lawyer (Bogart, whose Santana company made the film). But it's hard hitting in its own right, tautly crafted, and repeatedly stabbed through with Ray's impulsive generosity and anguish towards his characters.*
>
> —TP [Tim Pulleine], *Time Out Film Guide* (UK)

## 1950

## BORN TO BE BAD

*As director.* Sc: Edith Sommers, adapted by Charles Schnee. Additional dialogue by Robert Soderberg and Charles Oppenheimer. Based on the novel *All Kneeling* by Anne Parrish. Ph: Nicholas Musuraca.

Cast: Joan Fontaine (Christabel Caine), Robert Ryan (Nick Bradley), Zachary

Scott (Curtis Carey), Joan Leslie (Donna Foster), Mel Ferrer (Gabriel "Gobby" Broome), Harold Vermilyea (John Caine), Virginia Farmer (Aunt Clara Caine), Kathleen Howard (Mrs. Bolton), Dick Ryan (Arthur, Curtis's Butler), Bess Flowers (Mrs. Worthington), Joy Hallward (Mrs. Porter), Hazel Boyne (Committee Woman), Irving Bacon (Jewelry Salesman), Gordon Oliver (Harrison, the Lawyer).
(B & W, Robert Sparks for RKO, 94 mins.)

> *A rigorously unsentimental movie (excepting a ludicrous airfield scene both written and directed by studio boss Howard Hughes), beautifully staged and photographed (by Nicholas Musuraca, who also photographed* Out of the Past), *and with a nice comic tartness, especially in the way it views the Fontaine character's sweet-kid maneuvers and betrayals.*
>
> —James Harvey, *Movie Love in the Fifties*

## IN A LONELY PLACE

*As director.* Sc: Andrew Solt. Adaptation by Edmund H. North from the novel by Dorothy B. Hughes. Ph: Burnett Guffey.
Cast: Humphrey Bogart (Dixon Steele), Gloria Grahame (Laurel Gray), Frank Lovejoy (Brub Nicolai), Carl Benton Reid (Captain Lochner), Art Smith (Mel Lippman), Jeff Donnell (Sylvia Nicolai), Martha Stewart (Mildred Atkinson), Robert Warwick (Charlie Waterman), Morris Ankrum (Lloyd Barnes), William Ching (Ted Barton), Steven Geray (Paul, the Head Waiter), Hadda Brooks (Singer).
(B & W, Robert Lord for Santana Productions/Columbia, 94 mins.)

> *Hollywood atmosphere, existential malaise, and political subtext combine to inform a sensational love story, played on the edge of the void and strong enough to sustain one of the most shamelessly romantic lines in any movie: "I was born when you kissed me. I died when you left me. I lived a few weeks while you loved me." The line occurs twice, spoken at different points in the drama by each of the lovers, just to make sure that we never forget it.*
>
> —J. Hoberman, the *Village Voice*

## 1951
## ON DANGEROUS GROUND

*As director.* Sc: A. I. Bezzerides. Adaptation by Ray and Bezzerides from the novel *Mad with Much Heart* by Gerald Butler. Ph: George E. Diskant.

Cast: Ida Lupino (Mary Malden), Robert Ryan (Jim Wilson), Ward Bond (Walter Brent), Charles Kemper (Bill Daly), Anthony Ross (Pete Santos), Ed Begley (Captain Brawley), Ian Wolfe (Carrey), Sumner Williams (Danny Malden), Gus Schilling (Lucky), Frank Ferguson (Willows), Cleo Moore (Myrna Bowers), Olive Carey (Mrs. Brent), Richard Irving (Bernie Tucker), Patricia Prest (Julie Brent).
(B & W, John Houseman for RKO Pictures, 82 mins.)

> *A high point of neurosis in film noir ... [with] Robert Ryan as a cop so tautened*
> *by his calling that the simplest act turns savage.*
>
> —Anthony Lane, the *New Yorker*

## FLYING LEATHERNECKS

*As director.* Sc: James Edward Grant, based on a story by Kenneth Gamet. Ph: William E. Snyder.
Cast: John Wayne (Major Dan Kirby), Robert Ryan (Capt. Carl Griffin), Don Taylor (Lieutenant Vern "Cowboy" Blythe), Janis Carter (Joan Kirby), Jay C. Flippen (Master Sgt. Clancy), William Harrigan (Dr. Curan), James Bell (Colonel), Barry Kelley (Brigadier General), Maurice Jara (Lieut. Shorty Vegay), Adam Williams (Lt. Bert Malotke), James Dobson (Lt. Pudge McCabe), Carleton Young (Col. Riley), Steve Flagg (Capt. Harold Jorgensen), Brett King (First Lt. Ernie Stark), Gordon Gebert (Tommy Kirby).
(Technicolor, Edmund Grainger for RKO Pictures, 102 mins.)

> Flying Leathernecks *packs a surprising amount of intelligent insight in with*
> *its nationalistic rally cry.*
>
> —Jeremy Heilman, www.moviemartyr.com

## 1952
## THE LUSTY MEN

*As director.* Sc: Horace McCoy and David Dortort, suggested by a story by Claude Stanush. Ph: Lee Garmes.
Cast: Susan Hayward (Louise Merritt), Robert Mitchum (Jeff McCloud), Arthur Kennedy (Wes Merritt), Arthur Hunnicutt (Booker Davis), Frank Faylen (Al Dawson), Walter Coy (Buster Burgess), Carol Nugent (Rusty Davis), Maria Hart (Rosemary Maddox), Lorna Thayer (Grace Burgess), Burt Mustin (Jeremiah Watrus) Karen King (Ginny Logan), Jimmy Dodd (Red Logan), Eleanor Todd (Babs).

(B & W, Jerry Wald for Wald-Krasna Productions/RKO Pictures, 113 mins.)

*Wim Wenders includes a clip from this scene in* Lightning over Water, *a semi-fictional film he made with Ray as Ray was dying of cancer, and he pays homage to it in his film* Kings of the Road. *It sets the tone for the rest of the picture—the loneliness, the barrenness of the settings, the feeling of disconnection and loss. . . . Ray works from the personalities of his actors—Mitchum's ease and resignation are an important part of the movie—and from the stark settings and the world of the rodeo riders, the way they dress and speak and interact: They all share an awareness of mortality, the certainty that death or injury could come at any time for the men in the ring (the rodeo sequences themselves are hair-raising), and they talk about it, share their feelings, help each other get through it . . . a powerful picture with a unique mood—autumnal, sad and very soulful.*

—Martin Scorsese, "The Scorsese Selection," www.directv.com

## 1954
### Johnny Guitar

*As director.* Sc: Philip Yordan, based on the novel by Roy Chanslor. Ph: Harry Stradling.
Cast: Joan Crawford (Vienna), Sterling Hayden (Johnny Guitar), Mercedes McCambridge (Emma Small), Scott Brady (Dancin' Kid), Ward Bond (John McIvers), Ben Cooper (Turkey Ralston), Ernest Borgnine (Bart Lonergan), John Carradine (Old Tom), Royal Dano (Corey), Frank Ferguson (Marshal Williams), Paul Fix (Eddie), Rhys Williams (Mr. Andrews), Ian MacDonald (Pete).
(Trucolor, Herbert J. Yates for Republic Pictures, 110 mins.)

*Many of Ray's films, including his best, are flawed. And to me, it does not make any difference.* Johnny Guitar *might well be the best bad film in the history of film.*

—Christian Viviani of *Positif**

## 1955
### Run for Cover

*As director.* Sc: Winston Miller, from a story by Harriet Frank Jr. and Irving Ravetch. Ph: Daniel Fapp.

---

* In an e-mail to the author.

Cast: James Cagney (Matt Dow), Viveca Lindfors (Helga Swenson), John Derek (Davey Bishop), Jean Hersholt (Mr. Swenson), Grant Withers (Gentry), Jack Lambert (Larsen), Ernest Borgnine (Morgan), Ray Teal (Sheriff), Irving Bacon (Scotty), Trevor Bardette (Paulsen), John Miljan (Mayor Walsh), Gus Schilling (Doc Ridgeway).
(VistaVision and Technicolor, William H. Pine and William C. Thomas for Paramount, 93 mins.)

> *A curious but important film . . . the generational conflict and the violent path of [James] Cagney and [John] Derek's journey to self-knowledge echoes the themes of Ray's undisputed masterpieces,* Johnny Guitar *and* Rebel Without a Cause *. . . [and] is marvelously directed by Ray, who catches both the repressions of his characters and the violence necessary to break through them.*
> —Phil Hardy, *The Overlook Film Encyclopedia: The Western*

## REBEL WITHOUT A CAUSE

*As director.* Sc: Stewart Stern. Adaptation by Irving Shulman from a story by Ray. Ph: Ernest Haller.
Cast: James Dean (Jim Stark), Natalie Wood (Judy), Sal Mineo (John "Plato" Crawford), Jim Backus (Frank Stark, Jim's Father), Ann Doran (Mrs. Carol Stark, Jim's Mother), Corey Allen (Buzz Gunderson), William Hopper (Judy's Father), Rochelle Hudson (Judy's Mother), Dennis Hopper (Goon), Edward Platt (Ray Fremick), Steffi Sidney (Mil), Marietta Canty (Crawford Family Maid), Virginia Brissac (Mrs. Stark, Jim's Grandmother), Beverly Long (Helen), Ian Wolfe (Dr. Minton, Lecturer at Planetarium), Frank Mazzola (Crunch), Robert Foulk (Gene), Jack Simmons (Cookie), Tom Bernard (Harry), Nick Adams (Chick), Jack Grinnage (Moose), Clifford Morris (Cliff).
(CinemaScope and WarnerColor, David Weisbart for Warner Bros., 111 mins.)

> *This is a key moment in American film, poised on the brink of rock 'n' roll and the kingdom of the American teenager, yet bringing to a close the era of the brooding existential hero, the tradition that had gone from John Garfield to Brando and Clift, and which had suddenly risen up in the untidy life of Nicholas Ray as that ghost-in-waiting James Dean. And for a moment, two nervous wrecks—the actor and the director—were looking in time's mirror and the result was a film that survives as emotional melodrama, as a portrait of high school and of the impossible remaking of family in America. There are moments of pretension, of*

*stilted lines and unfulfilled striving. (Why not? It's about being a teenager.) On the other hand, it's as perfect an expression of the moment as a great song.*

—David Thomson, *Have You Seen . . . ?*

## 1956
## HOT BLOOD

*As director.* Sc: Jesse Lasky Jr., based on a story by Jean Evans. Ph: Ray June.
Cast: Jane Russell (Annie Caldash), Cornel Wilde (Stephano Torino), Luther Adler (Marco Torino), Joseph Calleia (Papa Theodore), Jamie Russell (Xano), Nina Koshetz (Nita Johnny), Helen Westcott (Velma), Mikhail Rasumny (Old Johnny), Wally Russell (Bimbo), Nick Dennis (Korka), Richard Deacon (Mr. Swift).
(CinemaScope and Technicolor, Harry Tatelman for Howard Welsch Productions/Columbia Pictures, 85 mins.)

> *While not really a success, Nicholas Ray's 1956 film about urban Gypsies, made between two of his masterpieces (*Rebel Without a Cause *and* Bigger Than Life*), has its share of interesting moments and vibrant energies, many of them tied to Ray's abiding interest in the folkloric. In some respects this color 'Scope feature comes closer than any of his other movies to the musical that Ray always dreamed of making.*
>
> —Jonathan Rosenbaum, www.jonathanrosenbaum.com

## BIGGER THAN LIFE

*As director.* Story and screenplay: Cyril Hume and Richard Maibaum, based on the article "Ten Feet Tall" by Berton Roueché in the *New Yorker*. Ph: Joe MacDonald.
Cast: James Mason (Ed Avery), Barbara Rush (Lou Avery), Walter Matthau (Wally Gibbs), Robert Simon (Dr. Norton), Christopher Olsen (Richie Avery), Roland Winters (Dr. Ruric), Rusty Lane (Bob LaPorte), Rachel Stephens (Nurse), Kipp Hamilton (Pat Wade).
(CinemaScope and DeLuxe Color, James Mason for 20th Century-Fox, 95 mins.)

> *It says something so poignant about both American life in the mid-fifties and American film. Fifties culture seemed so monolithic to the people who wanted to rebel against it: say, a blacklisted writer, or a homosexual kid in a small town.*

*But at the same time it's so fragile. It has so many fissures in it to begin with, it's just such a scant invention. Part of that has to do with the need to pretend that our great wealth and our world dominance and our way of life didn't just land on us as a weird accident of winning WWII but was somehow the American legacy and we've always had it and the war was just an interruption and now we're back to it.*

—Novelist Jonathan Lethem, interviewed by Jim Healy, www.cinema-scope.com

## 1957
## THE TRUE STORY OF JESSE JAMES

*As director.* Sc: Walter Newman, based on Nunnally Johnson's script for the 1939 film *Jesse James.* Ph: Joe MacDonald.

Cast: Robert Wagner (Jesse James), Jeffrey Hunter (Frank James), Hope Lange (Zee), Agnes Moorehead (Mrs. Samuel), Alan Hale Jr. (Cole Younger), Alan Baxter (Remington), John Carradine (Reverend Jethro Bailey), Rachel Stephens (Anne James), Barney Phillips (Dr. Samuel), Biff Elliot (Jim Younger), Frank Overton (Major Rufus Cobb), Barry Atwater (Attorney Walker), Marian Seldes (Rowena Cobb), Chubby Johnson (Arkew), Frank Gorshin (Charley Ford), Carl Thayler (Robby Ford), John Doucette (Sheriff Hillstrom).

(CinemaScope and DeLuxe Color, Herbert B. Swope Jr. for 20th Century-Fox, 92 mins.)

*The film bears all the hallmarks of a classic 50s Western—De-Luxe color, Cinemascope, day-for-night filters and Brylcreem quiffs. Although the studio interference caused the director to dismiss the film, it is a worthy addition to the Ray canon, reinforcing his reputation as a Hollywood auteur who turned any studio assignment into a thoughtful and personal work of art.*

—Paul Huckerby, www.electricsheepmagazine.co.uk

## BITTER VICTORY

*As director.* Sc: Ray, René Hardy, and Gavin Lambert, based on Hardy's novel *Amère victoire.* Ph: Michel Kelber.

Cast: Richard Burton (Captain Leith), Curd Jürgens (Major David Brand), Ruth Roman (Jane Brand), Raymond Pellegrin (Mokrane), Anthony Bushell (General R. S. Patterson), Alfred Burke (Lt.-Col. Callander), Sean Kelly (Lt.

Barton), Ramon de Larrocha (Lt. Sanders), Christopher Lee (Sgt. Barney), Ronan O'Casey (Sgt. Dunnigan), Fred Matter (Colonel Lutze), Raoul Delfosse (Lt. Kassel), Andrew Crawford (Pvt. Roberts), Nigel Green (Pvt. Wilkins), Harry Landis (Pvt. Browning), Christian Melsen (Pvt. Abbot), Sumner Williams (Pvt. Anderson), Joe Davray (Pvt. Spicer).

(CinemaScope, B & W, Paul Graetz for Transcontinental/Robert Laffont Productions/Columbia, 102 mins.)

> Bitter Victory *is aptly titled, starring Richard Burton condemned to a desert mission with the contemptibly pencil-pusher-risen superior who married his old love. Shot in black-and-white 'Scope on Libyan dunes, it's akin to the same year's* Paths of Glory *in its remorselessness about institutional cowardice, but personalized through Burton's Captain Leith—beyond cynical, brave, yet on the edge of brittleness.*
>
> —Nicolas Rapold, *The L Magazine*

# 1958
## WIND ACROSS THE EVERGLADES

*As director.* Sc: Budd Schulberg. Ph: Joseph Brun.

Cast: Burl Ives (Cottonmouth), Christopher Plummer (Walt Murdock), Chana Eden (Naomi), Gypsy Rose Lee (Mrs. Bradford), Tony Galento (Beef), Sammy Renick (Loser), Pat Henning (Sawdust), Peter Falk (Writer), Cory Osceola (Billy One-Arm), Emmett Kelly (Bigamy Bob), MacKinlay Kantor (Judge Harris), Totch Brown (One-Note), George Voskovec (Aaron Nathanson), Curt Conway (Perfesser), Sumner Williams (Windy), Howard I. Smith (George Leggett).

(Technicolor, Stuart Schulberg for Schulberg Productions/Warner Bros., 93 mins.)

> *Although the hero is, for once, a rebel with a cause, he is no less confused and helpless than Ray's earlier, more "negative" heroes.... When captured by the outlaws [Christopher] Plummer engages in an all-night drinking bout with their leader (a formidable, red-bearded Burl Ives), and each comes to a certain understanding and appreciation of the other's values. The range of feelings and moods conveyed in this extraordinary sequence is amazing; few moments in Ray's work so subtly yet forcefully express his own ambivalence. Where the audience expects a battle of wits ultimately won by the hero, what we actually see is an increasingly befuddled Plummer, and the emergence of a feeling akin, if not to friend-*

*ship, at least to mutual respect. Ray provides no pat answer, refuses to take sides, and leaves us with a bewildered sense of the relativity of all values.*

—Jean-Pierre Coursodon (with Pierre Sauvage), *American Directors*, vol. 2

## PARTY GIRL

*As director.* Sc: George Wells, based on a story by Leo Katcher. Ph: Robert Bronner.

Cast: Robert Taylor (Thomas Farrell), Cyd Charisse (Vicki Gaye), Lee J. Cobb (Rico Angelo), John Ireland (Louis Canetto), Kent Smith (Jeffrey Stewart), Claire Kelly (Genevieve, Farrell's Wife), Corey Allen (Cookie La Motte), Lewis Charles (Danny Rimett, Manager of the Golden Rooster), David Opatoshu (Lou Forbes, Farrell's Assistant), Kem Dibbs (Joey Vulner, Rico's Manager), Patrick McVey (Detective O'Malley), Barbara Lang (Ginger D'Amour, Party Girl), Myrna Hansen (Joy Hampton, Party Girl), Betty Utey (Cindy Consuelo, Party Girl).

(CinemaScope and MetroColor, Joe Pasternak for Metro-Goldwyn-Mayer, 99 mins.)

*Ray's direction, with its garish, searing streaks of color (red has rarely slashed the screen so violently), sharp diagonals, and quickly jerking wide-screen views, reflects its characters' raging energies and inner conflicts. A spectacular flameout of a dénouement reveals the self-destructive folly of unchecked ambition.*

—Richard Brody, the *New Yorker*

## 1960

## THE SAVAGE INNOCENTS

*As director.* Sc: Nicholas Ray. Adaptation by Hans Ruesch, Franco Solinas, and Baccio Bandini from the novel *Top of the World* by Ruesch. Ph: Aldo Tonti, Peter Hennessy.

Cast: Anthony Quinn (Inuk), Yoko Tani (Asiak), Carlo Giustini (Second Trooper), Peter O'Toole (First Trooper), Marie Yang (Powtee), Marco Guglielmi (Missionary), Kaida Horiuchi (Imina), Lee Montague (Ittimargnek), Andy Ho (Anarvik), Anna May Wong (Hiko), Yvonne Shima (Lulik), Anthony Chinn (Kiddok), Francis De Wolff (Trading Post Proprietor), Michael Chow (Undik), Ed Devereaux (Pilot). Narration by Nicholas Stuart.

(Super Technirama 70 and Technicolor, Maleno Malenotti for Magic Film/Appis Films/Gray Film-Pathe/Rank and Paramount, 110 mins.)

*It's possible to find many faults in Nicholas Ray's* The Savage Innocents *but you can't deny its slightly lunatic courage—gut it's got. In this respect, it resembles its director, one of the few American filmmakers who genuinely deserves to be called a maverick. Ray was hugely ambitious, willfully awkward, and his work flails alarmingly from the professionally competent and conventional to the utterly bizarre. His work is sometimes dazzlingly impressive and occasionally embarrassingly off-target, but he's got the obsession of a true visionary and in* The Savage Innocents *his vision is allowed to hold sway. For many years, it's been dismissed as an artistic and commercial failure and this is understandable because the film is somewhat removed, even alienating at times. But it's also madly, wildly beautiful.*

—Mike Sutton, homecinema.thedigitalfix.co.uk

# 1961
## KING OF KINGS

*As director.* Sc: Philip Yordan. Ph: Franz F. Planer, Milton Krasner, Manuel Berenguer.

Cast: Jeffrey Hunter ( Jesus Christ), Siobhan McKenna (Mary, Mother of Jesus), Hurd Hatfield (Pontius Pilate), Ron Randell (Lucius the Centurion), Viveca Lindfors (Claudia), Rita Gam (Herodias), Carmen Sevilla (Mary Magdalene), Brigid Bazlen (Salome), Harry Guardino (Barabbas), Rip Torn ( Judas), Frank Thring (Herod Antipas), Guy Rolfe (Caiaphas), Royal Dano (Peter), Robert Ryan ( John the Baptist), Edric Connor (Balthazar), Maurice Marsac (Nicodemus), Gregoire Aslan (Herod), George Coulouris (Camel Driver), Conrado San Martin (General Pompey), Gerard Tichy ( Joseph), Antonio Mayans (Young John), Luis Prendes (Good Thief), David Davies (Burly Man), José Nieto (Caspar), Ruben Rojo (Matthew), Fernando Sancho (Madman), Michael Wager (Thomas), Felix de Pomes ( Joseph of Arimathea), Adriano Rimoldi (Melchior), Barry Keegan (Bad Thief), Rafael Calvo (Simon of Cyrene), Tino Barrero (Andrew), Francisco Moran (Blind Man).

(Super Technirama 70 and Technicolor, a Samuel Bronston production for Metro-Goldwyn-Mayer, 171 mins.)

King of Kings *is not without flaws. But it has been unjustly marginalized in most examinations of Ray's work. . . . [While] not one of Ray's major achievements, it does contain significant features of authorship, cinematic style, and historical verisimilitude.*

—Tony Williams, *CineAction*

# 1963
## 55 Days at Peking

*As director.* Sc: Philip Yordan and Bernard Gordon. Ph: Jack Hildyard.

Cast: Charlton Heston (Major Matt Lewis), Ava Gardner (Baroness Natalie Ivanoff), David Niven (Sir Arthur Robertson), Flora Robson (Dowager Empress Tzu-Hsi), John Ireland (Sergeant Harry), Harry Andrews (Father de Bearn), Leo Genn (General Jung-Lu), Robert Helpmann (Prince Tuan), Kurt Kasznar (Baron Sergei Ivanoff), Philippe Leroy (Julliard), Paul Lukas (Dr. Steinfeldt), Elizabeth Sellars (Lady Sarah Robertson), Massimo Serato (Garibaldi), Jacques Sernas (Maj. Bobrinski), Jerome Thor (Capt. Andy Marshall), Geoffrey Bayldon (Smythe), Joseph Furst (Capt. Hanselman), Walter Gotell (Capt. Hoffman), Ichizo Itami (Colonel Shiba), Mervyn Johns (Clergyman), Alfredo Mayo (Spanish Minister), Martin Miller (Hugo Bergmann), Conchita Montes (Mme. Gaumaire), Jose Nieto (Italian Minister), Eric Pohlmann (Baron von Meck), Aram Stephan (Gaumaire), Robert Urquhart (Capt. Hanley), Lynne Sue Moon (Teresa), Lucy Appleby (Martha), Carlos Casaravilla (Japanese Minister), Michael Chow (Chiang), Felix Dafauce (Dutch Minister), Andrea Esterhazy (Austrian Minister), Mitchell Kowall (U.S. Marine), Alfred Lynch (Gerald), Nicholas Ray (U.S. Minister), Fernando Sancho (Belgian Minister), George Wang (Boxer Chief).

(Super Technirama 70 and Technicolor, a Samuel Bronston production for Rank/Allied Artists, 154 mins.)

> *In no respect a failure. With strong, memorable performances, muscular but imaginative and lucid direction, and a narrative that moves effortlessly between exciting scenes of battle and quieter, more meditative moments to create a very real feeling of private lives caught up in the huge shifts of history, it remains one of the finest epic spectaculars ever made.*
> —Geoff Andrew, *The Films of Nicholas Ray: The Poet of Nightfall*

# 1980
## Lightning over Water

Co-script and direction with Wim Wenders. Ph: Ed Lachman.

Cast (playing themselves): Gerry Bamman, Ronee Blakley, Pierre Cottrell, Stefan Czapsky, Mitch Dubin, Tom Farrell, Becky Johnston, Tom Kaufman, Maryte Kavaliauskas, Pat Kirck, Edward Lachman, Martin Müller, Craig Nelson, Timothy Ray, Susan Ray, Nicholas Ray, Martin Schäfer, Cris Sievernich, Wim Wenders.

(Eastmancolor, Wim Wenders for Viking Film, 91 mins.)

*Shot in 1979, as Ray rarely journeyed from his deathbed and as Wenders took a break from shooting his troubled first Hollywood film* (Hammett), Lightning over Water *is credited as a codirecting job between the two of them. It says more about the moral and therapeutic value of art and work than it does about Ray. Neither documentary nor narrative, it keeps pausing for odd asides and to dwell on Ray's physical decline and Wenders' own emotions, when the subject demands a greater focus. Even if it's not an ideal last testament, it still qualifies as an act of virtue that somebody even attempted to make one. Wenders has said that he would still have made the movie even if his cameras were empty, and the emotions behind every moment of* Lightning *support that claim.*

—Keith Phipps, The Onion A.V. Club

# *Other Credits*

## TELEVISION

### 1954
### HIGH GREEN WALL
*As director.* Episode of *General Electric Presents.*

## SHORT FILMS

### 1974
### WET DREAMS
*As director.* Episode 12, "The Janitor."

## MOTION PICTURES

### 1946
### SWING PARADE OF 1946
*Costory.*
Directed by Phil Karlson.

### 1964
### CIRCUS WORLD
*Costory.*
Directed by Henry Hathaway.

### 1977
### THE AMERICAN FRIEND
*Actor* (as Derwatt/Pogash).
Directed by Wim Wenders.

### 1979
### HAIR
*Actor* (as the General).
Directed by Milos Forman.

## DOCUMENTARY

### 1975
### I'M A STRANGER HERE MYSELF
Directed by David Halpern Jr. and James G. Gutman.

## UNFINISHED FILM

### C. 1975
### WE CAN'T GO HOME AGAIN
*As director.*

# Sources and Acknowledgments

**Queries and correspondence:** Norma Barzman, Walter Bernstein, Ernest Borgnine (via Harry Flynn), Robert Calhoun, Juan Cobos, Tom Farrell, Lamont Johnson, Arthur Laurents, Arthur Leipzig, Annegret Löwe, Ted Mahar, Sylvia Maibaum, Eugenio Martín, Gerald Peary, Irving Ravetch and Harriet Frank Jr., Susan Schwartz Ray, Allen and John H. Rindahl, John Sbardellati, Pete Seeger, Clancy Sigal, Claude Stanush, Bertrand Tavernier, Robert Wagner, Alan R. and Malvin Wald, Julian Zimet (a.k.a. Julian Halevy).

**Interviews:** Richard Baer, Jeff Chouinard, David Dortort, Bernard Gordon, Farley Granger, Millard Kaufman, Jud Kinberg, Mickey Knox, Joan Leslie, Richard Maibaum, Bill Pepper, Allene Roberts, José Lopez Rodero, Stanley Rubin, Marian Seldes, Stewart Stern, Herbert Swope Jr., Jon Manchip White, Philip Yordan.

**Advice and assistance in the U.S.:** Jeremy Arnold, Matthew Bernstein, Pat Broeske, Paul Buhle, Jean-Pierre Coursodon, Douglas Daniel, James V. D'Arc, Ronald L. Davis, Jim Drake, Lynne Morrish Drake, Scott Eyman, Philippe Garnier, Keith Halderman, Harry Hanson, Charles Higham, Brian Kellow, John Kern, Steven Korn, Bill Krohn, Al LaValley, Vincent LoBrutto, Glenn Lovell, Leonard Maltin, Joseph McBride, John McCabe, Dennis McDougal, Joe McNeill, Alisha Mendenhall, Marilyn Moss, Paul Gregory Nagle, James Robert Parish, Gerald Peary, Gene D. Phillips, Laurel Radomski, Joanna E. Rapf, Arnie Reisman, Christiane Retzlaff, Neal M. Rosendorf, Sasha Solodukhina, Michael Sragow, David Thomson, Dave Wagner, Duane Wright, Harold Zellman.

Especially: Ken Mate and his staff for their investigative acumen.

**Advice and assistance outside the U.S.:** Charles Barr, Isabel Matilde Barrios Vicente, Ruth Barton, John Baxter, Samuel Blumenthal, Jean-Loup Bourget, Christophe Damour, Frank Deppe, Bernard Eisenschitz, Terence Gelenter, Barbara Helgenberger, Enrique Herreros, Reynold Humphries, Yola Le Cainec, Daniel Lopez, Brian Neve, Anthony Tracy, Christine Retzlaff, Andre Rubin de Celis, Santiago Rubin de Celis, Bertrand Tavernier, Mary Troath, Christian Viviani, Gwenda Young, Francesco Zippel.

Special thanks to Dr. D. Antonio Castro Bobillo for inviting me to the Congreso Internacional in Madrid in 2008, where I discussed Ray and the blacklist.

I am also grateful to the staff and faculty of the School of History & Archives at University College Dublin, and to Marianne Doyle, Colleen Dube, and Janine Torrell of the Fulbright Commission of Ireland for welcoming me to Dublin for five months in 2009, a Fulbright teaching appointment that also permitted time for writing and research.

**Screenings and photographs:** John Baxter; Claire Brandt, Eddie Brandt's Saturday Matinee; Rosario Lopez de Prado, Filmoteca Espanola, Madrid; Rosemary Hanes, Moving Image Section, Library of Congress; Jerry Ohlinger's Movie Material Store; Scott McGee, Turner Entertainment Network; Paul Nagle; Allen Rindahl, Alan Rode and the Film Noir Foundation.

Special thanks to Francy Paquette of Allied Digital Photo in Germantown, Wisconsin, for many kindnesses and services.

**Archives and organizations:** Kristine Krueger, National Film Information Service (Production Code Collection), Margaret Herrick Library, Academy of Motion Picture Arts and Sciences; Center for Advanced Film Studies, American Film Institute; Rosalie Wagner, Aurora Public Library (Aurora, Indiana); Cinémathèque Française (Paris); Cecile W. Gardner, Reference Librarian, Boston Public Library; Charis Emily Shafer, Oral History Research Office, Butler Library, Columbia University; Rachel Howell, Texas/Dallas History & Archives, Dallas Public Library (Texas); Joyce L. Pike, Special Collections (Budd Schulberg Collection), Rauner Library, Dartmouth College; David M. Hardy, Section Chief, Records Management Division, Federal Bureau of Investigation; Office of U.S. Senator Russ Feingold (Wisconsin); Margo Stipe, Curator and Registrar of Collections, and Indira Berndtson, Administrator, Historic Studies, Frank Lloyd Wright Archives, Frank Lloyd Wright Foundation, Taliesin West (Scottsdale, Arizona); Rose Eddy, *Galesville Republican* (Galesville, Wisconsin); Leah Donnelly, Special Collections, Fenwick Library, George Mason University; Getty Research Institute (Frank Lloyd Wright Correspondence), Los Angeles, California; Don Dailey, local historian, and Stephanie Ralph, reference librarian, Granby Library (Granby, Colorado); Barbara Truesdell, Center for Study of History and Memory, Indiana University (Bloomington, Indiana); Lilly Library, Manuscripts Department (Clifford Odets Collection), Indiana University; Cara Gilgenbach, Special Collections (Robert Lewis Papers), Kent State University Library (Ohio); Connie Maginnis, Pastor, Kingfield United Methodist Church (Kingfield, Maine); Anita Doering, Brian Hannum, and Bill Petersen, Archives and Local History, City of La Crosse Public Library; Lois A. Groeschel, registrar in probate, La Crosse County; Steve Ross, director of student services, School District of La Crosse; Todd Harvey, Archive of Folk Culture (Alan Lomax Collection), Library of Congress.

Ian Stade, Special Collections, Minneapolis Central Library; Jackie Hess, director, Mitchell Public Library (Mitchell, South Dakota); Ellen Tuttle, communications officer, Nieman Foundation, Walter Lippmann House (Cambridge, Massachusetts); Lynne M. Thomas, curator, Rare Books and Special Collections (Willard Motley Collection), Founders Memorial Library, Northern Illinois University (DeKalb, Illinois); Ron Simon, Paley Center for Media (New York City); Mary Finney, Pendleton Public Library (Pendleton, Oregon); Andy Crews, Texana/Genealogy, San Antonio Public Library (Texas); Erin Corley and Elizabeth Botten, Archives of American Art (Esther McCoy Collection), Smithsonian Institution, Washington, D.C.; Cynthia Franco, Special Collections (Oral History Collection), DeGolyer Library, Southern Methodist University (Dallas, Texas); Spring Green Community Library (Wisconsin); Sylter Rundschau Archiv (Sylt, Germany); Scott McGee, TBS-TCM, Turner Entertainment Network; David F. Miller, Legal Department, 20th Century-Fox (Studio Production Records); Julie Graham, Arts Special Collections, University of California–Los Angeles (UCLA); Lilace Hatayama, Manuscripts Special Collections (John Houseman Papers), Charles E. Young Research Library, UCLA; Dyan Evans, Office of the University Registrar, University of Chicago; David Pavelich, Reference, University of Chicago Library; Special Collections, Regenstein Library, University of Chicago; James P. Liversidge, Popular Culture Collections, George A. Smathers Libraries, University of Florida; Kathryn Hodson, Special Collections (Richard Maibaum and Stewart Stern Papers), University of Iowa Libraries (Iowa City).

Ned Comstock, Archives and Special Collections (Jerry Wald Papers and Warner Bros. Production Records), University of Southern California (Los Angeles); Katharine Beutner, Harry Ransom Center (James Jones Papers), University of Texas–Austin; Joan Miller, Special Collections (Elia Kazan Papers), Wesleyan University; Winona Public Library (Minnesota); Linda S. Ghelf, Records and Registration, University of Wisconsin–La Crosse; Paul Beck and Linda L. Sondreal, Special Collections, Murphy Library, University of Wisconsin–La Crosse; Harry Miller, Wisconsin Center for Film and Theater Research (Dore Schary Papers), Wisconsin State Historical Society; Special Collections (Will Lee, Daniel Taradash, and George Wells Papers), American Heritage Center, University of Wyoming (Laramie); Cynthia Ostrof, Manuscripts and Archives, Yale University Library (New Haven, Connecticut).

Special thanks to the librarians of the La Crosse Public Library who helped me time and again with questions and research. I couldn't have done without the resources of the Raynor Memorial Library at Marquette University, especially the frequent advice and assistance of the reference department and the generous use of interlibrary loan.

While perusing the Lichtig sisters' papers in the Cinémathèque Française

library in the summer of 2008 I noticed a vaguely familiar face staring at me from across the table. We shook hands at the duplicating machine. Bernard Eisenschitz, whom I first met in Paris when working on my Jack Nicholson biography fifteen years earlier, was engaged in spadework for his new book about Fritz Lang, a previous subject of mine. I was busy poaching on the turf he had claimed for himself in his excellent book *Nicholas Ray: An American Journey*. We had a good chuckle about that overlap and met the next day for coffee and conversation.

Even though both are "warts and all," I have treated Eisenschitz's book and Susan Ray's compilation of her husband's writings and talks as "authorized" biographies. (Today Eisenschitz sits on the board of the Nicholas Ray Foundation.) Eisenschitz took shrewd advantage of access to many key individuals before they passed away, including members of the Kienzle family and Ray's ex-wives, girlfriends, and close professional collaborators. I have drawn from many of those interviews and from the trail his 1990 book blazed, acknowledging them as best as possible in my notes. I am also grateful for Eisenschitz's collegial tips and goodwill.

By the same token I have been intrigued by Ray and his films ever since I encountered the director during his flamboyant 1973 visit to the University of Wisconsin in Madison, back when I was an undergraduate there. Many people whom I met and interviewed over the next decades knew Ray, and they play a role in these pages: The list includes (but is not limited to) Ben Barzman, John Berry, Jules Dassin, Bernard Gordon, Millard Lampell, Jesse Lasky Jr., Arthur Laurents, Norman Lloyd, Joseph Losey, Richard Maibaum, Martin Ritt, Budd Schulberg, Stewart Stern, Daniel Taradash, and Philip Yordan. Although I do not quote from my talks with them directly unless the interviews were previously published, my discussions with them have informed my portrait of Ray.

Film scholarship is a continuum, and especially with the towering figures, there is always room for fresh research and corrections to history or hype. (I steal this thought from Dennis McDougal, who came to Milwaukee, treated me to dinner, and brazenly asked for total access to my Jack Nicholson files. I said yes and ended up blurbing his book, very different from mine.) With the great ones, there are always lingering ambiguities and mysteries to be argued or resolved by the next generation.

A handful of people helped me with this book, above and beyond the call of duty. Special thanks to the usual suspects: my sharp-minded agent Gloria Loomis; my longtime, peerless editor Calvert Morgan Jr., who tries to strengthen not only my writing but (bless him) my quavering voice; and finally my wife, Tina Daniell, and three children—Clancy, Bowie, and Sky. One way or another they all shared in the job of work.

# *Notes*

Only key specific sources not listed in the acknowledgments are cited.

## ONE: THE IRON FIST, THE VELVET GLOVE

*Special collections: Oral History Project, University of Wisconsin–La Crosse.*

"A big yellow barn . . ." and other Ferdinand Sontag quotes from Howard Fredericks's oral history with Sontag, 1979, Oral History Project, University of Wisconsin–La Crosse. "Bent towards incest . . ." and "Ever since I was four . . ." from Ray's "I am concerned with the state . . ." in *I Was Interrupted: Nicholas Ray on Making Movies,* edited by Susan Ray (University of California Press, 1993). "The loneliness of man . . ." from "Interview with Nicholas Ray" by Adrian Apra, Barry Boys, Ian Cameron, Jose Luis Guarner, Paul Mayersberg, and V. F. Perkins, *Movie* (May 1963). Unless otherwise noted, Ray is quoted on the subjects of his father, drinking, his family, and his boyhood in La Crosse from "I hate to bore people . . ." in *I Was Interrupted*. "I hated my father . . ." from Ray's "H.H." in *I Was Interrupted*. "I'd been a member . . ." and "The president of an illegal . . ." from Cliff Jahr's "Profile of Nicholas Ray," televised on *Camera Three* (CBS, 1977), included among the "extras" with the Criterion DVD release of *Bigger Than Life*. "Gordian knot of unbelievably . . ." from Mark Rappaport's "The Picture in Sal Mineo's Locker," www.sensesof cinema.com. "Nick didn't have a father . . ." from the interview with Susan Ray in *Live Fast, Die Young: The Wild Ride of Making "Rebel Without a Cause"* (Touchstone, 2005). "*His* family had much more . . ." from *Conversations with Losey* by Michel Ciment (Methuen, 1985).

"Maynard L: I spent ten dollars . . ." and "I got an A . . ." from the *Booster,* La Crosse Central High School Yearbook, 1929. Helen Kienzle quoted from *Nicholas Ray: An American Journey* by Bernard Eisenschitz (Faber and Faber, 1990). Background on Ray's involvement with Guy Beach Stock Company from "Two Local Men Meet on RKO Sound Stages in Hollywood for Filming

of New Production" in the *La Crosse Tribune* (Sept. 14, 1947). "Inflection, tone, volume, etc." and other coverage of Ray's radio contest from "Five Candidates Survive Radio Announcing Meet" (Mar. 22, 1929) and "Career of Radio Announcer Definitely Chosen by Youth Winning Contest Run Here" (July 21, 1929), *La Crosse Tribune and Leader-Press*. "Absolutely incapable" and "Did it come from . . . ?" from "Interview with Nicholas Ray," Charles Bitsch, *Cahiers du Cinéma* (Nov. 1958). "Night school graduate" from the *La Crosse Tribune and Leader-Press* ( June 5, 1929).

Ray's first college production is covered in *"February Flurries* of 1930 to Be Original Musical Comedy Revue" (Feb. 13, 1930) and "'February Flurries' Marks the Success of School Musical Revue" (Feb. 20, 1930), the *Racquet.* "A true expression of life" and other ideas attributed to Wilder from "Thornton Wilder Gives Unusual and Vivid Lecture" in the *Racquet* (Feb. 13, 1930). "The Bull-shevist" first appears in the *Racquet* on Feb. 20, 1931. "Thoughts while in Bath . . ." from the Feb. 27, 1931, issue; "Voting intelligence" and "our newly installed mayor . . ." from Apr. 24, 1931; "harp more on the environment . . ." from May 1, 1931; "The distribution of will-power . . ." from Feb. 20, 1931. "My first hitch-hike . . ." from Ray's American Film Institute (AFI) seminar (Apr. 26, 1973), and "his luck as an extra" from a CBS press release quoted in *Nicholas Ray: An American Journey*.

Books and other sources: George R. Gilkey, *The First Seventy Years: A History of the University of Wisconsin–La Crosse, 1909–1979* (University of Wisconsin–La Crosse Foundation, 1981); H. Margaret Josten, *La Crosse: A Century of Growth, 1842–1942* (La Crosse Business and Cultural Center, 1942); Myer Katz, *Echoes of Our Past: Vignettes of Historic La Crosse* (La Crosse Foundation, 1985); Walker D. Wyman, *History of the Wisconsin State Universities* (River Falls State University Press, 1968).

## Two: "Struggle Is Grand"

*Special collections: Eliza Kazan papers, Wesleyan University; Thornton Wilder papers, Yale University; Frank Lloyd Wright correspondence, Getty Research Institute.*

Kazan's description of Thornton Wilder and all other Kazan quotes, unless otherwise noted, from his autobiography, *A Life* (Knopf, 1988). Ray's reminiscences of the University of Chicago from "I hate to bore people . . ." and his sexual encounter with a professor from "In a Peapod . . ." in *I Was Interrupted*. "Wilder on stage" and coverage of the one-acts from *Cap & Gown*, the University of Chicago yearbook, 1932. "I didn't know whether I wanted to be a homosexual . . ." from "I hate to bore people . . ." in *I Was Interrupted*. "I'm not sure whether you mean . . ." from *Camera Three*.

"No way commercial" and the announcement of Ray's Little Theatre

Group from the *La Crosse Tribune and Leader-Press* (Jan. 17, 1932). "Entirely on the ability . . ." and the local review of *The Happy Journey to Camden and Trenton* from the *La Crosse Tribune and Leader-Press* (Feb. 17, 1932). "A ticklish part . . ." and the review of *Hay Fever* from the *La Crosse Tribune and Leader-Press* (May 1, 1932). Ray's home school for child actors reported in "Opening Private School in Drama" in the *La Crosse Tribune and Leader-Press* (June 17, 1932). "Young George Washington" and the July Fourth festivities from a series of articles in the *La Crosse Tribune and Leader-Press* (June 26 and 28, and July 3, 1932).

"Bazaar Bizarre" makes its first appearance (without a byline) in the Oct. 21, 1932, *Racquet*, which includes "I have been known . . ." and "apparently free of amorous entanglements." Ray's "r.n.k." byline first graces the Nov. 18, 1932, column ruminating on Homecoming. His thoughts on the prostitution of art are from the Dec. 2, 1932, issue. Ray's performance in *Candida* was extolled on the front page of the same edition.

"Those with the money . . ." and much of the background of life at Taliesin is drawn from the invaluable *The Fellowship: The Untold Story of Frank Lloyd Wright and the Taliesin Fellowship* by Roger Friedland and Harold Zellman (ReganBooks, 2006).

"I can't draw . . ." from Ray's AFI seminar. Details of Ray's life in 1933–34 come from the letters between him and Wright itemized in the five-volume *Frank Lloyd Wright: An Index to the Taliesin Correspondence* by Anthony Alofsin (Garland, 1988).

"Thrashed over. . . ," "dark years . . ." and "very stimulating . . ." from Ray's Aug. 10, 1933, letter to Wright. "I continue to battle . . ." and "I'll work like the devil . . ." from Ray's Sept. 29, 1933, letter to Wright. "Thoroughly broke" and "rather difficult . . ." from Ray's Oct. 25, 1933, letter to Wright. "That phase of modern architecture . . ." from Harold Stark's Aug. 7, 1933, letter to Wright. "Struggle is grand . . ." from Ray's Nov. 2, 1933, letter to Wright. "I am sorry that you lost . . ." from Ray's Sept. 15, 1933, letter to Wright. Wright wrote "my head is under" and "It is very difficult . . ." in a Sept. 18, 1933, reply to Ray. "Making a pest" and "I begin eating regularly" from Ray's Oct. 14, 1933, letter. "A stupid art class" from Ray's Oct. 25, 1933, letter to Karl E. Jensen.

"The drama of his life . . ." from "*Rebel*—The Life Story of a Film" by Nicholas Ray, *Daily Variety* (Oct. 31, 1956). All Jean Evans quotes, except where otherwise noted, from Bernard Eisenschitz's book. Taliesin's "orthodox" schedule from Ray's Feb. 16, 1934, "At Taliesin" newspaper column, reprinted in *"At Taliesin": Newspaper Columns by Frank Lloyd Wright and the Taliesin Fellowship, 1934–1937*, edited by Randolph C. Henning (Southern Illinois University Press, 1992). "A station for the flight of the soul" from *Frank Lloyd Wright and the Taliesin Fellowship*. "Mr. Wright believed . . ." from Ray's AFI seminar.

"An interpretation of the play . . ." from the Jan. 25, 1934, *Weekly Home News,* a Spring Green newspaper, which also misidentifies "Nicholas Bay." "First attempt . . ." and "The medium of the celluloid strip . . ." from Ray's Feb. 16, 1934, "At Taliesin" column. "Neither temple nor brothel . . ." from "Taliesin Student Calls Theater 'Idiot Child of a Sane Yesterday,'" carrying Ray's byline, in the Apr. 2, 1934, *Wisconsin State Journal.* "Movies taken in Greenland . . ." from "Taliesin's Winter Charm Described by Student" by Phillip Holliday in Madison's *Wisconsin State Journal* (Feb. 2, 1934). The "art and beauty" lecture recounted in the "Taliesin" column in the *Weekly Home News* (Apr. 19, 1934).

Ray was announced as "Director of the Taliesin Playhouse" in his hometown *La Crosse Tribune and Leader-Press* (Apr. 24, 1934). "Our way back . . ." from Ray's Feb. 16, 1934, "At Taliesin" column. "Frightfully eager to make good" from Frank Lloyd Wright's April 22, 1934, letter to Harold Stark. "Nick cut a handsome figure . . ." from *In Spite of Myself: A Memoir* by Christopher Plummer (Knopf, 2008). Henry Schubart is quoted from *Nicholas Ray: An American Journey.* "Big fellow—looks strong" from Wright's "Joke-Boy" column in the *Weekly Home News* (Apr. 20, 1934).

Ray's "battle" with Wright, quotes from his letter to Jean Evans, and Evans's account of her later "moralistic and vindictive" impression of Wright from *Nicholas Ray: An American Journey.* The sandstone façade/oak panels version of Ray's exit from Taliesin from "Nicholas Ray Hits Hollywood" by Robert LaBrasca in Madison's *Capital Times* (Mar. 16, 1973). Jonathan Rosenbaum's version of events from his article "Looking for Nicholas Ray" in *American Film* (Dec. 1981). "The horizontal was essential . . ." from Ray's Nov. 1958 interview in *Cahiers du Cinéma.* Ray's own sparse account of his sojourn in Mexico from *Nicholas Ray: An American Journey.* Ray's letter to Wright from Acapulco is dated June 1934; the one from 1937 is dated Aug. 27, while Wright's reply (by telegram) is dated Sept. 6.

Books and other sources: Richard H. Goldstone, *Thornton Wilder: An Intimate Portrait* (Dutton, 1975); Gilbert A. Harrison, *The Enthusiast: A Life of Thornton Wilder* (Ticknor & Fields, 1983); Edgar Tafel, *About Wright: An Album of Recollections by Those Who Knew Frank Lloyd Wright* (John Wiley & Sons, 1993); Frank Lloyd Wright, *Letters to Apprentices* (University California State Press, 1982).

## Three: Agitation of the Essence

*Special Collections: Alan Lomax papers, Library of Congress; John Houseman papers, UCLA; Esther McCoy papers, Archives of American Art, Smithsonian Institution; the Mercury Theatre/Theatre Union Oral History Project of Columbia University.*

"Advancing with true Marxist fervor . . ." from "Theatre of the Left" by

Bosley Crowther, *New York Times* (Apr. 14, 1935). "Probably the single greatest group . . ." is from the author's interview with Martin Ritt in *Tender Comrades* by Patrick McGilligan and Paul Buhle (St. Martin's Press, 1997). "Not beautiful" and "It was more realistic . . ." from Norman Lloyd's memoir *Stages: Of Life in Theatre, Film and Television* (Limelight, 1993). "Like a fresh wind blowing" is Will Lee from *Nicholas Ray: An American Journey.* "Sometimes we'd get testy . . ." from *Ballad of an American: The Autobiography of Earl Robinson* with Eric A. Gordon (Scarecrow Press, 1998). "He was always interesting, strange . . ." and "really burning" from Lloyd's interview with Ronald Davis in the Southern Methodist University Oral History Collection. "I never liked him much" from *Conversations with Losey.*

Vakhtangov is quoted from David Krasner's *Method Acting Reconsidered: Theory, Practice, Future* (Palgrave Macmillan, 2000). Ray discusses Vakhtangov as his "principal guideline" for directing actors in "In Class" in *I Was Interrupted.* "A powerhouse on wheels" is Earl Robinson quoted in *Nicholas Ray: An American Journey.* "Every strike, every picket line . . ." from the "Nicholas Ray: Rebel!" interview by Michael Goodwin and Naomi Wise in *Take One* (Jan. 1977). "Guerilla theater" is from "Rebel's Progress" by Andrew Kopkind in the *Real Paper* (Jan. 15, 1975). "Our lives obeyed the slogan . . ." from *Ballad of an American.* "We were a Communist theatre . . ." from *Nicholas Ray: An American Journey.* Ray is quoted on the influence of Al Saxe from *Nicholas Ray: An American Journey.* The genesis of the script for *The Young Go First* recounted in *Ballad of an American.* "Worshipped" but also "was frightened of him" is Perry Bruskin from *Nicholas Ray: An American Journey.* "This tremendous energy and this tremendous interest in you . . ." from Norman Lloyd's Southern Methodist University oral history. "Mr. Lawson Protests," John Howard Lawson's letter to the editor protesting the review of *The Young Go First,* is in the June 16, 1935, *New York Times.*

"All very indefinite" from "Future Book on the New Season," in the *New York Times* (Sept. 1, 1935). "One of the first theater groups . . . ," "We were in a sense . . . ," and "Al Saxe would start an improvisation . . ." from *Stages.* "It dawned on us . . ." from *Ballad of an American.* "Very unhappy" is David Kerman from Harry Goldman's 1982 interview with the actor, part of the Mercury Theatre/Theatre Union Oral History Project. "Approaching a movie technique" from *Conversations with Losey.* "I was not a member . . ." is Losey quoted in David Caute's *Joseph Losey: A Revenge on Life* (Faber and Faber, 1994). "Head the professional . . ." from "News of the Stage," the *New York Times* (Oct. 7, 1936). "We had two hours a day" from *Nicholas Ray: An American Journey.*

"Cabbage soup . . ." is Ray quoted in *Nicholas Ray: An American Journey.* "I lit a show . . ." is from "Film as Experience" by Joseph Lederer, *American Film*

(Nov. 1975). "By quoting poetry . . ." from "The Federal Diary," Scott Hart, *Washington Post* (Nov. 24, 1937). "With stowaway which will gain air . . ." from Ray's Sept. 27, 1937, letter to Frank Lloyd Wright. "Was certainly one of the most splendid young men . . ." and "like Damon and Pythias . . ." are Alan Lomax from *Nicholas Ray: An American Journey*. Lenore Thomas also quoted from *Nicholas Ray: An American Journey*. Ray's Washington, D.C., Political cabaret described in "Capital Night Clubs," *Washington Post* (Mar. 10, 1939), "War Tensity Puts Pall on D.C. Social Gaiety" by Hope Ridings Miller, *Washington Post* (Mar. 19, 1939), and "Non-Profit Cabaret Makes Bow in Washington; Non-Profit Revue Plays to a Capacity House," *New York Times* (Mar. 19, 1939). "I was very irritated . . . ," "confined to the Mitchell area . . . ," and "I have made several . . ." from Ray's Oct. 30, 1939, letter, dictated on WPA stationery, during a stopover in Jefferson City, Missouri, to Dr. Harold Spivack, chief of the Music Division, Library of Congress.

"Rushing around . . ." from Jean Evans's May 11, 1941, letter to Esther McCoy. "He wasn't true to her" and "I pitied his wife" from Pete Seeger's Jan. 24 and Feb. 12, 2008, correspondence with the author. "Out of the blue . . ." from Gavin Lambert's *Mainly About Lindsay Anderson* (Knopf, 2000). "The growth of jazz . . ." and "the Holiness Church . . ." from John Szwed's *Alan Lomax: The Man Who Recorded the World* (Viking, 2010). "Life was hell . . ." from Jean Evans's Apr. 1, 1977, letter to Esther McCoy. "The experiment . . ." is Alan Lomax quoted in Ronald D. Cohen's *Rainbow Quest: The Folk Music Revival and American Society, 1940–1970* (University of Massachusetts Press, 2002). "His homosexual experiences . . ." is John Houseman from *Nicholas Ray: An American Journey*.

Books and other sources: Joanne Bentley, *Hallie Flanagan: A Life in the Theatre* (Knopf, 1988); Bettina Berch, *Radical by Design: The Life and Styles of Elizabeth Hawes* (Dutton, 1988); Harold Clurman, *The Fervent Years* (Colonial Press, 1961); Shirley Collins, *America over the Water* (SAF Publishing, 2005); Ed Cray, *Ramblin' Man: The Life and Times of Woody Guthrie* (W. W. Norton, 2004); Edith De Rham, *Joseph Losey: An American Director in Exile* (Trafalgar, 1991); Robert Gordon, *The Purpose of Playing: Modern Acting Theories in Perspective* (University of Michigan Press, 2006); Bess Lomax Hawes, *Sing It Pretty: A Memoir* (University of Illinois Press, 2008); Norris Houghton, *Advance from Broadway: 19,000 Miles of American Theatre* (Harcourt, Brace, 1942); Charles F. Howlett, *Brookwood Labor College and the Struggle for Peace and Social Justice in America* (Edwin Mellen Press, 1993); Elise K. Kirk, *Music at the White House: A History of the American Spirit* (University of Illinois Press, 1986); Joseph Losey and Tom Milne, *Losey on Losey* (Secker & Warburg, 1967); William F. McDonald, *Federal Relief Administration and the Arts* (Ohio State University Press,

1969); Sophie Saroff, *Stealing the State: Sophie Saroff: An Oral History* (Community Documentation Workshop, 1983); Judith Tick, *Ruth Crawford Seeger: A Composer's Search for American Music* (Oxford University Press, 1997); Jay Williams, *Stage Left* (Scribner, 1974); Charles Wolfe and Kip Lornell, *The Life and Legend of Leadbelly* (HarperCollins, New York, 1992).

## Four: "Ungathered"

*Special collections: Robert Ardrey papers, University of Chicago; Robert "Bobby" Lewis collection, Kent State University Library; Department of Justice and Federal Bureau of Investigation Freedom of Information Act (FOIA) files; MGM Archival History Project, Turner Entertainment Network; Budd Schulberg papers, Dartmouth College.*

"The Joe Louis . . . ," "a regular philosopher . . . ," and "there's more of it under corn . . ." from Woody Guthrie's 1941 letter to Max Gordon quoted in full in Gordon's memoir *Live at the Village Vanguard* (St. Martin's Press, 1982). "The fifteen minutes was a little packed . . ." from Guthrie's Feb. 15, 1941, letter to Alan Lomax. "I wish there was some way . . ." from Lomax's Nov. 1, 1940, letter to Guthrie. "Goddam hillbilly music" from *Rainbow Quest.* "Too honest again . . ." from Guthrie's Feb. 20, 1941, letter to Lomax.

"A tough time financially" and "Nick and I and Tony . . ." from Jean Evans's May 11, 1941, letter to Esther McCoy. "A Woodrow Davy Wilson . . ." and "My need for getting out . . ." from Ray's July 10, 1941, letter to Alan Lomax. "Angry and resentful" and "I am the way I am . . ." from Evans's Oct. 16, 1942, letter to McCoy. "March thru hundreds of women" from an undated but signed letter from Ray to Budd Schulberg, in the Schulberg papers. Woody Guthrie's letter to Max Gordon commenting on the Lead Belly/Josh White duo (footnote) quoted from *Live at the Village Vanguard.*

"A great animator . . ." from Norman Lloyd's interview in the MGM Archival Project. These transcribed interviews, supplied to the author, offered background on Ray and many of his film productions. The interviewees included Corey Allen, Cyd Charisse, Farley Granger, Joan Leslie, Walter Matthau, Robert Mitchum, Maureen O'Hara, Anthony Quinn, Nicca Ray, Jane Russell, Barbara Rush, Budd Schulberg, Robert Sidney, George Wells, and Philip Yordan. Unless otherwise noted, John Houseman is quoted from volume two of his memoirs, *Front and Center: A Memoir* (Simon & Schuster, 1979). On occasion I switch to quoting from *Unfinished Business* (Virgin Books, 1988), which condenses, corrects, and slightly revises the earlier text. (For example, in *Front and Center,* Houseman says the Voice of America broadcast in twenty-two languages daily; in *Unfinished Business* he says it was "twenty-seven different tongues.") "In order to convince everybody . . ." from *Nicholas Ray: An American Journey.*

"Nick always looks happier . . ." from Alan Lomax's Dec. 13, 1941, letter to Woody Guthrie. Howard Taubman's "'Firing Line' Songs Thrill Audience" review of the Town Hall concert staged by Ray from the June 27, 1942, *New York Times*. "Talked sense . . ." from *Being Red* by Howard Fast (Houghton Mifflin, 1990). "Thoroughly investigated" and "On the night of so and so . . ." from Ray's *Take One* interview.

Ray's U.S. Department of Justice and Federal Bureau of Investigation files, obtained under the Freedom of Information Act, run several hundred pages of background and surveillance. Key documents include the Oct. 6, 1942, recommendation of Lawrence M. C. Smith, chief of the Special War Policies Unit, War Division, on Department of Justice stationery, urging that Ray be categorized with "the tentative dangerousness classification" of B-2; FBI director J. Edgar Hoover's confidential memo of Oct. 27, 1942, recommending that a "Custodial Detention" security index card be prepared for Ray; and Attorney General Francis Biddle's July 16, 1943, letter to Hugh B. Cox, Assistant Attorney General, and J. Edgar Hoover, voiding the "dangerous classifications" and "custodial detention" lists recommended by Hoover and the FBI.

Unless otherwise noted, Connie Ernst Bessie is quoted from *Nicholas Ray: An American Journey*. "She reminded me . . ." is Connie Ernst as described by Mary Welsh Hemingway in *How It Was* (Knopf, 1976). Also helpful to my portrait of Ernst was Ann Barley's *Patrick Calls Me Mother* (Harper, 1948) and Mervyn Jones's *Michael Foot* (Victor Gollancz, 1995). "The stink of the gallows" and "belonging to the theatre" from a surviving transcript of Ray's 1973 interview with University of Wisconsin–Madison students for the *Daily Cardinal* (the campus newspaper) and the *Velvet Light Trap* (film journal). "Went on a minor binge . . . ," "a creased and scrawling . . . ," and "graduation present" from Ray's Oct. 9, 1943, letter to Houseman (on Office of War Information stationery.) "I have to talk my ideas out . . ." from an undated letter from Ray among Houseman's papers.

"We had once wanted to marry" from Ray's "James Dean: The Actor as a Young Man" in *I Was Interrupted*. (This line, interestingly, was added to the revised version of Ray's 1956 article in *Variety*.) "I kiss Connie for you . . ." from Ray's undated letter to Houseman. Rep. Richard B. Wigglesworth's exchange with Office of War Information assistant director Vernon A. McGee from the National War Agencies Appropriation Bill for 1944, Hearings before the Subcommittee on Appropriations, Eighty-seventh Congress, First Session. Rep. Fred E. Busbey's attack on Ray and other alleged Voice of America Communists reported in "Probe Started of 22 Alleged Reds with OWI," *Washington Times-Herald* (Nov. 9, 1943). "Honorable mention . . ." from Ray's Nov. 20,

1943, letter to Houseman. "Thrown out of the OWI . . ." from *Nicholas Ray: An American Journey*.

"During the casting . . ." from *Nicholas Ray: An American Journey*. Ray describes his editing tutorials in "Cutting" in *I Was Interrupted*. "He hung around, took notes . . ." from *Kazan on Kazan* by Michel Ciment (Secker & Warburg, 1973). "It is very, very bad . . ." and "They think him a bit strange . . ." from Kazan's Aug. 9, 1944, letter to Molly Day Thacher, in Kazan's papers. "Doctors in the [Ray–Da Silva] screenplay . . ." from Virginia Wright's article profiling Da Silva in the *Los Angeles Daily News* (Apr. 25, 1945). The D. W. Griffith anecdote from Ray's "Homage to a Film Buff" in *I Was Interrupted*. *Tuesday in November* described in "An OWI Lesson in Civics and Other Items," A. H. Weiler, *New York Times* (Sept. 9, 1945).

"When it came to air time . . ." from Frances Buss's oral history in the Archive of American Television, Academy of Television Arts and Sciences Foundation. Articles about "Sorry, Wrong Number" by Judy Dupuy in the *Televiser* (vol. 1, 1946), the *Billboard* (Feb. 9, 1946), and *Variety* (Feb. 6, 1946) were also informative. "I'd come home at night . . ." from *Nicholas Ray: An American Journey*. Ray announced as director of *Beggar's Holiday* in "Miss Lillie May Do 2 New Shows Here," Louis Calta, *New York Times* (Dec. 24, 1946).

Books and other sources: Betsy Blair, *The Memory of All That: Love and Politics in New York, Hollywood and Paris* (Knopf, 2003); Jon Bradshaw, *Dreams That Money Can Buy: The Tragic Life of Libby Holman* (Morrow, 1985); D. G. Bridson, *Prospero and Ariel: The Rise and Fall of Radio: A Personal Recollection* (Victor Gollancz, 1971); Gary Carey, *Judy Holliday: An Intimate Life Story* (Seaview, 1982); Saul Chaplin, *The Golden Age of Movie Musicals and Me* (University of Oklahoma Press, 1994); David King Dunaway, *How Can I Keep from Singing: Pete Seeger* (McGraw-Hill, 1981); Joe Klein, *Woody Guthrie: A Life* (Knopf, 1980); David Hadju, *Lush Life: A Biography of Billy Strayhorn* (Farrar, Straus, 1996); Will Holzman, *Judy Holliday* (Putnam, 1982); Paul Milkman, *PM: A New Deal in Journalism, 1940–1948* (Rutgers University Press, 1997); Holly Cowan Shulman, *The Voice of America: Propaganda and Democracy, 1941–1945* (University of Wisconsin Press, 1990); Elijah Wald, *Josh White: Society Blues* (University of Minnesota Press, 2000).

## FIVE: ATMOSPHERE OF FEAR

*Special collections: Production Code Administration files, Academy of Motion Picture Arts and Sciences; Dore Schary papers, Wisconsin State Historical Society; Daniel Taradash collection, University of Wyoming; Willard Motley papers, Northern Illinois University.*

Charles Schnee is quoted from his bylined article "Films Enlist Amateur

Writers for Realism," *Los Angeles Examiner* (Oct. 25, 1959). "Extensive changes" from a May 12, 1947, letter from Production Code chief Joseph I. Breen to Harold Melniker of RKO. "Strengthening the voice for morality . . ." from a May 15, 1947, letter from Breen to Melniker. "Sex affair," and "this originally very difficult story" from Breen's June 10, 1947, letter to Melniker.

Farley Granger was interviewed by the author but is quoted from a variety of sources. (I spent an enjoyable and memorable evening with him and his partner Robert Calhoun, driving them to Chicago after the actor's personal appearance in Milwaukee promoting his memoir.) "I tried to make conversation . . . ," "Nick was completely articulate . . . ," "Houseman, a very canny man . . . ," and "Socially inarticulate, he was . . ." from Granger's memoir (with Calhoun) *Include Me Out: My Life from Goldwyn to Broadway* (St. Martin's Press, 2007). "I actually thought he was drunk . . ." from Granger's interview as part of the MGM Archival Project. "Intended to represent the long arm . . ." from Ray's 1963 *Movie* interview. "Such a thorough and painstaking . . ." from E. J. Strong's article "Forgotten Film Hit in London," *Los Angeles Times* (July 17, 1949).

Electronic news banks including (but not limited to) Access Newspaper Archive allowed me to search for accounts of Ray and people associated with his life and career in hundreds of American newspapers. Hedda Hopper, Louella Parsons, Dorothy Manners, and many other Hollywood correspondents are quoted from their columns in these news banks. While I do not cite every instance of usage, the scope of this coverage is suggested by a few examples noted here and elsewhere among the chapter notes. "A tall, athletic body . . ." from "Hollywood" by Gene Handsaker, which appeared in the *Progress,* Clearfield, PA (Oct. 12, 1949). "Outrageous, red, white and blue . . ." and "Men like Cecil B. DeMille . . ." from Frank Neill's "In Hollywood" column in the *Long Beach Independent* (Sept. 5, 1949). "The celluloid strip . . ." from *Camera Three.*

"An action unprecedented . . ." and Schary's public statement ("my own personal view . . .") from "Movies to Oust Ten Cited for Contempt of Congress," *New York Times* (Nov. 26, 1947). Maureen O'Hara from her book (with John Nicoletti) *Tis Herself: An Autobiography* (Simon & Schuster, 2005). "Imaginative, with what material he had" and "a neurotic man" from Thomas A. Arthur's May 31, 1974, interview with Melvyn Douglas in the Center for the Study of History and Memory, University of Indiana. Douglas's observation that Grahame "didn't have much of a range . . ." from Vincent Curzio's *Suicide Blonde: The Life of Gloria Grahame* (William Morrow, 1985). Curzio's book was an eye-opening source on the actress's life and career and especially her marriage to Ray (and, later, to Ray's son Tony).

"Our dull little picture . . . ," "the one courageous note . . . ," "The current

atmosphere of fear . . . ," and "And I wish I could report . . ." from Ray's July 16, 1948, letter to John Houseman. "No character, nothing . . ." is Paul Henreid quoted in *A.M.* Sperber and Eric Lax's *Bogart* (William Morrow, 1997). Besides Willard Motley's journal, which is quoted extensively in this text, his papers contained letters, legal documents, jotted notes, clippings, photographs, and other material relating to his novel and the screen adaptation of *Knock on Any Door.*

Daniel Taradash's papers offered a similar trove of documents, letters, script drafts and clippings. "Strange and remote" from David Thomson's interview with Taradash in *Backstory 2: Interviews with Screenwriters of the 1940s and 1950s* (ed. Patrick McGilligan, University of California Press, 1991). "The housing is as depressing . . ." from Taradash's Apr. 25, 1948, letter to Robert Lord. "I didn't like his dialogue . . ." from a note scribbled by Taradash found among his papers. "Bogart hasn't enough to do . . ." from Taradash's June 22, 1948, letter to Lord, citing the producer's concerns. "Points in my script calculated. . . ." from Taradash's undated typed itemization of scenes in his papers. "I am going to be awful tough . . ." from Lord's May 15, 1948, letter to Taradash. "Nick Ray has returned . . ." from Lord's May 6, 1948, letter to Taradash. "Both Bogart and Ray think . . ." from Lord's May 22, 1948, letter to Taradash. "The funny part of it is . . ." from Taradash's Nov. 1, 1948, draft letter to his agent Mary Baker.

Motley's four-page, typed letter to John Derek is dated July 25, 1948, after his trip to Hollywood. Motley's five-page, typed letter to Ray is dated the same day. "Can that Derek boy . . ." from Taradash's May 22, 1948, letter to Lord. "Terribly in need . . ." from Taradash's Apr. 22, 1948, point-by-point summary of proposed script revisions. "I begin shooting *Knock* . . ." from Ray's July 16, 1948, letter to Houseman. "afterwards, Bogie would come to me . . ." from *Nicholas Ray: An American Journey.* "Beyond our initial warm hello . . ." from *Include Me Out.* "Used to walk in empty lots . . ." from *Conversations with Losey.* "Believe it will be important . . ." from *Nicholas Ray: An American Journey.* "I thought we might make a comedy . . ." from Ray's *Take One* interview.

Books and other sources: Stephen Humphrey Bogart, *Bogart: In Search of My Father* (Dutton, 1995); "*Knock on Any Door:* How Single Courtroom Scene Involving Negro Was Screened in Humphrey Bogart's Powder-Puff Version of Motley Novel," *Ebony* (Jan. 1, 1949); Franklin Jarlet, *Robert Ryan: A Biography and Critical Filmography* (McFarland, 1990); Mickey Knox, *The Good, the Bad, and the Dolce Vita: The Adventures of an Actor in Hollywood, Paris, and Rome* (Nation Books, 2004); Jeffrey Meyers, *Bogart: A Life in Hollywood* (Houghton Mifflin, 1997); Ronnie Scheib, "Subconsciousness Raising," *Film Comment* (Jan.–Feb. 1981).

# Six: Mr. Nice Guy

Ray writes about Howard Hughes in "H.H." in *I Was Interrupted*. "Ray made me terribly nervous . . ." is Joan Fontaine from Ronald L. Davis's *Zachary Scott: Hollywood's Sophisticated Cad* (University Press of Mississippi, 2006). "Prided herself in knowing exactly . . ." from "In Class VI" in *I Was Interrupted*. "I was infatuated with her . . ." and "I wanted to be absolutely broke . . ." from "Back-gammon. Alarm rings . . ." in *I Was Interrupted*. Actresses Jane Greer and Jeff Donnell and acting coach Lillian Burns Sidney from *Suicide Blonde*. "I found him hard to deal with . . ." is Edmund H. North from his Southern Method-ist University oral history. "Make suggestions" and other Andrew Solt quotes from *Nicholas Ray: An American Journey*. Rodney (Rod) Amateau also quoted from the Eisenschitz book.

"My husband shall be entitled . . ." is from a publicity item that appeared in multiple syndicated newspaper accounts. Hadda Brooks's anecdote from her oral history in the Nathaniel C. Standifter Video Archive of Black Ameri-can Musicians, located at the University of Michigan–Ann Arbor. "At certain times when I would not drink . . ." from "The Attitude Toward Today" in *I Was Interrupted*. "After an involuntary performance . . ." from "In Class VI" in *I Was Interrupted*. "Shit! I can't . . ." from the documentary *I'm a Stranger Here Myself*. "Two original story ideas . . ." from *Nicholas Ray: An American Journey*.

Raymond Chandler is quoted from *Front & Center*. A. I. Bezzerides is quoted from an unpublished interview by Ken Mate, conducted for but never included in the *Backstory* series, among the author's papers in the Wiscon-sin Center for Film and Theater Research. "Some of the farmers . . ." from "In Class VI" in *I Was Interrupted*. "There was a constant dignity . . ." from Dore Schary's talk at Robert Ryan's 1973 funeral, in Schary's papers. "Very few suggestions . . ." is Ryan from *Nicholas Ray: An American Journey*. "Often asked . . ." is Ryan from Rui Nogueira and Nicoletta Zalaffi, "Recontre avec Robert Ryan," *Cinema 70*, no. 145 (April 1970), cited in the Eisenschitz book. "He was a much better actor . . ." from "Naturals" in *I Was Interrupted*.

"In the circle emanating from . . ." is Norman Lloyd quoted in *Live Fast, Die Young: The Wild Ride of Making "Rebel Without a Cause."* "Not a hotbed . . ." is Jules Dassin from *Tender Comrades*. Ray's parade in La Crosse celebrating the opening of *Flying Leathernecks* reported in "Nicholas Ray Visit Slated," *La Crosse Tribune* (Oct. 25, 1951). "I was meeting myself . . ." and "My dressing room was being repainted . . ." from Dick Lochte's interview with Robert Mitchum in *Mitchum: In His Own Words,* edited by Jerry Roberts (Limelight, 2000). "They said the picture needed three days' work . . ." is Mitchum from Andrew Britton's *Talking Films* (Fourth Estate, 1991).

Books and other sources: Frank Krutnik, Steve Neale, Brian Neve, and

Peter Stanfield, eds., *"Un-American" Hollywood: Politics and Film in the Blacklist Era* (Rutgers University Press, 1995); Andrew Horton, *Henry Bumstead and the World of Hollywood Art Direction* (University of Texas Press, 2003); Victor Navasky, *Naming Names* (Viking, 1980); Edmund H. North, Oral History, UCLA Special Collections; Lee Server, *Robert Mitchum: "Baby, I Don't Care"* (St. Martin's Press, 2001); Lee Server, *Screenwriter: Words Become Pictures* (Main Street, 1987); Steven C. Smith, *A Heart at Fire's Center: The Life and Music of Bernard Herrmann* (University of California Press, 1991); George E. Turner, "Heart of Darkness," *American Cinematographer* (July 1998); "Report on Atomic Espionage (Nelson-Weinberg and Hiskey-Adams Cases)" (House Un-American Activities Committee publication, 1949); *Shots in the Dark* (Allan Wingate, 1951); Allen Weinstein and Alexander Vassiliev, *The Haunted Wood: Soviet Espionage in America—the Stalin Era* (Random House, 1999).

## SEVEN: BREAD AND TAXES

*Special collections: Ben Maddow papers, University of California–Riverside; Clifford Odets papers, University of Indiana; Jerry Wald papers, University of Southern California.*

"Actually had almost thirty pages . . ." from *Camera Three*. "Nick and I, both stoned . . ." from the Lochte interview in *Mitchum: In His Own Words*. (In his interview at the National Film Theatre, also included in *Mitchum: In His Own Words,* the actor further confabulated about *The Lusty Men*: "We didn't have a script when it started. We had a letter from Tom Lee—it was about a seven-page letter—and we had something like twelve or thirteen pages of ideas, and sort of a beginning.") "Please be sure that I okay . . ." from Wald's Dec. 17, 1951, memo to production officials. The anecdote about Hayward's meeting with Ray and Mitchum from *Talking Films*. "Mitchum would bare his stomach . . ." from "Nick Ray Promises a Movie on 'Chicago Seven'" by Roger Ebert, *Los Angeles Times,* Mar. 8, 1970. "A strange guy . . ." is Arthur Kennedy quoted in Meredith C. Macksoud's *Arthur Kennedy: Man of Characters: A Stage and Cinema Biography* (McFarland, 2003). Mitchum's brother John wrote about "the Mystic" in *Them Ornery Mitchum Boys* (Creatures at Large Press, 1989).

Betty Utey is quoted from *Nicholas Ray: An American Journey*. The anecdote about Richard Brooks at the racetrack comes from "Notes by Ray," as described in a footnote to chapter 25 of the Eisenschitz book. "He was known to be great in the sack . . ." from Gavin Lambert's interview in *Live Fast, Die Young: The Wild Ride of Making "Rebel Without a Cause."* Hanne Axmann from *Nicholas Ray: An American Journey*. Lambert discusses the love affair of Ray and Edie Wasserman in *Mr. and Mrs. Hollywood: Edie and Lew Wasserman and Their Entertainment Empire* by Kathleen Sharp (Carroll & Graf, 2003). Unless

otherwise noted, Philip Yordan is quoted from interviews and correspon-
dence with the author and from his unpublished autobiography—two distinct
uncompleted versions, "A Bio" and "100 Films." I was encouraging Yordan's
progress on these manuscripts before his death in 2003. In addition, I con-
sulted Yordan's MGM Archival Project interview, which covered his collabo-
rations with Ray.

   "I've always felt that the psychology of color . . ." is from "Color Plays
Top Role in New Movie" by Ron Burton in the *Pasadena Star-News* (CA), June
28, 1958. Veteran Associated Press reporter Bob Thomas's reliable biography
*Joan Crawford* (Simon & Schuster, 1978), for which Ray, a longtime friend of
Thomas's, was interviewed, was my primary reference for what happened
behind the scenes of *Johnny Guitar*. But I also drew on Crawford's memoir
(with Jane Kesner Ardmore), *A Portrait of Joan: An Autobiography* (Paperback,
1964) and other books about the actress, including daughter Christina Craw-
ford's *Mommie Dearest* (Morrow, 1978), Roy Newquist's *Conversations with
Joan Crawford* (Citadel, 1980), Jane Ellen Wayne's *Crawford's Men* (Prentice
Hall, 1988), Lawrence J. Quirk and William Schoell's *Joan Crawford: The Es-
sential Biography* (University Press of Kentucky, 2002), Michelle Vogel's *Joan
Crawford: Her Life in Letters* (Wasteland Press, 2005), and David Bret's *Joan
Crawford: Hollywood Martyr* (Carroll & Graf, 2007). "One of the worst human
beings" is from Gavin Lambert's interview in *Live Fast, Die Young: The Wild
Ride of Making "Rebel Without a Cause.*"Quite a few times . . ." from Ray's *Take
One* interview. Sterling Hayden is quoted from his 1984 interview with Gerald
Peary, archived at www.geraldpeary.com.

   Winston Miller is quoted from John A. Gallagher's 1989 transcribed in-
terview with the screenwriter found among Miller's papers at the University
of Wyoming. (A shorter version was published in *Films in Review,* Dec. 1990.)
"What do they do . . ." from "Conversations with Nicholas Ray & Joseph
Losey" by Penelope Houston and John Gillett, *Sight and Sound,* Winter 60/61.
Viveca Lindfors is quoted from her Southern Methodist University oral his-
tory. Ray on Cagney from his *Movie* interview. "Both Nick Ray and I . . ." from
John McCabe's unfettered *Cagney* (Knopf, 1997). I also consulted Cagney's au-
tobiography *Cagney on Cagney* (Doubleday, 1976), which was ghostwritten by
McCabe. "I should have had my head examined . . ." from *Conversations with
Joan Crawford*. Truffaut's comments on *Johnny Guitar* from *The Films in My
Life,* as translated by Leonard Mayhew (Simon & Schuster, 1975).

   Books and other sources: Richard Baer, *A Memoir: I Don't Just Drop Names
to Sell Books* (iUniverse, 2005); Eric Bentley, *Thirty Years of Treason: Excerpts
from Hearings Before the House Committee on Un-American Activities, 1938–1968*
(Viking, 1971); Richard Brody, *Everything Is Cinema: The Working Life of Jean-*

*Luc Godard* (Metropolitan, 2008); Connie Bruck, *When Hollywood Had a King: The Reign of Lew Wasserman, Who Leveraged Talent into Power and Influence* (Random House, 2003); Antoine de Baecque and Serge Toubiana, *Truffaut: A Biography* (Knopf, 1999); Wheeler Winston Dixon, *The Early Film Criticism of Francois Truffaut* (Indiana University Press, 1993); Scott Eyman, *Empire of Dreams: The Epic Life of Cecil B. DeMille* (Simon & Schuster, 2010); Arthur Gregor, *A Longing in the Land: Memoir of a Quest* (Schocken, 1983); Charles Higham, *Hollywood Cameramen: Sources of Light* (Indiana University Press, 1970); Jim Hillier, ed., *"Cahiers du Cinéma": The 1950s: Neo-Realism, Hollywood, New Wave* (Harvard University Press, 1985); Annette Insdorf, *François Truffaut* (Cambridge University Press, 1994); Ron Lackmann, *Mercedes McCambridge: A Biography and Career Record* (McFarland, 2005); Beverly Linet, *Susan Hayward: Portrait of a Survivor* (Atheneum, 1980); Joseph McBride, *Searching for John Ford: A Life* (St. Martin's Press, 2001); Patrick McGilligan, *Cagney: The Actor as Auteur* (Oak Tree, 1982); Dennis McDougal, *The Last Mogul: Lew Wasserman, MCA, and the Hidden History of Hollywood* (Crown, 1998); Jean Narboni and Tom Milne, eds., *Godard on Godard* (Viking, 1972); Brian Neve, "Elia Kazan's First Testimony to the House Committee on Un-American Activities, Executive Session, 14 January, 1952," *Historical Journal of Film, Radio and Television* (June 2005); David Sterritt, *Jean-Luc Godard: Interviews* (University of Mississippi Press, 1998); Shelley Winters, *Shelley: Also Known as Shirley* (Morrow, 1980) and *Shelley II: The Middle of My Century* (Simon & Schuster, 1989); Peter Wollen, "Never At Home," *Sight and Sound* (May 5, 1994).

## EIGHT: THE GOLDEN WORLD

*Special collections: Stewart Stern papers, University of Iowa; Warner Bros. production files, University of Southern California.*

Few motion pictures have been covered so exhaustively in articles, books, and documentary films as *Rebel Without a Cause.* I have done my best to collect all the literature, a great deal of which recycles or overlaps the earliest accounts. The Warner Bros. production files and Stewart Stern's papers helped guide my coverage.

"Hollywood dinner dates . . ." from "Nicholas Ray Still a Rebel with a Cause" by Vincent Canby, *New York Times* (Sept. 24, 1972). "Wisconsin has never been so beautiful . . ." from "Healthy Condition of Film Industry Pointed to by Ray" in the *La Crosse Tribune* (July 13, 1954). Because Ray often told the anecdote of his post-*Dragnet* conversation with Lew Wasserman leading to the making of *Rebel Without a Cause,* there are multiple versions of what was said and what later transpired; my version is derived principally from Ray's *Camera Three* interview. "An adventurous studio . . ." also from *Camera Three.*

Again and again I drew from Ray's lengthy *Variety* article *"Rebel*—The Life Story of a Film," published to coincide with the first anniversary of James Dean's death. Ray's first encounters with Dean, Dean crossing paths with Clifford Odets, Ray's trip to New York pursuing Dean, the last time he and Dean saw each other, and Ray's comparison between Dean and a Siamese cat are among the key anecdotes, retold by Ray in later interviews, recounted in the *Variety* article for the first time. Inevitably anyone who interviewed Ray asked him about Dean or *Rebel*. Asked about the star during his American Film Institute seminar in 1973, the director said, "I no longer give interviews about Dean. I don't talk about him as I want to keep the reservoir filled up." But later, in fact, Ray did give other interviews about Dean.

Invaluably supplying Ray's perspective on the writing stages of *Rebel Without a Cause* was his bylined article "Story into Script," first published in *Sight and Sound* (Autumn 1956). Interestingly, "Story into Script" treats the progress of the script under the first two writers—Leon Uris and Irving Schulman—while stopping before the hiring of final writer Stewart Stern. Ray rarely discussed Stern, who is, for example, mentioned only twice in passing in *I Was Interrupted,* once pejoratively. Stern doesn't appear to have been interviewed for *Nicholas Ray: An American Journey.*

I repeatedly consulted Lawrence Frascella and Al Weisel's meticulously sourced *Live Fast, Die Young: The Wild Ride of Making "Rebel Without a Cause"* (Touchstone, 2005) and have tried to credit their original material in the text. Their evocative phrase "the teenage trinity," describing the lead trio of Jim Stark, Judy, and Plato, I adopted. "I think he hated himself . . ." from Gavin Lambert's interview for *Live Fast, Die Young: The Wild Ride of Making "Rebel Without a Cause."* "Find the keg of dynamite . . ." and "That one single concept . . ." from "In Class IX" in *I Was Interrupted.* "Exploitation campaign . . . ," "He's 25, looks 28 . . . ," and "intellectual approach . . ." from Ray's Oct. 18, 1954, memo to producer David Weisbart. "Is not only gaining insight . . ." from Ray's Oct. 7, 1954, memo to Weisbart. "Made me vomit . . ." from *Nicholas Ray: An American Journey.* "It was like an eye test . . . ," "His talent for inventing . . . ," "as I have two sons . . . ," and "Confronted with a giant replica . . ." from "Story Into Script."

"Aloof and solitary . . ." "Maybe a Siamese . . . ," and "intensely determined . . ." from *"Rebel*—The Life Story of a Film." "A far, far sicker kid" is Kazan quoted in Donald Spoto's *Rebel: The Life and Times of James Dean* (Harper-Collins, 1996). "He could never quite forgive . . ." is Ray from "Movie Fame for Dean Is Posthumous," Bob Thomas, syndicated by the Associated Press in the *Robesonian,* Lumberton, NC (Nov. 18, 1955). "I put him together with my son . . ." from *Camera Three.* "A monster . . ." is Leonard Rosenman from

*Rebel: The Life and Legend of James Dean.* "He wanted to belong . . ." is Ray from "Great Films of the Century: *East of Eden*" by Robin Bean, *Films and Filming,* May 1964. Silvia Richards is quoted from *Nicholas Ray: An American Journey.* "I didn't like working with Ray . . ." is Irving Shulman quoted from David Dalton's *James Dean: The Mutant King* (Straight Arrow, 1974).

Stewart Stern is often quoted from our e-mail exchanges and longtime correspondence. But I have also drawn from a number of other sources that feature interviews with the principal writer of *Rebel Without a Cause,* including Margy Rochlin's interview with Stern in my book *Backstory 2: Interviews with Screenwriters of the 1940s and 1950s* (University of California Press, 1997). "His 'moo' in Rebel is a souvenir . . ." from "Dialogue on Film: Stewart Stern" in *American Film* (Oct.1983). "Nick was in agony . . ." and "Without meaning to use specific . . ." from Kent R. Brown, *The Screenwriter as Collaborator: The Career of Stewart Stern* (Arno Press, 1980). "Who was having a terrible time . . ." and the inspiration of *On the Waterfront* from William Baer's *Classic American Films: Conversations with the Screenwriters* (Praeger, 2008).

My view of Natalie Wood is indebted to Gavin Lambert's compelling *Natalie Wood: A Life* (Knopf, 2004), which drew on the author's friendships with Ray and (later on) the actress to depict her behind-the-scenes romance with Ray during the making of *Rebel.* Wood and Dennis Hopper are frequently quoted from Lambert's book. Suzanne Finstad's *Natasha: The Biography of Natalie Wood* (Harmony, 2001) is equally authoritative, however, and Lambert often draws material from the earlier Finstad book.

"I felt exactly the way . . . ," "who wanted my ideas," and "golden world" is Natalie Wood from *Natasha.* (The latter may be a contraction of a statement from one of Wood's last interviews—Dick Moore, "A Last Visit with Natalie Wood," *McCall's,* Oct. 1984—in which the actress is quoted as saying, "He [Ray] opened the door to a whole new world. It was just glorious.") "This kid with a fresh scar . . ." and "All the other guys . . ." from *Natasha.* "Mysterious, laconic and powerful . . ." and "That [first] interview took place in the first week of February . . ." are Gavin Lambert quoted in "Dangerous Talents" by Sam Kashner, *Vanity Fair* (Mar. 2005). Jayne Mansfield's audition from *Natasha.* Ray's Mar. 1, 1955, memo ("We just spent three days . . .") from *Natasha.*

There are numerous versions of the anecdote Ray often told of Dean rehearsing the milk bottle scene, leading to the change in setting, the redesign of the living room to match Ray's residence, the blocking of the scene (Jim Stark's argument with his parents and physical tussle with his father), and the POV camerawork aligned to Dean's movements. My version borrows from the *Camera Three* interview in which Ray got up and acted out the moves. "It was all based on the . . ." from Ray's *Daily Cardinal* transcript. Ken Miller quoted from *Live Fast, Die Young.* Marsha Hunt quoted from *Natasha.*

"More like a Plato than a Billy Gray . . ." is Ray from *Natalie Wood: A Life*. The story of Sal Mineo's casting (including "I thought I dressed pretty sharp . . ." and Ray's frowning, "Sal. Every once in a while . . .") from H. Paul Jeffers's *Sal Mineo: His Life, Murder and Mystery* (Carroll & Graf, 2000). Richard Beymer from *Natalie Wood: A Life*. Ray's "Jimmy himself said . . ." and "as if *he* is your driver's license" from the Jeffers book, while "look at me the way I look at Natalie" is from *Natalie Wood: A Life*. "The first gay teenager . . ." is Mineo quoted in Boze Hadleigh, *Conversations with My Elders* (St. Martin's Press, 1987).

Stern recounts his visit to Kazan in *Classic American Films*. "Remember I worked with Frank Lloyd Wright? . . ." from Ray's *Take One* interview. Ray's claim that when Warner's threatened to shut down the production he tried to buy "all the rights to the film" (per footnote) is reported in *James Dean: The Mutant King*, for which the director was interviewed. "When you first see Jimmy . . ." from *James Dean: The Mutant King*. "That helps in the most external way . . ." from Ray's *Movie* interview. "Beautiful moods . . ." from *Camera Three*. "I taught him how to walk!" from Wim Wenders's book of photographs *Once* (D.A.P./Schirmer/Mosel, 2001). Ann Doran quoted from *Natasha*. Corey Allen quoted from *Nicholas Ray: An American Journey*. "Practically a codirector" from Jim Backus's *Rocks on the Roof* (Putnam's, 1962). "Jim Backus is an asshole" is Ray quoted in "55 Days with Nick Ray" by Mel Neuhaus in *Film Journal* (Spring 1994). "I liked Nick . . ." is Leonard Rosenman from *Natasha*. Dennis Hopper's "On the set Sal seemed always to be . . ." from *Sal Mineo: His Life, Murder and Mystery*.

"He was determined to do it . . ." from *Classic American Films: Conversations with the Screenwriters*. "Bit by bit emasculation" from Stern's May 5, 1955, letter to Steve Trilling. "I was glad that you finally realized . . ." from Stern's interview in *Live Fast, Die Young*. Stern's letter to Ray ("one of the happiest . . ."), dated May 19, 1955, is reproduced in Douglas L. Rathgeb's *The Making of "Rebel Without a Cause"* (McFarland, 2004). "My name is Nick Ray . . ." from Ray's June 7, 1955, interoffice communication to J. L. Warner. "Excellent" and "Dean beyond comprehension" from Jack Warner's July 1, 1955, memo to Steve Trilling. Jesse Lasky Jr. and Cornel Wilde from *Nicholas Ray: An American Journey*. "We had our holiday place . . ." from Ray's *Take One* interview.

Books and other sources: Patti Bellantoni, *If It's Purple, Someone's Gonna Die: The Power of Color in Visual Storytelling* (Focal Press, 2005); Peter Biskind, "*Rebel Without a Cause*: Nicholas Ray in the Fifties," *Film Quarterly* (Autumn 1974); Joe Hyams (with Jay Hyams), *James Dean: Little Boy Lost* (Warner Books, 1992); Jesse L. Lasky Jr., *Whatever Happened to Hollywood?* (Funk & Wagnalls, 1975); May Mann, *Jayne Mansfield: A Biography* (Pocket Books, 1973).

NINE: CIRCLE OF ISOLATION

*Special collections: Paul Gallico papers, Columbia University; Richard Maibaum collection, University of Iowa; 20th Century-Fox production and legal files, UCLA.*

"I didn't think anyone would pick up . . ." is from *Camera Three*. "He almost persuaded me . . ." from Ray's conversations with Lambert as recounted in *Mainly About Lindsay Anderson,* which treats Ray's life intimately in the immediate post-*Rebel* period and throughout the making of *Bigger Than Life, The True Story of Jesse James,* and *Bitter Victory.* "Without losing any scenes . . ." from Jack Warner and Steve Trilling's Sept. 20, 1955, telegram to Ray in Paris. Warner's publicity executive Carl Schaefer reports on his meetings with Ray and the strategy of promoting *Rebel Without a Cause* as a "sincere and intelligent" story as opposed to the "controversial" *Blackboard Jungle,* in his Sept. 16, 1955, letter to Arthur S. Abeles Jr. in Warner's London office. Roger Donoghue and Hanne Axmann from *Nicholas Ray: An American Journey.* "Much as I love the picture . . ." from Ray's Oct. 14, 1955, Convair aircraft company postcard to Steve Trilling. "Possibly if the timing . . ." from Trilling's Oct. 18, 1955, letter to Ray. "Never drove it" from Ray's *Take One* interview. "Tall, attractive . . ." is Jayne Mansfield as quoted in a nationally syndicated newspaper column item cited in May Munn's biography. Ray "cut absolutely no ice" from a Nov. 28, 1955, letter from Arthur S. Abeles Jr., London office, to Wolfe Cohen, Warner Bros.

Richard Maibaum's papers augmented my interview with Maibaum published in *Backstory: Interviews with Screenwriters of Hollywood's Golden Age* (University of California Press, 1986) and my follow-up correspondence with the writer and his wife, Sylvia Maibaum, after his 1991 death. The 20th Century-Fox legal files supplied information and detail about Ray's 1956 contract with the studio and the making of *Bigger Than Life* and *The True Story of Jesse James.* James Mason is quoted from his memoir *Before I Forget* (Hamish Hamilton, 1981) and from Rui Nogueira's illuminating "James Mason Talks About His Career in the Cinema," *Focus on Film* (Mar.–Apr. 1970).

"I think within two years . . ." is from Bob Thomas, "Movie Fame for Dean is Posthumous," one version of which was syndicated in the *Robesonian* (Lumberton, NC), Nov. 18, 1955. *"Rebel Without a Cause* out West" and "My preliminary production scheme . . ." from Ray's *Movie* interview. Walter Newman is quoted from Rui Nogueira's "Writing for the Movies: Walter Newman," *Focus on Film* (Autumn 1972). "This is an awfully difficult script . . ." from Molly Mandaville's Aug. 31, 1956, interoffice memo to Buddy Adler and higher-ups. "I do not understand . . ." from Adler's Sept. 10, 1956, memo dictated in New York to Mandaville. "All-American laughing boy . . ." from *Nicholas Ray: An American Journey.* "I'm sure he knew every possible . . ." from "In Class VI" in

*I Was Interrupted.* "The real reason they made it . . ." from Ray's *Film Journal* interview. "Continuous blackout . . ." from "I Was Thinking About a Man" in *I Was Interrupted.* Robert Wagner from his memoir (with Scott Eyman) *Pieces of My Heart* (Harper Entertainment, 2008). "I think some of the best scenes . . ." from *Nicholas Ray: An American Journey.* "I've only seen the movie once . . ." from Ray's *Movie* interview.

Helpful to my understanding of *Bitter Victory* was Carloss James Chamberlin's provocative "Regarding *Bitter Victory:* Hollywood's Philoctetes in the Desert, or La Politique des Comediens," at www.archive.sensesofcinema. com. Also enlightening was Anna Phelan Cox's "The Homosocial Struggle Versus the Heterosexual 'Home': The Dialectic of Desire in the Films of Nicholas Ray." Vladimir Pozner, Michel Kelber, and Rene Lichtig are quoted from *Nicholas Ray: An American Journey.* Christopher Lee from *Tall, Dark and Gruesome: An Autobiography* (W. H. Allen, 1977). "It's true that I lost . . ." from "Nicholas Ray: A Fine Director, Unemployed" by Vincent Canby, *New York Times* (June 8, 1959).

## Ten: Lost Causes

*Special collections: MGM production files, University of California–Los Angeles; Joe Pasternak collection, University of California–Los Angeles; Budd Schulberg papers, Dartmouth College; George Wells papers, University of Wyoming.*

"Always something of the poseur . . ." and "urgent theme of conservation" from Budd Schulberg's Dec. 16, 1981, letter to Andrew Sarris in the Schulberg collection. "I will check once more . . ." from Stuart Schulberg's Feb. 11, 1957, letter to his brother. "He's first-rate. Skilled . . ." is Steve Trilling quoted by Stuart Schulberg in the same letter. "For a number of reasons—not the least of them some uncertainty as to your availability" from Stuart Schulberg's Mar. 29, 1957, letter to Ray at the Hotel Negresco in Nice, France. "I know you will be as thrilled . . ." and "He seemed to us too physically magnificent . . ." from Stuart Schulberg's Aug. 22, 1957, letter to Ray at the Hotel Raphael in Paris.

"Flopped in his lap . . . ," "He was in a way a distortion . . . ," and "sop up the atmosphere . . ." are from the interview with Budd Schulberg in *Nicholas Ray: An American Journey.* The anecdote about the Everglades trip from the Eisenschitz book. Ray's undated, one-page, single-spaced, typed letter about Manon, addressed to "My very dear Budd" and signed "Always, Nick" is in the Schulberg papers. Christopher Plummer from *In Spite of Myself.* "I thought we'd all get together . . . ," "It was the first of three so-called attempts . . . ," the anecdote about the first read-through, and "in a sense that is what happened . . ." from *Nicholas Ray: An American Journey.* "Ives and Plummer both bedridden . . ." from a Jan. 10, 1958, "Budd and Stuart" telegram to

Steve Trilling. "Time, effort and cost . . ." from a Dec. 10, 1957, memo from Jack Warner and Trilling to Stuart Schulberg in Everglades City. "Methods of director unexpectedly intricate . . ." from a Dec. 19, 1957, Schulberg brothers telegram to Trilling. Roberta Hodes and Charlie Maguire are quoted from *Nicholas Ray: An American Journey*. "Schulberg refused to allow a range of respect among men" and Ray's accusation that Schulberg required a ghostwriter from his *Take One* interview.

"Just saw picture . . ." from Jack Warner's Apr. 22, 1958, telegram sent from New York to Steve Trilling in California. Stuart Schulberg's attempts to get Ray to view the "first cut" or subsequent versions of *Wind Across the Everglades* before the preview are recapped in his June 30, 1958, memo to Trilling. "Forget the whole matter . . ." from Trilling's July 1, 1958, interoffice communication with studio legal executive Roy Obringer. Ray reported his reaction to the *Wind Across the Everglades* preview in a three-page, double-spaced, undated letter addressed to "My Dear Budd" and copied to editor George Klotz, the Schulberg brothers, Steve Trilling, and Jack Warner.

George Wells is quoted with permission from a transcript of Eric Monder's 1992 interview with the writer, a portion of which appeared as "George Wells: Portrait of a Contract Writer" in *Classic Images* (June 1993). Ray discusses his color choices for *Party Girl* in "Color Plays Top Role in MGM's *Party Girl*," *Pasadena Star-News* (CA; June 30, 1958). "Like a true Method actor" and "I took him to the greatest . . ." from Ray's *Take One* interview. "As though you were smoking a joint" from Jean-Claude Missiaen's book *Cyd Charisse* (H. Veyrier, 1982), as cited in *Nicholas Ray: An American Journey*. "He [Ray] didn't have a clue about the [musical] numbers" from Charisse's interview in the MGM Archival Project.

"The first major script I wrote . . ." from "I Hate a Script" in *I Was Interrupted*. "I took more from the Archives of Copenhagen . . ." from Ray's *Take One* interview. Jacques Giraldeau and Aldo Tonti from *Nicholas Ray: An American Journey*. Peter O'Toole's wife, Siân Phillips, from *Public Places: My Life in the Theater, with Peter O'Toole and Beyond* (Faber & Faber, 2003). "All the Eskimo dialogue . . ." from Ray's *Take One* interview. "Terrible problems" and "On one or two occasions I even had to shoot . . ." from Jean Douchet's "Nicholas Ray les Dents du Diable sont mon meilleur film," *Arts* (May 4, 1960), as cited in *Nicholas Ray: An American Journey*. "The Star's a 'He-Man' off the Screen Too," *Winnipeg Free Press* (June 9, 1959), provides an unbylined, eyewitness account of Ray on the Arctic location of *The Savage Innocents*. "I suppose I should be tired . . ." is Ray from "*Nanook* 1960: Making a Film of Eskimo Life Today," the *Times* (Aug. 5, 1959). "The score had an Italian flavor . . ." from *Sight and Sound*, Winter, 1960–61. Eugene Archer's

article comparing Ray to Jean-Luc Godard and Michelangelo Antonioni appeared in the May 15, 1961, *New York Times*.

Books and other sources: Alfred Hayes, *Just Before the Divorce* (Atheneum, 1968); Tony Martin, Dick Kleiner, and Cyd Charisse, *The Two of Us* (Mason/Charter, 1976); Stuart B. McIver, *Touched by the Sun: The Florida Chronicles*, vol. 3 (Pineapple Press, 2001); Richard Porton, "Acting in the Grand Manner: An Interview with Christopher Plummer," *Cineaste* (Summer 2009); Budd Schulberg, *Across the Everglades: A Play for the Screen* (Random House, 1958); Stuart Schulberg, "Florida Screen Safari," *New York Times* (Jan. 19, 1958); Stuart Schulberg, "Letter to the Editor," *Films in Review* (May 1958).

## ELEVEN: THE MARTYRLOGUE

*Special collections: the Lucie and Renée Lichtig papers, Cinémathèque Française; Clifford Odets Collection, Indiana University.*

Vitally informing my *King of Kings* and *55 Days at Peking* narrative were the numerous Bronston organization documents channeled to me by Paul G. Nagle, who is writing his own book about the producer with Neal M. Rosendorf for the University of Texas Press. "For the first time since I completed . . ." from Ray's February 6, 1960, letter to Bronston, as cited in *Nicholas Ray: An American Journey*. "Pope's Direct OK . . ." appeared on the front page of *Variety*, Mar. 9, 1960. "A quiet and peaceful life" is Samuel Bronston quoted in "The Actor Who Will Play Christ" by C. Gregory Jensen in *Family Weekly* (Dec. 23, 1960). "Every place he lived . . ." and other Gavin Lambert quotes in this chapter from *Mainly About Lindsay Anderson*. Actor Robert Stack from his memoir (written with Mark Evans) *Straight Shooting* (Macmillan, 1980).

"Questionable bits . . ." from Bernard Smith's June 6, 1960, letter from Madrid to Sol Siegel. "The teaching method used in the synagogues . . ." is Ray speaking to Jean Douchet and Jacques Joly, "Nouvel entretien avec Nicholas Ray," *Cahiers du Cinéma* no. 127 (Jan. 1962), as cited in *Nicholas Ray: An American Journey*. "A Y-shaped grouping . . ." from "Last Supper Scene Changed for Film," *Big Spring Herald* (Texas), March 29, 1962. (The article appears without a byline and seems to be a publicity handout.) "The traditional, religious . . ." from "Christ Would Appear as Two-Fisted Spellbinder" by Erskine Johnson in the *Waterloo Daily Courier* (Iowa), Nov. 29, 1963. Ray Bradbury from *Listen to the Echoes: The Ray Bradbury Interviews* by Sam Weller (Stop Smiling Books, 2010).

"And [if] you like these plans . . ." from Ray's Feb. 11, 1961, letter to Clifford Odets in the Odets papers. Charlton Heston from his books *Charlton Heston: The Actor's Life: Journals, 1956–1976* (Dutton, 1978) and *In the Arena: An Autobiography* (Simon & Schuster, 1995). "Educating the critics . . ." from "Edu-

cating Critics" by W. J. Weatherby, the *Guardian* (Nov. 25, 1961). "A few over-awed fan-like words" from "Fueled by Enthusiasms: Jeffrey Crouse Interviews V. F. Perkins," *Film International* no. 9 (2004:3). Penelope Houston's article "The Critical Question" and Richard Roud's "The French Line" are in the autumn 1960 *Sight and Sound*. V. F. Perkins's views on "the world of Nicholas Ray" first appeared in issue no. 14 of the *Oxford Opinion* ( June 14, 1960). "We were planning . . ." from "City Natives Top Film Directors" by Roger Fuller, *La Crosse Sunday Tribune, Family Magazine* (Oct. 2, 1966). Serge Daney and Paul Grant define "the martyrlogue" in *Postcards from the Cinema* (Berg, 2007). Gore Vidal in this chapter from *Conversations with Gore Vidal,* eds. Richard Peabody and Lucinda Ebersole (University Press of Mississippi, 2005) and in chapter 12 from *Nicholas Ray: An American Journey.*

Ray defends *King of Kings* in "Bible-Film Critics Analyzed Sharply by Nichols Ray," Dick Williams, *Los Angeles Mirror* (Dec. 2, 1961). "I have always been concerned . . ." from "Last Supper Scene Changed for Film." "The wild expectations that were dreamt up . . ." from Philip Yordan's Mar. 9, 1962, letter to Bronston lawyer James E. Covington Jr. "The highest paid director . . ." is described in the Eisenschitz book as a repeated claim of Ray's in interviews during this period.

Bernard Gordon is quoted from *Hollywood Exile, or How I Learned to Love the Blacklist* (University of Texas Press, 1999). Over the years I frequently discussed Ray with Gordon and Philip Yordan. "One of Nick's troubles . . ." from "Dangerous Talents," *Vanity Fair* (Mar. 2005). "My mother said he was more excited . . ." is Nicca Ray from the same article. Ben Barzman is quoted from *Nicholas Ray: An American Journey.* Andrew Marton from Joanne D'Antonio's *Andrew Marton,* Directors Guild of America Oral History Series (Scarecrow, 1991). I also consulted Lee Server's *Ava Gardner: "Love Is Nothing"* (St. Martin's Press, 2006) for background on her involvement in *55 Days at Peking.*

## Twelve: Project X

*Special collections: David Helpern papers, University of Wisconsin–Madison; James Jones papers, University of Texas; Warner Bros. production files, USC.*

My version of Luis Buñuel's meeting with Ray is drawn from *Buñuel: 100 Years, 100 Anos* (Instituto Cervantes/Museum of Modern Art, 2000). Dr. Barrington Cooper is described from his Jan. 5, 2008, obituary in the *Times* (London). Frawley Becker is quoted from his memoir *And the Stars Spoke Back: A Dialogue Coach Remembers Hollywood Players of the Sixties in Paris* (Scarecrow, 2004). John Fowles from *The Journals,* vol. 1, ed. Charles Drazin ( Jonathan Cape, 2003). "Nick thought and spoke in English . . ." and other Barrington Cooper quotes from *Nicholas Ray: An American Journey.* "A film company

shooting a picture . . ." and William Fadiman's appraisal of Ray and the script of *The Doctor and the Devils* from a three-page undated memo in Warner's production files. "Working on the script daily . . ." from an Oct. 14, 1965, letter from entertainment attorney Lee N. Steiner to Eliot Hyman.

"I love the panorama of change . . ." from "I Like Sylt: Unser Exklusivinterview mit dem weltberühmten Filmregisseur Nicholas Ray," Herbert G. Hegedo, *Kuvzeitung sylt* (1969). "Here one could realize . . ." from "Aus Wanderern werden Gäste," Clara Enss, *Sylter spiegel* (summer 2001). I also relied on "Wenn ich geewinne, gewinnt die Inselt mit," from the Oct. 10, 1968, *Sylter rundschau* and the book *Sylt prominent* by local journalist Frank Deppe (Medien-Verlag Schubert, 2004). "He made one's ability . . ." from the V. F. Perkins interview in *Film International*.

Andrew Sarris wrote about *Party Girl* as part of "The Director's Game," *Film Culture* (Spring 1961), and the auteurist ranked Ray among the second tier of Hollywood directors in "The American Cinema," *Film Culture* (Summer 1961). Sarris penned his "Notes on the Auteur Theory" in *Film Culture* (Winter 1962–63). Dwight Macdonald wrote about Sarris and auteurism in his Oct. 1963 *Esquire* column. Pauline Kael's "Circle and Squares" appeared in *Film Quarterly* (Spring 1963). Sarris responded to Kael in "The Auteur Theory in the Perils of Pauline," *Film Quarterly* (Summer 1963). David Denby wrote about Kael's "embarrassing" lunch with Ray in "My Life as a Paulette," the *New Yorker* (Oct. 20, 2003). Gavin Lambert recalled mentioning Ray to John Ford in *Mainly About Lindsay Anderson*. "Not as good as *The Lusty Men* . . ." and "Directors who have not had the experience . . ." from *Camera Three*. "I started out as an actor . . ." from Vincent Canby's "Nicholas Ray, a Fine Director, Unemployed." George Cukor's opinion of Ray and *Wind Across the Everglades* from *Postcards from the Cinema*. Terry Curtis Fox recounted the anecdote about Ray and Fritz Lang in "Nicholas Ray, Without a Cause," the *Village Voice* (July 9, 1979).

"Abbie lifting his shirt . . ." is from Roger Ebert's interview with Ray in the *Los Angeles Times* (Mar. 8, 1970). Abbie Hoffman is quoted from *Nicholas Ray: An American Journey*. "I played the role of Judge Hoffman . . ." is Tom Hayden from *Rebel: A Personal History of the 1960s* (Red Hen Press, 2003).

Unless otherwise noted all Susan Schwartz Ray quotes come from her piece "The Autobiography of Nicholas Ray," introducing *I Was Interrupted*. Roger Ebert's interview with Ray from the Mar. 8, 1970, *Los Angeles Times*. The anecdote about Abbie Hoffman and "dead names" is from James Leahy's useful "Breathing Together: The Author in Search of Investors," www.sens esofcinema.com. (This was a reworking of an earlier article, also consulted for this book: "Blood and Ice: Images of Nicholas Ray," *Pix*, Spring 2001.)

Ray's last visit to La Crosse and his filming of Russell Huber from "Director
Uses Visit Home to Film Part of Movie" in the *La Crosse Tribune* (May 7, 1970).
"Fell asleep at the editing table" from Ray's *Take One* interview. Myron Meisel
from "Portrait of the Artist Buried in Film," *L.A. Reader* (Nov. 16, 1979). Perry
Bruskin from *Nicholas Ray: An American Journey*.

"He was more than a teacher . . ." is Tom Farrell from "We Can't Go
Home Again," *Sight and Sound* (Spring 1981). (I am also grateful to Farrell for
the earlier Melville/Ahab comparison.) "An adventure in time and space . . ."
from Vincent Canby's "Nicholas Ray: Still a Rebel with a Cause," *New York
Times* (Sept. 24, 1972). Jeff Greenberg wrote about the Harpur filmmaking
class in "Nicholas Ray Today," *Filmmakers Newsletter* (Jan. 1973). "We would
all drink together . . ." from Oren Moverman's interview with Danny Fisher in
the "Filmmakers on Film Schools" issue, *Projections 12* (Faber & Faber, 2002).
All Bill Krohn references from "The Class," *Cahiers du Cinéma* (May 1978). (An
English-language version of this article and a transcript of Krohn's extended
interview with Ray were provided to the author.) "The film they see . . ." from
"Film as Experience" by Joseph Lederer, *American Film* (Nov. 1975). "Very few
people . . . and we were starving . . ." is Charles Bornstein quoted in *Nicholas
Ray: An American Journey*. The anecdote about Susan Schwartz and Sterling
Hayden being stoned during the 1973 Cannes screening of *We Can't Go Home
Again* from *Nicholas Ray: An American Journey*. "Video creates a Socratic rela-
tionship . . ." from "Highlights from Cannes" by Betty Jeffries Demby, *Film-
makers Newsletter* (Nov. 1973). "It was something that somebody would do . . ."
is Philip Yordan quoted in *Nicholas Ray: An American Journey*. "He'd be zonked
out . . ." is Tom Luddy from Jonathan Rosenbaum's, "Looking for Nicholas
Ray," *American Film* (Dec. 1981).

Nicca Ray and Tom Farrell quoted from the *Vanity Fair* article. Chris Siev-
ernich quoted from "Looking for Nicholas Ray," *American Film*. "I am the best
damn filmmaker . . ." from "Nicholas Ray: From La Crosse to Hollywood" by
Rick Harsch, *La Crosse Tribune* (Jan. 14, 1996). "Although the film was a huge
success . . ." from Ray's *Movie* interview. "Just another straight to the nabe . . ."
from "55 Days with Nick Ray," *Film Journal* (Spring 1994). "A failure—unsuc-
cessful . . ." from "Film as Experience," *American Film* (Nov. 1975). "On the
grounds that those names . . ." from "Nick Ray in Portland" by Peter Nell-
haus, the *Animator* (Portland Art Museum, May–June 1973). Leslie Levinson
is quoted from *Nicholas Ray: An American Journey*. "Rebel's Progress," Andrew
Kopkind's interview with Ray, is in the Jan. 15, 1975 *Real Paper* (Boston).

"I have a camera in my head" and Ray's comparison of Marilyn Chambers
to "young Katie Hepburn" and Bette Davis from "Nick Ray Back; Lead Is
Porno Queen" by Addison Verrill, *Variety* (Apr. 21, 1976). Miloš Forman from

*Turnaround: A Memoir* (Villard, 1994). "An old friend . . ." from "Backgammon. Alarm Rings" in *I Was Interrupted*. "As a point of departure" is Wim Wenders from *Nicholas Ray: An American Journey*. "In an extreme state of rage" is Susan Schwartz Ray from *"Lightning* Ray's Final 'Despair'" by Clarke Taylor, *Los Angeles Times* (Jan. 10, 1982). William G. Cahan from *No Stranger to Tears: A Surgeon's Story* (Random House, 1992). "We lifted him on stage . . ." from Tom Farrell's e-mail correspondence with the author.

Books and other sources: James Jones, *To Reach Eternity: The Letters of James Jones,* ed. George Hendrick (Random House, 1989); Frank MacShane, *Into Eternity: The Life of James Jones, American Writer* (Houghton Mifflin, 1985); Jonathan Rosenbaum, "Circle of Pain: The Cinema of Nicholas Ray," *Sight and Sound* (Autumn 1973); Andrew Sarris, "The Acid Test of Auteurism," *Village Voice* (Nov. 11–17, 1981); Wim Wenders/Chris Sievernich, *Nick's Film/Lightning over Water* (Auflage, 1981).

# Permissions

## PHOTOGRAPHS

Kienzle family photographs courtesy of Allen Rindahl.

Ray's first Christmas, Ray and Jean Evans, and Ray with nonprofessionals while working for the Works Progress Administration courtesy of Bernard Eisenschitz and *Nicholas Ray: An American Journey*.

Front page of the *Racquet* courtesy of Murphy Library, University of Wisconsin–La Crosse.

Cast photograph of *The Young Go First* courtesy of the New York Public Library and Richard Valente and the Alfred Valente Estate. Photograph by Alfred Valente.

Photograph of the cast of *Rebel Without a Cause* at the first full reading of the script courtesy of Stewart Stern.

Photograph of Ray, Robert Wagner, and Elvis Presley courtesy of Robert J. Wagner from his book *Pieces of the Heart: A Life* (with Scott Eyman).

Ray and Harpur College students, Ray with Dennis Hopper, and Ray with Susan Schwartz courtesy of Mark Goldstein. Photographs by Mark Goldstein.

Ray on set of *Knock on Any Door*, Ray filming *On Dangerous Ground*, Ray with Robert Mitchum, Ray on a date with Joan Crawford, Ray with Natalie Wood, and Ray with Wim Wenders courtesy of Photofest.

All other photographs from the author's private collection. Many thanks to several helpful sources: Eddie Brandt's Saturday Matinee, Larry Edmunds Bookshop, Filmoteca Espanola (Madrid), Jerry Ohlinger's Movie Material Store, Alan Rode and the Film Noir Foundation, and the USC Cinema-Television Archives.

# MANUSCRIPTS

Melvyn Douglas interview by Thomas H. Arthur, May 31, 1974, quoted with permission of the Center for the Study of History and Memory, Indiana University.

Jean Evans is quoted by permission of Anthony (Tony) Ray and the Esther McCoy papers, Archives of American Art, Smithsonian Institution.

Elia Kazan's August 9, 1944, correspondence with Molly Day Thacher quoted with permission of the Elia Kazan Collection, Wesleyan University Cinema Archives.

Reminiscences of David Kerman courtesy of the Oral History Collection of Columbia University.

Oral histories from Viveca Lindfors, Norman Lloyd, and Edmund North are quoted with permission of DeGolyer Library, Southern Methodist University, Dallas, Texas.

Myron Meisel is quoted with his permission from "Portrait of the Artist Buried in Film," *L.A. Reader,* Nov. 16, 1979.

Willard Motley's journal and other writings are quoted courtesy of the Motley Estate, Christine Calhoun, and Denise LaMonte Smith.

Budd and Stuart Schulberg quoted courtesy of the Budd Schulberg Papers, Dartmouth College Library.

Frederick Sontag is quoted with permission of the Oral History Collection, Murphy Library, University of Wisconsin–La Crosse.

George Wells is quoted with permission of Eric Monder.

Ray's correspondence with Frank Lloyd Wright quoted courtesy of the Frank Lloyd Wright Foundation, Taliesin West.

# Index

Sarris, Andrew, 455–56, 480, 492
*Savage Innocents, The* (film), 381–88, 389, 393, 405, 413, 414, 426, 432
Saxe, Al, 55–56, 57, 58, 59, 60, 62, 73, 104
Schary, Dore: Academy Awards and, 113, 118; comments about Ryan of, 197; FDR Memorial and, 113, 124; Grahame's relationship with, 144, 147; Harpur student film and, 473; Houseman and, 124; HUAC testimony of, 141, 142; Losey's staging of Academy Awards and, 118; at MGM, 113, 149, 175, 373, 376; Ray and, 126, 139; reputation of, 113, 124; at RKO, 124, 126, 139, 149; *They Live by Night* and, 124, 131, 132–33; Waldorf-Astoria Hotel conference and, 141, 149; *A Woman's Secret* and, 143–45; as "youth movement" leader, 126
Schnee, Charles, 127–31, 133, 136, 175, 176, 270, 373, 376, 377, 410, 410n
Schulberg, Budd: Communism and, 227, 229, 357, 357n, 358; Donoghue story and, 267–68, 337, 361; drinking by, 368; firing of Ray and, 366, 367, 372–73, 435; Kazan and, 356, 357, 358, 368; Ray's commitment to *Wind Across the Everglades* and, 358–61; Ray's relationship with, 368, 372, 376; Ray's two-picture deal with, 358, 361; Sarris ranking of Ray and, 456; *Wind Across the Everglades* and, 357–68, 369, 370–75, 435, 456
Schulberg, Stuart: firing of Ray and, 366, 367, 372–73, 435; Ray's commitment to *Wind Across the Everglades,* 358–61; Ray's relationship with, 376; Ray's two-picture deal with, 358, 361; *Wind Across the Everglades* and, 357–68, 370–75, 435, 456
Scott, Adrian, 140, 141, 147, 199
Security Pictures, 402–3, 408, 411, 418, 437. *See also* Yordan, Philip
Seeger, Charles, 72, 77, 78, 79
Seeger, Pete, 77–78, 79, 81–82, 84, 94
Selznick, David O., 91, 113, 235
Senate Fact-Finding Committee on Un-American Activities (California), 141
*Sequence* journal, 178, 179, 231
Seven Arts Pictures, 447–48, 449
Sevilla Studios, 391, 400, 405, 407
Sezezechowski, Clarence. *See* Hiskey, Clarence Sezezechowski
Shulman, Irving, 276–78, 279, 283, 285, 307, 307n, 308
Siegel, Sol C., 394–95, 401, 404, 407
*Sight and Sound* journal, 319, 334, 386, 414, 455, 492
Simmons, Jack, 274, 293, 294
*Sit-Down* (play), 67–68
*Skin of Our Teeth, The* (play), 22, 101, 115
Skouras, Spyros, 228, 335, 344, 345
Snodgrass, Kathryn "Kay," 15–16, 17, 18, 20
Solt, Andrew, 183–84, 187, 222, 223
"Son of Man." See *King of Kings*

Sontag, Ferdinand, 5, 15, 26, 28–29, 30, 31
*Sorry, Wrong Number* (radio/TV show), 114–15, 262
Stack, Robert, 389, 397, 401
Stanislavski, Konstantin, 24, 53, 56, 63, 64, 225, 286, 292, 367, 486
Stark, Harold, 24, 27, 31, 33–35, 38, 45–46
State Department, U.S., 99, 100, 201
*States of the Union* (Voice of America), 93–94, 95
Stern, Stewart, 211, 278–84, 290, 292, 296–98, 305–8, 317, 354, 468, 477
Sternberg, Josef von, 211–12, 212n
Stevens, George, 275, 290, 308, 313
Strasberg Institute, 486–87, 488, 490
*Streetcar Named Desire, A* (play), 228, 267, 273, 295, 340
Supreme Court, U.S., 63–64, 65, 65n, 125, 141, 201
*Swing Parade of 1946* (film), 111
Swope, Herbert Bayard Jr., 335, 341, 344
Sylt Island: Ray on, 451–53, 458, 459

Taliesin Fellowship, 31–36, 38–48, 51, 52, 61, 81, 140, 276, 381, 427, 470
"Tambourine" project. See *Hot Blood*
Taradash, Daniel, 155–57, 158, 160, 162–63
Taylor, Robert, 140, 377, 378, 379, 479
television, 114, 124, 125, 262, 274
"Ten Feet Tall" (*New Yorker*), 320, 321–22, 323–25, 326–27; See also *Bigger Than Life*
Thacher, Molly Day, 58, 86, 100, 101, 105, 108, 272
"That Girl From Memphis" project, 116
Theatre of Action: Communism and, 72, 97, 141; HUAC hearings and, 73; Losey interrest in, 64; non-New Yorkers in, 68; radical theater movement and, 46–62; as training ground for Ray, 81; Washington Political Cabaret compared with, 74. *See also specific person*
Theatre Collective, 37, 38, 47, 49
*They Live by Night* (film): blacklisting and, 141–42; budget for, 136–37, 157; casting/shooting of, 131–37, 283; ending of, 235; European release of, 178–79, 231, 232, 233; Fontaine screening of, 175; Houseman-Schary discussion about, 124; Hughes takeover of RKO and, 150; Hughes views about title for, 131n; influence of Ray's personal life on, 8, 130; influences on, 2; postproduction editing of, 138–39; Production Code and, 118–20, 124, 127–31, 152; publicity for, 137, 138; Ray named writer-director for, 126–27; Ray's reputation and, 231, 232, 233, 260n, 414; Ray's views about, 163, 479; release of, 143, 150, 169, 178–79; retrospectives of, 415, 454; reviews of, 150, 178–79, 232, 319; screenings of, 142–43, 144, 159, 492; script/themes for, 117–20, 121–22, 126–31, 192,